BLUE

DOG

GEORGE RODRIGUE

FOREWORD BY TOM BROKAW

DESIGNED BY ALEXANDER ISLEY INC.

STEWART, TABORI & CHANG

NEW YORK

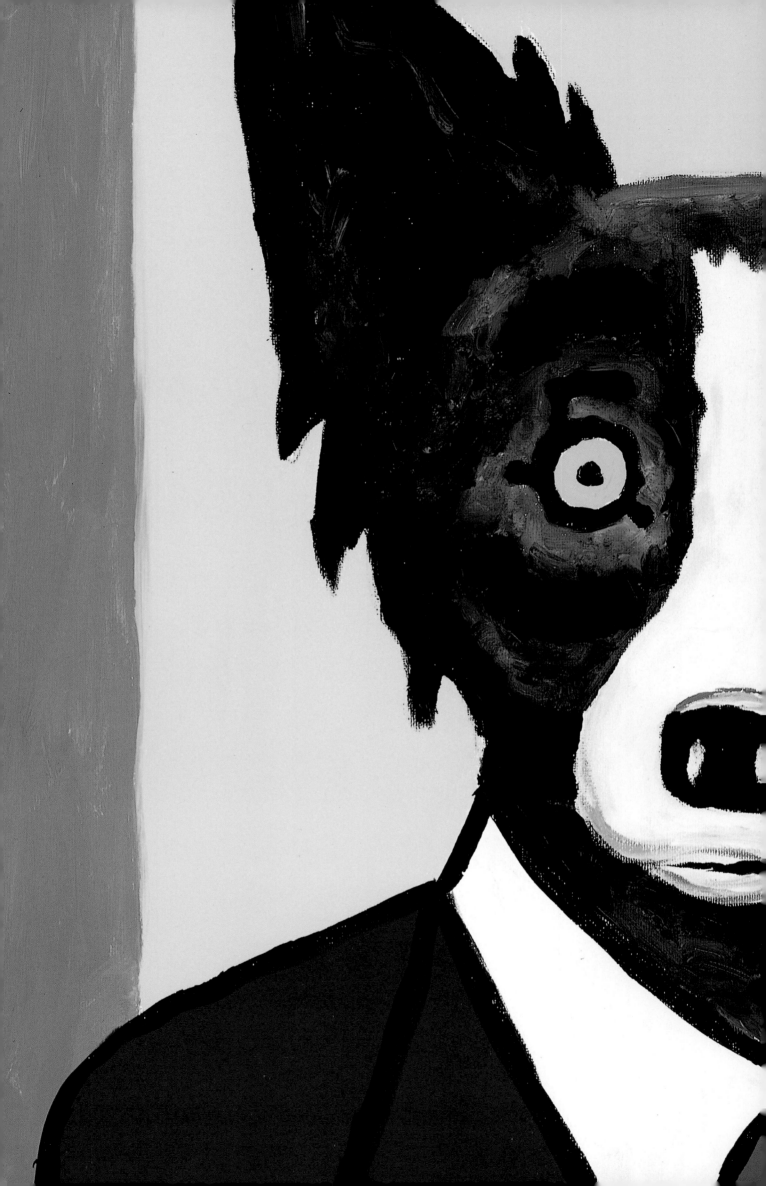

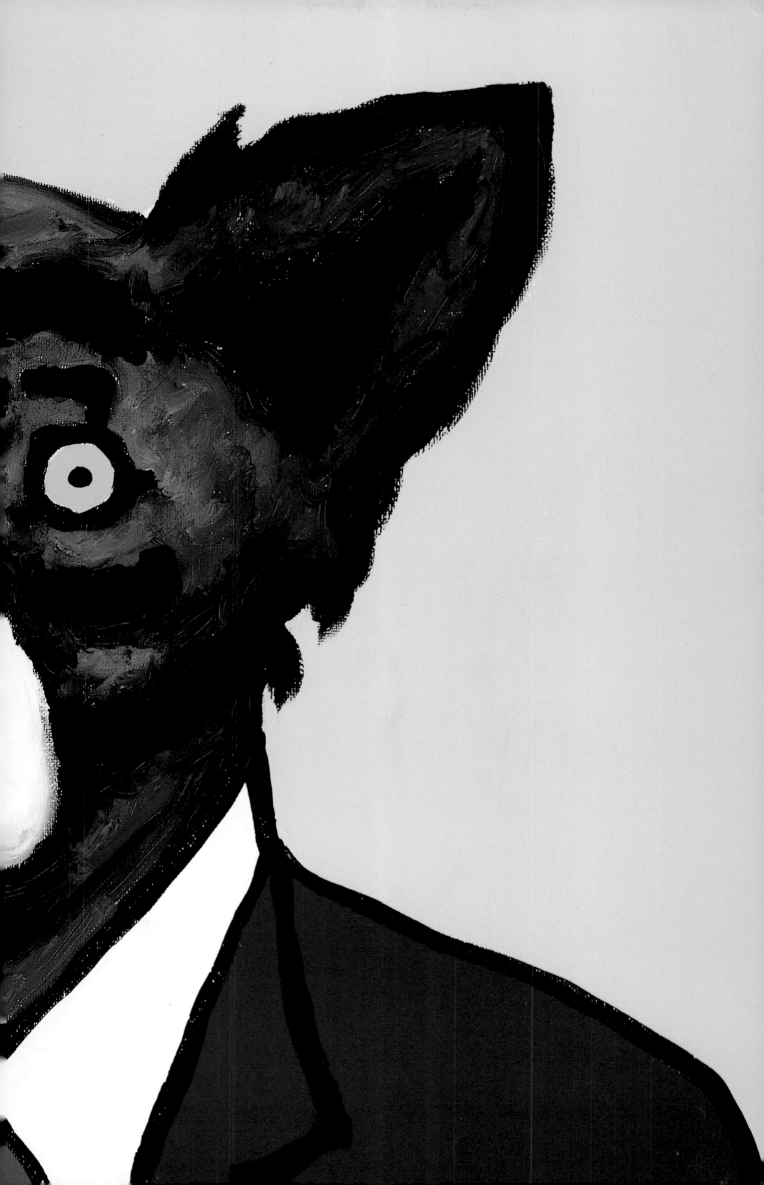

Deep in Blue Dog's eyes will always lurk the hopes and longings of

elancholy people, but, like the Cajuns, who always trained their eyes on the future,

Blue Dog must move forward.

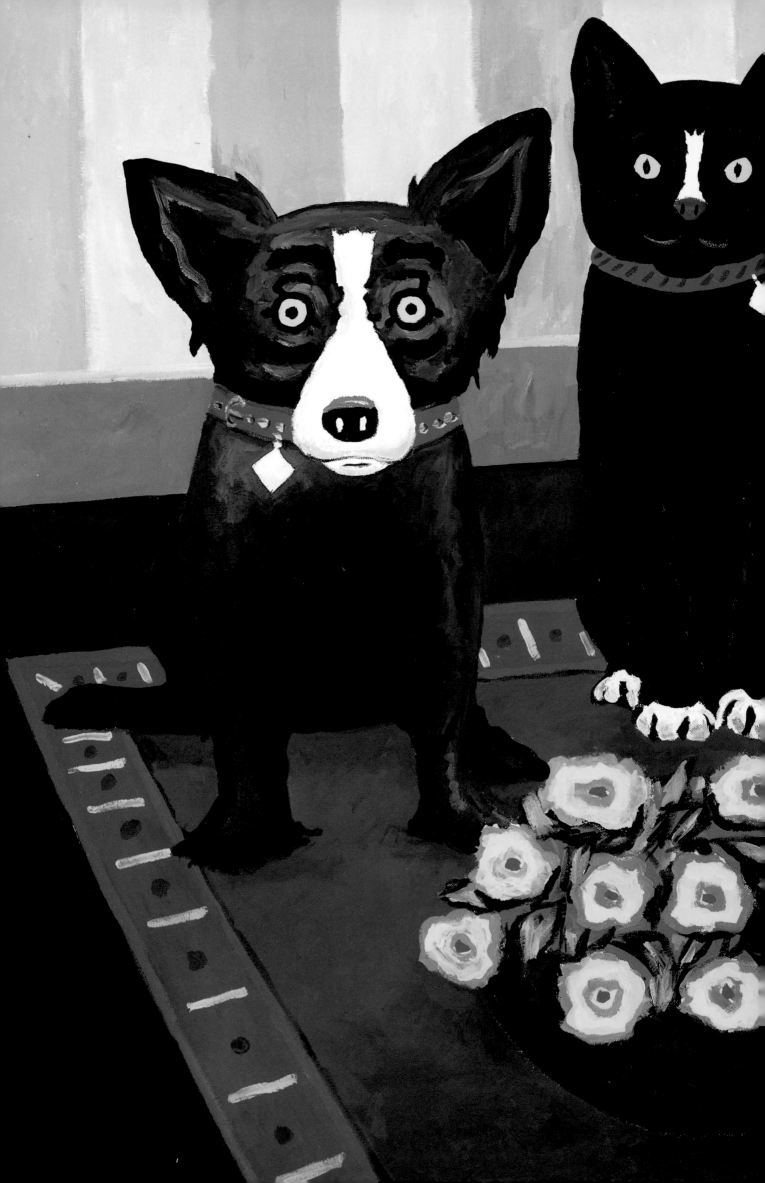

FOREWORD

Blue Dog and I share an office in my home. When I am
working, I can look up at the wall and see a picture
of Blue Dog staring out from within a television set.
The caption reads, "Sometimes I feel like a Blue Dog."
It's a funny, provocative commentary on the feelings I often have
as I look into the lens of a television camera and, by extension,
into the eyes of millions of Americans. "What are they thinking,"
I often wonder, "of the world I am describing to them?"

So it is one more persona for Blue Dog—a playful symbol of the
unspoken communication between anchorman and viewer. Of course,
what amuses me most of all is the unspoken part: the very enigma
of Blue Dog's baleful stare, the deeply silent expression in those
haunting eyes.

This amuses me because my friend George Rodrigue, the creator of
Blue Dog, is one of the most loquacious people I know. In the first
hour of our first meeting, George eagerly volunteered his life story, his
favorite Cajun foods, his best and worst real estate deals, his plans to
paint a portrait of George Bush, the friends we have in common, some
ribald Louisiana political lore, and a nonstop commentary on all that
was going on around him. It was punctuated by a great gleeful laugh
that is as much a part of his personality as his robust appetite for life.

However, when I saw his art I knew there was much more to this son of Cajun country. What too few know is that before he painted Blue Dog George was a highly acclaimed folk artist whose rich portrayals of backwater Louisiana life were eagerly collected. Well before Blue Dog made her first appearance, I was happy to purchase from George a stunning representation of a voodoo priestess visiting a Louisiana cemetery.

When I first saw Blue Dog in one of her early incarnations, I thought, "Hmmm, interesting." Then I turned away, but when I turned back and the dog was still staring at me, her ears alert, head slightly cocked, I began to understand George's excitement over his new work. He has captured more than the soul of a favorite but departed pet. In Blue Dog's steady and questioning stare, you can find personal introspection, a moment of imposed calm, and the unconditional love that dogs are justly famous for sharing.

Any appreciation of art is a subjective experience. If it moves you, lingers after you've walked away, makes you laugh, or simply infuses you with good feeling, it passes the test. Blue Dog does all that. And like the best of dogs, whatever their color, she asks nothing in return. Blue Dog is a reminder that there are some things in life that we should just accept on their own terms and never take for granted.

—TOM BROKAW

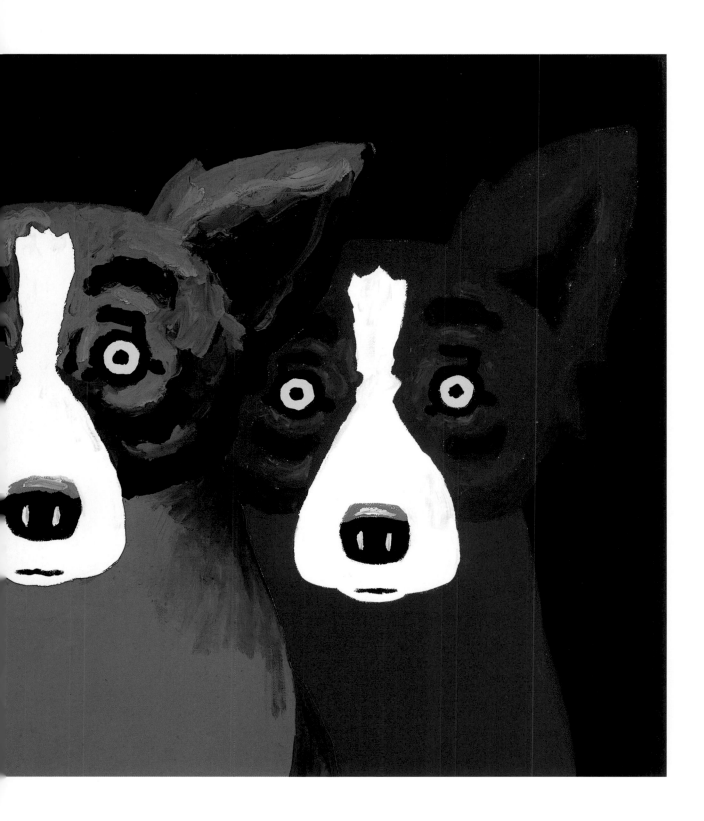

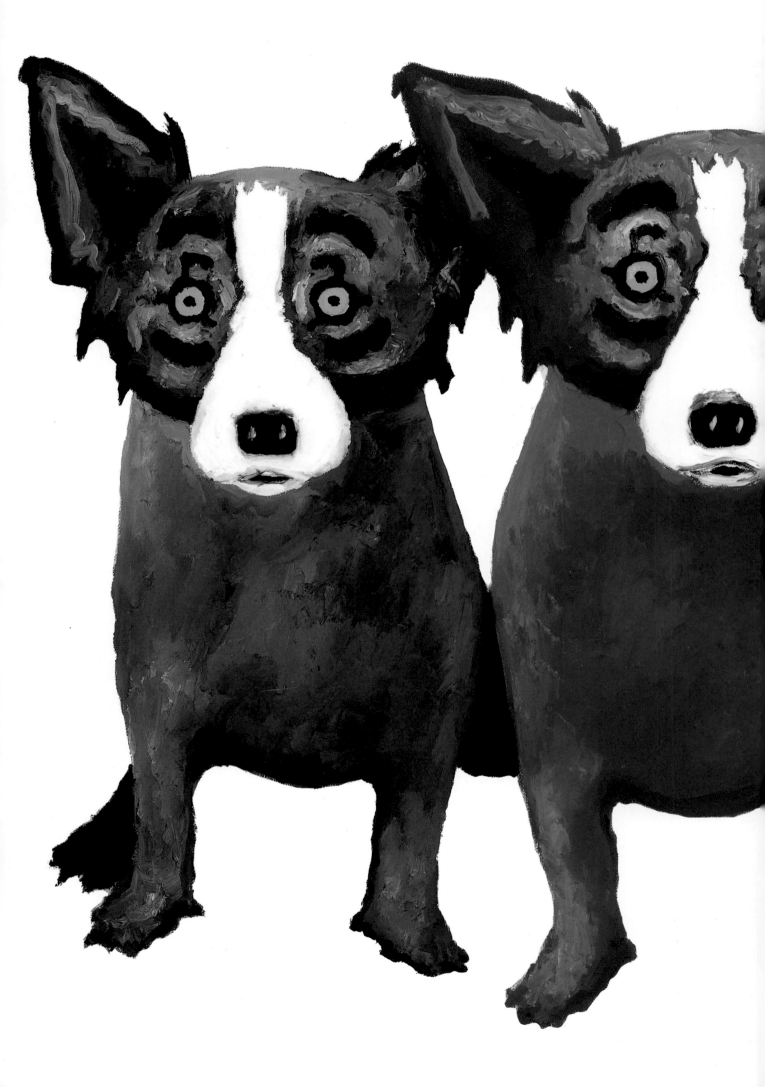

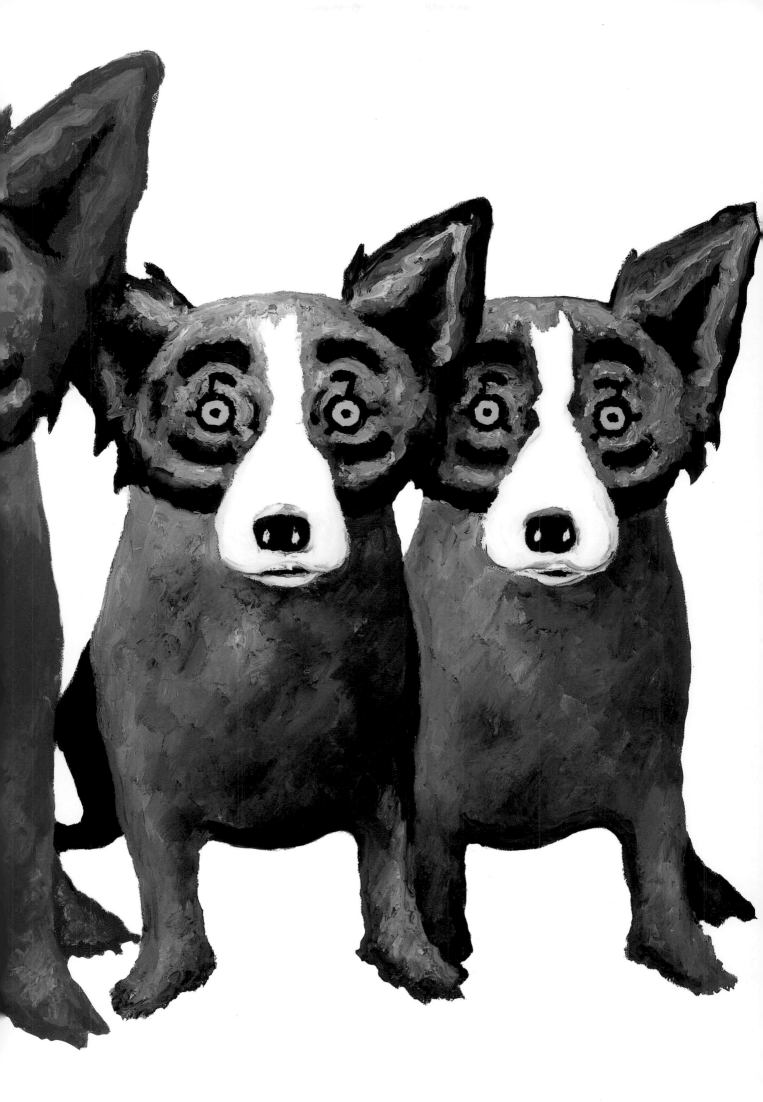

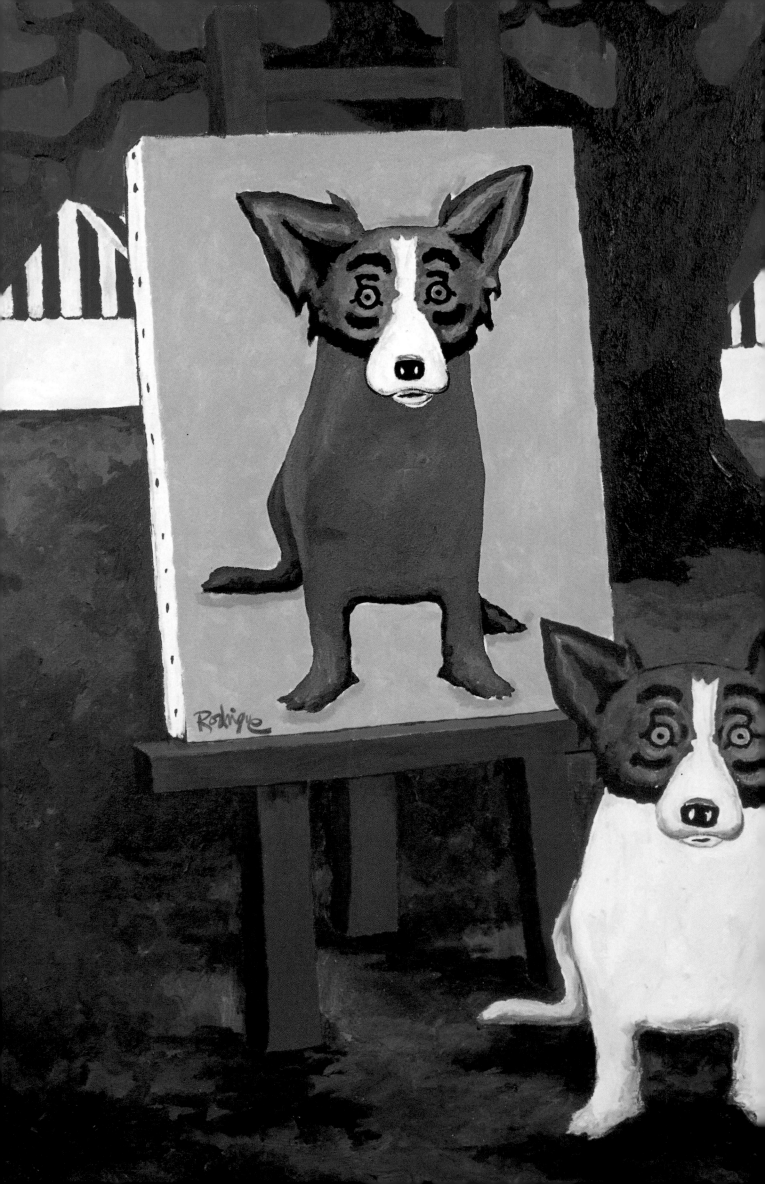

INTRODUCTION

When I first began painting Blue Dog about fifteen years ago, I had no idea where it would take me, and I suppose I can still say that today. Blue Dog was born in a corner of my soul where some very strong memories lurked—memories both of my lost black-and-white terrier/spaniel Tiffany and of the old Cajun werewolf legend of the Loup-Garou. Soon, Blue Dog began to take on a very distinct look and shape on my canvases, inhabiting the dark Cajun landscapes that I had been painting for years. Through Blue Dog, I found I was able to engage in a sort of dialogue with my lost canine companion, helping to guide her soul out of the netherworld of darkness and confusion where it dwelled. In the process, I learned a great deal about myself, about death, and about love.

Since then, Blue Dog has become such a fundamental part of my life that sometimes I wonder who's leading

19

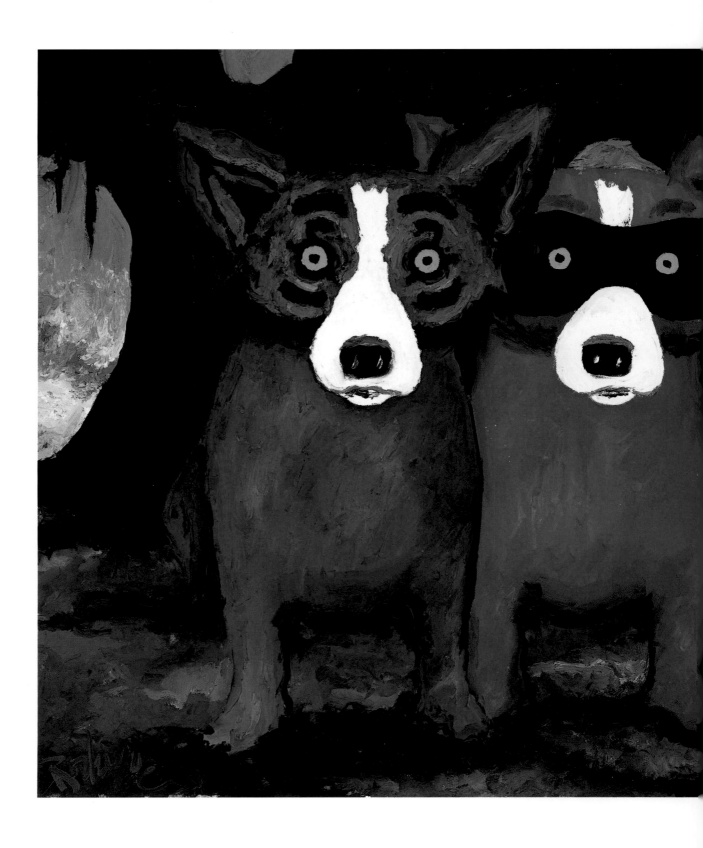

whom—dog or master? The answer, in the end, doesn't concern me. The wonderful thing about Blue Dog is that she's never hung up on playing a specific role; she will happily inhabit any world I put her in. Within Blue Dog is the history of the Cajun people and the history of myself—my joys and fears and visions, both of the world around me and the world yet to come. Yet Blue Dog is not a relic, bound to my past, nor is she an oracle that holds visions of the future. Most important, perhaps, Blue Dog is no longer simply a medium between me and the spirit of Tiffany.

Blue Dog has become something else: She has become a sort of traveler, and in some ways a vehicle. Through her I have been able to free myself from the dark Cajun landscapes where Blue Dog was born. Today, my paintings can take me anywhere. Through Blue Dog I can process the world around me— with all its complexity, color, noise, and absurdity. The paintings in this book reflect this new path.

I know that there is a whimsical quality to Blue Dog that people find appealing, and there is no doubt that Blue Dog helps me take the world a little less seriously. But painting her image is something I do take very seriously, and I feel that maybe it's time to put some of my thoughts into words. It's not about justifying my art or making it seem more important than it is.

It's about understanding my origins and feelings, which may help shed a little light on this creation that has been the focus of my life for the past decade and a half.

Painting depends on freedom. When you're feeling completely free, you can create, and this power to create is, in turn, the greatest freedom of all. Anyone can learn to paint a basket of fruit or a little terrier/ spaniel, for that matter—all it takes is technique. The challenge is to make the image haunting, to make it your own. I've always approached painting knowing that my job is not to make an accurate representation of a subject; it's got to transcend that. Salvador Dali was able to make wonderful transformations— a clock taking on liquid form, objects tearing loose from their physical origins. I, too, have come to a point where the subject of my paintings has unmoored herself from her origins, floating into ever-changing environments, always taking me along for the ride.

Over the past decade, I've discovered that I simply cannot *not* paint Blue Dog. Painting her has become as natural to me as eating and sleeping. I have become Blue Dog Man because I can never separate myself from her.

Blue Dog, I've discovered, has become the story of my life.

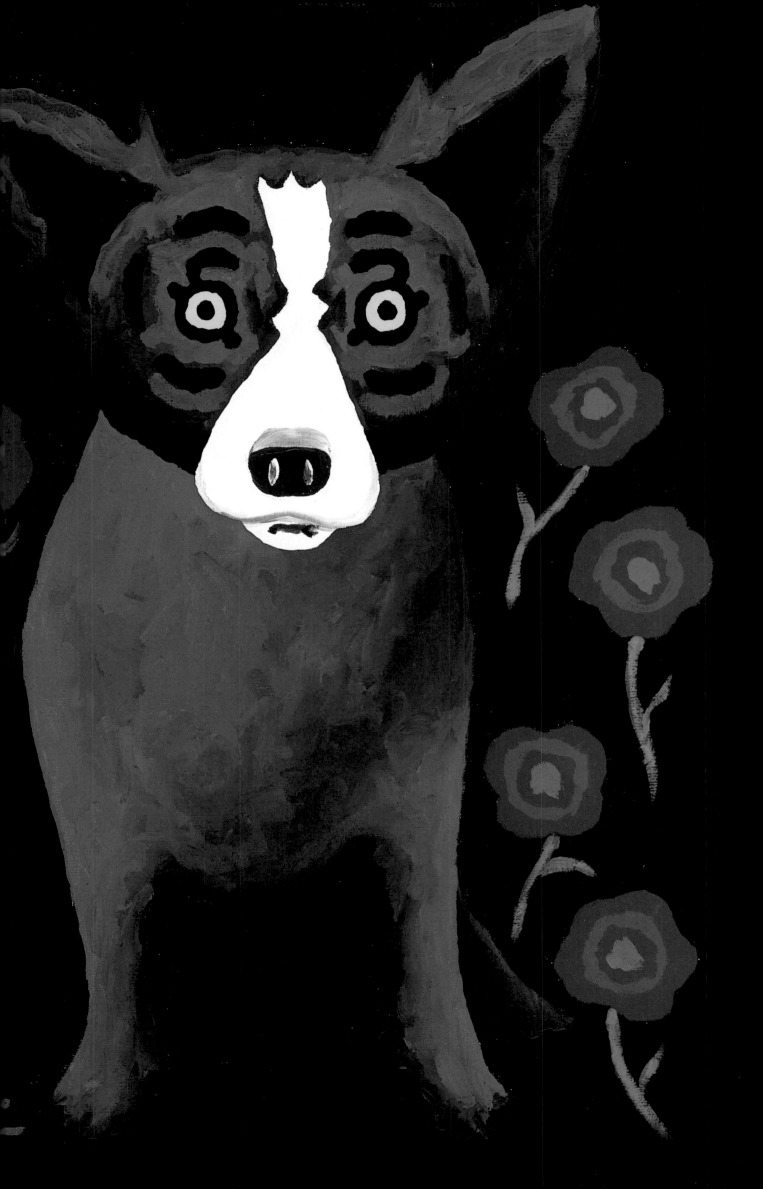

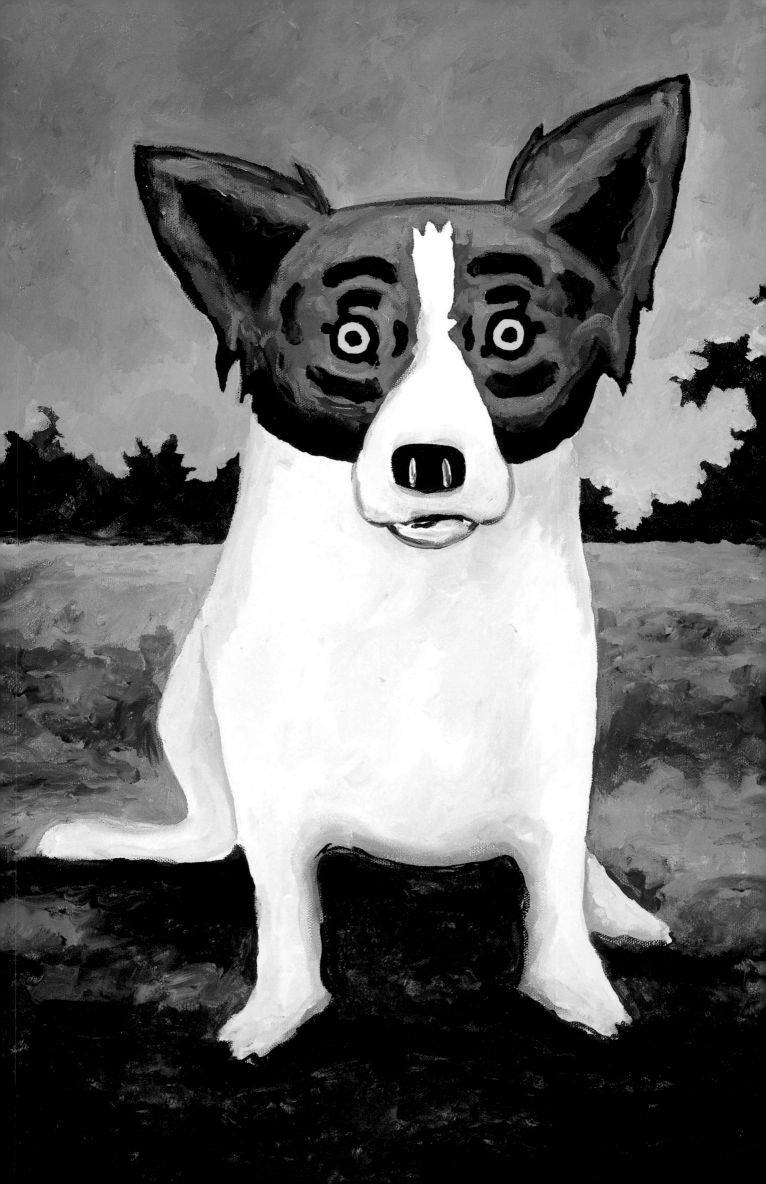

CHAPTER ONE

BLUE DOG'S BLUES

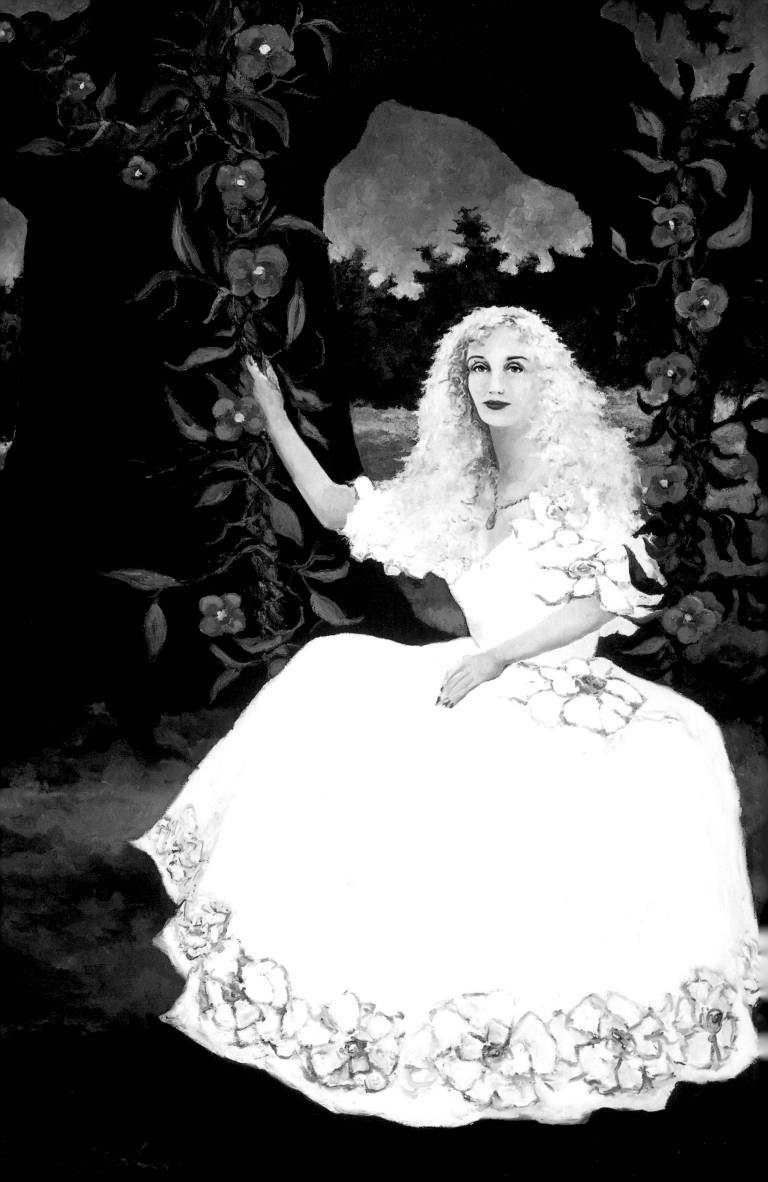

Jolie blonde, jolie fille, chère petite chérie,
Mon cher coeur, tu m'as délaissé.
Tu es partie avec quelqu'un, en Louisiane;
Tu m'as laissé dans ma douleur.

At the very heart of Cajun culture, woven into its language, its legends, and its history, is both a haunting sense of loss and an ever-hopeful sense of longing. These feelings constantly emerge in the stories and songs of French Louisiana—especially in "La Jolie Blonde," a beautiful Acadian waltz written in the 1930s by a prisoner in Port Arthur, Louisiana, as he pined for his lost love. "Pretty blonde," he sang, "pretty girl, dear little one, dear heart . . . You went away with another and left me in misery." The lost blonde lover who broke the prisoner's heart is actually just the reincarnation of an even older legend— that of the young Evangeline, who stands beneath an oak tree, waiting in vain for her beloved Gabriel to return to the bayou. In many ways, the sadness of the Cajun odyssey to southern Louisiana is perfectly embodied by Evangeline; the Cajuns are a people always waiting, it seems, for their Gabriel to return.

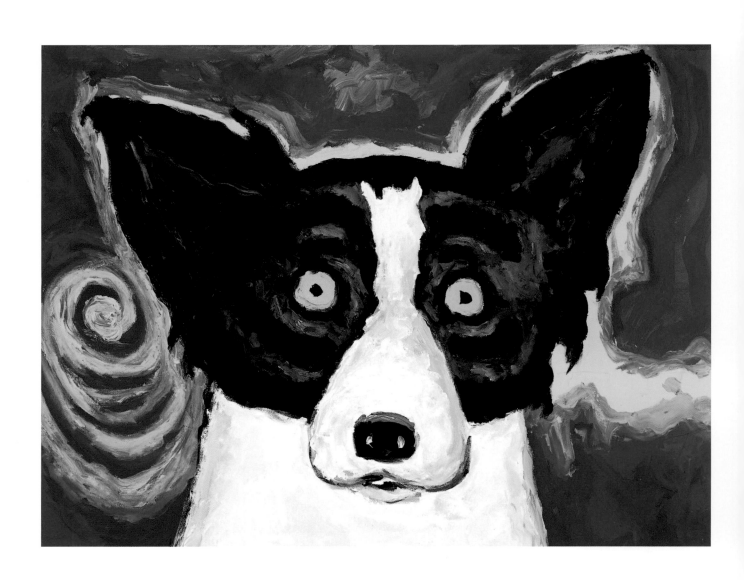

It is in the bayou, amid such legends of lost love, that Blue Dog was born. She began, in fact, as a sort of Loup-Garou—the traditional Cajun werewolf that boys and girls were told was lurking in the swamps and river basins, just waiting to snap up children who didn't get to bed on time. Blue Dog started as a feeling, an old, deep-rooted remembrance of how I grew up. The word that keeps coming back to me is "melancholy."

We were poor, yet we understood the richness of life.

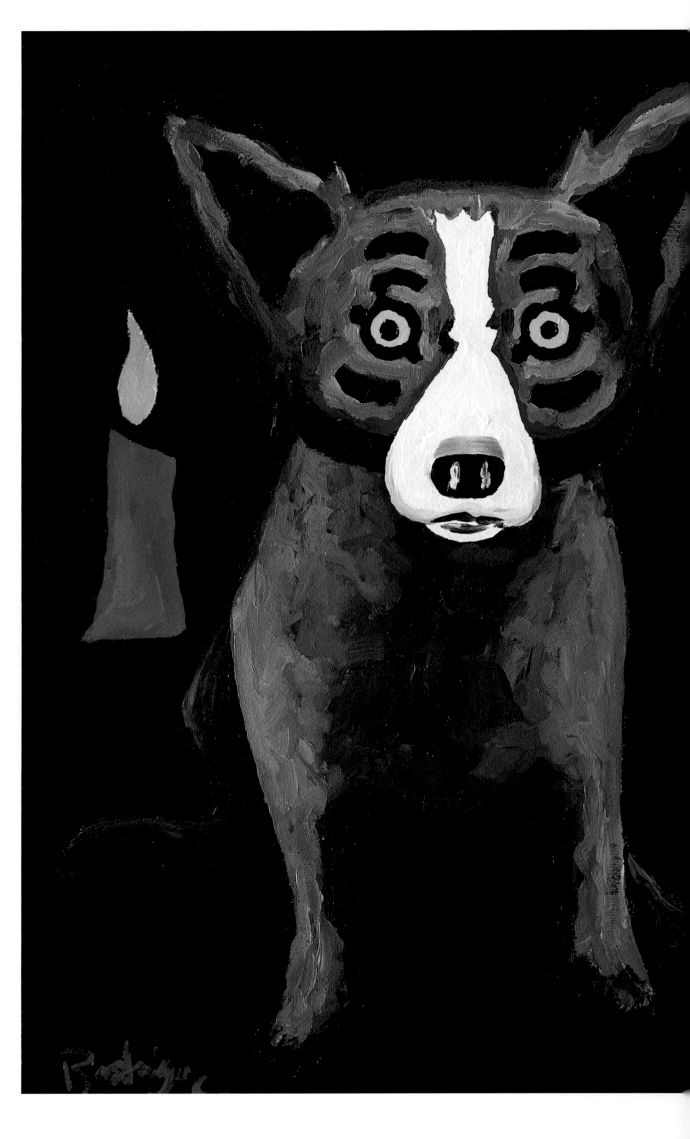

Soon, Blue Dog took the form of a painted channel through which I could convey my own feelings of loss—both for my lost companion and for the elusive, fast-fading culture of Acadiana, as Cajun country is commonly known.

Since then, Blue Dog has come to represent countless other ideas and feelings, many of them humorous and whimsical. Yet what few people recognize is that, at the very essence of her being,

I grew up engrossed in and schooled in the Catholic faith, which is prevalent in southern Louisiana. Although my own views have changed, I respect the devoted faith of many of my friends—especially my longtime friend and secretary, Bertha, who often worries about me more than I do about myself. The title of this painting, *A Novena for Me*, is what she says whenever she feels things are getting rocky.

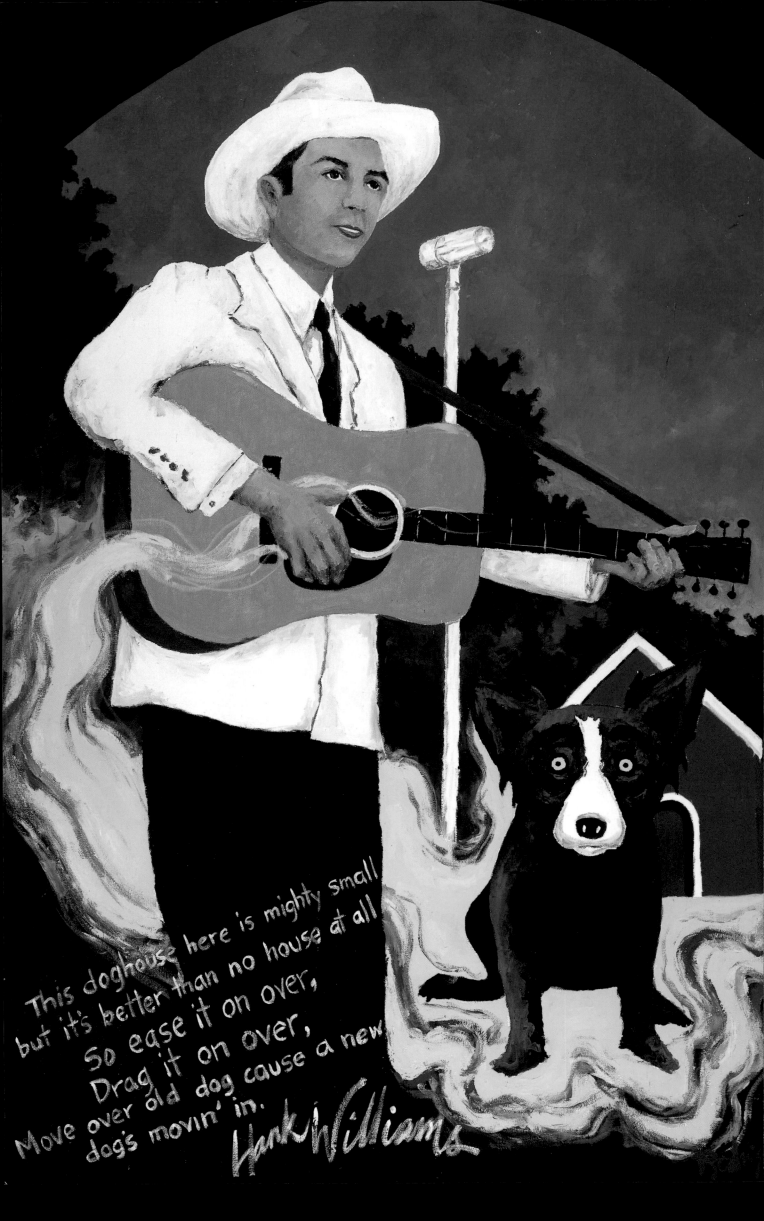

This doghouse here is mighty small,
but it's better than no house at all
So ease it on over,
Drag it on over,
Move over old dog cause a new
dog's movin' in.

Hank Williams

Blue Dog has got "the blues."

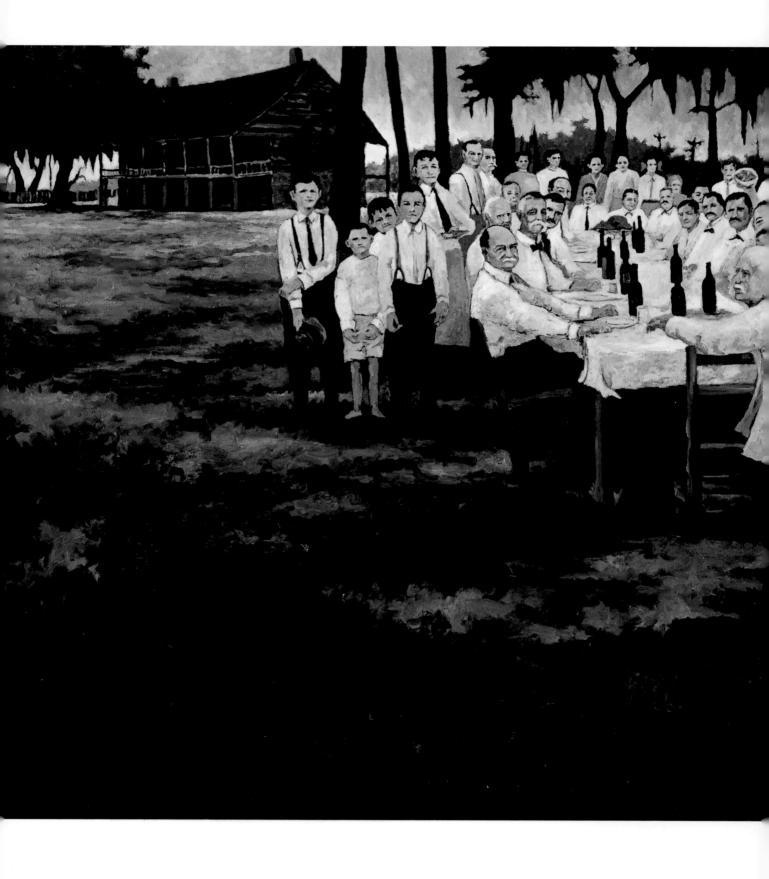

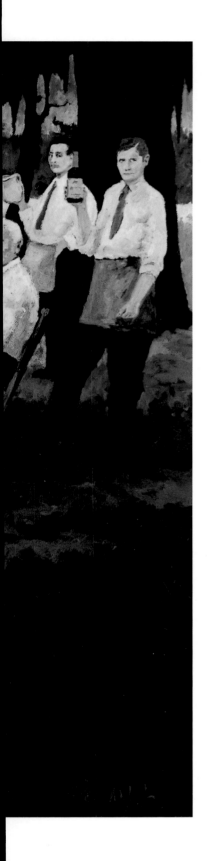

Just like the first Acadian settlers, she's stuck in a place that is completely foreign to her. Sometimes, I would paint Blue Dog as my own version of the *Jolie Blonde*, which would immediately recall the strains of that bluesy, sorrowful tune. On other canvases, I would place Blue Dog alongside New Orleans jazz musicians, to whom playing the blues comes easy. So the blues, and in some ways the whole musical tradition of the Cajuns, is intimately associated with Blue Dog.

To understand this creation that has become the focus of my life, you've got to understand a little bit about where I grew up. My daddy was a bricklayer, a hard worker, like virtually all the Cajuns. Yet Cajuns, while they work hard, also play hard when the weekend comes around. My parents' friends would pull the knives out of their belts, stick them into the trunk of an old live oak, hang their coats on the knives, and dance. They dressed up on weekends with nowhere to go, just to meet each other. The blues were everywhere for the Cajuns. But when they danced and had fun, they did it as hard as they could. This was their release. I grew up in that hardworking, hard-playing atmosphere.

35

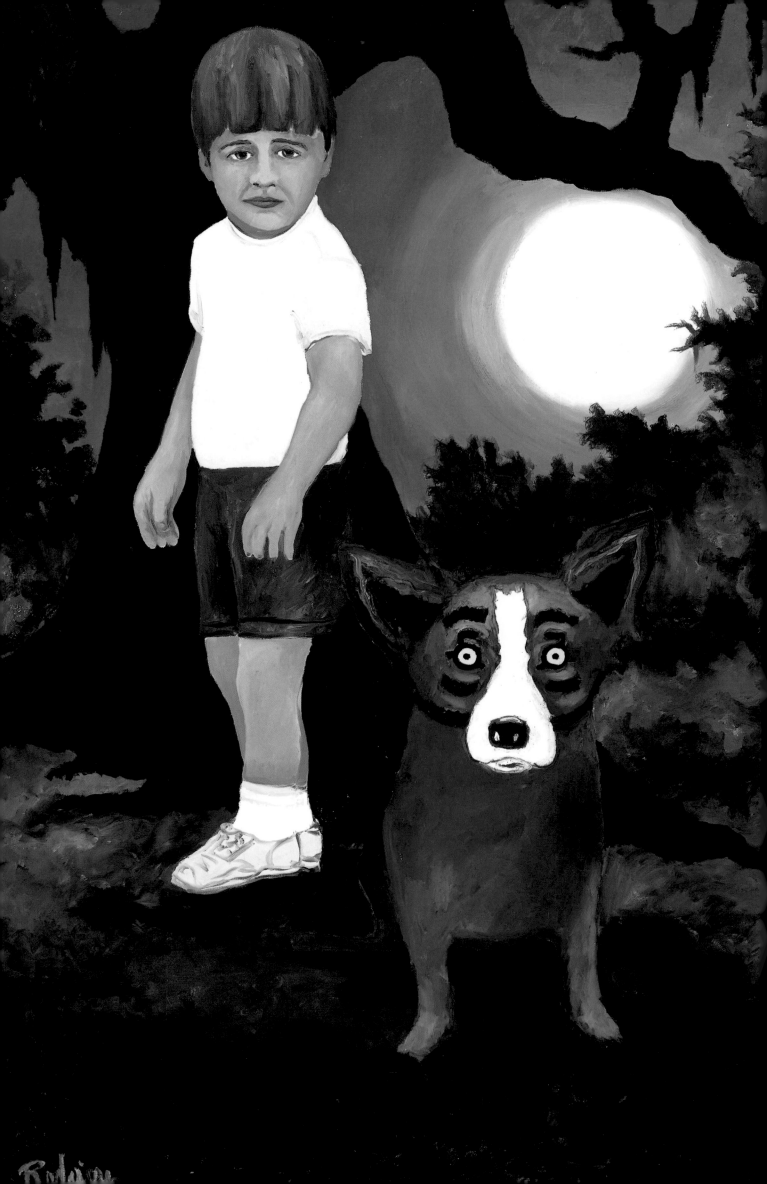

I was surrounded by older people: grandparents,
neighbors, aunts, and uncles. Family was very
important, and when my relatives talked about their
lives, I listened. I listened when they told me how
the French-speaking Acadians (the name that gave
rise to the term Cajun) made the grueling journey in
the eighteenth century from French settlements
in Canada into the remote, swampy Louisiana delta.
They told how my great-great-grandparents began
to carve a life out of this difficult, flood-prone land.

The bayou was the end of the line

This painting, which I
call *Autumn of My Life*, is in
some ways a return to the
seminal elements of the Cajun
series that got my career
started, especially the somber
light scheme and the brooding
oak tree. I owe much of my
early success to the Baton Rouge
architect and historian
A. Hays Town, who graciously
agreed to have a look at my
first five or six Cajun canvases.
His simple explanation of
what a painting should be and
how it should be approached
by the artist changed my
way of thinking about art forever.
He stated that a painting
should reflect the qualities of a
jewel, and that the artist
should approach his canvas as
though he were creating a
fine and rare artifact. To me,
this observation meant that the
artist should take the same
care and seriousness in creating
the work as the collector does
in purchasing it. Immediately, my
paintings began to reflect a
newfound pride, a new sincerity—
feelings I continue to apply
to my Blue Dog paintings today.

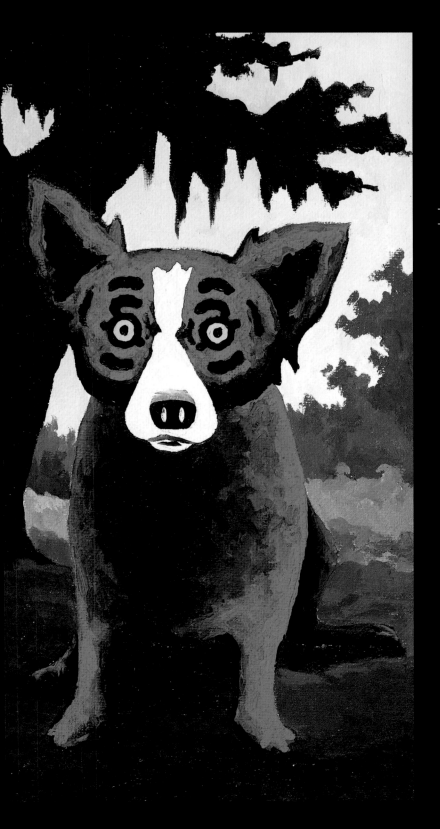

for the Cajuns;

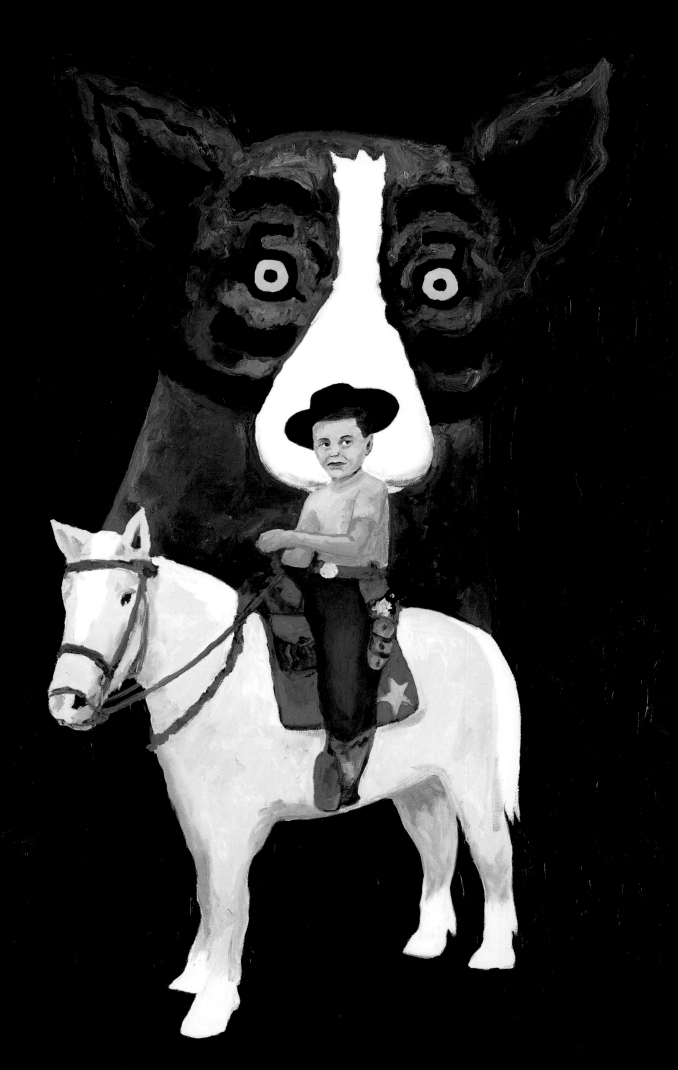

they settled here, isolated from the outside world by water on every side, keeping their old language and culture unchanged and intact. It more or less stayed that way until after World War II, when young men began to return home bearing the knowledge of other lands and peoples. As recently as the early 1950s, people spoke mostly French around here. The Cajuns were both deeply rooted and totally rootless. Now it's all changing. When I grew up here, you could still see horses and buggies on the Abbeville highway. When I first started photographing this land in 1961, after returning from art school, it was a little like Amish country.

I often paint from photographs. The inspiration for this painting, called *I Grew Up a Cowboy*, is a photograph taken by the Christian brothers who taught at our Catholic school in New Iberia. It was decided that we would each pose for our class photo seated on a pony. I took the whole thing very seriously at the time, and, perhaps not surprisingly, this picture is my mother's all-time favorite. Blue Dog looming in the background represents who I am today.

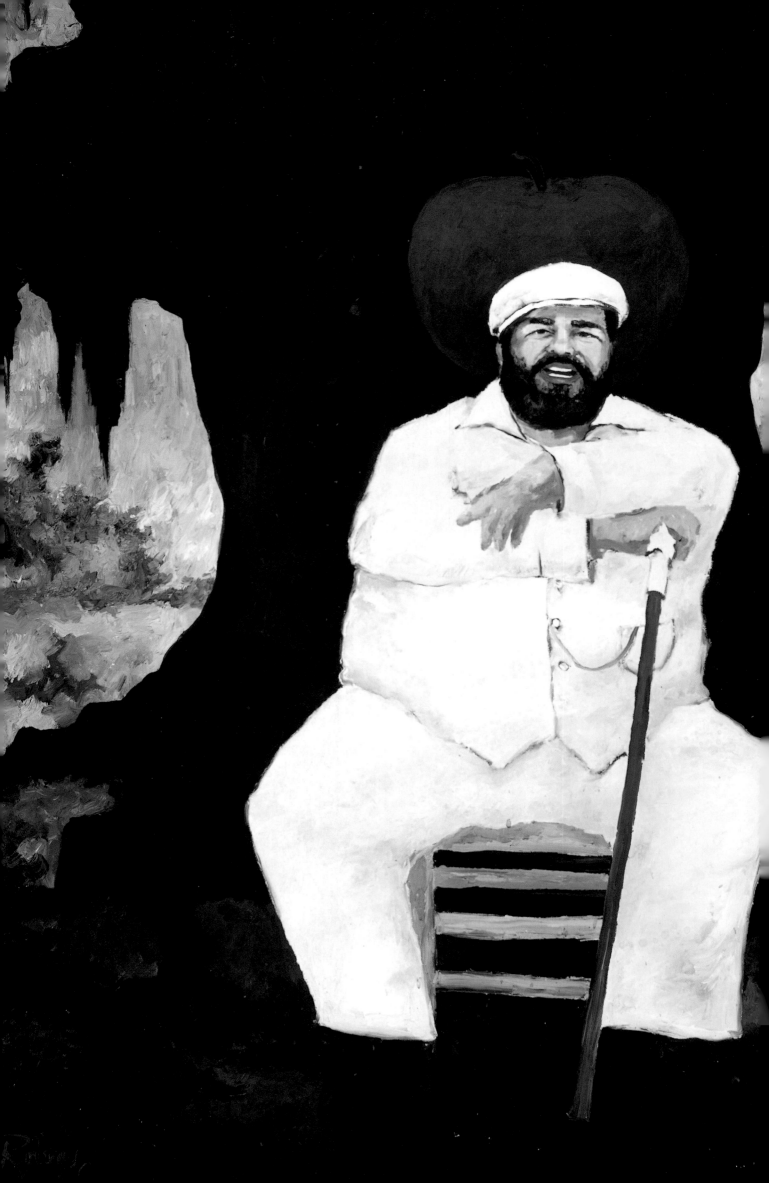

Back in the 1970s, when some of my first paintings of Acadiana were published, almost no one had heard the term Cajun. In fact, most people who had heard of us pronounced it Ka-yoon, ignoring the fact that the word was really just a slangy shortening of Acadian. For years, I continued to call myself Acadian, because Cajun used to be a term reserved for the poorest uneducated farmers. When I first started calling myself Cajun, people here didn't like it. In fact, many Acadians were still calling themselves French; to this day, my mother still does. It really wasn't until the 1980s, when my friend Paul Prudhomme's Cajun cuisine started getting noticed by food critics, that Cajun culture became both accepted and better understood.

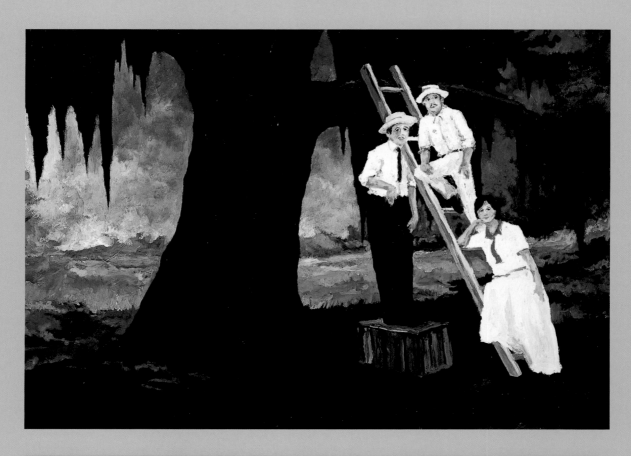

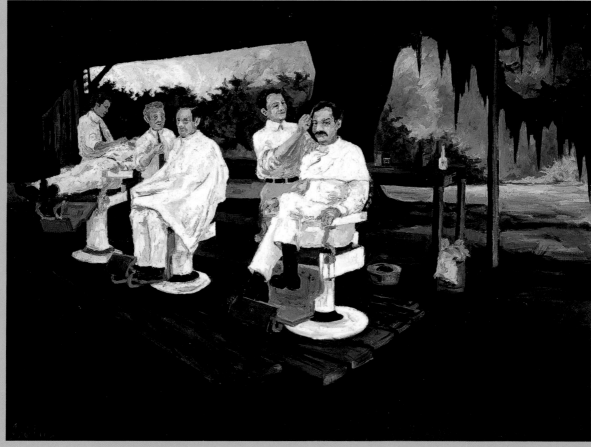

One thing I discovered after I began to make a living
as a painter was that I couldn't create unless the
subject of my paintings interested me deeply. In this
respect, I couldn't have been luckier; the culture
I knew and loved gave me ample inspiration for my
painting, and painting, in turn, allowed me to learn
more about my culture and ultimately about myself.

The Cajuns have always been a tight-knit, self-contained, and innovative community—whether they were collecting Spanish moss from the oak trees to stuff pillows and mattresses (as in *Climbing*, top) or running an open-air barbershop (as in *Broussard's Barbershop*, bottom). Because they were so isolated, the Cajuns had little choice but to improvise and invent. When the Broussard brothers decided to set up this barbershop, for example, their first priority was to obtain some proper barber's chairs. However, in order to ship four heavy chairs from New Orleans to Acadiana, they had to put them on a paddle boat that went from New Orleans, across the Gulf, up the Atchafalaya River to the Bayou Teche. In the end, the cost of shipping these fancy barber's chairs was so enormous that the Broussards had no money left to build their shop. So they simply put the chairs under a shed, where you could go every Saturday for a haircut.

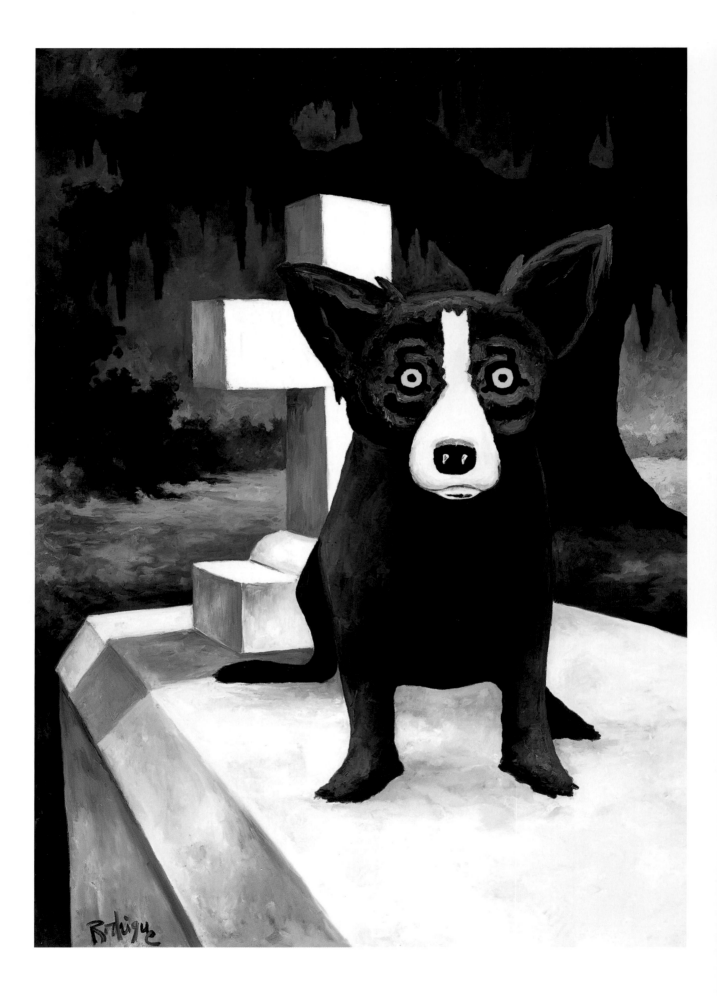

I set out to paint the Cajun world armed with a peculiar

feeling: I knew that, for me, beauty was a quality

that couldn't be defined by a single object or being.

Beauty abounds in life, but it is not born from a single source. Rather, beauty results from the unusual union of contrasting things.

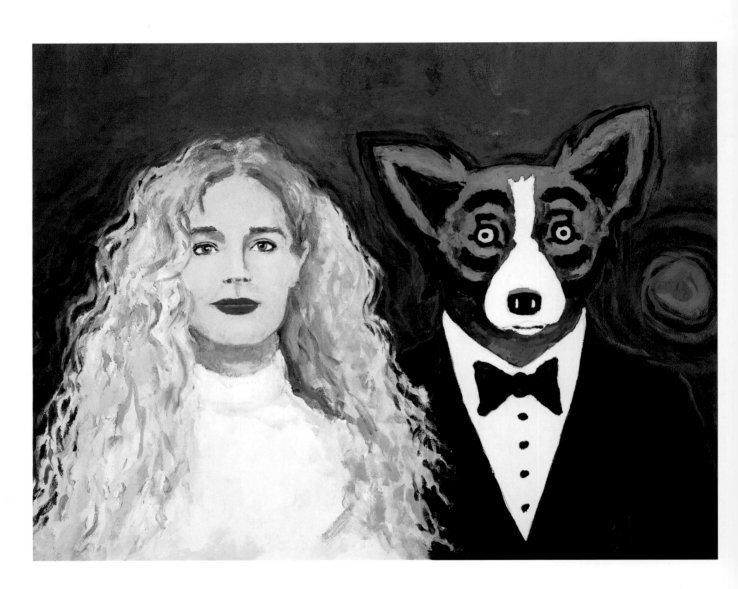

For years I painted the
Cajun legend of the *Jolie Blonde*,
who was immortalized in
the lyrics of a beautiful Acadian
waltz of the same name.
In March of 1997 I married my
own *jolie blonde* under a
hundred-year-old oak tree on
Jefferson Island, in the Louisiana
bayou. *Wendy and Me*
became our wedding invitation.

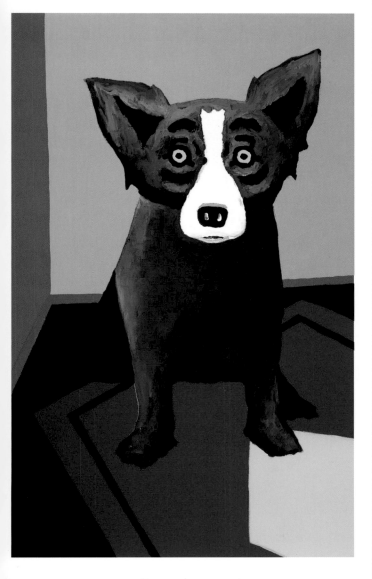

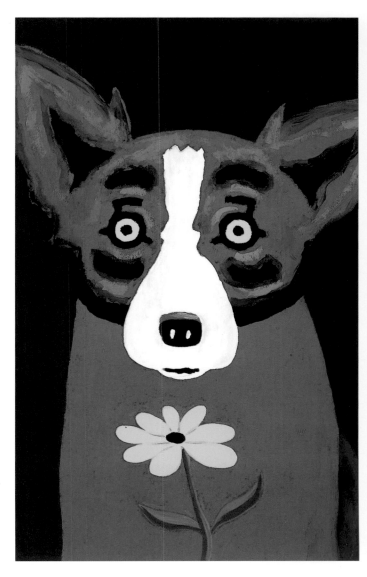

Lucky Dog

Daisy
acrylic on linen
24 × 20 inches
Private Collection

LOVE ME; LOVE ME NOT . . .

Blue Dog's Blues

Jazz Club of New Orleans
acrylic on linen
24 × 36 inches
Private Collection

THERE'S JAZZ IN MY BAYOU.

By the Light of the Journey

My Cubist Corner
acrylic on linen
30 × 24 inches
Douglas Collection

STUCK IN A CORNER; TIME TO MOVE ON . . .

Beyond the Bayou

We do not Think Alike
acrylic on canvas
24 × 30 inches
Private Collection

I'M NOT ALONE UNDER THESE OAKS.

Beauty, to me, is a relationship. Most Cajuns, as individual human beings, might not possess any particular beauty, but their relationship to their surroundings, to the bayous and the swampy land, and, of course, to each other is deeply beautiful. Cajuns took on a special beauty when they arrived in this odd, secluded world.

I started out with simple landscapes, trying to get a feel for how to represent the unique natural environment of the bayou. Immediately, the huge, moss-draped oak trees so common in French Louisiana became a central element of my canvases—just as they had become a defining symbol in the life of the Cajuns.

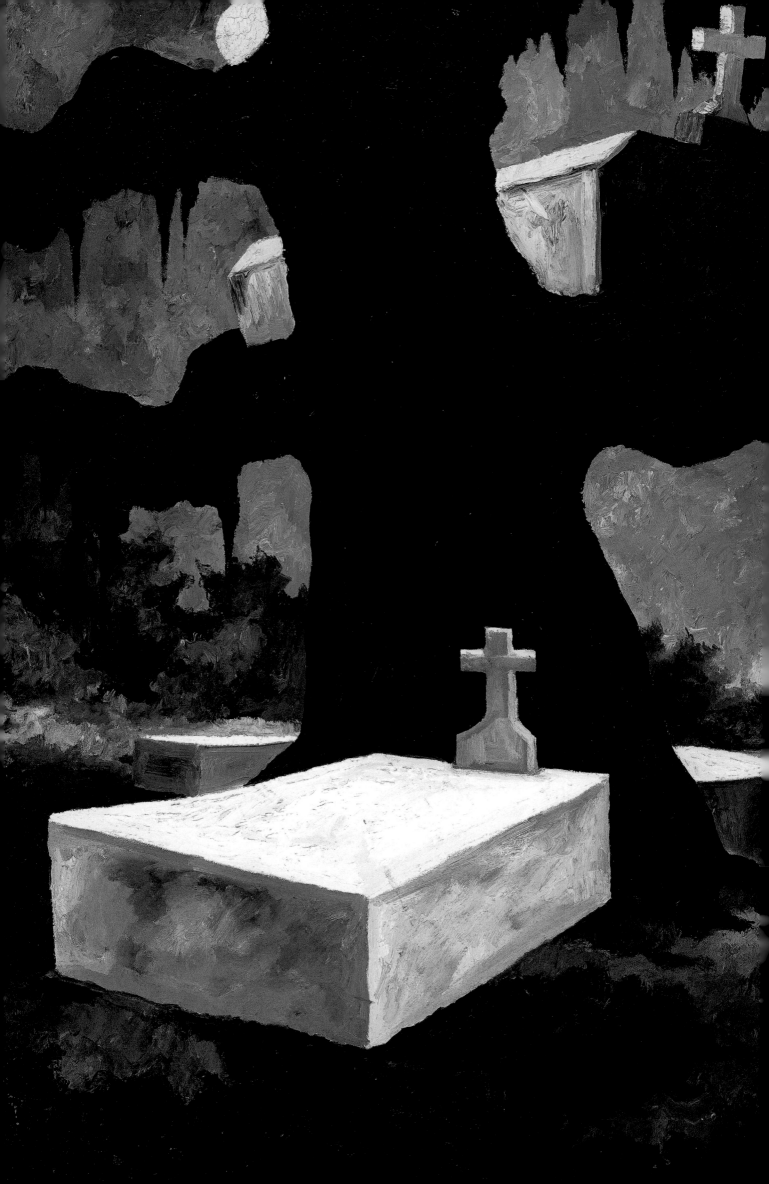

I call this painting *A Safe Place Forever.* When I was a child, a flood swept through the great Atchafalaya basin, carrying with it everything that wasn't nailed down or buried (and you can't bury much in the swampy bayou). When the waters receded, I was among the first to discover a large stone casket cradled in the branches of a huge oak tree. The people in the parish took this as a fearful omen, and so there the tomb stayed for many weeks, haunting us from its perch.

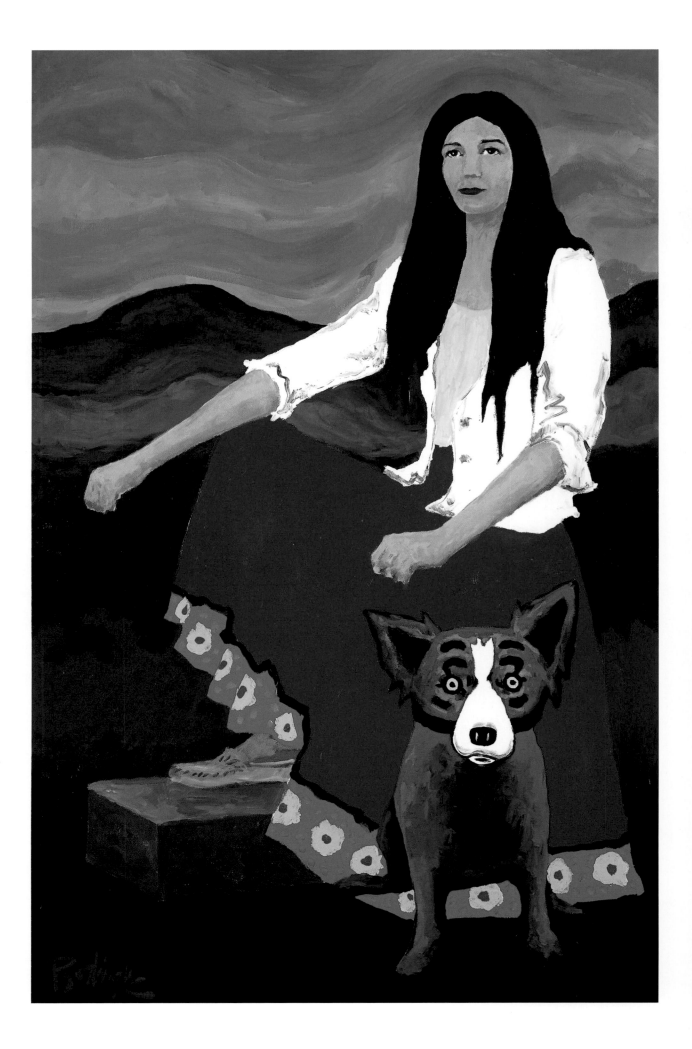

and they often stood in the middle of a town's central square. Sometimes the Cajuns would even build a dance floor around them.

It was only after many years of painting Cajun landscapes that I was able to step away from my canvases and say,

"My work embodies a departure from the norm; it's original, it's new, it's totally different. I've done what I set out to do."

It was a wonderful moment, and I could have painted in the same mode forever. But soon I felt compelled to put people in my landscapes. In my mind, the people were always there, but they were literally hidden behind the trees. I decided that, when human figures finally came out, they had to be very primitive, very defined, floating like ghosts above the landscape. I was pulling these figures out of their environment and

Many years ago, near Sante Fe's Pink Adobe, I met and photographed an Indian woman by the name of Evergreen Lake. She had a distant, haunting look that reminded me of the faces of the traditional Cajun healers, or *traiteurs*, who were the subjects of some of my paintings. Since then, this woman has appeared in a number of my paintings, sitting by bayous and under oak trees, floating like a ghost in the dark landscape. In *Santa Fe on My Mind*, she sits as a proud symbol of Native American culture, with Blue Dog by her side.

53

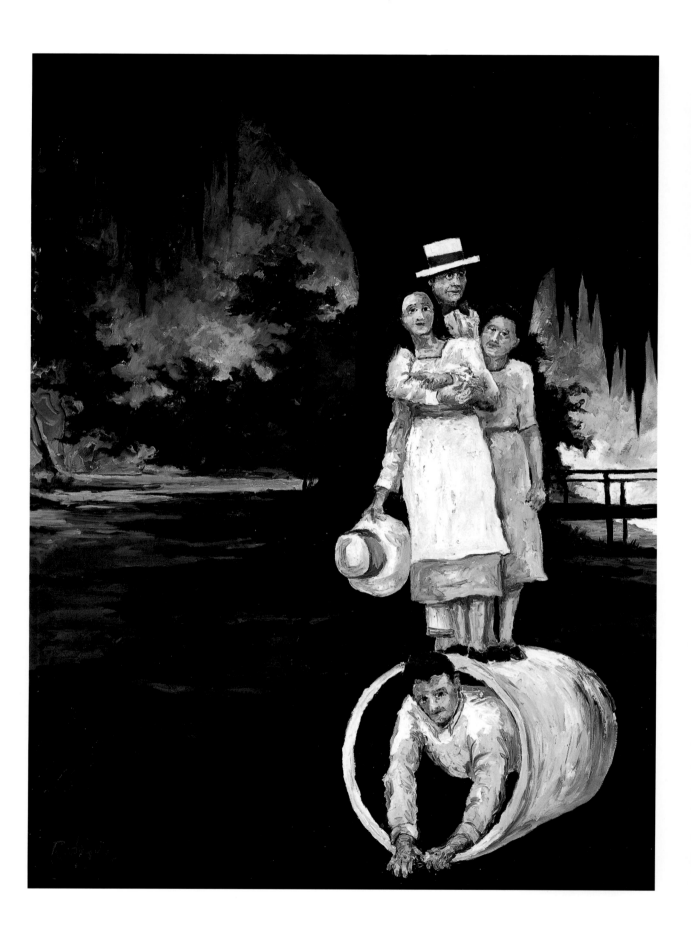

putting them back in in a different way. My paintings began to describe a new world of shapes and forms—often unsettling, but always exciting. When my compositions became more complicated—and even when Blue Dog came along—these same strong shapes remained.

It is said that when the first Acadian settlers, many of whom could not read or write, were asked by local colonial officers to sign official documents, they simply drew an X next to their printed names. This accounts, apparently, for the strange spellings, still seen today in Louisiana, of otherwise common French names: Thibodeaux, Rousseaux, Fontenaux, and Boudreaux. Families bearing these names appear in several of my Cajun paintings—including this one, called *Boudreaux in the Barrel*.

Just like my Cajun figures, Blue Dog herself emerged from that dark landscape, out of those huge trees. In her earliest form, as an incarnation of the Loup-Garou. Blue Dog had rough, slightly savage features, including glowing red eyes.

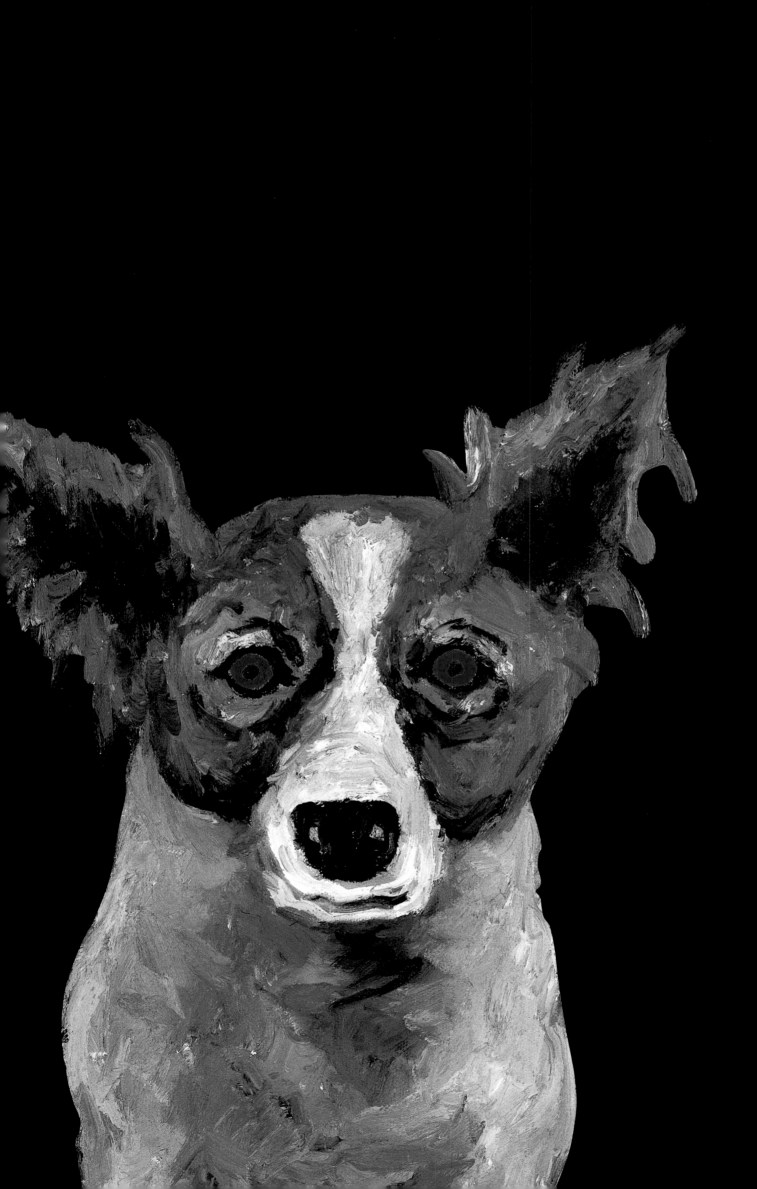

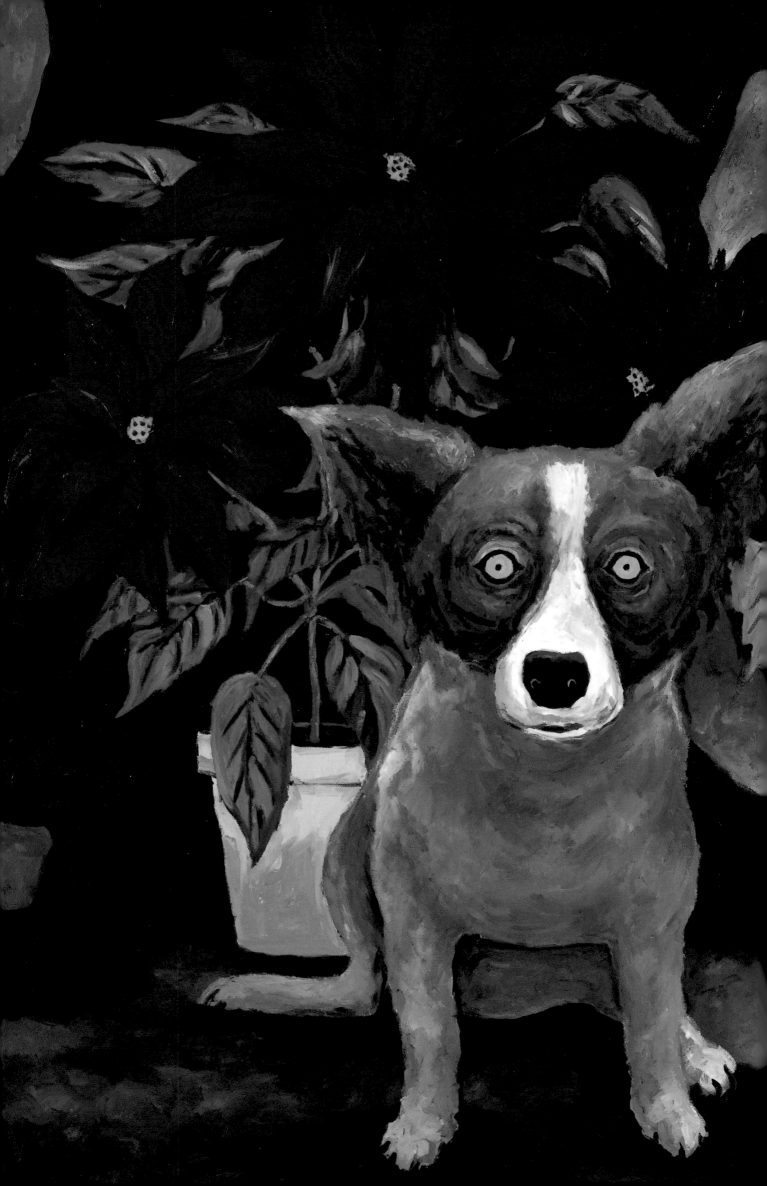

Blue Dog was more earthy at first; she came out of the earth, out of the Spanish moss of the trees. Soon, though, Blue Dog began to stand apart from her environment: Her eyes changed color and her edges became more defined.

Blue Dog, I realized, *had to stand alone.*

Her aloneness was part of the sense of isolation—of floating, of having been transplanted—that for me defined the Cajuns.

As Blue Dog became more removed from her
surroundings, her environment followed suit, becoming
less natural-looking and more abstract, though still
very much rooted in Cajun motifs. The abstraction
that began to evolve in Blue Dog wasn't entirely
new to me, however. Even my early Cajun paintings
incorporated some of the elements of abstract
expressionism—especially the breaking down of field,
line, and form, and the shifting of foreground and
background. You can see this effect even in my earliest
Cajun paintings, where the sky, peeking through the
branches of the great oaks, is not a void, but a positive
shape, a projection. I began to apply this technique
to many of my Blue Dog paintings. Negative space
becomes positive, and Blue Dog's sense of place is
made even more ambiguous.

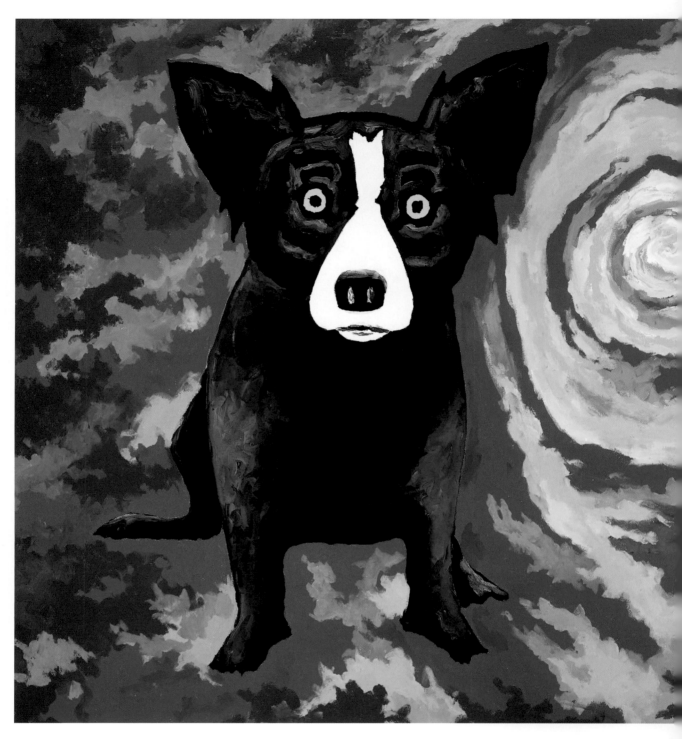

Living near Louisiana's
Gulf Coast, we are keenly aware
of the weather, especially
during hurricane season.
Hurricane Georges whipped
through Acadiana in 1998,
and I was determined to let Blue
Dog share the experience of
witnessing a hurricane. Needless
to say, the cyclone in *Blue
Storm Rising* is slightly more
colorful—but certainly no more
forceful and energetic—than
the one I viewed through the
rattling windows of my house.

Today, Blue Dog inhabits a world infinitely larger than the bayou where she was born. Like the Cajuns, who endured their hardships by keeping their eyes trained on the future, Blue Dog always moves forward.
Yet deep in Blue Dog's eyes there will always be a reflection of Cajun history, of the hopes and longings of the uprooted Cajun people.

More than that, there will always be the sense of a journey, an odyssey,

like the one the Cajuns made more than two centuries ago.

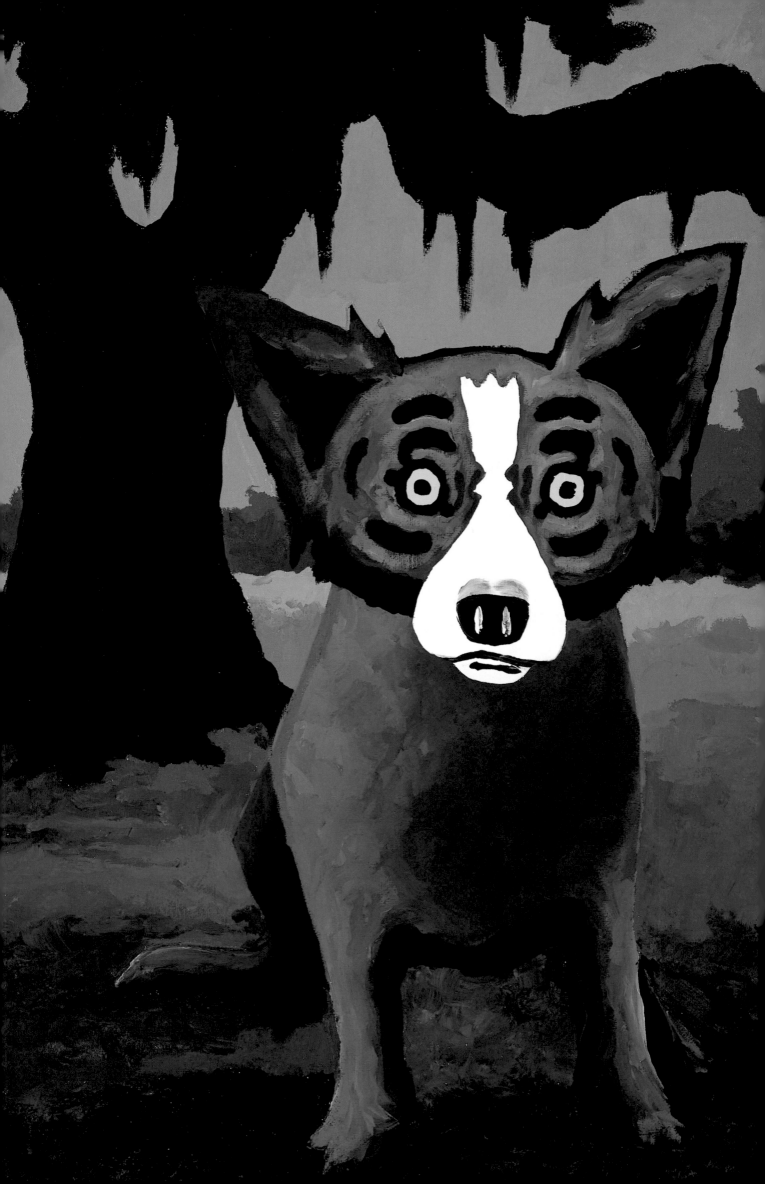

BEYOND THE BAYOU

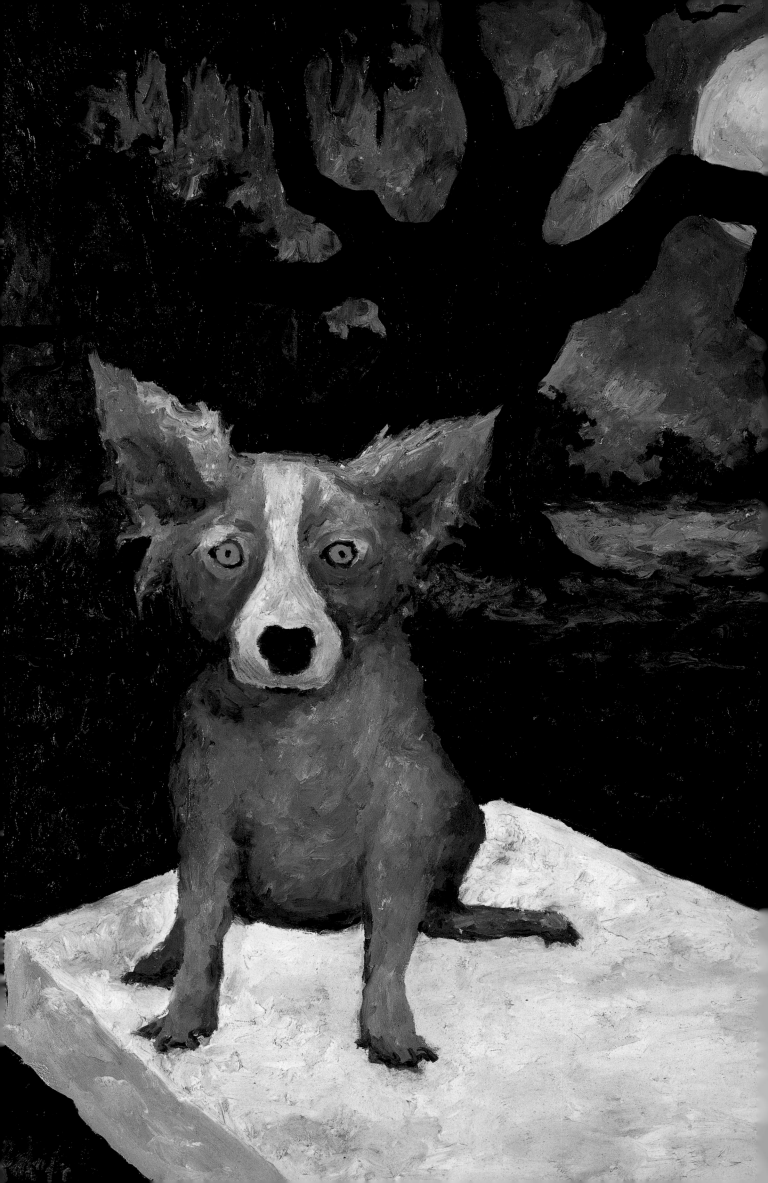

*At the river's source were bayous,
ghosts, and lost souls; at the river's
mouth was a vast ocean of
hope, light, and infinite possibility.*

Rather suddenly, I found myself face to
face with this new creation that kept
finding its way into my Cajun landscapes.
This dog wasn't going away, and it
didn't take long for me to realize that my art had arrived
at a crucial turning point. Yet I had no idea where
this dog would take me—nor did I know how far I could
take the dog. For a long while, Blue Dog continued to
travel through my imagination as a sort of Loup-Garou,
filling the Cajun scenes in my canvases with her
ghostly presence. Pale blue—sometimes even gray or
white—scruffy, and sometimes red-eyed, she rarely
ventured beyond the dark, heavy Louisiana landscapes,
full of oak trees, thick moss, bayous, and cemeteries.

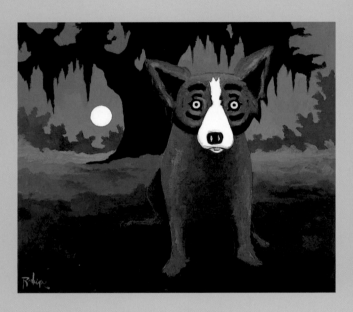
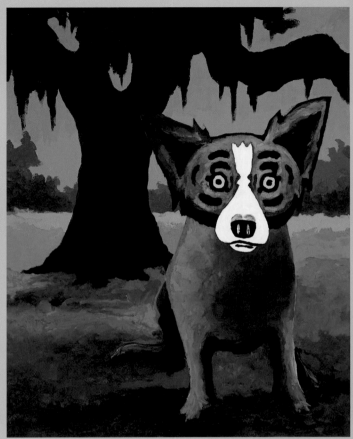
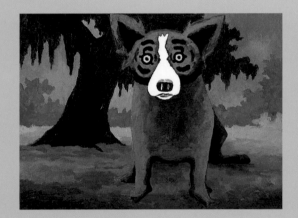
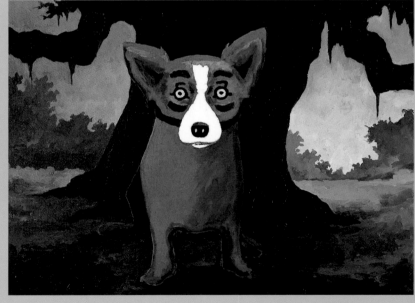

Soon, though, the dog began to lose her ghostly qualities, and before long I realized that this painted dog had taken on a very specific persona—it had somehow become the reincarnation of Tiffany, the little black-and-white terrier/spaniel that used to keep me company in my studio. Tiffany's soul was lost, and her search for me and for her home began to take her—and therefore the setting of my paintings—into strange new corners of my imagination. I found that the very style of my paintings was beginning to change, depicting new, more boldly colored environments.

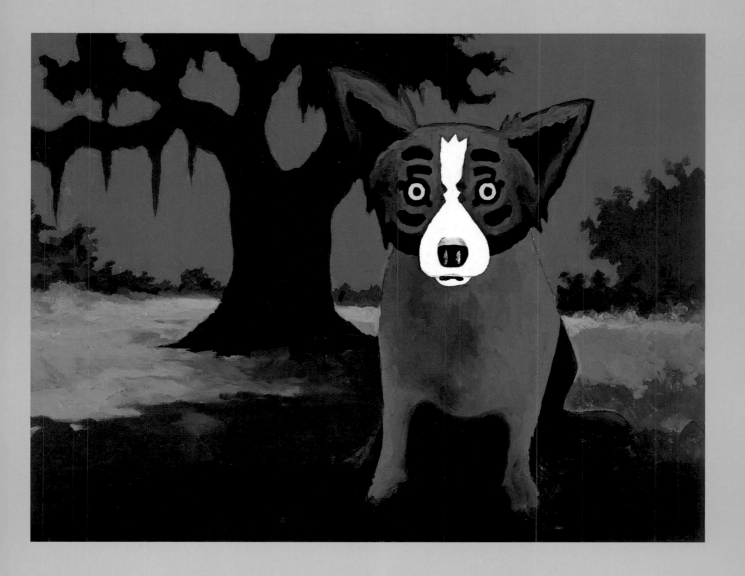

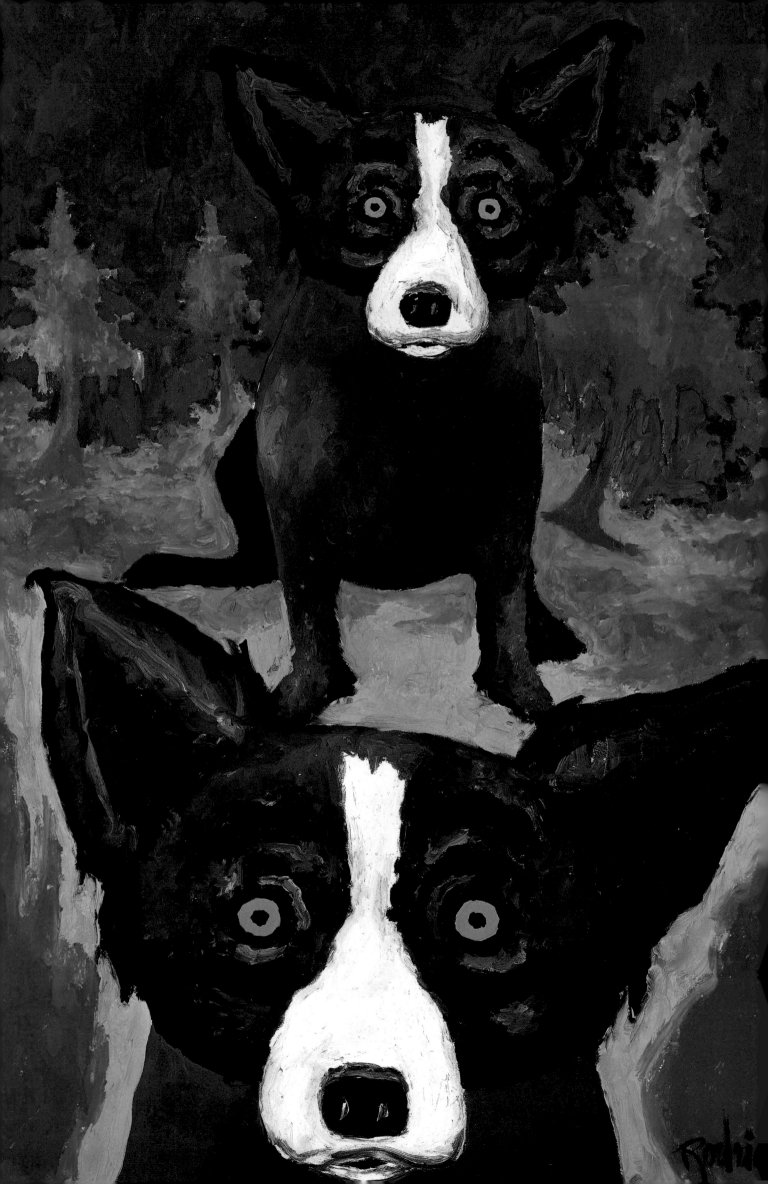

Blue Dog, I discovered, was lifting me and my art out of the Louisiana bayous and dropping me off in some very interesting locales.

All my paintings begin as a graphic concept as opposed to an articulated thought. When I begin to paint a picture, I have no idea what it's going to be about; it's very spontaneous. My paintings are not just executed, they have to evolve. All I know is that Blue Dog will be there; everything else is up for grabs. That's where the excitement is. At some point while I'm painting, a title comes to me—like this one, *I've Got You on My Mind.* But words are clumsy, and it's often the deep, visual feeling that sticks with me after I finish a canvas.

Eventually, Tiffany's search for her new home became *my* search for a whole new type of painting, one that went beyond the breakthroughs I had made in my earlier Cajun paintings. All good artists reach a point in their careers when they arrive at something totally new: a new style, subject, or feeling that must be reckoned with and explored to its very limit. Blue Dog and I stood at this crossroads, and I knew that I had to choose a path and move forward; I also knew that Blue Dog, in some form or another, had to come with me. I don't remember exactly when, but at some point, I understood that what I was painting was no longer the Cajun Loup-Garou or the spirit of Tiffany. Blue Dog had become something new and exhilarating—filled with sadness at times but just as apt to be imbued with humor, irony, anger, love, and even desire. Yet she had become more than simply a receptacle for all my emotions; she was a versatile, challenging new visual element in all of my paintings.

71

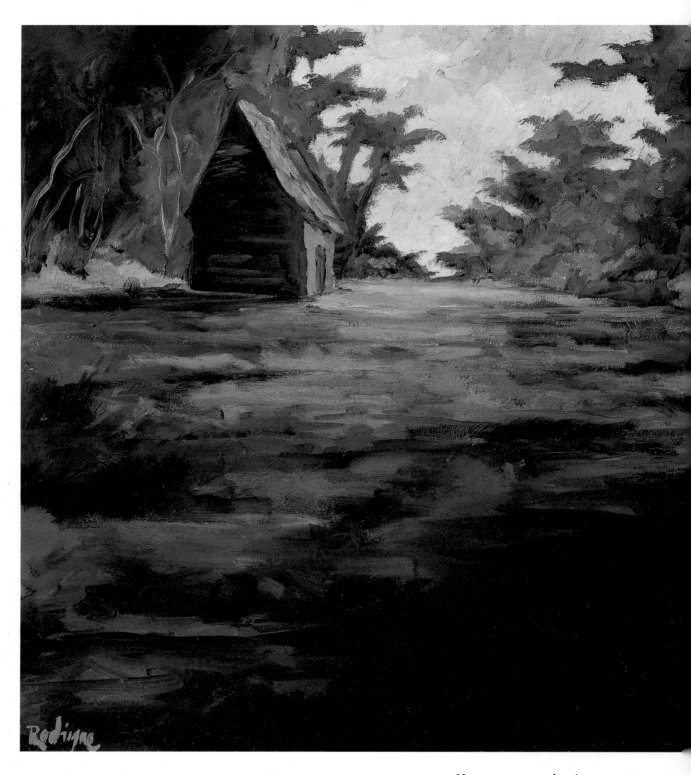

Rodrigue

Many years ago, when I
was in art school, one of my
teachers instructed us to
paint a painting with a palette
limited to black, white,
and brown—not unlike the color
scheme in this piece, *Hebert's
Cabin in Breaux Bridge*. When I
was finished, the teacher
looked at my composition and
was able to say, "This guy
loves color. He has a very keen
sense of it." Of course, I
was dumbfounded, but I later
understood that the crucial
element in a painting is the way
in which the colors *relate* to each
other, however few they are.

I had made a breakthrough, yes; but contrary to popular belief, creative breakthroughs like this aren't always lightning bolts hurled from above. The old course my art had been following for years wasn't simply abandoned; rather, Blue Dog had evolved. She had arrived at a confluence of rivers and chosen a new tributary. Back at the river's source was the realm of Cajun folk legends, muted landscapes, and lost souls; with Blue Dog I had followed this course as far as I could.

Where this new river's course would end, I had no idea.

What I did know was that these unfamiliar, swiftly moving waters were taking me into ever more colorful and exciting territory.

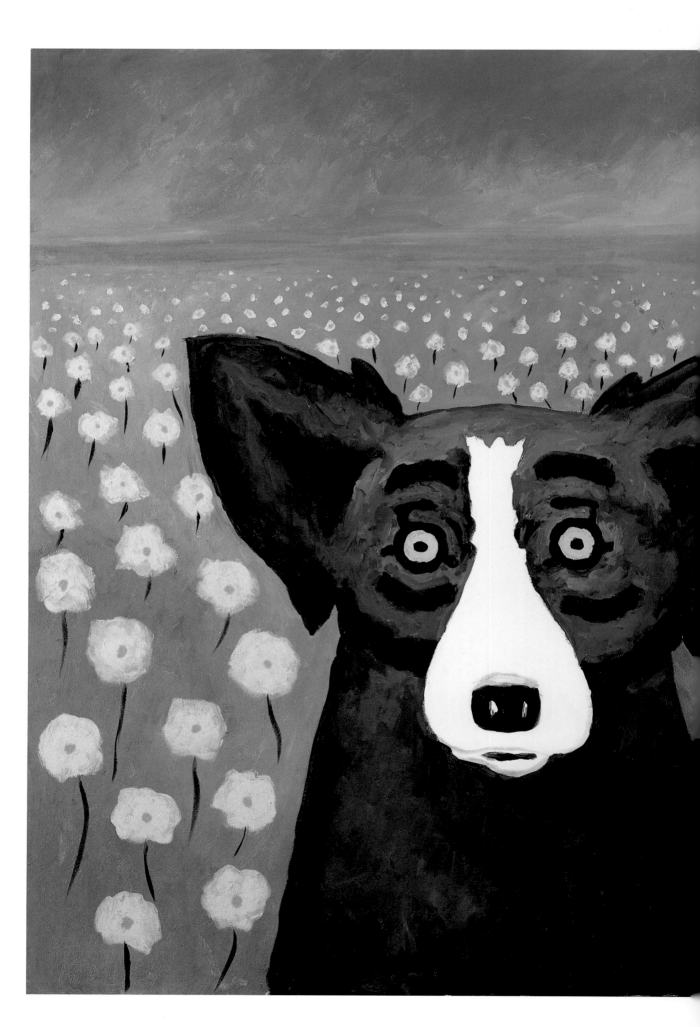

I had been painting Cajun life for twenty years, and
if I had chosen simply to ignore this past, to ignore
Blue Dog's origins, my creation would be rootless.
It would have become little more than a cartoon.
Blue Dog allowed me to see my culture in a new way,
and I realized that I could take the familiar elements
of my past and make them my own—I could create
an art that was as original and unique as my own
handwriting or my own fingerprint. A sort of liberation
had taken place, and the further I got from dark Cajun
themes the closer I got to Blue Dog. I understood
that the Cajuns alone couldn't take me where I needed
to be. Blue Dog had to become a reflection of so
much more—of me, of the way I live, of the way we
all live. I wanted my paintings to reflect events in the
present, not just what was lost to the past. One of
my Blue Dog paintings, entitled *Forever Starts Here*,
seemed to mark this sense of a new beginning.

The bold colors of my recent
Blue Dog paintings are artificial,
but the colors and lighting
of my early Cajun paintings
like *The Leblanc Brothers*
are often unnatural as well.
The people are impossibly
incandescent—in fact, they
generate their own light.
The light comes from within.

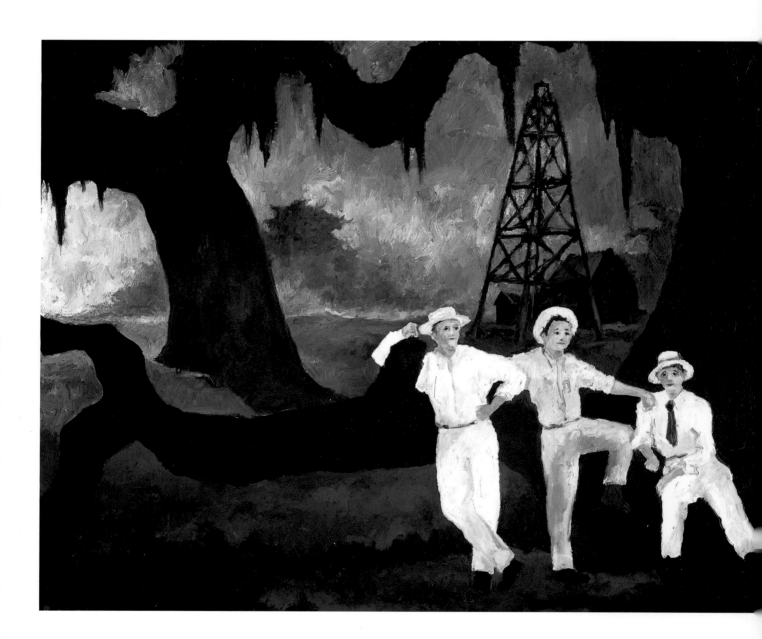

Just like Tiffany, I, too, was crossing a spiritual divide.
As I painted Blue Dog in new situations, I felt at times
that I was painting my way deeper into the unknown—
perhaps into the same spirit world that Tiffany had
been lost in. At other times, when I felt lost or scared,
I felt I was trying to paint my way *out* of that world
back into the more familiar one. Sometimes I was simply
caught in the middle—not between heaven and
earth, necessarily, but between the physical world most
of us know and another, infinitely larger dimension.
Entering this new world wasn't a simple, sudden event.
I understood that achieving some sort of transcendence
wasn't as simple as contemplating a sacred text or
listening to a preacher on television; you've got to *create*
this transcendence, to find a way to express this
world in your own way.

Somehow, I realized, this infinite new world wasn't *out there*; it was somewhere right inside me.

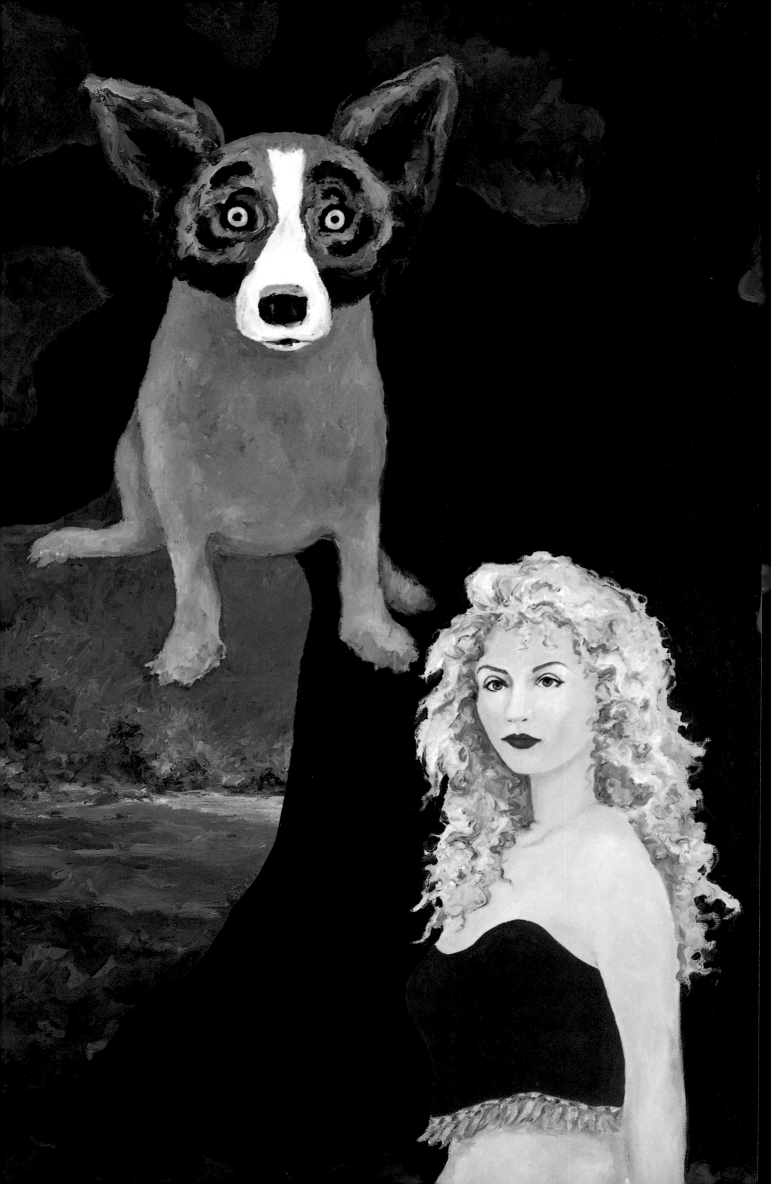

With this newfound sense of freedom, Blue Dog could go anywhere, and I could follow. We were both crossing this spiritual divide, sometimes in opposite directions. It wasn't just the settings of the paintings that began to change; Blue Dog herself seemed capable of adopting an infinite variety of characters. Sometimes she seemed to represent a man, sometimes a woman, and sometimes a spirit; and yet it went beyond that as well. There was more to it than simple role-playing. It became clear to me that the essence of Blue Dog was altogether separate from any particular real-life source. In her purest form, she had little to do with man, dog, or human spirits. I came to understand Blue Dog as a *shape* that I could use to describe my world.

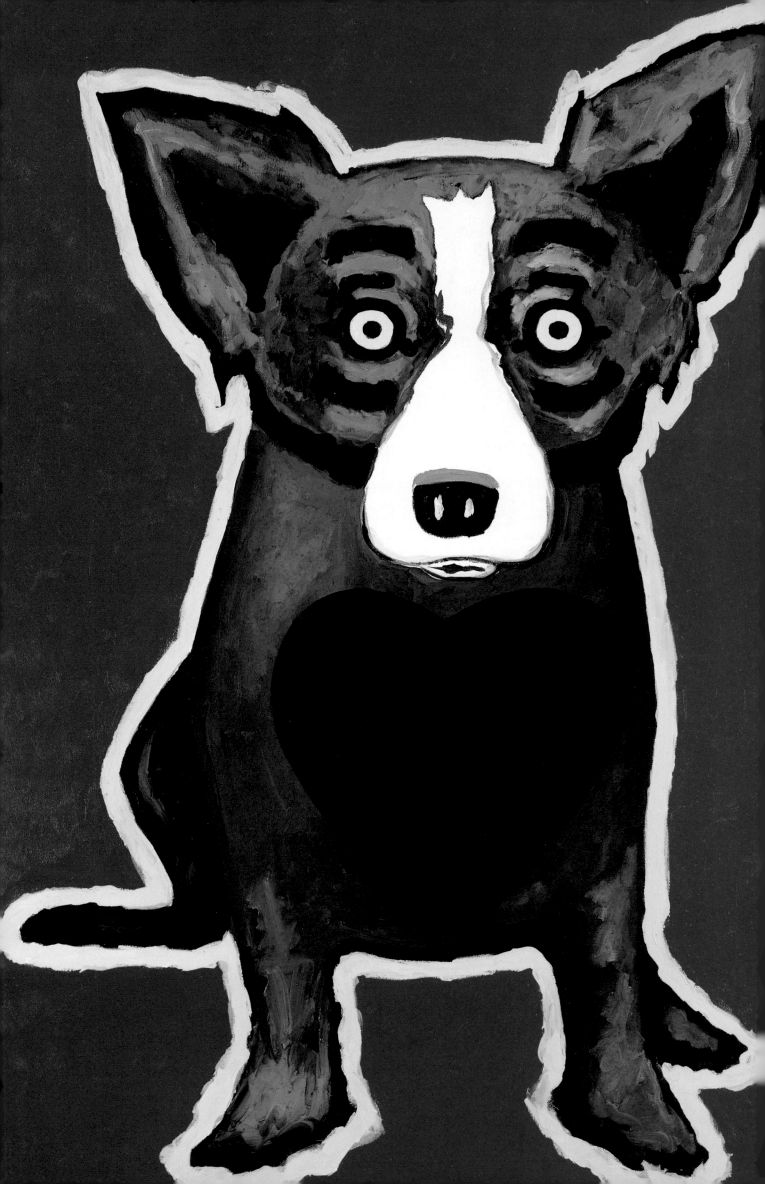

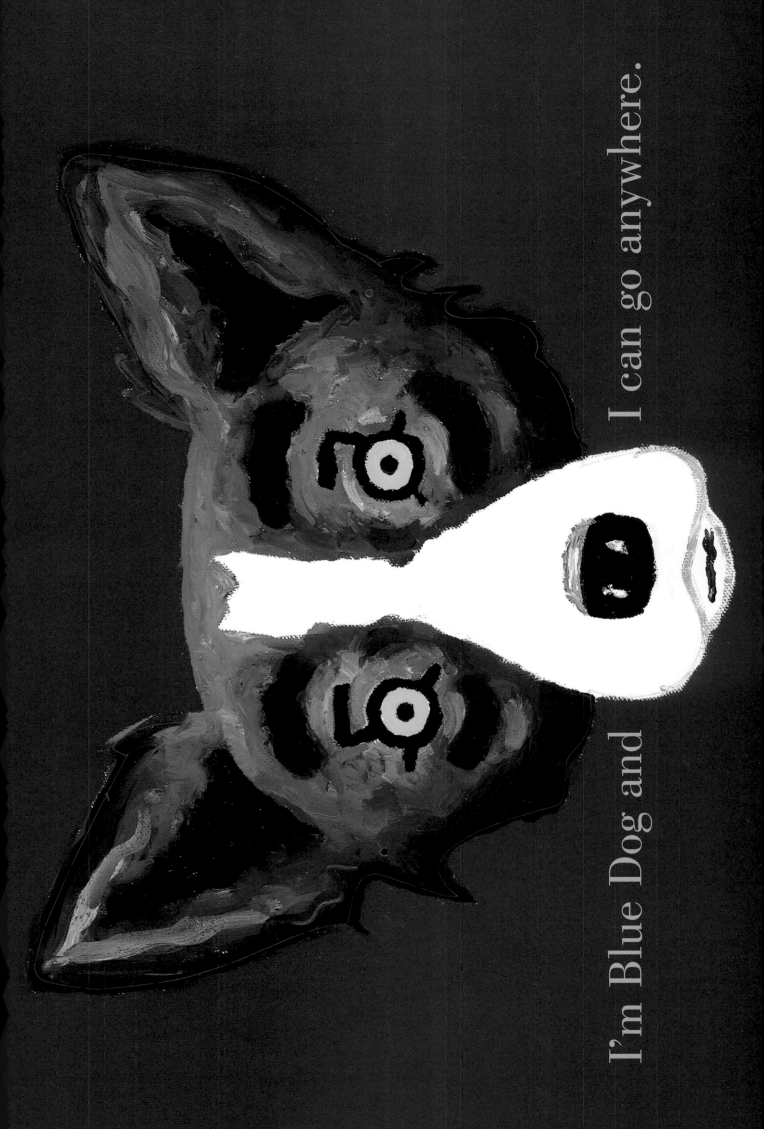

I'm Blue Dog and I can go anywhere.

See the world through Blue Dog's eyes—
your own Blue Dog mask

Instructions:
Carefully punch out the Blue Dog mask,
the two holes on either side, and the
eye holes along the perforations. Insert a
length of string or ribbon into each of
the side holes and tie a knot in one end
of the string, securing it to the hole.
Be sure that you cut off enough string
or ribbon to comfortably secure the
mask to your face. Tie the loose ends of
string tightly behind your head.

I also began to notice something else. As Blue Dog
paintings began to fill my studio and my gallery,
I realized that this image gained added force because
of the fact that it was constantly repeated. Of course,
I knew that I didn't invent repetitive imagery in art—
we all owe a debt to Andy Warhol and others in
that department. I did realize, however, that I had
done something different with the idea. In her multiple
forms, Blue Dog was becoming a new whole.
One dog says something very different from three,
or thirty, for that matter. Even within the same
painting, I started to play one form off the other to
give a different sense of good and bad, a sense
of different identities. Despite the repetition, though,
Blue Dog was somehow new each time.

My ninety-four-year-old
mother has said to me many
times, "Paint some more of
those oak trees. That's what the
people want." But the
trouble with those huge, dark
oaks, I gradually discovered,
was that they were silent and
brooding, and I grew tired
of being so quiet. The presence
of Blue Dog, on the other
hand, is anything but quiet and
subtle. In *Love of My Life*,
a Blue Dog with a heart on her
chest, surrounded by a thick
yellow aura and set against a
lush magenta field, *shouts* love
and freedom. And while it
may shout something else for the
viewer, one thing is certain:
This canvas won't just hang on
a back wall, blending in
with the living-room furniture.

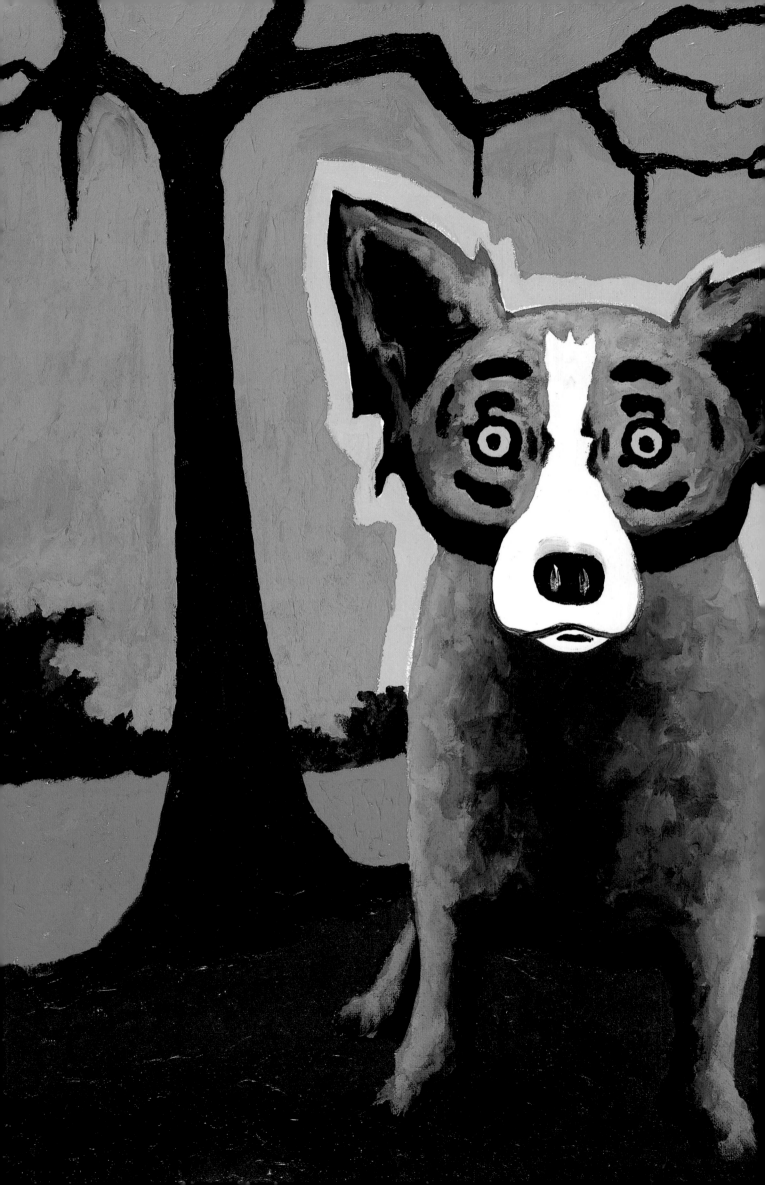

In *Save Me from the River*,
Blue Dog stands against a rushing
blue river, fearing perhaps
that she will be swept away.
Yet Blue Dog is part of this river
just as the river is part of the
ebb and flow of American culture.

In my mind, Blue Dog had become more abstract,
less tied to any one source in the real world.
Even so, I could not deny the fact that the origin of
this image was still a cute little dog—and that
many people would always respond to it as such.
I took this as a challenge: Fondness for man's
best friend may pull viewers in, I figured, but Blue
Dog had to transcend this surface connection.
I thought of the Impressionists. Early critics dismissed
them, considering them Sunday-afternoon painters
with no respect for classical and religious themes.
Monet painted flowers; Manet painted people
relaxing outdoors; Degas painted dancers. Yet their
paintings were not about backyard gardens, luncheons
on the grass, or the offstage antics of ballerinas;
they were about the magical way light and color could
make these elements of daily life transcendent.
They were doing something different; these painters
managed to elevate mundane themes through their art.

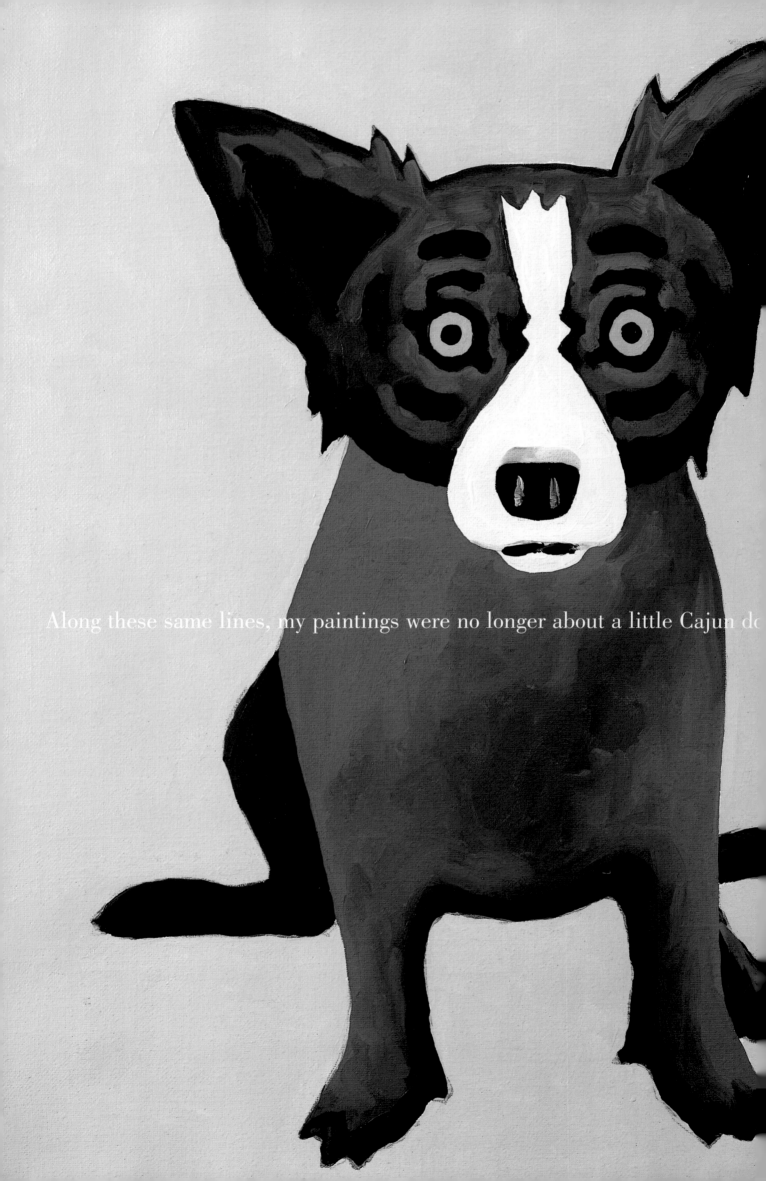

Along these same lines, my paintings were no longer about a little Cajun d

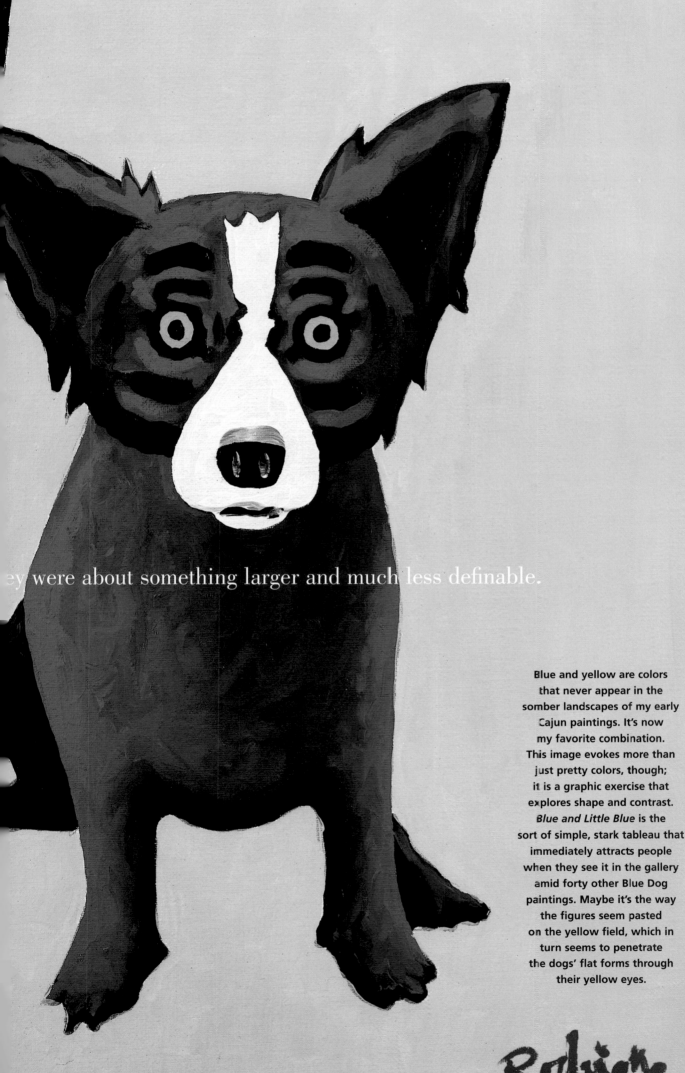

ey were about something larger and much less definable.

Blue and yellow are colors
that never appear in the
somber landscapes of my early
Cajun paintings. It's now
my favorite combination.
This image evokes more than
just pretty colors, though;
it is a graphic exercise that
explores shape and contrast.
Blue and Little Blue is the
sort of simple, stark tableau that
immediately attracts people
when they see it in the gallery
amid forty other Blue Dog
paintings. Maybe it's the way
the figures seem pasted
on the yellow field, which in
turn seems to penetrate
the dogs' flat forms through
their yellow eyes.

Rodrigue

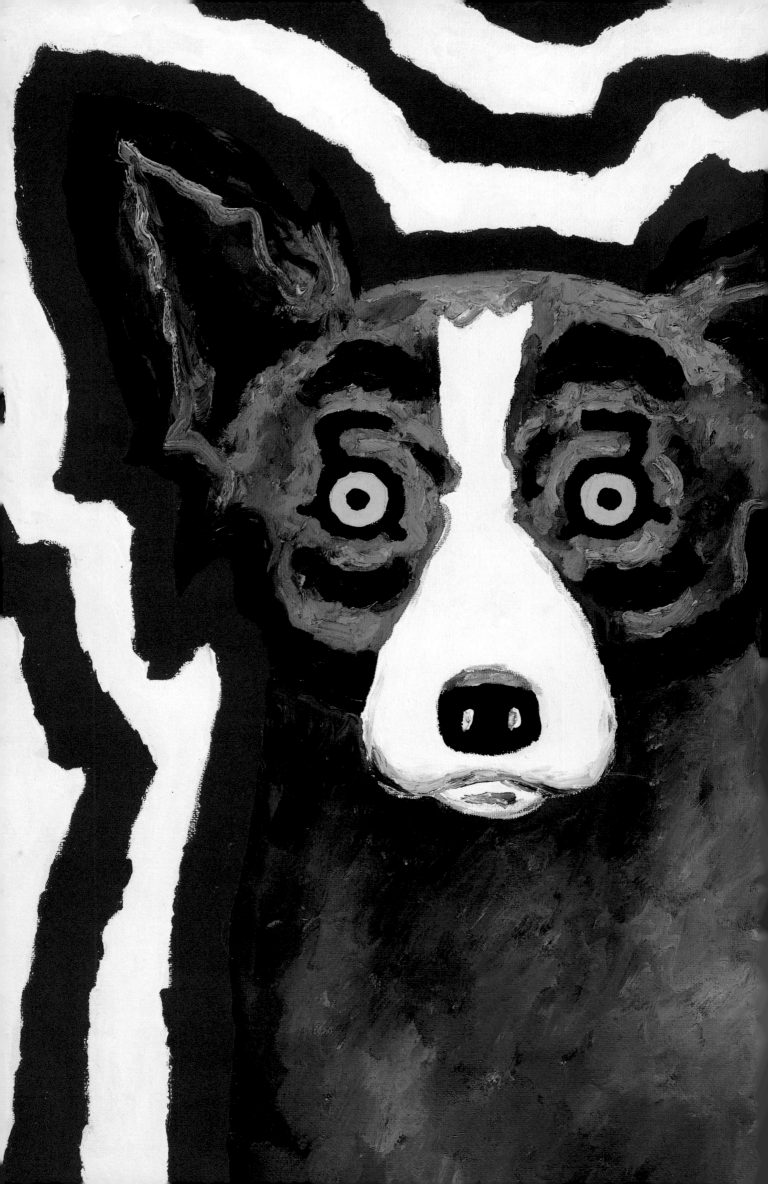

For the first time in many years, I felt I was truly moving forward. It was a feeling I wanted to have all the time, not just once in a while. I became keenly aware of all sorts of previously unseen details in my environment, and

I finally understood that to keep moving forward you not only have to look to the future, you have to *inhabit* the future.

I created twenty paintings—including *I Live for My Country*—for a 1996 exhibit at Union Station in Washington, D.C.; I called the series "Blue Dog for President." I'm so often told that Blue Dog has become an American icon that pairing her with patriotic themes seemed natural. The pairing reflected a personal transformation as well. I had for so many years been referred to exclusively as a Louisiana artist, even when I traveled abroad. Thanks to the popularity of Blue Dog, however, I'm more frequently called an American artist these days. This was a great leap for me. I'm proud to define myself and my family as Cajun, but by being accepted beyond my regional roots I can enjoy embracing an ever-larger family.

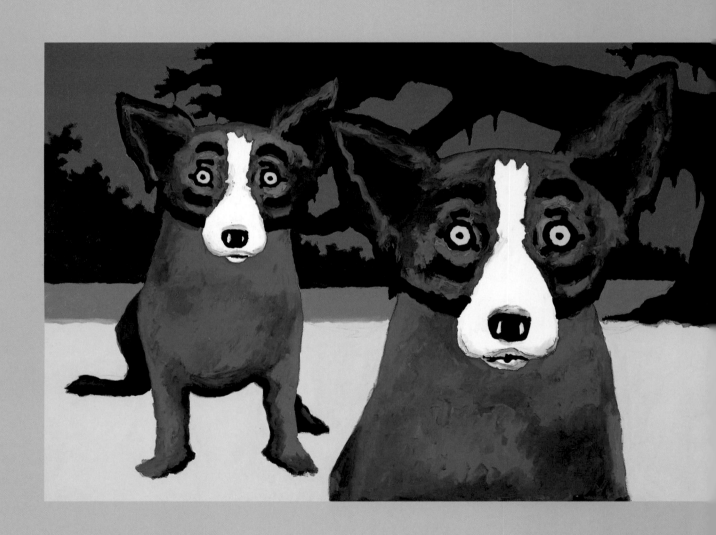

For art—and life, for that matter—to be fulfilling, it has
to constantly celebrate newness and feel the bristling
latent energy of all the things around us. This doesn't
mean ignoring the past; it just means looking at
events, people, and things in an entirely new light.

So, slowly but surely, Blue Dog began to lead me away
from her Cajun past into sometimes playful,
whimsical new situations. Yet at no time was I cavalier
about my approach to creation; whatever their
content, my paintings were *serious*. The seriousness
of my approach to my subjects made the paintings
work. Blue Dog would not become a cartoon or
a glib commentary on life; she had to be part of a
composition made up of profound elements.
These elements had less to do with Cajun history than
with the feelings, subjects, and images that filled
my life from day to day. I had welcomed Blue Dog into
my own contemporary life, which, like anyone
else's, was filled with all the dazzling sounds and
images of the modern material world.

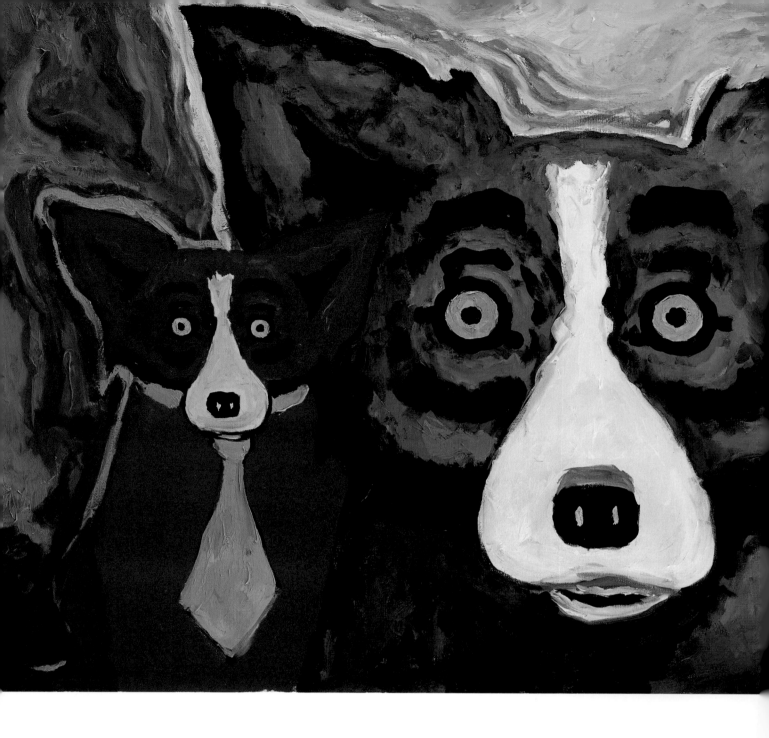

When I first decided to
paint Cajun landscapes, I knew
that light would play a unique
role in my work. In Louisiana,
the light is always distant,
obscured by a low sky and the
moss-draped branches of the
oak trees. In my recent paintings,
however, I've manipulated
my old "rules" in order
to reflect new moods and new
environments. My Louisiana
is not dark these days.
Indeed, it is full of color and light.
In *Angel on My Shoulder*,
Blue Dog's bad counterpart—
always in red—sits off to
one side; on the other side is the
light of artistic freedom,
emanating from the very same
oak tree that once obscured it.

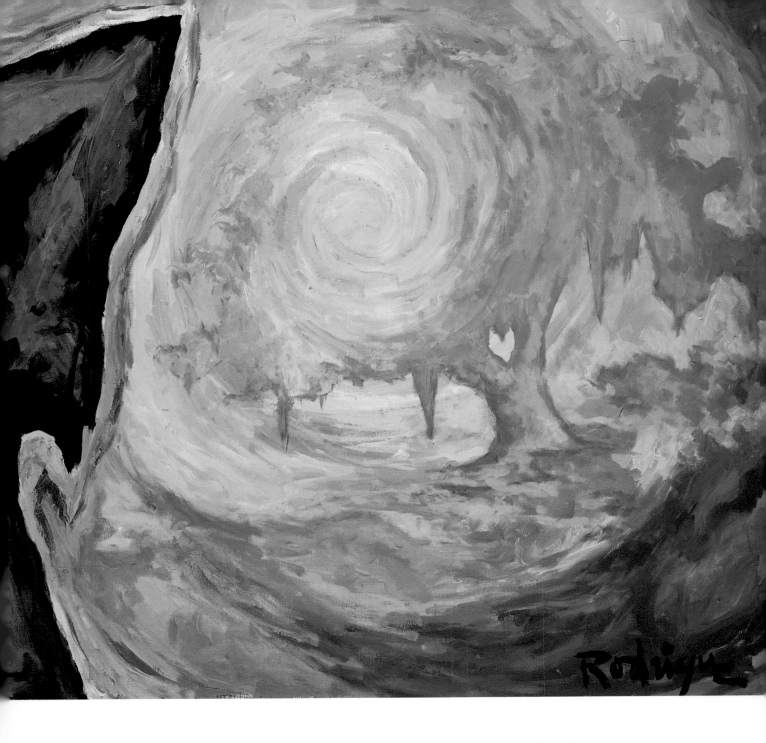

I guess I hoped that by introducing Blue Dog to
this world, she could in turn help me gain a better
understanding of my own life and environment
and maybe—just maybe—tell me a little something
about what it means to be human.

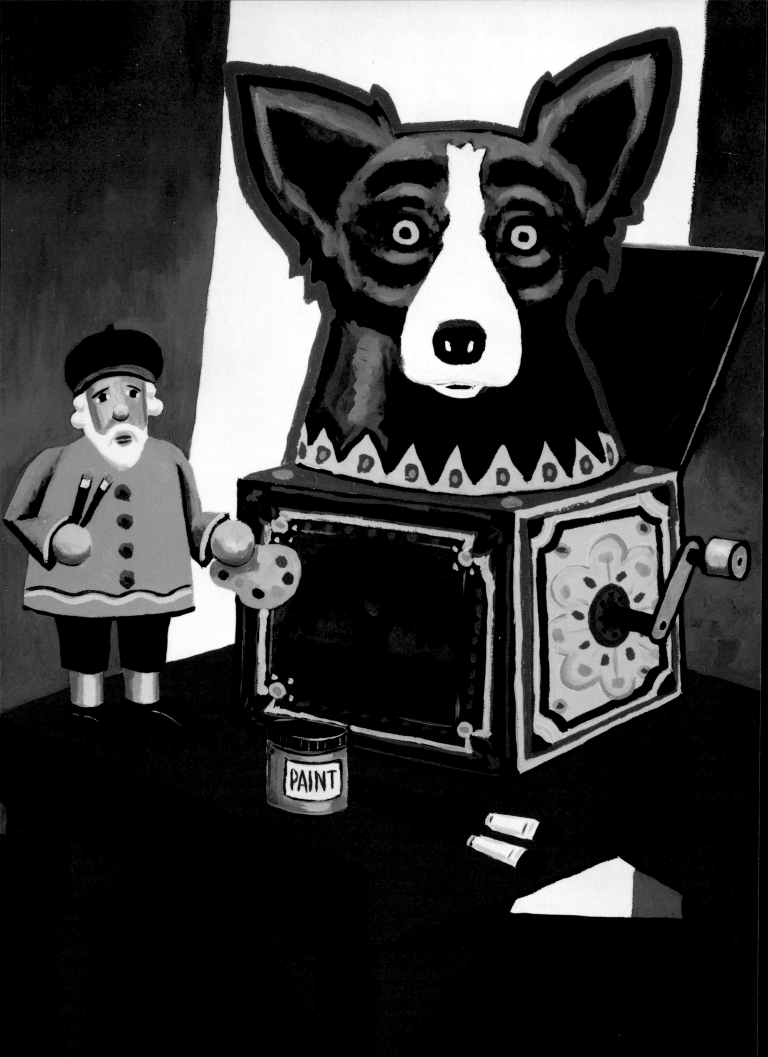

LUCKY DOG

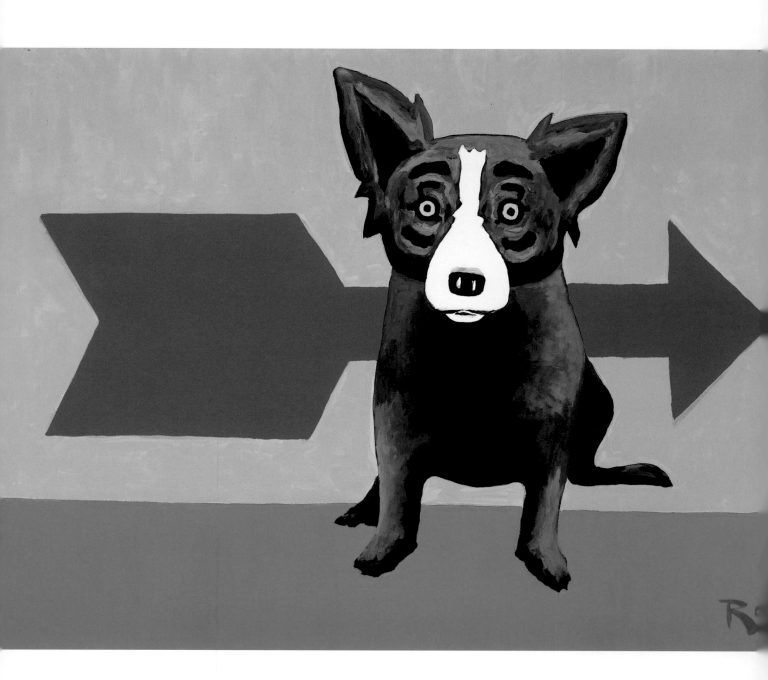

"There's just something about that dog . . ."

I began to hear those words bounce around my New Orleans gallery like an echo as Blue Dog paintings filled the walls. I became fascinated by watching people react to the paintings: Hurried passersby would often stop in their tracks in front of the gallery, finding themselves drawn inside. Soon, I could barely keep up with the growing interest in the Blue Dog series. Questions and requests started coming in from all directions and from every different type of person: artists, musicians, housewives, television personalities, schoolchildren—everyone. I had been exhibiting and selling my Cajun landscapes and portraits for twenty years, but I had never encountered anything like this.

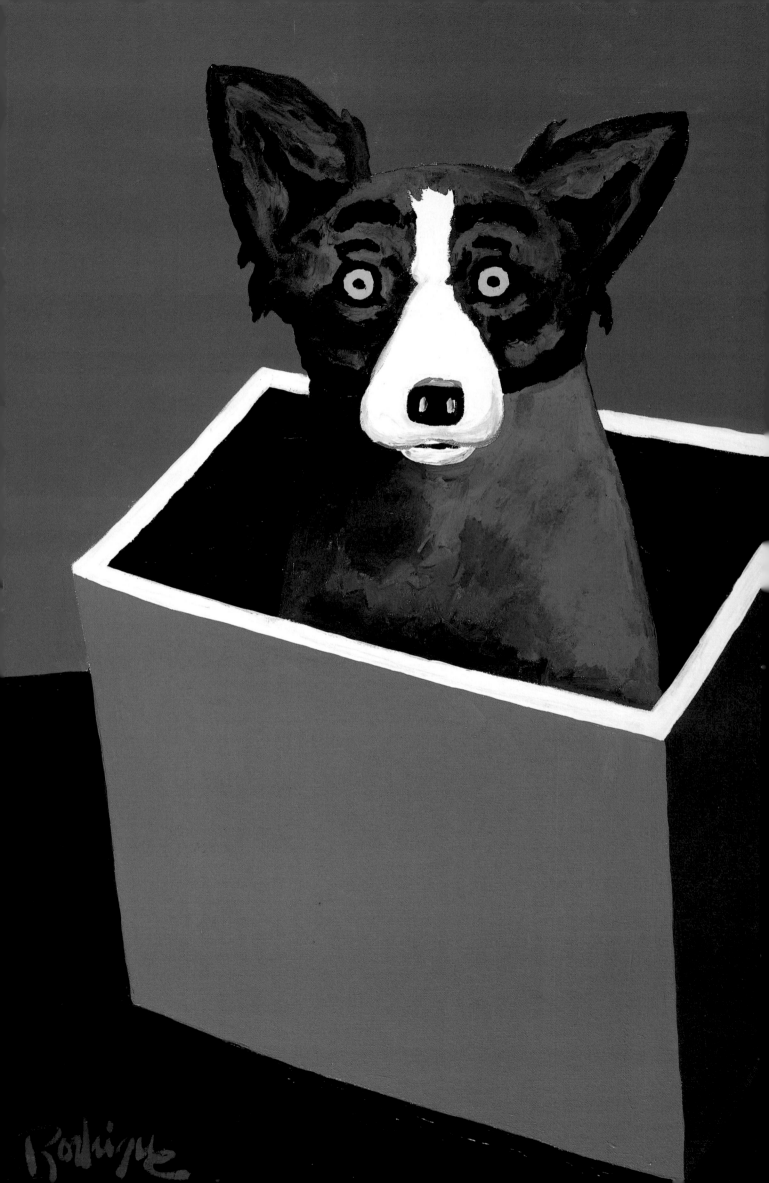

What I found most intriguing was the fact that there

seemed to be no limit to the range of emotions

and feelings that Blue Dog could bring out in viewers.

With the gaze of each new visitor, Blue Dog was

reinvented. Some instantly recognized the sadness and

melancholy within the dog; others were moved to

reflect on their own lost pets; still others seemed tickled

or amused by the repeated image of this impossibly

colored canine. Some critics called it folk art, others

called it low art, others dubbed Blue Dog a mascot for

America's journey into the new century. What had

begun as an outgrowth of my Cajun roots and a personal

expression of loss was now, for better or worse,

an icon—an emblem, a receptacle for the desires and

feelings of anyone who happened to be looking at it.

All my paintings are about contrasts. The most obvious, of course, is between Blue Dog and her yellow eyes. I've also become increasingly concerned with contrasts in volume and shape; in *Box o' Blue Dog*, the flat, shadowless sides of the box, set against a two-dimensional background, somehow accommodate the voluminous, organic shape within.

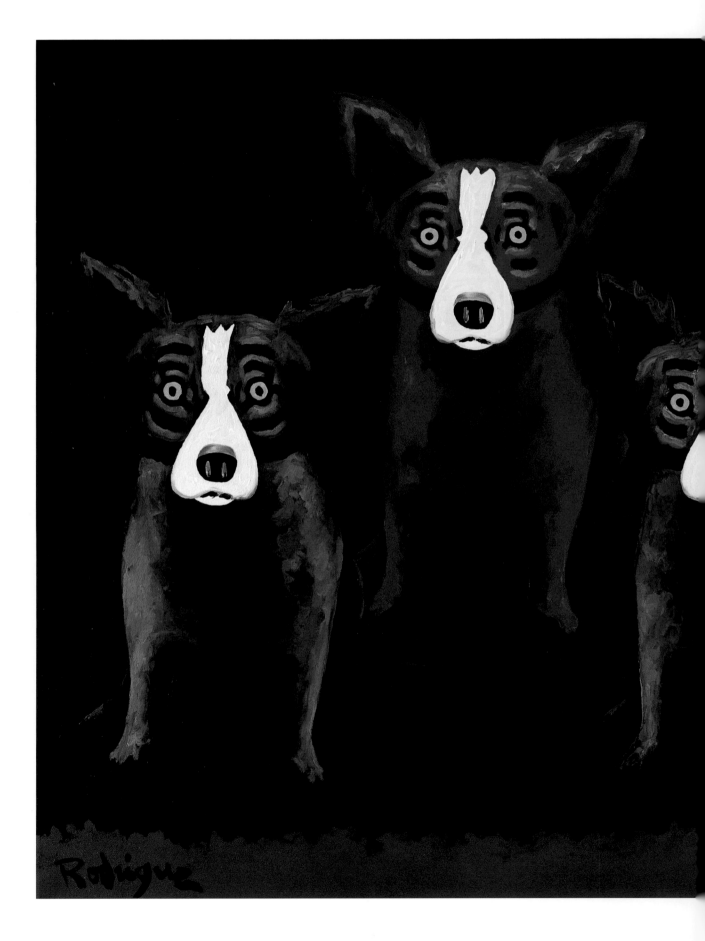

Yet Blue Dog had to remain an original creation that was a reflection of my heart and soul.

All this attention, of course, did have an effect on the way I thought about my work. Just as I was starting to coax Blue Dog out of the Cajun realm and into my modern world, the modern world itself came along and staked its own claim. The challenge I faced was simple: I had resolved to place Blue Dog in contemporary environments, but I still had to keep my paintings personal, to make sure they remained a pure expression of myself and not of the growing expectations of others. If Blue Dog remained truly my own, she could help me look at my world in a fresh way. I knew that the one way to accomplish this was to allow Blue Dog to comment on what was happening all around me.

I painted *High above the Clouds* during the Art Festival in Carmel, California, before a crowd of onlookers in the gallery. I've always thought that people enjoy watching me paint because they can see a blank canvas become a complete painting in a few hours. In these situations, I work fast and with large brushes. Most of my paintings take much longer and involve tighter brush strokes.

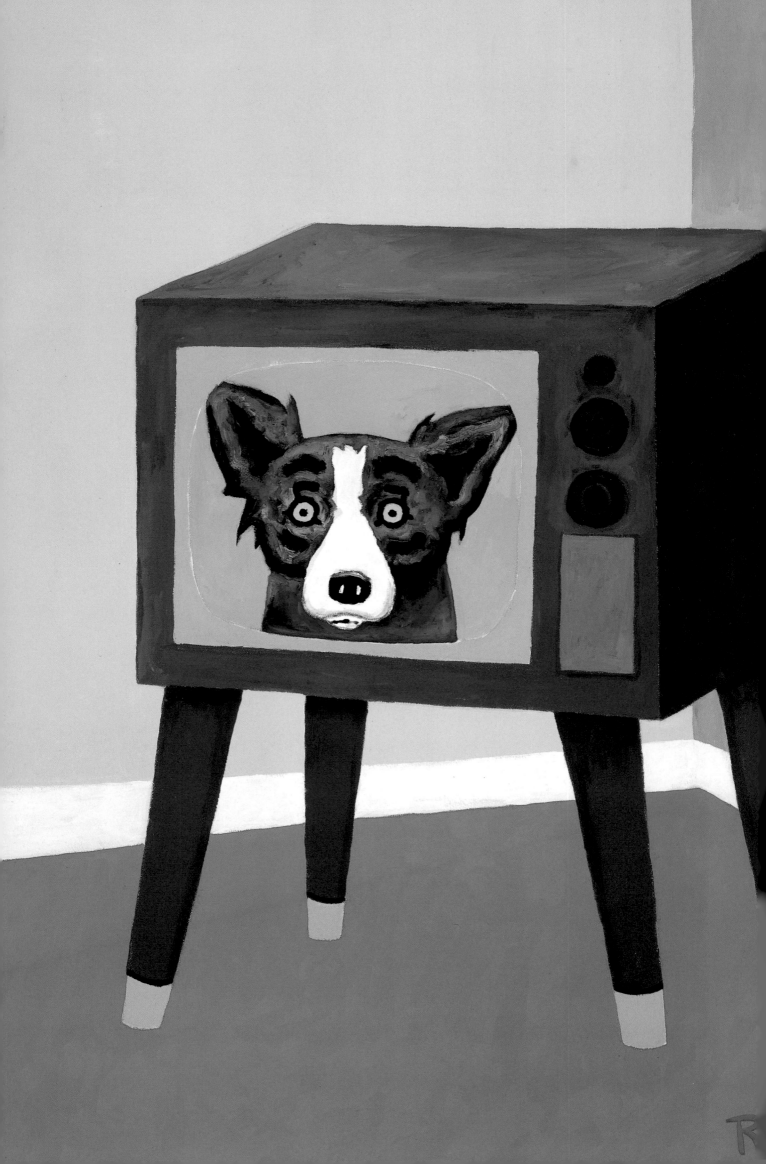

Appropriating an iconic image and allowing it to comment upon contemporary society and mass culture is nothing new—the pop art of the 1950s and 1960s had perfected this. The challenge for me was to understand how the contemporary world was affecting *me*. To do this, I began to place Blue Dog in all sorts of different situations and backgrounds. Many of the paintings were graphic experiments, explorations of line, color, and form. Whole new palettes and compositional schemes opened up to me. The subject matter could be anything—from the Lone Ranger to Elvis to the American flag. The sources just emerged, as they always had, while I was painting. I would hit on an idea, let it gel into a graphic concept, and then jot down a title as it came to me. The inspirational source could be popular music, jazz, MTV, local news, celebrities—anything. Whatever the inspiration, the result had to

surprise me.

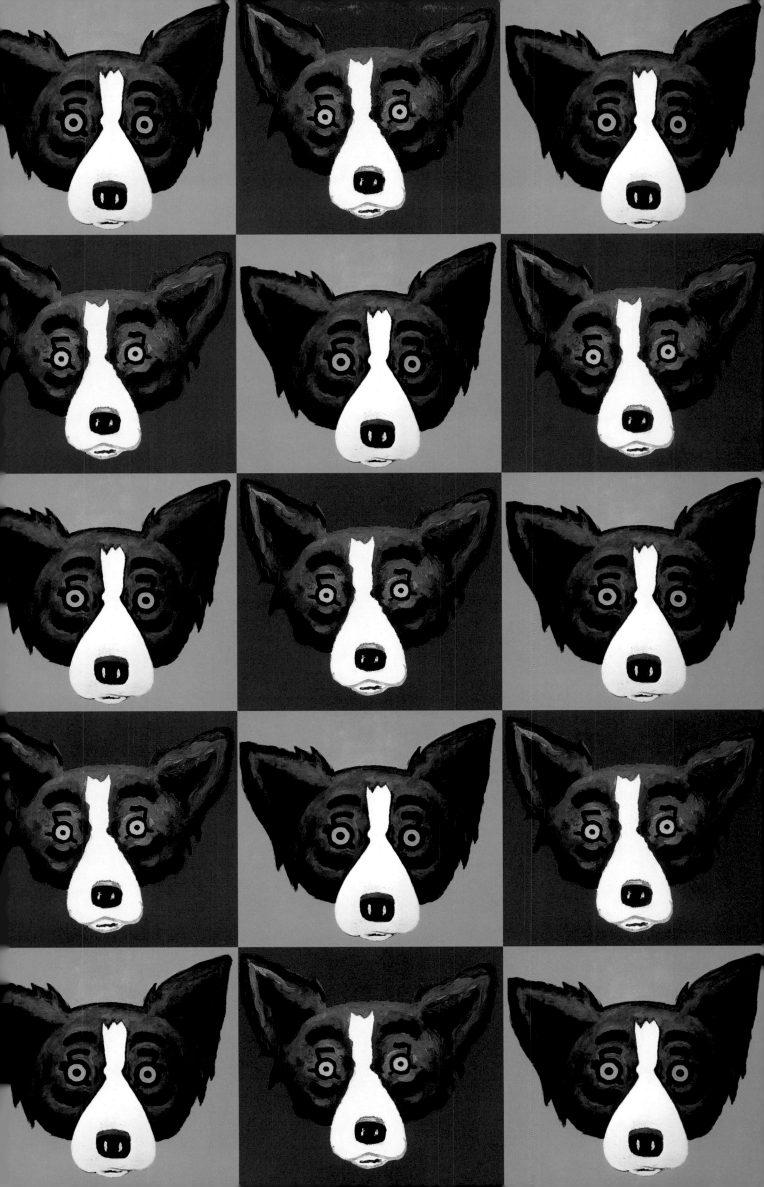

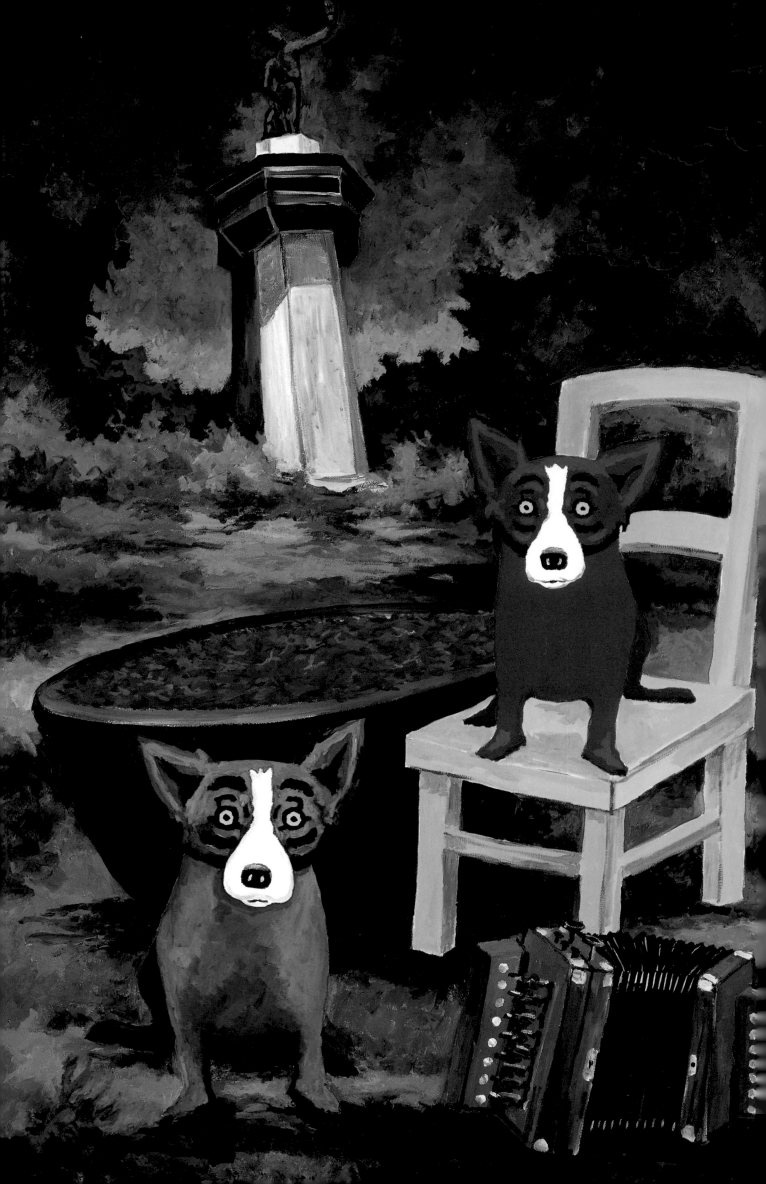

From time to time, people would ask me if it felt confining to paint the same figure over and over again. Why didn't I flesh it out, turn it around, make it bark—make it *do* something? I guess what people found hard to understand is that it was precisely Blue Dog's flatness, her sameness, that made her liberating. She is cut out and transplanted; she has become an icon that transcends herself and every little world she inhabits. I would occasionally dress her in a suit and tie, or change her coloring, but her basic form had to stay the same.

I did this painting, called *Boiling My Blues Away*, for the Alabama Crawfish Boil, held every spring in Birmingham, Alabama. Each year thousands of people flock to Birmingham to satisfy their appetite for boiled crawfish, fried crawfish, and crawfish etouffé—not to mention big helpings of spicy Zydeco music. Vast quantities of the tiny, tender shellfish are boiled in huge pots like the one shown here. This painting shows that Blue Dog today is as comfortable presiding over a joyous celebration as she was brooding under a somber, Cajun oak tree.

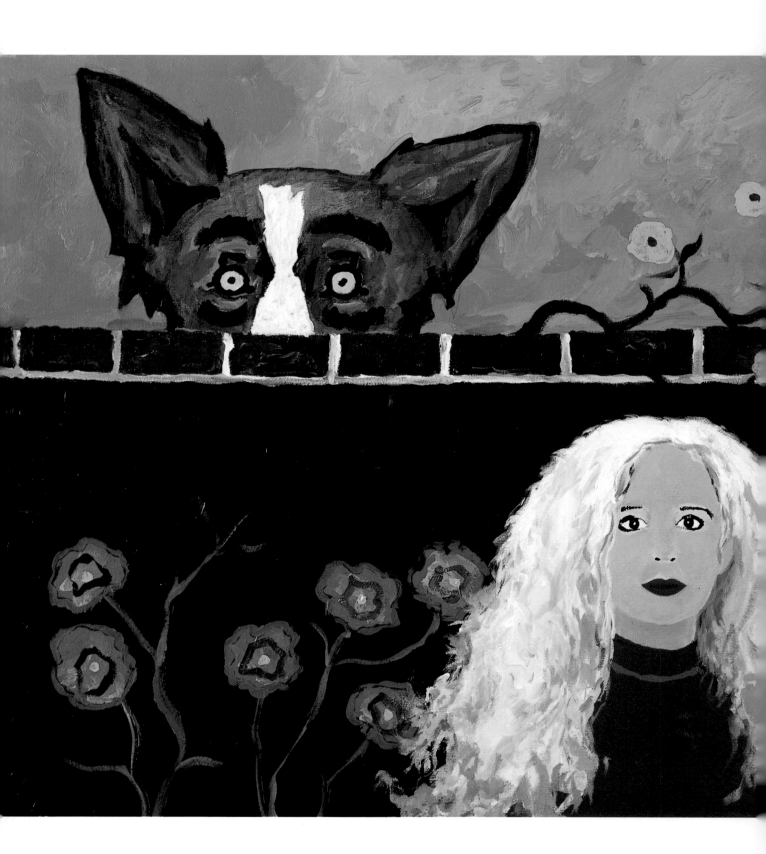

As soon as
you change that—
as soon as you
try to stuff Blue Dog,
animate her,
or peek behind her—
her power is lost.

In My Secret Garden was inspired
by my wife, who told me
that she has a secret garden—
a private sanctuary all her own.
As I peer over the wall into
her world, I am touched to
see that her favorite thing to do
is to plant blue flowers for me.

Blue Dog would then become just a

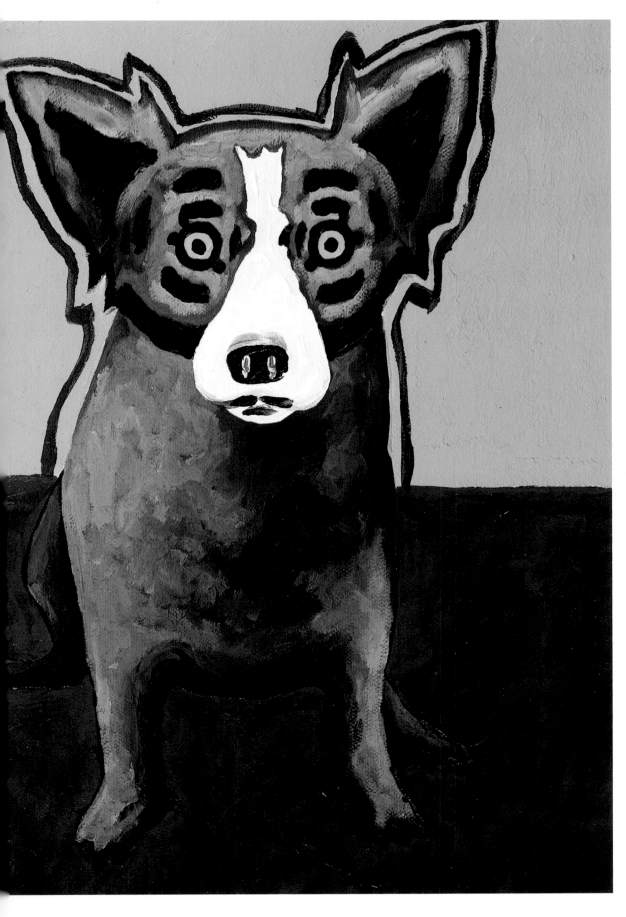

dog.

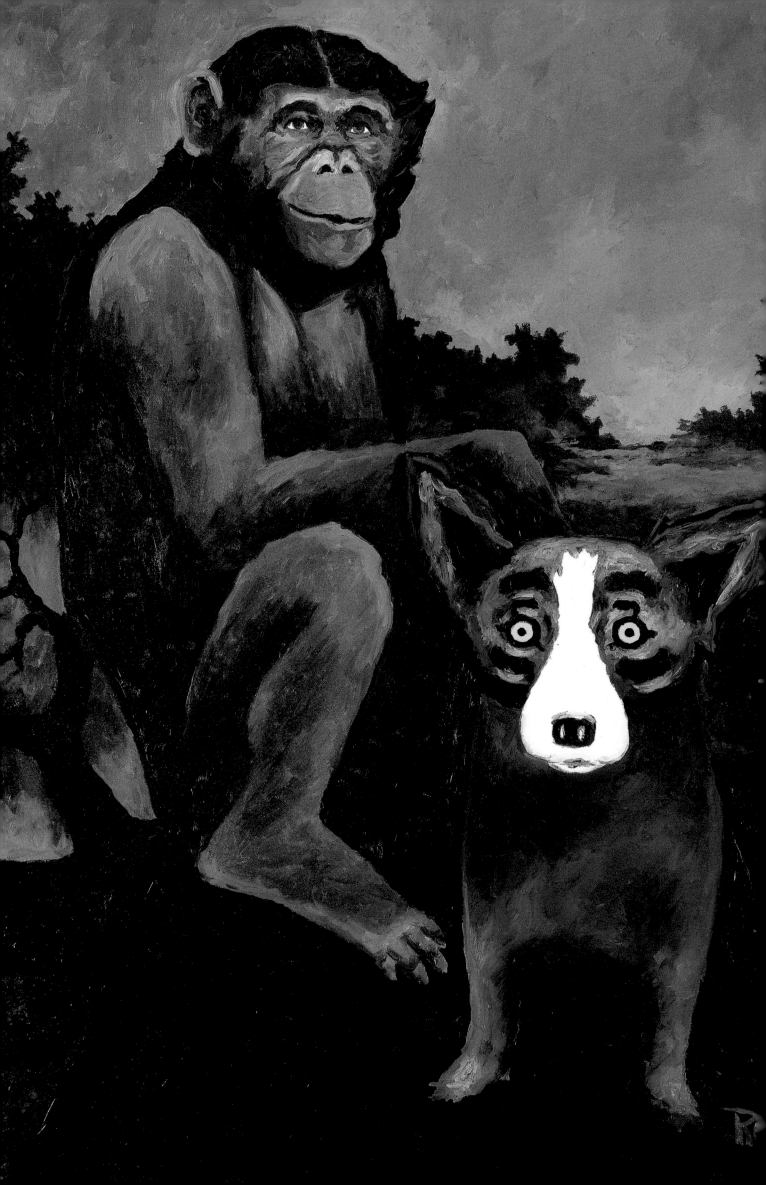

So, on the one hand, when I began to paint her,

Blue Dog was, in a visual sense at least, unchangeable.

In a much more profound way, however, she was

ever-changing. Not only was she altered by every new

environment I happened to put her in and by the

new roles she played in my life, but even a single

Blue Dog painting could take on countless new meanings

and forms depending on who was looking at it.

Of course, anyone who studies the Blue Dog series

as a whole will begin to understand things about my

life, but the fact is, once the paint is on the canvas,

she is outside of me. The image is not in my head

anymore. It is out in the world—free to be something

entirely different from what I might have intended

it to be. The thought is both unsettling and exhilarating.

As the title of this painting,
Searching for Darwin, suggests,
we often turn to the words
of Charles Darwin in our quest to
find the origins of human life.
It is perhaps an endless quest,
but in Blue Dog's world,
finding the answer can be as easy
as asking the nearest ape.

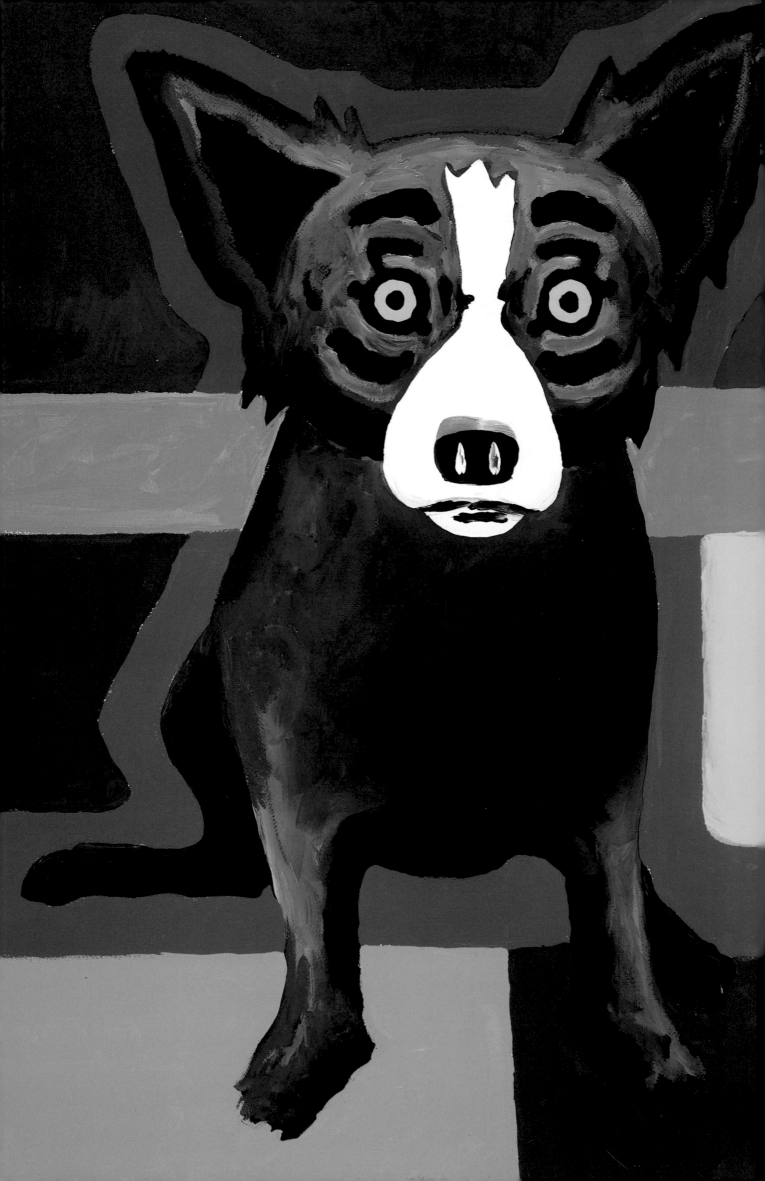

When I first began to paint Blue Dog this way,
I simply didn't care whether my work was "high" or
"low" art; my main concern was simply to keep
Blue Dog vital and expressive and necessary to me.
I knew that the moment Blue Dog stopped being fresh
in my mind, I would cease painting her. I began to
treat the Blue Dog series as a sort of personal science—
a series of creative exercises that sought answers
to persistent questions both about life and about the
visual elements of my painting.

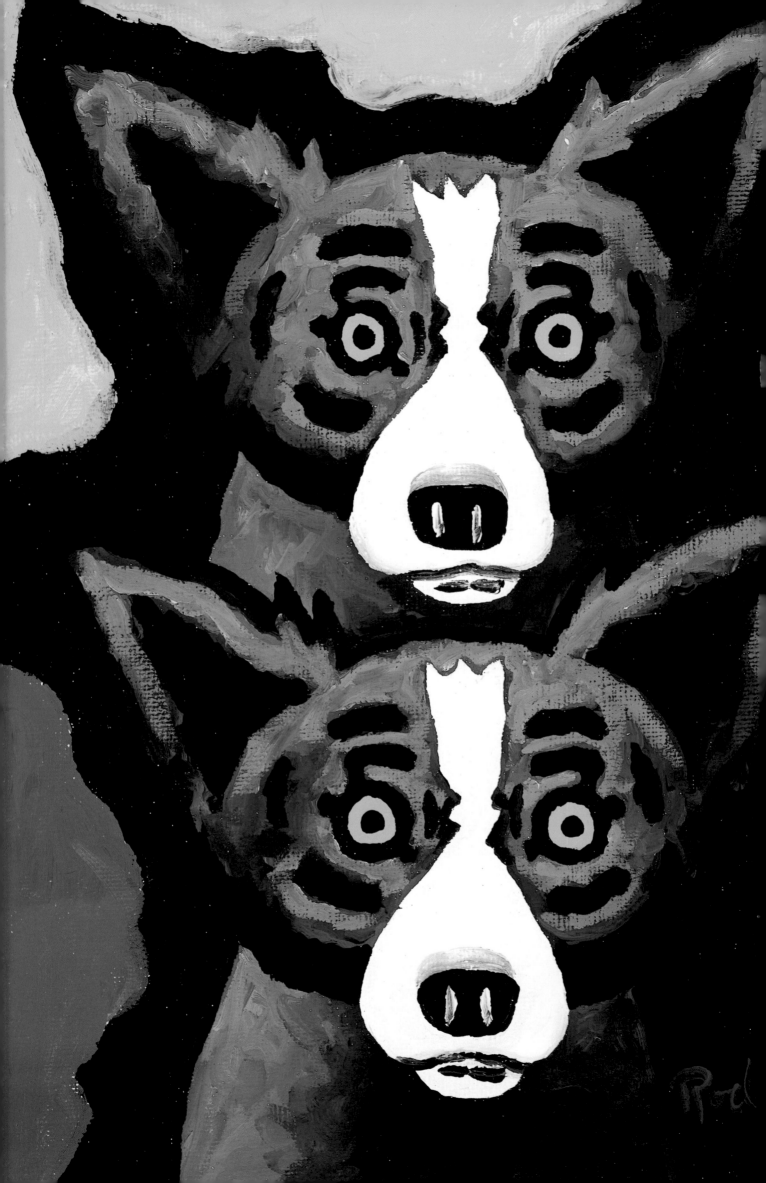

I started to reflect on my body of work in a way
I hadn't before, and I came to realize that I was not
alone in seeing my painting as a science. Art, in
fact, has often been treated as such, with sets of rules
and areas of expertise. What may seem mundane
in art today was once a breakthrough, just as a scientific
norm was once a breakthrough. I thought of the
great breakthroughs in art made in recent decades—
like those of Pollock, Rothko, Warhol, and others.
These painters applied techniques in ways that other
artists hadn't conceived of or had simply ignored.
Pollock, for example, embraced the childlike impulse
to splatter paint—something I can remember doing
for craft projects in grade school—and channeled
it into remarkable new compositions.

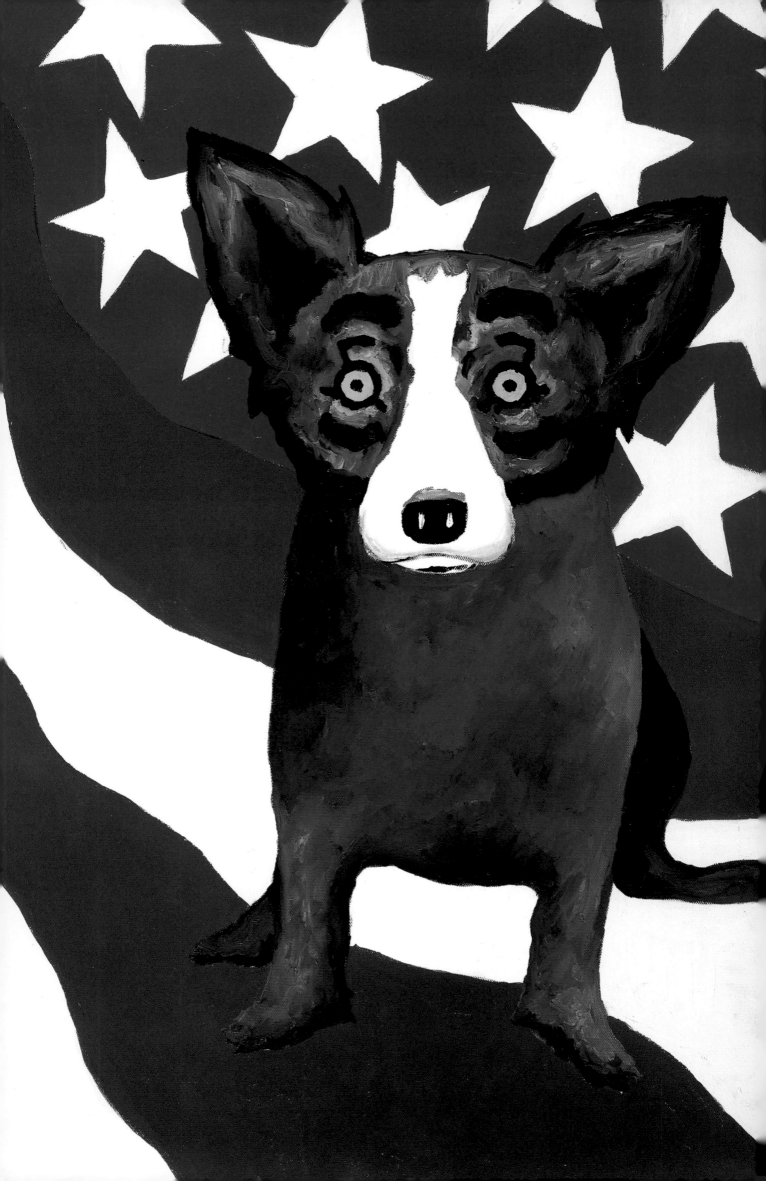

I wasn't particularly concerned, however, with whether Blue Dog represented any sort of historical breakthrough. What concerned me was infinitely more subjective. Blue Dog had helped me make several personal breakthroughs—in both my life and my way of painting. In order to keep moving forward toward the next frontier, I had to be vigilant and committed, making sure that Blue Dog remained, above all, sincere. Sometimes, I would toy with elements of commercial art in Blue Dog paintings as a way of exploring the role of mass-produced images in my life. Yet in commercial art there is always a real-world object or product measuring the art's success or failure. What set Blue Dog apart from, say, a logo was the fact that Blue Dog could advertise nothing but herself. She would always remain a pure expression; she had to.

More than simply a patriotic symbol, the American flag is a bold tapestry of color, form, and field—with its sweeping red and white vertical bands and its crisp, five-pointed stars set against an azure field. It is only when these diverse elements come together— as they do here in *Stars and Stripes and Me*—that they compose the recognizable flag, just as the diverse peoples from myriad origins unite to form America.

In this realm of pure expression there is no good or bad, just "new" and "different."

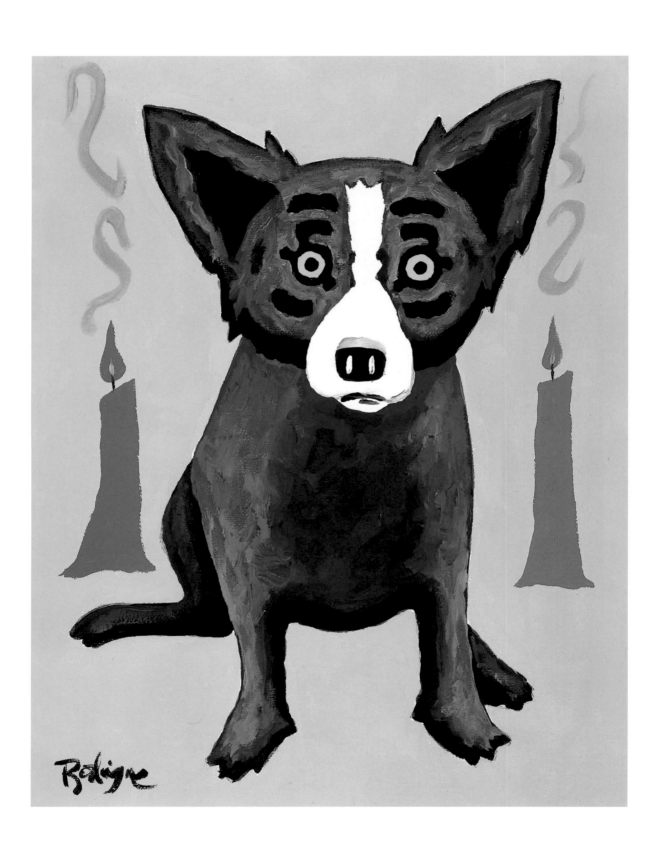

Being new and different in the modern world is not an easy task.

We are living in an ever-expanding universe filled with an overwhelming abundance of information—television, the Internet, E-mail, phones, and faxes—and I knew that Blue Dog and I couldn't possibly keep up with even a fraction of it. With such an extraordinary accumulation of images and ideas all around me, I knew that the one way to cope with it all was to recapture some sort of simplicity. I had done it before, when I had returned to Louisiana in search of the simple life I had left behind years before. I knew I could do it again with Blue Dog. However many complicated, baffling situations I put her in, she remains the one reassuring constant. When other people look at a Blue Dog painting, it might be that they, too, can find, for a moment at least, that same reassurance.

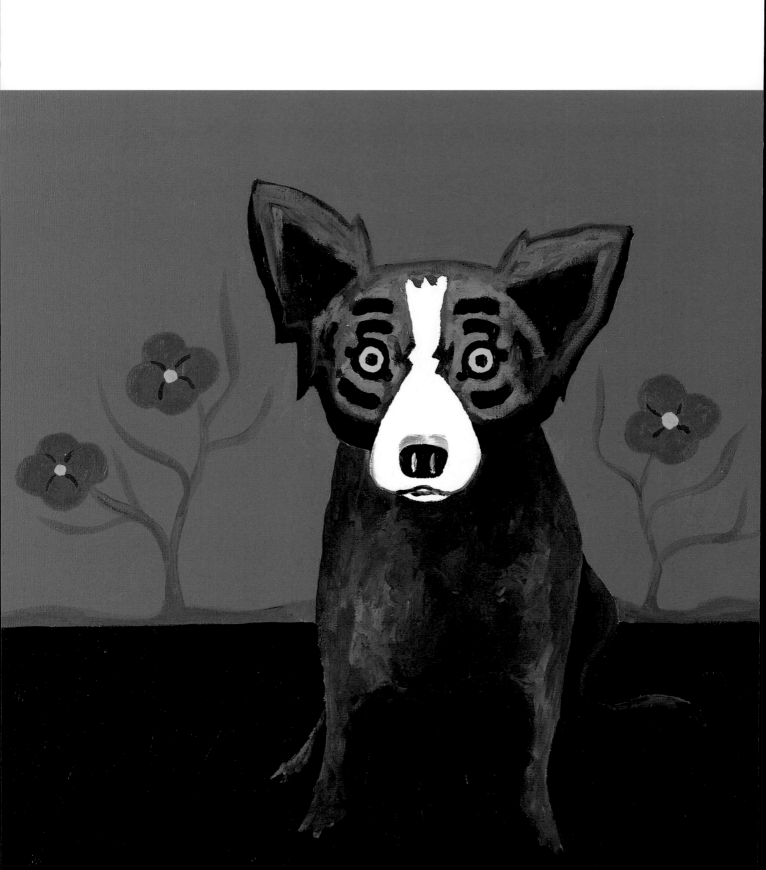

There is something else, though, something older than Blue Dog, that helps keep my vision of life very simple. When I first decided to paint, I started out with literally nothing but a single paintbrush and a nickel. I used the nickel to buy some cheap paint and surplus canvas. From those simple beginnings, everything else was born. I take comfort in the fact that if my life becomes too complicated and everything around me begins to crumble, I can always go back to that paintbrush and nickel. In that respect, the most valuable thing I possess is the very thing that no one can take away.

By including flowers in my paintings, I know that I enter risky territory; painted flowers can so often evoke bad amateur still lifes and cheap hotel-room kitsch. To overcome this, I choose to paint flowers in a simple and idealistic way. Here, in *The Flowers Speak to Me*, the flowers possess a childlike fragility that creates a subtle, poetic counterpoint to the stout form of Blue Dog.

The challenge for me is not to expec

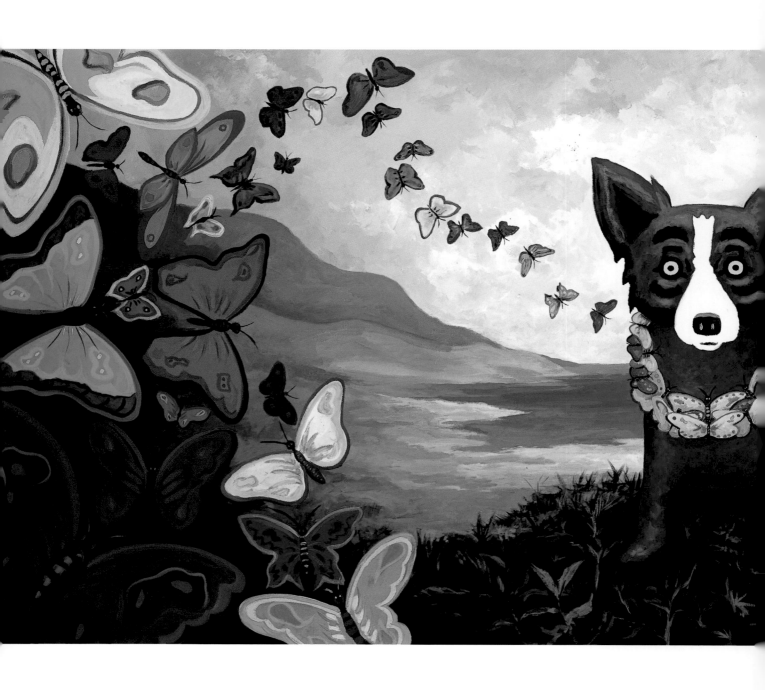

he unexpected, but to celebrate it.

I've come to understand that the one thing you can count on in life is change. It is the only constant, and that can be awfully frightening. Yet change is precisely what lends life its richness. Blue Dog has changed my life in so many ways, yet my basic mission remains unchanged: to continue to surprise myself with this unusual creation. In a chaotic world where we are surrounded by innumerable new images and sounds every day, I think this is no small task.

I take encouragement from the fact that, amid all the dazzling distractions of the modern world, a simple blue dog can make people pause and ponder some of life's questions—and maybe even find an answer or two.

Old Hawaiian postcards have always interested me, and I have a closet full of vintage Hawaiian shirts. When designing *Hawaiian Blues*, I kept my ninety-four-year-old mother occupied for two days by asking her to cut out pictures of butterflies, which I then pasted all over a sketch. In the final painting, the butterflies appear to be pasted on an old Hawaiian postcard—just as Blue Dog appears to be pasted onto every situation.

125

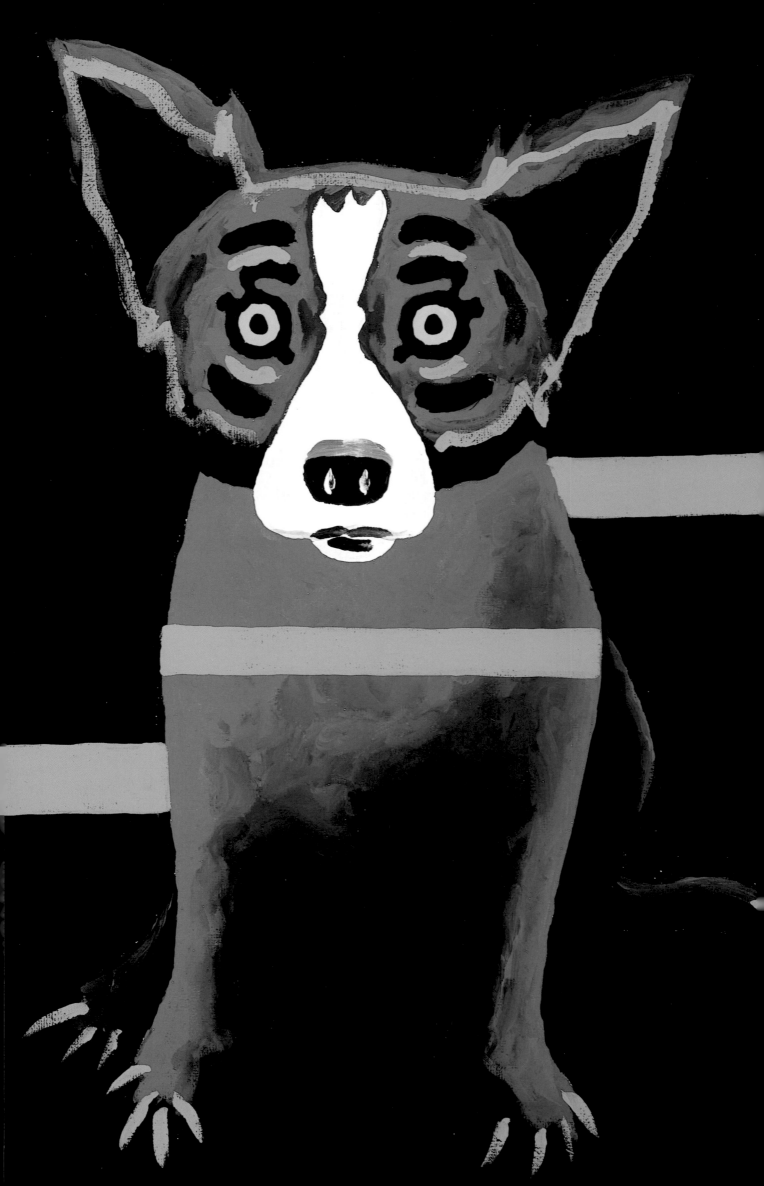

BY THE LIGHT OF THE JOURNEY

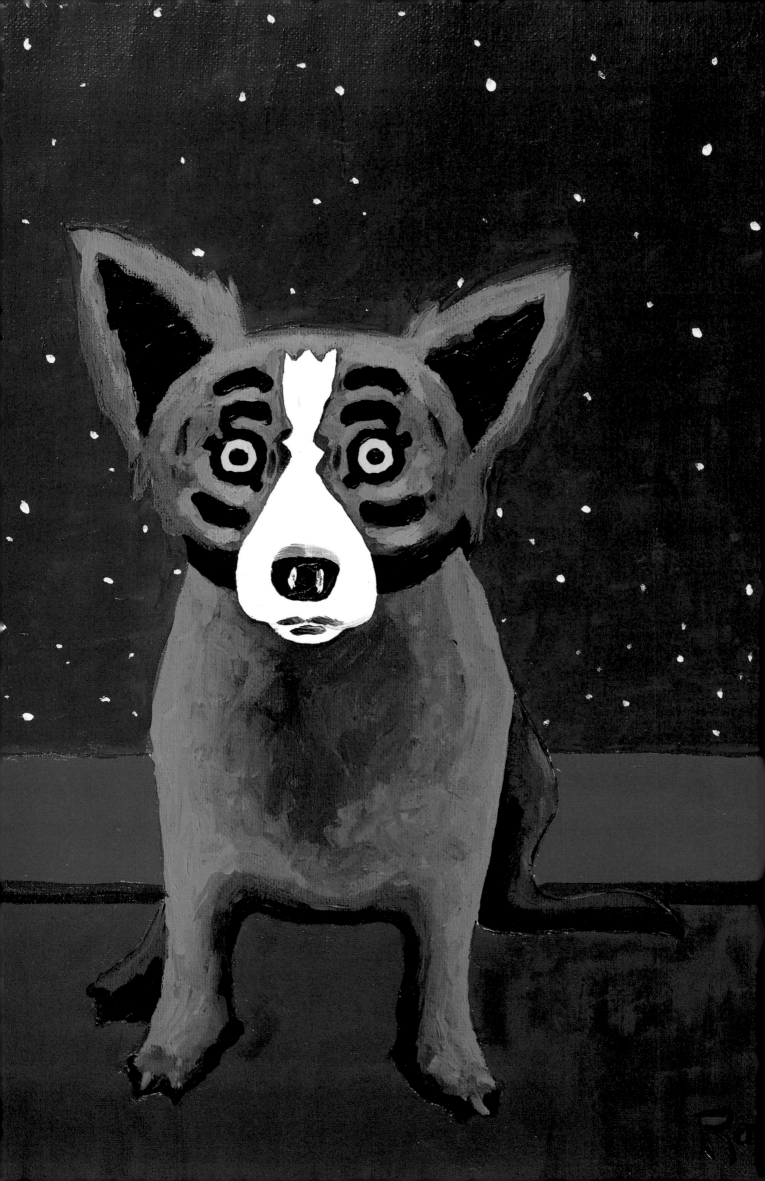

The journey is the reward.

Not long ago, I began to notice an interesting
feature that appeared in a handful of
my recent Blue Dog paintings: Drawn
across the backgrounds and figures of the
canvases was a series of arbitrary lines. It eventually
came to me that these lines, however crude and sim-
ple, are my quiet way of expressing the various paths
my life has taken. I have no doubt now that my art is a
journey, one that has taken many turns but is far from
over. Like any journey, mine is marked by certain
milestones—some that take the form of sudden
epiphanies and others that are more like gentle bends
in a river. Over the years, Blue Dog has proven an odd
and unpredictable, but always faithful, companion on
this remarkable odyssey.

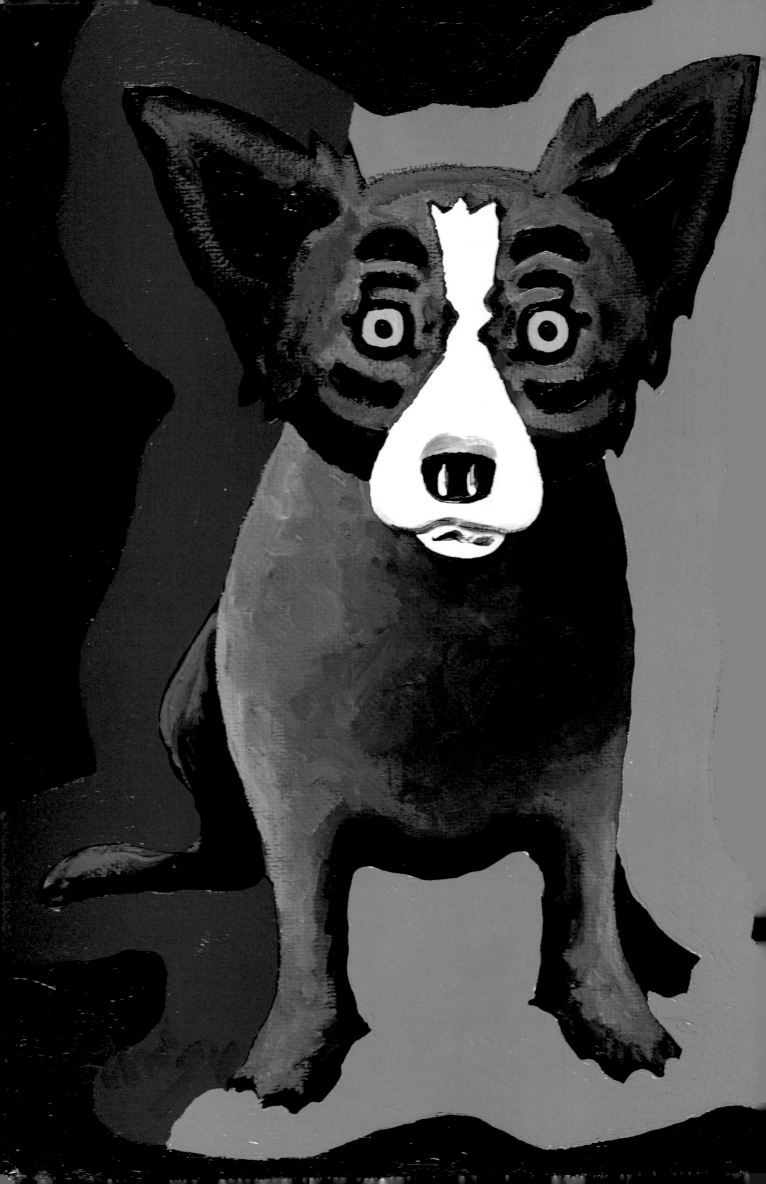

Any artist will tell you that choosing to devote a life
to creating art can be a very lonely decision—
that the moments of heady freedom can quickly be
followed by emptiness and despair. There is no set of
written rules by which an artist can measure success
or failure, and this absence of rules can be both
liberating and scary. Certainly, loneliness is one of the
themes I often return to in my Blue Dog paintings
(part of the reason Blue Dog was born, of course, is
that I felt alone without her), but loneliness is no
longer what Blue Dog is *about*. I guess you could say
that I am the most blessed of artists:

I can never be truly lonely in my art because I have Blue Dog.

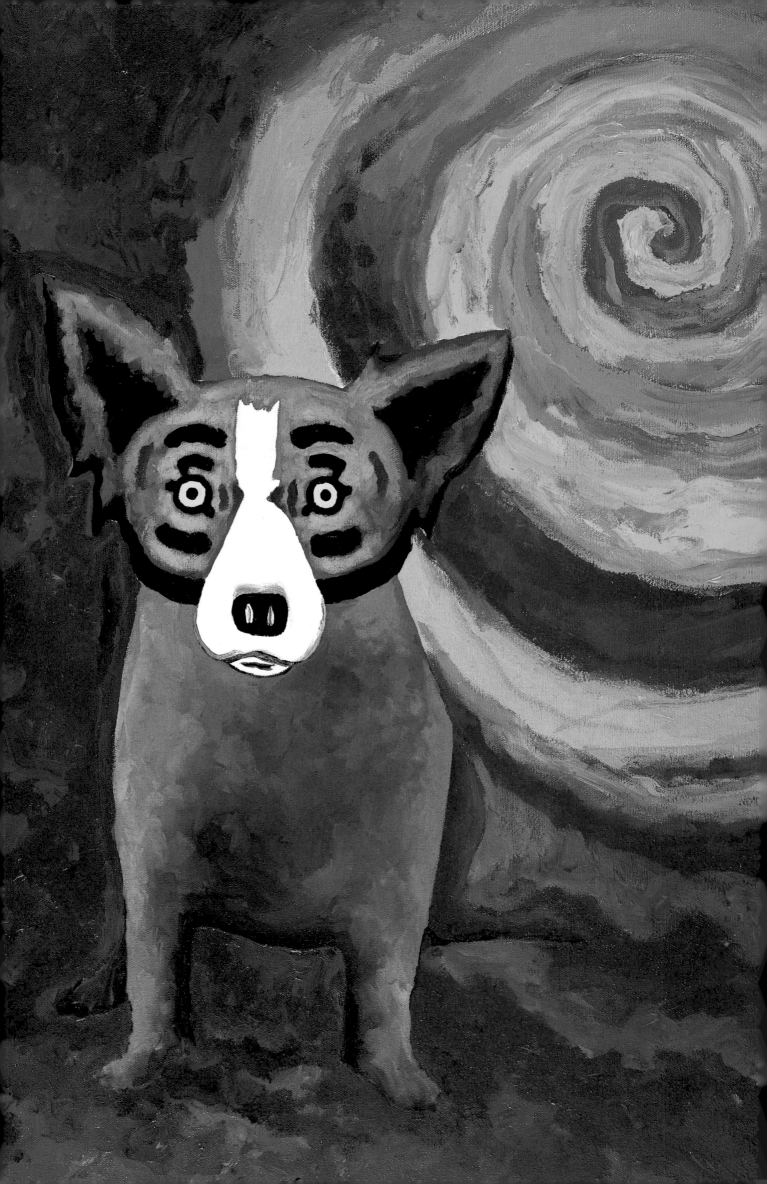

Together with Blue Dog, I am able to explore some of life's most bewildering questions: Where do we come from? Why are we here? What gives our lives meaning? Having grown up in a religious environment, I have always been told that the answers to these questions lie in faith—end of story. That solution seems too simple to me; in fact, I've discovered that many of life's revelations do not come in the form of discrete answers. Rather, knowledge and understanding are most often gained only in the *search* for answers.

It is this endless search that my paintings are about. Lurking in Blue Dog's expectant gaze are the fundamental, perhaps unanswerable, questions of life.

Like virtually every living being, I often wonder what happens when we die; I wonder whether our perception of time and space is erased. It's a topic I don't mind discussing at length, and it's a theme that constantly finds its way into my paintings. The swirling imagery in this painting, called *Crossing Over*, is one way I chose to express my ever-changing visions of life and death. I often represent the cosmos as a vast swirl or pinwheel. To me, the universe is a mad mix of time, space, and our own perceptions of why we exist.

133

The conventional notions c
and sin and salvatioi

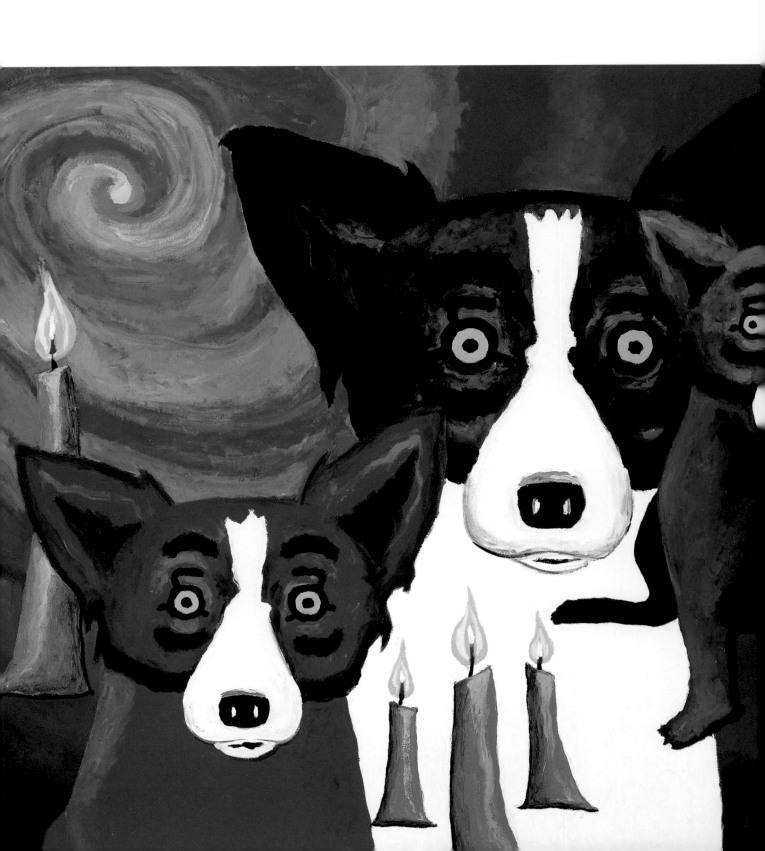

ood and evil, heaven and hell,
ever rang true for me.

Existence for me is a sort of continuum, and I can only
measure my worth in terms of my relationships to
my fellow human beings and to nature. This approach
to spiritual fulfillment, I discovered, is a lot older than
the beliefs I learned in parochial school. Fulfillment
for me comes not from following a set of rules and rituals,
but from enriching my connections to the people
and things around me. As a painter, I have a very keen
awareness of these connections; I feel the components
of my environment reaching out to me visually all
the time. In return, I give back to the world, through
my paintings, a totally transformed vision of the
people and things that touch my life—from my family
and the folks in my hometown to the flowers in
my backyard and the big oak trees of Louisiana.

**Blue Dog has been nothing
to me if not a journey.
I've even been told by some
people that Blue Dog has
become an icon for our collective
journey into the twenty-first
century. Here, in *By the
Light of the Journey*, Blue Dog,
in multiple forms, offers
to light the way.**

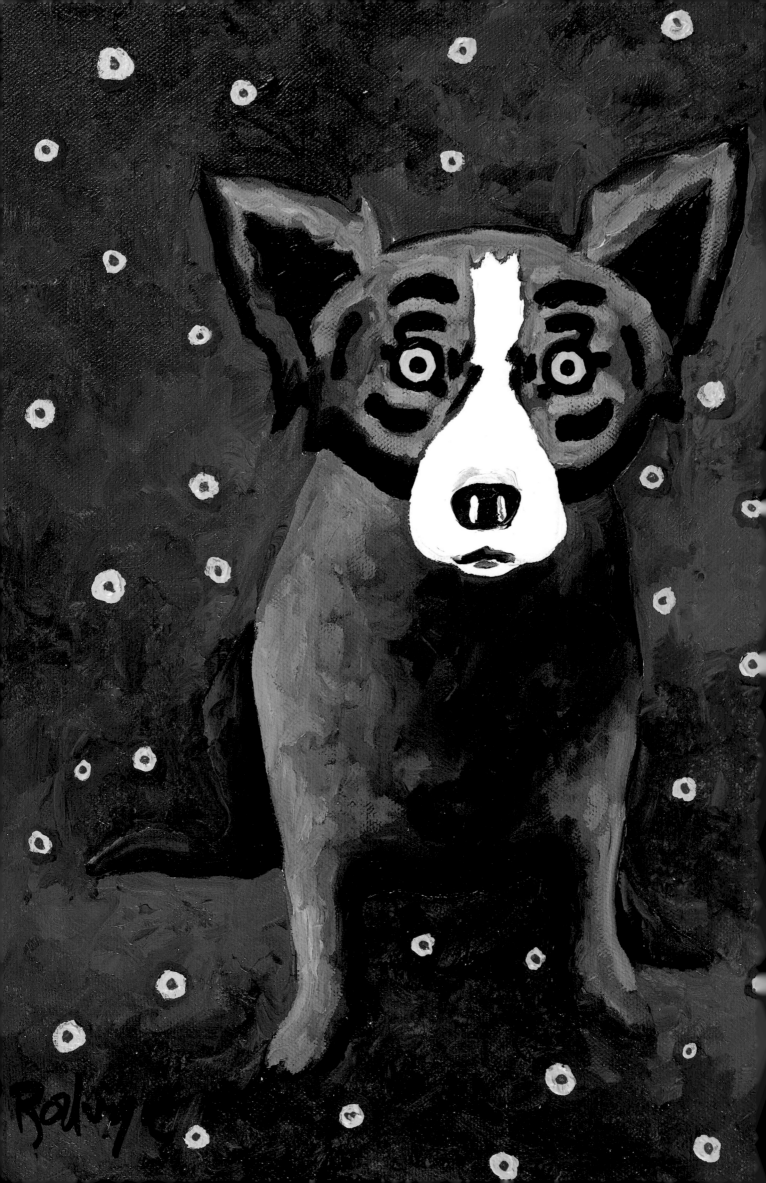

Contrary to the assumption of many people familiar with Blue Dog, every Blue Dog I paint is not the same shade of blue. I vary the color of her coat slightly depending on the background. Often, in fact, I have to go back and repaint Blue Dog after I've finished the background to achieve the right contrast, as I did here, in *Flowers of the Night*.

In this respect, I suppose, Blue Dog really is an icon; she is a vessel I can use to carry all these visions. Yet Blue Dog is not some object of worship. On the contrary, I simply hope that Blue Dog moves people in the same way she moves me—that she prompts them to ask themselves questions and, even more important, to be happy even if they do not know all the answers. Once I realized that I don't have to have all the answers, I found that it was much easier to embrace life, to accept its changes and pitfalls, and to move forward with my art.

For a long time, I felt I was working in the shadow of other artists as I struggled with my technique, trying to locate my own artistic vision. With my Cajun paintings, I knew I had finally struck upon something different—a new approach to light and form and a subject that had long been hidden from the rest of the world. Blue Dog, I think, has brought me full circle.

My mission is n
true to myself, t
total honesty wh
to me, and, of
forward in my se
understandin

One thing I kno
of painting Blu

ow simply to be

o describe with

at is happening

course, to move

arch for a better

g of the world.

w: If I get tired

e Dog, I'll stop.

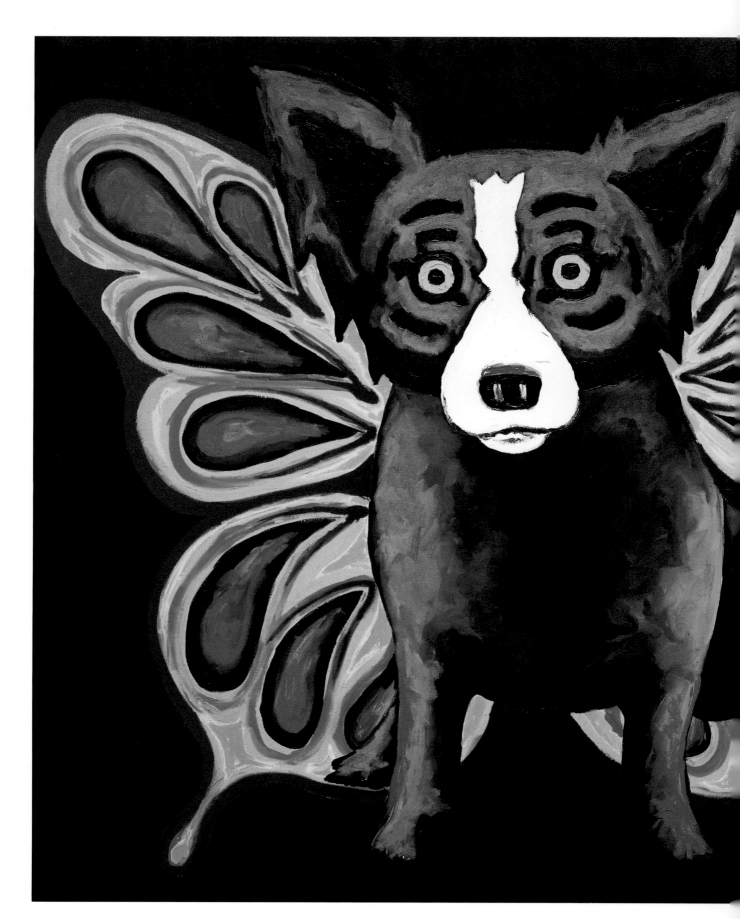

One of my teachers taught me that lesson a long time ago: If you're ever lucky enough to produce art that becomes popular in your lifetime, you'd better like it. Otherwise you become a prisoner of your own creation. It is a trap that one can easily fall into. I feel pretty safe for now; I simply can't imagine my life without Blue Dog.

Today, Blue Dog paintings hang in homes and public buildings all over the world, and I get a lot of satisfaction from knowing that Blue Dog will live on in these places long after I'm gone. Perhaps people will continue to talk about my work for decades to come; perhaps they won't.

What I do know
is that Blue Dog,
in some form
or another, will
remain a presence
in the hearts
of the people who
have come
to know her — and, I hope, in the hearts of al

...those who may join Blue Dog in her journeys yet to come.

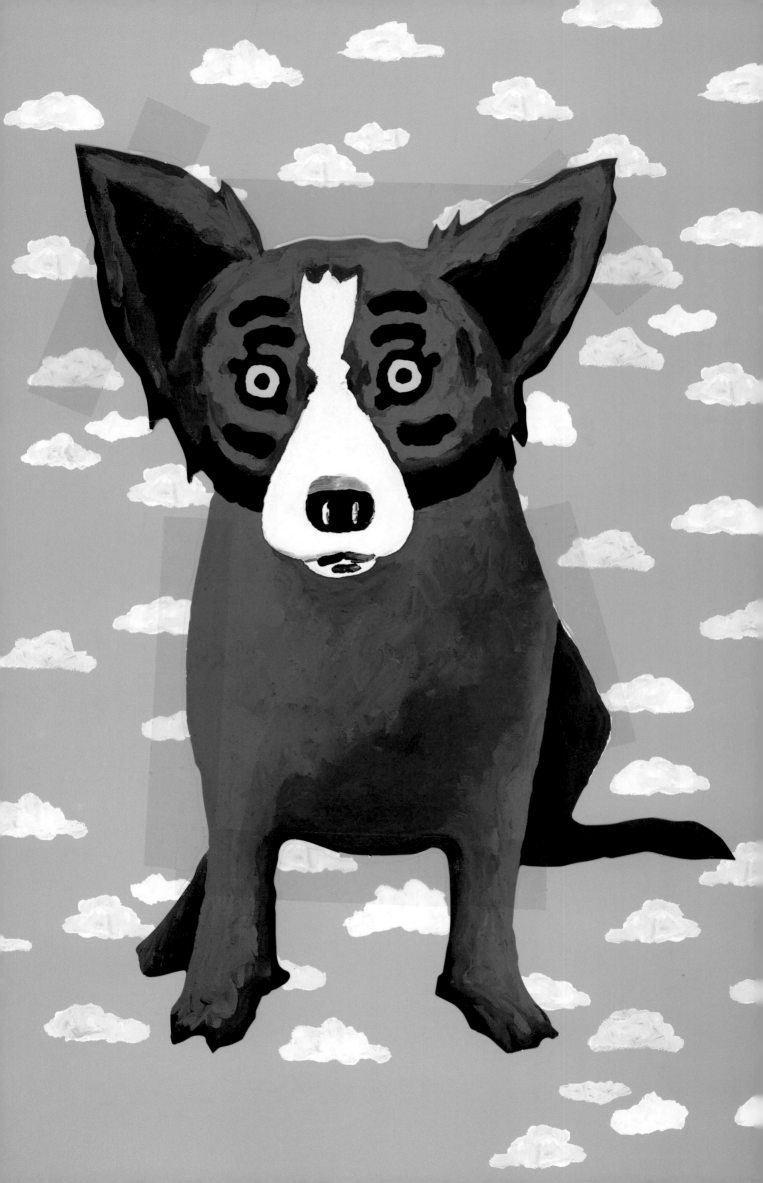

Text and pictures compiled and edited
by David McAninch
Project editor: Sandra Gilbert
Production: Deirdre Duggan

Published in 1999 by
Stewart, Tabori & Chang
A division of U.S. Media Holdings, Inc.
115 West 18th Street
New York, NY 10011

Distributed in Canada by
General Publishing Company Ltd.
30 Lesmill Road
Don Mills, Ontario, Canada M3B 2T6

Library of Congress
Cataloging-in-Publication Data

Rodrigue, George.
Blue dog man / by George Rodrigue;
foreword by Tom Brokaw. p. cm.
ISBN 1-55670-976-5
1. Rodrigue, George Catalogs.
2. Tiffany (Dog) in art Catalogs.
3. Rodrigue, George—Sources. I. Title.
ND237.R69A4 1999
759.13—dc21 99-15470
 CIP

Design by Alexander Isley Inc.

Printed and bound by
Toppan Printing Company, Ltd., Tokyo, Japan

1 3 5 7 9 10 8 6 4 2
First Printing

FOR WENDY

Painting Titles

ACKNOWLEDGMENTS

When my publisher called and asked me to write a page of
acknowledgments for *Blue Dog Man*, I took pen in hand and began.
After a few minutes of thinking about what to write, I realized that
my words were going to sound like an Academy Award acceptance
speech. So, for anyone who likes that sort of thing, here goes:

I would first like to thank my wife of two years, Wendy,
who has assisted me and put up with me throughout our marriage.
Without her, this project would not have been possible.

I would also like to thank my new friend David McAninch,
who helped me put my thought processes as an artist down on
paper, so that readers can understand them.

I have been grateful every day since this project began,
almost one year ago, to Leslie Stoker, her terrific group at
Stewart, Tabori & Chang, and to the endlessly creative designer
Alexander Isley. They all went out of their way to make this book
a high-quality and honest publication. Furthermore, they
return phone calls; they embrace my ideas; and, above all else,
they always do what they say. These are qualities hard to find in
many people, much less in a large company.

Special thanks to Sandra and Mary at the Carmel, California,
gallery; Marsha, Lawrence, and Douglas at the New Orleans gallery;
and Bertha, Diane, and Missy, who head up my studio and office in
Lafayette, Louisiana. Wendy and I greatly appreciate their help in
every project we undertake. We know that without them, we would
not have achieved the success we enjoy today.

I am also extremely grateful to my good friend Tom Brokaw
for taking time out of his busy schedule to write the foreword for
Blue Dog Man.

Thanks again, Roz.

— GEORGE RODRIGUE

AUGUST '98

Happy
Birthday!
Merrick!
with
Love xx

Bruce & Aveil

Grass Tree, Flinders Ranges National Park, South Australia.

STEVE PARISH

DISCOVER AUSTRALIA

Photography Steve Parish
Text Pat Slater

Steve Parish
STEVE PARISH PUBLISHING PTY LTD

3

Cape York Peninsula, like so much of Australia, offers the traveller new worlds of adventure and discovery.

INTRODUCTION

Memories shape our lives.

Memories remind us of our successes and our failures, allow us to daydream and to drift in time. In memories, we can revisit the beautiful places of our world, relive experiences which made us what we are today.

Our human senses are often the magical passwords that open the doors into the world of memory. For me, the sense of sight is extremely powerful. When I remember a scene, my mind produces immediate mental images of forms, shapes, colours and textures.

Because of this strong visual imaging ability and a love for the natural world, I took up photography at an early age and for many years concentrated my efforts on wildlife and wild places. Finally, because I wanted to produce images which included all of Australia, I had to venture into the cities. My first experiences at urban street photography were quite painful - the noise and bustle and crowds of people were, to me, a waking nightmare.

Gradually I adapted and learned to appreciate the forms, shapes, colours and textures of the cities and towns of Australia. Now, after some years of "street-walking" with my cameras, I feel I am discovering my country all over again, as a nation of people living and growing together.

In this book, I have gathered together photographs which for me epitomise Australia. I have included the continent's major natural areas and some of the wild creatures which live there. I have added images of Australia's built environment and momentary encounters with the people of Australia at work and at play.

As you turn the pages of this book, I hope you will share my ongoing discovery of this wonderful country.

Steve Parish

CANBERRA

AUSTRALIA'S NATIONAL CAPITAL

It is a delight to go sightseeing in Canberra. The city has something to offer everyone, with its magnificent lake, its wonderful gardens, its impressive national buildings and monuments, its embassies, excellent shops and great restaurants.

It is easy to find Canberra's landmarks. Walter Burley Griffin's plan for Canberra, finally implemented in 1925, visualised a Parliamentary Triangle which would join places on a land axis running from Mount Ainslie through Red Hill to Bimberi Peak with those on a water axis and a municipal axis. Seven decades of civic achievement since then have developed the city as a worthy National Capital.

Canberra is a year-round mecca for visitors. Autumn brings spectacular foliage to parks and gardens. Summer is excellent for exploring the cool interiors of institutions such as Parliament House and the National Gallery. Winter means crisp cold, perhaps snow and a local passion for Rugby League. Spring sees Floriade, the festival of flowers and a chance to experience this very contemporary city in party mood.

Within the limits of the Australian Capital Territory are Tidbinbilla Nature Reserve, with its famous mob of kangaroos and other wildlife, Cockington Green's miniature village, Mt Stromlo Observatory - these and other attractions are well worth a visit.

Below: The Carillon on Aspen Island, in Canberra's Lake Burley Griffin, was a 1963 gift from the British Government.
Opposite: A view of Canberra from Mount Ainslie shows a green, tree-filled city on the shores of a placid lake.
Following pages: Walter Burley Griffin's land axis is focused on Capital Hill and the Houses of Parliament,
then crossed by the water axis formed by Lake Burley Griffin. On the further shore of the lake,
Anzac Parade leads to the Australian War Memorial, at the foot of Mount Ainslie.

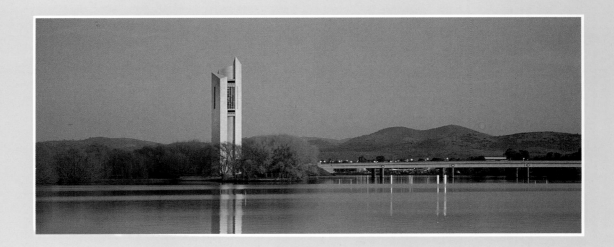

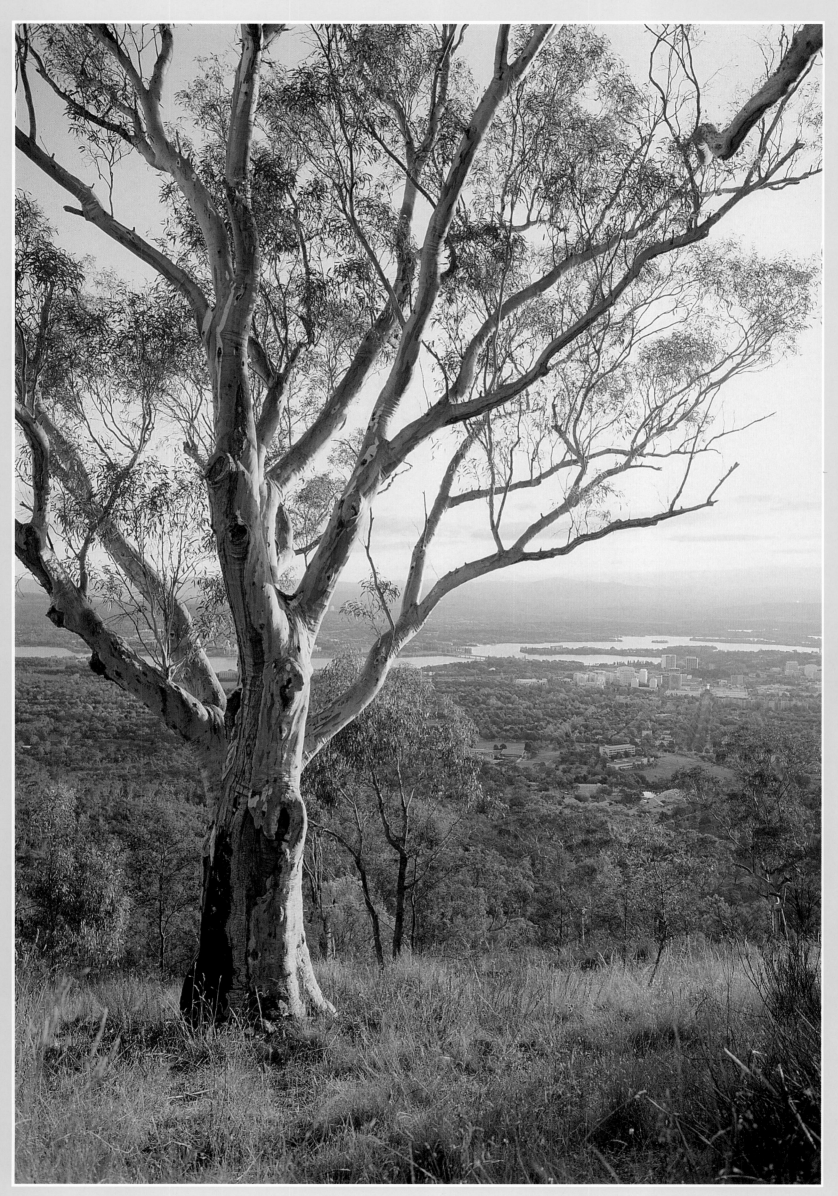

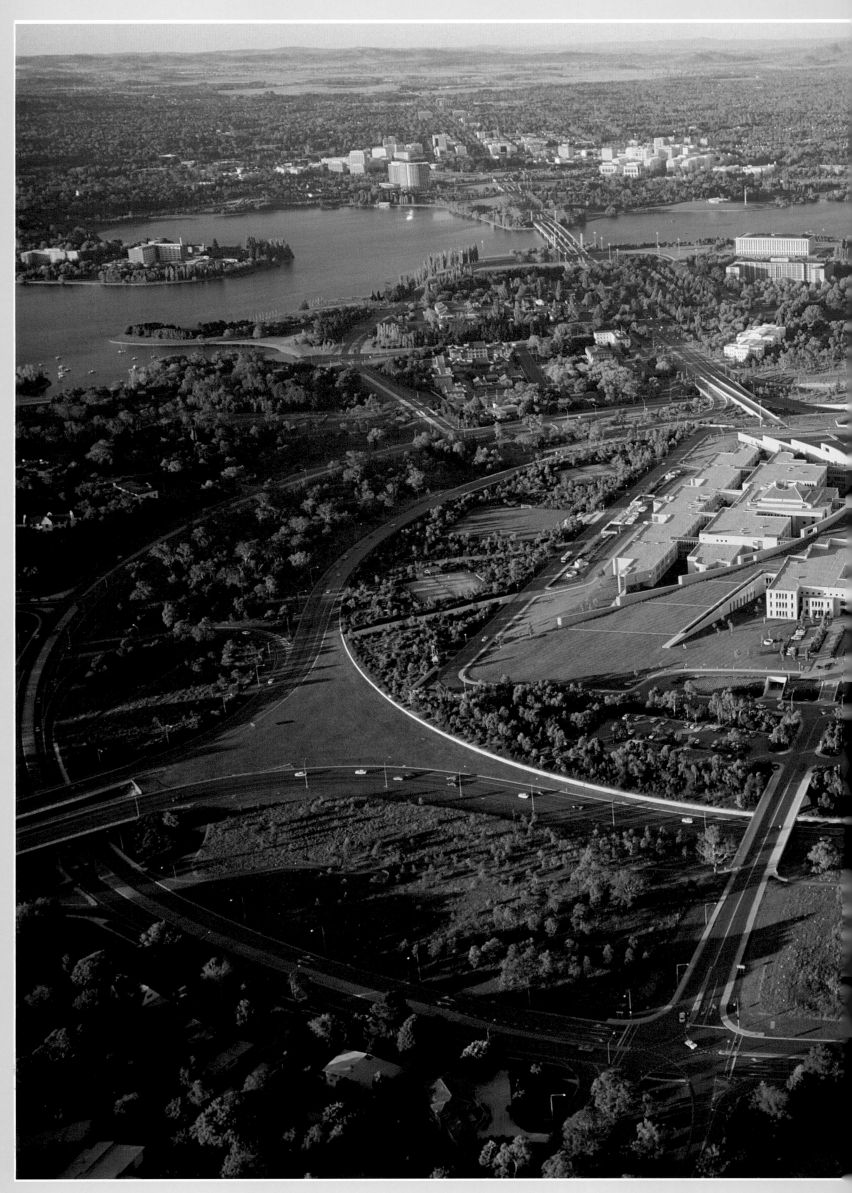

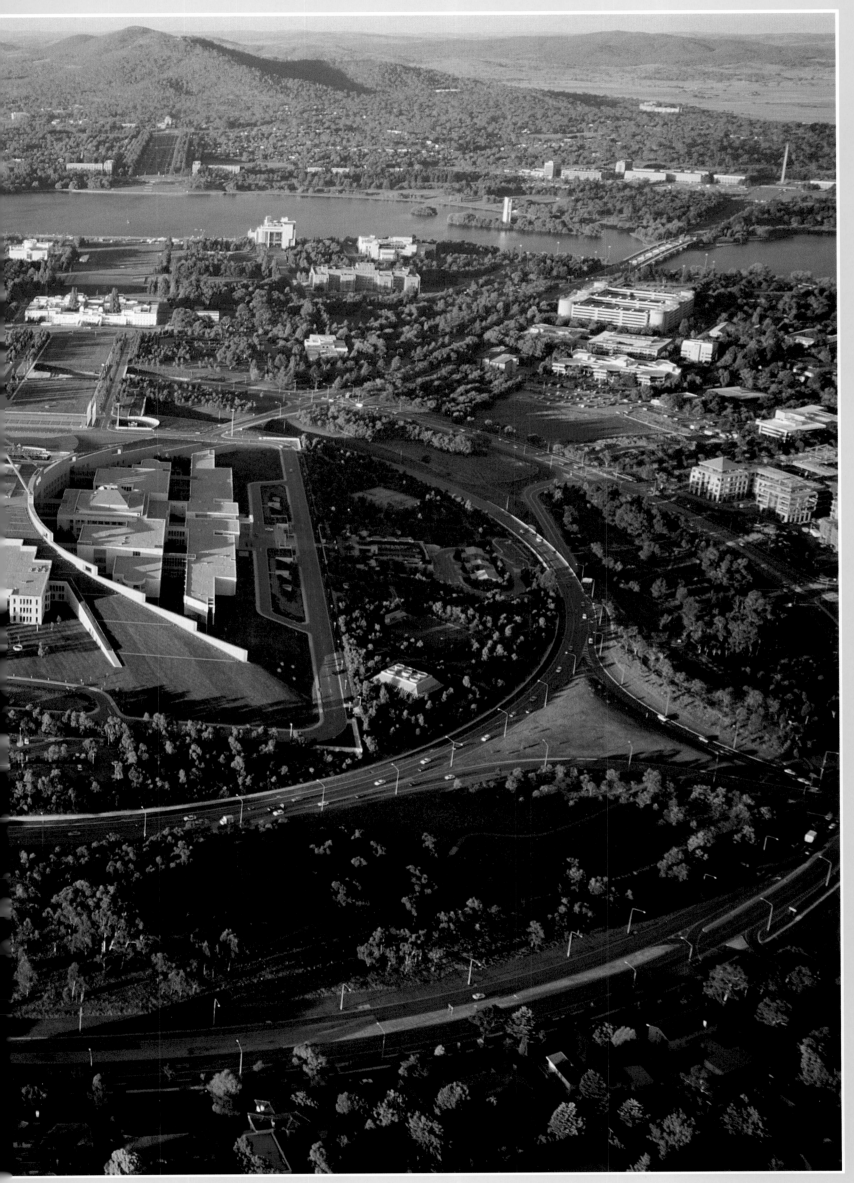

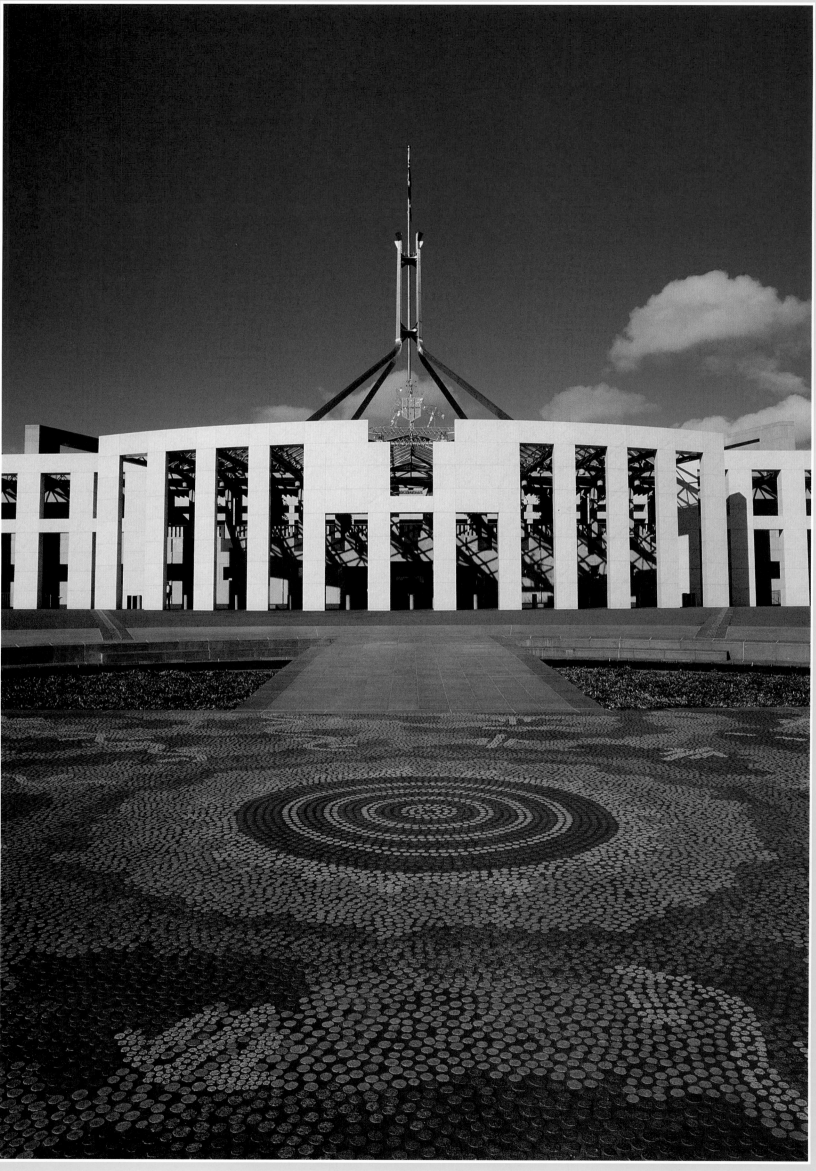

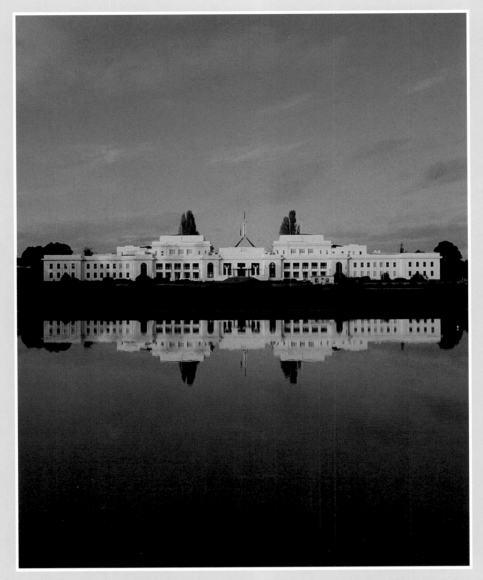

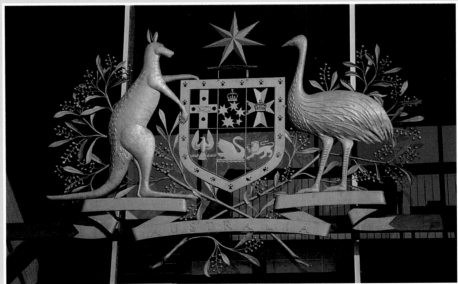

Parliament House: Seat of Australian government

The original Parliament House was erected in 1927. Today, the old building has been superseded by the new Parliament House opened by Queen Elizabeth II on 9th May, 1988. The summit of Capital Hill was excavated, then assembled again around the new construction, so that today Parliament House appears part of the landscape, retaining the grand vista of Walter Burley Griffin's vision. New Parliament House contains more than 2,000 rooms, which are open to the public 364 days of the year. A fine view of Canberra can be seen from the walkway that passes over the building.

———————————————— ✦ ————————————————

Above: This transitional Parliament House was opened in 1927 and served until 1988.
Below: Australia's Coat of Arms is a familiar motif in Canberra.
Opposite: Michael Nelson Tjakamarra designed the mosaic before Parliament House, which symbolises the coming-together of Dreamtime ancestors to enact ceremonial "business".

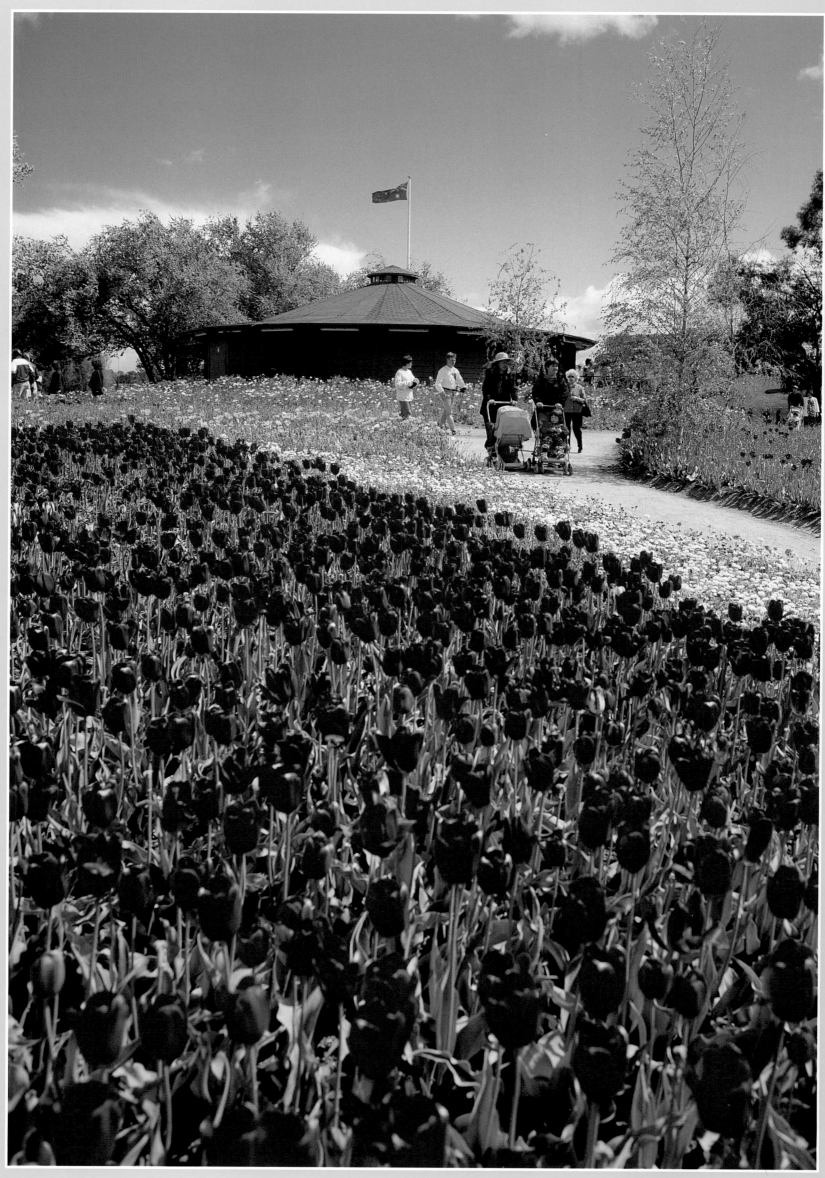

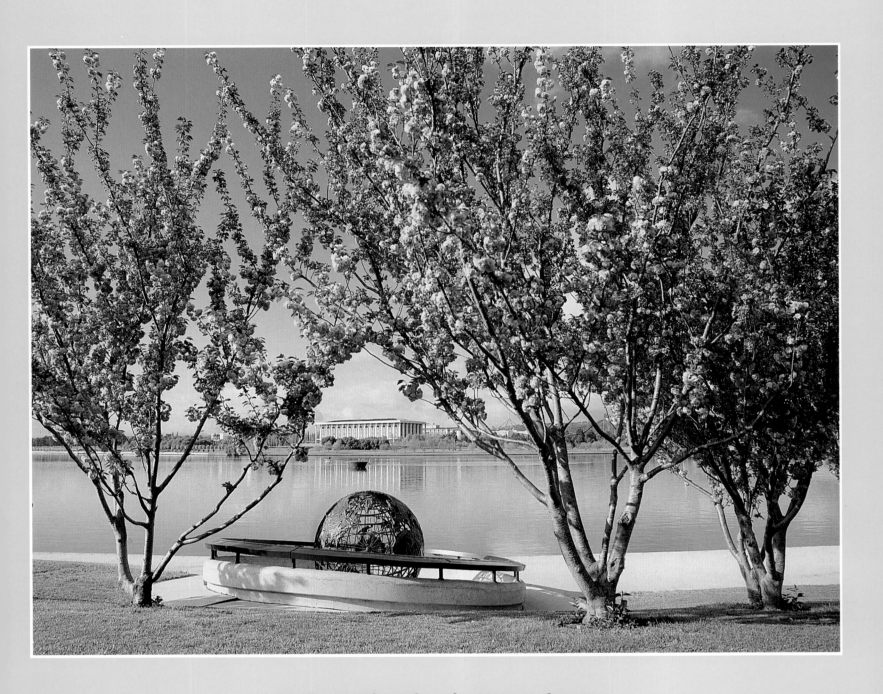

Canberra: Showplace for Nature's beauty

All land in Canberra is owned by the Federal Government and development here has been controlled carefully. This is a city which favours trees over billboards, and lawns and gardens over concrete and paving. Those who love open spaces and green places feel at home here.

The starkness of Canberra's winter, when many deciduous trees are leafless, is followed by a blaze of spring blooms. Commonwealth Park, with its lovely annual display of tulips, is only one of many lakeside recreational areas, while in the Australian National Botanic Gardens, on the lower slopes of Black Mountain, are to be found plants native to this country displayed in regional groupings.

———————————— ★ ————————————

Above: October blossom frames the Terrestrial Globe on Regatta Point and, in the distance, the Australian National Library.
Opposite: Each Springtime, Floriade sees Commonwealth Park ablaze with flowers.

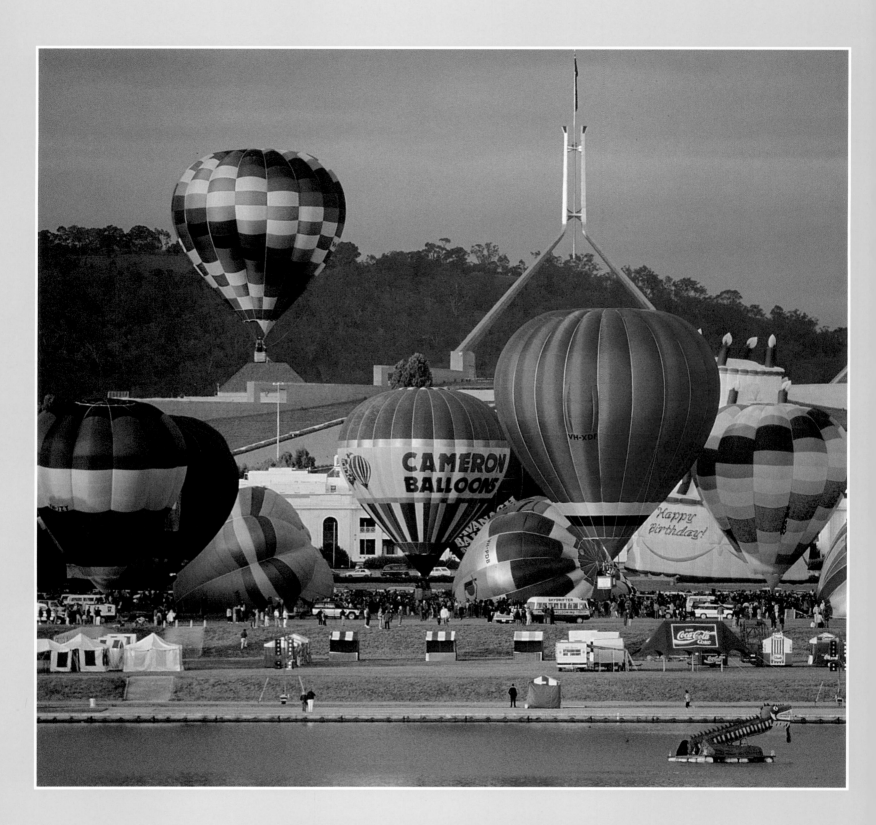

Canberra: An overview of an elegant city

During the Canberra Festival each March, a fleet of hot-air balloons takes those eager to see Canberra from the air on a never-to-be-forgotten journey. Looking down upon this largest of Australia's inland cities, the impression is of elegant proportions, impressive public buildings and sparkling water, circled with parklands and enhanced by neat, well-planned suburbs.

★

Above: In March each year, the Canberra Festival sees balloons drift buoyantly in front of Parliament House.

Canberra: A city for outdoor pleasures

Canberra's parks are designed so people using them can walk, cycle, picnic or just sit, appreciating the harmony of water, sky and trees. The contrast between exotic plant species and Australian natives adds to the variety of the landscape. Autumn in this inland city is cold enough to colour deciduous leaves and Canberra's gardens are magnificent in this mellow, fruitful season.

✦

Above: April brings warm tones to Canberra's deciduous trees.

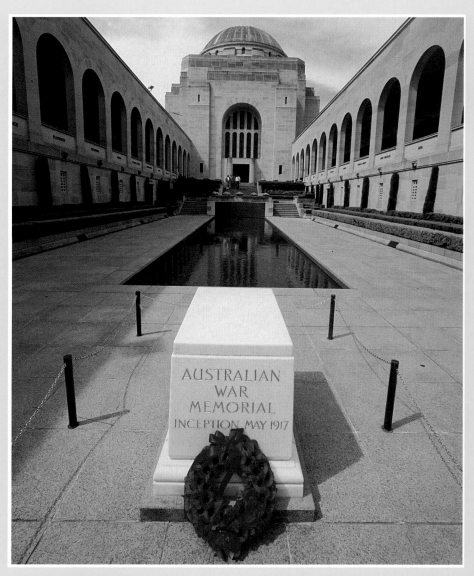

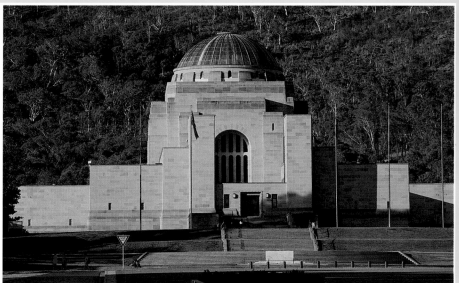

The Australian War Memorial: Lest We Forget

The Australian War Memorial is for many people one of Canberra's major attractions. It is a shrine which honours over 100,000 Australians who gave their lives in times of war. The National Anzac Day ceremony is held here each 25th April.

✦

Above: The Memorial's Pool of Reflection leads to the domed Hall of Memory.
Below: The Australian War Memorial.

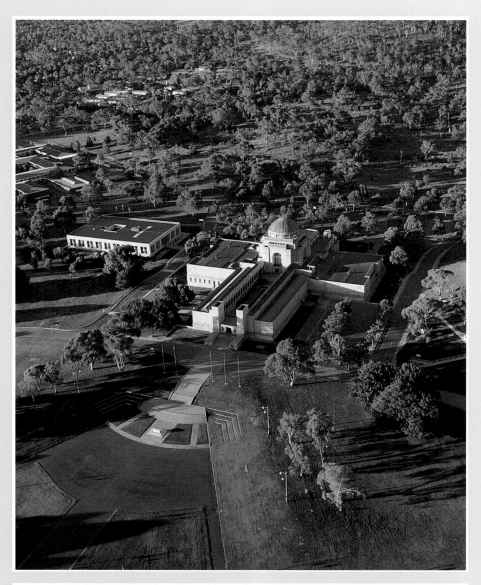

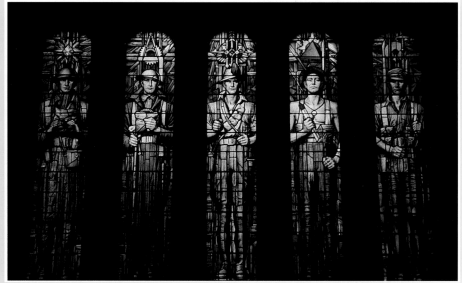

The Australian War Memorial: "In Memoriam"

The many displays in the War Memorial provide insight into how Australians have played their parts once their country has been committed to conflict. Here are remembered men and women who were tested in time of war and not found wanting.

✦

Above: An aerial view of the War Memorial complex.
Below: Stained-glass windows in the Hall of Memory.

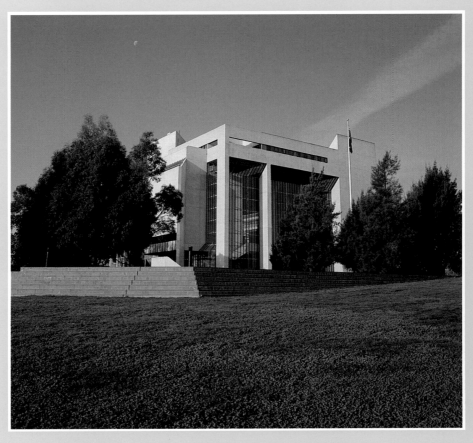

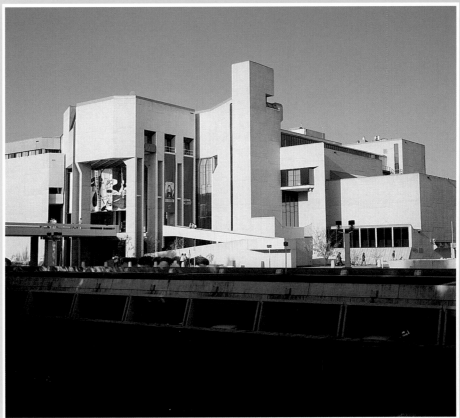

National Gallery and High Court: Arts and Law

The magnificent National Gallery of Australia houses works
from national and international collections in its eleven
principal galleries on three levels. The High Court of Australia,
opened in 1980, is the country's final court of appeal. Both
institutions stand on the southern shore of Lake Burley Griffin.

★

Above: The High Court of Australia.
Below: The National Gallery of Australia.

The National Science and Technology Centre

At the National Science and Technology Centre in Canberra's King Edward Terrace, visitors can find out for themselves why things work and apply scientific principles to a variety of activities. The Centre, a joint Australian and Japanese Bicentennial project, was opened in November, 1988.

✦

Above: The National Science and Technology Centre of Australia.

NEW SOUTH WALES

THE PREMIER STATE

The State of New South Wales was established in 1788, when Captain Arthur Phillip founded a British penal colony at Sydney Cove. In the two centuries since, New South Wales, which occupies around ten per cent of Australia's mainland, has become a major primary and industrial producer, containing over one-third of the continent's population, most of them living along the fertile coastal strip.

No discovery of Australia would be complete without experiencing Sydney, a cosmopolitan city where whatever a visitor seeks can be found. Sydney offers Port Jackson, the world's greatest harbour, a taste of history, cultural experiences, sophisticated pleasures or the simple life of sun and sea. It has the self-assurance of one of the world's great cities.

Behind the sun-blessed, fertile coast of New South Wales lies the Great Dividing Range, its slopes covered with lush rainforests in the northern parts of the State and rising to scenic alpine peaks towards the Victorian border.

Inland, over the range, are the grain-growing Western Plains, which shade into "the Outback". This is pastoral and mining country, a tough land, to be explored and savoured at leisure for its beauty, its wildlife and the unique characters of its hospitable people.

---✦---

Below: A replica of Captain Bligh's famous "Bounty" lies moored at Circular Quay, Sydney Cove.
Opposite: Sydney Opera House was lit in Olympic colours for the announcement that
Sydney will host the Olympic Games in the year 2000 (photo by Phillip Hayson).
Following pages: As night falls, Opera House and Harbour Bridge are illuminated above the wine-dark waters of Port Jackson.

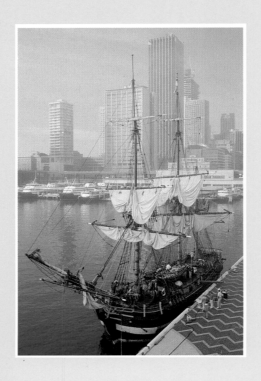

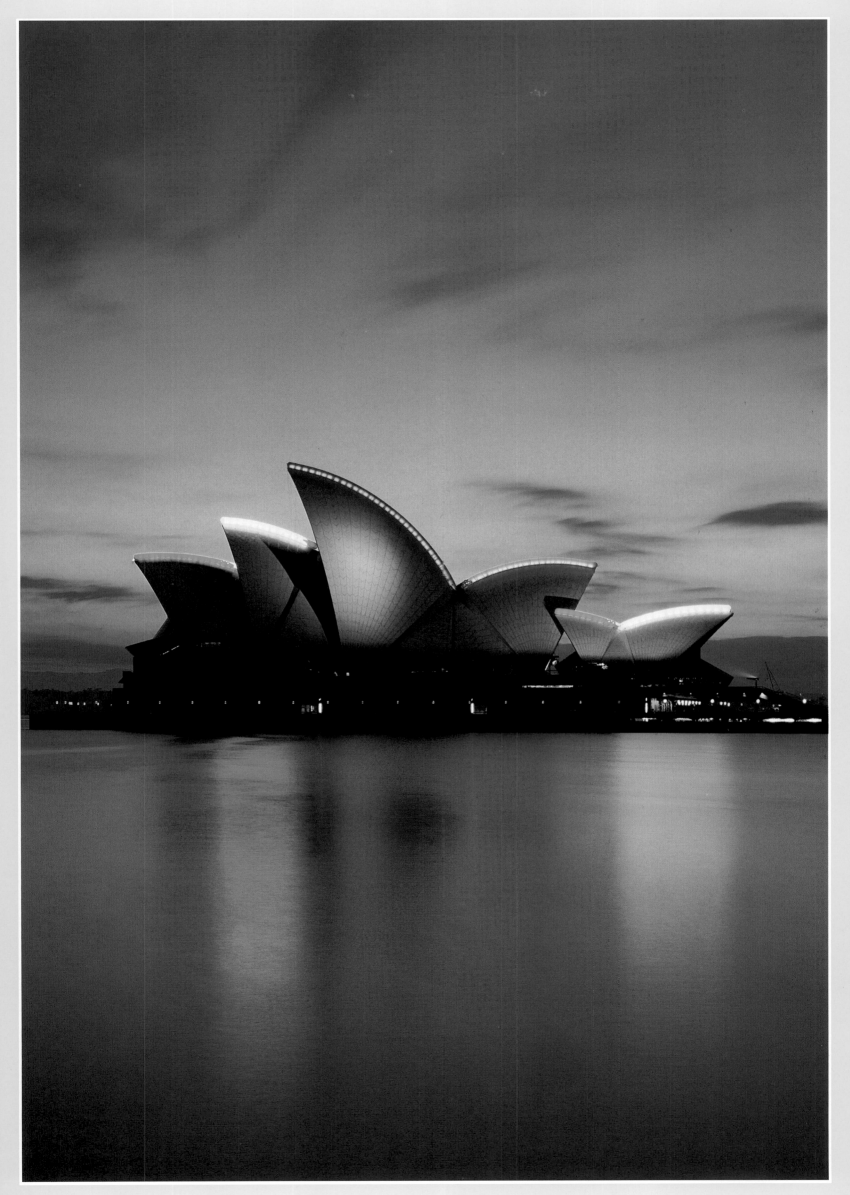

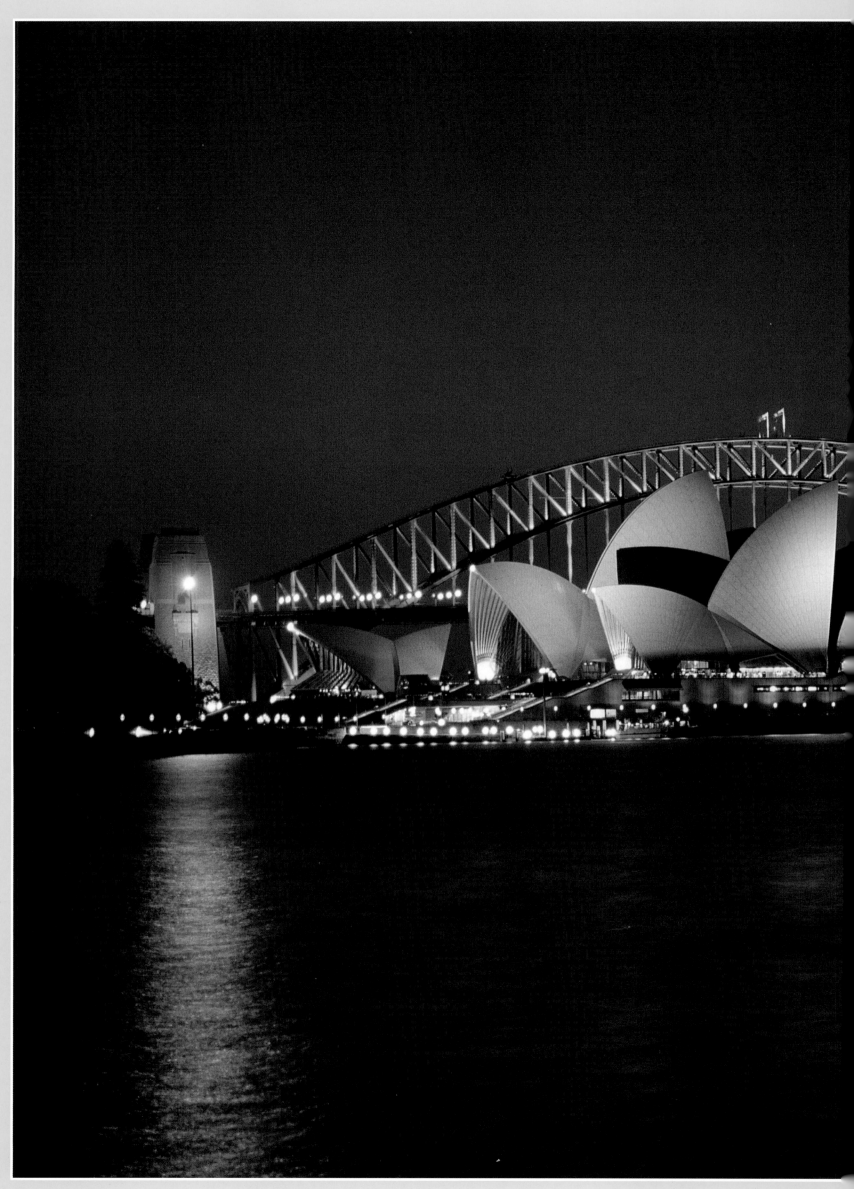

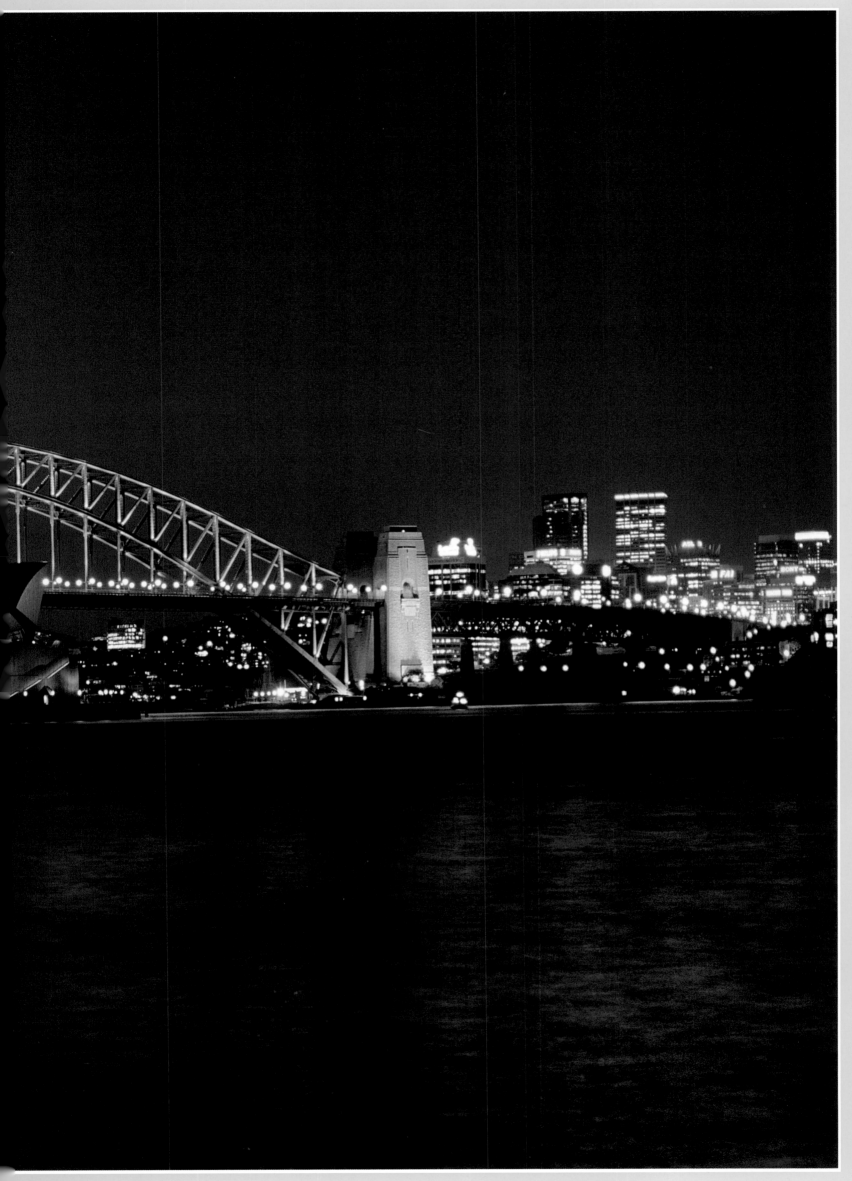

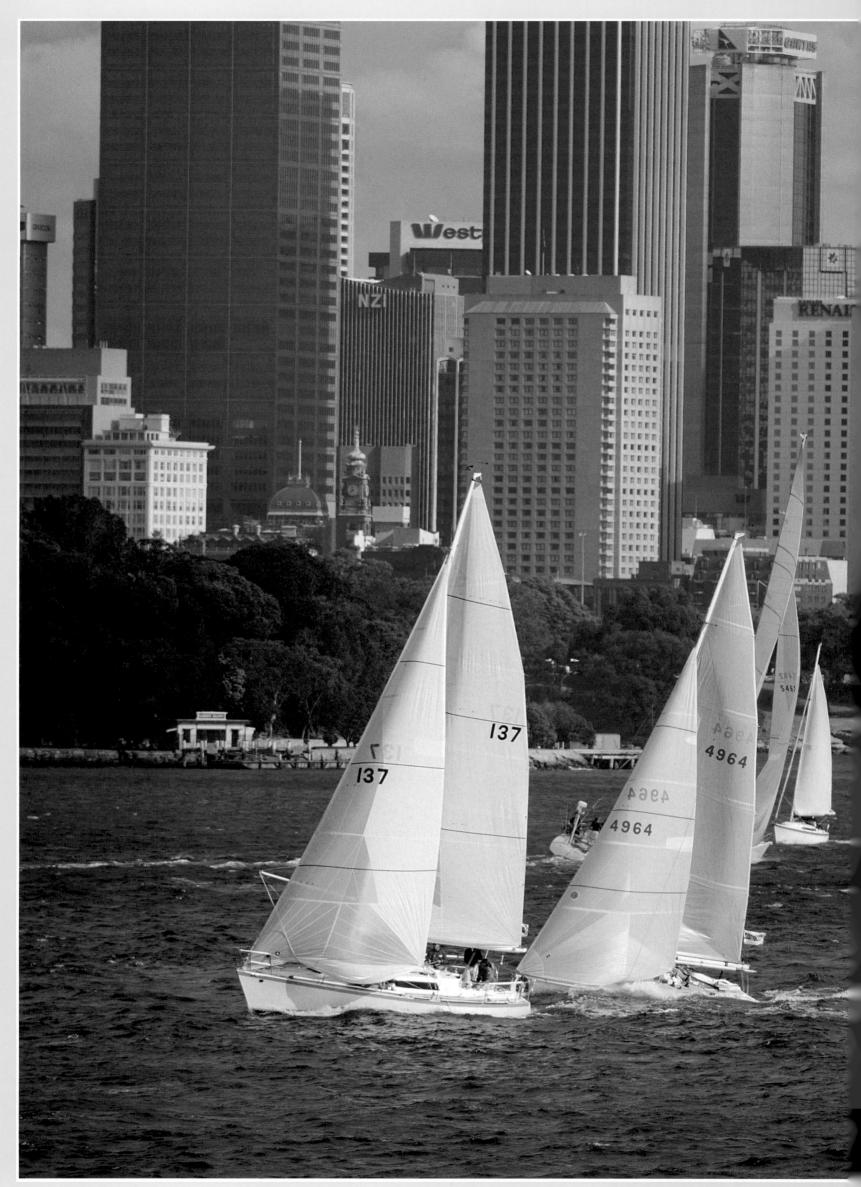

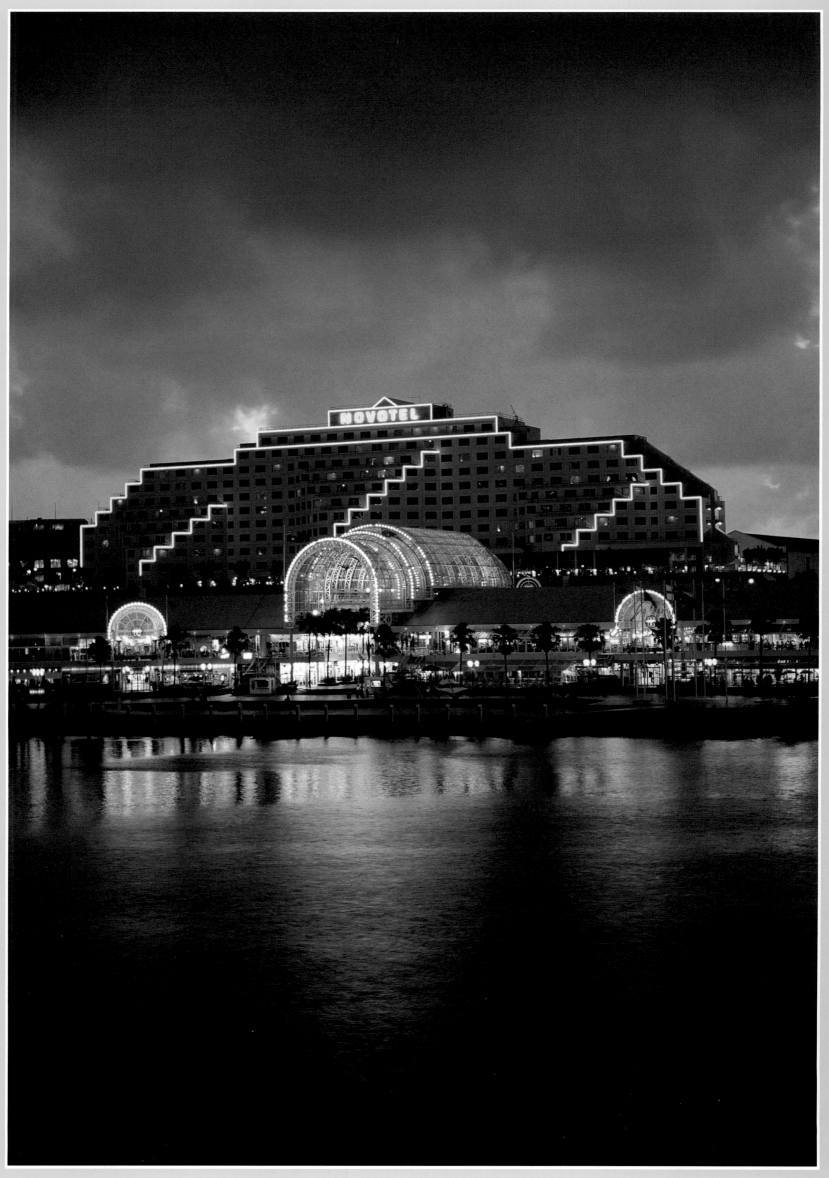

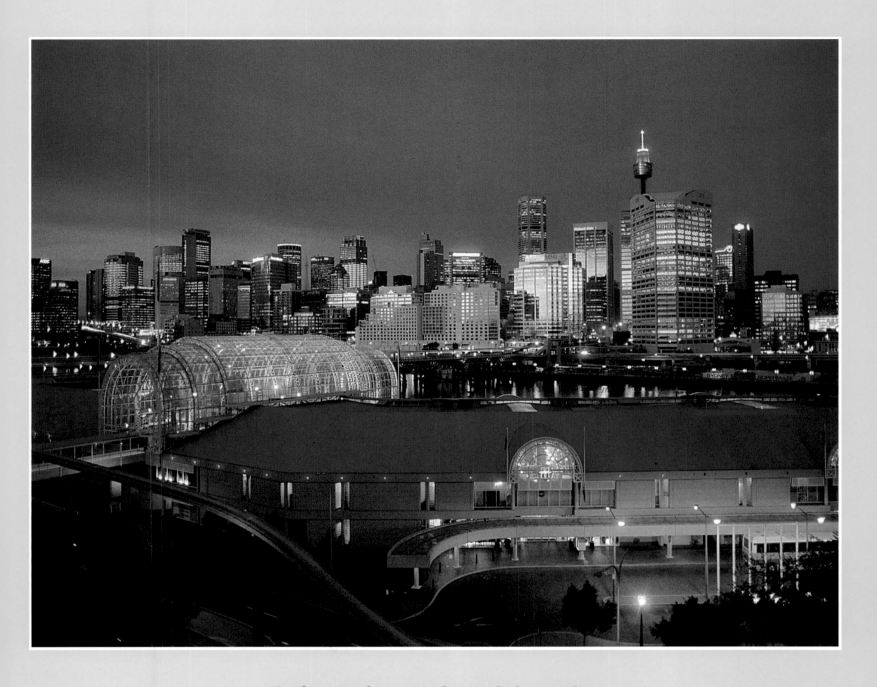

Darling Harbour: Harbourside hospitality

Darling Harbour was opened in 1983, after its renovation from a decrepit dockyard and railway goods terminal. It is now one of Sydney's major attractions, containing the Harbourside Festival Marketplace, the Sydney Aquarium, comprehensive convention centres, fine accommodation, promenades and the famous Chinese Garden.

This magnificent complex is reached by a walkway over the Pyrmont Bridge, or by a Sydney-scanning monorail, or by ferry. The weight gained by diners at the Darling Harbour restaurants can be walked off at the Sydney Aquarium, the Powerhouse Museum and the National Maritime Museum.

Above: View towards Sydney city centre across the Darling Harbour complex.
Opposite: Twilight on the Harbourside Festival Marketplace and Novotel Hotel, Darling Harbour.
Previous pages: Sailing is a passion with Sydneysiders, who have the waters of Port Jackson at their disposal.

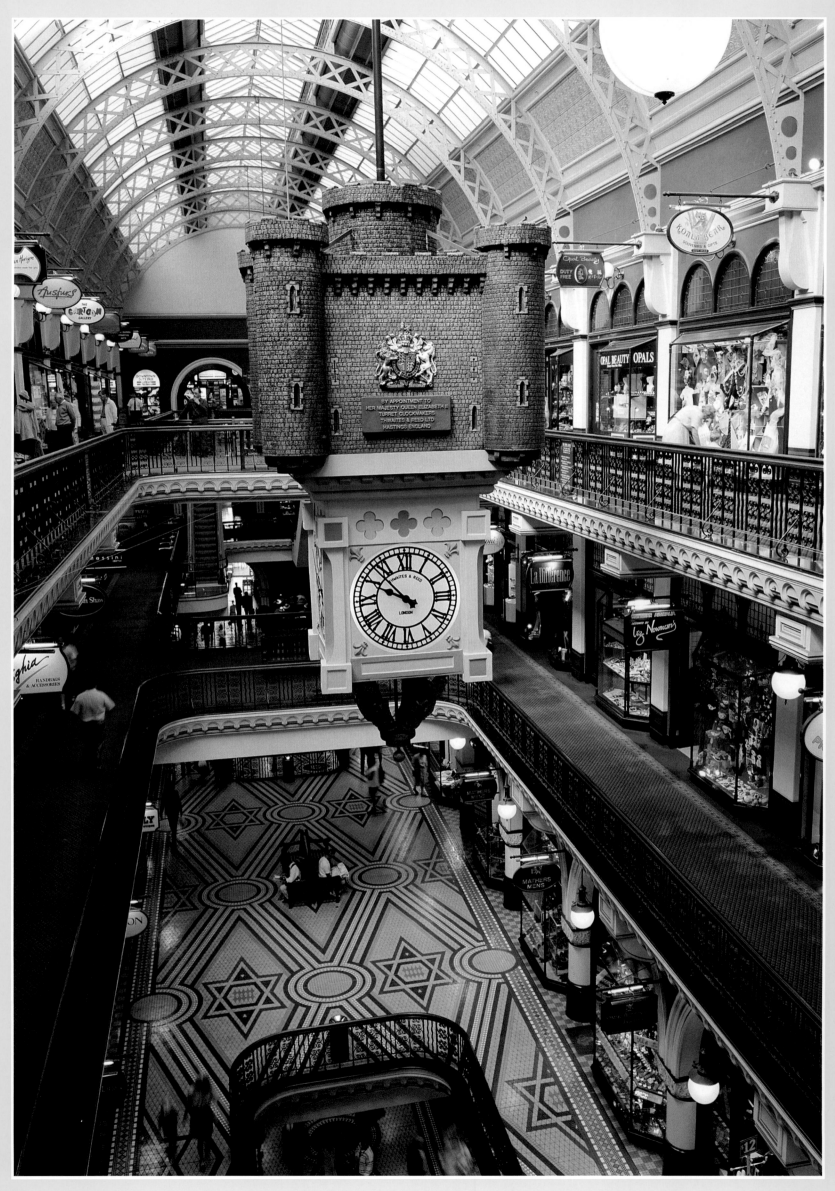

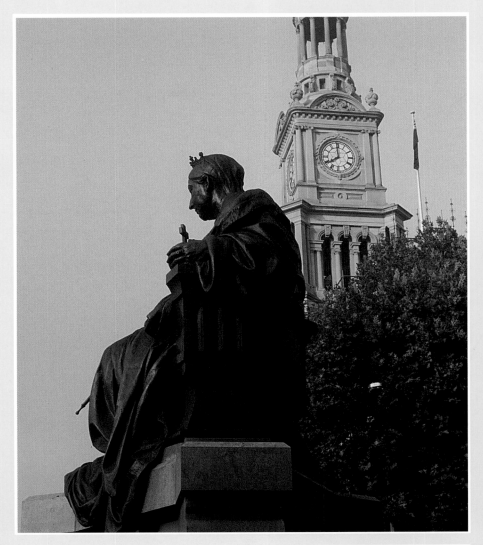

Old Sydney: History on display

If you want to savour the history of Sydney, go to The Rocks, where the site of early settlement grew into a nineteenth-century slum, which by the 1960s was seen as ready for demolition. The Rocks was saved and restored, and now provides a window into Sydney's past. Another rewarding expedition is to the Queen Victoria Building, symbol of Sydney's nineteenth-century prosperity from wool, wheat and gold. Once markets, it has been refurbished for modern times. The nearby Town Hall was completed in 1874.

✦

Above: Queen Victoria in bronze sits outside the Queen Victoria Building and below the clock-tower of Sydney Town Hall.
Below: The historic Rocks area offers fascinating buildings from Sydney's convict and colonial days.
Opposite: The massive Queen Victoria Building, with its sandstone and stained glass, is now a venue for quality shops.
Following pages: The Three Sisters, in the Blue Mountains National Park, a scenic area which is close to Sydney.

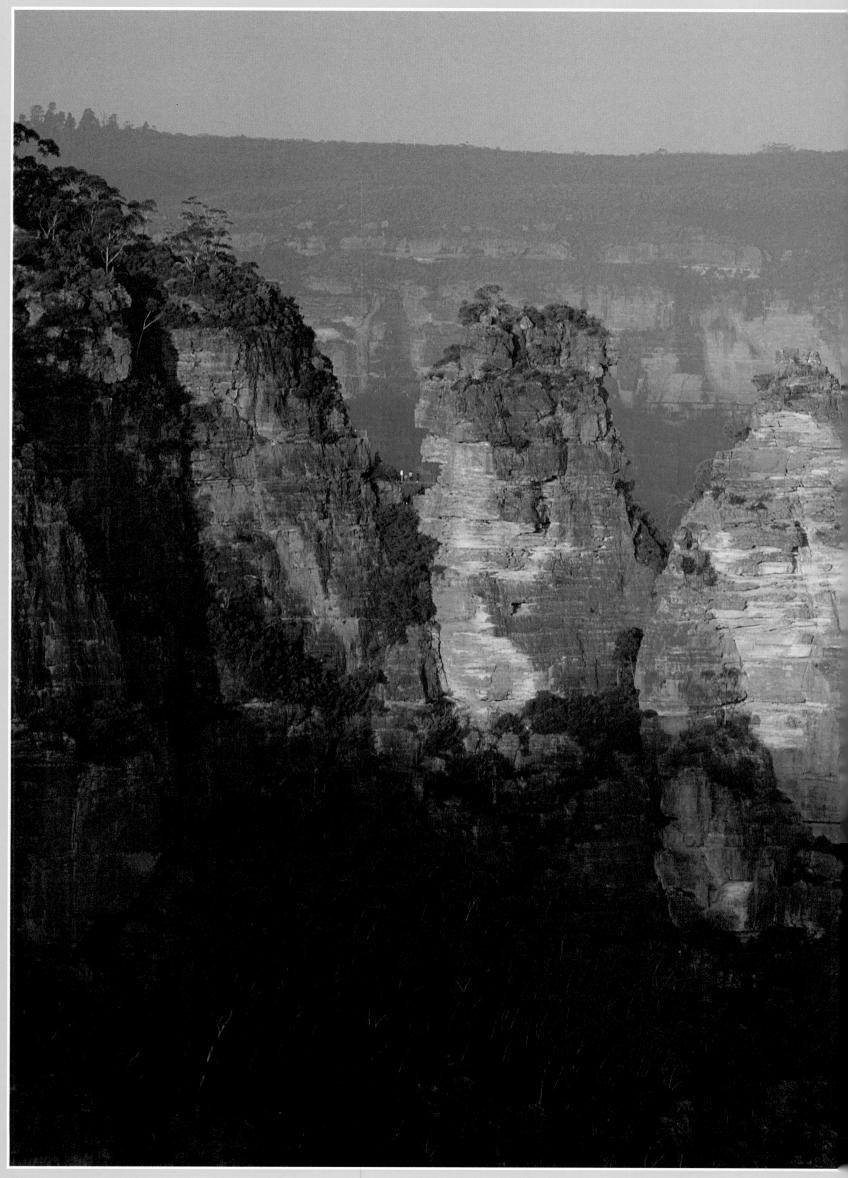

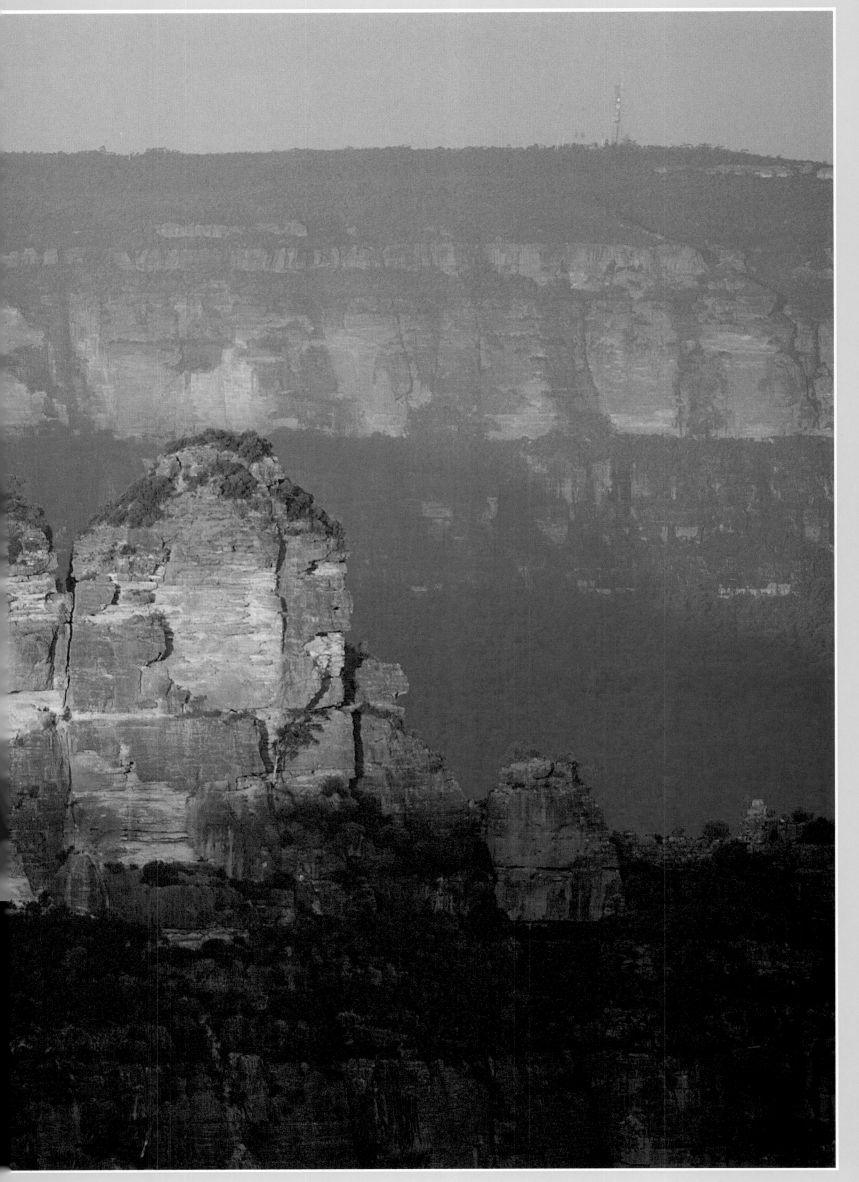

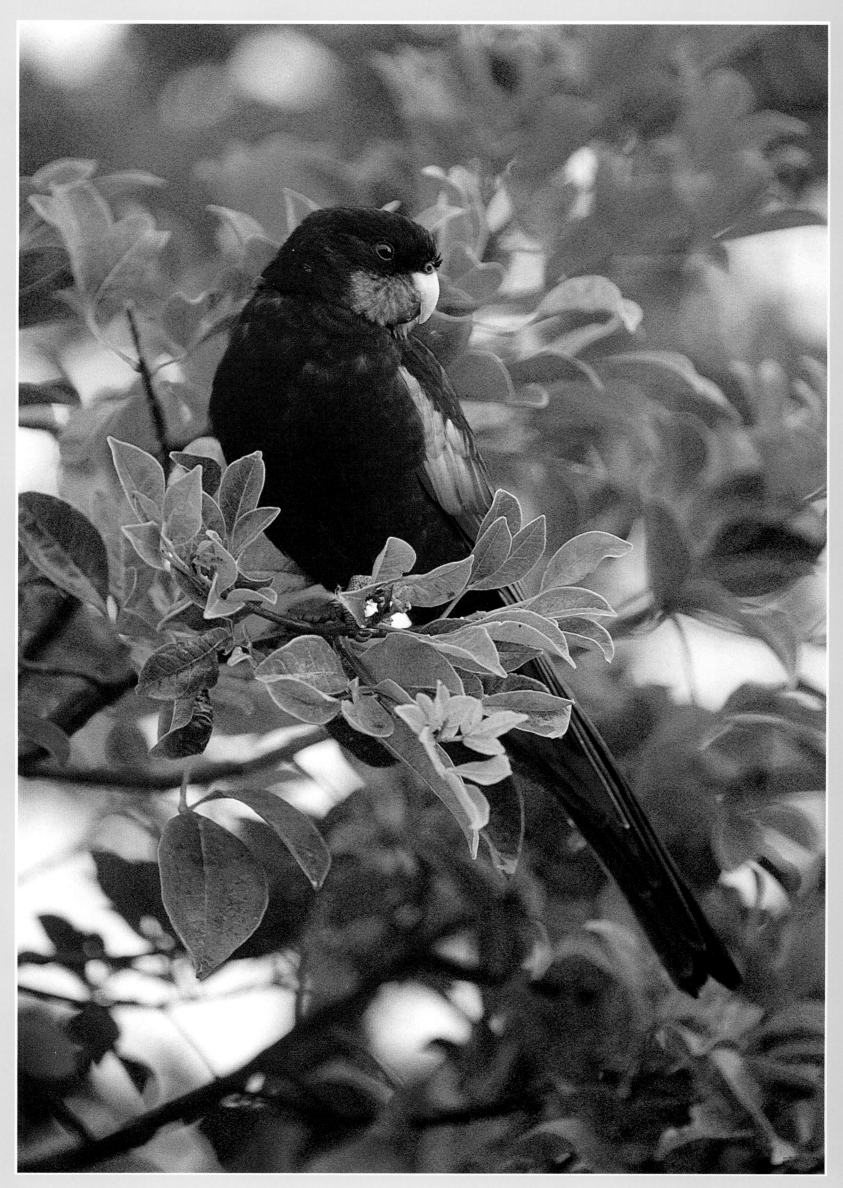

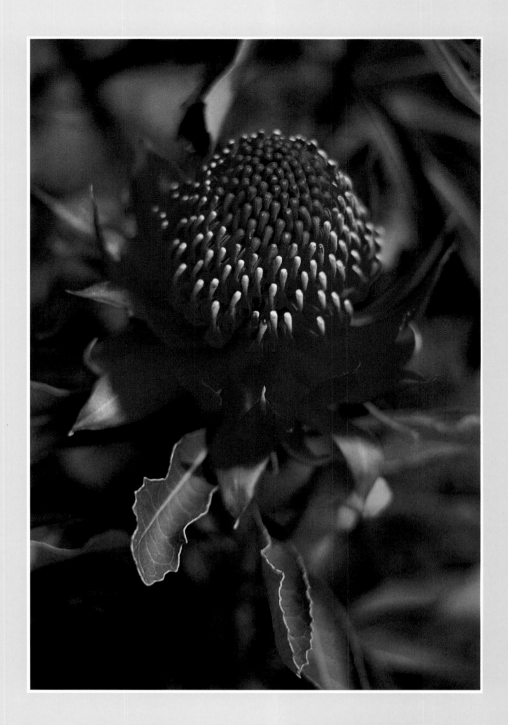

The Blue Mountains: Beyond the blue horizon

The Blue Mountains, 65 kilometres from Sydney, have for more than a century provided a haven for people retreating from the city's bustle. Now the mountains' spectacular scenery and the opportunities they hold for adventure draw visitors from all over Australia and from abroad.

Rising to around 1,100 metres above sea-level, the mountains offer precipitous cliffs, deep forested gorges and bushwalking which will test even the experienced hiker. For the less energetic, there are scenic bus-tours, valley-viewing from the Katoomba Scenic Skyway and leisurely exploration of some of Australia's most beautiful gardens.

Blue Mountains National Park, gazetted in 1967, is around 240,000 hectares in extent. A noted scenic attraction, the Three Sisters are massive sandstone pillars which, according to legend, were once Aboriginal girls who were turned to stone by their father when they were threatened by a monster.

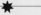

Above: The Waratah, floral emblem of New South Wales, bears brilliant, bird-attracting flowers in Spring.
Opposite: The Crimson Rosella is a colourful parrot, which is particularly common around Echo Point Lookout, from which the Three Sisters can be viewed.

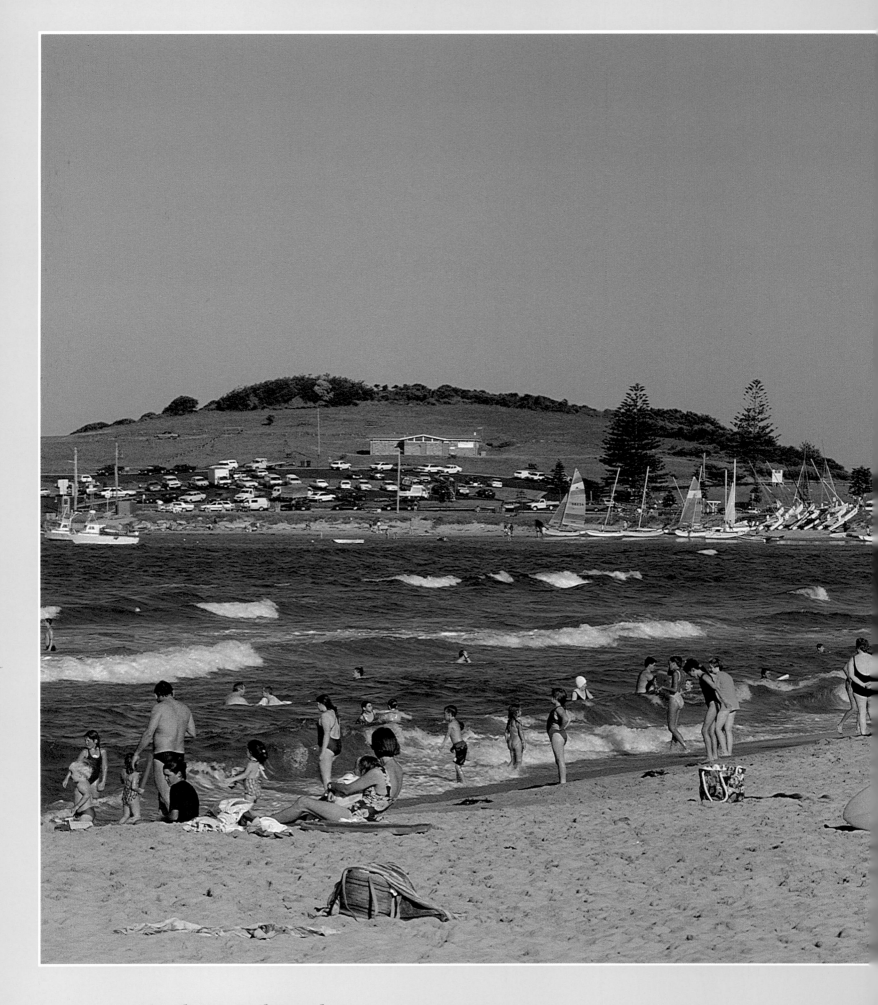

Just playing in the sand

Australians love going to the beach. All ages, all shapes and sizes of human beings are to be found on Australia's beaches, soaking up the sun or shaded from its rays, swimming, surfing, playing games, sailing or just lying around, relaxing.

Not only pleasure-seekers throng to the beach. There are people who are serious about catching fish, there are divers, fitness fanatics and that archetypal Australian figure, the surf lifesaver, dedicated to keeping the unwary or unwise from a watery fate.

Sydney's northern beaches stretch from Manly, serviced by a ferry service dating back to 1847, to Palm Beach. To the south, Bondi (seven kilometres from the city), Coogee and Cronulla are popular.

The coast of New South Wales north and south of Sydney has some of the world's best beaches, with clear, sparkling water and free access to sand and ocean for all who enjoy relaxing at the seaside. The towns spaced along the coast are happy, welcoming places from which to explore these sunny shores.

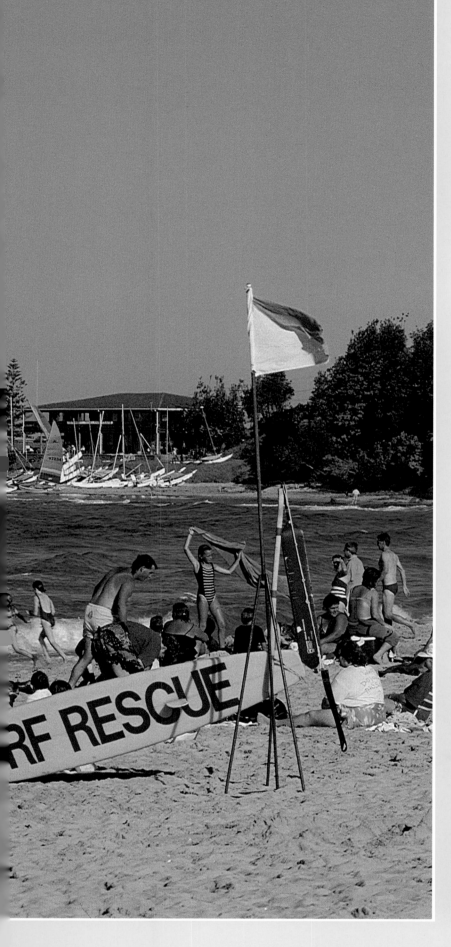

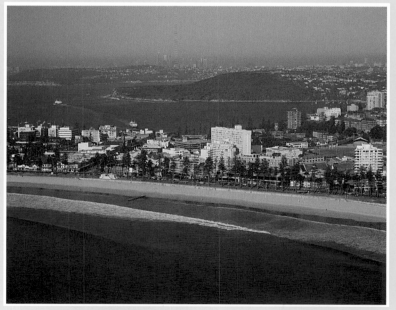

Above: This popular beach is at Terrigal, on the Central Coast of NSW.
Above right: Bondi Beach, south of Port Jackson's South Head.
Centre right: Lifesavers keep Australian beaches safe.
Below right: Manly, one of Sydney's northern beaches, was named after Aborigines who
were described as "manly" by Captain Arthur Phillip.

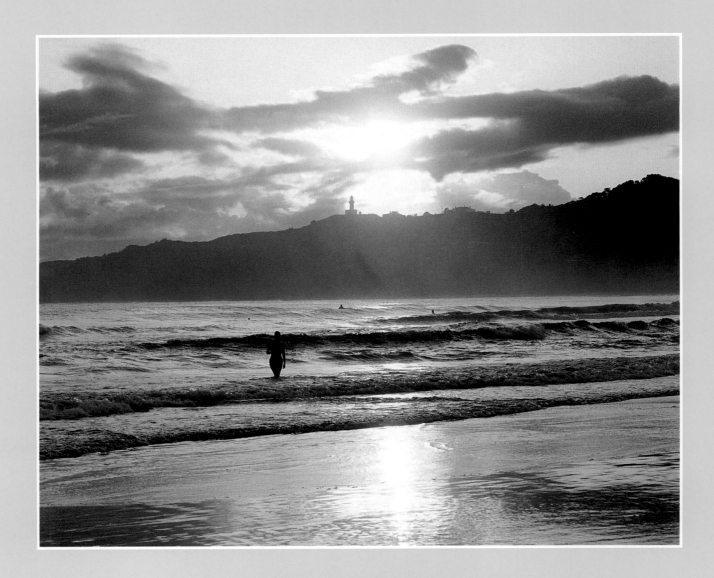

Byron Bay: An idyllic place

Byron Bay makes a great base from which to explore not only the beaches of the Northern Coast but also a hinterland of mountains and forests. The area has a long history as a meeting-place for social activities - Aboriginal people gathered here for thousands of years to enact ceremonies.

The magnificent forests of the area were logged in the second half of the nineteenth century and the timber sent cascading down gully "shoots" to be shipped from the town which was officially known as Byron Bay from 1884. Today, Byron Bay is a delightful town frequented by people who love the sea and all it has to offer and who enjoy the mild, subtropical climate, which allows rainforest to linger in areas such as the Booyong Nature Reserve.

---★---

Above: Cape Byron is the most easterly point on the Australian mainland. Captain Cook named it in 1770, after the grandfather of the famous English poet Lord Byron.
Opposite: The lighthouse on Cape Byron was constructed in 1901. The rays of the lamp can be seen for 43 kilometres out to sea.

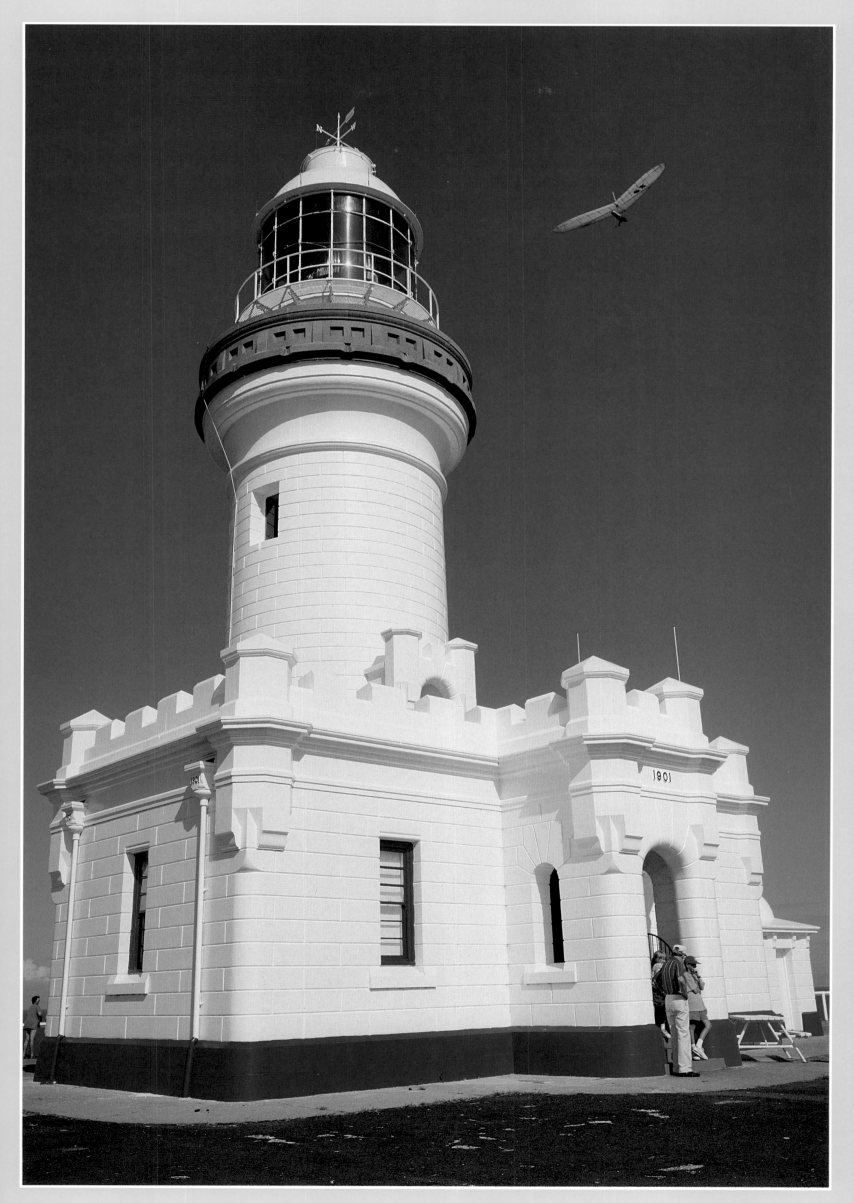

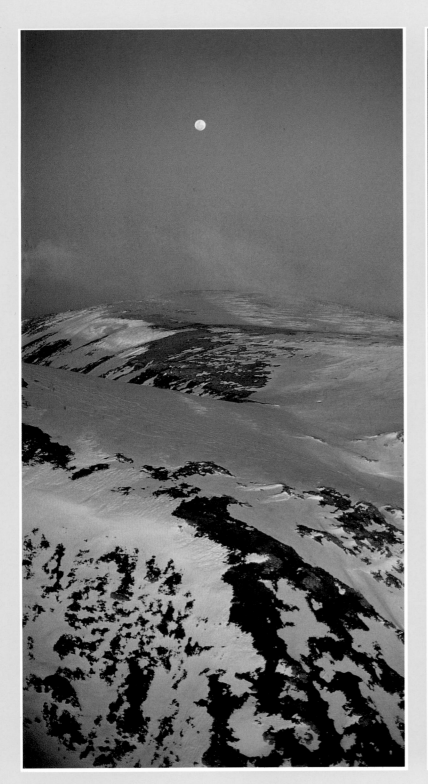
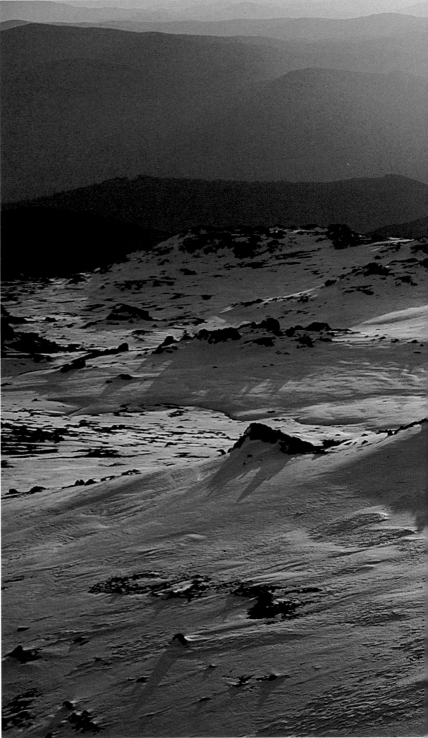

The Snowy Mountains: Year-round playground

The Snowy Mountains amply reward visitors at any season of
the year. Winter sees the peaks covered with snow and the
slopes with skiers. Spring melts the snow and brings wombats
and wildflowers out to enjoy the sunshine. Summer attracts
bushwalkers and anglers to enjoy the cool crisp air and
magnificent scenery of the High Country.

———————————————— ★ ————————————————

*Above: The moon rises over the snow-clad Australian Alps,
summit of the Great Dividing Range.
Above right: Once almost inaccessible "high country" used in summer to pasture
sheep and cattle, the Alps have become a tourist and snow-sports mecca.*

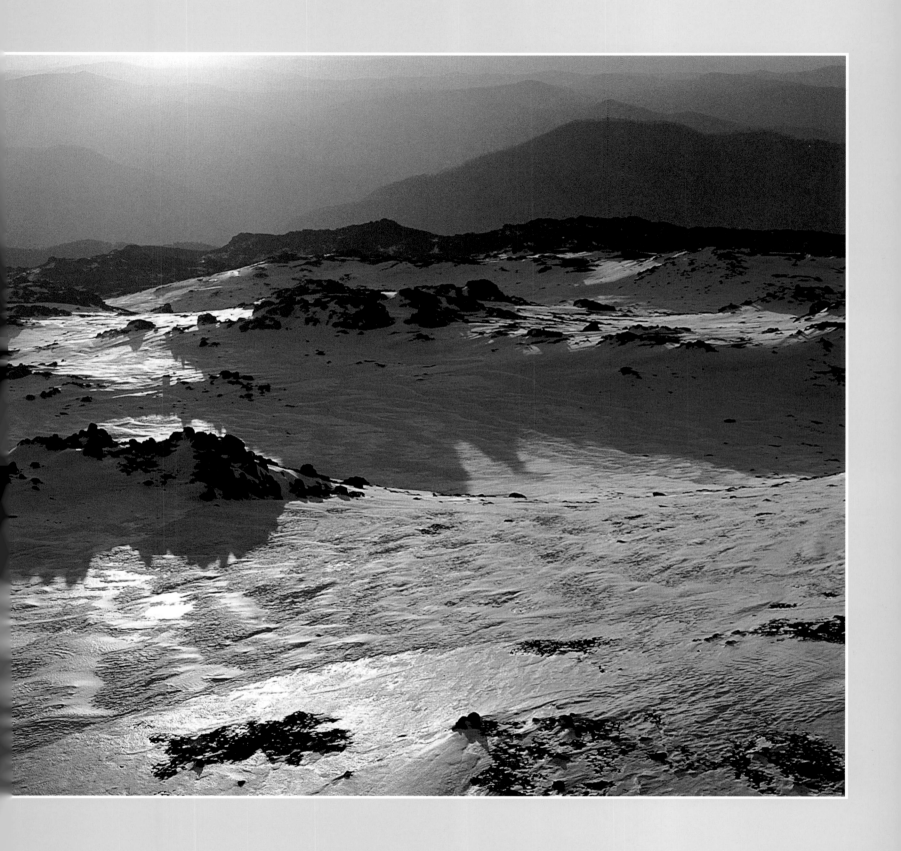

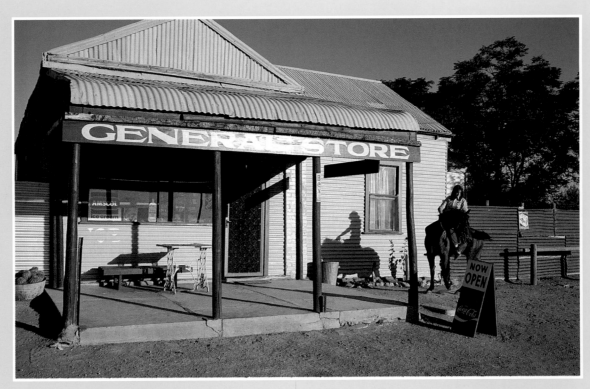

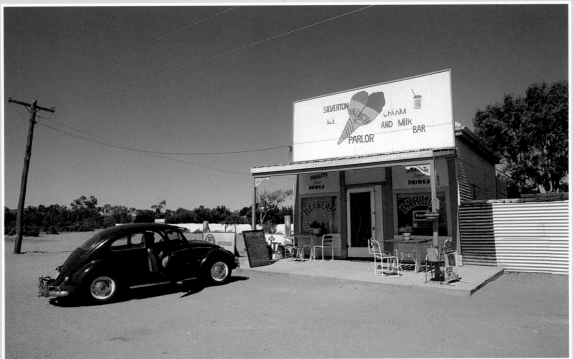

Take a break on the road

Country towns once had four essential elements - the store, the pub, the school and the police station. Today, the teachers and police may have been moved to larger centres, but the store and the pub remain and there are always plenty of travellers to refresh themselves at these oases. Often, a picturesque, old-fashioned shop-front will hide very modern facilities.

★

Above and below: In the tiny town of Silverton these stores still proudly serve the public.
Silverton, near Broken Hill, NSW, has served as location for some noted movies set in the Australian Outback.

The faces tell it all

The character of the country creates the country character.
Hard work and the challenges of a tough environment have left
their legacy in these faces. The Outback has a powerful hold on
those who live there. If you are passing through, it is
worthwhile stopping off, yarning awhile and finding out just
what ties such remarkable people to this challenging country.

✴

Top left and clockwise: Six faces of Australia's Outback: farmer, southern NSW;
cameleer and camel, western NSW; miner, Broken Hill; jillaroo, Western Plains; opal miner, Lightning Ridge.

VICTORIA

THE GARDEN STATE

One of the many beauties of Victoria is that, because of the great variety of landscape types within its boundaries, new vistas appear at almost every turn of the road. In a comparatively short journey, the traveller can experience mountains, lakes, pastures, forests, farmlands, arid country and spectacular coastal scenery. If you are that traveller, take time to discover the glorious Grampians, with their peaks, forests and heaths. Travel through the rich grazing-land of the Western District, then cruise along the Great Ocean Road, with pauses to marvel at Port Campbell National Park, or wander the rainforest gullies of the Otway Ranges. Visit the Alps, then take a trip down the majestic Murray River, life-support for south-eastern Australia.

At last, all roads come to Melbourne, a kaleidoscope of a city, glorious with its tree-bordered boulevards, fiercely competitive in its sporting life. This is a city whose inhabitants love to eat out and socialise along the banks of the Yarra, or on the Port Phillip beaches. It is at the same time a wonderful example of a nineteenth-century Victorian city and as contemporary as tomorrow.

Melbourne is a city with attitude, style and savvy. Its electric trams rock softly past ultra-modern shopping complexes and historic buildings, galleries and theatres, gardens and parklands. Near Melbourne, there are the Dandenong Ranges and the Mornington Peninsula, then the traveller can go on eastwards to lush Gippsland and the Lakes.

Below left to right: Captain Cook's Cottage stands in Fitzroy Gardens; Springtime's abundance is displayed in the Conservatory, Fitzroy Gardens; the Yarra River runs through the heart of Melbourne.
Opposite: Aerial view over the War Memorial to Melbourne city. In the centre, to the left of St Kilda Road, are the National Gallery of Victoria and the Victorian Arts Centre.

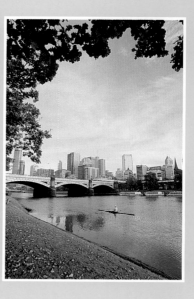

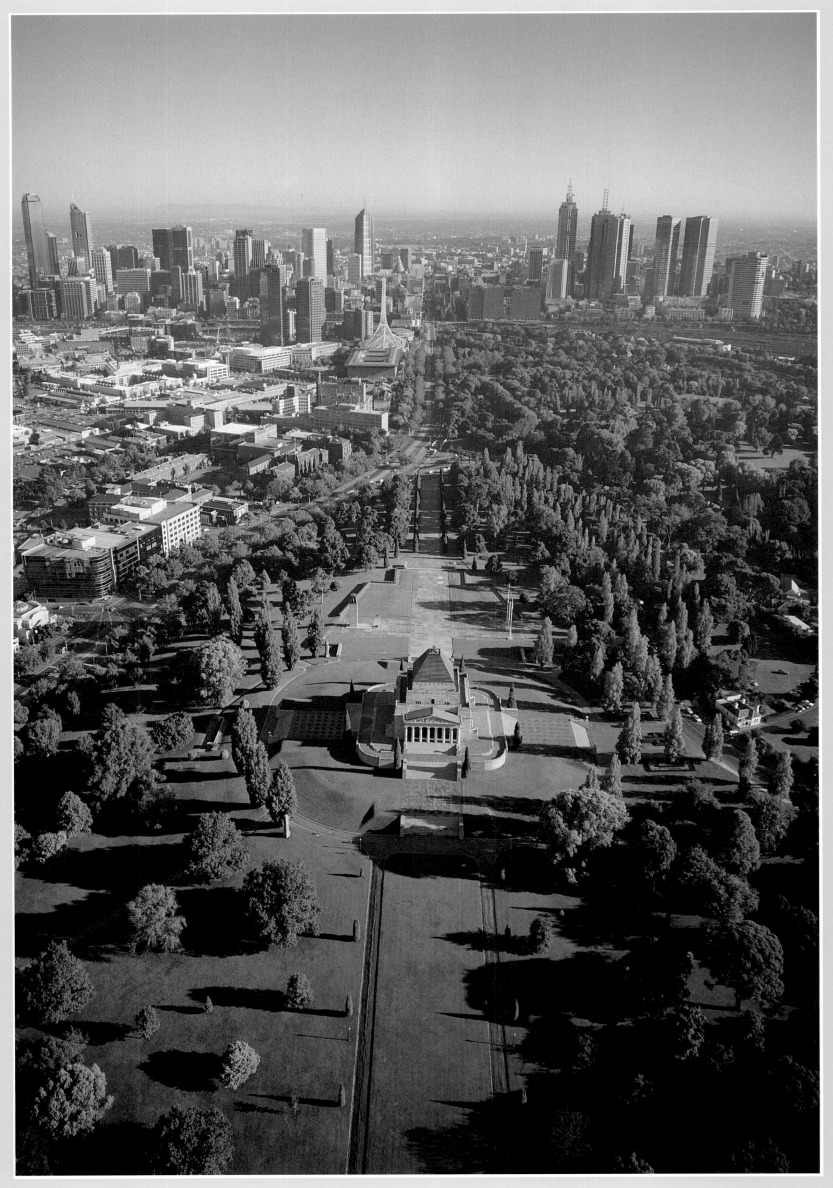

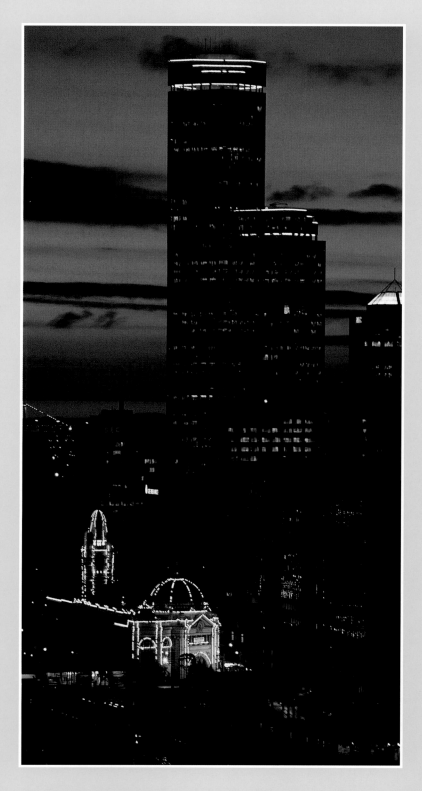

Flinders Street Station: Where journeys begin

It is said that if you stand near the main entrance to Flinders Street Station, sooner or later everyone you have ever known in Australia will pass by. The station was constructed in 1910, where Flinders Street crosses Swanston Street, and has been a hub of Victoria's magnificent railway system ever since. Standing opposite the Station are two very different Melbourne icons - St Paul's Cathedral and Young and Jacksons Hotel.

✦

Above: Flinders Street Station shines brightly at night.
Above right: "Under the clocks" at Flinders Street Station is a popular meeting place for the people of Melbourne.
Following pages: left: The Yarra and Melbourne at dawn; right: footbridge from South Gate complex to the northern bank of the Yarra River.

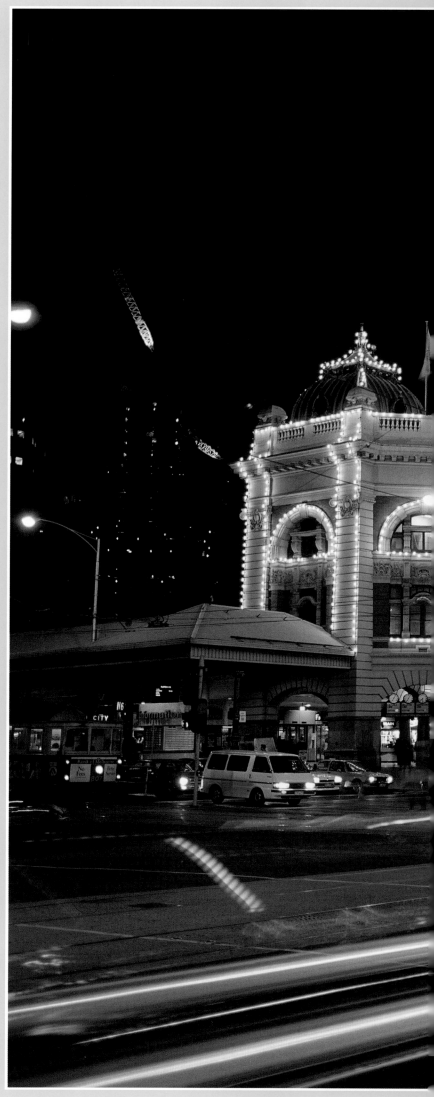

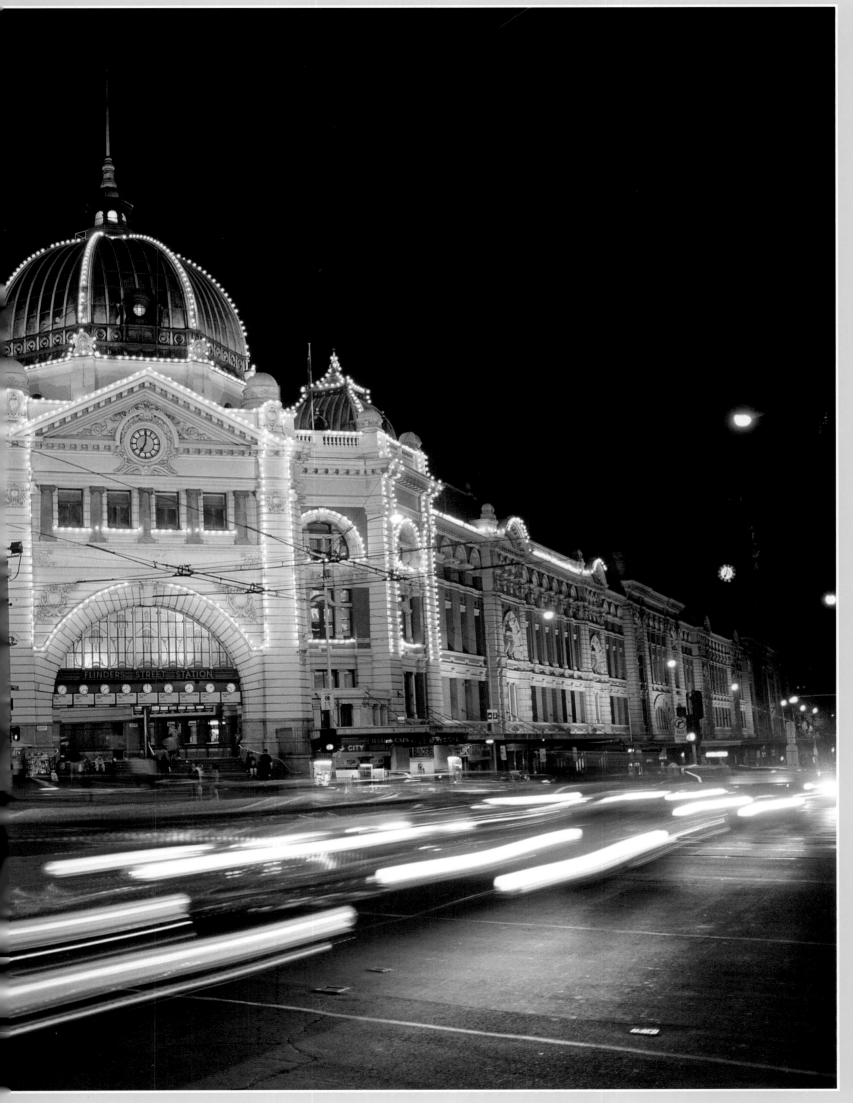

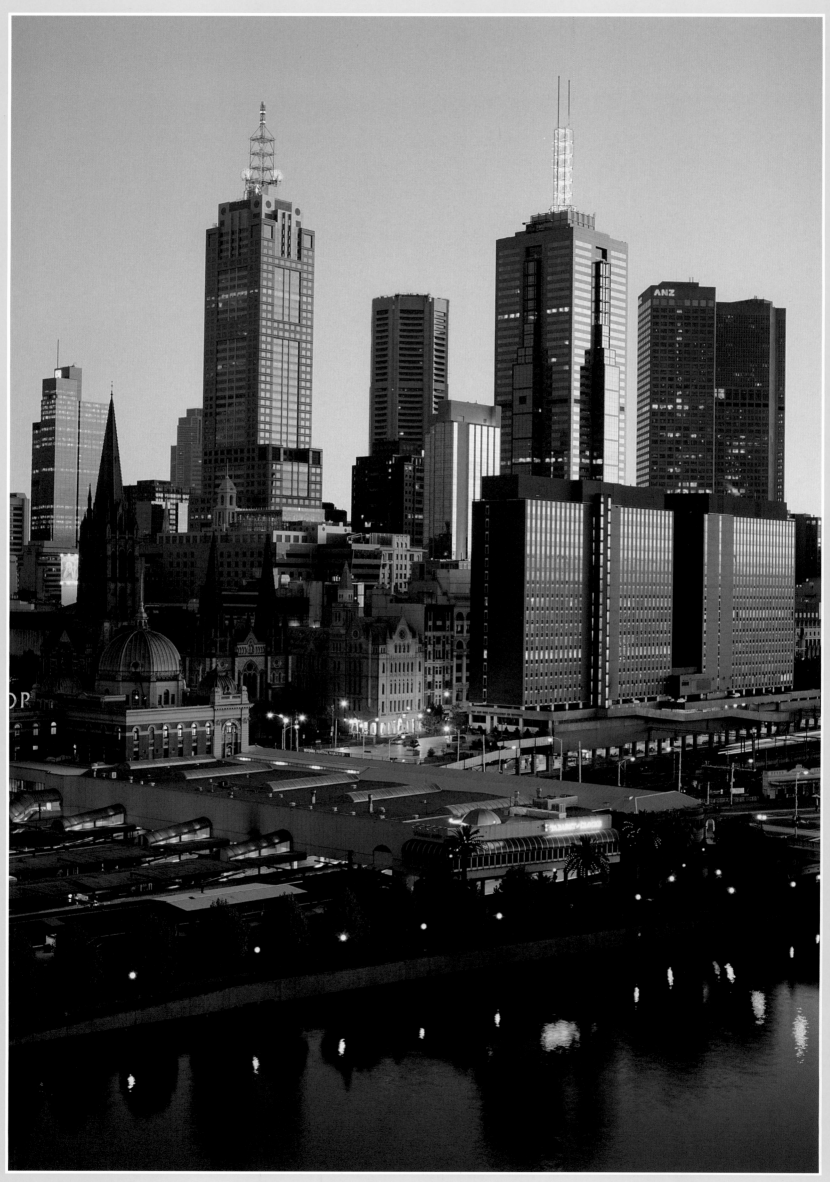

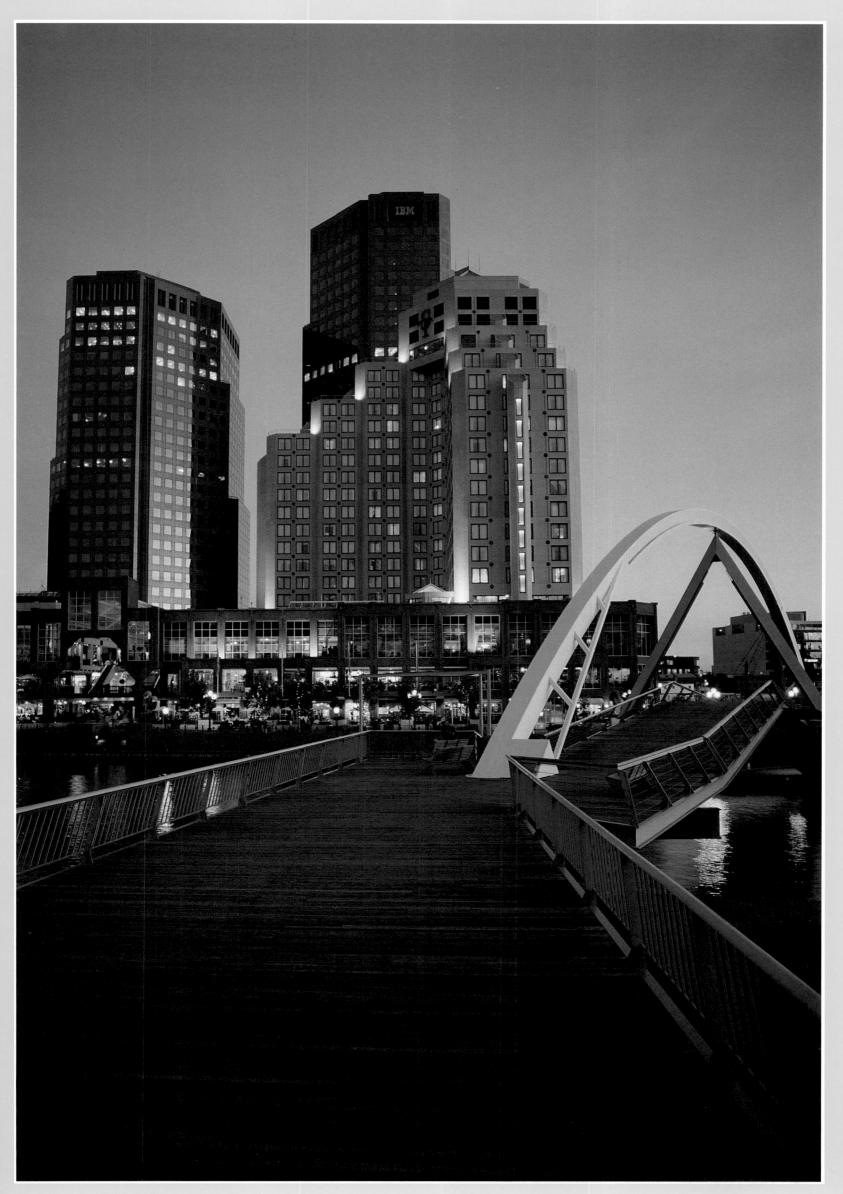

Above left: Balloon and biplane in front of the historic Shot Tower inside the dome of Melbourne Central. Above right: The pavement becomes an artist's gallery.
Below left: Southgate awaits the lunchtime cafe-crowd. Below right: More art in the street.

Melbourne: A city for shoppers

Shopping in Melbourne is a soul-satisfying experience. The city blocks offer every form of merchandising outlet known. Enjoy the suave style of Melbourne Central, with its ultra-modern, ultra-classy department store and boutiques, the more intimate venues such as Block Arcade and Royal Arcade, wide, shop-fringed thoroughfares including the tram-haunted Bourke Street Mall, and the free-for-all, everything-for-sale atmosphere of the renowned Queen Victoria Market.

★

Above: The Toorak tram is only one of Melbourne's famous fleet of trams.
Below: A Melbourne tram passes Melbourne Central.

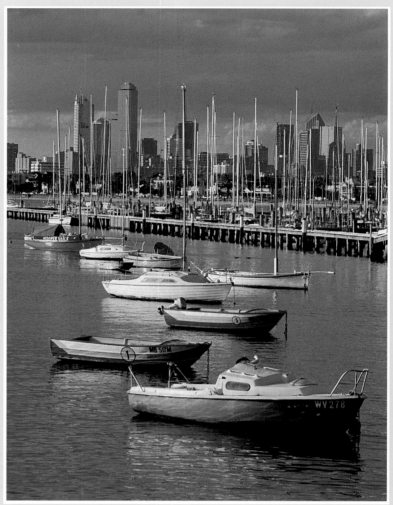

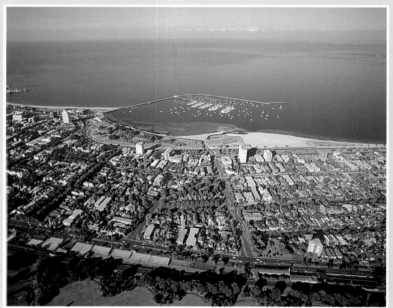

At play in Port Phillip Bay

Port Phillip Bay provides Melbourne with a seafront which offers every recreational opportunity. You can swim, sail, or fish, watch birds, water-ski or scuba dive. Cycling and roller-blading are popular bayside activities for the young and the young-at-heart.

If it's calmer pursuits you prefer, what about strolling the St Kilda Pier, to see and be seen, after browsing in the market stalls on the Esplanade? Then sit down to coffee, or a meal, at any one of the excellent cafés and restaurants which are common in Melbourne's bayside suburbs.

✦

Above: Looking towards the city of Melbourne across Port Phillip Bay.
Below: An aerial view of Brighton.
Left: A few of the much-coveted, lovingly-maintained bathing boxes at Brighton.

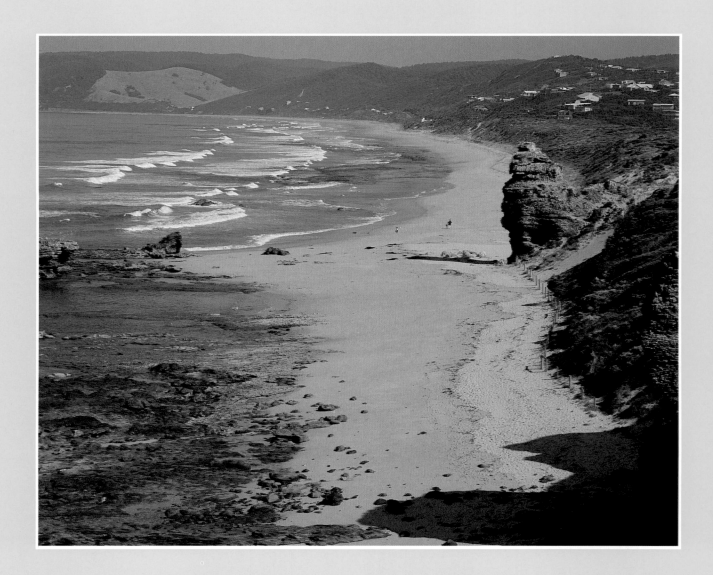

Great Ocean Road: Harbours and headlands

The best way to explore the south-west coast of Victoria is to take the Great Ocean Road, which travels for 300 kilometres along the ocean's edge and offers access to the wonders of the Otway Ranges, as well as to other magnificent national parks.

The road was begun in 1918 and built by soldiers who had returned from the First World War to unemployment. After it had been completed in 1936, it was dedicated to those who died in the "war to end war".

Today's traveller can journey from Torquay to Anglesea to Lorne, Apollo Bay, Warrnambool and beyond, discovering relics of the whaling and timber-getting past and enjoying the superb beaches. The rainforests of the Otways offer tall timber and lovely waterfalls. To the west is Port Campbell National Park, the "Shipwreck Coast" which has claimed 142 wrecks and where the Twelve Apostles (eight to be seen from the Great Ocean Road lookouts) stand sentinel in the ocean.

———————————— ✴ ————————————

Above: Looking across Aireys Inlet to Fairhaven Beach, in a scenic area accessible from Victoria's Great Ocean Road.
Opposite: East of Port Campbell stand the Twelve Apostles.

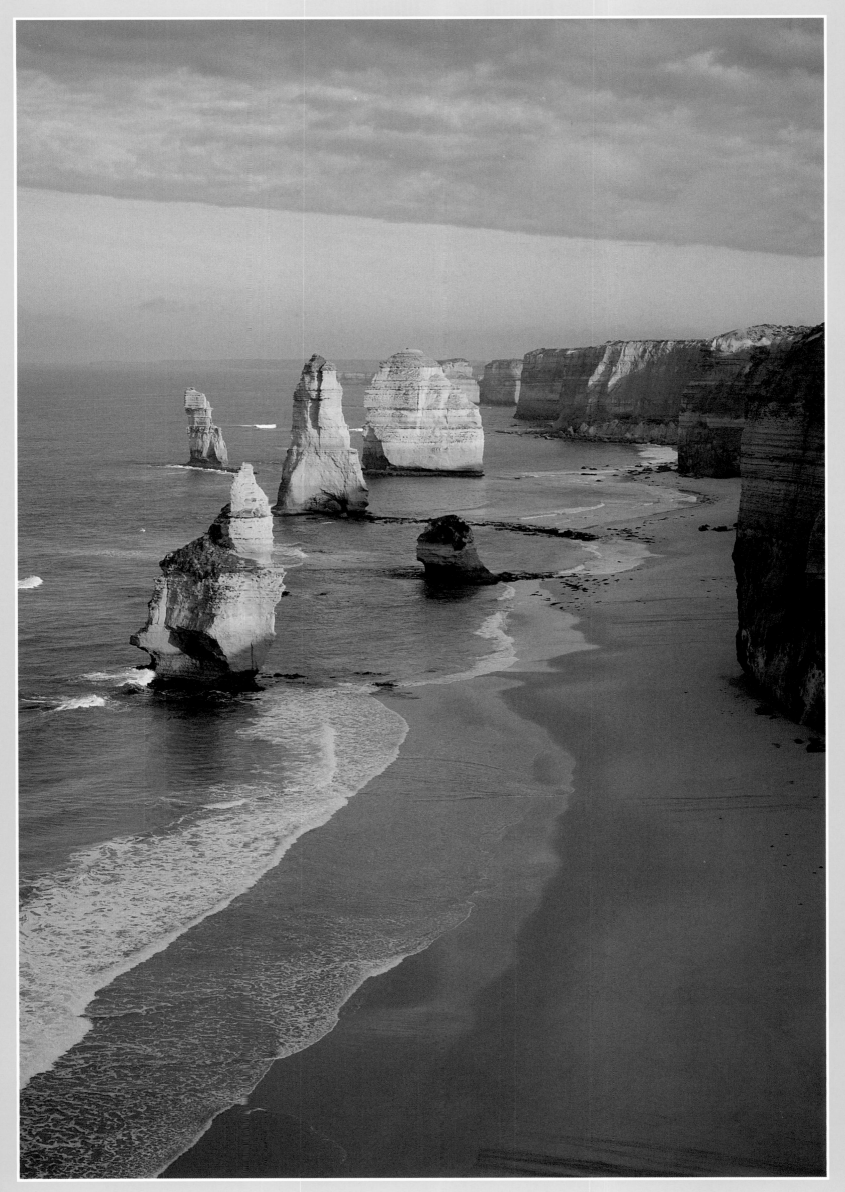

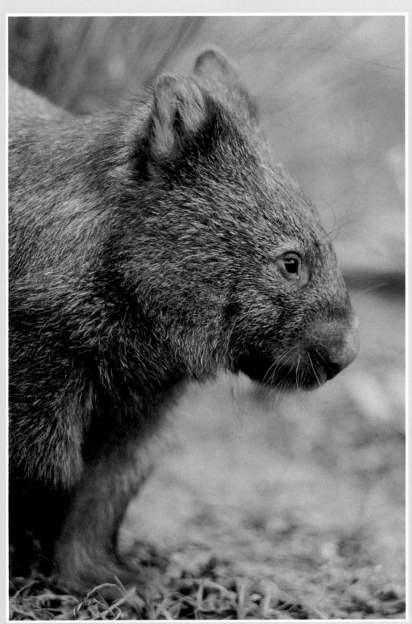
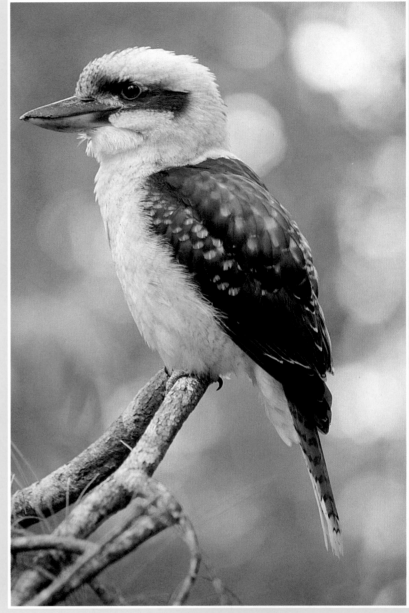

The Otway Ranges: A wildlife haven

The high rainfall of the Otway Ranges supports forests of towering mountain ash, mountain grey gum and southern blue gum, and sustains creeks and waterfalls surrounded by mossy boulders and ferns. Sheltered mountain gullies hide stands of ancient Antarctic beech trees.

Wild denizens of the Otway Ranges include around 45 species of native mammals, such as possums, kangaroos, the Platypus and the Common Wombat. There are approximately 250 species of birds, more than half of which breed in the park.

———————————————✶———————————————

Above left: The Common Wombat spends day in a burrow, forages at night.
Above right: The Laughing Kookaburra wakes the forested ranges each dawn.
Opposite: Hopetoun Falls, one of many beautiful cascades in the Otway Ranges.

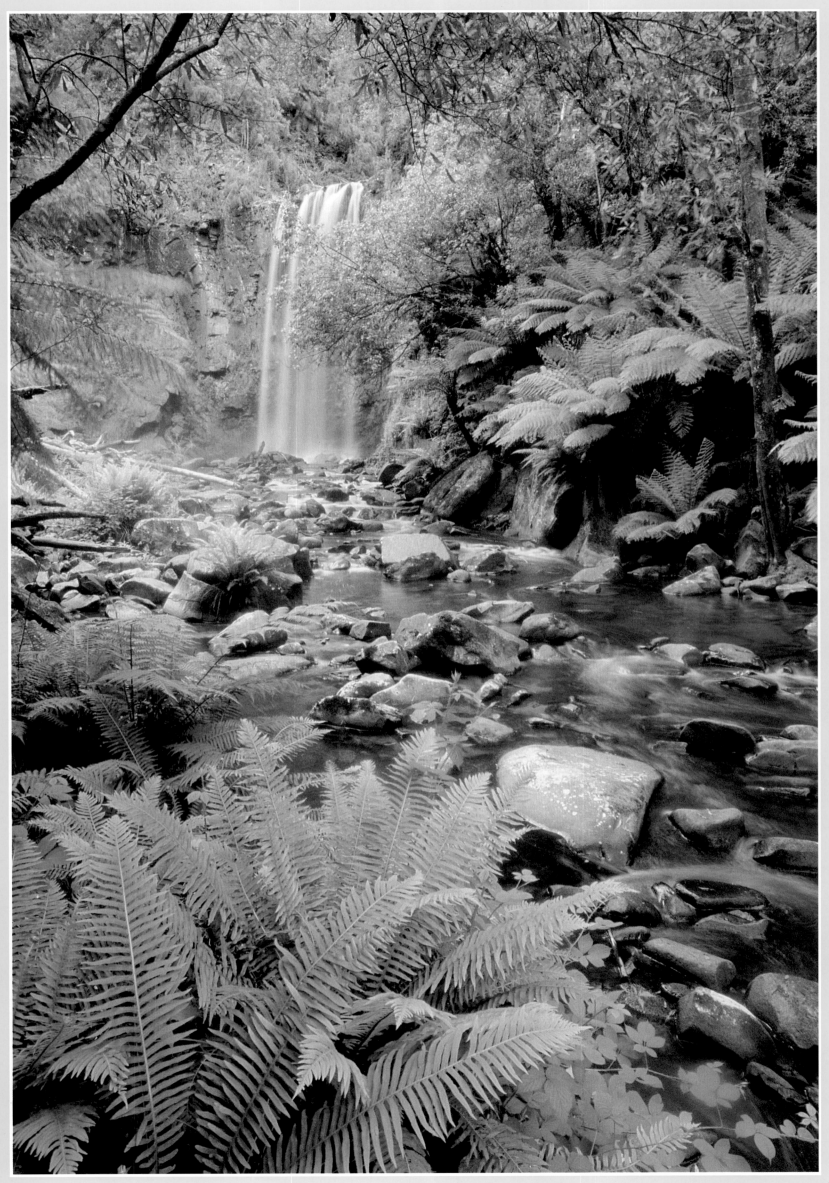

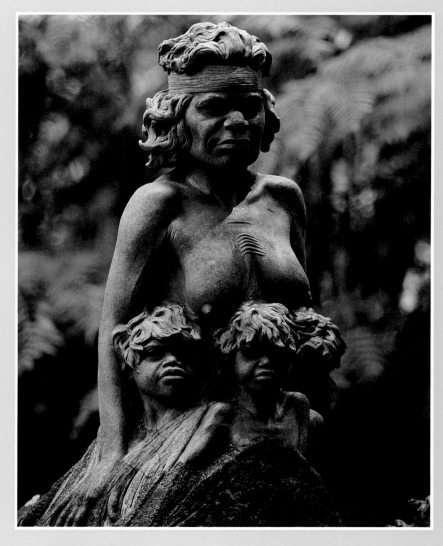

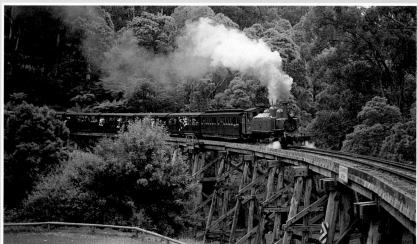

The Dandenongs: Gardens and green silences

Less than fifty kilometres from Melbourne are the Dandenong Ranges, where magnificent forest still stands in steep-sided gullies haunted by the voice of the lyrebird. Beautiful gardens, galleries, restaurants, guesthouses, picnic grounds and plant nurseries are found in abundance in the Dandenongs, but there are still plenty of trails for the bushwalker to explore. "Puffing Billy", a relic of the steam age, carries entranced passengers through the ranges from Belgrave to Emerald Lake.

Healesville Sanctuary, a prime attraction of the Dandenong area, was opened in 1934 and is noted for its remarkable collection of Australian wildlife, including Koalas.

———————————————— ✳ ————————————————

Above: William Ricketts created works based on the Aboriginal concept of oneness with the environment.
Below: "Puffing Billy" chugs and toots along its track for 13 kilometres through the Dandenong Ranges.

Above: "Tilly" is just one of the charming Koalas waiting to greet visitors to Healesville Sanctuary.
Below: The Dandenongs' cool winters mean a seasonal glory of azaleas, rhododendrons and other blossoms.
Following pages: Sheep safely graze in lush pastures in a rural Victorian scene.

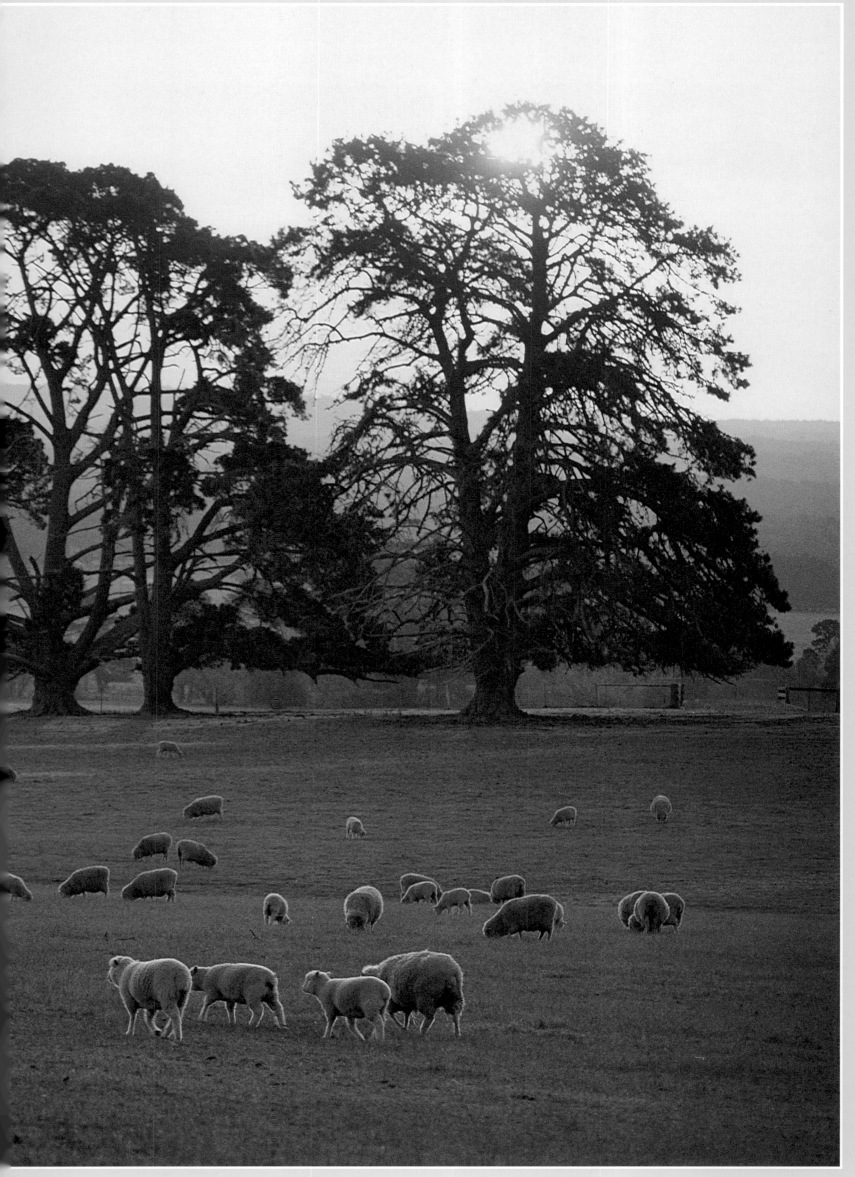

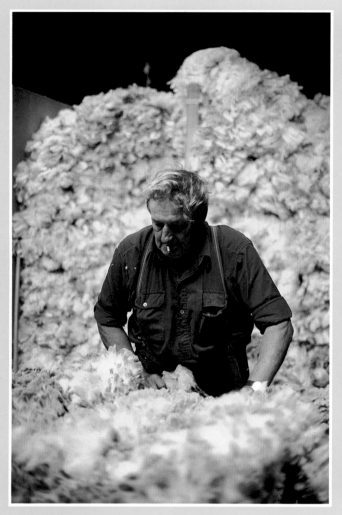

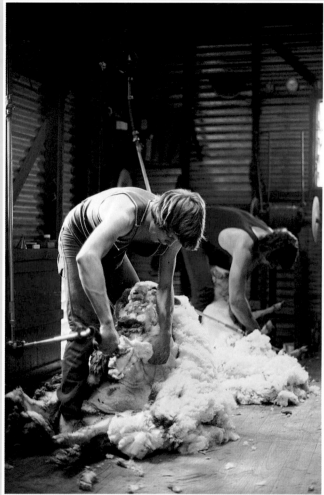

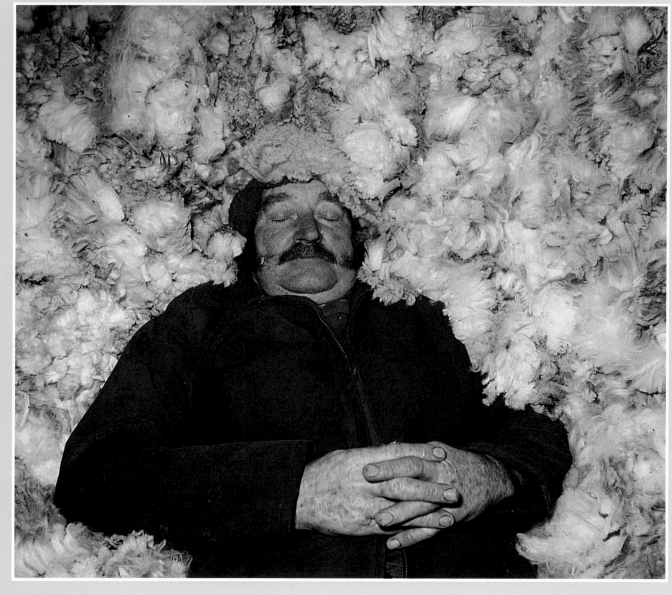

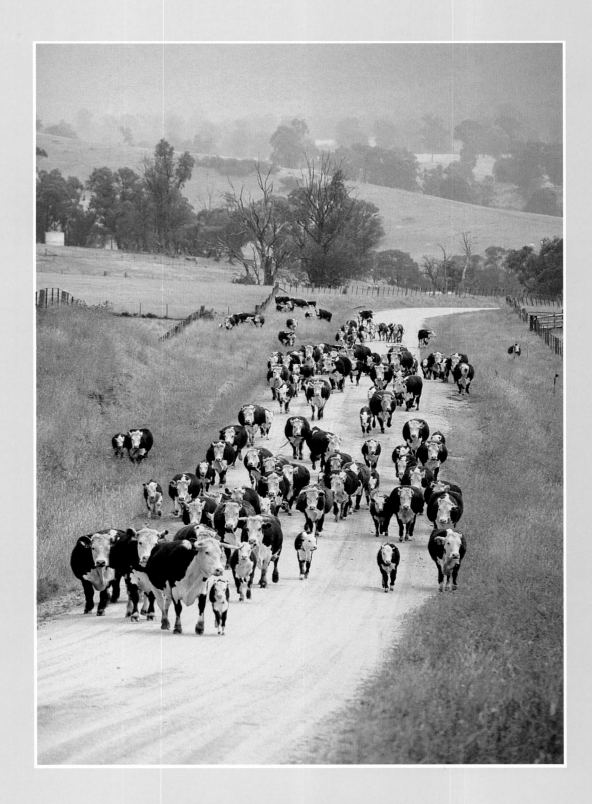

Rural Victoria: Life on the land

Victoria's rural areas are home to some of Australia's best-bred and most productive cattle and sheep. Its Merino wool is second to none in quality and it produces exceptionally fine dairy and beef cattle. The pastoral industry has quietly supported the State almost since the first settlement in 1834. Sheep and cattle have underwritten the boom times of the gold rushes and carried Victoria's finances through more than one lean spell. Today's pastoralists have added to their fine-woolled sheep and fat cattle a new occupation - offering old-fashioned country-style hospitality to visitors eager to experience the fascinations of life on the land.

✦

Opposite, top left and clockwise: Sorting the silver fleece; shearer at work; gun shearer relaxing during lunch break.
Above: Cattle ambling along a Victorian country road.

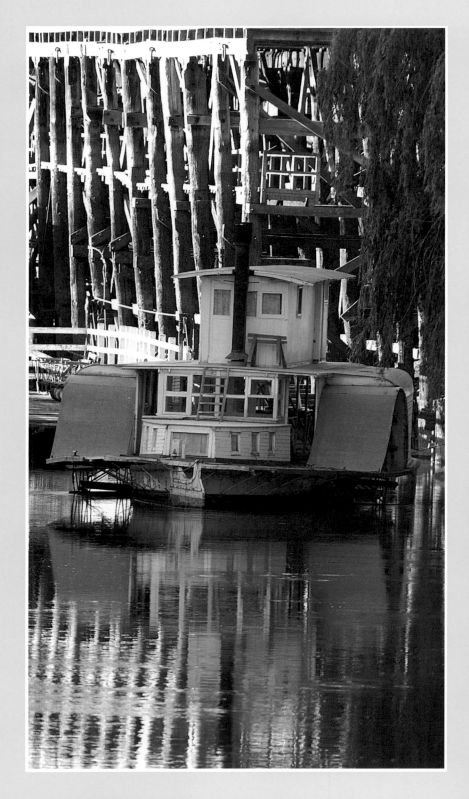

The Murray: Australia's greatest river

Water may take three months to travel the more than 2,500 kilometres from the source of the River Murray, in the Australian Alps, to the river's mouth at Lake Alexandrina. For much of its length the river forms the boundary between the States of Victoria and New South Wales and it supplies the water needs of a large number of people.

In the roaring days of the 1860s and 1870s, the Murray was a busy waterway. Echuca was home port for paddlewheelers carrying wool, timber, wheat and other cargo along the Murray. Eventually, railways took this trade away and today the paddlewheelers are treasured museum exhibits, or pleasure craft carrying happy holidaymakers.

★

Above: Paddlewheelers once brought wheat, timber and wool to Echuca, to be sent on by rail to Melbourne.
Right: Sunrise on the Murray River floodplains.

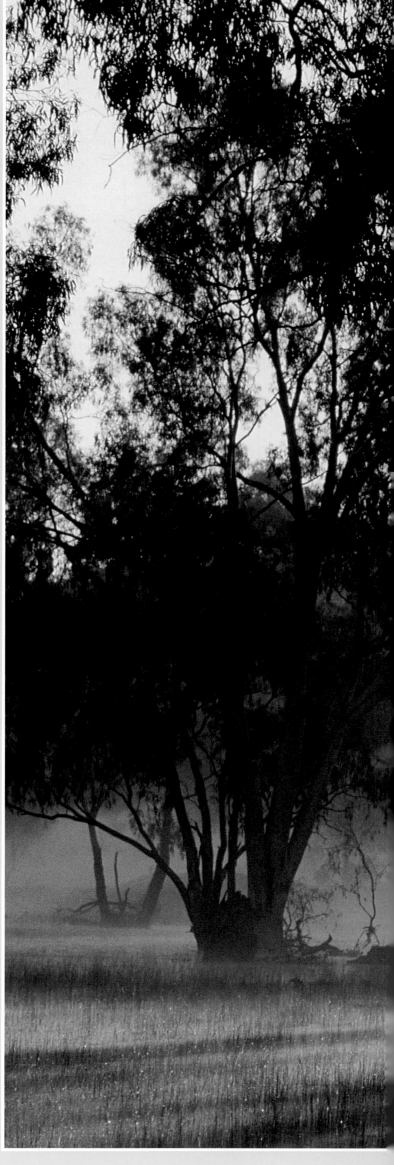

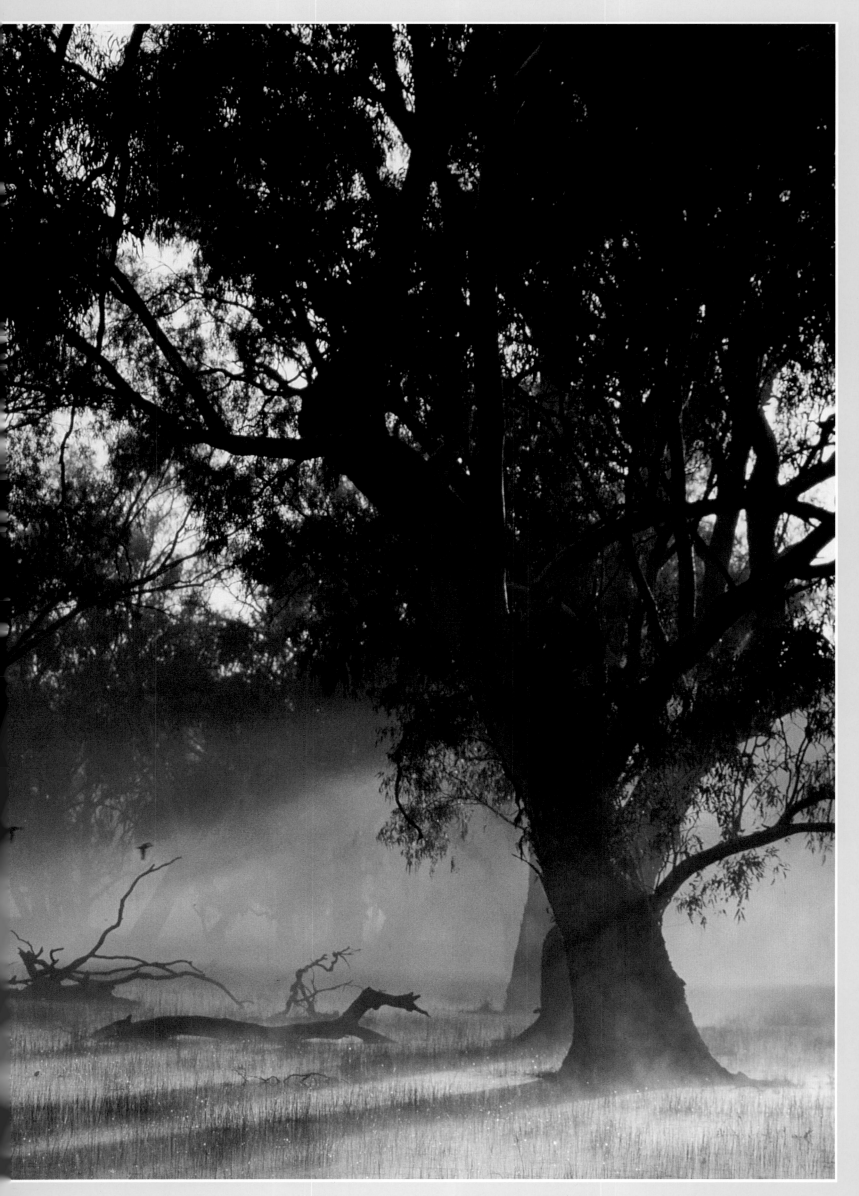

TASMANIA

THE WILDERNESS STATE

Tasmania does nothing by halves. When it is civilised, it echoes the gentility of an earlier age and a way of life established in Europe half a world away. When it is wild, it is wild indeed - a land of precipitous ranges, desolate high heaths, moody mountain lakes and rugged coastlines.

The island was settled by the British in 1803 and remained a penal colony for half a century. European crops, building methods and social customs transplanted easily to this temperate place. When transportation ceased in 1852, there were many solid stone constructions left to bear witness to the grim days of convict labour.

Today, Port Arthur Penal Settlement lies in ruins but Hobart, Launceston and smaller centres are a satisfying blend of new and old construction, where every street corner brings architectural discoveries and every garden is a horticultural delight.

Tasmania is a place to explore at leisure, taking time to sample some of the best seafood in the world and to appreciate the charm of hosts who have made bed-and-breakfast into an art form. There are well-made, if winding, roads which lead through pretty farming towns and fertile pastures and orchards to sheltered coves and wonderful beaches. There are other roads which lead to the magnificence of wilderness - Mount Field, Cradle Mountain and Lake St Clair, Southwest National Park, Freycinet National Park and, crowning glory for adventurers, the Franklin-Lower Gordon Wild Rivers National Park.

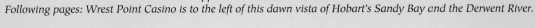

Below left: An aerial view of Hobart, the capital city of Tasmania.
Below right: Secluded waters and rugged mountains ornament Tasmania's wild places.
Opposite: Victoria Dock, Hobart.
Following pages: Wrest Point Casino is to the left of this dawn vista of Hobart's Sandy Bay and the Derwent River.

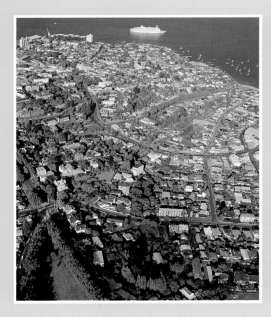

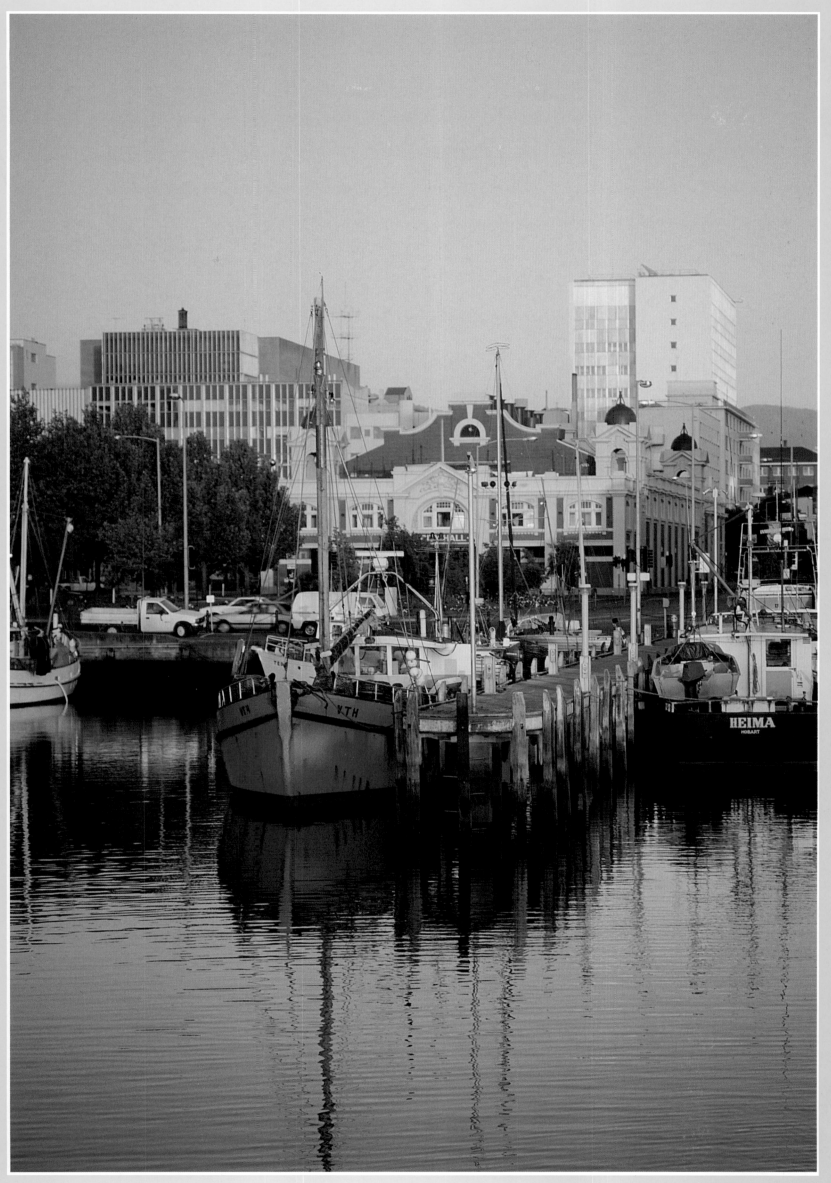

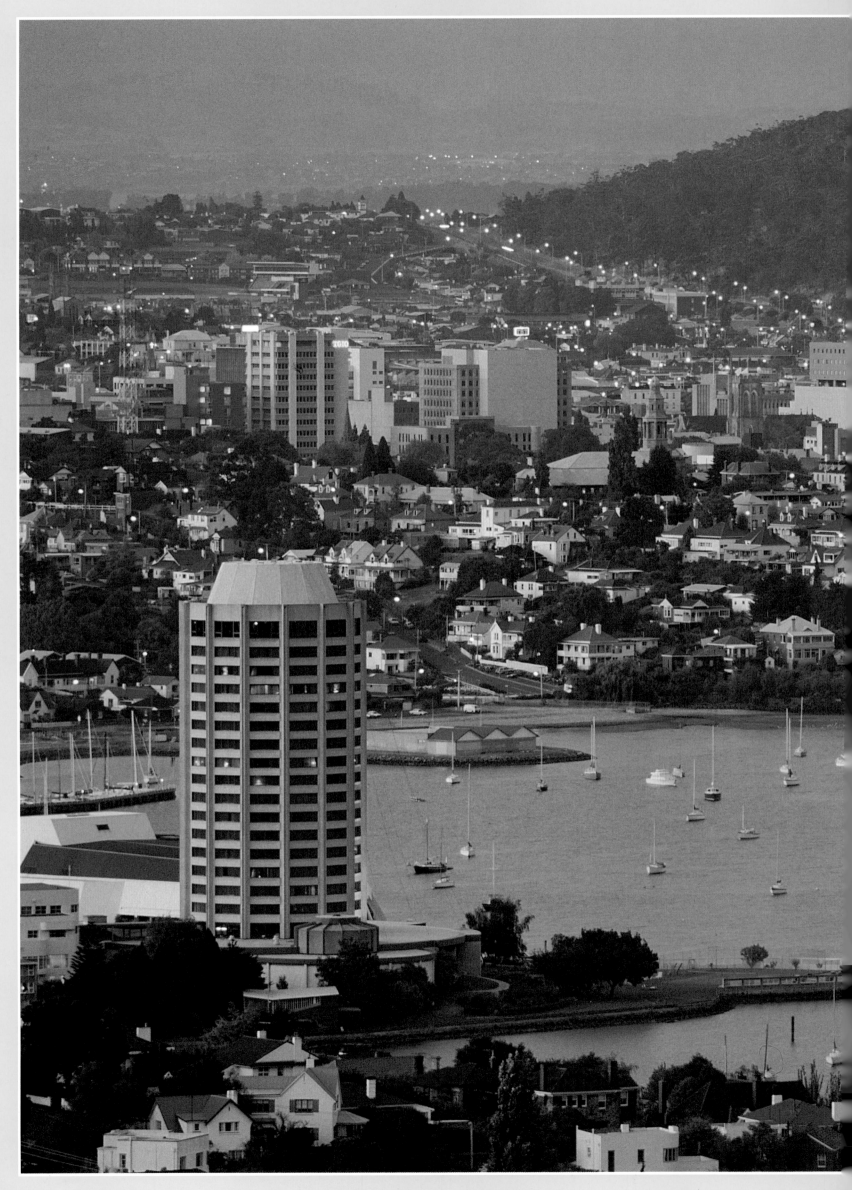

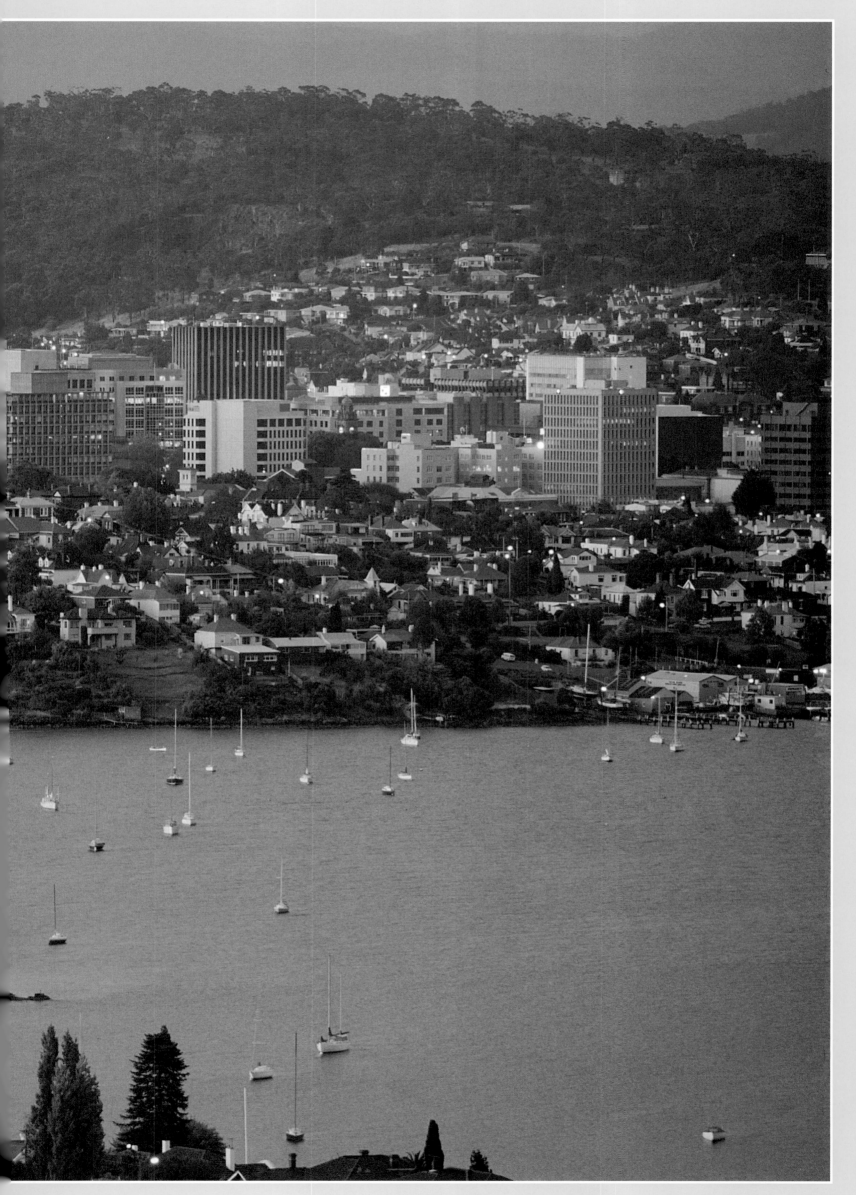

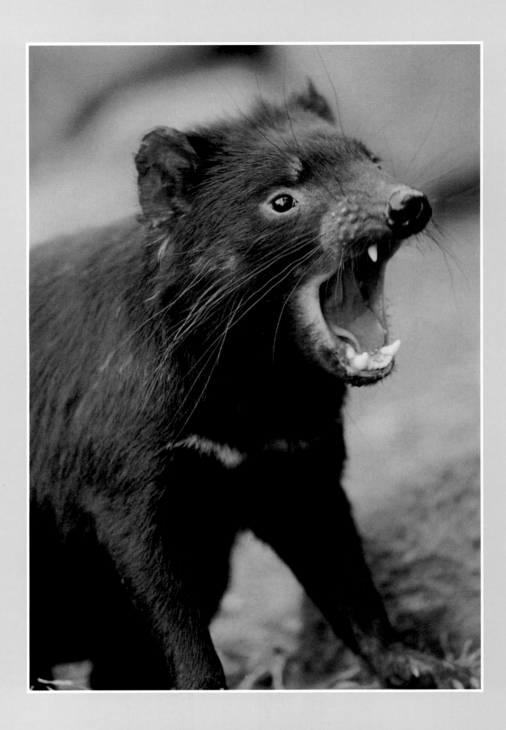

Tasmania: An island full of surprises

Bass Strait is 240 kilometres wide and neither the overnight voyage on the ferry nor the briefer air trip prepares the traveller for stepping from the bustling mainland into another, more leisurely world.

There are parts of Tasmania, mainly those where logging or mineral extraction have held sway, which are less than scenic, but, wherever in the island the traveller may be, it is only a short drive to ordered farmland, or to soaring mountains, tree-hidden rivers and forests that conceal derelict huts.

Tasmania is home to some fascinating creatures. This is an island full of wildlife, from confident possums to squabbling Tasmanian Devils, inquisitive wallabies and a host of other mammals and birds. It is odds-on that the visitor to Tasmania will never see that vanished wonder the Thylacine. However, the animals readily viewed in the island's forests and swamplands, along its seashores or on its mountains, add a host of reasons to make the crossing of Bass Strait.

Above: The Tasmanian Devil is a marsupial found only in the island State.
Opposite: Russell Falls, Mount Field National Park. The last Thylacine was trapped in this region in the 1930s.

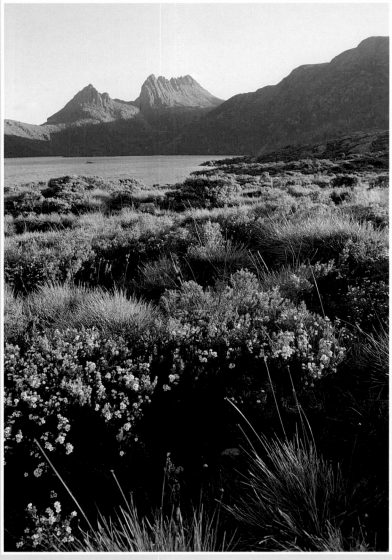

Cradle Mountain-Lake St Clair National Park

An hour's drive south of the port of Devonport, Cradle Mountain-Lake St Clair National Park covers approximately 160,000 hectares and was listed by the World Heritage Committee in 1982. The 85-kilometre Overland Track connects Cradle Mountain with Lake St Clair and takes about five days to traverse. Lake St Clair, which was discovered by Europeans in 1826, has a depth of over 200 metres; it lies in a basin gouged out by two glaciers.

It is advisable to walk the Cradle Mountain-Lake St Clair track in the summer months, when it is possible to enjoy the stands of King Billy Pine, deciduous beech and Tasmanian myrtle and the mountain wildflowers with some assurance of good weather.

✳

Above: Lake Dove seen lying in front of Cradle Mountain,
in Cradle Mountain-Lake St Clair National Park.
The landscapes of the Cradle Mountain area were carved by glaciers.
Opposite: The rainforest of Cradle Mountain-Lake St Clair National Park is a world
of primeval beauty. This area is known as "the Ballroom Forest".

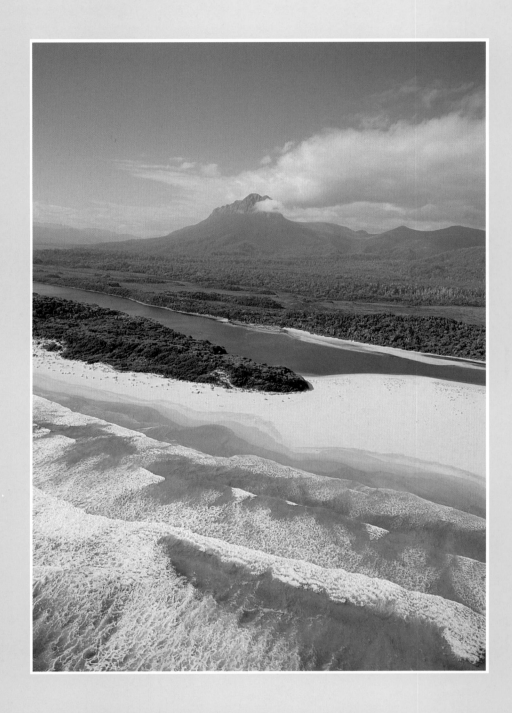

Tasmania's Southwest: A world heritage

The southwest of Tasmania contains country which is classed as World Heritage wilderness, almost unvisited by Europeans until recent times. Whalers harvested their living crop in the early nineteenth century; later came the timber-getters, shipping Huon Pine from Port Davey. Later still, exploration for minerals gave glimpses of the magnificence of the southwest.

The declaration of the Franklin-Lower Gordon Wild Rivers National Park in 1981 was a turning point in the story of conservation. Today, Tasmania's southwest and its southern coast are the destination of those who wish to experience some of the most beautiful and majestic of the world's remaining wild places and their remarkable plants and animals.

Above: Prion Bay and New River Lagoon. Southwest National Park.
Opposite: The rugged and sky-touched Arthur Range.

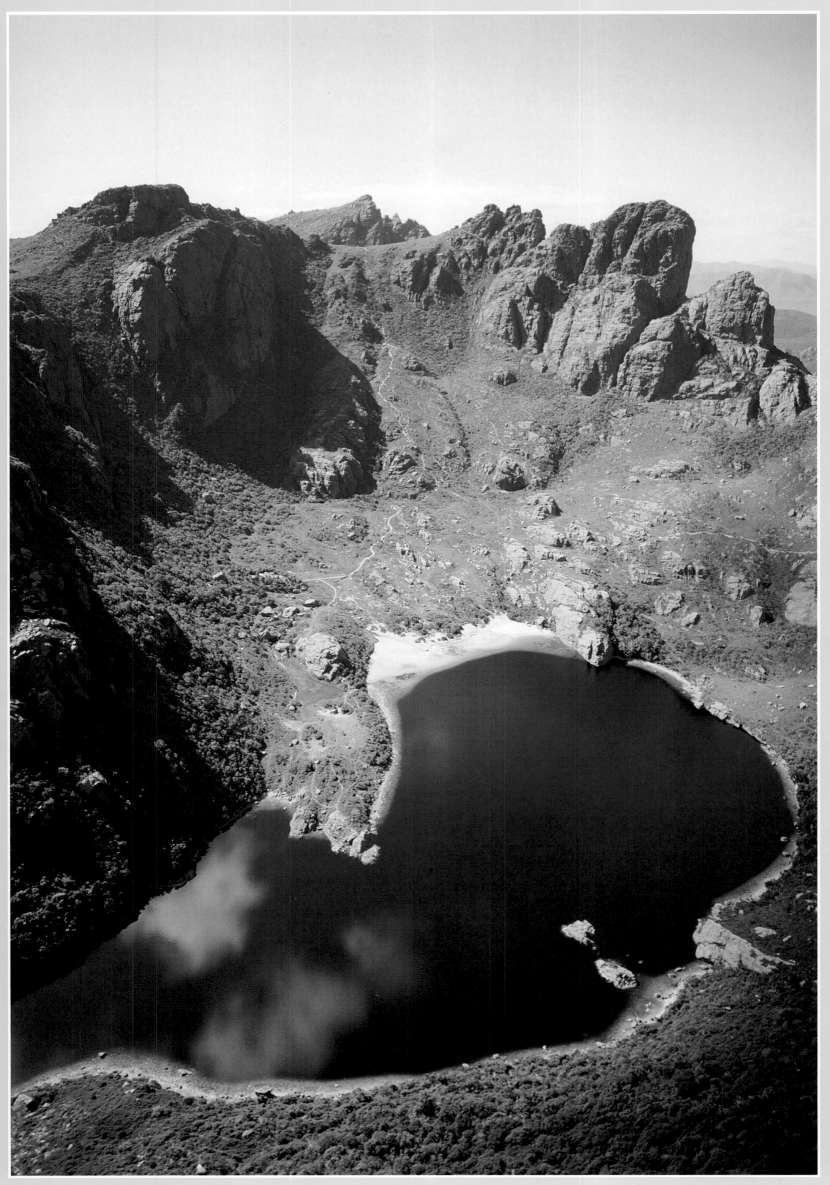

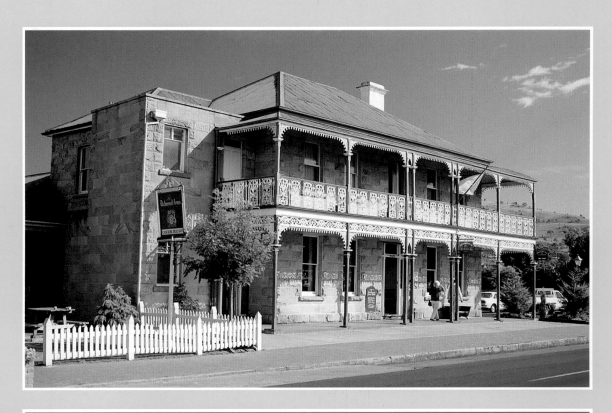

Richmond: Where history comes alive

The charming town of Richmond grew where travellers crossed the Coal River 26 kilometres from Hobart, on the way to Port Arthur. The famous Richmond Bridge is said to be haunted by the ghost of a brutal overseer murdered by the convicts under his command. Eventually, the Sorell Causeway stole Richmond's traffic, allowing the town to remain a delightful colonial relic which displays Tasmania's living history.

★

Above: The Richmond Arms Hotel.
Below: Richmond's beautifully-kept homes add to the town's charm.
Opposite: The Richmond Bridge, Australia's oldest bridge, was built by convicts between 1823 and 1825. Behind the bridge stands St John's Church.

Port Arthur: Relic of a grim past

Port Arthur Penal Settlement was founded in 1830 by Governor George Arthur. Inmates were expected to undertake "the most unceasing labour" under "the most harassing vigilance". They worked from dawn until nightfall in silence. When the gaol was closed in 1877, the buildings were abandoned. Some have now been restored by the National Parks and Wildlife Service. The horrors of the past are easy to imagine when wandering amongst the ruins, looking at the Model Prison, where solitary confinement and "soundless, sightless isolation" replaced the lash, or reflecting on the Isle of the Dead, where nearly 1,800 convicts and 200 officials and free settlers were buried.

✶

Opposite: Ruined chapel, Port Arthur Penal Settlement.
Above: Port Arthur's prison walls have been breached by fire and time.

SOUTH AUSTRALIA

THE FESTIVAL STATE

South Australia originated as a colony of free settlers. However, the stately buildings of Adelaide are at no disadvantage compared to edifices constructed by convict labour in other State capitals. Surveyor-General Colonel William Light's design was magnificently realised and today the green city of Adelaide, sheltered by pleasant hills and near to the waters of St Vincent Gulf, is a wonderful place to explore at leisure.

A short stroll along North Terrace reveals many fascinating buildings - Government House, the War Memorial, the State Library, Museum, the Art Gallery, Adelaide University, the Railway Station and the Casino, and a host of monuments. A few steps more bring to view the stunning Adelaide Festival Centre, with its concert hall and theatres. A street away is the shopper's paradise, Rundle Mall and the sightseer can then walk on to admire majestic Victoria Square.

Near to Adelaide, in the Mount Lofty Ranges and in the Barossa Valley, German settlers pioneered fertile areas, where today picturesque towns such as Hahndorf and Tanunda are famous for old-world hospitality, vineyards and a flourish of festivals. McLaren Vale is another notable winemaking area south of Adelaide. The beautiful beaches of the Fleurieu Peninsula and the seaside resort of Victor Harbor are well worth a visit, while a ferry from Cape Jervis makes the short voyage to Kangaroo Island, which offers scenic national parks and wildlife.

The rugged Flinders Ranges, with their changing colours and stark beauty, lie north of Adelaide. The Yorke Peninsula is a water-sports playground and the Eyre Peninsula offers superb beaches and stunning coastal scenery. Inland are opal towns such as Coober Pedy, while legendary Lake Eyre awaits the adventurer. The State's southeast is a triangle of lakes, forests and farms, fertile and green by courtesy of the River Murray, which flows to the sea near the wilderness of the Coorong, with its wealth of bird life.

Below: Adelaide's biennial Festival of the Arts is internationally famous.
Opposite: Twilight over Torrens Lake, a scenic feature of Adelaide created by impeding the flow of the River Torrens.
Following pages: An aerial view of Adelaide, with Torrens Lake and the Festival Centre in the foreground.

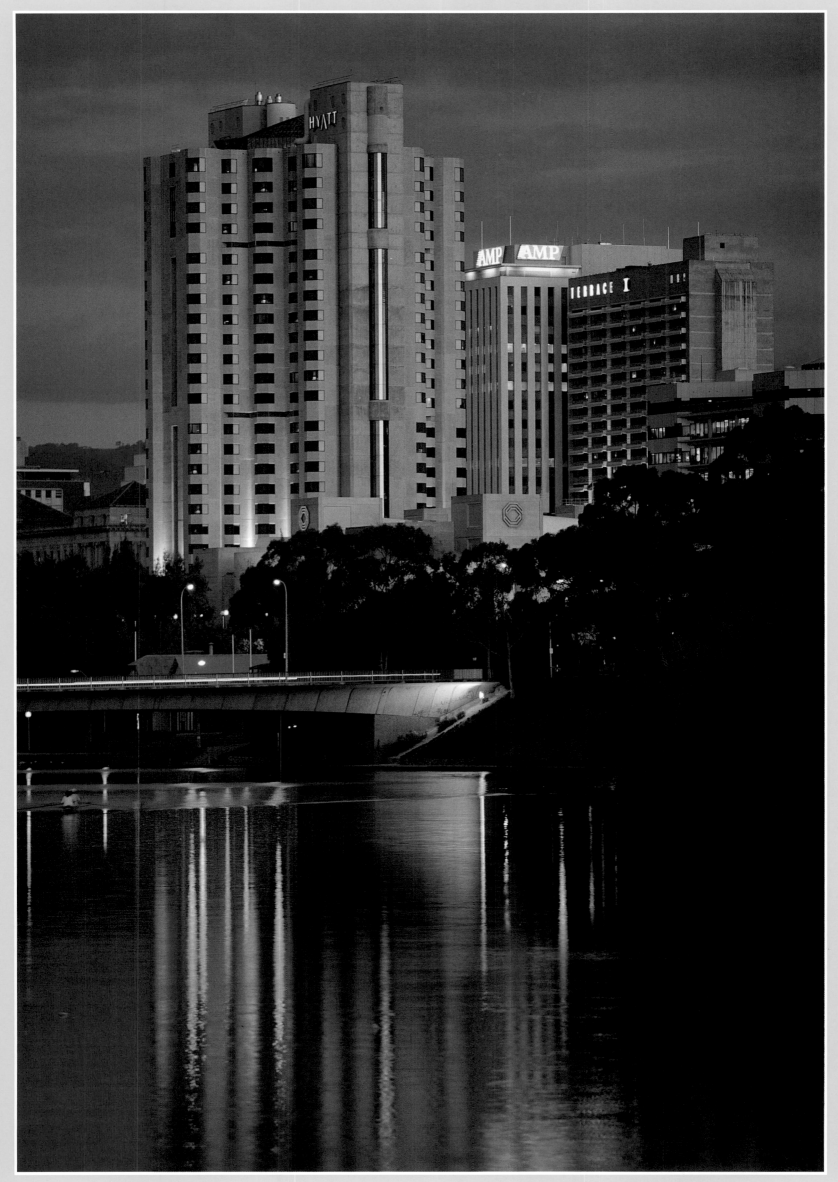

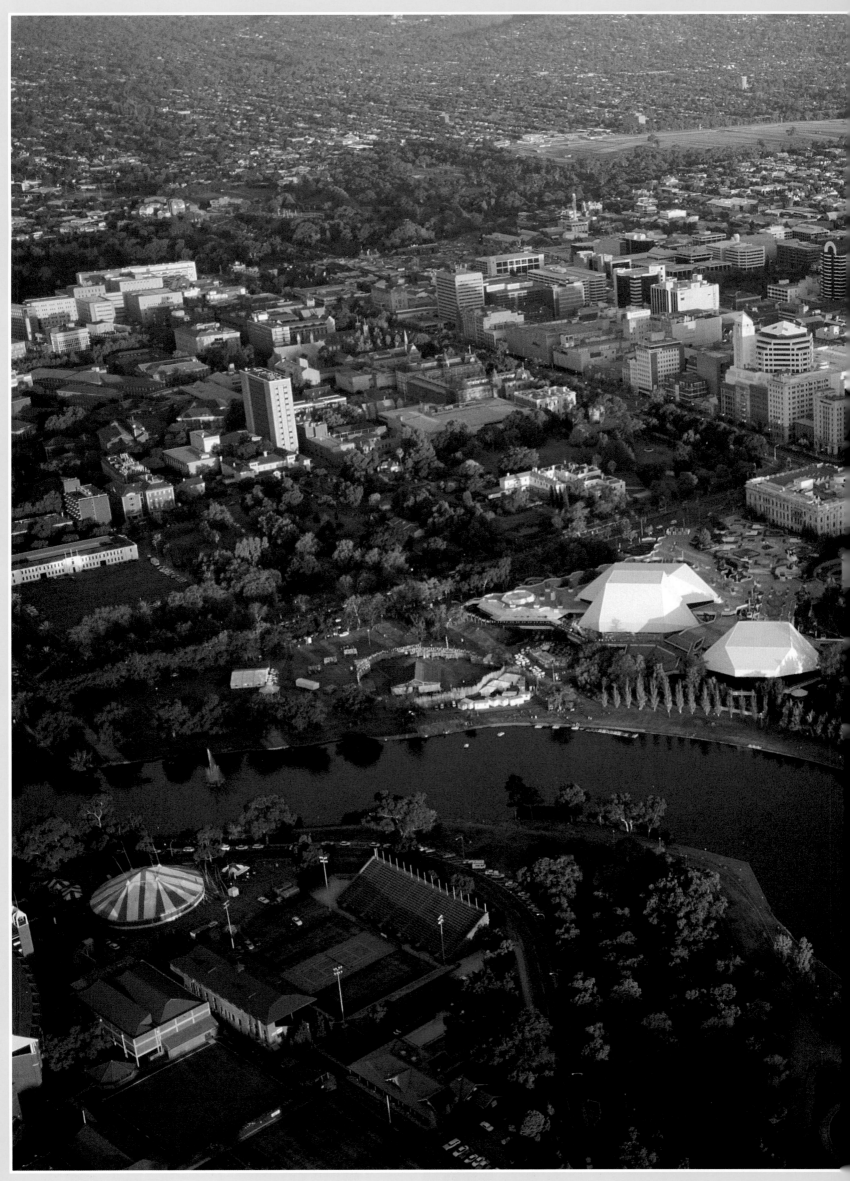

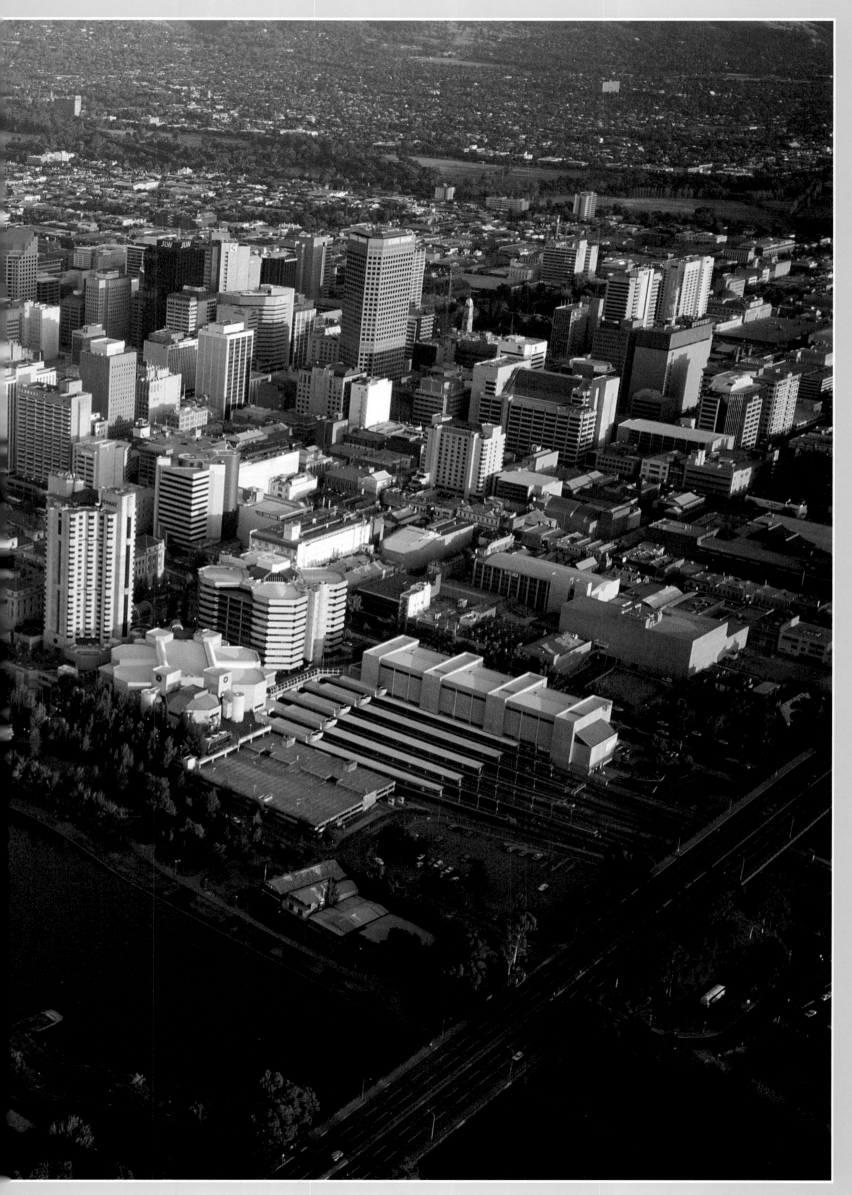

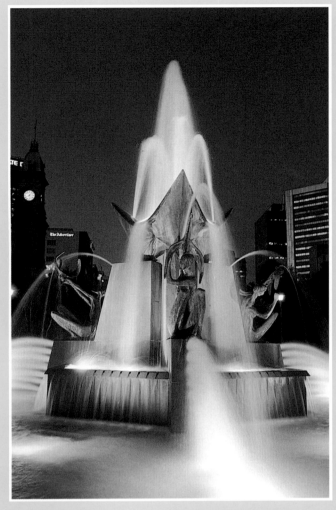
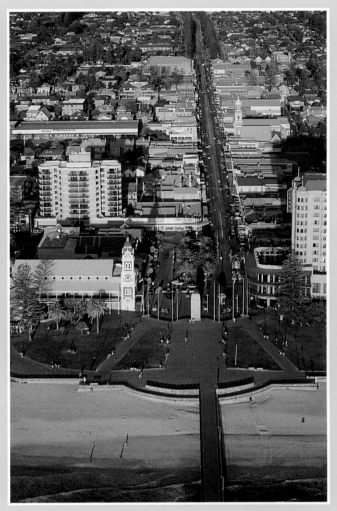

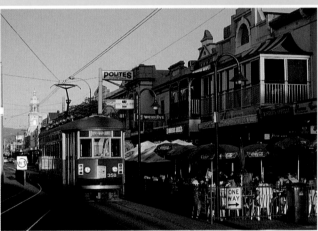

Adelaide: A city for discoveries

No visit to Adelaide is complete without a journey in the famous Bay Tram from Victoria Square to the top of Jetty Road. Once, Glenelg was a seaside resort for the well-to-do, now it is everyone's playground. Other Adelaide entertainments include visiting the Casino, eating at any of an enormous range of restaurants, going to the Central Market, or searching out art and crafts at galleries and workshops.

Above left and right: The Victoria Square Fountain; aerial view of Glenelg, where early settlers came ashore on the mainland.
Below left and right: Adelaide Casino and Railway Station on North Terrace; sidewalk cafes at Glenelg.

South Australia: The Festival State

The internationally-renowned Adelaide Festival of Arts is held for three weeks in March every second year, while the Come Out Youth Festival takes place in the year between. Glendi is the Southern Hemisphere's largest Greek festival.

There are Vintage Festivals in the Barossa and the wineries of the Fleurieu Peninsula. The Barossa wineries also host an annual Gourmet Weekend. McLaren Vale holds a Bushing Festival in October, Willunga holds a Springtime Almond Blossom Festival, while in January Hahndorf holds its famous German Schutzenfest. The Riverland has its own festivals and oceanside Port Lincoln holds a Tunarama Festival.

✷

Above: The Adelaide Festival Centre is a focus for artistic activity.

The Barossa: A valley of vineyards

In 1837, Colonel Light, a veteran of the Napoleonic Wars, named an area north of Adelaide "barrosa", or "hill of roses", after a battle in the Spanish Peninsula, which coincidentally took place in a wine-making area. The present-day Barossa Valley is about 30 kilometres long and its fertile soil, hot, dry summers and reliable winter rains are well-suited to the cultivation of wine-making grapes. There are more than 30 Lutheran churches in the valley and their spires, rising about the trim and tidy valley towns, reflect the area's German and strongly religious heritage.

✦

Above: An historic store in the town of Tanunda.
Below: One of the Barossa Valley's many craft shops.
Right: Tanunda is known as "the gateway to the Barossa".
Following pages: Flinders Ranges National Park.

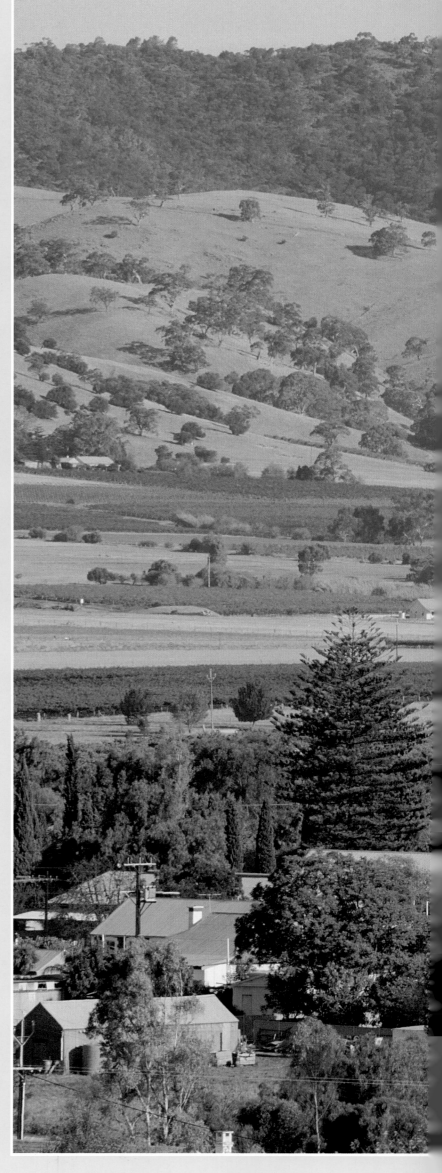

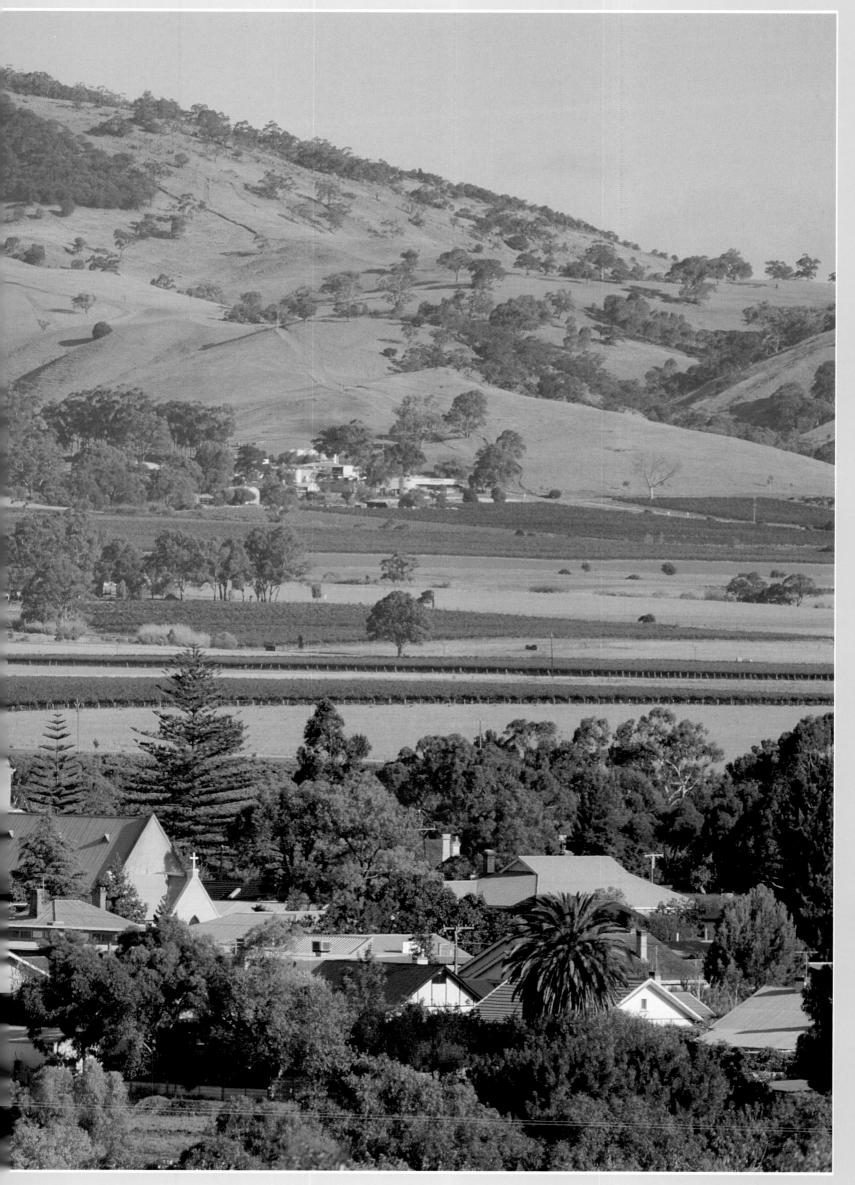

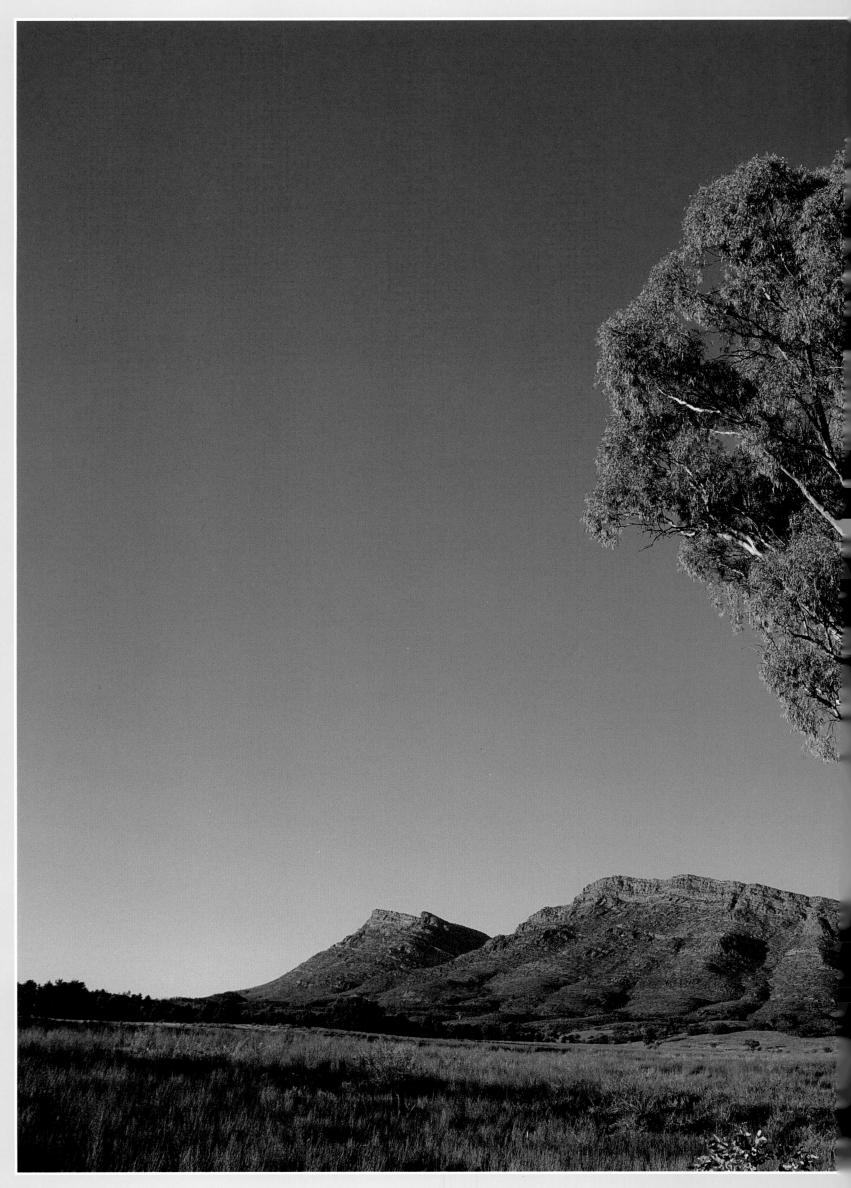

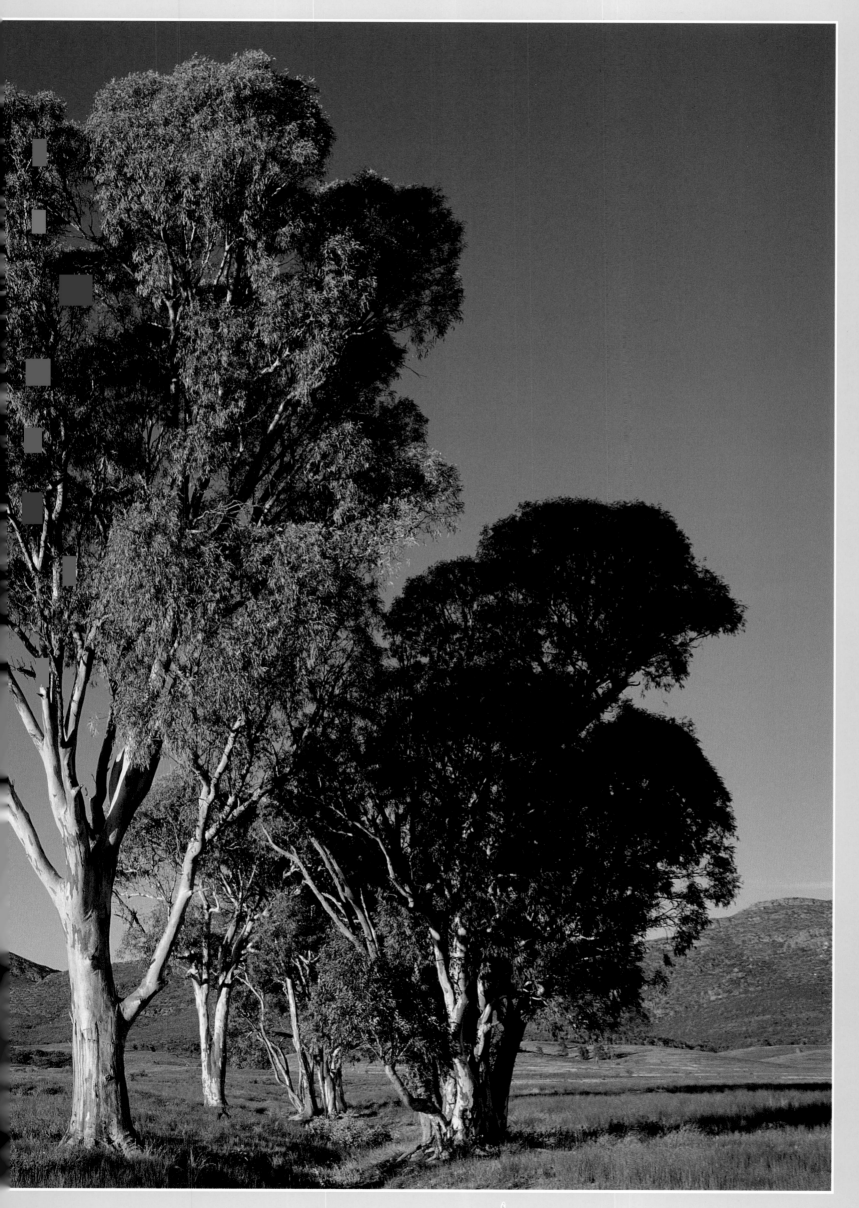

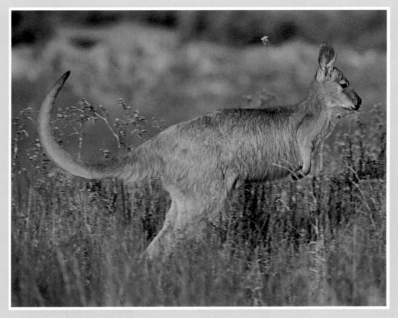

The Flinders Ranges: Scenic and popular

The scenic Flinders Ranges, approximately 430 kilometres
north of Adelaide, are popular for touring, walking, climbing
and camping. The Flinders Ranges National Park extends over
nearly 100,000 hectares of the ecologically fragile ranges.

———————————— ★ ————————————

Above: A Wallaroo thuds away amongst summertime Flinders Ranges vegetation.
Centre: The Flinders Ranges rise abruptly from the plain.
Below: Spectacular Wilpena Pound reaches 1,200 metres in height at St Mary's Peak.
Opposite: Sturt's Desert Pea, floral emblem of South Australia, is common in the Flinders Ranges.

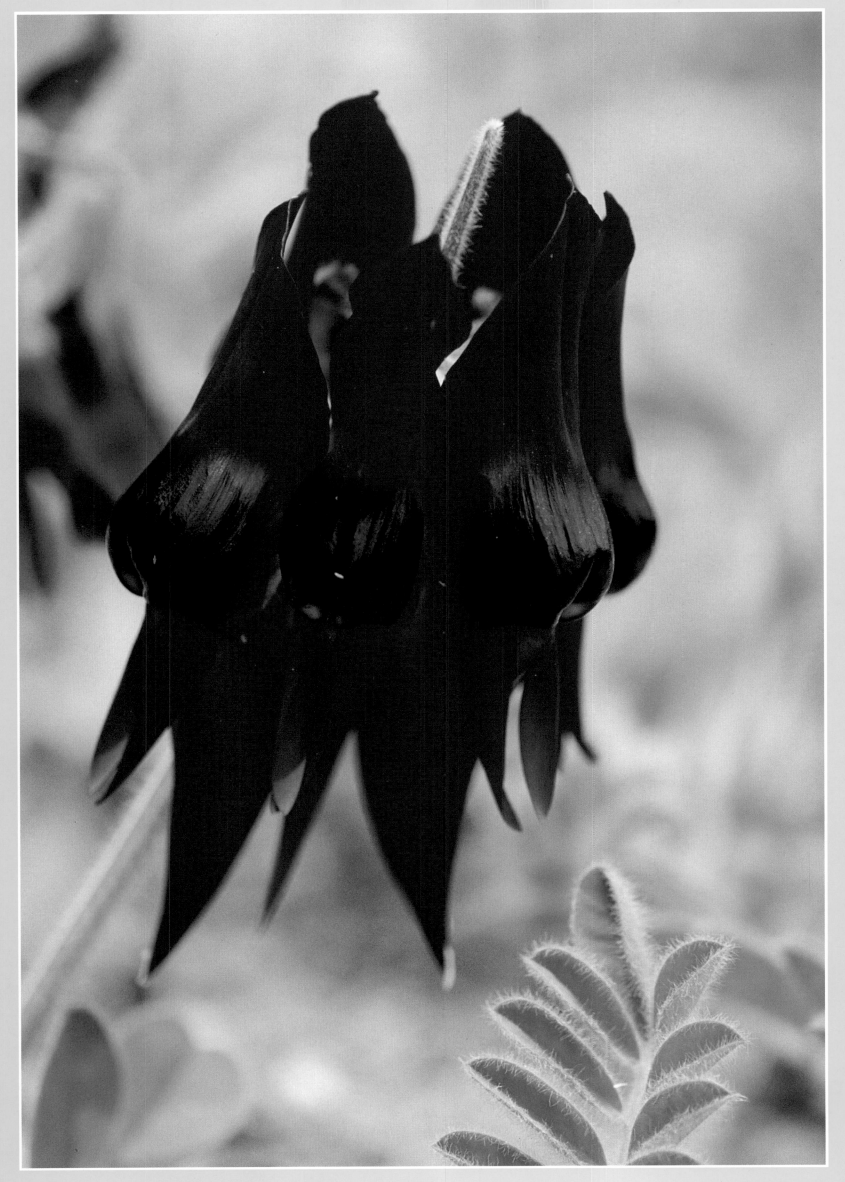

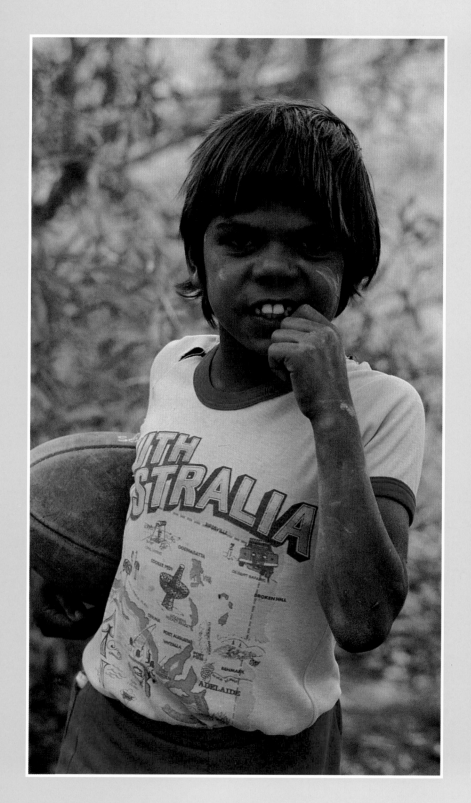

Playing Outback

South Australia has a population of 1.5 million, is rich in mineral wealth and is one of Australia's most industrialised States. Most of the primary industries, such as fishing and the cultivation of vines and orchards, are coastal. The people of the Outback make a living from sheep, cattle or mining. They exist in a tough landscape and work hard, and when they get together to play they thoroughly enjoy themselves.

✳

Above: Australian Football rules in South Australia!
Opposite: The William Creek Gymkhana raises funds for
the Flying Doctor Service.

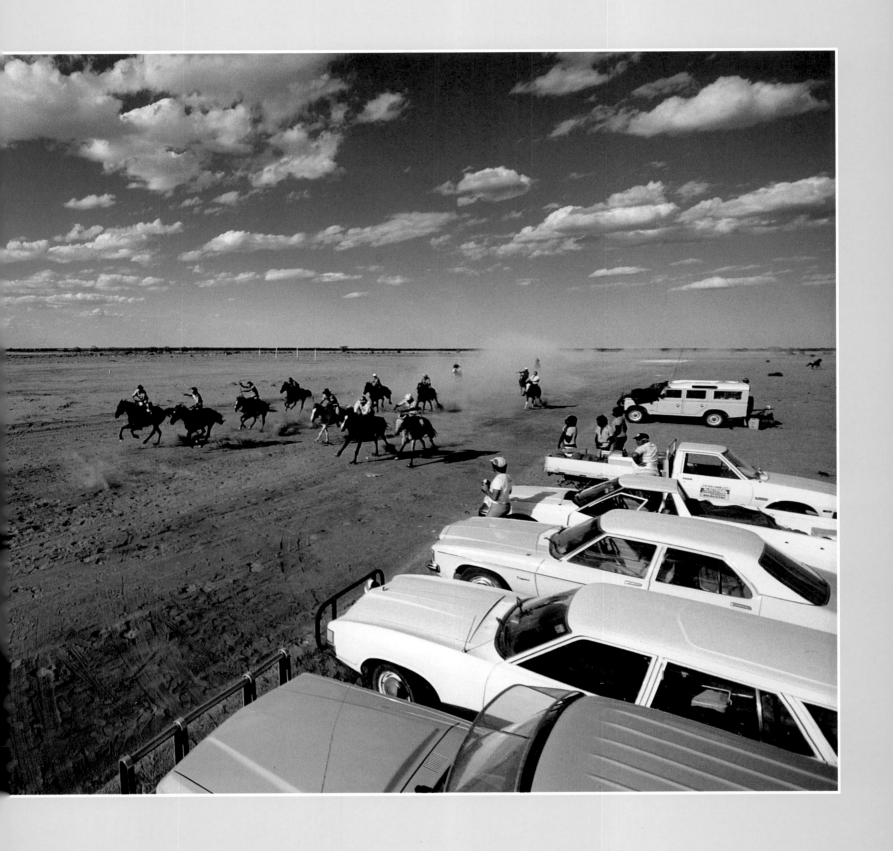

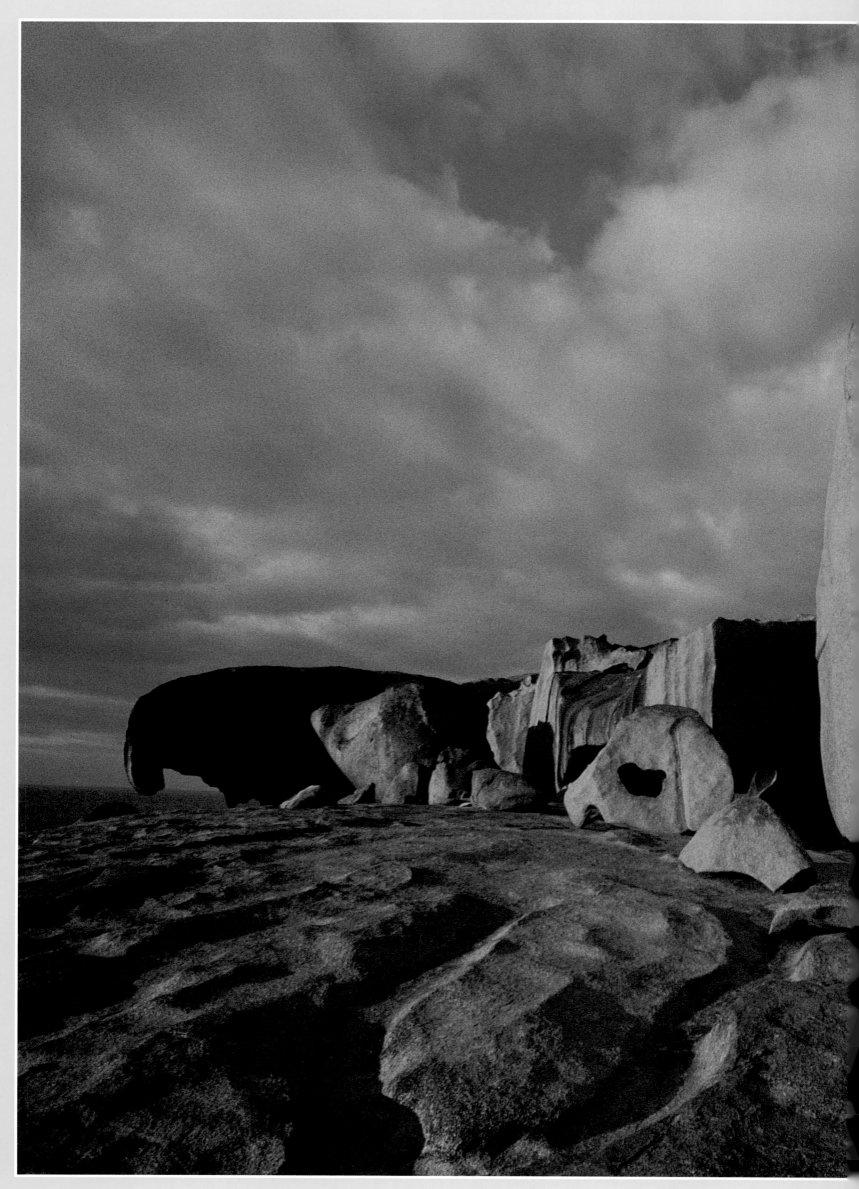

Kangaroo Island: Beauty and wildlife

Kangaroo Island, half an hour's flight from Adelaide (or catch the ferry from Cape Jervis to Penneshaw), is Australia's third-largest island and contains sixteen national and conservation parks. Sealers and whalers had worked the area for three decades before the first official British settlers landed in 1836. Today, the island's wildlife is a bonus added to scenic attractions.

✶

Above: The lighthouse at Cape de Couedic was built in 1906. A flying-fox was used to haul materials up the cliff from the sea to the site.
Below: At Seal Bay Conservation Park, several hundred Australian Sea-lions form a breeding colony.
Opposite: The Remarkable Rocks are large, angular, weathered granite blocks, standing on the granite dome of Kirkpatrick Point.

The Eyre Peninsula: Seafood and spectacular scenery

Port Lincoln, on the south-east of the tip of the Eyre Peninsula, is famous for its fishing fleet and seafood and is an ideal base for expeditions to view some very beautiful coastal country. Coffin Bay National Park, 50 kilometres east of Port Lincoln, offers dunes, headlands and lovely bays, as well as plenty of wildlife. Kellidie Bay Conservation Park is an extension of Coffin Bay National Park. Lincoln National Park, with its coastline of precipitous cliffs, is only 25 kilometres south of Port Lincoln.

---✺---

Above: Coffin Bay National Park, on the southern extremity of the Eyre Peninsula.
Opposite: Cape Carnot lies southwest of Port Lincoln.

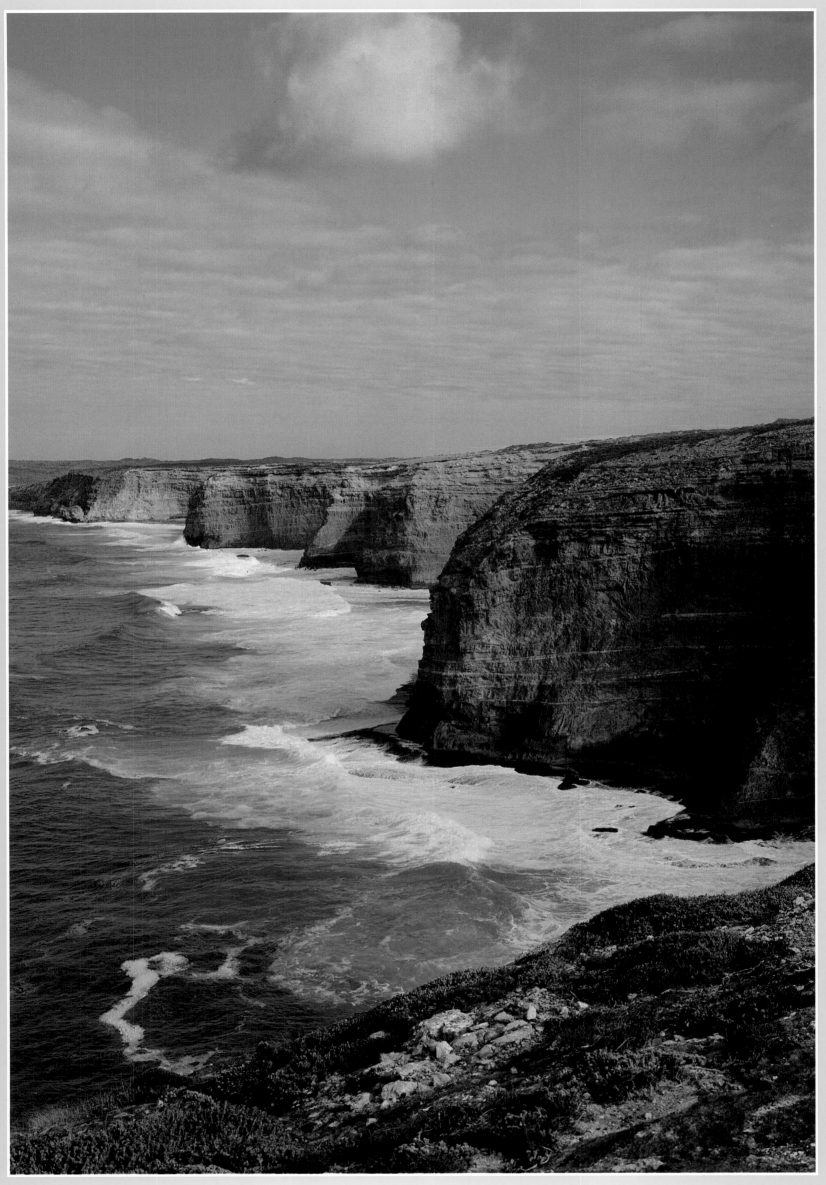

WESTERN AUSTRALIA

THE WILDFLOWER STATE

The twin cities of Perth, capital of Western Australia and historic Fremantle, its port, are linked by the Swan River, which meanders from the Darling scarp, then flows under the Causeway and widens into Perth Water. The river squeezes itself under the Narrows Bridge, is joined by the Canning River, spreads out into Melville Water and finally reaches the sea between the man-made North and South Moles at Fremantle.

The banks of the Swan are lined with gracious homes, sailboat clubs and parks where many come to picnic and play in, or beside, the water. Those who do not care for these delights can drive to the Indian Ocean, which offers a smorgasbord of easily-accessible beaches.

To discover vast Western Australia, begin the journey in June, in the far northern Kimberley region. Here are fantastic ranges, craggy gorges and wide golden plains scattered with Boab trees and termite mounds. July could be spent in the scenic Pilbara and at Ningaloo National Park and exploring Shark Bay, with its friendly dolphins. Then move south in August, to sample seafood and the easy life in Carnarvon and Geraldton, then visit Kalbarri and Nambung National Parks and see the coastal heaths ablaze with wildflowers.

September and October should be spent in the southwest, sampling the wines of the Swan Valley, exploring Perth and Fremantle, then touring south past Bunbury and Busselton to Cape Naturaliste and Cape Leeuwin. Then, as the weather warms and the wildflowers spread their glory into cooler places, move to the south coast and its wonderful National Parks - the Stirling Ranges, Fitzgerald River, Cape Le Grand and Cape Arid. (You can save the fascinating Goldfields for next winter.)

It's Australia's largest State and if you've never been there, start planning a visit now!

★

Below: The Black Swan, seen here with cygnets, is the faunal emblem of the State of Western Australia.
Opposite: The Pinnacles are limestone pillars rising from the coastal sands of Nambung National Park.

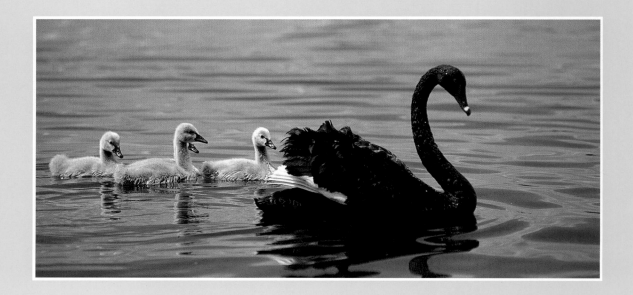

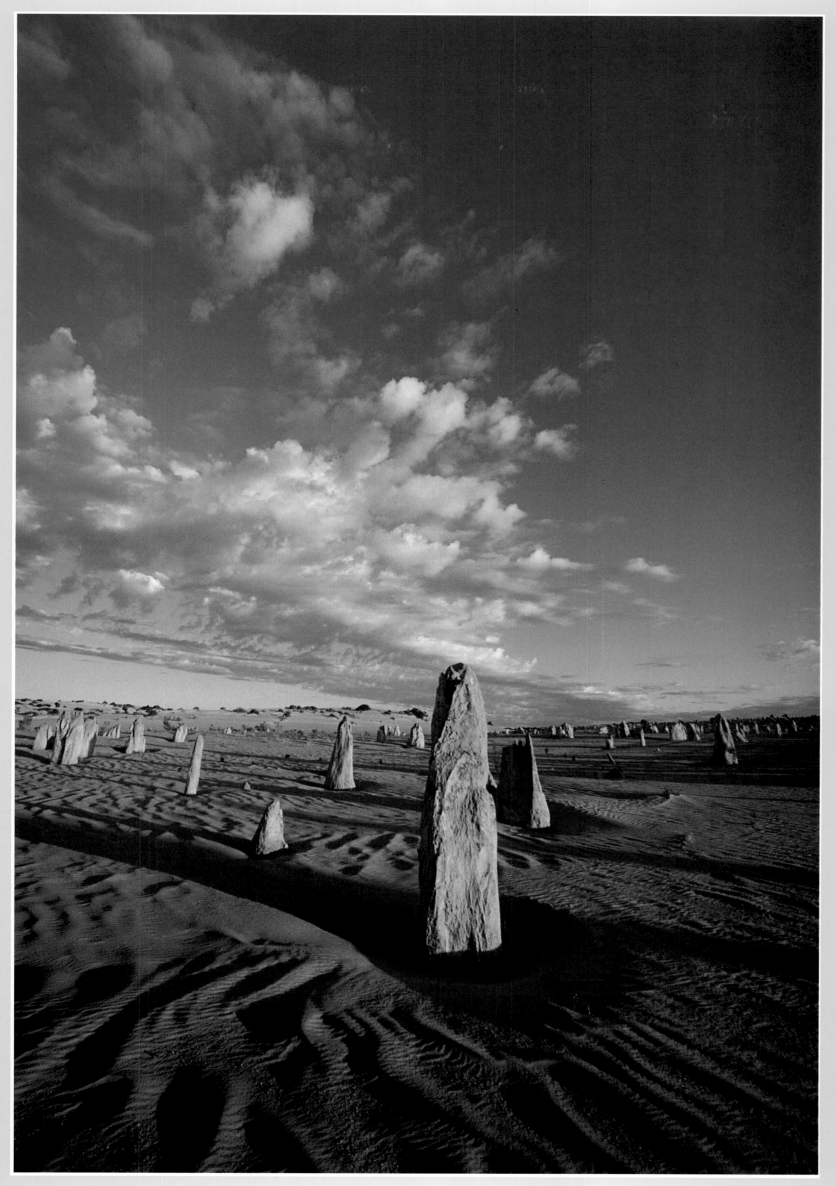

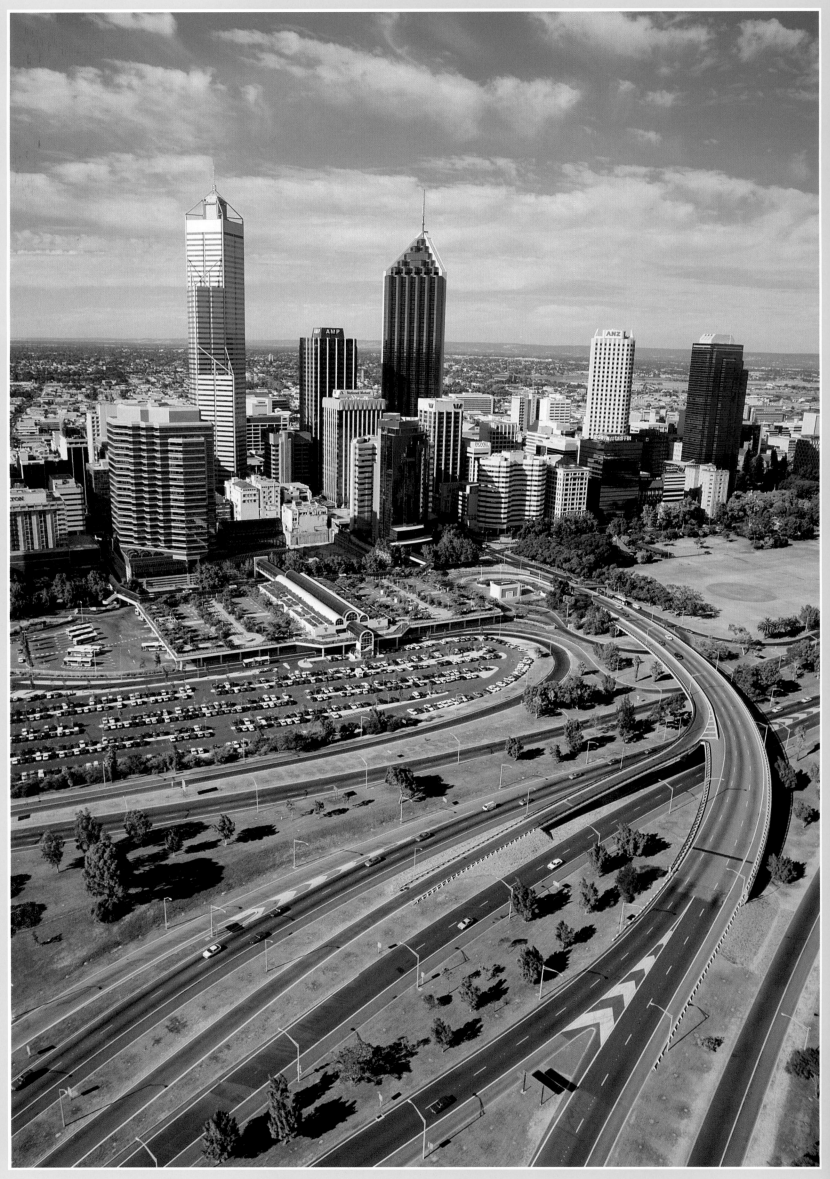

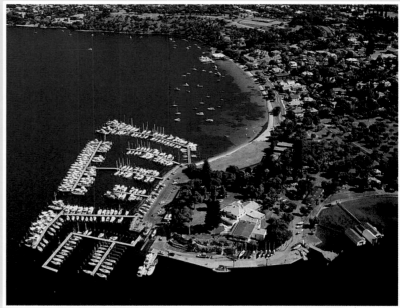

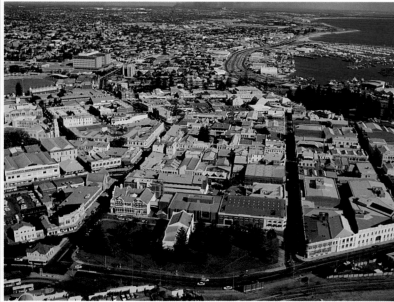

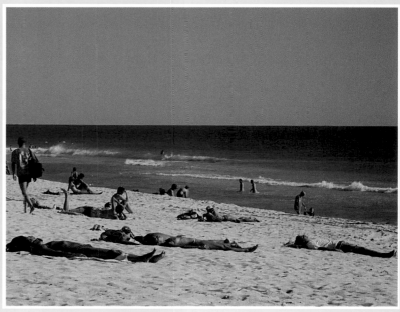

Above left: Weekend barbecue in the parklands bordering the Swan River.
Above right: A number of yacht clubs provide excellent facilities on the Swan River.
Below left: An aerial view of Fremantle shows Elder Place in foreground, Fremantle oval top left,
and the Fishing Boat Harbour and Success Harbour top right.
Below right: Sunworshippers on one of Perth's magnificent beaches.
Opposite: An aerial view across Perth city from Northbridge towards the Darling Range.
Following pages: A night view of Perth from Kings Park.

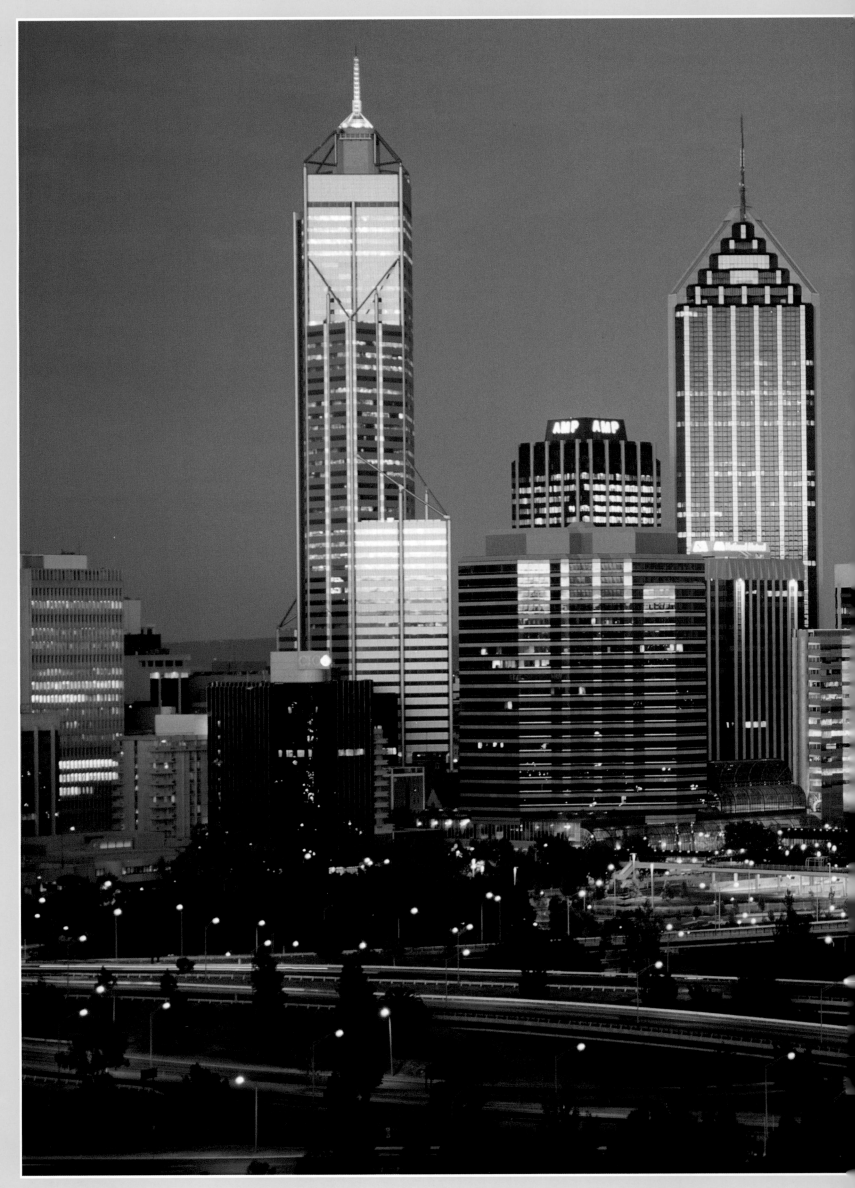

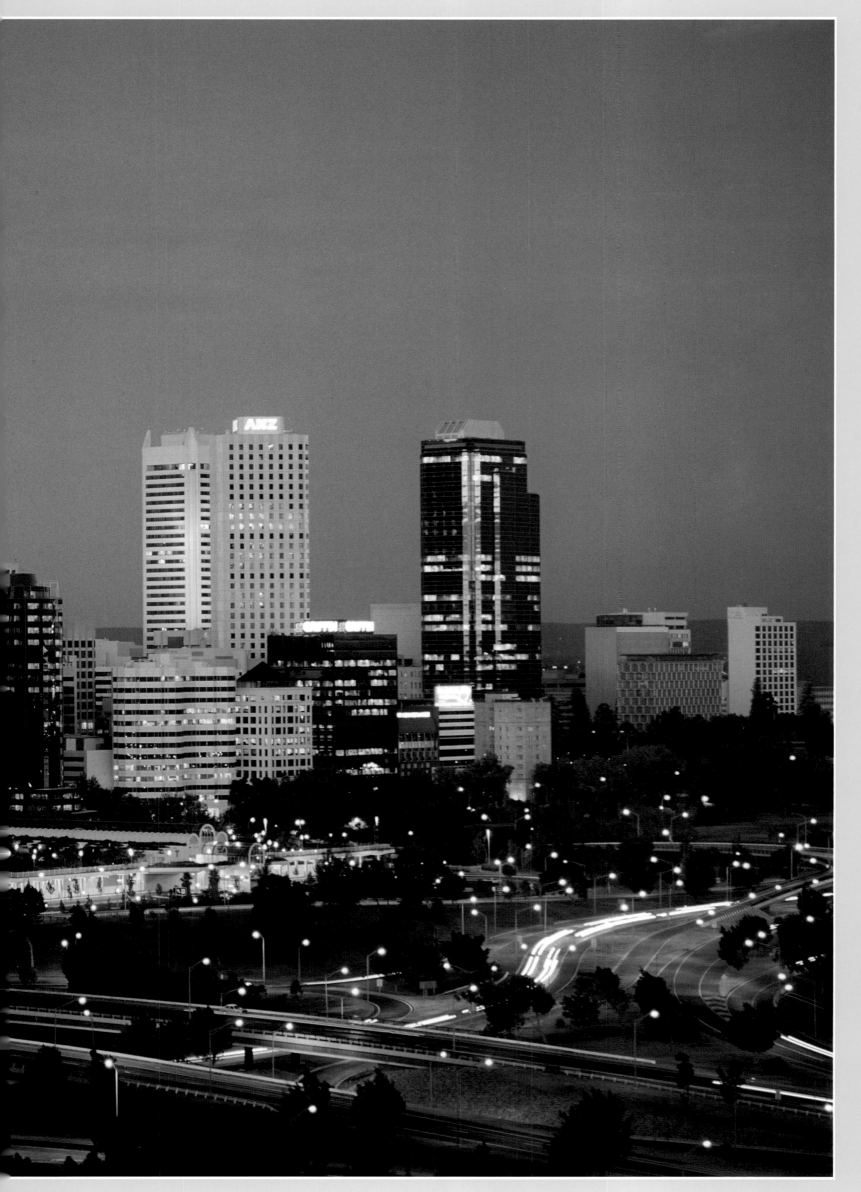

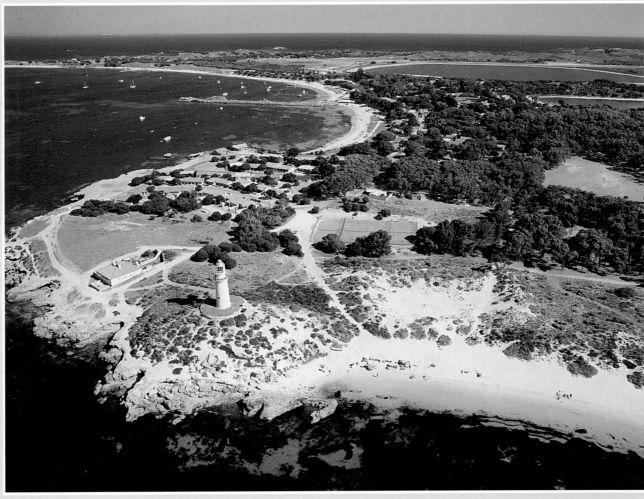

Above: The limestone headlands of Rottnest Island shelter wonderful clearwater coves.
Below: Thomson Bay settlement viewed over the Rottnest Lighthouse and (right) Pinky Beach.

Rottnest Island: Where Quokkas roam free

Rottnest Island is 20 kilometres northwest of Fremantle. It is eleven kilometres by five, with a coastline full of delightful bays and beaches. Sensible development has kept much of the island's charm unspoiled - no private cars are allowed - and Dutch Captain Willem de Vlamingh's 1696 description of Rottnest as "terrestrial paradise" seems still suitable three centuries later. Vlamingh thought the little hopping animals he saw on the island were rats (hence the name "rats' nest"). They are Quokkas, marsupials related to wallabies, which today amicably share their island with delighted holidaymakers.

---✦---

Above: The Quokka, a small marsupial related to the wallabies, is very common on Rottnest but not often seen on the mainland.

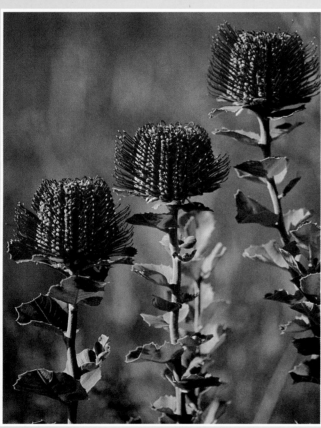

Floral beauty

The flora of Western Australia is world-renowned amongst botanists because of the large number of unique plant species included. To non-scientists, the West's wildflowers are simply staggering in variety of shape and colour.

★

Above left and clockwise: Yellow Buttercup; Fringed Lily; Morning Iris; Scarlet Banksia.

The flowering Southwest

The sandplains and heaths on both sides of Australia support a great variety of flowering plants. In Western Australia, these areas extend from Perth north almost to Shark Bay and along the South Coast as far east as Cape Arid.

✳

Above left and clockwise: Mangles Kangaroo Paw; Orange Banksia; Baxter's Kunzea; Everlasting Daisies.

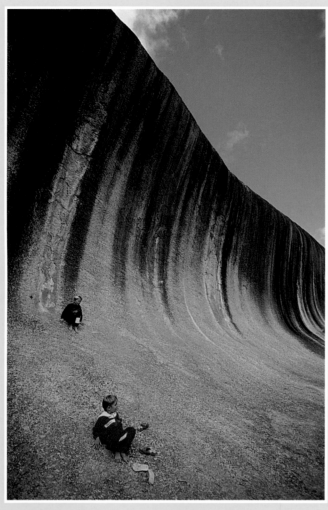
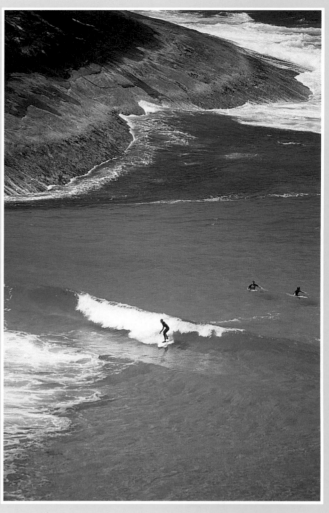

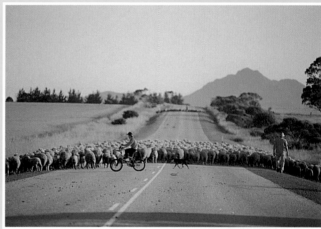

The Southwest: Fertile and friendly

Southwest Western Australia has some of the continent's
greenest pastures, mightiest trees and most dramatic coastline.
Albany, the first town established in the State, is one of many
centres for farming and pastoral activities, and stands near
some of Australia's most dramatic coastal scenery.

Above left and right: Wave Rock, near Hyden, is a spectacular granite formation; surfer near Albany.
Below left and right: The towered Albany Post Office; herding sheep is a family activity on this southwest farm.

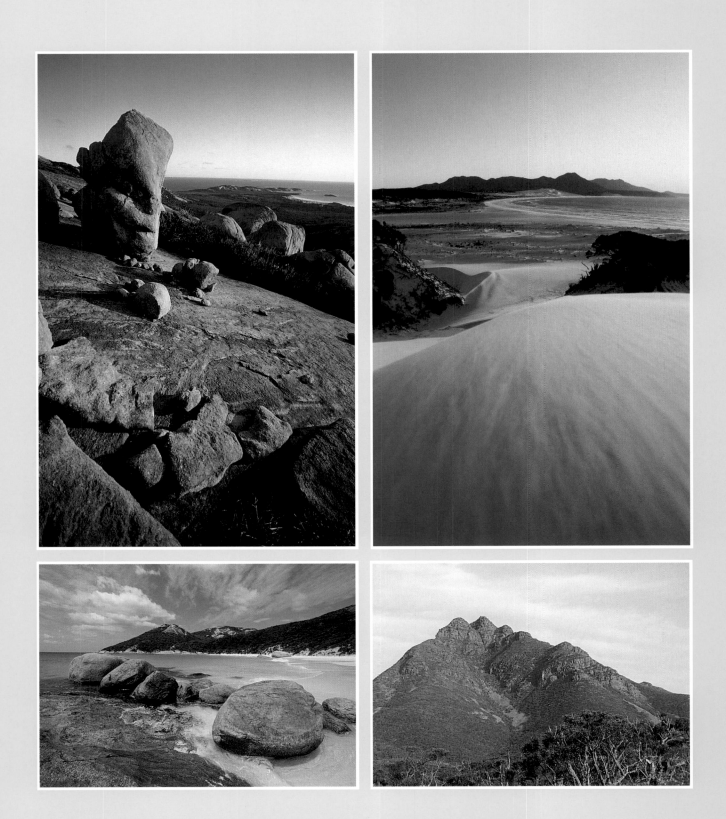

Southwestern wilderness: Nature's kingdom

The coasts of southwest and southern Western Australia
deserve a leisurely visit if the traveller is to appreciate the full
beauty of wave-pounded, rocky headlands and beautiful bays
and beaches. Inland, are tall forests and bird-rich heathland,
which is ablaze with wildflowers in Spring.

✦

Above left and right: Granite boulders are typical of the southern coast of Western Australia; Fitzgerald River National Park.
Below left and right: Two Peoples Bay near Albany; the Stirling Ranges, famous for wildflowers, consist of rounded, gravelly mountains.

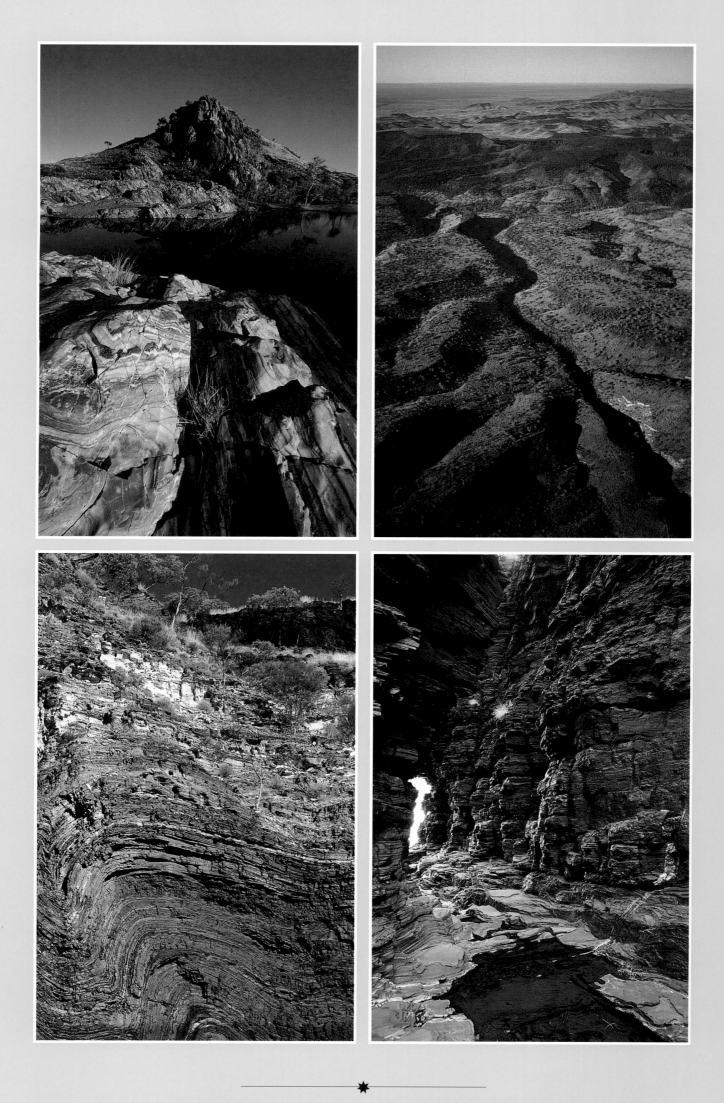

Above left and right: The jasper outcrop which gives the nearby town of Marble Bar its name; the Hamersley Range.
Below left and right: Ancient folded rock strata are characteristic of the Pilbara; Weano Gorge, in the Hamersley Range.

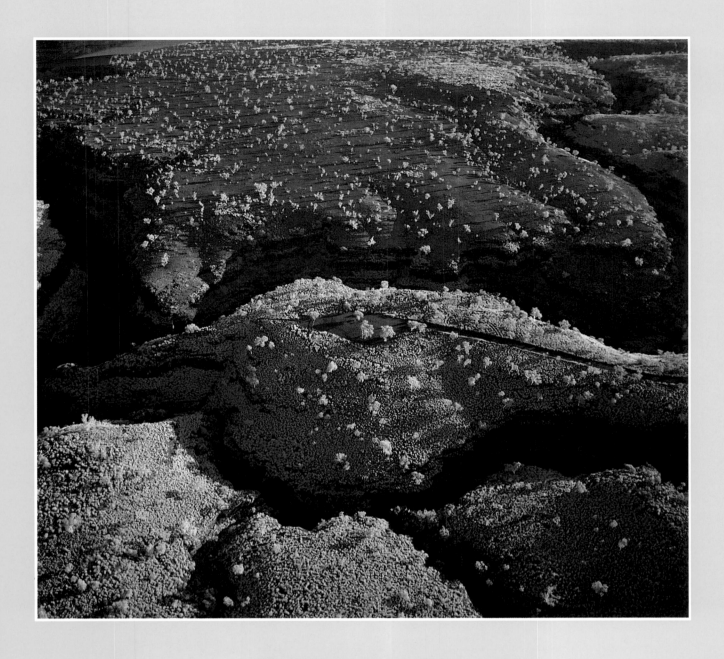

The Pilbara: An iron land

The ancient rocks of the Pilbara originated more than 2,500 million years ago as sediments of iron and silica deposited on the floor of an ancient ocean. Today, the massive iron ore deposits of the area generate mining, whose support towns form handy bases for exploring the area. In the Pilbara, red, eroded ranges are dotted with spinifex grasses and pale-trunked eucalypts, while coolibahs and cajeputs grow along dry watercourses. The Hamersley Range National Park, also known as Karijini National Park, covers 600,000 hectares and offers spectacular ranges, whose deep gorges conceal pools which attract birds and other wildlife.

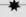

Above: The ancient rock mass which forms the northwest corner of Australia was long ago lifted high above sea level, folded and buckled, then dissected into deep gorges by rivers and eroded by eons of weathering.

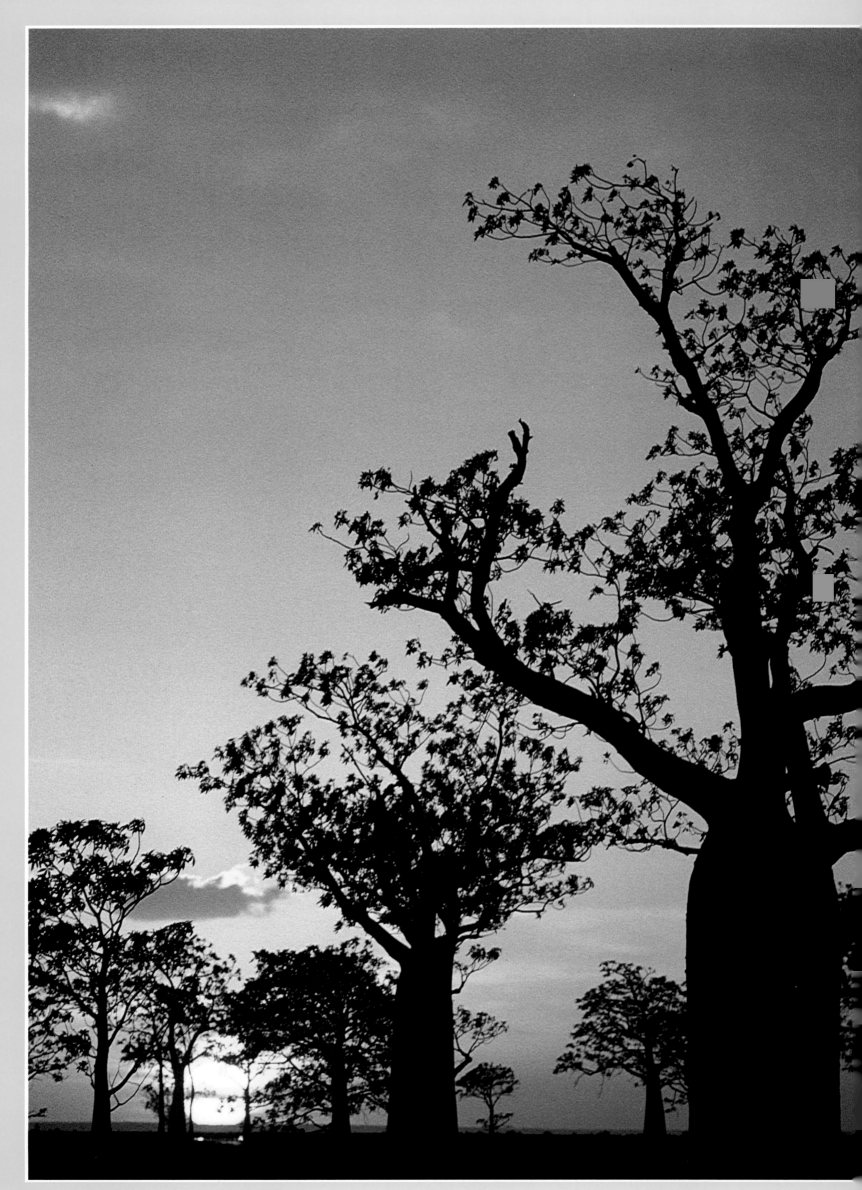

The Kimberley: Cattle country

Between 1883 and 1886, cattle were driven overland to the Kimberley from the Eastern States. Today, in many areas of the Kimberley, mobs of station cattle still roam unimpeded by fences. Sometimes as feral as the donkeys and pigs which co-exist in the area, they are mustered in the Dry season by stockmen whose skills equal any attributed to the legendary cowboys of the Old West. A ringer can stay on anything with a mane and tail, but today the thunder of hooves may be accompanied by the chatter of helicopter blades where beasts have to be retrieved from particularly tough country.

---✶---

Left: The Boab tree grows on sandy plains, on stony hillsides and beside creeks and billabongs in the west and east of the Kimberley.
Above and below: Today's stockmen still begin work before dawn and finish after sunset.

111

Above: A rugged Kimberley landscape.
Below: Prince Regent River National Park, one of the world's
remaining wilderness areas.

Above: Purnululu (Bungle Bungle) National Park was established in 1987.
The domes rise to 300 metres above the plain and are made of easily-eroded sandstone.
Below: The Fitzroy River flows for over 600 kilometres from the Durack Range to King Sound near the town of Derby.

NORTHERN TERRITORY

AUSTRALIA'S TOP END

Port Darwin was named after naturalist Charles Darwin in 1839. The town of Palmerston was established there in 1869; its name was officially changed to Darwin by the Federal Government in 1911.

The bombing of Darwin during World War Two and the destruction caused by Cyclone Tracy in 1974 left their impact, in military relics and memorials, and a rebuilt, cyclone-resistant city. Today's Darwin, which is geographically closer to Asia than to other Australian capitals, is a multicultural modern city. A sojourn in Darwin should include a tour of the excellent Museum of Arts and Sciences and the East Point War Museum. Other attractions include the magnificent Botanic Gardens, Darwin Mall, the Diamond Beach Casino and the markets at Mindil Beach. Within an easy drive from the city are Howard Springs Nature Reserve, bird-rich Fogg Dam Conservation Reserve, the South Alligator River with its famous Saltwater Crocodiles and the excellent Territory Wildlife Park.

The Top End in the summer monsoon season can be hot and very wet, but there are good all-weather roads from Darwin to Litchfield National Park, with its wonderful waterfalls, and to Kakadu National Park, where rain falling on the stone escarpment floods the coastal wetlands. In the Wet, some attractions are almost inaccessible. However, the surging vitality of the Top End at this time is memorable. In the Dry season, it is possible to penetrate the country more deeply, see birds and other wildlife concentrated on billabongs and waterways and travel in comfort in the pleasant winter sunshine. A visit to Katherine Gorge (Nitmiluk National Park), three hours' drive from Darwin along the Stuart Highway, will give one last memorable experience of calm waters reflecting towering sandstone cliffs, before travelling southwards towards the Red Centre.

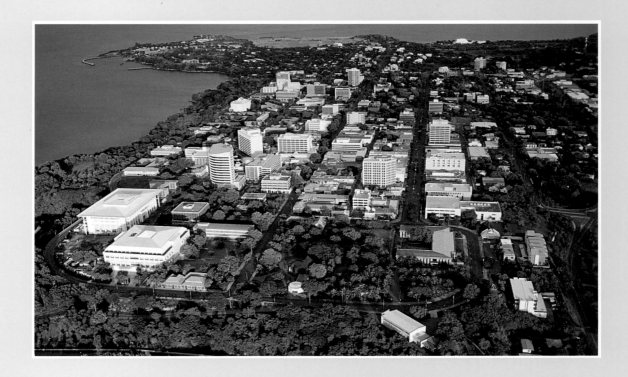

Above: Black citizens and white citizens of the Territory have much to learn from each other.
Opposite: An aerial view of Darwin city.

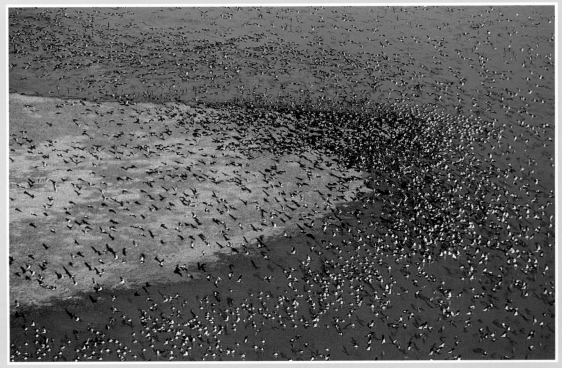

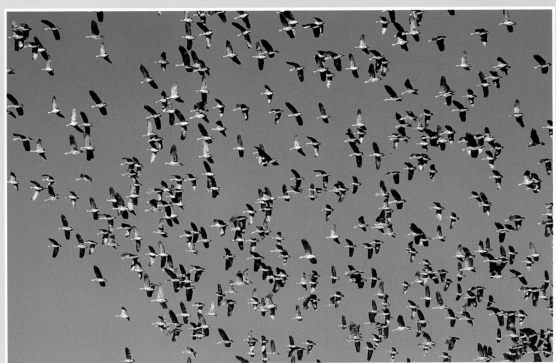

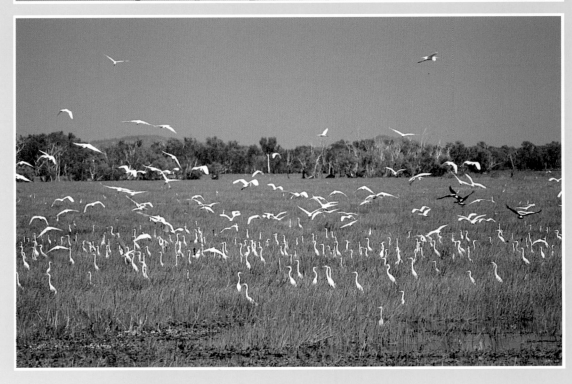

Top End wetlands: Birdwatchers' paradise

During the Dry season, waterbirds congregate around rivercourses and billabongs across the Top End and are easily viewed. As the floodplains fill after the Wet breaks, the birds spread out to feed and to nest. Access for birdwatchers is more difficult, but the insights into breeding behaviour to be gained are fascinating.

---------------------------------✱---------------------------------

Above: Birdwatchers on Yellow Water, Kakadu National Park.
Below: Kakadu wetlands provide ideal breeding grounds for waterbirds, crocodiles, fish, frogs and insects.
Opposite top to bottom: Magpie Geese; Whistling-ducks; Egrets.

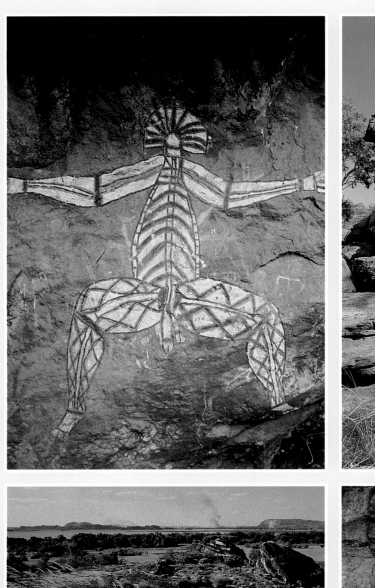

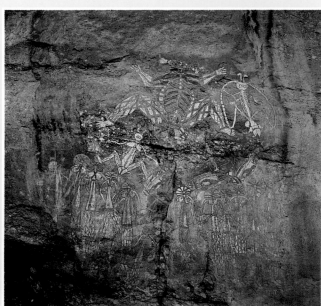

Kakadu: Ramparts of stone

The sandstone escarpment that forms the edge of the ancient
Arnhem Land Plateau stretches for 600 kilometres across the
Top End. Massive outliers isolated by erosion from the plateau
stand on the plain, refuges for wallabies and rock-loving birds.
Aboriginal art in caves and overhangs of the "stone country"
provides a record dating back tens of thousands of years. In
the Wet season, rain falls in torrents on the escarpment, drops
over the edge in spectacular waterfalls, then floods into the
rivers and wetlands of the coastal plains below.

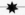

Above left and right: Aboriginal art at Nourlangie Rock, Kakadu National Park; Ubirr, Kakadu National Park.
Below left and right: Stone country, Ubirr, Kakadu National Park; Aboriginal art is common in caves and overhangs in Kakadu.
Opposite: Twin Falls, seen here in the Wet season, is a spectacular feature of Kakadu National Park.

THE RED CENTRE

AUSTRALIA'S LIVING HEART

The most remote area of Australia, right in the centre of this enormous continent, is also the easiest for which to map out a sightseeing itinerary. Fly or drive south from Darwin, north from Adelaide or west from Brisbane to Alice Springs, then set out on the grand tour of the famous sights of The Centre.

This desert country is safe for those who obey the rules. Either travel with a reputable public carrier, or make sure your vehicle is in good order, carry water and stay on main roads.

Near to Alice are the MacDonnell Ranges, with their gaps and gorges: Ormiston Gorge and Pound, N'Dhala Gorge and Trephina Gorge. Further afield are Finke Gorge National Park, with its primeval Palm Valley, the fantastic red gorge of Watarrka (Kings Canyon) and statuesque, solitary Itirkawara (Chambers Pillar).

The Lasseter Highway will lead to Australia's best-known monuments, magnificent Uluru (Ayers Rock) and many-headed Kata Tjuta (the Olgas). Uluru rises 348 metres above the plain and is the eroded top of an enormous underground sandstone mountain. Kata Tjuta is a group of smooth domes. Like other less massive formations in this light-haunted country, they change colours as the sun crosses the sky and afford striking views at sunrise and sunset.

Apart from sun-resistant birds and insects, wildlife in these regions can be elusive unless the watcher is prepared to walk at dawn or dusk. In these cooler hours, desert-wise animals forage, while those which need to drink come to water hidden in the clefts of the ranges.

★

Below: Alice Springs is located almost in the middle of Australia and is an ideal base from which to explore the MacDonnell Ranges and other scenic features of the Centre.
Opposite: Itirkawara (Chambers Pillar) is a sandstone remnant of a long-eroded range of hills.

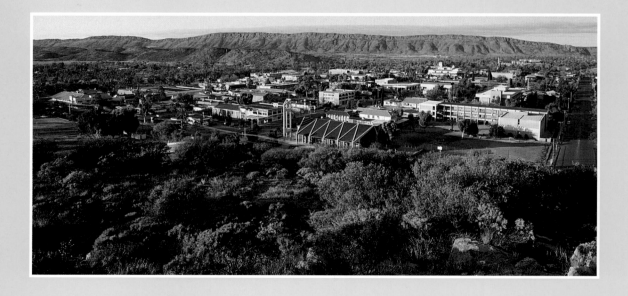

The Simpson Desert: A living heart

The plants of the Red Centre are well-adapted to long periods without rain. Their leaves are reduced in size, or covered with hairs or wax, to prevent excess water-loss; some, like saltbush and bluebush, can excrete the salt their roots draw from the soil. In a dry spell - which may last for years - the red sand and blue sky dominate the subdued silvery grey-greens and browns of the vegetation. After rain, hidden seeds sprout and shoot, and old stems put out new leaves. The desert plants blossom in a multitude of colours. This vegetable wealth, new-set seeds and multiplying insects provide a rich feast for birds and small mammals and for a brief time the desert is a garden of plenty.

✳

Above: The Simpson Desert after rain. Desert plants blossom after rain and set seed which will endure through the next dry spell.
Opposite: In the arid north-east of South Australia, desert plants grow where their roots reach water, but sand-dunes stand bare.

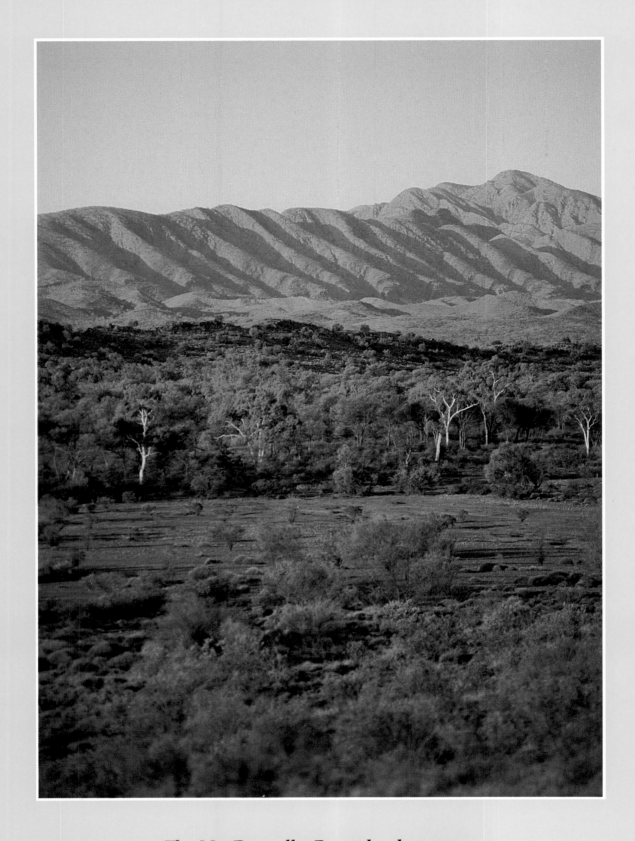

The MacDonnells: Rugged red ranges

The MacDonnell Ranges stretch in east-to-west ridges across
Central Australia. Ancient river systems once flowed north to
south across them, cutting great gorges through the hard
Heavitree Quartz which is a major constituent of the ranges.
Standley Chasm, Simpsons Gap, Ormiston Gorge, Haasts Bluff,
Trephina Gorge and Arltunga Historical Reserve are all places
to discover in the MacDonnells.

———————★———————

Above: The MacDonnell Ranges run in a series of ridges across the centre of Australia.
Opposite: Cool water in Ormiston Gorge and Pound National Park, in the Western MacDonnell Ranges.

Above: The Wild Horse Race at the annual Alice Springs Rodeo, a major Territory event.
Below: Moving a mob of cattle along on the Barkly Tablelands.
Opposite: A competitor in the Bending Race at the Alice Springs Rodeo.

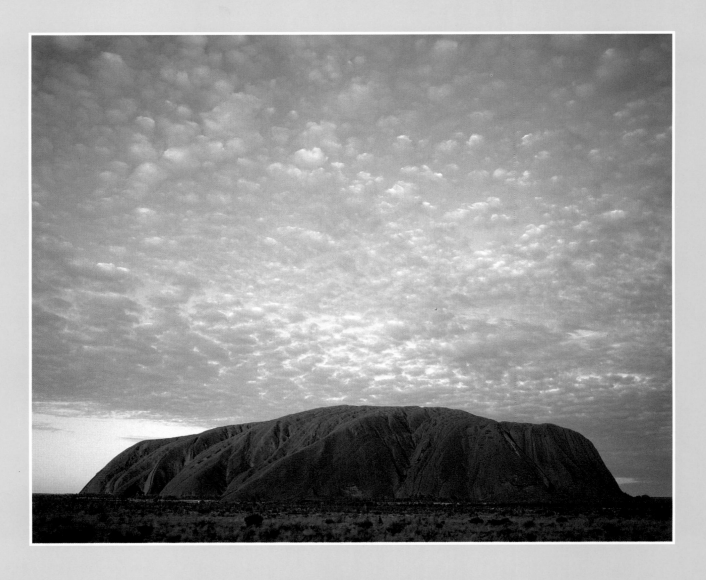

Uluru: The monolith

Uluru National Park is in the southwest corner of the Territory, 460 kilometres from Alice Springs. It is easy to make the pilgrimage by air, but many prefer to approach Uluru after crossing the vastness of the desert. If, during some cooler moment in the five hours' drive, they take the time to stop and explore a little on foot, they will discover that this arid land is home to fascinating plants and animals.

No photograph and no words can prepare the newcomer for the vastness and majesty of the Rock, or the effects of sunlight and shadow upon its surfaces. Two groups of Aboriginal people, the Yankunytjatjara and the Pitjantjatjara, belong to the area, which for them has special significance. Restrictions placed upon visitors by these traditional owners and by the Australian Nature Conservation Agency should be respected.

Above: Uluru the tip of a buried mountain.
Opposite top to bottom: Waiting to watch the sunset light on Uluru;
climbing Uluru; a guide interprets Uluru to visitors.

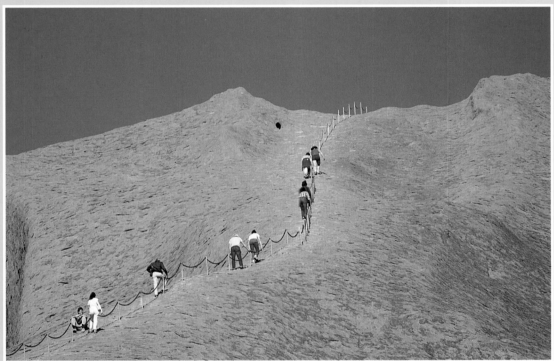

Kata Tjuta: "Memorials from ancient times"

Kata Tjuta is 32 kilometres from Uluru and Mount Olga, the highest of Kata Tjuta's many domes, rises 200 metres above the highest point of the Rock. There are more than 30 great dome-shaped boulders, covering an area of about 30 square kilometres in all. Between the individual domes are narrow ravines, many of which contain rock pools in their shaded depths.

Visitors to Kata Tjuta and Uluru can make their base at Yulara International Tourist Resort, a "low-impact oasis" built outside the boundary of Uluru National Park and opened in 1984.

Above: Kata Tjuta means "many heads".
Below: Kata Tjuta was described by Ernest Giles in 1872 as "rounded minarets, giant cupolas and monstrous domes ... memorials from the ancient times of earth".

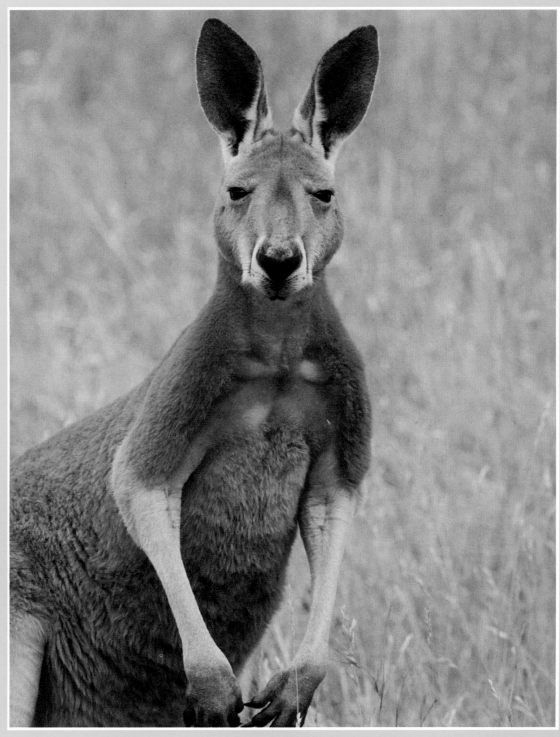

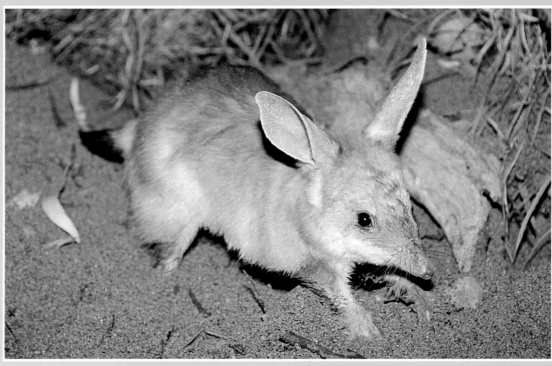

Above: In the Centre, the Red Kangaroo lives where native grasses and water are available.
Below: The Bilby is a rare bandicoot, which shelters from the daytime heat in a burrow.

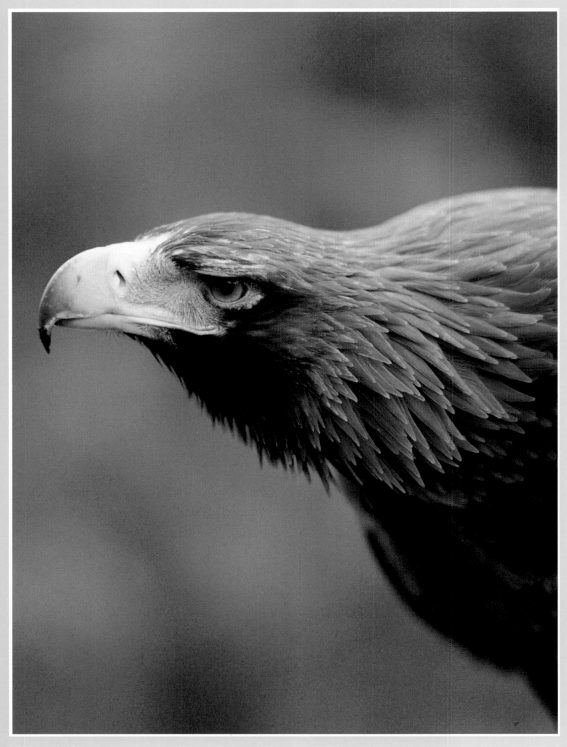

Above: The Wedgetailed Eagle soars high above the arid land It may be seen at closer quarters feeding on road kills.
Below: The Dingo, Australia's wild dog, does not bark but howls. It may hunt over a wide area, but needs access to water.

QUEENSLAND

THE SUNSHINE STATE

Queensland's capital city, Brisbane, is in the extreme south-east of a big State with many rich natural resources. There is plenty of room for a number of regional centres of population to flourish where Nature's semitropical and tropical gifts are especially bountiful.

Toowoomba, queen city of the fertile Darling Downs, is less than two hours' drive west from Brisbane, while, to the south and north of the capital, are the Gold Coast and the Sunshine Coast. Northwards lie coastal cities like Rockhampton, the beef capital of Australia, with its wonderful colonial homes, Townsville, the north's administrative centre with its world-famous marine research facilities, and Cairns, a tropical and cosmopolitan city which is the gateway to the Far North, especially for international visitors.

Take a long, leisurely journey of exploration, from the Gold Coast right up to the wilderness of Cape York. Explore the coastal rainforest, play in the Whitsunday Islands and enjoy the Great Barrier Reef. On the return trip, detour inland past magnificent outlying spurs of the Great Divide, through some of Australia's best grazing land and experience the Outback celebrated in the Stockman's Hall of Fame at Longreach.

Brisbane itself is Australia's friendliest city, where outdoor living has been elevated into an art form. Set on its lazy river, Brisbane can equal the sophistication of southern capitals, while adding its own laid-back lifestyle. South Bank and Riverside, the magnificent Performing Arts Complex, Queen Street Mall, theatres, shops, boutiques and wonderful restaurants - Brisbane offers these, plus tropical gardens and a garland of surrounding forests and national parks.

Below: Sailing in the Whitsunday Islands.
Opposite: Whitehaven Beach, Whitsunday Island.

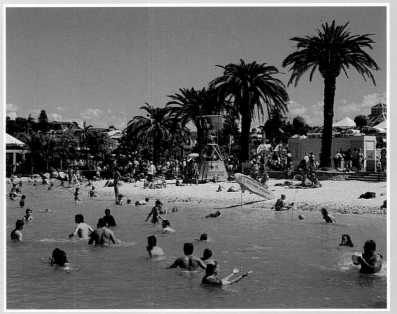

Brisbane: A sociable city

Since the 1988 World Expo showed the way, Brisbane has taken many giant leaps forward in the areas of hospitality and entertainment. South Bank now stands on the Expo site, near the State Library, the Art Gallery, Performing Arts Complex and Museum. The Brisbane River, slipping under its four great city bridges, bordered by jacaranda and poinciana trees, is a quiet background to these and many other city landmarks.

Brisbane was a penal settlement from 1824 until 1839. In the late nineteenth century it became a busy port, in the twentieth a centre of industry and commerce. As the twenty-first century dawns, Brisbane is a fast-growing, prosperous city. Homes in inner suburbs are highly prized and lovingly restored by their happy owners and the Brisbane lifestyle makes the most of southeast Queensland's warm, sunny climate.

✦

Above: South Bank stands beside the Brisbane River on the site of World Expo 88.
Below: Paddington, one of Brisbane's older suburbs.
Left: The lights of Brisbane, capital of Queensland, reflected in the Brisbane River.

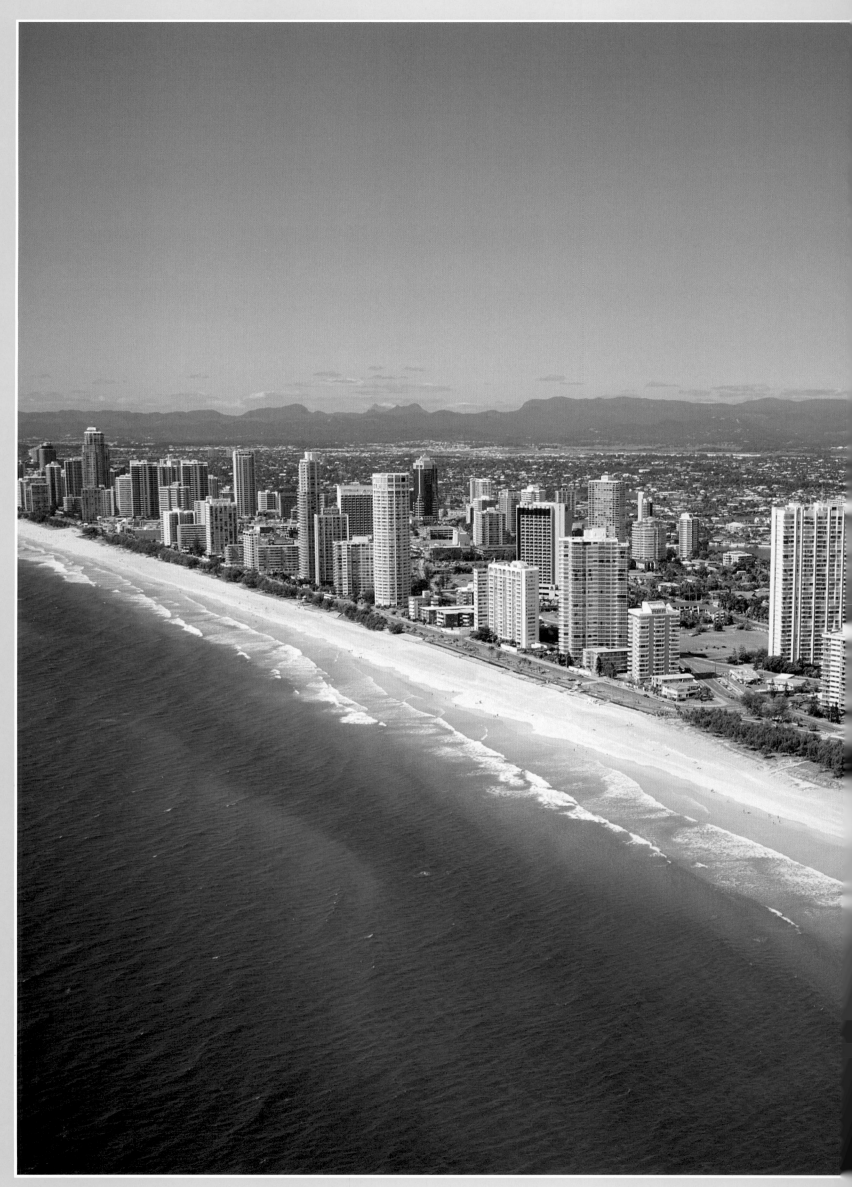

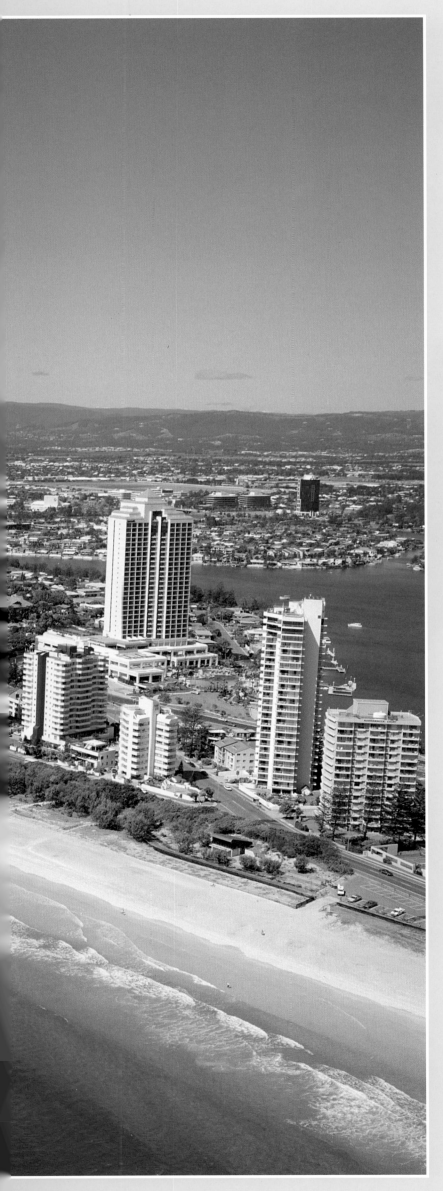

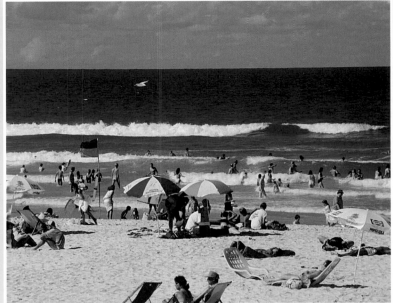

The Gold Coast: Sunblessed sands

The 43 kilometres of beach which form Queensland's Gold Coast bask in sunshine around three hundred days of each year. The Coast is cooled by the blue-green Pacific Ocean and can offer a lifestyle as simple or as worldly as the heart desires. Sea World and Warner Brothers Movie World attract many, while others prefer to browse in modern shopping centres, or just lie on the beach. At Currumbin Sanctuary, wild lorikeets come to be fed.

A short distance inland is a world of ancient rainforests, waterfalls and unique wildlife. The parks in and near the MacPherson Ranges, including Lamington, Mt Cougal, Springbrook and Mt Tamborine, are full of wild places of heart-stopping beauty, whose cool green shade contrasts with and complements the golden, sun-warmed beaches of the Coast.

★

Above: Warm sun, cool sand, blue sky and sparkling sea are everlasting attractions at the Gold Coast.
Below: The surf is up, the sun is shining - who could ask for more?
Left: The highrise buildings of Surfers Paradise stand between the Pacific Ocean and the Nerang River.

The Sunshine Coast: A secret shared

Until recent years, the Sunshine Coast just north of Brisbane was less well-known than its southern rival and those who prized its peace and magnificent beaches were not unhappy to have it so. Today, the secret is out. The attractions of the area, which include the coastal holiday towns of Caloundra, Noosa and Maroochydore, scenic Bribie Island and Coolum Beach, and extends northwards to the magnificent Cooloola National Park, are widely appreciated.

The hinterland encompasses fertile farmlands and dramatic mountain scenery, including the volcanic remnants which, in 1770, Captain James Cook named the Glasshouse Mountains. National Parks to be explored here offer forested ranges and also coastal plains typical of the original heathland of the area, rich in flowering plants and in birds and mammals.

———————————— ✦ ————————————

Above: The Glasshouse Mountains, just north of Brisbane, were once volcanic vents.
Opposite: At anchor in Pumicestone Passage, between Bribie Island and mainland Queensland.

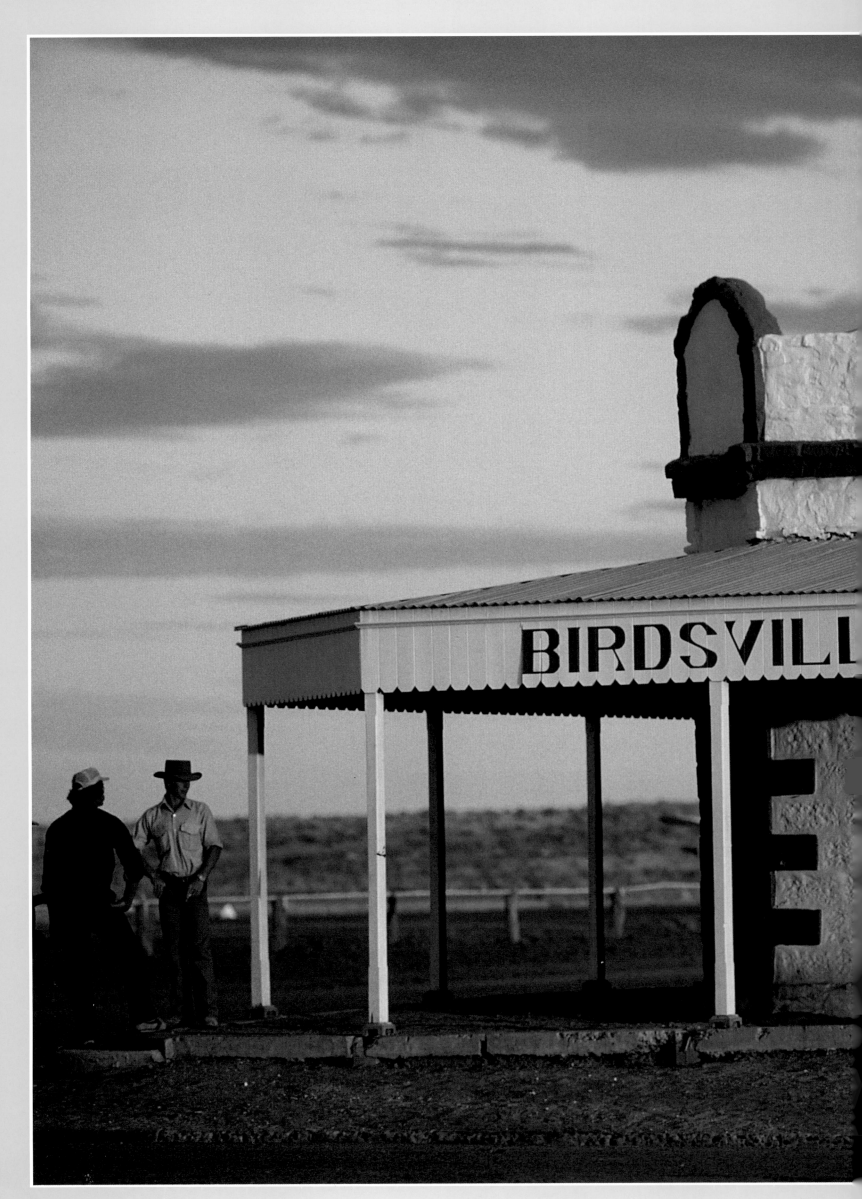

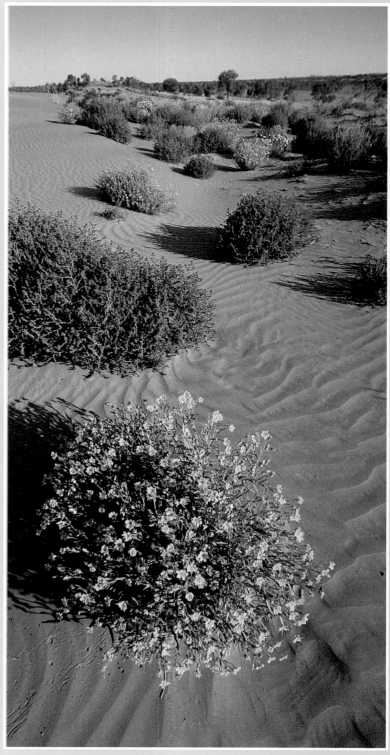

The Birdsville Hotel: The loneliest pub

Birdsville, at the northern end of the Birdsville Track, has been a famous watering-place on the Queensland-South Australia stock route since the 1870s. The town stands in Queensland, just north of the South Australian border and just west of the red sand-dunes of the Simpson Desert.

In August-September each year, the famous Birdsville Hotel serves up to 5,000 people during the Birdsville Races, which were first held in 1882. Today, funds from this popular event go to the Royal Flying Doctor Service.

★

Left: The Birdsville Hotel is an oasis in the arid Outback.
Above: After rain falls, flowers decorate the dunes of the Simpson Desert.

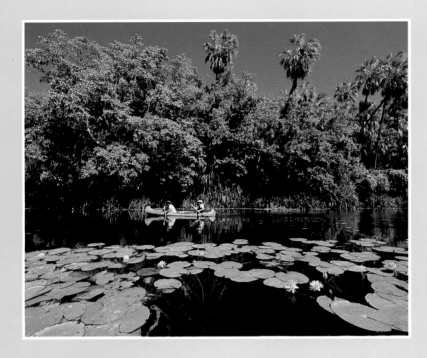

Lawn Hill: A jewel in Queensland's crown

Lawn Hill National Park is near the Queensland-Northern Territory border and can be reached by driving south of Burketown and taking the track west from Gregory Downs bush pub. The Park was opened in 1985 and covers 12,000 hectares.

That much can be learned from the map. What cannot be conveyed by any map is the surprise and delight the traveller feels after crossing the arid plains to find Lawn Hill's sandstone gorge, with walls up to 70 metres in height. Its cool, clear creeks and waterfalls are surrounded by lush tropical vegetation, including pandanus, figs, cajeputs and Livistona palms. No wonder it is known as "the jewel in the crown of Queensland's National Parks".

✳

Above: Canoeing through paradise - in Lawn Hill Gorge.
Right: Lawn Hill Gorge.

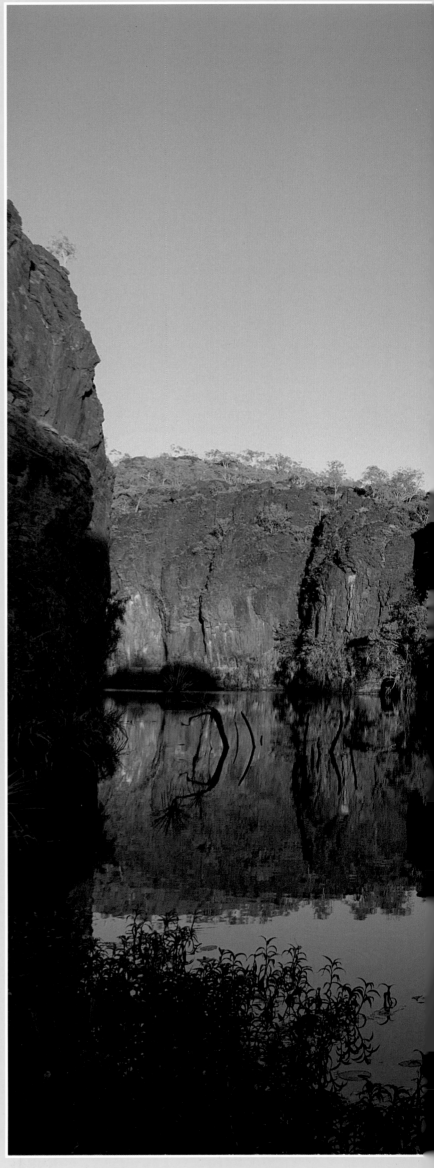

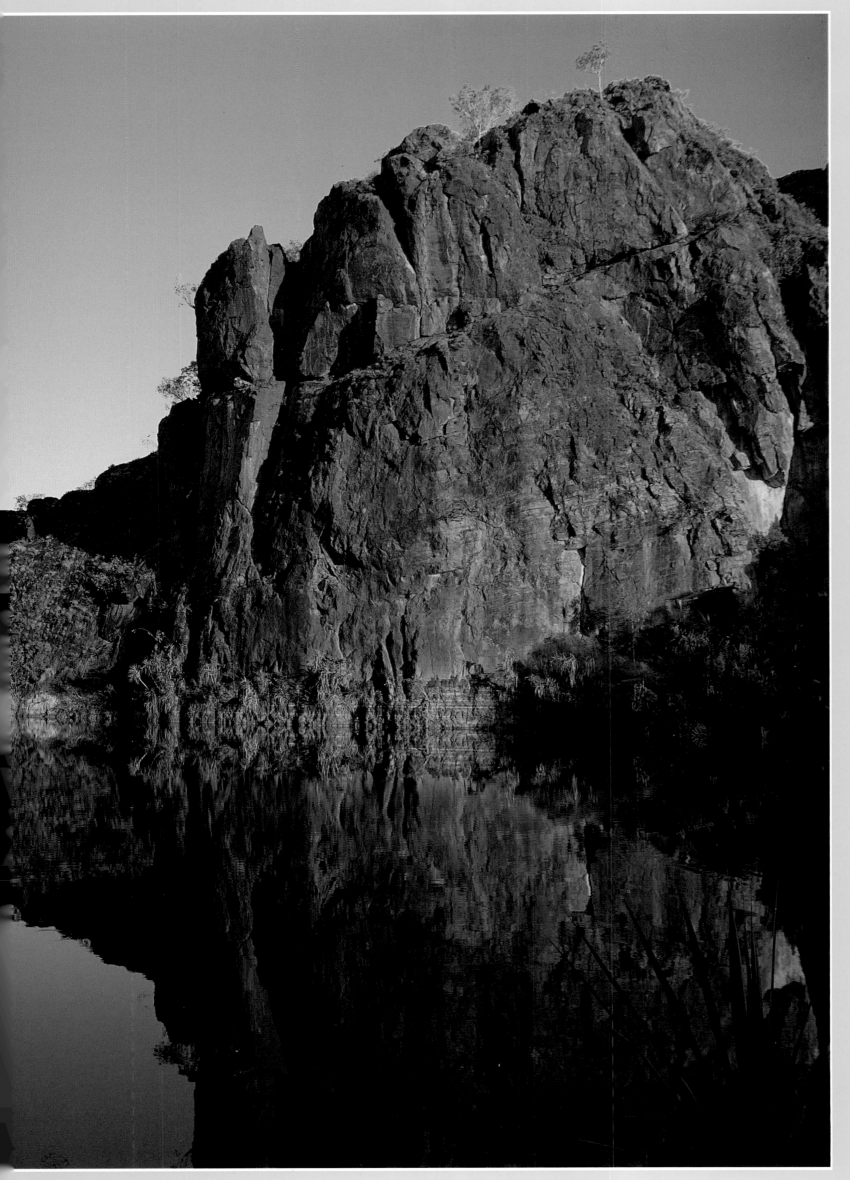

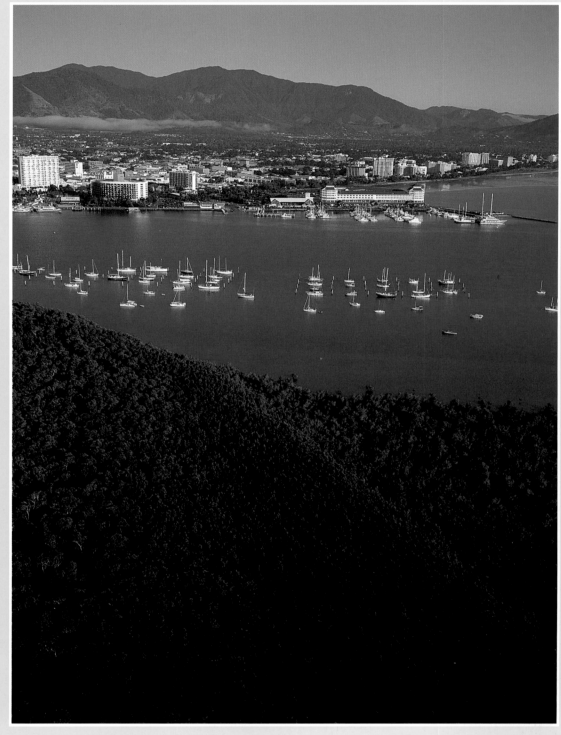

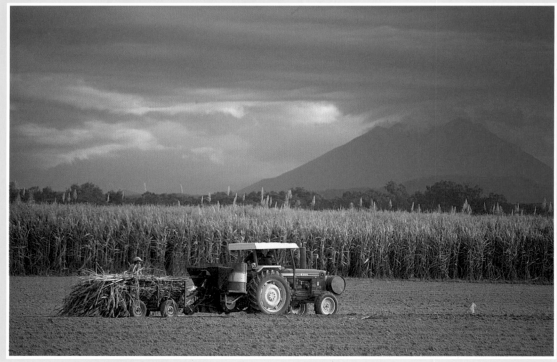

What is a Queenslander?

The term "Queenslander" may mean a person or a style of architecture. The typical wooden "Queenslander" stands on stilts, which provides extra living space below the house, has wide verandahs, high ceilings and a steep iron roof, which quickly sheds tropical downpours and allows possums to occupy their own attic space. All is directed to providing shade and to allowing air to circulate freely. The "Queenslander" is usually surrounded by a garden of lush tropical vegetation.

A journey north through coastal towns will provide a visual feast of "Queenslanders" and will provide views of other Queenslanders at their daily occupations, one of the most picturesque of which is cane-farming. Other Queenslanders up here run cattle, go fishing, extract minerals or, increasingly, are involved in welcoming visitors to the exciting tropical North.

★

Above and below: Cooktown's architecture is a blend of the practical and the elegant. The funds for the latter can often be traced to the gold rushes of the 1870s. This Rockhampton "Queenslander" stands on stilts, has wide verandahs and breezeways.
Opposite above and below: Cairns, chief city of tropical Northern Queensland; sugar cane is a staple crop in Queensland's coastal north.

Toowoomba: A flowering city

Toowoomba stands on the edge of the Great Divide and the highway from Brisbane winds steeply up "the Range" before emerging into a town of gracious gardens and pleasant parks. This centre for the prosperous Darling Downs holds four annual celebrations: Green Week is in April, Gardenfest in May, the Carnival of Flowers and Farmfest in September. The area's first European settlers were pastoralists, but by the early twentieth century the success of mixed farming in the area brought grain silos, butter, cheese and bacon factories to the towns of the Darling Downs.

★

Above: Sunset over Toowoomba, the major centre of the fertile Darling Downs.

Queensland's Outback: "G'day mate!"

Outback Queensland boasts multitudes of sheep and cattle and
some of the friendliest, most hospitable humans on the face of
the earth. Winton, Longreach, Blackall, Barcaldine - these are
towns where someone is always ready to stop and yarn about
floods, fires, droughts, mouse and grasshopper plagues and the
good times which went between all the disasters. This is the
home of Qantas Airlines and the Australian Labor Party and of
a dream which became ironclad reality, the Stockman's Hall of
Fame, which owes its origins to the vision of the legendary
RM Williams and the noted bush artist Hugh Sawrey.

★

Above: The Stockman's Hall of Fame in Longreach is a monument to the people of Australia's Outback.

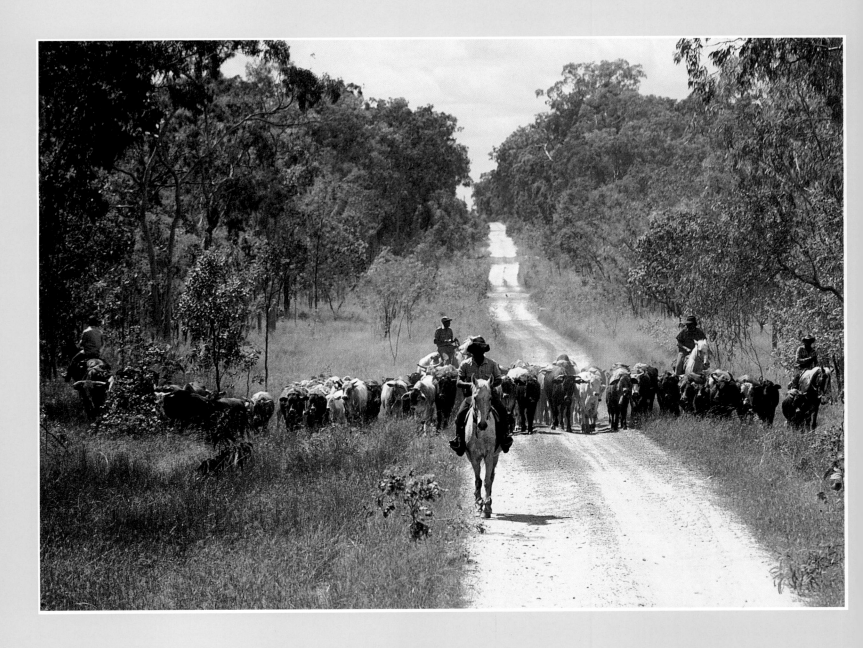

Overland!

There are plenty of stories associated with Queensland's cattle country. In 1870, Harry Redford (Captain Starlight) and four mates "acquired" around 1,000 beasts at Longreach and drove them nearly 2,500 kilometres over uncharted country to South Australia. The cattle were sold, but Redford was arrested, sent back to Queensland and tried at Roma. The jury, quite properly admiring his feat, returned a verdict of Not Guilty and Rolf Boldrewood immortalised the tale in *Robbery Under Arms*.

✷

Above: Cattle of tropical breeds have proved ideal for the warmer parts of Queensland.
Opposite: Youngsters grow up fast in the remote areas of the Outback.

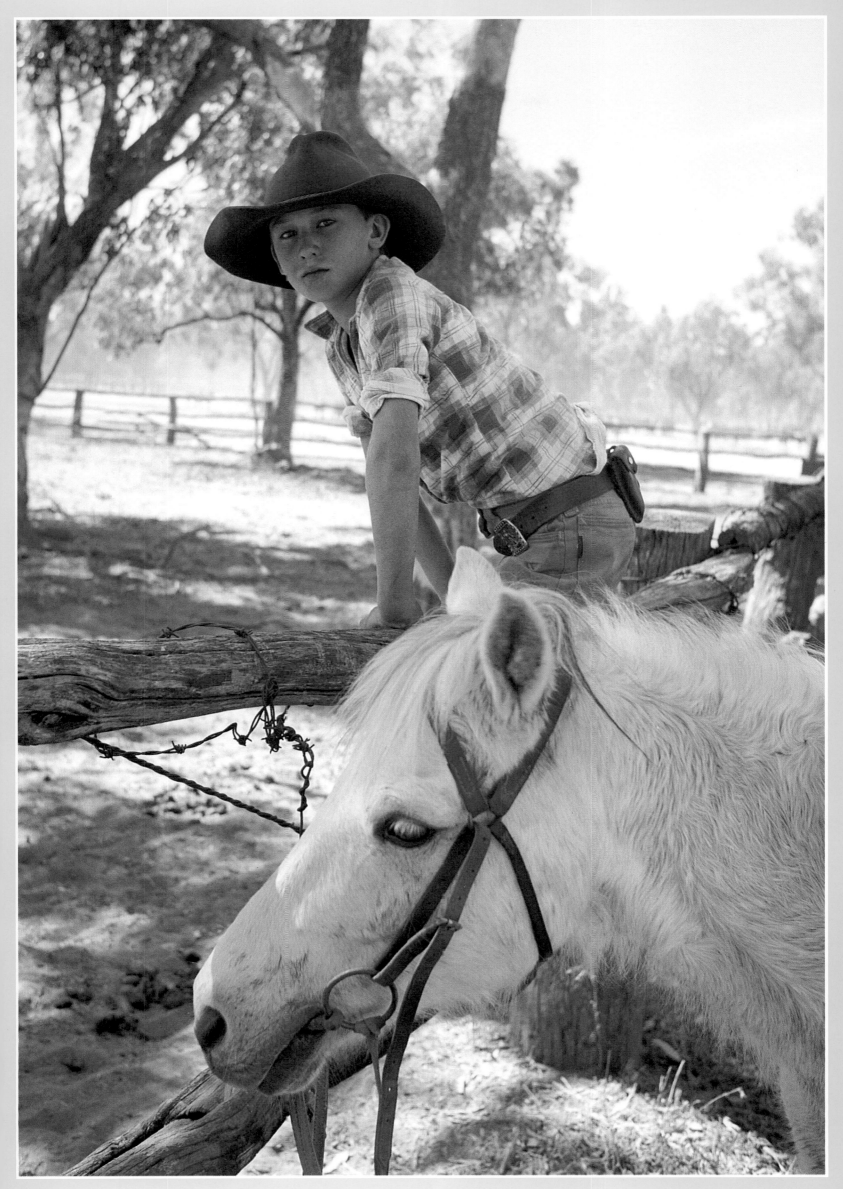

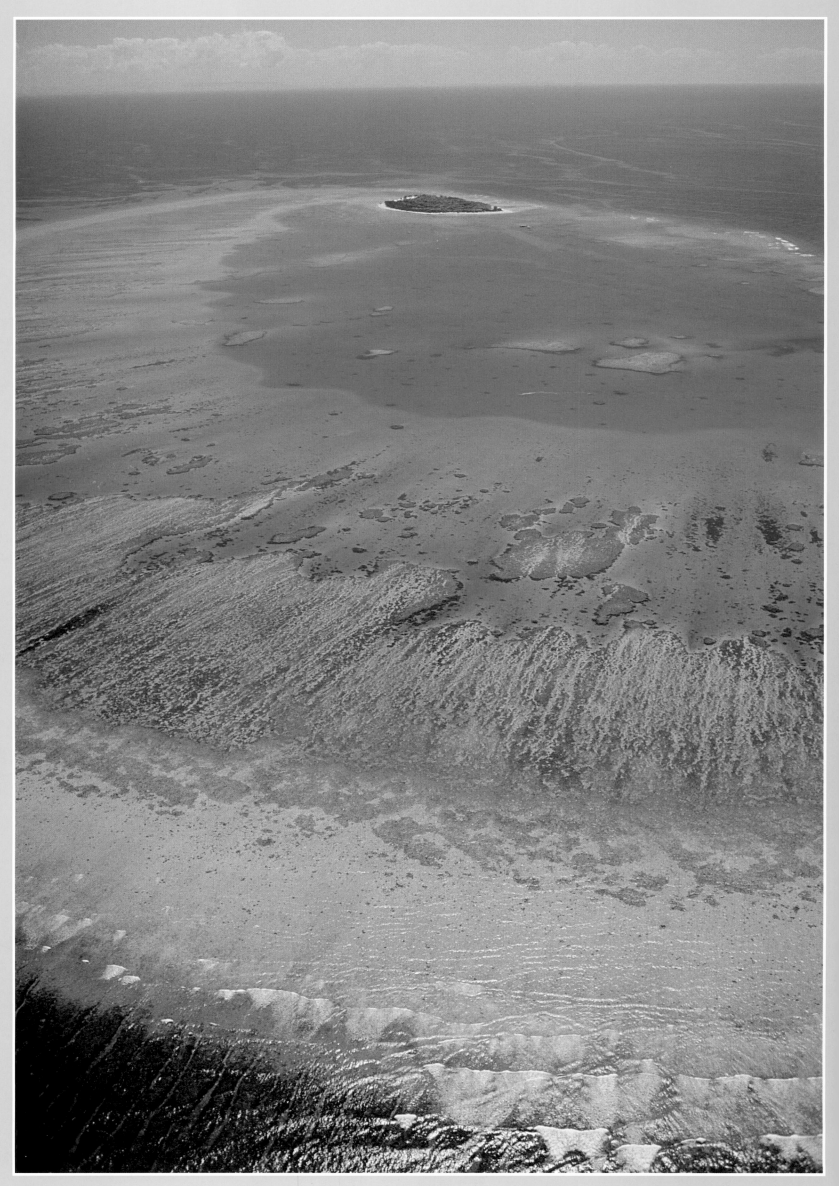

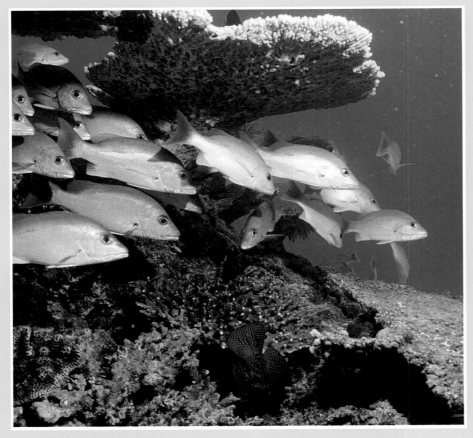

The Great Barrier Reef: It's magic!

The stretch of warm clear tropic sea and coral we call the Great
Barrier Reef contains nearly three thousand individual reefs
and about four hundred islands. Composed of four hundred or
more kinds of soft and hard corals it stretches from Papua
New Guinea to the Bunker Group, east of Bundaberg, on
Queensland's continental shelf. The Reef was recognised as a
World Heritage area in 1981. It is, quite simply, one of the
wonders of the world and to visit it and experience what it has
to offer is one of the wonders of anyone's lifetime.

✦

Above: A coral reef is home to myriads of fish and other marine animals.
Below: Gorgonian coral and diver.
Opposite: Lady Musgrave, one of the islands scattered like jewels across Great Barrier Reef waters.

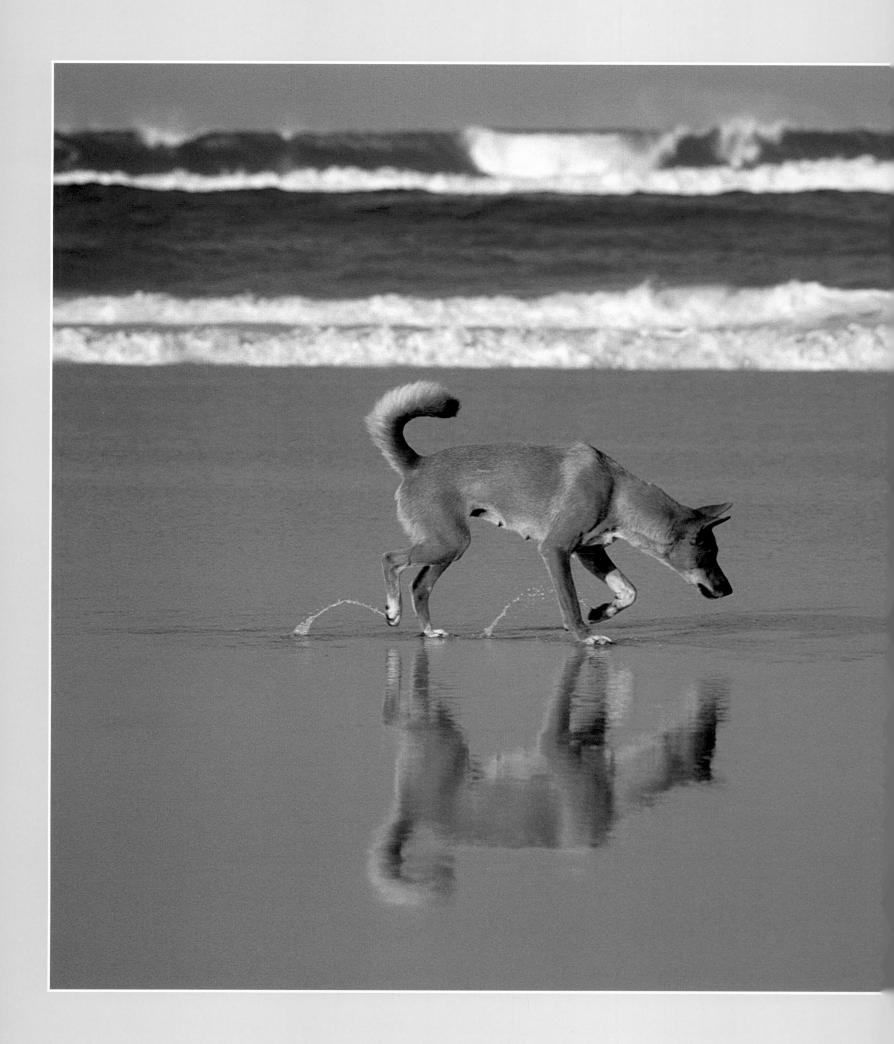

Fraser: The great sand island

Fraser Island is 123 kilometres long, averages 14 kilometres wide and is about 184,000 hectares in area. At Fraser it is possible to fish, swim in the sea or in one of the island's beautiful freshwater lakes, explore primeval rainforests, or admire stunning cliffs of eight-million-year-old coloured sands, and sand-dunes which may reach 230 metres in height. This largest sand island in the world is a Heritage area, the first site listed on the register of Australia's National Estate.

Above: Fishing is popular and productive on the islands of the Great Sandy Region.
Left: A Dingo explores a Fraser Island beach.

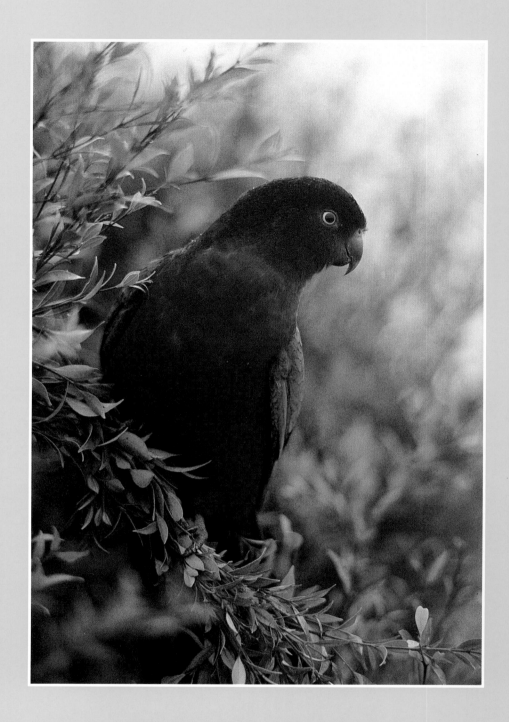

The rainforest: A living cathedral

To walk in rainforest is to step into a living cathedral. Far above, the vaulted roof is a canopy of leaves, where pigeons and parrots chorus as they search for bright fruits. Tall trunks descend like pillars from the leaves and prop themselves on the damp soil with winged buttress roots. They are linked by creepers, ornamented with orchids and ferns and their bark is bright as stained-glass with lichens and mosses. From somewhere deeper in the forest comes the muted summons of a waterfall, beckoning you deeper into this majestic green world.

✦

Above: The King Parrot is a brilliant inhabitant of the rainforest.
Opposite: Chalahn Falls, in Lamington National Park, Queensland.

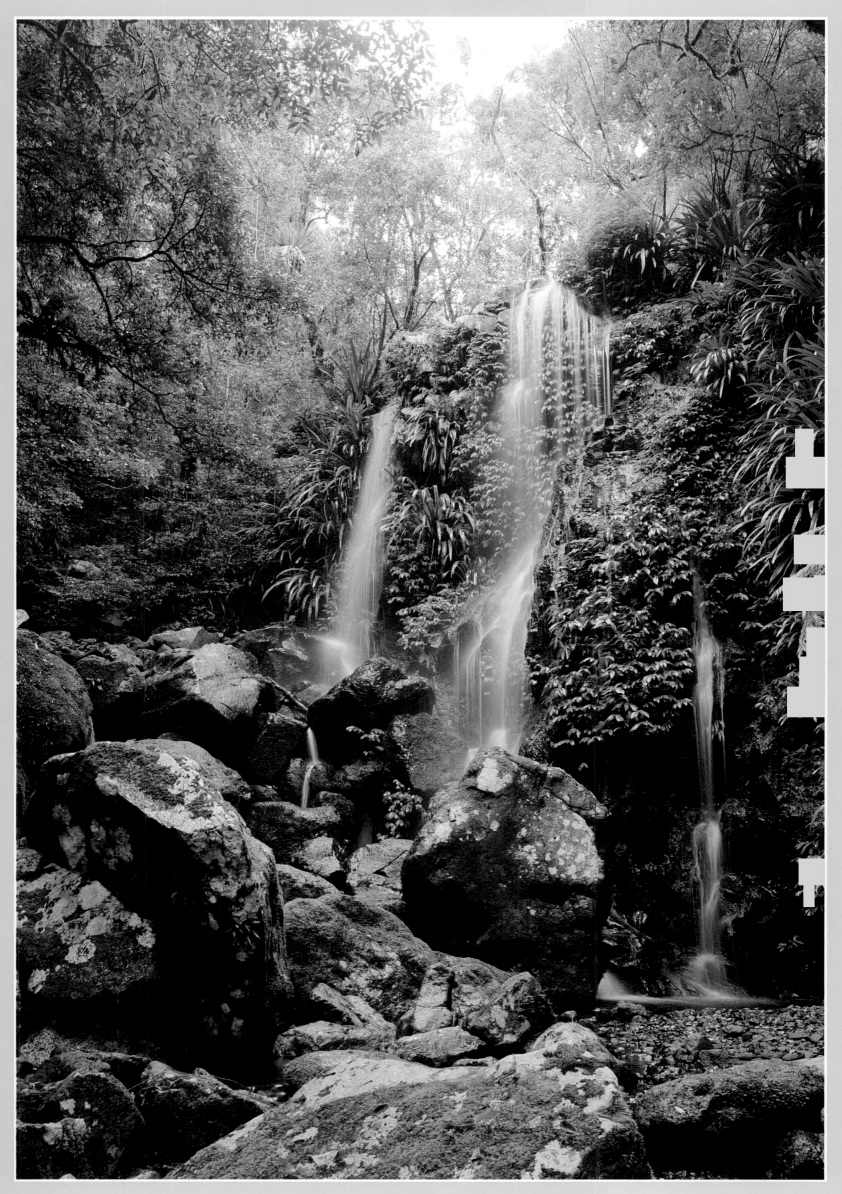

Discover Australia!

The best way to discover Australia is to travel around its wide expanses, taking your time, appreciating its landscapes, wildlife and people. You don't need to mount a major expedition, which will take six months to complete and cover thousands of kilometres. Explore areas close to home at first, then extend your operations further afield.

Before you set out, it is a good idea to learn something about the Australia you will discover. There is plenty of information available on Australia's many National Parks, its wildlife and its cities and towns.

Generally, it is wise to visit northern and central Australia in the Dry season, from May to October, when the weather is comparatively cool and dry. Southern Australia, including Tasmania and the East coast, offers great experiences year-round, though winter in more southerly areas may be chilly. Southwest Western Australia with its wildflowers is particularly attractive in Spring and the Great Barrier Reef is magic at any time.

Rushing from place to place, one eye on a timetable, is not the best way to discover this great land. If you can do so, take your time and regard the journey as being as important as the destination. Early morning and late afternoon are the best times to view landscapes and wildlife. Remember that special permits may be necessary to camp in some areas and to visit Aboriginal land. Wherever you go in the Outback treat the land and its inhabitants with respect - leave no souvenirs of your visit and take away only photographs and memories.

Every now and then on your journey, climb from your transport, walk away, then stop, look and listen. Take a deep breath and savour the scents of the land. Look near and far. Feel the texture of trees and rocks, water and sand against your skin.

Discover Australia with all your senses and make it part of your heart and soul.

---★---

The map shows the location of some of Australia's national parks and reserves. Their names are listed below.

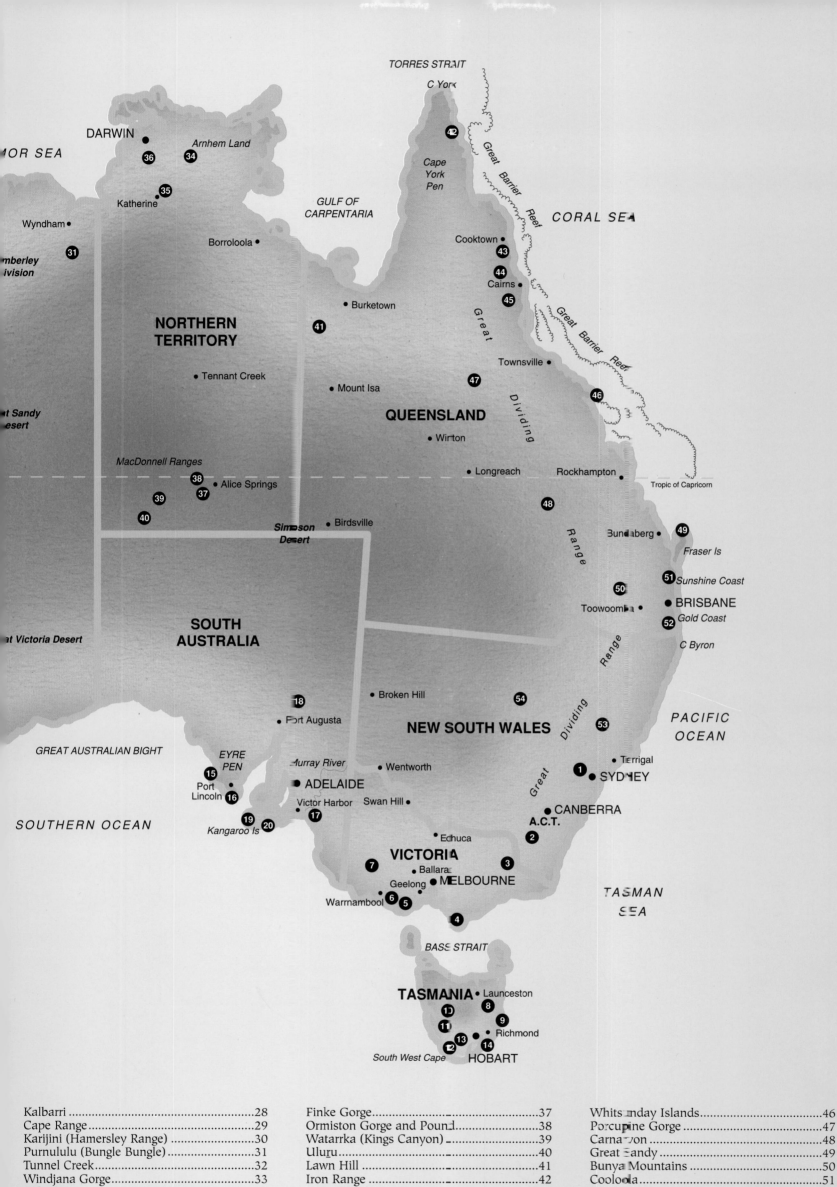

DARWIN
TIMOR SEA
Arnhem Land
36 34
Katherine
35
Wyndham
Kimberley
Division
31
NORTHERN
TERRITORY
Tennant Creek
Great Sandy
Desert
MacDonnell Ranges
38 Alice Springs
39 37
40
Simpson
Desert
Birdsville
SOUTH
AUSTRALIA
Great Victoria Desert
Borroloola
Burketown
41
GULF OF
CARPENTARIA
Mount Isa
QUEENSLAND
Winton
Longreach
TORRES STRAIT
C York
42
Cape
York
Pen
Great Barrier Reef
CORAL SEA
Cooktown
43
44
Cairns
45
Townsville
47
Great Barrier Reef
46
Dividing
Rockhampton
Tropic of Capricorn
48
Bundaberg
49
Fraser Is
Range
51 Sunshine Coast
50
Toowoomba
BRISBANE
52 Gold Coast
C Byron
Range
GREAT AUSTRALIAN BIGHT
EYRE
PEN
15
Port
Lincoln
16
19 20
Kangaroo Is
SOUTHERN OCEAN
Broken Hill
54
18
Port Augusta
NEW SOUTH WALES
Murray River
Wentworth
ADELAIDE
Victor Harbor
Swan Hill
17
Echuca
VICTORIA
7
Ballarat
3
Geelong MELBOURNE
6 5
Warrnambool
4
Dividing
Range
53
Great
Terrigal
1 SYDNEY
CANBERRA
A.C.T.
2
Dividing
PACIFIC
OCEAN
TASMAN
SEA
BASS STRAIT
TASMANIA Launceston
10 8
11 9 Richmond
12 13
14
South West Cape HOBART

It's impossible alone

Many people have contributed directly and indirectly to the creation and publication of this book. I would like to thank you all sincerely.

To acquire some of the images, co-operation was required from several departments of Australia's National Parks and Wildlife Services. Particular thanks are due to the Federal, South Australian and Queensland Departments. Special thanks also to Phillip Hayson, for his great photograph of Sydney Opera House lit for the triumphant Olympic Games 2000 announcement.

The majority of the photographs were exposed with Nikon 35mm F4 cameras and some with a Mamiya 120mm RBZ camera. The film used ranged from Kodachrome 64ASA to Ektachrome X and Ektachrome EPZ 64ASA and 100ASA, the latter processed by Prolab of Queensland.

Finally, but never last in my thoughts, I would like to thank Jan Parish and the national sales and administrative staff of Steve Parish Publishing Pty Ltd. My wife and partner, Jan has accompanied me on many expeditions - thank you Jan, for everything you are and everything you have done for me and for Steve Parish Publishing.

First published in Australia, 1994, Steve Parish Publishing Pty Ltd
PO Box 2160 Fortitude Valley BC Queensland 4006
© copyright Steve Parish Publishing Pty Ltd, 1994
Reprinted 1996 (twice)
Reprinted 1997
Printed in Hong Kong by Creative Printing Limited.
ISBN 0 947263 74 8

PRODUCTION DETAILS
Photography - Steve Parish
Text - Pat Slater
Design - Paul Byrne
Computer artwork - Phillipa McConnel - Oats

To the Fish Market

Bhuleshwar Street.
By an unknown artist,
painted between 1865 and
1868.
Oil painting on board,
44 x 60 cm.
Private collection.
Traces of painted murals may
be seen on the lower walls of
the house on the left. On the
right is the old private
vegetable market, which was
destroyed by fire in 1868; it
was subsequently replaced by
the still thriving Bhuleshwar
Market. The scene includes a
street gas-lamp. Since these
were first introduced into
some roads in Bombay in
October 1865, it becomes
possible to date the picture
to sometime between this
event and the market fire. As
in William Carpenter's street
scenes, a variety of different
communities throng the
foreground.

BOMBAY TO

publications

MUMBAI
CHANGING PERSPECTIVES

Edited by Pauline Rohatgi, Pheroza Godrej, and Rahul Mehrotra
With additional photography by Bharath Ramamrutham

Marg Publications gratefully acknowledges the financial support provided for this volume by:

Tata Sons Limited
Forbes Group of Companies
Shapoorji Pallonji & Co. Ltd.
Tata Exports Limited
Tata Housing Development Co. Ltd.
Oriental Heritage Trust
Tata Refractories Limited
TRF Limited

Marg Publications also gratefully acknowledges in this golden jubilee volume
the years of continuous support provided by:

THE TATA GROUP OF COMPANIES –
 IN PARTICULAR TATA STEEL AND TATA CONSULTANCY SERVICES
SHRENUJ & COMPANY LIMITED

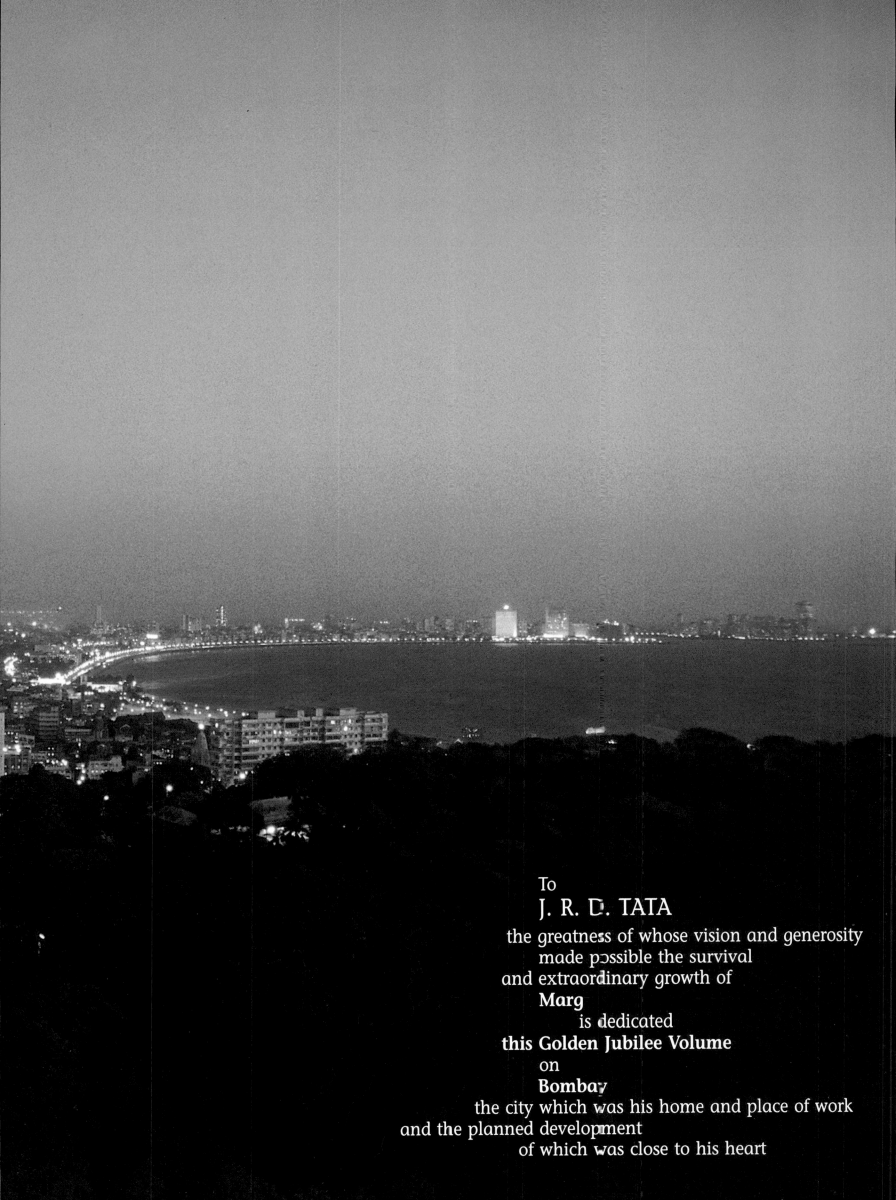

To
J. R. D. TATA
the greatness of whose vision and generosity
made possible the survival
and extraordinary growth of
Marg
is dedicated
this Golden Jubilee Volume
on
Bombay
the city which was his home and place of work
and the planned development
of which was close to his heart

CONTENTS

General Editor
PRATAPADITYA PAL

Senior Editorial Executives
SAVITA CHANDIRAMANI
RIVKA ISRAEL
Editorial Executives
ARNAVAZ K. BHANSALI
L. K. MEHTA

Copy Editor (Consultant)
MEHER MARFATIA

Design Executive
NAJU HIRANI
Production Executive
GAUTAM V. JADHAV
Design and Production Assistant
VIDYADHAR R. SAWANT

Design Editor
SUBRATA BHOWMICK

Price inclusive of map: Rs 3000.00 / US$ 98.00

Copyright Marg Publications, 1997

ISBN: 81-85026-37-8

Library of Congress Catalog Card Number: 97-900351

No part of this publication may be reproduced or stored
in a retrieval system, or transmitted, in any form or by any means,
without the prior written permission of the copyright holders.

This edition may be exported from India only by the publishers,
Marg Publications, and by their authorized distributors
and this constitutes a condition of its initial sale
and its subsequent sales.

Published by J.J. Bhabha for Marg Publications
on behalf of the National Centre for the Performing Arts
at 24, Homi Mody Street, Mumbai 400 001.

Colour processing by Khurshed Poonawala
at Comart Lithographers Limited, Mumbai 400 025.

Black and white processing by
Tata Donnelley Limited, Mumbai 400 025.

Printed by A. S. Vadiwala at
Tata Donnelley Limited, Mumbai 400 025, India.

Illustrations on previous pages

Pages 4-5
View from the Oval of the High
Court, the University Tower with
the Stock Exchange in the
background, and the Old
Secretariat on the right.
Photograph:
Subrata Bhowmick, 1997.

Pages 6-7
View looking north from Malabar Hill
showing the repetitive high-rise
buildings that have come to
characterize most of
Bombay's urban landscape.
Photograph: Bharath Ramamrutham,
1996.

Pages 8-9
View of Back Bay from
Malabar Hill.
Photograph:
Bharath Ramamrutham, 1996.

Part II - Places, Symbols, and Icons

Part III - Making an Urban Landscape

Map (on separate folded sheet)

ACKNOWLEDGEMENTS

First, we should like to record our personal tribute to the founders of *Marg* — Modern Architectural Research Group — Mulk Raj Anand, Anil De Silva, Karl Khandalavala and the Architectural Editors, who launched this exceptional journal devoted to the arts and architecture of India fifty years ago.

The idea of a special volume devoted to Bombay (now re-christened Mumbai) to celebrate the golden jubilee of *Marg* was conceived several years ago when the late Mrs Roshan Sabavala was looking after Marg Publications. It was she who invited us to undertake this daunting task, and we are most grateful. All at Marg Publications, and especially Radhika Sabavala, have given their unfailing support. It has been a great pleasure to work together with such a cooperative team and we thank everyone most warmly. Above all, it is to Dr Pratapaditya Pal that we owe our particular thanks, not only for his expert guidance and suggestions, but also for his patience during the preparation of this volume. We also extend our appreciation to our designer, Subrata Bhowmick, for his creativity and dedication during the last few months of the volume's preparation.

Our contributors have provided a variety of scholarly and pioneering articles that highlight a wide range of subjects relating to Bombay. To each, our most sincere thanks, not only for writing, but also for their sustained interest in the entire volume. In this respect we wish to thank especially Kalpana Desai, Sharada Dwivedi, and Christopher London for their ever forthcoming advice. Their valuable assistance has eased our path far more than words can express.

Almost one-fourth of the illustrations have been specially photographed by Bharath Ramamrutham. We are deeply grateful to him for the great care he has taken in fulfilling the wishes of every contributor whose article he has illustrated. M. F. Husain, India's leading contemporary painter, sketched Back Bay from Malabar Hill specially for the book, and we greatly appreciate his kind cooperation and generosity. We also wish to thank all those who have assisted us in finding, or lending, often rare or previously unknown pictures of Bombay. As a result, we now realize that much more illustrative material relating to the city still exists. We thank especially Mary Beale, Sue Cox, Roy Brindley, William Drummond, Farooq Issa, Michael Graham-Stewart, Indar Pasricha, Geoffrey Roome, and Robert Travis.

Most of the maps, paintings, prints, and early photographs, however, have been obtained from various institutions, and we thank them all most sincerely for granting us permission to reproduce their material. Acknowledgements are also included along with individual articles, but we should like especially to mention the India Office Library and Records (Oriental and India Office Collections), The British Library; the British Museum; the Royal Geographical Society; the Victoria and Albert Museum; the Cambridge University Library; the Mitchell Library, Glasgow; the Yale Center for British Art, New Haven; the John Carter Brown Library, Rhode Island; the Canadian Centre for Architecture, Montreal; the Bhau Daji Lad Museum, Mumbai; and the Peninsular and Oriental Steam Navigation Company, London. We are also deeply grateful to the London office of Arthur Andersen & Co. for their assistance.

We have constantly relied not only upon the advice of experts on the subject, but also upon the kindness of many other people without whose support we could not have completed this project. We are unable to give details of all the help provided, but we trust that everyone will appreciate the reasons for our gratitude. Accordingly, we thank most sincerely F. S. Aijazuddin, A. K. Banerjee, Terry Barringer, P. S. Bhogal and the staff of the Department of Archives, Government of Maharashtra, Shyam Chainani, Andrew Clayton-Payne, Constance Clements, Andrew Cook, Fr. John Correia-Afonso, S. J., Karen Cunningham, Devangana Desai, Jyotish Desai and the staff of the Bhau Daji Lad Museum, Mumbai, Kalpana Desai and the staff of the Prince of Wales Museum, Mumbai, Manek Doongaji, Saryu Doshi, Elizabeth Fairman, John Falconer, Antony Farrington, Madhav Gandhi, S. R. Ganpule and the staff of the Bombay University Library, the late Naval P. Godrej, Soonu Godrej, S. P. Godrej and the staff of the Godrej group of companies, Sadashiv Gorakshkar, Shirley Imray, Homi Jal, Amrita Jhaveri, Patricia Kattenhorn, the late Karl Khandalavala, Coomi Kapadia, Farida Kapadia, Jerry Losty, Rumi Majoo, Fr. Aubrey A. Mascarenhas, S. J. and the staff of the Heras Institute, Mumbai, Paul Mellon, Judy Nelson, Foy Nissen, Patrick Noon, Divia Patel, Graham Parlett, Mangala B. Phatak, C. S. Raje, Romita Ray, Stuart Reider, D. R. SarDesai and the staff of the Asiatic Society of Bombay, Cyrus Shroff, Gail Shuster, Mitha and Pheroze Shroff, Joan D'Souza, Sybil D'Souza, Nalini and Haridas Swali, Deborah Swallow, Mary Swarbreck, Caroline Waring, Scott Wilcox, Martha Yellig, and everyone who has taken an interest and discussed various aspects of the city with us.

As always, our families, especially Nondita Mehrotra, Jamshyd Godrej, and Roy Rohatgi, have given us constant encouragement and support. Their understanding of this project and its complexities has helped ensure that it has been much more of a pleasure than a burden. We sincerely hope that the end result will do justice to everyone's expectations, and form a small contribution to this never-ending subject of study—the city of Mumbai.

INTRODUCTION

PRATAPADITYA PAL

Time present and time past
Are both perhaps present in time future,
And time future contained in time past.
— T. S. Eliot, *Four Quartets*, "Burnt Norton", I

Malabar Hill! The Hanging Gardens! Victoria Terminus! Brabourne Stadium! The Gateway of India! and, of course, Marine Drive. . . . These were magical words for someone growing up in Calcutta in the forties and the early fifties. Even though we were partial to Calcutta, all those who had visited Bombay then used to admire the city as the most disciplined and the best maintained metropolis in the subcontinent.

It was still impressive in the autumn of 1965 when I first visited the city, especially after Calcutta which had been devastated by the East Bengal refugee problem and the governments' — at all levels — inability to cope with it. But, having come to Bombay after three years in Europe, one's standards were quite different and the city failed to measure up. Unbridled growth and development, as well as explosive demographic problems had taken their heavy toll and Bombay had inexorably started its move towards the less than spotlessly clean, overcrowded, often squalid and unaesthetic megalopolis that is known today as Mumbai. Like most other Indian metropolises, the city was not prepared to cope with the simultaneous pressures of politics, commerce, and population.

Little over fifty years ago, even before the subcontinent became divided into two nations as a parting gift of the Raj, a group of concerned and enlightened citizens of Bombay banded together to launch a magazine. In its very first issue an announcement was published which we reproduce alongside, with its original design.

It is interesting that even while parts of the subcontinent were witnessing some of the most horrific communal violence in the history of the country, *Marg* was attempting in its own way some kind of rapprochement by incorporating both Arabic and Nagari lettering in the design of the announcement. To paraphrase Charles Dickens, while in some ways it was the worst of times, in other ways it was also the best of times. A year's subscription then cost only Rs 16, an amount which today would not be adequate to print even a sentence.

Both the country and society have changed dramatically since then. It was still a land of maharajas, elephants, tigers, and

MARG means - - - - Pathway

MĀRG brings you the only Magazine on Architecture and Art in India. It will give you articles and pictures on:—

. . . Building; housing and construction; interior decoration; lighting; town, country and national planning.

. . . Arts and crafts; painting; sculpture; music; drama; dance; film and folk art.

. . . Textiles; ceramics; glass; carpet weaving; metal works; furniture designing; etc.

. . . A regular feature on the Indian home;

. . . New trends in Architecture and Art abroad, for which well known foreign critics will write for MĀRG

Subscription for a year
Rs. 16/- in India, Rs. 8/- abroad (4 annas extra if cheques are drawn on banks outside Bombay)

This volume is typical of the standard MĀRG hopes to sustain and to surpass.

other marvels of man and nature. Fifty years later they are all on their way to extinction but *Marg* has survived. Not only has it survived despite inflationary pressures and the regrettable apathy of most wealthy and educated Indians, but it continues to flourish as the only magazine devoted to the original aims of its founders, thanks to its faithful subscribers, unfailing patrons, and dedicated staff.

Because *Marg* was launched in Bombay in October 1946, it was felt that the city should be the focus of at least one of the issues published in the organization's Golden Jubilee year. Not only is this a significant anniversary for *Marg*, but it happens to coincide with a watershed year for the city. For 1996 is the year when the state legislators decided to change the city's name from Bombay to Mumbai. Since the name change is only symbolic rather than substantive and will not contribute one iota to the more pressing needs of the city's design or infrastructure, it was decided that this was a good juncture to reflect on the past as well as the future of Bombay/Mumbai.

The book is divided into three sections. Entitled "Perceptions and Observations", the first section takes a nostalgic trip into the past. It is not the purpose of the six essays to provide a connected history of the city's genesis and early growth, but to remind us of early Bombay's physical features in relation to its harbour which has always remained an important factor and has contributed to its characterization as the Gateway of India. Especially exciting is the little-known visual material in this section consisting of early survey maps, artists' impressions, and photographs. Not only do the maps enhance our understanding of the

pattern behind the growth of the settlements and the gradual changes of the topography, but they also reveal the commitment of the early administrators to managing the expansion. The Maratha map which adorns the dust jacket of the book is particularly interesting for its affinity with contemporary images.

The flesh for the bones provided by early cartographers is added by the picturesque and romantic impressions of the islands by two eighteenth-century British artists James Forbes and James Wales. Whatever their own reasons for recording in such detail the topographical features of the islands, all Indians should be grateful to both professional and amateur European artists for preserving in such vivid images what has been lost forever. One of the most remarkable works by a British artist published here for the first time is the complete panoramic view of the Fort recording every detail with astonishing accuracy.

Few visitors to Mumbai today will be aware of the fact that until recently the hub of the city was the Fort. This is where the East India Company settled a wide variety of peoples with diverse skills which then developed into a mosaic of communities that give Bombay much of its character. The essays in the second part of the book attempt to provide a sense of the city's character and vitality through some of its sacred places, symbols, and icons. Some of these still exist, though they are not always easy to find; others have fallen victim to nationalistic ardour.

Although I have been visiting Bombay regularly now for three decades, it was only a couple of years ago that I learned that, as in London, so also in this city there is a Victoria

and Albert Museum. In fact, it is no longer known by that name, although the charming gardens in which the museum is located still retain the memories of the royal couple. It is to this green haven in overcrowded Byculla that we must go to meet some of the personalities — mostly British — who not only shaped the physical features of this city but contributed to its character as well.

In this sense, by banishing the statues and symbols of the Raj to the Queen's gardens in Byculla, we have also turned our backs on the city's history which in turn formed its character. The latest victims in this process of change are of course the city itself and its most famous landmark, the Victoria Terminus. Instead of usurping another's glory, the Maratha hero would have been better served with a monument that surpassed the railway terminus in magnificence and splendour. Thus, both physically and symbolically, the city's character is altering inexorably from Bombay to Mumbai.

The most admirable features of Bombay's cityscape are its Gothic revival buildings raised in the last century after the fortifications were removed. Indeed, it is because of these buildings that Bombay is often cited as a "unique Victorian city" (a curious irony in a city that seems determined to disassociate its Victorian connections). Indeed, the city planners and city fathers of Mumbai, as they face the challenges of the new millennium, will do well to visit Melbourne, Australia to see how another rich repository of Victorian architecture has preserved its heritage while meeting the needs of a modern metropolis.

Another innovative phase in the history of the city's architecture that reflects its cosmopolitan character and international outlook began in the 1930s when many residential and office complexes as well as theatres adopted the Art Deco style. Significantly, this style was not imposed on the city by a government, as was the case with the neo-Gothic, but was embraced by the citizens. And just as Bombay is the Mecca of Victorian architecture in Asia, and not just

India today does not have to invite architects and city planners from abroad to solve its urban problems. In fact thirty-two years ago it was through the pages of *Marg* that a group of young planners presented their vision of New Bombay. In reproducing that blueprint and reassessing its impact, *Marg* is once more making a fundamentally important contribution in alerting the city and its civic leaders to the enormous task that lies ahead. In introducing the 1965 issue on Bombay, the magazine's editor Dr Mulk Raj Anand hoped that the Bombay plan would help create a "city for ourselves, our children and children's children". "Let us have the courage to dream," he wrote, "for in dreams begins responsibility."

Have we yet woken up from the dream like Rip Van Winkle and assumed our responsibility? Not according to one citizen of Mumbai whose letter to *The Times of India* was published on March 5, 1997:

The Name of the City

Sir,—I write with reference to your recent edit, "Mumbai's Red Herring" (February 21). The zealots who insist on 'Mumbai' as against 'Bombay' seem oblivious to the fact that there are few cities in the world so hideous as ours. Every repulsive lineament of poverty and filth is represented here; there is a harassed, knife-edge quality to daily life; every imaginable sign of desolation and neglect ornaments Mumbai's streets.

Our political leaders cannot offer even the slightest semblance of a coherent plan for urban renewal. In the meanwhile, the citizenry suffer a nightmarish succession of crises: water shortages, house collapses, housing shortages, the coercive evictions of tenants by unscrupulous landlords, fatal food-poisoning, the breakdown of telephone services, train derailments, power blackouts. While the city's good-natured anarchy leaves one exhausted at the end of each day, there are no rationally integrated goals to bring order into the chaos.

Will the renaming of the city magically cure the population explosion, the crime rate, the pandemic disease profile, the fear of ethnic conflict and the xenophobic bigotry that have come to afflict this city?

F.N. RIVETNA
Mumbai.

the subcontinent, so also is it a rich resource of the Indian expression of Art Deco. Every effort therefore should be made to preserve this wonderful heritage. It is gratifying to learn from at least one article in the third and final part of the book that both individuals and institutions are now taking an active interest in conserving the city's distinctive and physical landmarks.

However, standing on the threshold of a new millennium, one is aware that the city is a complex organization with enormous economic, demographic, political, and environmental problems. Even more challenging is the fact that the landmass available to the city for expansion is limited, and its commercial success is also its curse. Population pressures, shortage of housing, inadequate infrastructure, and haphazard growth all contribute to problems that may be seemingly insoluble to the sceptic. What will we gain by becoming an atomic power or the computer capital of the world if we cannot meet the minimum expectations of the people?

Hopefully, no such letter of despair and frustration will be published thirty years from now.

PERCEPTIONS AND OB

SERVATIONS

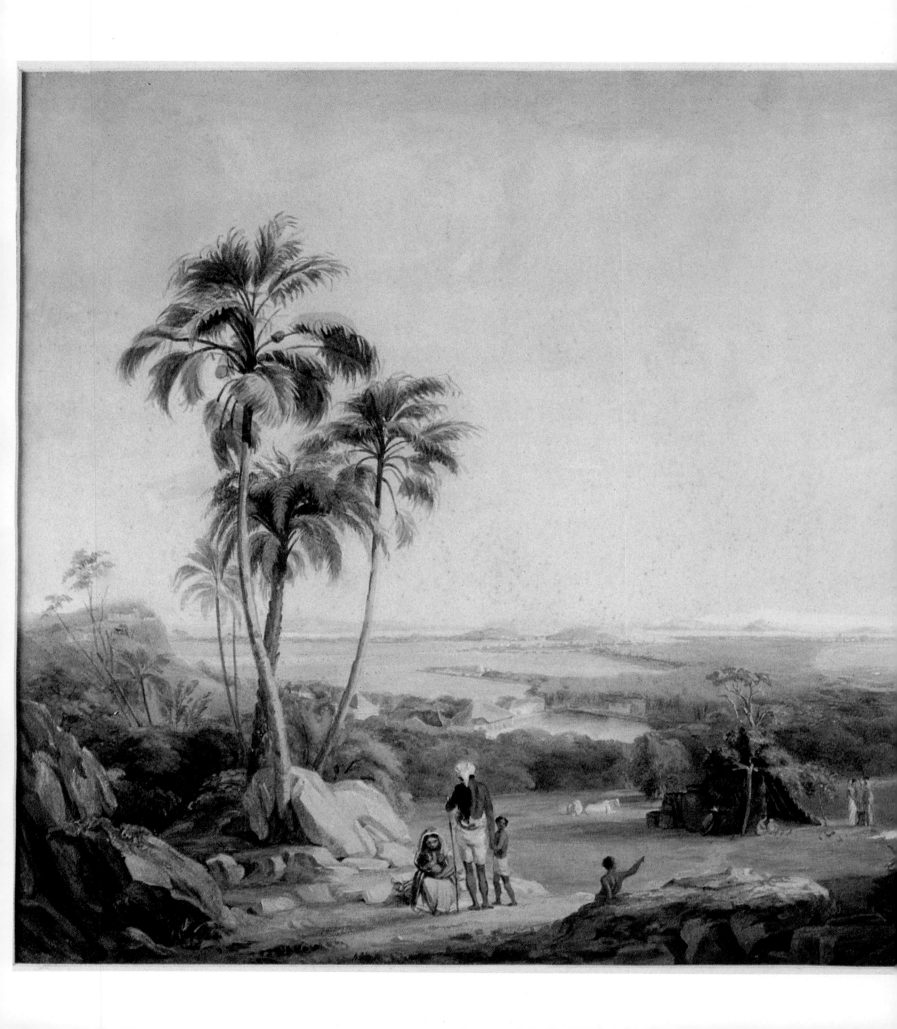

View south-eastwards from Malabar Hill across Bombay Island to the harbour and mainland.

Ascribed to William Frederick Witherington (1785-1865), painted about 1820 from an earlier drawing by Lieutenant-Colonel John Johnson (*circa* 1769-1846) of the Bombay Engineers.

Watercolour, 38 x 68.5 cm.

Courtesy India Office Library and Records (OIOC), The British Library, London.

This panoramic view was taken from a position on the eastern slope of Malabar Hill close to the Parsi burial ground, one *dakhma* of which is visible on the extreme right. An Indian family enlivens the foreground. Beyond the palm trees to the left, old Prospect Lodge stands on a rocky outcrop forming part of the northern ridge of Malabar Hill known as Cumballa Hill. Its site today would be at the end of Anstey Road, a cul-de-sac off Altamount Road. Other European bungalows, including the Retreat and Tankaville, lie below the slope near Gowalia Tank. Beyond the tank lies the temple of Gamdevi, the village goddess, almost surrounded by fields. Also in the middle distance, Girgaum woods extend across to Back Bay, the full sweep of which is visible to the tip of Colaba Island and its lighthouse.

The most prominent distant landmark is St Thomas' Church within the Fort. The sprawling Indian township is faintly visible around the base of Naoroji Hill, while Mazagaon Hill appears more distantly to its left. Beyond, the island of Elephanta dominates the stretch of harbour, and the mainland can be seen extending southwards and out of sight.

Originally situated on a small group of islands off the west coast of India, the peninsula of Bombay today comprises about sixty-five square kilometres. The story of this cosmopolitan city, enacted on one of the smallest urban stages in the world relative to the number of its people, is highly complex. Now connected with the former islands of Salsette and Trombay, the peninsula tapers in a south-westerly direction into the two promontories of Malabar Hill and Colaba, jutting into the Arabian Sea. Bombay's harbour, the single most important factor in its history, lies between the peninsula and the mainland. This backdrop of the subcontinent consists of high and low tracts of land — the Deccan plateau above with the Konkan strip below. These areas are divided by the Western Ghats, which extend for hundreds of miles parallel to the coastline, their rocky, forested slopes descending in a succession of terrace formations to the numerous creeks, estuaries, hills, and marshlands of the Konkan. Access from Bombay to the inland regions of the country was thus never an easy task. Nevertheless, since this was the only sheltered harbour along the entire west coast, it was Bombay's maritime potential that, above all, influenced the path of her history.

INTRODUCTION TO PART I

The aim of the first part of this volume is to highlight Bombay's former physical and urban features, in relation to the harbour and the sea, through the eyes of early map-makers, artists, and photographers. Their perceptions and observations provide invaluable evidence, enabling one to build up pictorial images of old Bombay before any major land reclamations occurred, and long before the adjacent mainland became part of the Bombay Metropolitan Region. Since the configuration of the original island group has changed radically over the last two centuries, these features can be properly understood only within a time context. For example, today's map of Bombay will reveal little of its eighteenth-century layout. Yet by comparing these documents, notably those dating from the eighteenth century onwards, it becomes possible

For captions to the illustrations above and on the facing page, see pages 32, 48, 62, 81, 109, and 117.

View of BOMBAY in 1773.

TOWN HALL, BOMBAY.

to appreciate earlier topographical features and, as a result, to understand some of the changes that have taken place.

The story of Bombay did not begin with the marriage between Catherine of Braganza and Charles II, when Bombay was acquired by the English Crown, but centuries earlier. Nevertheless, this event has been chosen as a convenient starting point by Susan Gole in her article on early maps, since it was then that the visual documentation of Bombay began in earnest. Although maps of the Bombay environs dating from the seventeenth and early eighteenth centuries vary greatly, they generally have one distinct common feature — the harbour. Seldom are two maps alike unless they were copied from one another. They varied mainly because the region's topography depended not only upon the season, but also upon the time of day, since the areas between the islands were constantly under tidal influence. In these and in subsequent maps, the limitations of the islands' territory are clearly evident in the frequent emphasis on the relationship between land and water, and on the boundaries and foreshores. Other early charts concentrated on the hazards to vessels in the harbour and on various means of avoiding them.

In time, as the Fort developed and as the swamps between the islands were filled up and reclaimed as land, residential districts spread throughout the islands. It was always the harbour, however, that formed the main focus and *raison d'etre* of the settlement, the running of which was taken over from the English Crown by the East India Company in 1668. As Bombay's population grew, accurate large-scale surveys became essential for the government to establish more efficient control, and thereby to rule more effectively. The story of the surveys of the islands, starting with that of Thomas Dickinson, is taken up in the article by Matthew Edney. These surveys and their accompanying reports helped to protect the owners' land-rights, and they were also instrumental in the collection of revenue. For the East India Company surveyors, however, this difficult

task was further exacerbated by the complexities of Bombay's ever-changing and restricted terrain.

Such spatial constrictions of Bombay's arena are key features in the overall topographical story. Unlike other cities where boundary expansion and commercial growth normally would be synonymous, Bombay being surrounded by water always faced a problem. This situation is clearly evident in the pictures by James Forbes and James Wales, whose views of the islands made during the latter half of the eighteenth century form the earliest and most vivid visual records. These views, as explained in Pauline Rohatgi's article, were not connected with any government exercise, but were made by the artists for personal reasons and to portray the topographical character of the islands. The artists accordingly chose some of the highest viewpoints from which to draw their scenes. As a result, when their views are observed together especially in relation to early maps, they convey an impression of almost the entire area of the Bombay islands. In fact, with the exception of the Fort and its adjoining precincts, which were so carefully recorded by Jacques De Funck in his mid-eighteenth century map, their views depict more intricate details of the various localities than any maps dating from the same period.

In addition to the Fort precinct, the two promontories, Colaba and Malabar Hill, also remained somewhat distinct in character. Colaba developed as the naval cantonment. Malabar Hill, originally thickly wooded with a few coastal fishing villages, contains several important early religious sites. The sanctity of these, plus the difficulties of access from the Fort, ensured its gradual cultivation as a residential area during the nineteenth century. Malabar Hill has been highlighted in the article by Pheroza Godrej because in recent years its image has changed more rapidly and radically than any other residential area of Bombay. Yet the many surviving pictures bring the early days of Malabar Hill vividly to life. In terms of pictorial images, with the exception of the Fort, it is probably the best documented locality within the islands.

The Fort area, always the focal centre, became firmly established as the nucleus of government administration and commercial enterprise by the 1820s. Building programmes included the construction of a new Mint and a Town Hall designed in the then fashionable, and boldly confident, neo-classical style. Vistas within the walls of the Fort, dating from the 1820s and 1830s, are best seen through the eyes of an Indian artist, José M. Gonsalves, who worked as a topographical artist and lithographer in Bombay. Although his prints are somewhat naive in style, they vividly capture the new cityscape, for he was obviously impressed by these neo-classical buildings and included many in his scenes. But the most impressive view of Bombay in those pre-photography days is, as described by Teresa Albuquerque, a complete circular panorama in watercolour by Captain Thomas Wingate, drawn from the terrace of one of the tallest houses within the walls of the Fort. It is published in this volume for the first time. In each of its ten sections, Wingate acutely observed every detail and systematically recorded the entire urban scene in a unique overview of the city. Thus, whereas Gonsalves provides glimpses of the Fort area at street level, Wingate captured a bird's-eye view of the Fort, its adjacent areas, and distant landmarks. These include the hills of Mazagaon and Malabar, from which Forbes and Wales had made several drawings over half a century earlier. Even compared with subsequent photographs, some of which were also taken as panoramas, this document remains unmatched as an early pictorial image of Bombay.

Although Bombay was not the first city in India to establish a photographic firm, it does carry the distinction of being the first to have a photographic society. The Photographic Society of Bombay was formed in October 1854 under its President, Captain Harry J. Barr. Thereafter, as discussed by Janet Dewan in her analytical article on the early commercial studios in the city, photography was practised by both amateurs and professionals. It was soon adopted by various government departments as a means of visual documentation. Photographs quickly superseded paintings and prints as the primary visual source for studying aspects of the city, its buildings, peoples and their occupations from the mid-1850s onwards. Views of the Fort, its walls, gateways, streets, and buildings were among the most popular subjects during the early days of photography. Accordingly, a fine record portraying its appearance prior to the demolition of the walls still exists.

The great range of early visual material — maps, sketches, watercolours, oil paintings, prints, and photographs — depicts a sequence of images which show different settings of this island city. Through them, growth patterns between the various localities visibly begin to emerge over a period of time. Although collectively these pictures represent only a small fraction of the wealth of surviving visual documents, the selected perceptions and observations provide glimpses into the past appearance of the region, before multiple influences affected its development, creating the urban complexities that form part of Bombay's character today.

When Catherine of Braganza, daughter of the King of Portugal, brought her dowry to Charles II of England in 1662, included among the gifts was a map of Bombay. The island was one of the many parcels of land possessed by the Portuguese on the west coast of India, and by no means one of their most important strongholds. In fact, it had been leased for many years by various nobles who had made it their home, and at the time of the marriage there were about a dozen families settled there in small homesteads clustered around the large fortified main house — the Quinta, or Manor House within Bombay Castle. The fortified town of Bassein on an island of the same name to the north, had a larger Portuguese population, and was more firmly under the control of the Jesuits.

WHEN WE GET THERE: BOMBAY

SUSAN GOLE

The Dowry Map

The map that accompanied the marriage treaty came in for much discussion. The text of the treaty was ambiguous. The English King was to receive "the Port and Island of Bombay in the East Indies, with all the rights, territories, and appurtenances whatsoever thereunto belonging; and together with the income and revenue, the direct, full and absolute dominion and sovereignty of the said port, island and premises." But there was no English survey of the area; in fact few English people had even set foot on the shore, and the treaty contained no more precise description than the words above. Did the "Port of Bombay" include both sides of the harbour, and which specifically was the "Island of Bombay"? What about the many smaller islands in the bay? Their number depended upon the season of the year, for what was dry land at one time became a rushing torrent at another. Many of the English nobles had very little idea where Bombay was, let alone its exact delineation, and some thought it quite close to Brazil. This all became of paramount importance when the resident Portuguese, supported by the Viceroy in Goa, refused to give up their power and their trading rights. A further agreement of 1665 failed to settle the dispute, as it mentioned only the island of Bombay.

The map was put on display at the home of the Earl of Southampton, when the Privy Council sat there, but then it seems to have disappeared. As the struggle with the Portuguese continued (despite an English governor having reached the Indian coast to take control of the new possession) there was a diligent search for this important document, but no trace of it could be found. It may well have been pasted on cloth, perhaps put into a frame, and then taken home by one of the clerks when it no longer seemed to be useful.

In the meantime, the Council for Plantations, one of the new bureaucratic organizations set up to handle the growing English possessions abroad, tried to sort out the problem of Bombay. One of the most active on the Council was William Blathwayt, and when he retired from office many years later, he took home with him an atlas of maps acquired by the Council, which appeared to be out-of-date, or at any rate no longer "official". As a result of this we still have a large map of Bombay dating from not later than 1685. It was perhaps an exact copy of the original Portuguese map, with some additions and

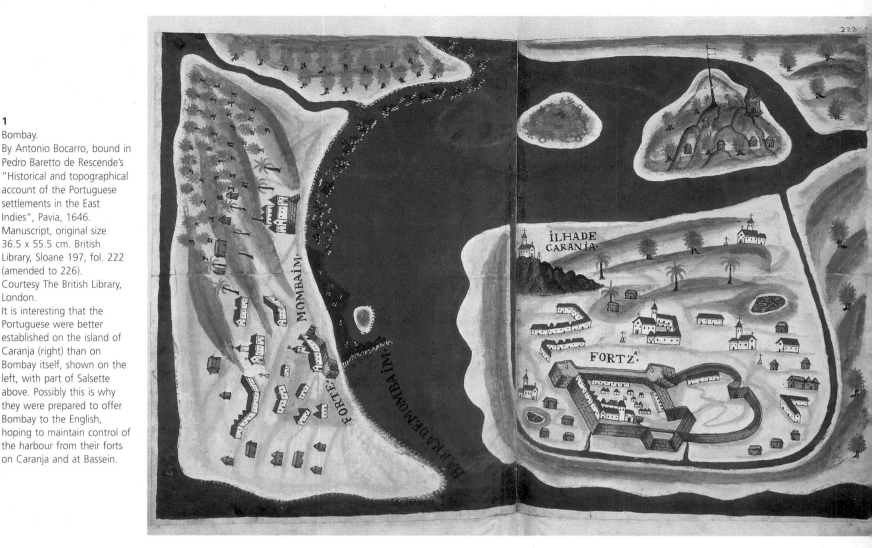

1

Bombay.
By Antonio Bocarro, bound in Pedro Baretto de Rescende's "Historical and topographical account of the Portuguese settlements in the East Indies", Pavia, 1646.
Manuscript, original size 36.5 x 55.5 cm. British Library, Sloane 197, fol. 222 (amended to 226).
Courtesy The British Library, London.
It is interesting that the Portuguese were better established on the island of Caranja (right) than on Bombay itself, shown on the left, with part of Salsette above. Possibly this is why they were prepared to offer Bombay to the English, hoping to maintain control of the harbour from their forts on Caranja and at Bassein.

corrections added by hand (figure 4).

However, this was not the only map of Bombay available at the time. In 1635 Antonio Bocarro, keeper of the archives and chronicler for the Portuguese Viceroy, made a report of the Portuguese possessions in the Indies, and illustrated it with many portraits and maps (figure 1). Several copies were made and one set has, on its first

IN EARLY MAPS

page, the name of Francis Parry, British ambassador to Portugal in 1670. This is probably the map that the East India Company referred to in later disputes about the extent of land they were renting from the English King, though they included a more accurate map in a representation made to the English parliament in 1724.*1

An English sketch of the harbour had been made as early as 1626* (when a joint Anglo-Dutch fleet landed and burnt the governor's house and several others), but its existence was possibly not generally known in London. David Davies, its maker, was in the *Discovery* and took part in the sacking of the town. John Fryer's map of 1672* is frequently reproduced, but the original on which it was based is not noted.

Dangerous Rocks at the Harbour Entrance

Towards the end of the seventeenth century, the harbour of Bombay was included in the logs of several ships, sometimes with detailed instructions for avoiding the dreaded "Sunken Rock" which was just off the coast near the Fort. Edward Barlow drew a very fair map in his log in about 1671. John Tyrrell was master of the *Phenix*

when it reached Bombay on June 10, 1685. On May 3, when he was off the island of Miotto (Mayotte in the Comoros), a request had come for him to supply a captain for a captured ship, the *Bristto*, to take it on to Bombay. This was done, but unfortunately the captured ship was in poor condition and as the monsoon had begun, was unable to cope with the high seas. It sank at noon on June 4, and though all the sailors were able to transfer to the *Phenix*, they lost most of their clothes. The anonymous keeper of the log regretted that out of his seven suits, he had managed to save just two spare coats, two pairs of cloth breeches, four waistcoats, two shirts, and two pairs of drawers, but was without any neckcloth. He also had a "great Could and a terrible paine in my head",

Part of the Coast of India

The Going into Bassere

4½ 5 4
5 4
5 4 4
4½ 4½ the Place of Riding
4½ 3½ for y Winter
3½
4½
3½
3
Trombay

Elphanta

Butchers Island
1½
4 8
8½
7 7
7 7½
5 8
3½ 4
3
6 5 8 9 9 1½ 3
4 5 4½

Sallset Island

4½ 3½ 2½ 2
4
Sion
Sallset
5
5
Subre
5
4½
4
3½
Caiman
3
4
4½
Bandura
Mayem

Ecc de Padre
Polo rmo

Colaj

Salt ponds
Masagom

Fishing Stakes
Cross Esland
5½
6

7 foot
5
4 4½ 4½
4½

Bombay
Townee Castle

Bombay Esland

Latt 19-00

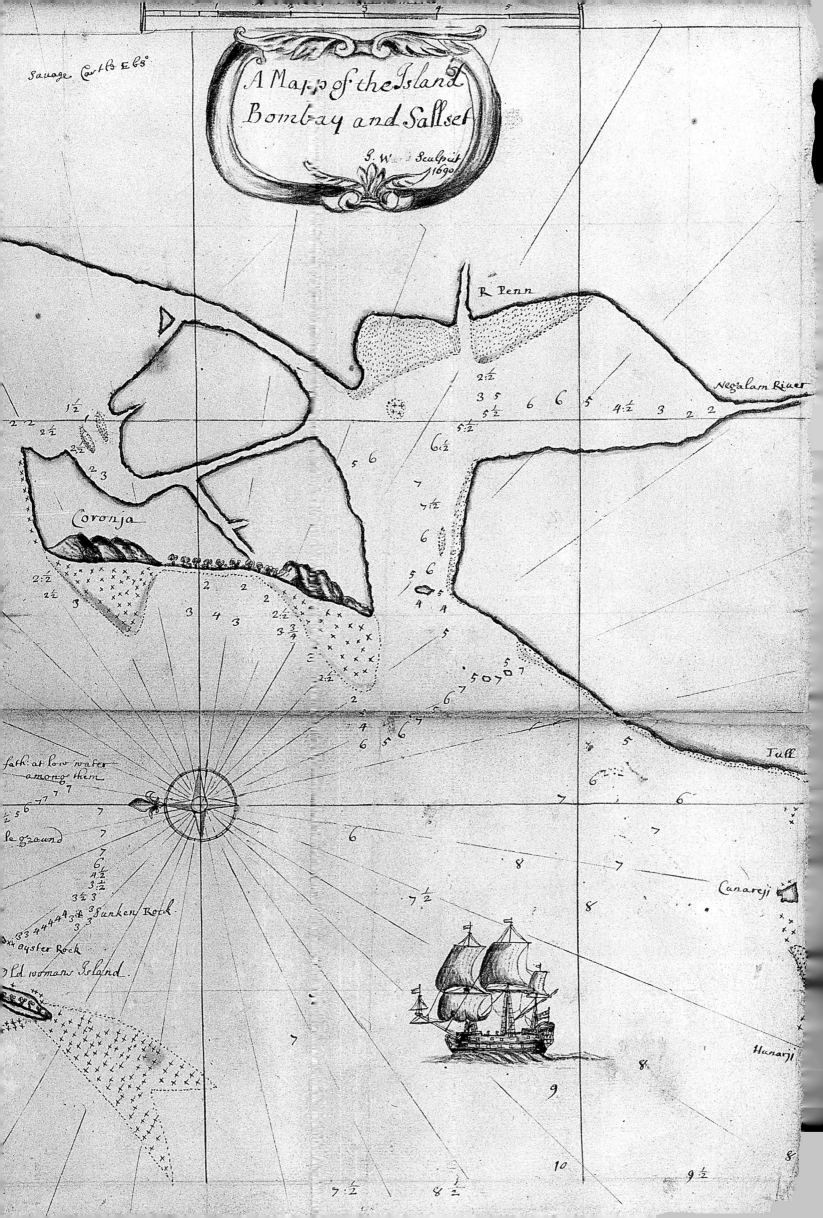

Savage Cart Ebs

A Mapp of the Island
Bombay and Sallset

G. W. Sculpsit
1690

R Penn

Negalam River

Coronja

fath: at low water among them

le ground

Sunken Rock

oyster Rock

Old womans Island

Tull

Canareji

Hunarji

Derections for the Island of Bumbay

When yo. have the Highest Toddy tree on the outwomens Island Shot in
with ye 7 Trees on Bealibar hill then your are abreast of the Sunken Rock
but if it be Thicke Weather so as your Cane See the white house at B
be sure to keep it about a hanspike length open of the outward bastine
of the forte for in keeping of them in one you will Run directly on ye
Sunken Rock but in keeping of ye forte and the hous open yo. goe Clear of all

Part of ye Island

of Bumbay

whose Latte is 19—00 N.

Bealibar hill

ye white hous B Massgun point

outwomens Island

Fishing Staks

ye forte

MidLground

oister Rock

Sunken Rocke

Fish.g Staks

7
7
7
7
7
7
6 $\frac{1}{2}$
6 $\frac{1}{2}$
6
6 $\frac{1}{2}$
5 $\frac{1}{2}$ 5
5 $\frac{1}{2}$
5 $\frac{1}{4}$ 5

6
6 $\frac{1}{4}$
6 $\frac{1}{4}$
6 $\frac{3}{4}$
7
7
7

7 $\frac{1}{2}$
7 $\frac{1}{2}$
7 $\frac{3}{4}$
8
8 $\frac{1}{4}$
8 $\frac{3}{4}$
8
8 $\frac{1}{2}$
8
8 $\frac{1}{2}$

2
(previous pages)
"A Mapp of the Island Bombay and Salsett." By Jacob Ward, 1690. Manuscript, original size 36 x 50 cm. British Library, Add. MS 18989, fol.40a. Courtesy The British Library, London.
The anonymous compiler of the *Benjamen's* log described Bombay as a "very low land rising out of the water thick of toddy trees"
This is one of the earliest maps to give a fairly accurate depiction of the whole bay.

3
(facing page)
Directions for avoiding the "Sunken Rock" while sailing into Bombay harbour, from the manuscript log of the *Phenix*: "When you have the Highest Toddy tree on the ould woman's Island Shot in with ye 7 Trees on Malibar hill then you are abreast of the Sunken Rock but if it be Phare (?) Weather so as your Lane be the white house at B be suer to keep it about a hanspiks Length opon of the outward Bastine of the forte for in keeping of these in one you will Run directly on ye Sunken Rock but in keeping of the forte and the hous open you got Plan of all." Manuscript, original size 35 x 21 cm. British Library, Sloane 854, fol.107b. Courtesy The British Library, London.

4
Bombay Harbour.
By William Blathwayt, *circa* 1678.
Manuscript on vellum (two sheets joined), original size 52 x 125.5 cm. British Library facsimile (in monochrome), maps 196.e.1; commentary, maps 59.b.45.
Courtesy John Carter Brown Library at Brown University, Rhode Island.
This is perhaps the best map that was available in England for Charles II to learn what his new territory looked like. Though the original is lost, this copy was probably made to order by chart-makers living near the Thames for the Plantations Office, to settle the dispute with the Portuguese about the extent of the land that was to be handed over. The Bombay islands are represented immediately to the right of the Salsette Islands, with the island of Caranja above, near the mainland. The handwriting and colouring is similar to other maps in the atlas, now in the possession of the John Carter Brown Library.

so that "I cannot Minde the Logg as I have done." He bemoaned the loss of all his instruments and his water-soaked books. When he reached Bombay he was sick with a flux, and went to the hospital, where despite the borrowed clothes, he was most unhappy with his treatment by doctors who neglected him. Luckily for us, he was well enough to include in his log a finely drawn sketch of the harbour, and detailed instructions for incoming pilots, even if it did depend on lining up two trees, hardly permanent fixtures for later sailors (figure 3).

Another log written a few years later, in 1690, on the "Good Ship *Benjamen*" also contains a map of the harbour, on a smaller scale and covering a much wider area. This was drawn by Jacob Ward (or G. Webb, the text is unclear), and includes a delicate cartouche (figure 2). Here the directions for avoiding the "Sunken Rock" were more reliable: "give the Oyster rock a hansome distance the Lengths mark to keep Clear of the Sunken rock is to keep the white house [Mark House] on massagon [Mazagaon] just open of the Fort then there is no danger." Despite the lack of punctuation, common at the time, the text is still intelligible. This was not a healthy time to be in Bombay, and during the four months of the monsoon that they "wintered" there, the deaths of nine persons from the ship were recorded: Mr Sexton, Passenger; Thomas Sell, Carpenter; Stephen Warner, Armourer; John Pike, Cooper; Stephen Jones, Cooper's mate; David

Griffeth, Gunner; and Henry Norris, Christian Greason, and John Arris.

This rough drawing is obviously the source for the first published map of Bombay harbour, which was included in John Thornton's 1703 *English Pilot. The Third Book,* with the title "A New Mapp of the Island of Bombay and Salsett". Thornton was successor in the publishing business to John Seller, whose manuscript map is preserved in the Bibliothéque Nationale, Paris. This bears no date, but Thornton must have believed that the map drawn by Ward/Webb was more accurate, and consequently used it for his publication. His atlas also contained a chart of the Ganges delta that was copied from one by William Hack.

There are records of other maps being prepared during the English struggle to gain control of Bombay, but they are no longer extant. Arnold Browne, Captain of the *Dunkirk*, had surveyed the area in 1662, but his map is known only from letters; we cannot even be sure that it actually reached London. This is the "draught" mentioned by Governor Gerald Aungier in a letter dated September 26, 1662, which he hoped to send shortly to Surat. Henry Gary also mentioned it in a letter sent from Goa on December 31, 1662. Another "Drawing of the Island of Bombay, with the Shoals and Soundings 1674", prepared by Andrew Welch, was recorded in a sale catalogue a hundred years later, but has now disappeared.

B O M B

Bombahew town

Bombahew Island

Mahim

Caiman

Sunal dagre

Salsett Island
Ston

Trombay

Eli
phant

Coronia

AHEM

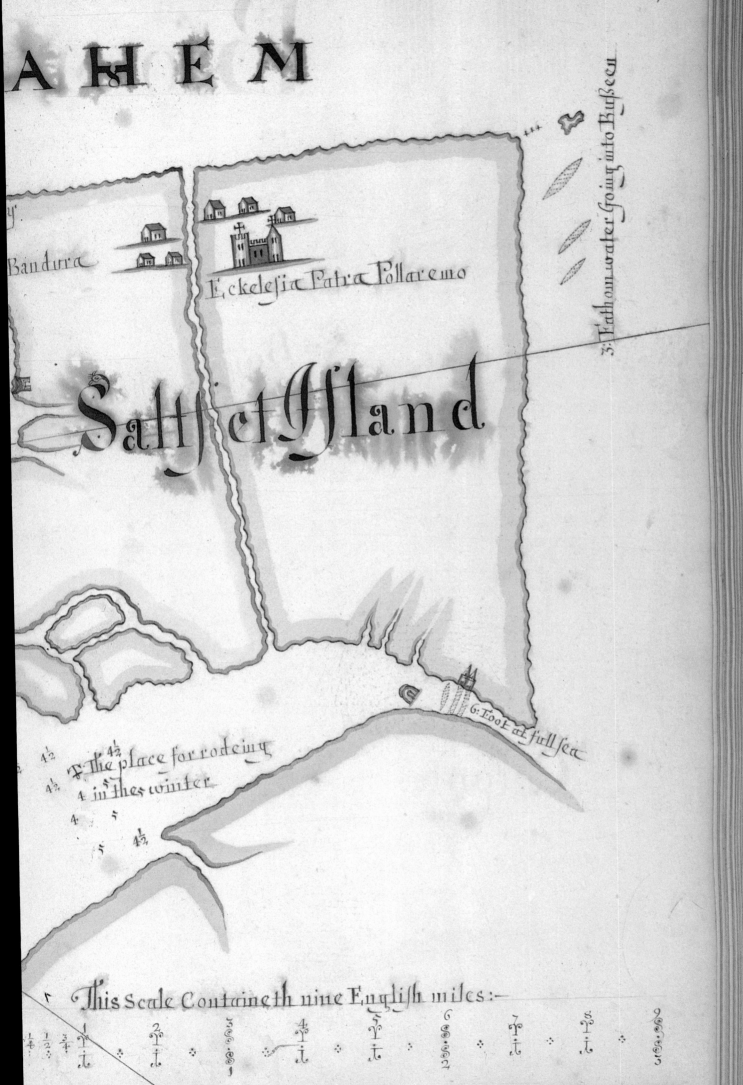

Bandura

Eckelesia Patra Pollaremo

Saltset Island

3: Fathom water Going into Bußeen

6: Foot at full Sea

4½ 4½ The place for rodeing
4½ 4 in thes winter
4 5
5 4½

This Scale Containeth nine English miles:—

¼ ½ ¾ 2 3 4 5 6 7 8 9

Three that have survived were drawn by William Hack of the Thames School of Chartmakers in London. The atlas of manuscript charts is dated 1700, and some of them are known from several copies. Possibly those of Bombay were prepared up to twenty years earlier. They are particularly interesting because all three show completely different shapes for the island of Bombay and adjacent coastline. The first, No. 14, shows one large island, and has the title "A description of Bombay which belongs to the Crown of England by the marriage of King Charles the Second with Queen Catherine". The second, No. 17, shows many smaller islands, and was perhaps prepared during the monsoon when water lay over much of the land that was dry during the rest of the year (figure 5). The third, No. 19, is on a smaller scale, and shows the island tucked partially into a large bay, on a fairly straight coastline. An interesting note is added to another map: "The City of Goa & all its dependencies doth justly belong to the Crown of England by the marriage of King Charles the Second with Queen Catherine." Perhaps it was thought that a claim to the whole of the Portuguese territory in India might hasten the release of that part which was rightly felt to be English.

During the eighteenth century, charts were included in most of the hydrographic atlases, some of them updated with new information, others repeating earlier mistakes. Although each Company ship must have carried one, few have survived. Two were published in France in 1763 (François Bellin) and 1767* (Anonymous), and another in about 1790 (copies of the 1763 and 1790 maps are in The British Library Oriental and India Office Collections), while Carsten Niebuhr's drawing* appeared in 1764.

Most of these maps were re-engraved for translations or later editions of the original books. In 1763, William Nichelson published a large-scale chart of the harbour on eight sheets, on a scale of four miles to the inch. It shows detailed depths, but very little information about land features. It was only towards the end of the century that detailed hydrographic surveys were being made all along the coasts, and it was thanks to Alexander Dalrymple

that so many of them were published (figure 6).

An interesting map has been preserved at the city's Bhau Daji Lad Museum. Known only from a later copy, it shows the island of Bombay with the English Fort, and the much larger island of Salsette (figure 7). Place names are those of the country in Marathi, not those in common use among the English. It follows the indigenous style of map-making, with as much detail given to fish in the creeks and the local shipping as to features of the terrain.

The lower half of the map, with four ships (*galbats*) depicted as they would have appeared to a spectator on the land side, represents the Arabian Sea. At the top is the mainland lying to the east, broken by three creeks painted in blue, with fish moving in various directions. Between the sea and the mainland lie Salsette Island (the larger area to the left) and Bombay Island to the right, both of which are separated from the mainland by Thana Creek and Bombay Harbour.

Fortifications

Once the English had managed to wrest control of Bombay from the Portuguese, it was necessary to improve the fortifications against marauding Europeans as well as Indian fleets and armies. Governor George Oxendon wrote to London on January 15, 1669 that one of the earliest questions to engage his attention was the defence of Bombay: and Captain Whitehorne, of the *Return,* was commissioned, with others, to make a survey of the island for that purpose. The "large draught of this island" was prepared by Captain Samuel Smith, on specially ordered Ahmedabad paper, and sent home with Whitehorne, and it was considered "the exactest of any hitherto sent to you". We cannot judge the correctness of this statement since the map is now missing.

The sketch published by John Ovington* purports to show the Fort (Bombay Castle) as it was in 1668, and it has been surmised that it was based on one drawn by Henry Gary. There are several records of surveys being made, but unfortunately we now have none of the maps that they produced. Herman Blake (or Bake) was appointed Engineer and Surveyor-General of Bombay in 1670. He spent several months on a survey to show the "Works" and rights of property, but illness prevented him from completing his work. Other surveys were ordered in 1679, 1710, and 1747, but whether any maps resulted from them is uncertain, as none has survived.

Fortunately a large manuscript plan of the fortifications, that was prepared in 1756, has been preserved in the British Library (figure 8). This was by Jacques De Funck and has the title "A Description of Bombay Town's Fortification, Castle and Dungaree Fort.

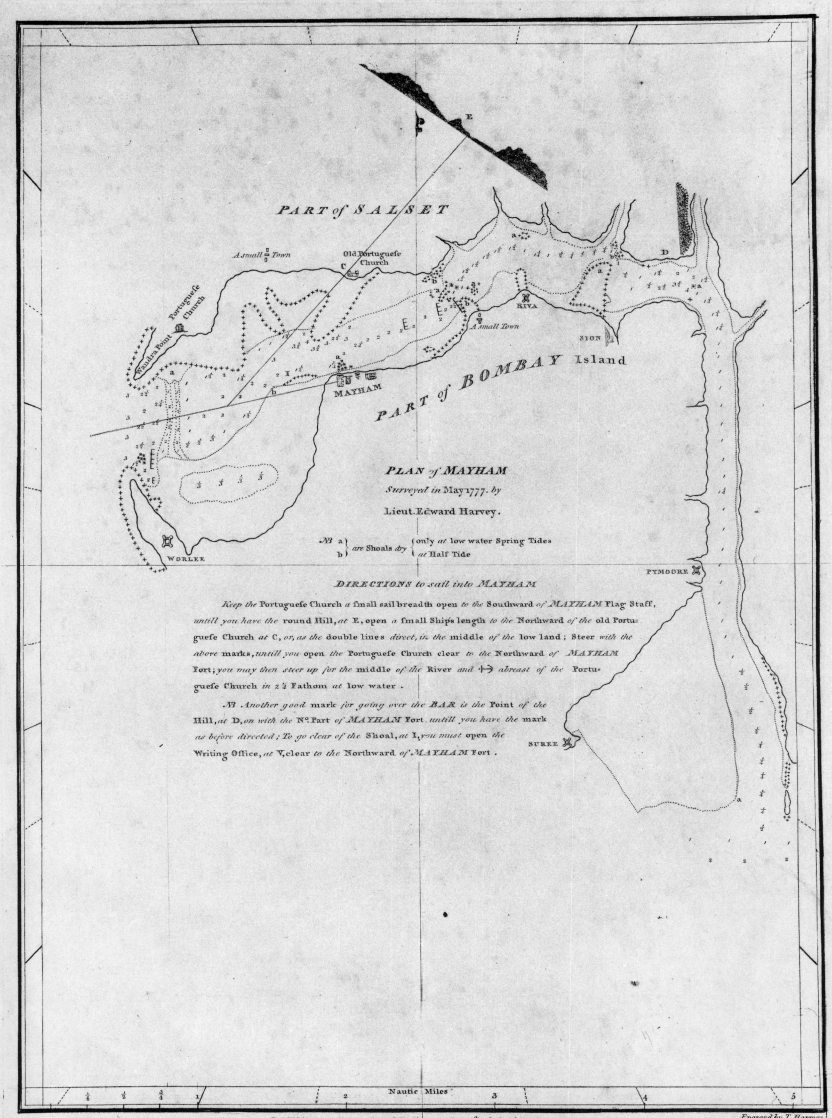

PART of SALSET

A small Town

Old Portuguese Church

D

Portuguese Church

Candra Point

RIVA

A small Town

SION

PART of BOMBAY Island

MAYHAM

WORLEE

PLAN of MAYHAM

Surveyed in May 1777. by

Lieut. Edward Harvey.

PYMOORE

NB a) are Shoals dry (only at low water Spring Tides
 b) (at Half Tide

DIRECTIONS to sail into MAYHAM

Keep the Portuguese Church a small sail breadth open to the Southward of MAYHAM Flag Staff, untill you have the round Hill, at E, open a small Ship's length to the Northward of the old Portuguese Church at C, or, as the double lines direct, in the middle of the low land ; Steer with the above marks, untill you open the Portuguese Church clear to the Northward of MAYHAM Fort ; you may then steer up for the middle of the River and →← abreast of the Portuguese Church in 2¼ Fathom at low water .

NB. Another good mark for going over the BAR is the Point of the Hill, at D, on with the N° Part of MAYHAM Fort untill you have the mark as before directed ; To go clear of the Shoal, at I, you must open the Writing Office, at V, clear to the Northward of MAYHAM Fort .

SUREE

| ¼ | ½ | ¾ | 1 | | 2 | Nautic Miles | 3 | | 4 | | 5 |

Publish'd according to Act of Parliament Jan. 7th 1781. by A. Dalrymple

Engrav'd by T. Harmar

7

Copy of a Maratha map of Bombay and District, apparently prepared originally for the Peshwa by his Agent in Bombay, probably during or after 1774.

Manuscript, original size · 26 x 36.2 cm. Bhau Daji Lad Museum, F/262. Photograph: Subrata Bhowmick, courtesy the Bhau Daji Lad Museum, Mumbai.

The Marathi inscriptions, starting with the mainland at top left anticlockwise translate as follows: "Kalyan Fort" (highlighted in red), "Kos 6" (i.e. distance from a certain point), "Parshik Bunder", "Kos 2", "Belapur Fort Sarkar" (Belapur Fort government — situated next to Panvel Creek); then clockwise as follows: "Panvel Harbour", "Karnala Sarkar", "Kos 2" (located across the creek), "Bunder Awade", "Deogarh Fort Sarkar" (below, towards the sea, probably on Great Caranja Hill).

On Salsette island clockwise from the left: "Ghodbunder" (Ghorbander District), "Prant Sasti" (Province Salsette), "Sasti Fort" (Salsette Fort, probably Thana Fort, the capital of Salsette), "Chowki Bandre Sarkar" (police or customs post, Bandra), "Yashwant Gadh", "Daravi" (Dravi Island). Both Ghorbander and Dravi Island are shown correctly adjoining Bassein Creek (extreme left), which leads into Kalyan Creek.

On Bombay Island from left to right: "Mahim", "Kos 6", "Mumbai Ingraj" (i.e. English Mumbai). The small island in the harbour is also marked "Ingraj". This is almost certainly the island of Elephanta which became an English possession in 1774, having previously belonged to the Marathas. Based on this probability, the map has been dated to during or after 1774. This map is not meant to be an accurate survey of the region. Instead, it is a diagrammatic representation with various symbols conveying important information, made perhaps at a time when the Marathas might dislodge the English from their stronghold in Bombay.

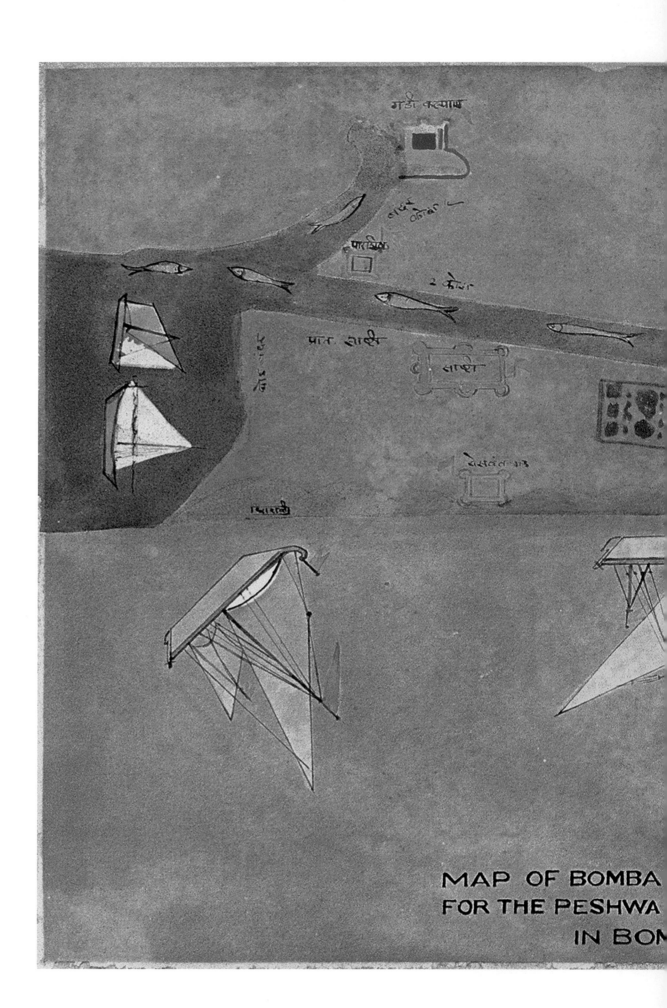

MAP OF BOMBA
FOR THE PESHWA
IN BON

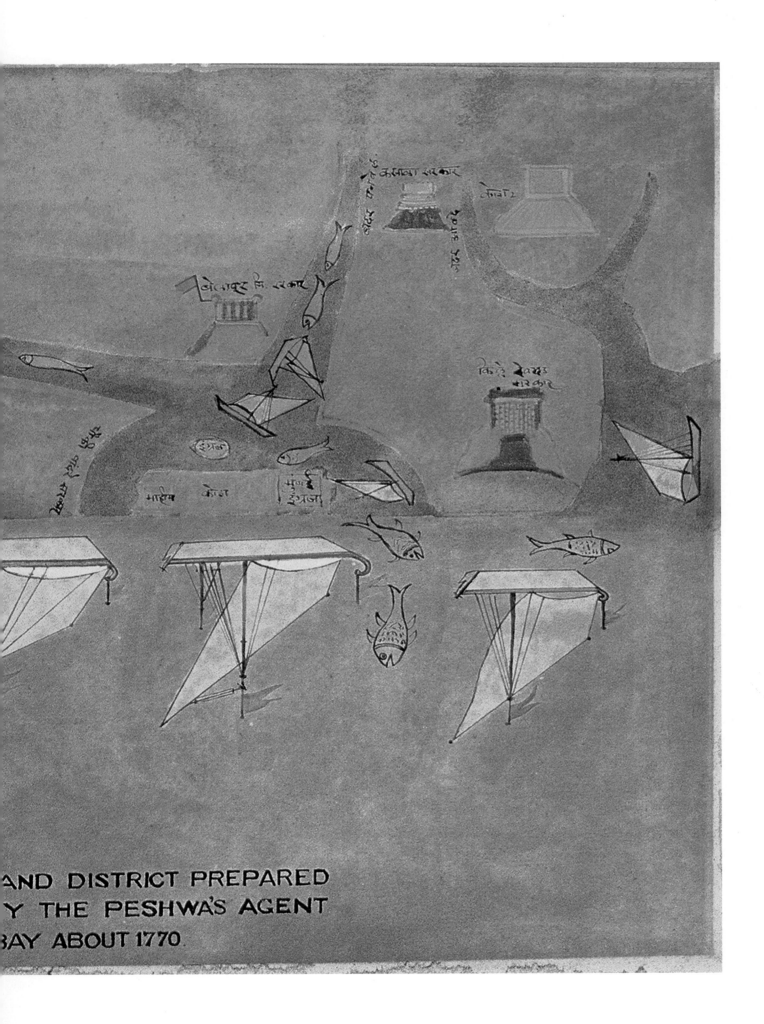

AND DISTRICT PREPARED
Y THE PESHWA'S AGENT
BAY ABOUT 1770.

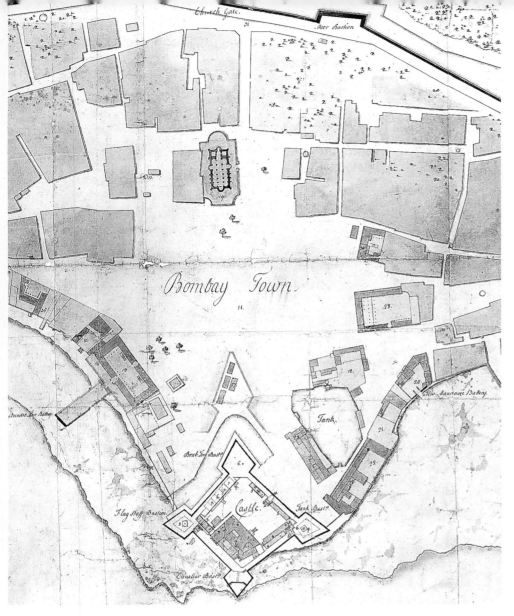

On the map: *Church Gate.* *Boor Bastion* *Bombay Town.* *Tank.* *Castle* *Flag Staff Bastion.* *Tank Bastion.*

8
Detail from "A Description of Bombay Town's Fortification, Castle and Dungaree Fort". By Jacques De Funck, drawn in 1756.
Manuscript, original size 123 x 259 cm. The British Library, K115.57. Cab.12, Roll 1; the accompanying text is at K115.57-2.
Courtesy The British Library, London.
The central part of the town is shown here, with the Castle in the lower part. Along the shore, the high and low water lines are clearly shown.
(See Key on facing page.)

Prepared for Richard Bourchier, President and Governor of the Council"; it is on a scale of 12 ³/₄ inches to 500 yards, and not only shows each path and track, the high and low water lines, separate fields, and even buildings along the roads, but it is accompanied by a report describing everything in great detail. Many residences are identified, such as "The Doctor's Lodgements" and "The Major's House". De Funck received £40 a year for his services as engineer/surveyor, in addition to his pay of £200 as captain of the artillery. He worked for three years on his survey. But as so often happened to people employed by the East India Company, an acrimonious dispute arose about the speed with which his work was progressing, and De Funck left the service a disgruntled man. He claimed that all the plans he had prepared were handed over to the Bombay government, though they complained that all they received were rough sketches, and he must have kept the better ones for himself. The copy illustrated here came to the British Library with the collections of George III, so perhaps it was never seen by the East India Company, which may be the reason for its survival.

During the wars against the French in south India, there was always a fear that they might cast envious eyes towards Bombay, and in fact maps of the town and island were published in France, emphasizing their interest. A French plan of the Fort was published in 1758 (known from a photozincographed copy of 1902)* and it differs quite markedly from that included in J. H. Grose's book of 1772.* Both show the lines of roads and the locations of important buildings, and are probably based on the large-scale plans by De Funck. By this time, there was considerable development beyond the confines of the Fort, both of the country houses of the Europeans and the crowded Indian settlements, but no map showing them was published until later.

Early Surveys

In the early nineteenth century, the Presidency of Bombay was beginning to feel its strength, and turn to better methods of collecting taxes, and running its most important town. In 1772, it had been decided that "an exact and accurate survey should be made of the whole Island, that the situation of these Villages, & of all the Honble Company's Oarts [gardens] & Grounds may be exactly laid down as well as those of all Persons whatever. ... under the directions of the Collector, whom the ... Principal Engineer must furnish with the most skilful persons for doing it." Accordingly Lieutenant Charles Turner applied, claiming he could manage the whole survey on his own, but soon after he was sent to Broach and nothing remains of any work he may have begun. Sir Charles Warre Malet actually possessed, in 1785, a sketch of Bombay harbour and its environs prepared by Captain Charles Reynolds, which he admitted had been made in a hurry "from materials that had not yet had the sanction of official authority" but he hoped to be able to forward soon "an authentic chart of these parts". Its whereabouts are not now known. William Blachford, sometime after 1792, also started a survey of Bombay Town "to ascertain the superficial measurement of each house occupied by the garrison", but it is not known if he ever completed it. William Brook[e]s was engaged on a "Plan of Bombay Fort" in 1793 on a scale of 200 feet to the inch, but it is no longer extant. He was then appointed to complete a survey of the Mazagaon Estate, and to continue his surveys through the island for "revenue purposes and political stability". The surveyors of the army were mainly employed in the triangulation and survey of the mainland's interior, and could spare few capable men to undertake the detailed work required to lay down the exact measurements of the city areas.

Collection of taxes, however, was always a strict requirement, particularly for the richer parts of the island. When Thomas Dickinson was appointed Revenue Surveyor of Bombay in 1812, the surveys were undertaken

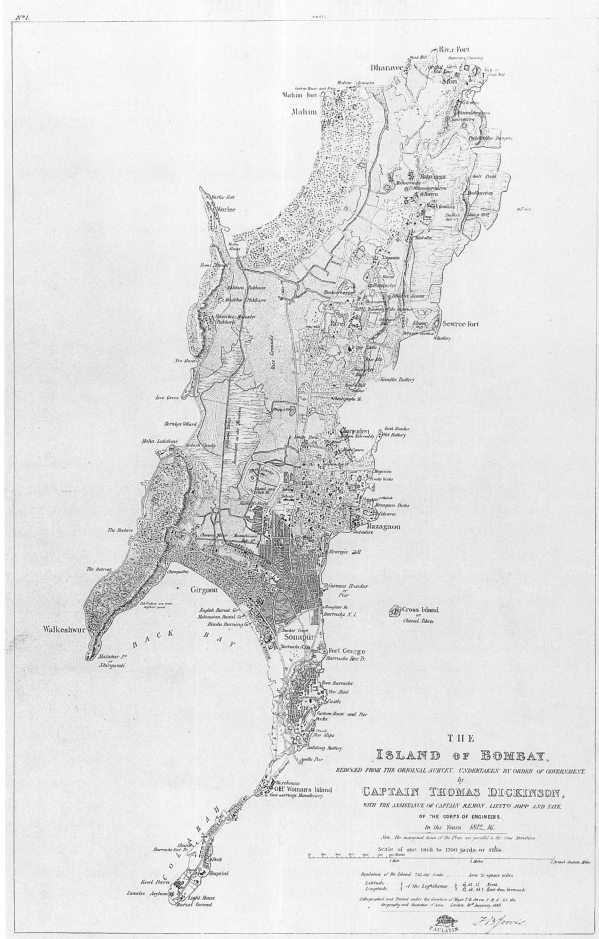

9
"The Island of Bombay, reduced from the original Survey, undertaken by order of Government, by Captain Thomas Dickinson, with the assistance of Captain Remon, Lieuts. Jopp and Tate of the Corps of Engineers. In the Years 1812-16. Lithographed and printed under the direction of Major T. B. Jervis for the Geographical Statistics of Asia, London, 31st January, 1843."
Original size 42.5 x 26.7 cm. Scale 1" to 1200 yds. The British Library, Oriental and India Office Collections, X/2622/1.
Courtesy India Office Library and Records (OIOC), The British Library, London.

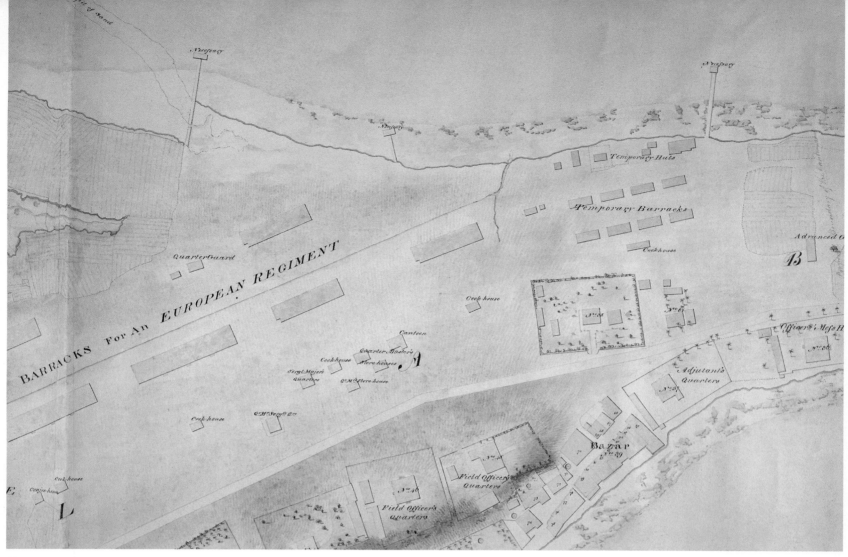

Within the map image:
Barracks For An European Regiment
QuarterGuard
Temporary Huts
Temporary Barracks
Cookhouse
Advanced O
Canteen
Quarter Masters Store houses
Serjt Majors Quarters
Q.M.Serjts house
Cook house
Q.M.Serjt Qr
Officers Mess H.
Adjutant's Quarters
Bazar
Field Officers Quarters
Field Officer's Quarters
Cook house

10

Detail from Thomas Dickinson's "Revenue Survey of Colabah and Old Woman's Island 1813", showing the Lunatic Asylum, Regimental Hospital, and Powder Magazine.
Manuscript, original size 71 x 300 cm. Scale: 1" to 100 ft. The British Library, Oriental and India Office Collections, X/2616.
Courtesy India Office Library and Records (OIOC), The British Library, London.
The great care with which these surveys were prepared can be seen from this detail. The surveyors would have drawn their measurements on smaller sheets of paper, and then fitted them all together in the office.

11

(with key)
"An Elevated View of the Islands of Bombay and Salsette, with the Surrounding Country."
Published by Robert Cribb in London, 1803, with a key (P. 1150 and P. 1151).
Coloured aquatint with etching, 40.5 x 76 cm; size of key 17.5 x 41 cm.
Courtesy India Office Library and Records (OIOC), The British Library, London.

in earnest. He held the post for nine years and after coordinating the various survey projects that were then being undertaken, he began preparing a large-scale survey of the whole of Bombay Island, Colaba, and Old Woman's Island. By 1813, he was surveying the town on a scale of 40 feet to the inch on 18 sheets, and having copies made for use in the Collector's office. The survey was then extended to Salsette. Dickinson not only made detailed measurements, despite a continual lack of support from the government and repeated reductions of his staff, but he also classified the soils and crops, and assessed the revenue to be paid on each holding. Gradually the fieldwork was taken over by Indians trained in the techniques of surveying. It was found that not only were they much cheaper to employ, they were also better able to withstand the rigours of the climate in a job that required being out in the sun day after day. Dickinson's maps remained in manuscript, so must have had a limited usefulness until a reduced copy was published in 1843 (figures 9 and 10). They were so accurate, however, that they were still of value as late as 1905.

Bombay in 1803

For those who wish to have a contemporary look at Bombay at the beginning of the nineteenth century, there is no finer way to see it than in the "Elevated View" published by Robert Cribb in 1803. He states in the dedication that it was prepared from the original picture

in the possession of Charles Warre Malet, and it was clearly produced when there was a fear of the colony being overrun by the Marathas. Many legends refer to places then held by them, such as Grisalda and Arnaul, and St Jerom's Fort at the pass by which they entered Salsette. Monajee Angria's fort on the island of Elephanta is shown, as well as his capital at "Kullabie Town" (figure 11).

While Dickinson's surveys were the first to map the whole of the island in detail, they also mark the end of the first phase of British involvement. They were prepared before the explosion of industrial development with its cotton mills and tenement building, and before the railways made the Presidency more accessible to the rest of the subcontinent. The British area around the Fort continued to be almost a planned town, but in the meantime Indian Bombay was growing to the north, and the changes in the coastline with large-scale reclamation were to make whole new areas available for development. Dickinson's maps in the early decades of the nineteenth century were found to be useful for many years, but by the end of the century it would be necessary to make regular surveys to keep abreast of the numerous changes and developments in the city.

Notes

1. Maps marked with an asterisk have been published many times. They can be found in the *Bombay Gazetteer,* Vol.XXVI, Pt 3 or in S. M. Edwardes, *The Rise of Bombay: A Retrospect* (Bombay, 1902). Edward Barlow's map has been published in C. Fawcett, *The English Factories in India* (Oxford, 1936).

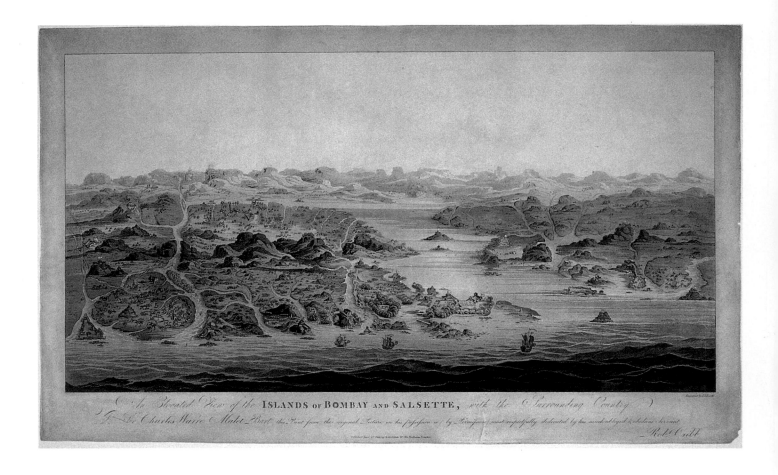

An Elevated View of the ISLANDS of BOMBAY AND SALSETTE, with the Surrounding Country

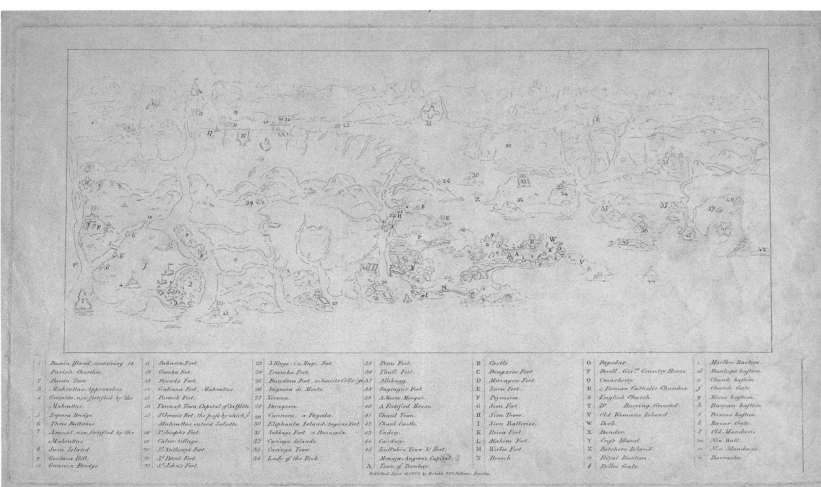

Through the seventeenth and eighteenth centuries, the British mapped the islands of Bombay from the perspective of the sea, and the city from the perspective of its harbour and Fort. Little cartographic attention was given to the land itself. There are brief records of some surveys having been made of the properties within and around the town's walls in the seventeenth and eighteenth centuries. "Survey" has often signified a non-cartographic inventory of property (whether landed or not) or an assessment of a site's suitability or quality in some respect. The early surveys seem to fall into this category; certainly, no maps have survived.[1] It was not until the nineteenth century that the British began large-scale cartographic surveys of the islands. Map literacy began to expand within the middle tiers of the East India Company's bureaucracies during the later 1700s. Bombay's administration was not an exception, and cartographic surveys slowly became a standard feature of any issue which involved real property rights.

The expansion of the Bombay Presidency's mainland territories proved to be a major factor in the increase in map literacy. The Presidency acquired the island of Salsette in 1776 and the parganas of Broach and Surat in 1803. Major growth came with the end of the Maratha wars and the cession in 1817-18 of vast territories by the Maratha princes.

The Company needed to organize the new lands. They needed to map them. The coastal strip of the Konkan, including the Bombay islands, was topographically mapped by Captain Thomas Best Jervis of the Bombay Engineers between 1819 and 1830. Jervis and his Indian assistants, whom he trained himself, mapped the country and its features at a scale of one inch to a mile (1:63,360), simultaneously collecting population statistics. Jervis also wrote lengthy memoirs describing the physical and economic geography of each district. Despite his own hyperbole for his achievement — he wrote that "there is no more important and difficult portion of the British Indian Empire so exactly, accurately, and fully

DEFINING A UNIQUE SURVEYING AND BOMBAY AFTER 1800

MATTHEW H. EDNEY

completed" — Jervis' survey was not actually very good. It was not until the late 1840s that the Surveyor-General of India could have Jervis' manuscripts properly corrected (figures 2 and 2a).

The Bombay islands are a small entity on such topographical maps, part of a much larger geographical perspective which treated all parts of British India equally. In theory, the same was true of the large-scale cadastral

1

"Geological Map of Bombay and Salsette Island." By George Buist to accompany his "Geology of Bombay". 1:126,720. Lithograph with hand-applied watercolour, 73 x 32 cm. Courtesy Royal Geographical Society, London.

City: Mapping

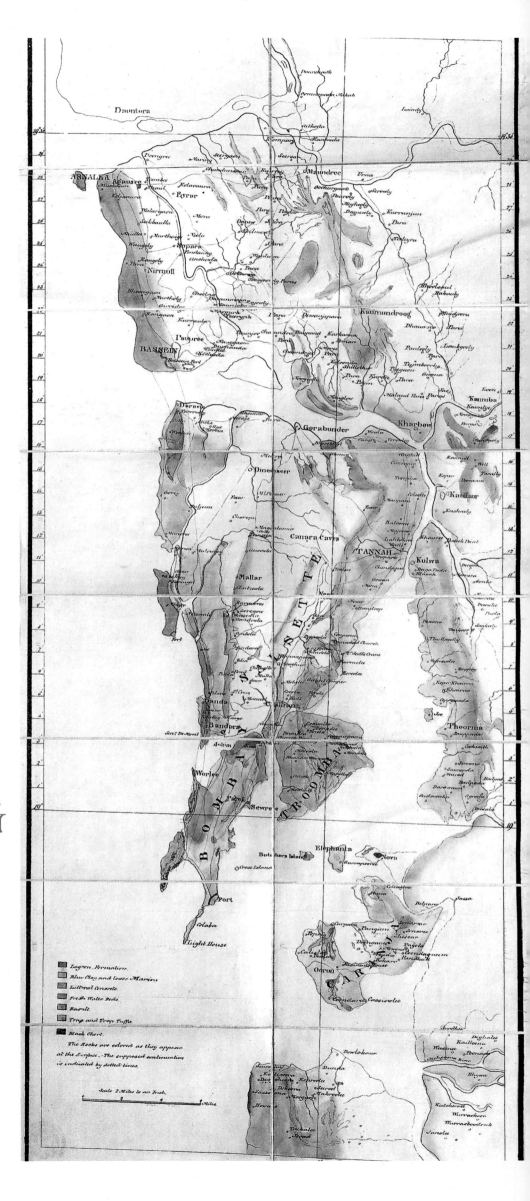

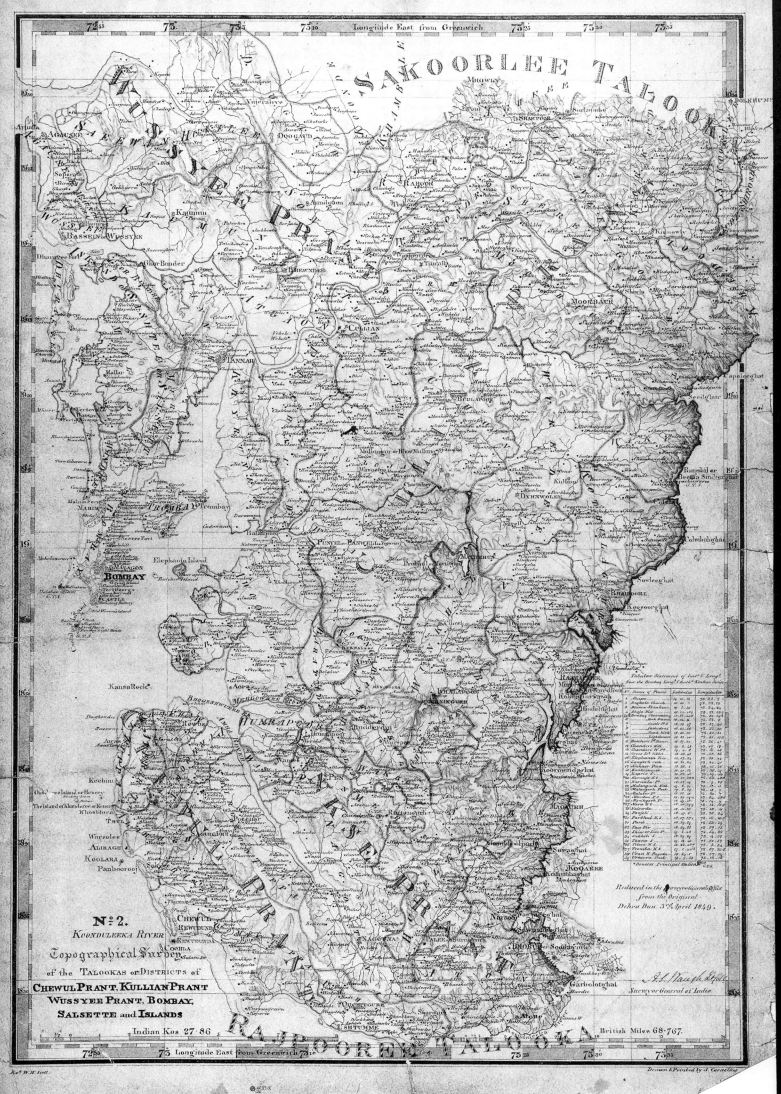

SAKOORLEE TALOOKA

WUSSYEE PRANT

N.º 2.

KOONDULEEKA RIVER

Topographical Survey

of the TALOOKAS or DISTRICTS of

CHEWUL PRANT, KULLIAN PRANT
WUSSYEE PRANT, BOMBAY,
SALSETTE and ISLANDS

Indian Kos 27·86 British Miles 68·767.

RAJECOREE TALOOKA

Longitude East from Greenwich

Reduced in the Surveyor Generals Office
from the Original
Dehra Dun 3.ª April 1849.

Surveyor General of India

Engd by W.H. Scott. Drawn & Printed by J. Cornelius

G.T.S. Denotes Great Trigonometrical Survey Stations.

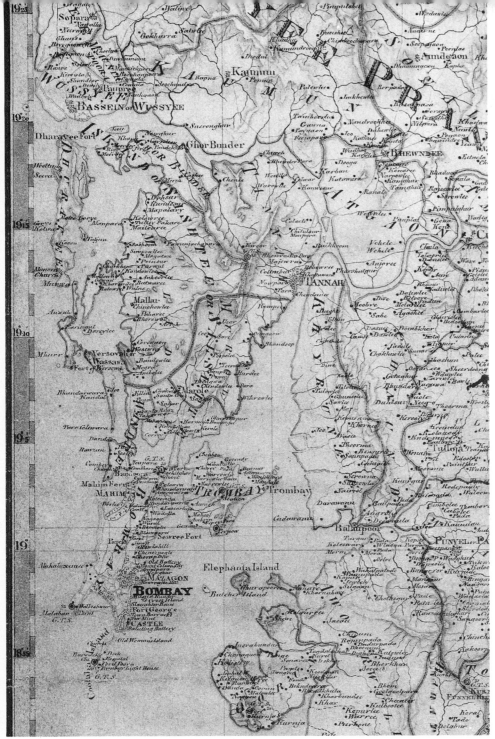

2
Topographical Survey of the Talooks or Districts of Chaul Prant, Kalyan Prant, Bassein Prant, Bombay, Salsette and Islands, sheet 2 of North and South Konkan.
Original executed by William Scott and copied onto stone by J. Cornelius, Dehra Dun: Surveyor-General's Office, April 3, 1849, ca. 1:253,440. The British Library, Oriental and India Office Collections, X/2749/2. Courtesy India Office Library and Records (OIOC), The British Library, London.
This map is one of five sheets running north-south along the coastline, reduced from Thomas Best Jervis' original surveys at 1:63,360 (1819-30) and corrected by control points determined by the Great Trigonometrical Survey.

2a
Detail of figure 2 showing the Bombay islands' region and part of the mainland.

surveys of the Bombay islands. These were designed to be no different from the cadastral surveys of the other British territories, either in their techniques or in their broader purpose of defining land tenures and ownership. However, the surveys of the Bombay islands were structured in such a way that they were effectively quite distinct from the others: a unique city required unique surveys.[2]

Defining Bombay's Basic Image:
Thomas Dickinson's Cadastral Survey (1812-27)

Two events in the early years of the nineteenth century indicated to the British that there was an urgent need for a good cadastral survey of the Bombay islands. The rebuilding of over four hundred buildings destroyed in the great fire of February 17, 1803 required the title to each property to be properly ascertained. The committee entrusted with the task proposed that a detailed land survey be undertaken to define precisely the limits of each property as the first step in a rationalization of the Company's property. In the end, however, no such survey

was made. Subsequently, in April 1811, increases in the taxes assessed on both coconut oarts and distilled toddy led to a series of riots by the coconut growers. The resultant reforms included the appointment of Lieutenant John Hawkins as a "revenue surveyor" with the explicitly non-cartographic task of counting the number of trees in each oart and of assessing their produce. Hawkins resigned in February 1812. His successor, Captain Thomas Dickinson, found the disarray in the oarts to be symptomatic of the entire islands' revenue system. Many proprietors could not even produce proof that they did indeed hold the title to their lands; there were also no less than nine distinct forms of tenure, some dating back to before the Mughal era, in the islands' eighteen square miles. Dickinson therefore proposed a series of reforms which he hoped would make the Company's rights as "lord of the land" certain and would clarify all subordinate tenancies.

A cornerstone of Dickinson's reforms was the construction of "a plan sufficiently comprehensive for every revenue purpose, and exhibiting on an immense scale, not only the exact contents and boundaries of each estate, but every species of property [tenure]". The maps themselves would be constructed at a scale of forty feet to an inch (1:480) and would include all the details of each property: boundaries, trees, buildings, gardens, etc. Dickinson would determine the types of tenures; he would also conduct a thorough population census.[3] The Governor and Council agreed.

The government seems to have accepted Dickinson's proposal for a cadastral survey, when it had rejected the proposal put forward nine years before, because a fundamental change in British policies regarding land had occurred. In Bengal and in the plains of the Carnatic, the British had settled the land on the tax-farmers (zamindars) in an attempt to create a British-style gentry. Each zamindar received the title to the lands he tax-farmed; the British then assessed the land revenues at the gross level of the entire estate. This zamindari system required the precise demarcation only of estate boundaries to prevent property disputes. When British officials in the Madras Presidency began to settle the territories annexed from Mysore (in 1792-1801), they found that Haidar Ali and Tipu Sultan had eliminated tax-farming to enhance the revenues entering their coffers.

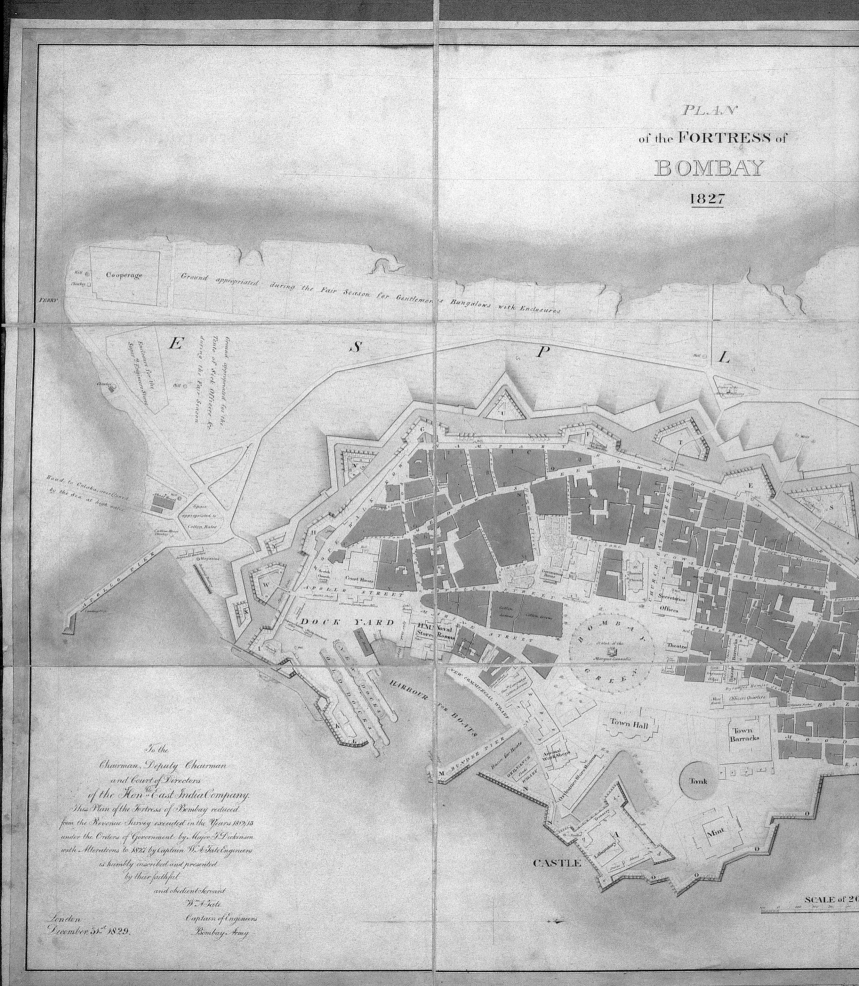

PLAN
of the FORTRESS of
BOMBAY
1827

Cooperage

Ground appropriated during the Fair Season for Gentlemen's Bungalows with Enclosures

FERRY

E S P L A

Enclosure for the Sappers & Engineers Corps

Ground appropriated for the Tents of Sick Officers &c. during the Fair Season

Road to Colaba, overflowed by the Sea at high water

Space appropriated to Cotton Bales

Custom House Chowkey

RAMPART

Court House

APOLLO STREET

APOLLO STREET

DOCK YARD

H.M.'s Naval Store Rooms

CHURCH GATE STREET

Secretaries Offices

BOMBAY GREEN

Statue of the Marquis Cornwallis

Theatre

Town Hall

Town Barracks

HARBOUR FOR BOATS

NEW COMMERCIAL WHARF

BUNDER PIER

Ordnance Store Room

Arsenal Work Shops

Tank

CASTLE

Laboratory

Mint

To the
Chairman, Deputy Chairman
and Court of Directors
of the Hon.ble East India Company.
This Plan of the Fortress of Bombay reduced
from the Revenue Survey executed in the Years 1812/13
under the Orders of Government by Major J Dickinson
with Alterations to 1827 by Captain W. A. Tate Engineers
is humbly inscribed and presented
by their faithful
and obedient Servant
W.m A Tate
Captain of Engineers
Bombay Army

London
December 31.st 1829.

SCALE of 20

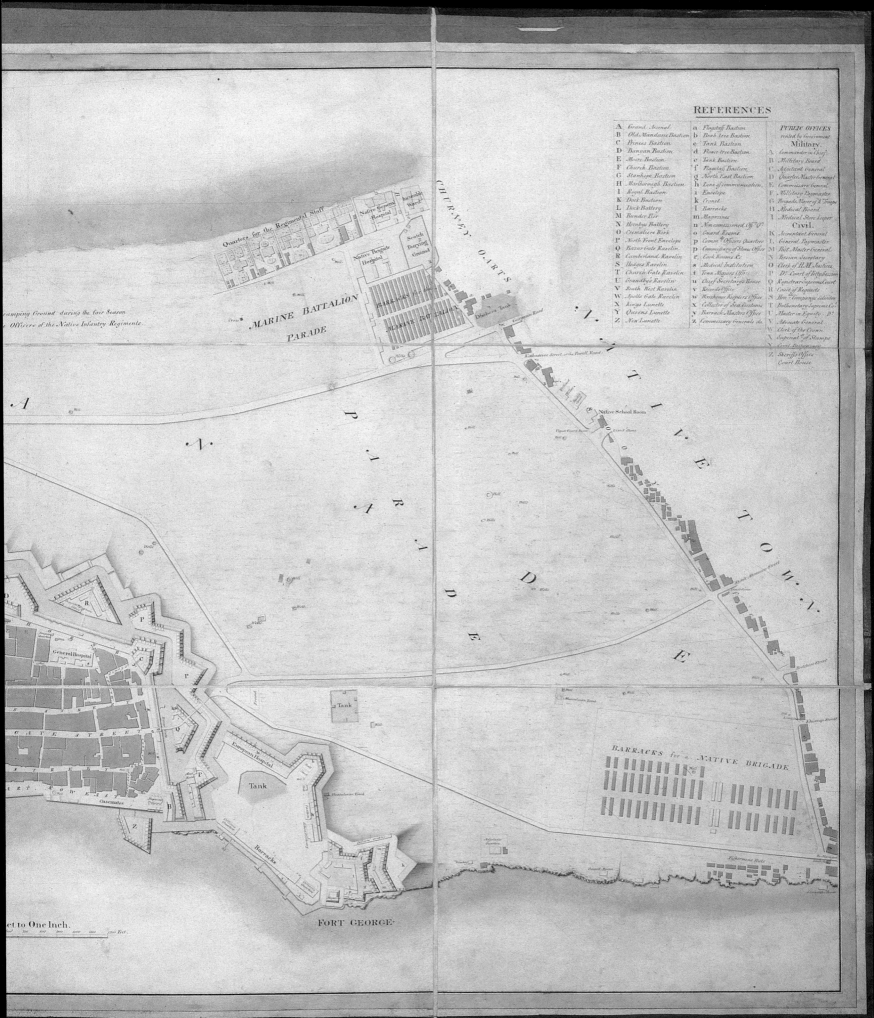

REFERENCES

					PUBLIC OFFICES
A	Grand Arsenal	a	Flagstaff Bastion		vested by Government
B	Old Mandarine Bastion	b	Brab tree Bastion		**Military**
C	Princes Bastion	c	Tank Bastion	A	Commander in Chief
D	Banyan Bastion	d	Flower tree Bastion	B	Military Board
E	Moore Bastion	e	Tank Bastion	C	Adjutant General
F	Church Bastion	f	Flagstaff Bastion	D	Quarter Master General
G	Stanhope Bastion	g	North East Bastion	E	Commissary General
H	Marlborough Bastion	h	Line of communication	F	Military Paymaster
I	Royal Bastion	i	Envelope	G	Brigade Mayor of Troops
K	Dock Bastion	k	Cronet	H	Medical Board
L	Dock Battery	l	Barracks	I	Medical Store keeper
M	Bunder Pier	m	Magazines		**Civil**
N	Hornby Battery	n	Non commissioned Offr Qrs	K	Accountant General
O	Cremailiere Work	o	Guard Rooms	L	General Paymaster
P	North Front Envelope	p	Commn Officers Quartres	M	Post Master General
Q	Bazar Gate Ravelin	q	Commissary of Stores Office	N	Persian Secretary
R	Cumberland Ravelin	r	Cook Rooms &c	O	Clerk of H.M. Justices
S	Hodges Ravelin	s	Medical Institution	P	Dr Court of Petty Session
T	Church Gate Ravelin	t	Town Majors Offe	Q	Regr of Supreme Court
U	Grandbys Ravelin	u	Chief Secretarys House	R	Court of Requests
V	South West Ravelin	v	Records Office	S	Prothonotary Supreme Co
W	Apollo Gate Ravelin	w	Warehouse Keepers Office	T	Master in Equity Do
X	Kings Lunette	x	Collector of Sea Customs	U	Advocate General
Y	Queens Lunette	y	Barrack Masters Office	V	Clerk of the Crown
Z	New Lunette	z	Commissary Generals do.	W	Superind of Stamps
				X	Civil Dispensary
				Z	Sheriffs Office
					Court House

CHURNEY OARTS

Quarters for the Regimental Staff

Native General Hospital

Incurable Ward

Native Brigade Hospital

Scotch Burying Ground

...camping Ground during the fair Season

...Officers of the Native Infantry Regiments.

MARINE BATTALION

PARADE

BARRACKS for the

MARINE BATTALION

Dhobers Tank

Gorgumm Road

Kalhadeere Street, or the Purell Road

N A T I V E P A R A D E

N A T I V E T O W N

Native School Room

Vepat Guard Room

Loves Street

Crank Booming Street

Butchers Street

GATE STREET

General Hospital

European Hospital

Tank

Casemates

Barracks

Tank

BARRACKS for a NATIVE BRIGADE

Fishermans Huts

...et to One Inch.

FORT GEORGE

The settlement officers now settled the land directly on individual "proprietors" (ryots). The ryots were given the title to the land that they farmed and land revenues were assessed by the field. The ryotwari settlement was, by 1810, accepted throughout British India as the preferred revenue system because of the argument that it would promote a free peasantry.[4] The Bombay administrators were also sympathetic, even though at that time they had responsibility for little territory, and so approved Dickinson's plans to cut out the middlemen and to deal with individual cultivators directly.

Ryotwari settlement required the precise delimitation of each field boundary and its area. A laborious cadastral survey was therefore necessary. Dickinson did not, however, receive the necessary help. Some junior military officers were detached to help him, but all were returned to their regimental duties within five years; the one exception was Lieutenant William Tate who extended the survey onto Salsette Island in January 1814.[5] Dickinson himself was often required to undertake more pressing engineering tasks, so much so that the survey was almost moribund when he was finally removed in 1821. Very early in the survey, in 1813, Dickinson did produce finished maps of Bombay town and of Colaba and Old Woman's Island, perhaps in an effort to demonstrate the worth of his work to the government (see Gole: figure 10).

After 1821, Tate had sole responsibility for the survey. He quickly implemented a system that had been tried and tested in the Deccan: he recruited and trained Indians to undertake the detailed cartographic survey, which then left him free to settle titles and to assess revenues. The survey was completed in 1827. The original plans — at 40, 100, or 300 feet to an inch (1:480, 1:1,200, 1:3,600) — remained in manuscript. From these, Tate made several maps at reduced scales, such as a plan of the Fort at 200 feet to an inch, 1:2,400 (figure 3) and general maps of the whole island at various scales between 1826 and 1831.[6]

The Dickinson-Tate survey defined the basic cartographic image of Bombay islands and town for the rest of the century. The image was of course frequently updated as the island city grew and changed. Nonetheless, the survey was sufficiently comprehensive and accurate so that each subsequent cadastral survey added to the details but did not supplant the image itself. The image was initially set by Tate's manuscript maps, with multiple copies being made as needed for various government departments. As the time taken up in copying maps increased with demand, and as the Company's strictures against keeping maps in manuscript form to ensure their secrecy weakened, maps began to be printed in India and London, by both the government and commercial printers. One important factor was that the quality of maps lithographed in Bombay was not as good as those produced in Calcutta and Madras, let alone those in London; it does not seem to be until later in the century and with the introduction of photozincography that the quality improved.[7]

Perhaps the first printed image derived from the survey was a rather crude copy of the southern portion of Tate's map of the Bombay islands at 1:14,400, published in Bombay by one P. White in the 1830s. But it was not until 1843, however, that the Dickinson-Tate outline of the Bombay islands was printed neatly, and slightly reduced to 1:31,200 by Thomas Best Jervis during his second career as a London map publisher (see Gole: figure 9). Jervis' image was in turn copied by others, as for example in an inset showing Bombay on a map of about 1865 of the railway lines of the Great Indian Peninsula Company.[8]

Defining Bombay's Physical Structure: Topography and Geology

Beneath the surface network of property lines lies the physical island group itself, which was not immune from British attention. R. X. Murphy, a member of the Bombay Geographical Society, was drawn to the topic first in the 1830s, but only by accident. His initial intention had been to establish ethnological distinctions among the inhabitants of Bombay. A thirteenth-century manuscript mentioned Mahim island and Murphy realized that what he had always thought of as one island had once been several distinct islands separated by tidal flats. He promptly set out to define Bombay's original configuration. Given his linguistic interests, Murphy's principal sources of evidence were toponyms. Thus, the "neighborhood of the [Mazagaon] gaol is termed Oomer-khadee" and because "*khadee* is always applied to salt water creeks nearly dry at low, and covered at high water," that land must once have been subject to tidal inundation. With such toponyms, local traditions, and some accounts of the Company's construction of dikes in the early eighteenth century, Murphy modified the

COPY of a MAP
of the
Island of Bombay and Colaba
To illustrate Mr Murphy's paper Page 135

Scale 3000 Feet to an Inch

Dickinson-Tate image of the island to map out seven original islands (figure 4). The reconstruction is still seen as definitive even though it would not be considered particularly rigorous if it were done today because Murphy did not make use of any geological knowledge.[9]

Conversely, when the secretary to the Bombay Geographical Society sought information to construct a geological map of Bombay, Salsette, and portions of the mainland, he used Murphy's reconstruction to help distinguish between the older rocks and the more recent sediments (figure 1). George Buist made his map in about 1850, drawing on any exposures of the islands' structure that he could find, from wells and records of house foundations to the most recent construction works. Little effort had been made in the past to collect such information (although many analyses of the various rocks and sediments had already been published) so that Buist had only a smattering of data-points from which he could make only a rather small-scale map. Buist derived the islands' general structure (shown in dashed lines) from Murphy's map and by extrapolating from the geological patterns of the larger area. Of special interest is how Buist solved the issue of reproducing in colour. Before colour lithography was perfected, the only option was to apply colour by hand. But that was too expensive for a private individual. Buist instead employed youths at the School of Industry (set up in 1850 as a means of keeping orphans off the streets and out of prison, and in which they were trained in a variety of crafts) to colour his maps and geological cross-sections at the remarkably cheap rate of, on average, one rupee for a hundred illustrations. Of course, as Buist warned his readers, the quality of the colouring was not the best, but it was better than nothing and provided an opportunity to reform wayward children.[10]

At about the same time as Buist's map was published, the Indian government established the Geological Survey of India. The new Survey's principal task was to locate and study economically important mineral deposits. In the process, the geologists did produce some geological studies which were not entirely economic in character. Thus, A. B. Wynne, an assistant of the Geological Survey, made a close study of the geology of Bombay in 1864, as part of a larger survey of western India formed in 1863. Wynne's sources were similar to

GEOLOGICAL MAP

OF THE ISLAND

OF

BOMBAY

Approximate Scale.

Bombay Light House [Lat. N. 18. 53. 40 / Long E. 72. 51. 10] From G. T. S. Bombay Long.ᵈ Series

Geologically mapped by A. B. Wynne.
F.G.S. Assistᵗ Geol: Surv: of India 1864.

COLOURS. &c.

Alluvium and other Superficial deposits 7
Basaltic Trap of Malabar Hill 6
Fresh water Beds, Shales and Flags 5
Amygdaloidal Trap 4
Gray Trap with Shales interstratified 3
Sion breccia 2
Black rock of Antop hill & Felstone 1
Dips
Horizontal Beds
Fossil localities

On stone by Romanauth Dass.

LITHᵈ BY H. M. SMITH SURVEYOR GENERAL'S OFFICE CALCUTTA AUGᵗ 1865.

5
"Geological Map of the Island of Bombay."
By A. B. Wynne, Calcutta: Surveyor General's Office, August 1865, lithographed by Romanauth Dass, to accompany Wynne's "Geology", plate 1 (see note 11), ca. 1:95,000.
Lithograph with hand-applied watercolour, 23.3 X 40.9 cm.
Courtesy India Office Library and Records (OIOC), The British Library, London.

6
"Map of the Island of Bombay Completed to 1866."
Bombay, 1866, 1:7,200. The British Library, Oriental and India Office Collections, X/2625.
Lithograph with hand-applied colour and hill shading, each sheet 71 x 50.8 cm.
Courtesy India Office Library and Records (OIOC), The British Library, London.

Buist's but he was able to take advantage of the geological formations exposed by the more recent construction of railroads and sluices and the extension of the waterfront. The result is a very detailed and much larger-scale map, based on Jervis' lithograph but with numerous additions (figure 5).

A comparison of the two maps reveals some broad similarities, particularly in the two bands of hard metamorphic rocks forming the islands' western and eastern ridges with the recently deposited alluvium in between. As might be expected, however, Wynne's study differs greatly regarding precise detail. And, of course, because the map was produced under the aegis of an official government agency, the cost of hand-colouring was not a barrier.[11]

Defining New Lands: Extending the Foreshore and Filling the Interior

The eighteenth-century reclamation of the interior of the islands was only the start of a long process of substantial human modification of Bombay. In the nineteenth century, the city steadily expanded northwards, with houses, railway lines (the first line opened in 1853), warehouses, and industrial mills (first in 1854) consuming the agricultural land. After 1860, the entire foreshore of Bombay was progressively reclaimed using material from levelled hills, in part to eliminate the sewage-polluted shallows and in part to provide new dock and industrial facilities as well as space for buildings which would be properly commensurate with the splendour of the British Raj.[12] One obvious result was that Colaba and Old Woman's Island were transformed into a promontory of the larger Bombay Island. A second was that a huge fund of information for Buist, Wynne, and other geologists was uncovered. All this growth required planning and management, and therefore numerous large-scale maps.

The process of reclamation of the foreshore is reflected in two maps produced in the 1860s (and based on the Dickinson-Tate image of Bombay). The first, an anonymous manuscript sent to London for the information of the bureaucrats in the India Office, illustrates the coastline south of Mazagaon with all the various projects colour-coded according to the institutions responsible for the reclamation (public or private consortium) and the state of each project, in progress or

proposed. Progress by the middle of the decade can be seen in the second map, printed in 1866, which shows the extensive areas claimed for reclamation around the entire southern portion, merging with Colaba and Old Woman's Island (figure 6). The new docks north of the Fort are seen to be half completed, and the Back Bay reclamation is proceeding apace to allow for an expansion of the Esplanade and for a second railway corridor. North of the city, the region is still quite agricultural, but already the railroads and several new, very regular roads are promoting urban sprawl.

Furthermore, the spot heights behind the great breach (Hornby Vellard) between Malabar Hill and Worli indicate the attempts to drain the final areas of marsh and standing water.

The expansion of the Esplanade was a reaction to another urban development of the 1860s: the removal of the Fort's ramparts to make more space for government and commercial buildings. Funded in part by the sale of lots on the newly available space,[13] this development consumed the interior portions of the original Esplanade, requiring new land to be added on its outer edge. The proposed use of the new space is shown in a spectacular 1864 bird's-eye view produced by the Rampart Removal Committee (figure 7). From high above Back Bay, we look down on the site of the former Fort, soon to be dominated by a ring of major buildings, such as the High Court, and on a coastline which would have been quite unrecognizable to an inhabitant of Bombay in 1800.

Defining a Unique City: Bombay and the Presidency Revenue Surveys

As important to the later nineteenth-century reform of Bombay city as the extension of the foreshore were internal improvements. The old wells and "sweeper's passages", the open-air sewers, were replaced by water mains and sewage systems. New thoroughfares were run through the congested "Native Town". For these purposes, completely up-to-date, large-scale maps of the city and island were necessary. The older maps, based on Dickinson's and Tate's work, were simply not adequate for the task. The result was the undertaking of a second

cadastral survey of Bombay, supervised by Major (later Lieutenant-Colonel) George Laughton, between October 1865 and November 1872.

The final maps were of sufficiently large scale — 1:480 (in the town) or 1:1,200 (in the rest of the island) — to encompass "every house, the court-yards of houses, all private passages, door steps, lamp posts, water and fire plugs, wells, drains, gutters, &c., in fact everything that is a fixture, and which could be shown on a scale of 40 feet to an inch, or in other words, every fixed object of the size of a foot square". The surveyors also determined the

FORT and ESPLANADE BOMBAY.
Birds Eye View
SHEWING PROPOSED ARRANGEMENTS

B

relative heights of a large number of places across the islands, and around the coast, in order to help define the implementation of the new drainage, sewer, and water lines. The heights themselves were determined with respect to a point on the steps of the Town Hall which was arbitrarily assumed to have a height of 100 feet. The predicted cost was over £30,000 but from the start it was expected that about one-third of this sum would be recouped by selling the maps.[14]

Laughton's survey produced some 210 sheets, each the same size, one hundred at the smaller scale, the remainder at the large. Laughton ensured that the same symbols and design were used on each sheet, regardless of the scale. Figure 8 is a 1:1,200 sheet, covering the eastern edge of the original island of Mahim. It is clearly demarcated by its walled coconut plantations, and the largely treeless rice fields on neighbouring reclaimed land, crossed by drainage ditches, and by both the Bombay, Baroda and Central India Railway, and the Great Indian Peninsula Railway. This distinction in the map's symbolism, highlighting the geological variegation of Bombay, is actually visible on all the general maps. Figure 9

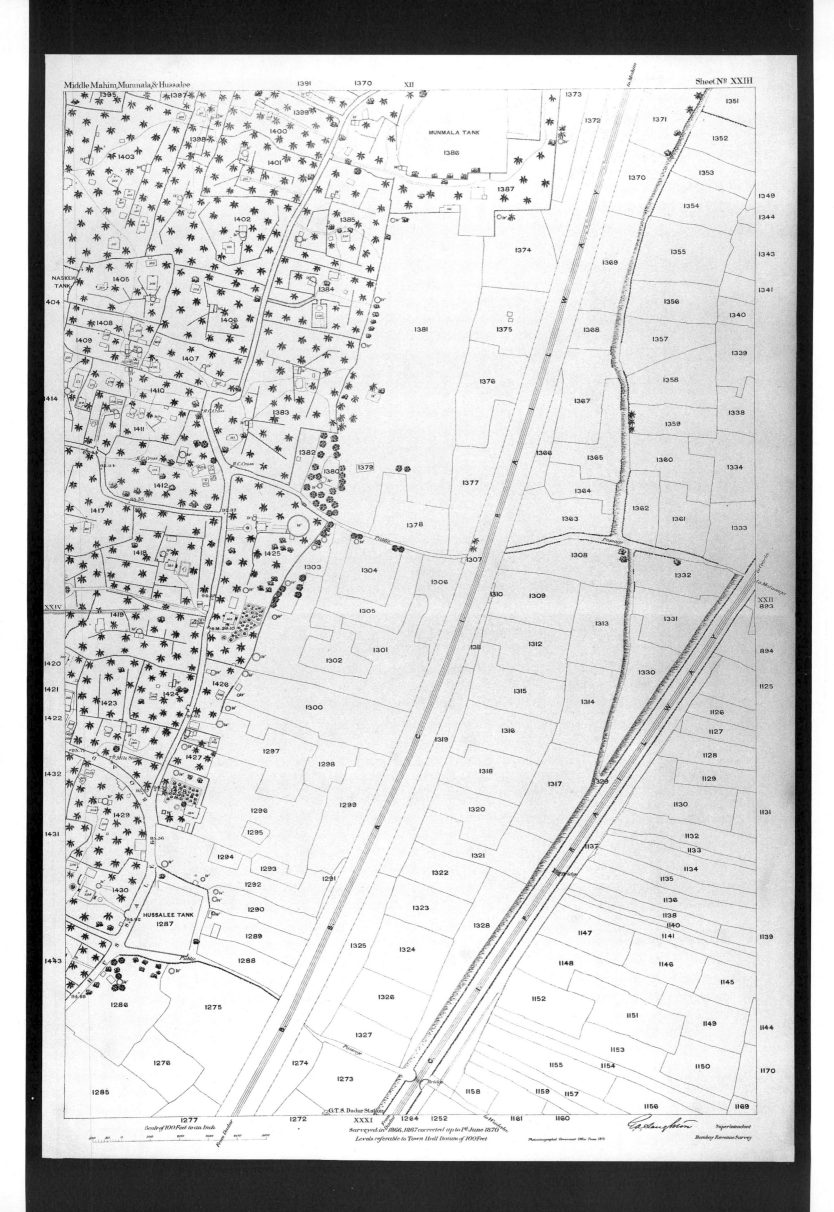

MUNMALA TANK

NASKEH TANK

HUSSALEE TANK

G.T.S. Dadur Station

Scale of 100 Feet to an Inch

Surveyed in 1866, 1867 corrected up to 1st June 1870.
Levels referable to Town Hall Datum of 100 Feet

Photozincographed Government Office Press 1871

Superintendent

Bombay Revenue Survey

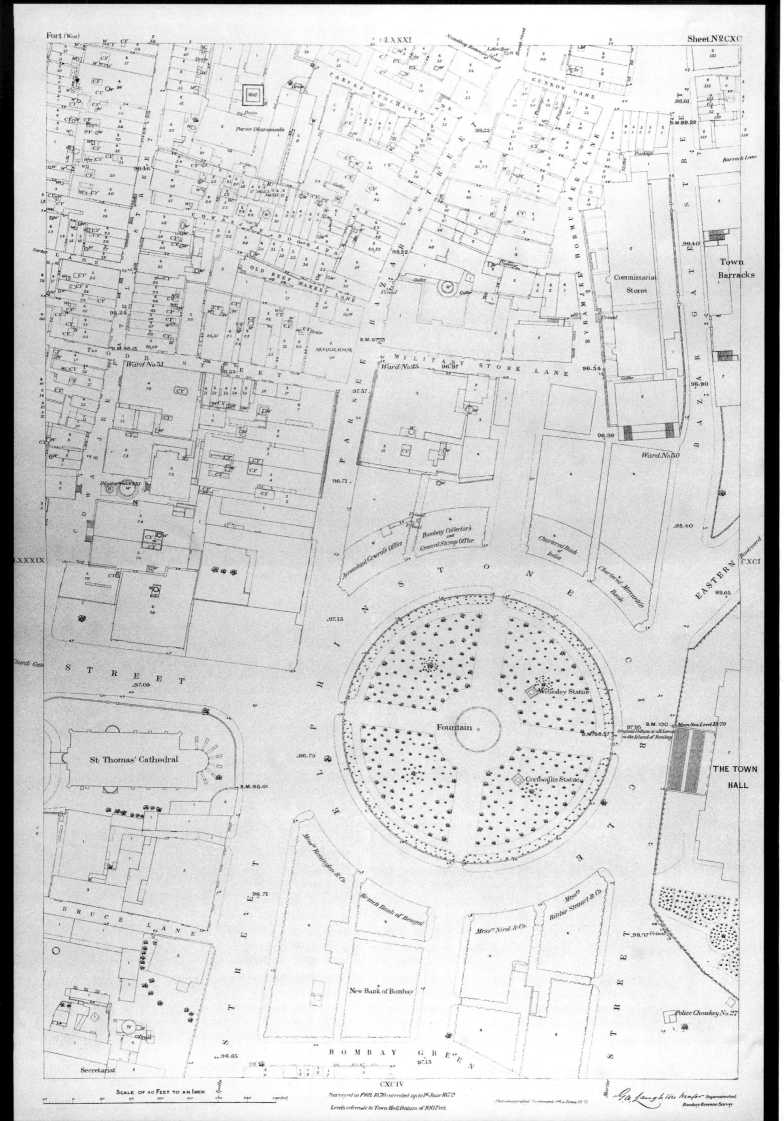

CLXXXI

PARSEE PUNCHAYET LANE

GUNBOW LANE

Barrack Lane

BYRAMJEE HORMUSJEE LANE

Town Barracks

Parsee Dhurumsala

Commissariat Stores

COWASJEE PATELL STREET

BAZAR

OLD BEEF MARKET LANE

B.M.99.22

.98.61

.98.22

.98.24

MILITARY STORE LANE

96.34

Ward No 25

96.97

98.90

97.57

96.89

Ward No 30

98.40

98.65

PARSEE

Ward No 31

BAZAR

STREET

DODD STREET

Bombay Collector's and General Stamp Office

Accountant General's Office

Chartered Bank of India

Chartered Mercantile Bank

EASTERN Boulevard CXCI

COWASJEE STREET

LXXXIX

96.71

97.13

ELPHINSTONE CIRCLE

Wellesley Statue

Church Gate

STREET

.97.05

Fountain

B.M. 100 Mean Sea Level 1870

B.M. 98.57

THE TOWN HALL

St. Thomas' Cathedral

96.75

B.M. 98.01

Cornwallis Statue

Messrs Remington & Co.

BRUCE LANE

96.71

Branch Bank of Bengal

Messrs Nicol & Co.

Messrs Ritchie Stewart & Co.

.98.37

STREET

New Bank of Bombay

Police Chowkry No 27

Secretariat

Apollo

BOMBAY GREEN

96.85

97.13

SCALE OF 40 FEET TO AN INCH

Surveyed in 1869, 1870 corrected up to 1st June 1872

Levels referred to Town Hall Datum of 100 Feet

Photozincographed Government Office Poona 1872

G.A. Laughton Major Superintendent

Bombay Revenue Survey

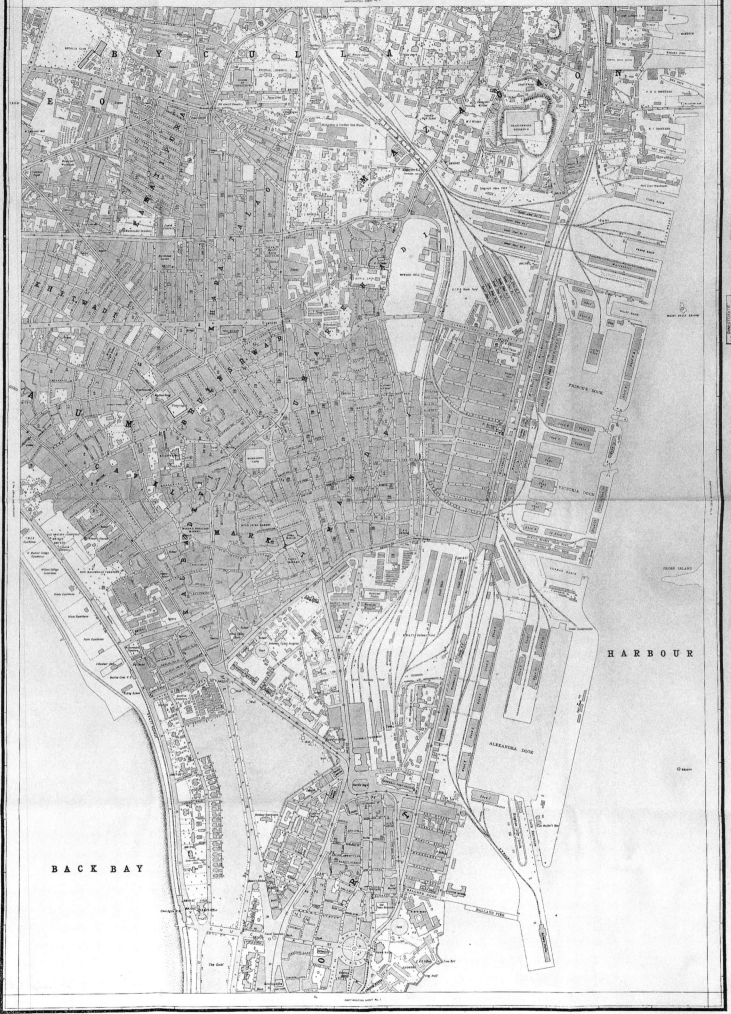

BACK BAY

HARBOUR

Supdt: Bombay City Survey

REFERENCES & SYMBOLS

BENCH MARK HEIGHT	+BM1090	AVIARY	Av	POST OFFICE	PO	JEWISH SYNAGOGUE	JS
TEMPLE		SCHOOL	Sch	TELEGRAPH OFFICE	TO	FIRE BRIGADE STATION	FBS
MOSQUE		POLICE CHOWKI	PC	POST & TELEGRAPH OFFICE	PTO	TRAM LINE	
CHURCH	Chl	POLICE STATION	PS	RAILWAY STATION	RS	RAILWAY LINE	

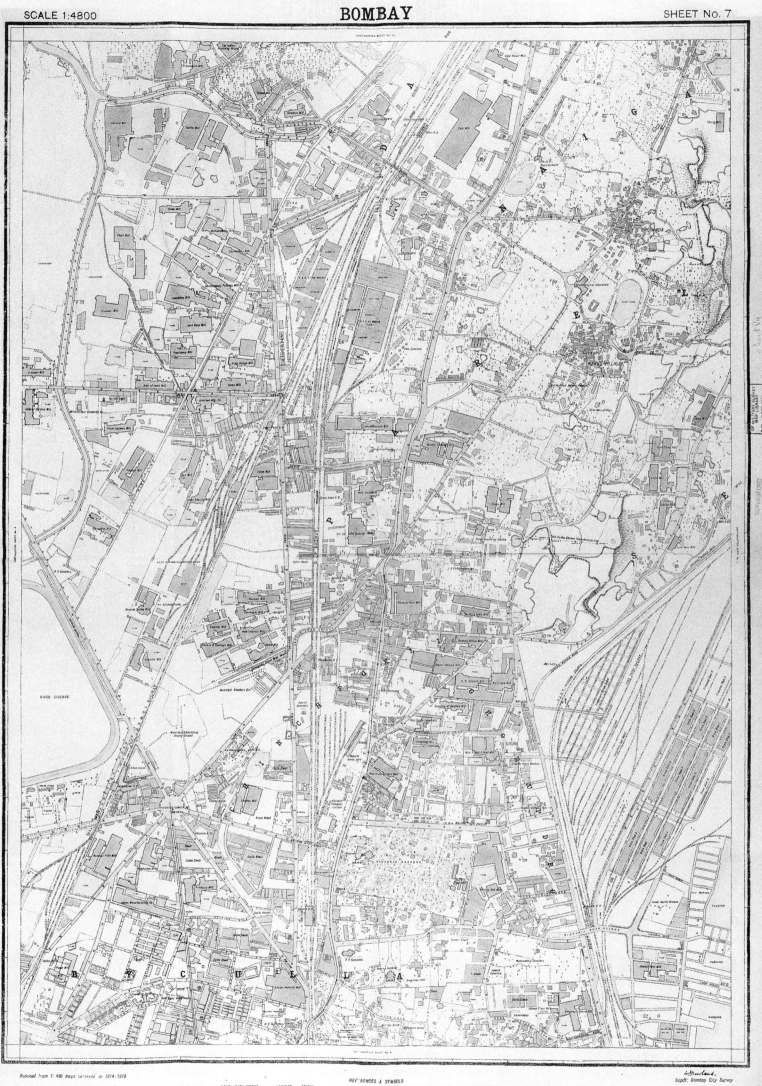

Reduced from 1: 480 maps surveyed in 1914-1918

REFERENCES & SYMBOLS

BENCH MARK HEIGHT	BRIDGE	AVIARY ... Av	POST OFFICE ... PO	JEWISH SYNAGOGUE ... JS
TEMPLE		SCHOOL ... Sch	TELEGRAPH OFFICE ... TO	FIRE BRIGADE STATION ... FBS
MOSQUE		POLICE CHOWKI ... PC	POST & TELEGRAPH OFFICE ... PTO	TRAM LINE
CHURCH ... Ch		POLICE STATION ... PS	RAILWAY STATION ... RS	RAILWAY LINE

Supdt. Bombay City Survey

is a 1:480 sheet of the western edge of the Fort. The dominant feature is Elphinstone Circle with the Town Hall to the right. On the steps to the latter is the benchmark for all Laughton's levels. The maps were generally recognized as being of outstanding quality. Aitken referred to the "beauty and correctness of these surveys".

W. G. Pedder, the Municipal Commissioner, announced the completion of the survey and of "the publication of Colonel Laughton's admirable survey maps"; he also looked forward to being able to implement a regular scheme of street names and addresses now that he could determine which streets existed. The survey sheets were also reduced to a single map, about six feet high, of the entire island at a scale of 1:2,400.[15]

There were some problems, however, which might have seriously affected the survey. Police had to keep the crowds away from the surveyors while they worked in the congested "Native Town". Furthermore, the regular surveyors, all brahmins, refused to enter the sweepers' passages so that low-caste surveyors had to be specially employed. The most serious problem was formed by the objections to the surveyors' rights of entry into houses in order to delimit yards and private wells. However, the Municipal Commissioner and his subordinates had already, in 1865, been empowered by the Presidency government to enter any private property on official business; armed with printed notices, the surveyors could thereafter access and map all areas of Bombay.[16]

Laughton's survey was undertaken as part of the general scheme of cadastral mapping and ryotwari settlement in the Bombay Presidency. The first such surveys were begun even as Tate completed the first Bombay survey; they were substantially reformed in 1837-41. Laughton had himself worked on the Deccan cadastral surveys before being entrusted with the mapping of the Bombay islands. He was well versed in the necessary techniques. Indeed, the island survey seemed to be no different from the others on the mainland. A necessary component of these surveys was the precise fixing and registration of property boundaries. In Bombay city, Laughton's men drove iron stakes into the ground at the junction between properties and the city established regulations to ensure that they would not be tampered with; more generally, they compiled detailed lists of properties and ownerships. But there the similarities ended. The mainland surveys were, first and foremost, agricultural in character and were not designed to assess suburban and urban property. The value of such property is derived not from its agricultural quality but from its location in or near a city. Starting in 1863, with Ahmedabad in Gujarat, the Bombay Presidency began a new series of "city surveys" to take such economics into account. Bombay's inhabitants were immediately threatened because the city surveys entailed the confirmation of tenures, which had already been accomplished under Dickinson and Tate. Were the new surveys an attempt to evict residents? Such concerns led the government in 1868 to write explicitly in revised regulations adopted for the city surveys that they "shall not apply to the City of Bombay".[17]

Bombay was the first city in western India to industrialize and to expand far beyond its historic centre. Laughton's survey had difficulty in keeping track of all the changes. Although his maps might appear to present a snapshot of each portion of the city at particular moments, each finished sheet was subject to extensive corrections in manuscript. And, of course, the industrial and urban expansion did not stop when Laughton finished his work in 1872. The need for a completely new survey had become obvious by the turn of the century. Indeed, it was so obvious that it was not even postponed by the First World War: the new survey was made between 1914 and 1918 at a uniform scale of 1:480. It progressed faster than Laughton's because it dealt only with geometry; the register of properties had already been established by Laughton. Figures 10 and 11 are taken from a reduced, twelve-sheet version at 1:4,800 showing, firstly, the northern edge of the old Fort, long since defenestrated, and part of the original "Native Town", which has been extensively modified, and secondly, an area of mills in the centre of the islands. These maps benefited from technological developments, so that their colours were printed: light blue for stationary water; dark blue for canals and coast; pink for buildings and towers (such as those for electric transmission lines); yellow for roads; green for grassy, park areas; and amber for the hachures which highlight relief.

The survey of 1914-18 was the last undertaken of Bombay under British rule; thereafter its maps were simply updated as necessary by the municipal authorities.

The cadastre became a palimpsest of changes and historical development to rival that of the Dickinson-Tate image of the whole island. This rich sequence of mapping makes Bombay unique in western India. In India as a whole, only Madras and Calcutta have a similar tradition. Unlike the other cities of the region, Bombay was a British city and was treated as such. The unambiguous legal pronouncement of 1868 simply enshrined the economic uniqueness of the city and island which was already being manifested in its cartography.

Abbreviations

BL-British Library, London
OIOC-Oriental and India Office Collections, The British Library, London
RGS-Royal Geographical Society, London

Notes

1. Mariam Dossal, "Knowledge for Power: The Significance of the Bombay Revenue Survey, 1811-1827", in *Ports and Their Hinterlands in India (1700-1950)*, ed. Indu Banga (Bombay: Manohar, 1992), pp. 227-43, especially pp. 228-32; Susan Gole's essay in this volume; and Reginald H. Phillimore, *Historical Records of the Survey of India* (Dehra Dun: Survey of India, 1945-58, 4 vols.), Vol. 1, p. 147.

2. I provide the more general context in *Mapping an Empire: The Geographical Construction of British India, 1765-1843* (Chicago: University of Chicago Press, 1997); for details of the surveys, refer to all volumes of Phillimore, op.cit.

3. Dossal, op.cit., pp. 237-42, is the most detailed work on Dickinson's survey; this is complemented by Phillimore, op.cit., Vol.2 pp. 186-87 and Vol. 3, pp. 167-69.

4. C. A. Bayly, *Indian Society and the Making of the British Empire, New*

Cambridge History of India, Vol.2, part 1 (Cambridge: Cambridge University Press, 1988), pp. 108-09, 129-30.

5. William A. Tate. "Plan of the Revenue Survey of the Gorye Lands in the Dharavee District on the Island of Salsette", May 1, 1817, 1:4,800, OIOC X/2617; idem, "Plan of the Revenue Survey of the Dharavee District on the Island of Salsette", October 1, 1817, 1:9,600, OIOC X/2618.

6. William A. Tate, "Sketch of the Islands of Bombay and Colabah, Showing the Position of all the Principal Military Buildings, Out-Posts, &c.", February 16, 1826, OIOC X/2619; idem, "Plan of the Islands of Bombay and Colaba 1827", December 31, 1829, 1:14,400, OIOC X/2620; idem, "Plan of the Islands of Bombay and Salsette, Reduced from the Revenue Survey completed in the Year 1827", December 1831, 1:28,800, OIOC X/2621/1.

7. Andrew S. Cook, "The Beginnings of Lithographic Map Printing in Calcutta," in P. Godrej and P. Rohatgi (eds.), *India: A Pageant of Prints* (Bombay: Marg Publications, 1989), pp. 125-34. For criticism of Bombay map printing, see George Buist, "Proceedings: Chartography [sic]", *Transactions of the Bombay Geographical Society,* Vol. 12 (1854-56), pp. lxvii-lxxiv, especially lxxi.

8. P. White, "Plan of the Fort and Part of the Island of Bombay" (np, nd but *circa* 1835); copies are RGS: S.132 and OIOC-X/2643; I assume that this was printed in Bombay because of its crudity. "The Island of Bombay reduced from the Original Survey undertaken by Order of government by Capt. Thomas Dickinson, with the assistance of Captain Remon, Lieuts. Jopp and Tate, of the Corps of engineers, in the years 1812-16", 1:31,200 (London: T. B. Jervis, 1843); the title is a misnomer as it was based on Tate's final maps. "The Island of Bombay", 1:31,200, inset to "[Map of] The Great Indian Peninsula Railway Company" (np, nd but *circa* 1865), RGS: S/G.12.

9. R. X. Murphy, "Remarks on the History of Some of the Oldest Races now Settled in Bombay; with Reasons for Supposing that the Present Island of Bombay Consisted, in the 14th Century, of Two or more Distinct Islands", *Transactions of the Bombay Geographical Society,* Vol. 1 (1836-38), pp. 128-39, especially p. 138. Derived images occur for example in Samuel T. Sheppard, *Bombay* (Bombay, 1932), facing p. 56; A. D. Pulsaker and V. G. Dighe, *Bombay: Story of the Island City* (Bombay, 1949), frontispiece and the note on pp. 11-12 concerning the attribution to Bombay of Ptolemy's *Heptanesia;* and Meera Kosambi, *Bombay and Poona: A Socio-Ecological Study of Two Indian Cities, 1650-1900* (Stockholm, 1980), p. 42. One critique has been made: Joseph Gerson da Cunha, *The Origin of Bombay* (Bombay: Bombay Branch, Royal Asiatic Society, 1900), pp. 23-24.

10. George Buist, "Geology of Bombay", *Transactions of the Bombay Geographical Society,* Vol. 10 (1850-52), pp. 167-238, especially p. 238.

11. A. B. Wynne, "On the Geology of the Island of Bombay", *Memoirs of the Geological Survey of India,* Vol. 5 (1866), pp. 173-225.

12. Sheppard, op.cit., pp. 54-86, summarizes the reclamations.

13. See J. A. Fuller, "Plan Showing the Sites Selected and Approved by Govt. for all the Public and Private Buildings on the Esplanade" (Bombay, *circa* 1865), 1:2,400, OIOC X/2649. This copy is a lithographed base with extensive manuscript (ink and watercolour) annotations regarding the purchasers and proposed uses of each lot.

14. Arthur Crawford, *Annual Report of the Municipal Commissioner of Bombay for the Year 1867* (Bombay, 1868), pp. 20-21 (quotation); Russell Aitken, *Annual Report of the Municipal Executive Engineer [for 1868]* (Bombay, 1869), Vols. 1-4; C. Thwaites, *Annual Report of the Municipal Executive Engineer [for 1869]* (Bombay, 1870), Vol. 8; Clements R. Markham, *A Memoir on the Indian Surveys* (London: W. H. Allen, 1878, 2nd edn.), pp. 196-97.

15. Aitken, op.cit., Vol. 1; W. G. Pedder, *Annual Report of the Municipal Commissioner of Bombay for the Year 1872* (Bombay, 1873), p. 20. "Map of the Island of Bombay, Enlarged from Col. Laughton's Survey Map of 400 Ft. to an Inch, Prepared for the Municipality of Bombay" (Bombay: R. Rozario, 1882), 1:2,400, BL maps 143.e.24.

16. Crawford, loc.cit.

17. (Bombay) Act No. IV of 1868, "An Act to make further provision regarding the application of (Bombay) Act I of 1865 to Towns and Cities; and to restrict the application of (Bombay) Acts II and VII of 1863 in Towns and Cities, and otherwise to amend (Bombay) Act I of 1865", sec. 22; see "Correspondence regarding the City Surveys in Gujarat, under Act IV, 1868 (Bombay)", *Selections from the Records of the Bombay Government* ns 135 (Bombay, 1873), especially pp. 150-53. In general, see R. G. Gordon, *Part 1 — Historical,* vol.1 of *The Bombay Survey and Settlement Manual* (Bombay, 1935, 2nd edn.).

Once proclaimed "Queen of Asiatic Cities" and "Isle of Palms", Bombay has inspired numerous writers, poets, and artists. Whereas such striking declarations in the extensive literature on this island city might leave much to the imagination, pictures by British artists generally convey vivid impressions of the region. Their paintings and prints from the latter half of the eighteenth century onwards are mostly accurate representations. Through these pictures, and also by consulting relevant maps and descriptions, it becomes possible to visualize the early topography of the Bombay islands. These documents, and in many cases later photographs, are especially important whenever any comparison between a picture and the same view today is impossible. They obviously help in the identification of landmarks. They also help in determining the extent to which style in landscape painting, the Topographical and the Picturesque for example, influenced the artists' perceptions and interpretations of the subject — an essential exercise when analysing pictures.

As compared with the other Presidency towns of Calcutta and Madras, which offered artists greater opportunities for patronage, views of eighteenth-century Bombay are rare. Before about 1770, the most popular subject was the Fort's main frontage as viewed from the harbour. Even so, these pictures tended to be symbolic representations of the East India Company's presence in Bombay, rather than accurate topographical images. They were usually by people who had never ventured to India. The first notable exceptions were two Scotsmen of the same generation, James Forbes and James Wales, who were working in Bombay at different times and in totally different capacities. Yet the story of their artistic activities is interlinked. Above all, they were the first to make drawings of the Bombay islands systematically on the spot, and not from imagination. Despite their distinction as early draughtsmen, neither was foremost a landscape painter. Forbes was an East India Company civilian, who began his career in Bombay and worked for some

EARLY IMPRESSIONS
JAMES FORBES
BOMBAY 1766-95

PAULINE ROHATGI

seventeen years before returning to England in 1784. He was an amateur artist, largely self-taught as he himself claimed. Wales was an experienced though relatively unknown professional painter in the British Isles, who arrived in Bombay in 1791 to make a livelihood in portraiture. They also wrote journals in India that reveal much about the environment.

1
"View of the Breach Causeway [Hornby Vellard]." By James Wales, original drawing made 1791-92; print (No. 5) from *Twelve Views of the Island of Bombay and its Vicinity,* published London, 1800.
Hand-coloured etching, 38.2 x 64.5 cm.
According to Wales' description, the Causeway is shown "At its commencement taken from the Road [Warden Road] leading up to Mr. Page's House and the Breach Pagoda [Mahalaxmi Temple], including a view of the interior Breach Water, with the opposite side of the Island along the Parill Road." Even then, the foreground (later Haji Ali Circle, now removed to create a road junction) had the beginnings of a circular layout. A well lies near the village dwellings. The lane to the right became Tardeo Road, while part of the middle distance, seen under water, is occupied by the present-day racecourse.

OF THE ISLANDS: AND JAMES WALES IN

Until now, the most realistic early impressions of Bombay were to be found only in their prints — the three engraved views in *Oriental Memoirs* by Forbes, and the set of etchings, *Twelve Views of the Island of Bombay and its Vicinity* by Wales. The recent rediscovery of a collection of illustrated manuscripts by Forbes is therefore highly significant, especially since it includes several hitherto unpublished watercolours of the Bombay region. The manuscripts also contain about eighty of Forbes' letters from India to his family in England. Almost every letter is illustrated with original watercolours by Forbes himself. Numbering over five hundred, the paintings not only add

a visual dimension to many of his observations in the letters, they also provide additional information about Forbes' artistic interests and activities in India. The thirteen volumes of "Descriptive Letters and Drawings" formed the basis of both his text and many of the illustrations in *Oriental Memoirs* which was published in London in 1813.[1]

The Islands in Elevation

Already between 1766 when James Forbes arrived in Bombay, and 1795 when James Wales died in the city, Bombay was developing from the group of islands into the peninsula that it is today. This group of seven,

2
"View from Belmont",
Mazagaon Hill.
By James Wales; original
drawing 1791-92; print (No.
8) from *Twelve Views of the
Island of Bombay and its
Vicinity,* published
London,1800.
Hand-coloured etching,
38 x 64 cm.
Looking southwards from
Mazagaon Hill, the views in
figures 2 and 4 depict
Bombay Island and the
harbour estuary. The first,
taken from William Paddock's
house, Belmont, includes the
noted landmark for vessels
entering the harbour, Mark
House (later Belvedere House)
on the brow of the hill.
Forbes' viewpoint is
identifiable in Wales' scene
below the pathway leading to
the house, near the edge of
the hill. Although Forbes'
picture is considerably smaller,
he has included features of
Bombay Island in greater
detail — the Fort with
Bombay Castle (wrongly
shown as almost detached
from it), the Esplanade, the
Indian township, and
Girgaum woods. Nowrojee
Hill closes the scene to the
right, while the same palm
grove on the plain below
appears in both pictures. This
view is impossible today, for
road, railway, and dock
developments have claimed
much of Mazagaon Hill. A
portion still remains, however,
clad with scrub and the
occasional palmyra tree — a
reminder of its former
character.

according to the early map-makers, was among countless islands along the Konkan coastline and its hinterland of the Western Ghats. Collectively they then encompassed about eighteen square miles (see Edney: figure 4).

Southernmost was the low-lying strip of Colaba next to the smallest, Old Woman's Island. The adjacent Bombay Island was the largest and most developed. It contained the Fort, adjoining the harbour to the east, and the Esplanade. North of the latter was the Indian township, westward of which lay Girgaum woods, terminating with Malabar Hill, projecting into the Arabian Sea. Behind the Fort and beyond the Esplanade, Back Bay extended in an almost semicircular curve from Colaba to Malabar Point. Also bordering the sea were the elongated islands of Worli and Mahim. That of Mazagaon included the hilly promontory overlooking the harbour, and the flats of Byculla. North of Mazagaon, the plains of Parel and Matunga combined with several rocky outcrops, notably at Sewri and Sion, to form the seventh island. Across Mahim Creek, which connected the harbour with the sea at the islands' northern boundary, was the larger mountainous group of Salsette islands. The similarly jungle-covered landmass of Trombay Island lay in the upper reaches of the harbour near the entrance to Thana Creek.

Despite urban development in many localities, the terrain of these islands was still predominantly rural. Both Forbes and Wales made excursions or "jaunts" probably by palanquin or occasionally on horseback, through palmyra and coconut groves, passing rice fields, salt pans, and fishing hamlets, to draw the landscape. Although sketching tours in the British Isles had been fashionable among both professional and amateur artists for several decades, in India this activity was just beginning. In fact Forbes was one of the earliest practitioners in the country. Whereas they each drew the landscape for different reasons — Forbes for pleasure and to embellish his letters, Wales as a commercial venture for the print market — their pictures exhibit images that provide a unique insight into the eighteenth-century topography of Bombay, especially when viewed collectively. Yet to people aware of

certain environmental conditions at that time, such as the pestilential swamps in low-lying areas, their views might seem almost idyllic.

Views from Mazagaon Hill
The top of the highest hills of Malabar and Mazagaon were among the most popular vantage points within the islands for observing the scenery. The long ridge of Malabar Hill commanded sweeping views across Back Bay and the southern islands to the mainland, while Mazagaon Hill provided viewpoints for spectacular panoramas in all directions, including the harbour and Bombay Island (figures 2 and 4). Clearly taken from different spots only a short distance apart, these views by Wales and Forbes are typical of their variant landscape styles. While maintaining topographical accuracy, Wales emphasized the picturesque elements of the scene: soaring palmyras silhouetted against the sky, and bold contrasts of light and shade in the foreground. Forbes drew the landscape quite differently. Giving much the same attention to both near and distant objects, he drew details such as the animals and shipping, the foreground rocks, and buildings of the Fort, in similar graphic detail. He achieved a sense of distance by exaggerating the angles of the shorelines, and by placing Colaba Island (incorrectly when compared with maps) sharply at right angles to the main axis of Bombay Island. Thus while the landscape style of Wales incorporates features of the contemporary Picturesque movement, that of Forbes harks back to an earlier technique of topographical draughtsmanship known as the prospect view. Its forerunners were the map (as drawn from direct observation rather than scientific survey) and the bird's-eye view, which were also intended to depict the lie of the land and its salient features.

James Forbes (1749-1819)
Although his family claimed descent from Scottish nobility, the Earls of Granard, Forbes was the son of a London merchant, Timothy Forbes. After a formal education, he was appointed to the lowly rank of Writer in the East India Company at the customary age of sixteen. Sailing in March 1765 on board the *Royal Charlotte*, his diverse interests became apparent during the voyage. By the time he reached India, he had already sent home several letters giving "an account of the manners and customs of different nations and the various productions of nature in foreign climates".

In his first letter from Bombay dated March 15, 1766, Forbes told his family that "on the twenty second of February we at last saw the long wished for island of Bombay; and the next morning anchored in the harbour exactly eleven months from the time of leaving

VIEW from BELMONT

London. Published May 1787, by Edw.d Orme, 288 Strand

N°. 8

Gravesend" (figure 3). Although this view is similar in subject to earlier pictures of the Fort from the harbour, Forbes was the first artist to ensure a degree of topographical accuracy. Furthermore by placing the most important building, the East India Company's Factory (headquarters of the Bombay Presidency) in the centre of the composition, he was following another convention of the prospect view.

Forbes spent the first six years in Bombay, after which he rose rapidly through the Company's ranks. Subsequently all his major postings were in other places in western India. In 1772 he was appointed Member of Council at Anjengo. In 1775, he was assigned as secretary to Colonel Thomas Keating, whose army in Gujarat was assisting the Peshwa, Raghunath Rao. Soon afterwards, afflicted by illness, Forbes returned to England but was back in Bombay by mid-1777. His last two postings were again in Gujarat, as Custom Master at Broach and then Collector at Dhuboy. In addition to writing letters, Forbes kept a daily journal in which he sketched and recorded information about the local customs and the ecology of the different regions. He wrote descriptions of places he visited and of buildings he admired. He also noted contemporary events. By the time he left India, he had filled almost one hundred and fifty notebooks and although recorded apparently for personal interest, such information would have been useful in his professional work.[2] He was obviously an able administrator, with an even more promising career, had he remained with the Company instead of retiring in 1784.

The Factory buildings contained the Custom House, warehouses, offices, and the Writers' apartments. Here Forbes lived and worked as a Writer for the first few years of his career. His clerical duties involved writing up the Company's record books, and in another letter he recounted the daily routine: "The morning was dedicated to business; every body dined at one o'clock; on breaking up, the company went to their respective houses to enjoy a siesta, and return after a walk or ride in the country, to pass the remainder of the evening, and sup where they had dined." While his colleagues might spend their leisure in this way, Forbes would read literature by moonlight on the roof of his lodgings. His favourite recreation was

4
(facing page)
"A View of Bombay, taken from one of the Mazagon Hills, near Belvidere."
By James Forbes, 1782.
Pen and ink with watercolour, 18 x 26.5 cm.
See caption to figure 2.

View of BOMBAY in 1773.

3
"View of Bombay."
By J. Shury after an original drawing by James Forbes, 1773; print from *Oriental Memoirs*, published London, 1813.
Engraving, 16.3 x 25.5 cm.
This view represents the main front of the Fort as it would have appeared from the harbour during most of the eighteenth century. In his accompanying description, Forbes noted the sequence of buildings: "... commencing [left] with the Dock-yard; and including the Admiralty, Marine House, English Church [St. Thomas'], Pier, Bunder [the East India Company's Factory], Castle, Dungaree Fort or Fort George, and other conspicuous buildings, taken from the shipping opposite the Bunder Pier." The Factory, subsequently much enlarged, still survives as the Old Custom House (Collector's Office) and is today a listed heritage building. Dock development and other alterations to the Fort precinct, however, long ago obscured this particular view.

A View of Bombay.

taken from one of the Mazagon Hills.

near Belvidere — 1782.

J. Forbes —

6

(facing page)
"The Governor's House at Bombay."
By James Forbes, 1770.
Pen and ink with watercolour, 17 x 25.5 cm.
This, the second Government House (the first was within Bombay Castle) remained the official residence of the Governor until 1829. In the eighteenth century, as shown in Forbes' watercolour, it was enclosed by elaborate railings flanked by neat lodges for the household servants, and a well cultivated garden at each side. According to early maps, the garden also extended behind the house. Two guards are on duty at the main gateway, which has a stone shelter on each side. The main building still survives (albeit much altered) on Apollo Street and is now a listed heritage building.

drawing, which for him was "like music to the soul of harmony". In his preface to *Oriental Memoirs*, he also explained that as an artist he had "no other instruction than a few friendly hints from Sir Archibald Campbell [later Governor of Madras], who during a short residence in Bombay in 1768, encouraged my juvenile pursuits". Though not known for his artistic competence, Campbell's army training would have included survey drawing. Nevertheless, Forbes mastered various techniques by emulating different styles. He not only collected specimens of oriental art, but his own paintings of birds and flowers, for example, resemble pictures by Chinese artists, while his studies of the local people are reminiscent of Indian miniatures.

In Bombay, Forbes initially recorded the islands' flora and fauna, making almost scientific drawings of the trees, flowers, birds, animals, and insects. Among the illustrations to his letters, these studies are the most

numerous and technically the most accomplished. Though beyond the scope of this article, natural history became his overriding passion, later earning him the reputation of being one of India's leading amateur naturalists. His interests then extended to the local communities and the government and lifestyle of the British in Bombay. From his apartment, he would observe the people on Bombay Green. He could also see the church (later consecrated St Thomas' Church) and the Company's buildings including Government House (figure 5). By March 1770, he had accumulated a "Collection of Views and Drawings taken on the Island of Bombay and places adjacent", which he also sent home. His accompanying letter, which relates to chapter eight of *Oriental Memoirs*, contains an account of the Fort: "The town is about two miles in circumference, surrounded by a modern fortification, mounting nine hundred pieces of cannon; with a deep ditch, draw-bridges, three principal double gates [the Apollo, Church, and Bazaar Gates], and several smaller outlets.... The only Protestant church on the island stands near the centre of the town: a large and commodious building, with a neat tower."

The "Collection" also included watercolours of two Government Houses. These are noteworthy as the earliest known views of the buildings, painted before any major alterations took place (figures 6 and 7). Government House within the Fort is an elegant two-storeyed mansion,

5

"View of Bombay Green, taken from the Writer's Apartment at the Bunder."
By Charles Heath after an original drawing by James Forbes, 1768; print from *Oriental Memoirs*, published London, 1813.
Engraving, 15.5 x 22.5 cm.
Bombay Green, now Horniman Circle, in the heart of the Fort area has always formed the nucleus of Bombay town. Many surrounding buildings, at least until the removal of the Fort walls, belonged to the East India Company as part of the Presidency's administrative framework. In Forbes' day, the Green itself was the cotton market (bales are visible in the left foreground), the military parade ground, and a general meeting place. He also described the view: "It includes part of Government House [extreme left], the English Church [St Thomas'], Secretary's Office, the residence of the Second in Council, and the scenes daily occurring in this part of the town of Bombay."

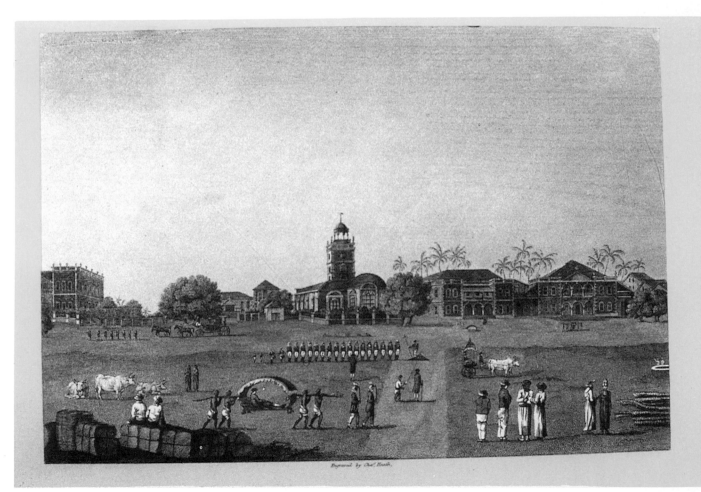

187.

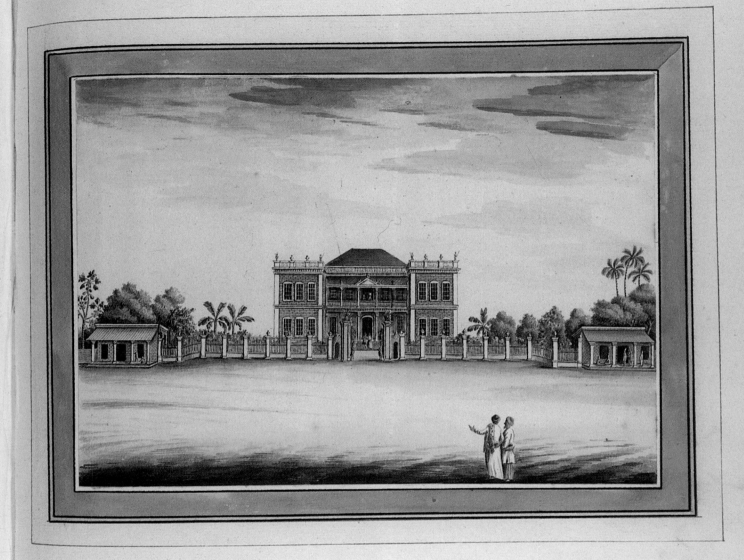

The Governor's House at Bombay.

J. Forbes 1770 —

7

"A View of Parell, the Country Seat of the Governor, at Bombay." By James Forbes, 1769. Pen and ink with watercolour, 17 x 28.5 cm.

Formerly a Jesuit college, this was the country house of the Governor from 1719 until the 1880s. Its banqueting hall, which replaced the old Portuguese chapel, and the ballroom above, were the scene of many elaborate functions during the days of the Raj. A long avenue of trees led from the main gate to the house, which Forbes has represented by the line of trees reflected in the tank. A small shrine occupies the left foreground. The northern end of Malabar Hill (Cumballa Hill) appears on the horizon (left), with the shrine of Haji Ali, and the Breach Causeway extending across to Love Grove and the island of Worli. Until this watercolour was found, the earliest known views including the Breach Causeway were those by James Wales, dating from 1791-92. The considerably enlarged Government House subsequently became the Haffkine Institute, which specializes in the study of tropical medicine, and is a listed heritage building.

its shallow wings topped by a parapet and a long verandah above the main entrance. Following the traditional style for prospect views of English country houses, Forbes portrayed the building symmetrically within its grounds from a slightly elevated viewpoint. At a later date, a rear extension was added and pitched roofs were placed on the side wings of the building, thereby destroying its original design.

The Governor's country residence at Parel, located six miles to the north of the Fort, was accessible by taking the Church Gate exit, crossing the Esplanade, entering the Indian township and continuing along the Parel Road to the main gates of its extensive compound. The grounds included the tank, which was situated further from the house than is indicated here by Forbes. In 1771 shortly after the watercolour was painted, William Hornby was appointed Governor of Bombay. He turned this house into a main residence, and probably began alterations. From his viewpoint, looking south-westwards, on the nearby terraced elevation, Forbes could also see the Breach Causeway beyond the rice fields of Parel and the Breach water. In his letter of December 1767, he referred to this low-lying area between Malabar Hill and Worli, explaining that "a considerable part of the flat country is at times overflowed by the sea; altho' a strong breach of masonry has been erected, at great expense, to prevent its incursions".

The third view in *Oriental Memoirs* shows Bombay Island taken from a slope, rather than the ridge, near Malabar Hill (figure 8). So far as is known, this is a unique eighteenth-century view of Gowalia Tank. When compared with early maps, however, the composition appears distorted. Either Forbes or, more likely, the engraver foreshortened distances and positioned the foliage to enhance its picturesque qualities. Although the original watercolour was painted in 1771, as early as 1767 Forbes had observed that "within these few years each eminence is adorned with a villa, and each spot that will admit of cultivation is sown with rice, or planted with cocoa-nut; which in extensive woods lend their friendly shade to thousands of neat cottages, and form delightful

rides impervious to a tropical sun". This engraving and the prospects from Mazagaon Hill (figures 2 and 4) combine to provide a vivid impression of Bombay Island and Colaba from two different perspectives.

Forbes and Wales in England

There is no doubt that Forbes encouraged James Wales to work as a painter in Bombay. Fulfilling his earlier promise to his family, Forbes retired from the Company when he was thirty-five. He returned to England and bought an estate at Stanmore near London. Meanwhile James Wales arrived in London from Scotland. Although his paintings were admired, patrons were not sufficiently forthcoming to enable him to support his family. Perhaps to assist him, Forbes commissioned him to paint two of his own drawings of India, which were published by Wales as engravings in 1790. One depicts the interior of the Temple of Elephanta, which Forbes had drawn on the spot in 1774 (figure 9). Although Wales was yet to see the site for himself, this experience probably initiated his artistic and archaeological interests in the cave temples of western India. Shortly afterwards, he was granted permission by the East India Company Directors in London, to practise as a portrait and landscape artist in Bombay.

James Wales (1747-95)

Born at Peterhead in Aberdeenshire "of respectable parents", Wales was educated in Aberdeen, where he also worked as a painter before moving to London. Although competition among portrait painters was harsh, the vogue for the Picturesque was presenting new opportunities to landscape artists. Drawing expeditions in the British Isles had extended to countries around the world, resulting, for example, in illustrated travel books. Favourite subjects included grandiose mountain scenery, rivers and waterfalls, exotic architecture such as palaces, mosques, and forts, besides buildings preferably in ruins and adorned with foliage. To artists in search of picturesque subjects, India clearly provided innumerable examples throughout the country. Writers on the Picturesque aesthetic advocated certain principles to render the picture more pleasing to the spectator, including repositioning its various components and manipulating effects of light and shade to enhance the composition.

Already forty-four years old, Wales arrived in Bombay on July 15, 1791, without his family and with no security of the kind provided by the Company to Forbes. He was dependent upon commissions and would certainly have been advised accordingly by Forbes before leaving England. Forbes doubtless gave him an introduction to Sir Charles Warre Malet to whom, as "a friend with whom I

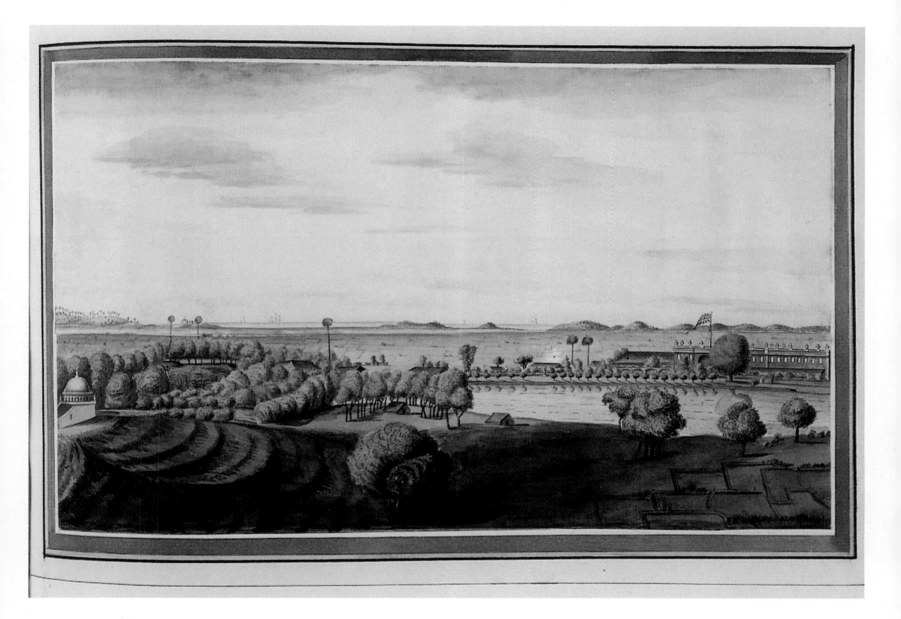

spent my juvenile years in distant climes", he later dedicated *Oriental Memoirs*. Malet, who was then British Resident at the Maratha court in Poona, became Wales' most important patron. During the next four and a half years, Wales visited Poona regularly and soon had a circle of patrons including the young Peshwa, Madhu Rao Narayan.

Although Wales kept a diary during visits to Poona, he does not seem to have done so in Bombay. A few documents relating to the preparation of his Bombay prints have survived, however, in addition to the published descriptions of each view.[3] Nevertheless, being primarily a portrait painter, why Wales attempted this task singlehandedly, and without the facilities of a print workshop in Bombay (although printing establishments had existed for almost two decades), remains a mystery. Influenced by the growing demand for prints, besides illustrated travel books, he could have been prompted by

the recent success of Thomas Daniell's twelve engraved views of Calcutta. Produced in Calcutta in 1786-88, they formed the only precedent as a set of prints of a Presidency settlement. Wales may have planned his project even before leaving England and if so, he was probably encouraged by Forbes to collect names of subscribers there. In any event, he almost certainly carried the large copperplates to be etched, with him to Bombay. However, his eventual choice of somewhat limited and basically unpicturesque subjects in Bombay (despite the existence of attractive features such as temples and mosques) would have appealed mainly to subscribers who were familiar with the Bombay environs.

Inspired on his arrival by the seasonal monsoon, Wales spent the first few months making drawings of the islands, often at sunrise or sunset when he found the light to be most conducive for sketching. On February 1, 1792, he announced his "PROPOSALS FOR PUBLISHING BY

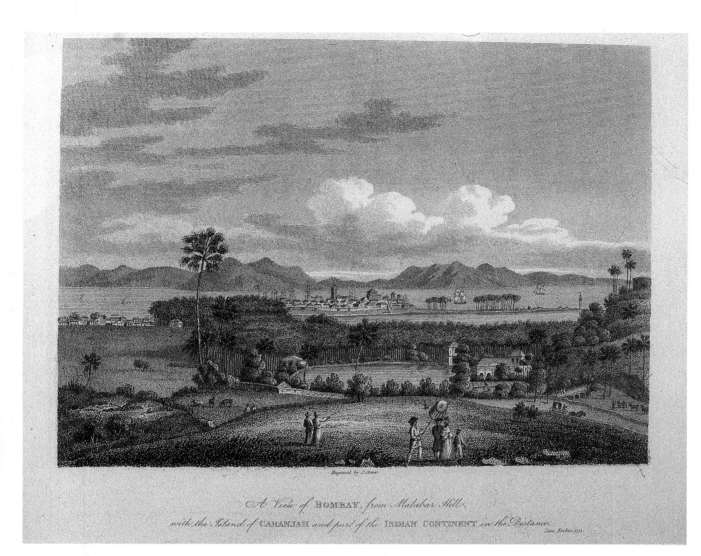

A View of BOMBAY, from Malabar Hill,
with the Island of CARANJAH and part of the INDIAN CONTINENT in the Distance.
Jam: Forbes 1771.

"A View of Bombay Island, with the Island of Caranjah and part of the Indian Continent in the Distance." By J. Storer after an original drawing by James Forbes, 1771; print from *Oriental Memoirs*, published London, 1813.
Engraving, 16 x 22 cm.
As noted by Forbes, "This View contains the fortified town, and harbour of Bombay.... The nearer landscape represents the country on Bombay, consisting chiefly of Cocoa-nut woods and rice-fields, interspersed with English villas and plantations. Those in this engraving are the Retreat [right] and Tankaville, on the borders of a tank of fresh water [Gowalia Tank, now filled up], near Malabar Hill; on which is seen one of the Parsee tombs." Taken from present-day Kemp's Corner, between Malabar Hill and Cumballa Hill, it is possible to locate the area though it is highly developed. The road in the foreground became Gowalia Tank Road, while the adjoining causeway formed an approach to Malabar Hill.

10

The printed prospectus, dated February 1, 1792, for James Wales' "PICTURESQUE Prospects upon the Islands of BOMBAY, SALSETTE and ELEPHANTA".
Under the title *Twelve Views of the Island of Bombay and its Vicinity*, the prints were eventually published posthumously in London in 1800. Nine prints in this list, including the two panoramas, Bombay harbour and the view from Malabar Hill, were included in the publication, which was dedicated to Sir Charles Warre Malet.

9

(facing page)
"The Temple of Elephanta." By James Phillips after a painting by James Wales, *circa* 1789-90, made from a drawing by James Forbes, 1774; print published by James Wales at Hampstead near London, 1790.
Etching and line-engraving, 34 x 64 cm.
James Wales was living at Hampstead when he published this print of the temple on Elephanta Island in Bombay harbour. It depicts the interior of the Great Cave with its most impressive feature, the colossal three-headed bust of Shiva, the Trimurti. Forbes included the same view as an illustration in his *Oriental Memoirs*. The composition embodies several features of the Picturesque style, such as the foreground foliage, and people admiring the sculptures, thereby adding a sense of scale to the scene.

BOMBAY 1st, FEBRUARY, 1792.

PROPOSALS FOR PUBLISHING BY SUBSCRIPTION.

PICTURESQUE Prospects upon the Islands of BOMBAY, SALSETTE and ELEPHANTA, DRAWN by JAMES WALES, and ENGRAVED and COLOURED, so as to represent finished drawings.——*Viz.*

A View of BOMBAY HARBOUR, from a high Bungallo near the BUNDER,
A View near CAPTAIN BLACHFORD's house, a Sun setting scene,
A View from MALABAR HILL, late in the afternoon,
A View from MR. TATE's house, at Love Grove, at sun rising,
Two Views from SION FORT,
A View from MR. PADDOCK's house, a Morning scene,
A View from the Island of ELEPHANTA, which will comprehend the figure of the ELEPHANT, and part of the Elephanta with a beautiful distant View of Butchers Island and BOMBAY with its HARBOUR and SHIPPING,
A View from Mount Passier,
A View from the mountain above the Cannery Caves,
The View of BOMBAY HARBOUR and that from MALABAR HILL are so very extensive and long, that they cannot be properly contained in less than two PRINTS each,——which makes twelve PRINTS in all, altho' only ten Prospects.

CONDITIONS.

1st. The size of each Print to be *two Feet two Inches*, by *one Foot four Inches.*

2d. Groups of Human Figures, *&c.* will be introduced, Illustrative of the manners and customs of the Inhabitants, and the Trees, Plants, Shurbs, *&c.* in the fore ground of these *Pictures*, will be characterized, so as to please the eye of the botanist.

3d. The price will be *One Hundred and Fifty Rupees*, the whole sett without frames, or *Three Hundred and Fifty Rupees*, elegantly *Framed* and *Glazed*, in the same manner as the *Elephanta* and *Banyan tree* Prints.
One half of the Money to be paid into the house of at subscribing, and the other half upon the delivery of the Prints, which will be in the course of next year,

4th. As much time and attention will be required to colour those Prints, very few will be finished but what are Subscribed for; and those at the advanced price of 180 *Rupees each Sett.*

SUBSCRIPTION, PICTURESQUE Prospects upon the Islands of BOMBAY, SALSETTE and ELEPHANTA, drawn by JAMES WALES, and ENGRAVED and COLOURED, so as to represent finished drawings" (figure 10). At Rs 150 per set, or Rs 350 if supplied "elegantly *Framed* and *Glazed*", the price was reasonable as compared with Daniell's Calcutta prints, which were almost Rs 200 for the twelve views.

Wales' plans progressed and he soon had an impressive list of about seventy subscribers, including George III, Directors of the East India Company, the Governor of Bombay, Sir Robert Abercromby, Malet, and Forbes.

A double panorama of the harbour looking eastward is the only close-up view by Wales of the Fort area (figure 12). Stylistically it is topographical rather than

VIEW FROM BELMONT
London. Published May 1800 by R. Bull 30 Holles

11

"View from Belmont",
Mazagaon Hill.
By James Wales; original
drawing, 1791-92; print (No.
7) from *Twelve Views of the
Island of Bombay and its
Vicinity,* published London,
1800.
Hand-coloured etching,
38.5 x 64.5 cm.
This view looking eastwards,
as described by Wales was
"Toward the back of the
Harbour, including part of the
Village of Mazagon, the
Islands of Carranjar [right],
Elephanta, and Butcher [both
left], bounded by the Hills in
the Mahratta Country." The
fishing village of Mazagaon
extends along the shore
beyond the plain of rice
fields. The large house on the
right over the hill is probably
Storm Hall, while a small
chapel with a bell-tower is
visible through the palmyra
trees. A boat-building yard
containing timber adjoins the
road, probably Gunpowder
Lane on the left. Two toddy-
growers, one up a tree,
appear in the foreground.

picturesque. Wales made his original drawing in the afternoon "from a high Bungallo [sic] near the BUNDER [Factory]", belonging to the influential ship-owner and businessman, Pestonjee Bomanjee Wadia (1758 - *circa* 1816) who was one of several Parsi subscribers to the set of views. He was also an agent in Bruce, Fawcett & Co. (later Remington & Co.). His residence in the Fort was almost next door to the Factory, which is partially visible behind the battlements on the extreme left.[4] With graphic clarity, Wales drew Bombay Castle, its flagstaff, the piers enclosing the large and small docks, and the "great bustle on the bunder [pier]".

The remaining views in the set, mostly taken from or near the residences of other subscribers, capture the rural aspects of the Bombay islands. His prospectus also noted that "Groups of Human Figures, etc. Illustrative of the manners and customs of the Inhabitants, and the Trees, Plants, Shrubs etc. in the foreground of these *Pictures*, will be characterized, so as to please the eye of the botanist." Perhaps Wales had the interests of Forbes in mind, since all the remaining prints, including the second double

panorama taken from the ridge of Malabar Hill, contain these pictorial details. One of his rare surviving watercolours of Malabar Hill is a preliminary study for this panorama (see Godrej: figure 10).

In addition to figure 1, two more views from William Paddock's house, Belmont, convey equally vivid panoramic scenes from Mazagaon Hill (figures 11 and 13). Apart from the obvious Picturesque treatment of the composition, the exact delineation of the landscape has the characteristics of a large-scale map, with every lane, field, and building apparently recorded. As another subscriber, Paddock who was then a Senior Merchant in the Company, doubtless would have wished the views from his house to be in the set. In fact Wales replaced the two scenes of Salsette, "A View from Mount Passier [Montpezier]" and "A View from the mountain above the Cannery [Kanheri] Caves", with additional views from Paddock's house. When examined together, figures 7 and 11 give a clear image of the central area of the Bombay islands. The Breach Causeway, visible in the distance of both, also appears in close-up in two other prints by

VIEW FROM BELMONT
London Published May 1, 1800 by R. Gill, 293, Holborn

13

"View from Belmont", Mazagaon Hill.
By James Wales, original drawing made 1791-92; print (No. 9) from *Twelve Views of the Island of Bombay and its Vicinity,* published London, 1800.
Hand-coloured etching, 38.5 x 64 cm.
Wales described this view looking north-westwards, as "Taking in that part of the Island between the Hill of Belmont [Mazagaon] and the Breach Water; Malabar Hill to the left; the Breach or Causeway in front; and the country extending from Love Grove [Worli] towards Mahim on the right." His viewpoint was close to the road leading to Belmont, seen on the hill (left). An outhouse, roofed with Mangalore tiles, occupies the foreground, while the middle distance represents the suburb of Byculla with a number of garden houses along the Parel Road. Across the road and within a large compound, one can see the stand and clubhouse of the old racecourse.

Wales. One was taken from the road leading to Breach House, home of another Senior Merchant and Secretary to the Government, William Page. This broad perspective, looking in the opposite direction from the previous view, extends from Mazagaon Hill (right) to Trombay Island (left) with the distant mainland visible between (figure 1). This print replaced "A View near Captain [William] Blachford's house", otherwise all the other subjects listed in Wales' "Proposals" were published.

The hilltop Fort of Sion at the islands' north-eastern extremity was another key vantage point. Wales included two views from Sion Fort, which he described in his preparatory notes as "Grand scenes some sepoys in the foreground or coming up the Hill — If a part of the embrasure or a gun can be seen in the foreground so much the better. Cattle grazing in the foreground & distance will look well — Trees with ricks of Hay in them — New and picturesque. The Outlines of all must be very distinct indeed and done on well burnished plates — other ways the Tints can be depended upon" (figure 14).

Unfortunately Wales' interest in the scenery of the

Bombay islands was shortlived. Even after etching and burnishing the copperplates, and printing at least one proof set of prints, the project came to a halt. He was obviously intending to publish them in Bombay rather than in England. But like Thomas Daniell, for whom the Calcutta prints had been "a devilish undertaking", since "I was obliged to stand Painter, Engraver, Copper Smith, Printer and Printer's Devil myself", Wales probably found the task too arduous. In June 1792, he left for Poona where his portrait practice soon became lucrative. Even when he met Thomas and William Daniell in Bombay the following year, their interests focused on the nearby cave temples more than the scenery of Bombay. After Wales' sudden death in October 1795, Sir Charles Warre Malet took charge of his drawings, his diaries, and the etched copperplates, returning with them to England. As a result of his efforts, and probably with help from Forbes and the Daniells, Wales' *Twelve Views of the Island of Bombay and its Vicinity* was published in London on May 1, 1800.[5]

The production and survival of these views by Forbes and Wales was thus largely fortuitous. Fortunately as a

result, today it is possible to visualize the topography and to perceive the rural characteristics and extent of urban development within the Bombay islands some two hundred years ago. Both men portray a scenic but fragile and vulnerable environment. Nearly every picture includes the waters of the harbour or the sea, in addition to stretches of land almost at sea level. The region's proneness to flooding and its strictly limited land resources are obvious. As environmentalists, Wales and especially Forbes observed urban developments, and they were conscious of the impact on various localities. Forbes even kept abreast of changes after returning to England, noting several in *Oriental Memoirs*. Yet neither of them was trying to make any profound statement through his pictures. They viewed the islands of Bombay much as they would have observed the scenery of the British Isles, specifically within the terms of stylistic licence for landscape art. As eighteenth-century perceptions, their pictures and descriptions form an important early episode in the topographical history of Bombay, especially when compared with subsequent images. Over the following decades, both artists and writers increasingly recorded their impressions of the region. In 1839 for example, the author Marianne Postans still found Bombay to be the "Isle of Palms" and, by the end of the century according to Governor Richard Temple, it had become "Queen of Asiatic Cities".

Acknowledgements and Notes

For her invaluable advice while preparing this article and especially for helping me to identify Pestonjee Bomanjee Wadia as one of the subscribers to James Wales' views of Bombay, I wish to thank Dr Kalpana Desai.

1. These manuscripts were formerly in the library of St Mary's College, Oscott in England but they disappeared into a private collection after being sold at Sotheby's in 1966. Now after many years of searching they have been found. The noted art collector and benefactor, Mr Paul Mellon, gifted them recently to the Yale Center for British Art in the USA. I am especially grateful to Mr Mellon for allowing me to include pictures from the manuscripts before their official registration as part of the Center's collection. I should also like to express my gratitude to Dr Elizabeth Fairman, Curator of Rare Books and Manuscripts at the Yale Center for British Art. In 1993, when I visited the Center for a month, she not only helped to find the Forbes manuscripts, but

she also recognized the missing collection when, to our delight, it was presented to the Center a few months later. I also thank the staff of the Prints and Drawings department for all their help and kindness during my return visit to see this collection.
A further note of explanation is required about these thirteen volumes. They were actually prepared by Forbes as a digest of his original letters from India to his family in England. While the originals remained with family members, Forbes made transcriptions from them in his fine copper-plate script, especially for his only child, Elizabeth Rosée. They were his gift for her twelfth birthday, April 11, 1800. His inscription in the first volume records that her "thirst for knowledge, and ardent desire of improvement at an early age, has given an additional pleasure to every hour which was spent on these volumes...." Forbes had devoted the previous six years to their preparation. The leather-bound volumes measure 53 x 36.8 centimetres, and the Whatman paper, which includes 1794 watermarks, is gilt-edged. The letters themselves, each of which is of considerable length, cover his entire stay in India and his four voyages to and from the subcontinent. In 1839, the manuscripts were presented to Oscott College by his grandson, Charles, Comte de Montalembert, where they remained until the Sotheby's sale.

2. The folio volumes with which Forbes returned to England in 1784 no longer appear to be extant. It is probable that he cut many of the drawings and paintings out of these volumes and re-mounted them in the thirteen manuscript volumes for his daughter: many paintings in the latter are mounted on the pages, while clearly others were painted afresh from his own originals. Forbes also included a complete set of the prints of Bombay by James Wales, which were published on May 1, 1800 shortly after Elizabeth's birthday.

3. The diaries of James Wales and his memorandum prospectus, and list of subscribers to the Bombay views are also in the Yale Center for British Art (Paul Mellon Collection). The diaries contain more personal information about his life in India than the letters of Forbes. After Wales' death, Sir Charles Warre Malet not only took charge of his effects, but he eventually married Wales' daughter, Susanna. The Wales collection remained in the Malet family for several generations, until a large part of it was purchased by Mr Mellon, who then presented it to the Yale Center for British Art. See also M. Archer, *India and British Portraiture*, London, 1979, pp. 333-55 (chapter on James Wales).

4. Pestonjee Bomanjee Wadia's residence in the Fort is clearly marked as situated between Marine Street and the "Large Basin" close to the Factory, in the manuscript map by Charles Waddington (Bombay Engineers) in the India Office Library and Records. It is titled "Plan of Bombay Castle, and the Old and New Docks; comprehending Hornby Battery, Bunder-Pier and the Intermediate Buildings" and is dated July 1813 (IOLR: X/2641). A comparison between Wales' view and the map, plus the fact that Pestonjee Bomanjee was a subscriber to the set, confirms that the view was drawn from his residence. Despite its later date this map also helps in judging the high degree of topographical accuracy in this view of the harbour by Wales.

5. No actual title page to Wales' set of Bombay prints has ever been found but the printed booklet, containing the letterpress describing each view, is titled *Twelve Views of the Island of Bombay and its Vicinity. Designed and Engraved on the Spot by Mr. James Wales, and brought to this country by Sir Charles Warre Malet*, London, 1800.
The lettering on each print includes the following: *London Published May 1, 1800 by R.* [Robert] *Cribb. 288. Holborn Jas Wales delt. et sculpt* [i.e. James Wales drew and etched].
The title of each print is as follows:
1. and 2. (double panorama) *View of Bombay Harbour.*
3. and 4. (double panorama) *View from Malabar Hill.*
5. *View of the Breach Causeway.*
6. *View of the Breach from Love Grove.*
7. - 9. *View from Belmont.*
10. and 11. *View from Sion Fort.*
12. *View from the Island of Elephanta.*
A proof set of prints before letters in the Yale Center for British Art (part of the Wales collection from the Malet family) bears pencil inscriptions describing each view, which contain additional information about some of them. Although these do not appear to be in Wales' handwriting, this proof set may have been printed and coloured by Wales himself in Bombay.

Figure Acknowledgements

Figures 1, 2, 9, 11-14 are reproduced courtesy India Office Library and Records (OIOC), The British Library, London; figures 4, 6, 7, 10 courtesy the Yale Center for British Art, Paul Mellon Collection, New Haven; and figures 3, 5, 8 courtesy Farooq Issa, Phillips Antiques, Mumbai.

14
"View from Sion Fort."
By James Wales, original drawing made 1791-92; print (No. 11) from *Twelve Views of the Island of Bombay and its Vicinity*, published London, 1800.
Hand-coloured etching, 38.2 x 64.5 cm.
As described by Wales this view was "Taken from the interior [of Sion Fort] including the Country and River between it and Mahim, with part of Salsette across the River [Mahim Creek], terminated by the Church of Nostra Signora del Monte [Church of Mount Mary, Bandra]." By the time Wales made his original drawing, the Fort had become a refuge for disabled sepoys, one of whom appears in the picture beyond the cannon in the foreground. Sion Fort, along with those of Mahim, Worli, Mazagaon, Sewri, and others once formed boundary strongholds, protecting the Bombay islands at strategic points. Mahim woods is visible on the horizon with Riva Fort on the extreme right. The road at the foot of the hill became Sion Road, which now leads to the Eastern Express Highway. In Wales' day it led to one of the ferries that crossed Mahim Creek to the Salsette islands.

VIEW FROM SION FORT

London, Published May 1st 1799 by R. Colll. 9 St. Mellan

Thy towers, Bombay, gleam bright, they say,
Across the bright blue sea,
But ne'er were hearts so light and gay,
As then shall meet in thee![1]

A visitor to Bombay in the last decade of our millennium will certainly see gleaming towers, but not the ones referred to by Bishop Heber in 1825. Of all the changes which have occurred in Bombay, one of the most dramatic is the development of Malabar Hill. During the last twenty-five years the outline of the hill has altered beyond all recognition with the addition of numerous apartment tower-blocks. On taking a tour of the hill today, one has to negotiate a constant stream of traffic, winding amidst the tall buildings in one of the most densely populated residential areas of the city. Here once stood sylvan forests, inhabited by plenty of birds and small animals. Today, as the light of dawn breaks over the mainland hills, if one strides at a brisk pace up one of the rough steps hewn out of the rockface off Walkeshwar, one can still imbibe a brief sense of the earthy freshness and the stillness of the leeward panorama of the past (figures 1 and 2).

Malabar Hill, rising over eighty-five metres from the sea, encompasses the sweep of Walkeshwar, Government House, Banganga Tank and its surrounding environs, Hanging Gardens, All Saints' Church, the Towers of Silence, and the western drive of Nepean Sea Road. Let us now go back in time, and examine some of the dramatic changes that over the last century and a half have turned the former hill-station-like atmosphere of Malabar Hill into the affluent glitz which it embodies today.

From the Sandy Beaches of Chowpatty

The word Chowpatty dates back to the time of the early Hindu settlements when the sea may have formed four channels or "Chow-pati" (Chowpatty) in the neighbourhood. The sea also in those times swept through the Worli breach at high tide, and "swamped" those regions which now form the central sections of the city, giving rise to names like *Paidhoni* or "Foot-Wash", and *Umarkhadi* or "Fig Tree Creek".

WHITHER THE TOWERS?
THE CHANGED VIEW

PHEROZA J. GODREJ

Facing the sands of Chowpatty, as we know it today, stands Wilson College named after the Reverend Dr John Wilson, Scottish missionary and Oriental scholar. The building, designed by John Adams in the domestic Gothic style and constructed in 1889, stands as a legacy to institutionalized higher education. Dr Wilson came to Bombay in 1829 at the age of 24, with his wife Margaret. "The Ambroli (Khetwadi) Mission House was his home for the first thirty years and in 1862 he shifted to 'Cliff Cottage' a new residence on Malabar Hill — still wild and remote in those days!"[2] In 1869 on the fortieth anniversary of his arrival in Bombay, a special meeting

1

Malabar Point and Back Bay,
circa 1850s.
By John Brownrigg Bellasis,
from a sketchbook made in
Western India and the
Deccan, 1822-56.
Pencil and watercolour,
9.3 x 21.2 cm.
The projecting balcony in the
left foreground may be part
of the Governor's house,
since the view was taken
from the Point. Looking
across part of Back Bay, the
inlets along the southern
shore of Malabar Hill and the
bungalows on the hill itself
are clearly shown. It also
includes one of the Towers of
Silence, slightly right of
centre on top of the hill with
Chowpatty beach and
Girgaum woods in the far
distance.

was held in his honour at the Town Hall during which was pronounced: "Amongst the many Protestant missionaries who have come to India, John Wilson was undoubtedly an outstanding figure...."[3]

Even during Wilson's day, the ride to Malabar Hill from the sands of Back Bay involved an encounter of "sights and odors too horrible to describe — to leap four sewers whose gaping mouths discharged black streams across your path, to be impeded as you neared Chowpatty by boats and nets and stacks of firewood, to be choked by the fumes from the open burning ghat, and many an ancient fish like smell."[4] Even so, Henry Francis

as it was steep and narrow, later inhabitants called it "Siri" or "the Ladder".

Climbing up the steep side of Walkeshwar Road, in a south-westerly direction towards Malabar Point, the bay lies towards the east and the old Siri Road to the west. From here we begin to see rocky gardens cut out of the steep cliffs. Evelyn Battye described the view vividly when she wrote: "There are far reaching views, out over the Arabian Sea of long prowed dhows with beautiful lofty sails. These sea-going boats were swept across from Africa with the trade winds, reaching India in May with their cargoes of fruit and ivory and bringing the monsoon to drench the

OF MALABAR HILL

Hancock was inspired to paint from the sands of Chowpatty (figures 3-5).

Former Siri Road and Today's Walkeshwar Road

Around 1534, the pathway known as Siri Road (now Shri Chiranjilal Loyalka Marg) led from the village Gamdevi (named after the shrine of Gamdevi or village goddess) up the jungle-covered slopes of Malabar Hill and through the babul plantations to the great banyan-girt temple of Walkeshwar, and Shrigundi, a stone of purification on the very edge of the sea. The stream of worshippers from the west coast (Konkan region) gradually followed this pathway leading up the hill and,

country. In September and October the dhows returned with the wind, laden with cotton, tea, spices and silks."[5]

On the left of the "Ladder" was a plantation of *Acacia arabica* or babul, and the homage paid to it occasioned the building of the noted Hindu shrine of Babulnath. Some distance to the north of it on still higher ground is a continuation of the "larger area of Malabar Hill", which is known even today as Cumballa Hill, taking its name from the grove of "Kambal", or *Odina wodier*, which flourished on its slopes (figure 6).

On the old Siri Road which became the main thoroughfare at the turn of the nineteenth century, was

the "Gamdevi Road" of the twentieth century.[6] At the time this was written, a wood-yard had grown up around the house, which was almost concealed from view by wood stacks. However from its hall one could command a view of Back Bay, a portion of Girgaum, the Esplanade, and the Fort. In 1865, the brow of the hill was cut away to provide filling for the Chowpatty reclamation and the sea-face road which now runs directly to Malabar Hill.

2
View of the Harbour with European houses, *circa* 1850s.
By John Brownrigg Bellasis, from a sketchbook made in western India and the Deccan, 1822-56.

Pencil and watercolour, 20.1 x 32.6 cm.
This view includes an English couple admiring the scene which "gives but a faint representation of this lovely landscape, commencing with the distant Ghats which.... add to the interest of the scene by their broken and printed outline.... Immediately under Caranjah, the fort of Bombay becomes visible, with the spire of the Cathedral, and the steeple of the Scotch church standing conspicuously among the crowded buildings." Anon., *Life in Bombay*, 1852.

Surrey Cottage (long since pulled down), the residence of the Duke of Wellington in 1801-02. "It is a mere hut of a place, such as a subaltern of the Bombay Army would perhaps turn up his nose at," wrote a correspondent of *The Bombay Times* in 1856. The house stood about halfway up the now non-existent brow of Malabar Hill, on the right as one ascended Siri Road. It was described as, "situated between the road and the sea at the curve of the bay towards Malabar Hill, close to where the road from Byculla turns into the breach road from the Fort". This explanation will be clearer to the present generation by remembering that "the road from Byculla" corresponds to

Subsequently not only the house, but also the ground upon which it stood disappeared.[7] The fate of many more old bungalows has been in jeopardy for many decades, with the result that few of them remain today.

During the nineteenth century, the town was creeping gradually over reclaimed ground throughout the islands. This was facilitated by the construction of new roads, the most notable of which, Grant Road named after the Governor, Sir Robert Grant (1835-38), was built during his term of office. It linked Byculla with the "palm groves of Chowpatty"[8] and hence with Malabar Hill. As more roads opened up, further opportunities for the

3
Henry sketching — admiring audience.
By Madeline Hancock, from a sketchbook, *circa* 1865.
Pen and ink on silk,
12.2 x 24.8 cm.
One cannot be sure that Madeline's caricature of her husband, Henry Francis Hancock, seen here sketching on Chowpatty was made while he was making his drawing for the same watercolour as in figure 5, but there are obvious links between the two pictures. The spectators in the scene portray the cosmopolitan inhabitants of the city, identified by their various dress and headgear.

4
A scene on Malabar Hill.
By Madeline Hancock, from a sketchbook, *circa* 1865.
Pen and ink on silk,
13.5 x 25.6 cm.
This picture from the same sketchbook is also inscribed by Madeline herself: "A scene on Malabar Hill — just the sort of thing we drive thro' every day — and you may fancy us in the carriage which is just disappearing. The two little men are a coachman & gharawalla. The old woman on the right is fanning Indian corn which she is roasting on cinders and the other one is pulling the husks off. The woman on the left has a basket of cucumbers on her head. Those are two [Parsi] merchants walking along. And perhaps you observe that in the centre is a cart full of women. I have no remark to make on them excepting that there they are!" Despite this being almost a caricature, her study nevertheless conveys a vivid impression of the street life and activity taking place on the hill at that time.

5
View of Malabar Point taken
from Chowpatty.
By Henry Francis Hancock,
dated 1879.
Pencil and watercolour,
49 x 100 cm.
Private collection.
Part of Malabar Hill, with
Walkeshwar Road leading to
many bungalows, appears on
the right. In the distance to
the left is Colaba and the
Prongs lighthouse. A couple
of Kolis with their catch are
in the foreground which is
dominated by two beached
dhows. Dr John Fryer, in *A
New Account of East India
and Persia, being Nine Years'
Travels 1672-1681* (London,
1698) described Malabar Hill
as "a rocky, woody,
mountain; yet sends forth
long grass."

development of residential localities arose. Another important thoroughfare, Gowalia Tank Road, running from east to west, divided Malabar Hill to its south and Cumballa Hill to its north, giving easy access to both.

Walkeshwar Temples — Solitude at Land's End

At the extreme edge of the promontory known as Malabar Point, was discovered a strangely cleft rock, a

6

(*previous pages*)
View southwards from Cumballa Hill across Girgaum woods, Back Bay, Bombay city, and the harbour to the mainland.
By Edward Brotherton Carroll, early 1890s.
Oil painting on canvas, 56 x 89 cm.
Private collection, London.
This view was taken from the ridge of Cumballa Hill, probably at the end of the present Anstey Road, a cul-de-sac off Altamount Road. To the right is part of Malabar Hill and Babulnath Temple as it appeared before the late nineteenth century renovations. Lower down the slope is a small tank, probably part of the temple complex. Amid the profusion of trees comprising Girgaum woods, Gowalia Tank, though not visible, would be situated to the right of the grand classical style building in the left foreground.
Carroll has included Wilson College (completed 1889) at Chowpatty, marked by three turrets of different designs. These are no longer extant. The building with the triple ridge roof near Wilson College is the Mackichan Hall, a boys' hostel belonging to the college. Most of the other buildings, some of which are also adorned with turrets, are private houses. These form the beginnings of the extensive residential development that took place at Chowpatty and Girgaum, especially from the turn of the century onwards. The chimney possibly belongs to the Paper Mill at Girgaum.

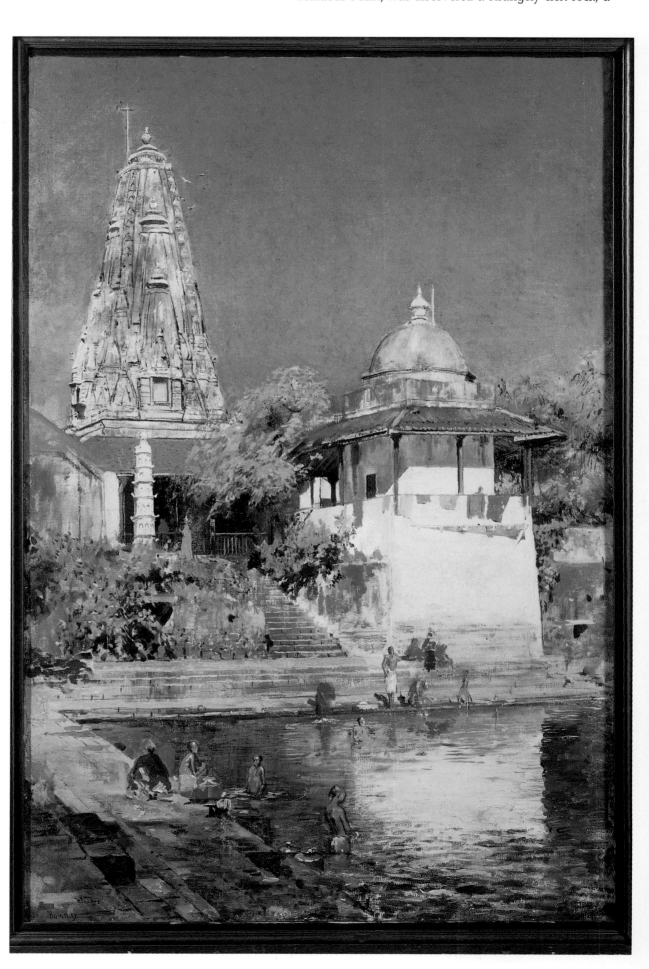

yoni, incessantly surf-buffeted and inaccessible in stormy weather. Being of Dravidian origin, the spot was referred to as "Shrigundi", and interpreted to mean "Lucky Stone". To further mark the sanctity of the spot, staunch Shaivites built a mighty temple. The influence of the shrine and rock has been considerable over the centuries. From the fishermen "to the aged yogi" with rosary of *rudraksh* berries, many an inhabitant of surrounding districts during the Shilahara and later epochs must have visited the temple. On passing through the trees to the land's verge, the pilgrims "sought regeneration by the perilous passage of the *yoni*". The original name of the area was "Shrigundi". But a tale has sprung up responsible for the name of the locality. Rama, so runs the legend, halted here on his journey to Lanka to rescue Sita. Since he was a Shiva devotee, he performed a daily puja to a lingam brought for him every day by Laxman from Benares. One day, however, Laxman was delayed. So Lord Rama shaped a lingam from the sand (*valu* = sand, *Ishwar* = Lord) and hence the name *Walu-ka-Ishwar* or Walkeshwar. Nevertheless, the place where he worshipped is a considerable distance away from the site of the present Walkeshwar temples (figure 7).

Some parts of Walkeshwar today still conserve the calm of those old Shilahara days. On the foreshore we find a little colony of *sanyasis*, dwelling amid the relics and temples against the soft wash of the sea and the sigh of the wind in old trees. Prominent amongst those who are said to have passed through the rock were Shivaji, Maharashtra's illustrious warrior general, Kanhoji Angria, an Admiral of the Maratha fleet, and the Peshwa, Raghunath Rao.

Banganga Tank — Purification of the Pilgrim's Soul

Situated on the south-west tip of Malabar Hill is the Banganga Temple tank and complex, including about thirty temples, two *mathas* (hermitages), and a number of *akhadas* (gymnasia). Today these comprise the oldest surviving structures in Bombay. Two tales are popularly recounted as to the origin of the tank. One states that Rama, who needed to obtain water for his daily puja, and finding none, launched an arrow (*bana*) "into the nether regions". As a result he released the river Bhagirati (the underground Ganga) "which straight away welled up and formed the tank", giving the water source its name, Banganga. Another version notes that Parshurama shot

an arrow from the Sahyadris. It is believed that the early tank and temple built by the Shilaharas between the ninth and eleventh centuries were repaired by the Yadavas in the thirteenth century. Powerful springs can refill the tank (measuring 104 by 114 metres and 10 metres deep) in eight days. The modern temple was rebuilt in 1715 by Rama Kamat, treasurer of the Matha of the Gowd Saraswat or Shenvi community. The Gowd Saraswats' Matha has been in existence at Banganga for about four hundred and fifty years and they are the owners not only of the tank itself, but also of a number of temples and houses in the area. There is also a temple dedicated to Parshurama.[9] Close by, on the western end of the promontory, is a traditional Hindu cremation ghat.

Government House — A Seat of Power

Coming up Walkeshwar Road one notices halfway up, a winding lower road approaching Government House from the north-east, which together with the upper road is lined with well tended trees, shrubs, and creepers. The lower road was constructed by Lord Elphinstone (1853-60) and was widened in 1869 and lodges added at the entrance to Government House.

Proceeding along Walkeshwar Road to the very edge of the precipice and continuing along the straight road we reach Malabar Point and Government House, for many years the hot weather residence of the Governors of Bombay. Sir Evan Nepean, Governor of Bombay (1812-19), had a small room at Malabar Point and his successor, the Honourable Mountstuart Elphinstone (1819-27) erected a bungalow, which Bishop Heber described as "a very pretty cottage in a beautiful situation on a rocky and woody promontory actually washed by the sea spray."[10] Lady Falkland was very fond of Malabar Point and is said to have spent one or two hot seasons here. Sir Richard Temple (1877-80), who refused to live at Parel, transferred his headquarters to Malabar Point,[11] and thus finally established this residence as the official Government House.

Government House continues to be the gubernatorial residence to this day, straddling the summit and most of the eastern part of the promontory. Being the only convenient residence available to the Governor, much money was spent from time to time adding amenities to make it suitable for the purpose. By 1905, for example, considerable improvements had been made for the visit of

8
Aerial view of Malabar Point including Government House and Banganga Tank.
By an unknown photographer, 1937.
"Surrounded by sea on three sides, with a thick forest stretching from the gate of the lower road and a small sandy private beach by the side of the forest, the Raj Bhavan complex now occupies an area of 49 acres. It enjoys a well deserved reputation as one of the finest buildings in the State."
From: *Raj Bhavan, Bombay*, compiled by Capt. Atul Kasal, ADC to the Governor, November 1994.

the Prince and Princess of Wales (later King George V and Queen Mary), which included the installation of electric lights and fans.[12] By then Government House had a great many outlying bungalows besides the residence of the Governor (figure 8). These are used for various purposes such as accommodation for the officers and staff of the Governor and private and military secretaries.

The house had a bandstand which was situated to the east of the dining hall. It had an extensive garden and beautifully manicured lawns, under the superintendence of an expert European gardener specially appointed for this purpose. On its tip there is a lighthouse and tower, the ruins of which were noted by Maria Graham in 1812 in her *Journal of a Residence in India*. A flagstaff 100 feet in height also stood at Government House, and a flag is still kept flying when the Governor is in residence.

After independence, the Governor's residential complex came to be known as Raj Bhavan. It now includes four large guest houses — Jal Lakshan, Jal Lakshan Annexe, Jal Chintan (Point Bungalow), and Jal Poojan (Bay Bungalow), the Banqueting Hall and Durbar Hall which can seat over two hundred and fifty people, and various residences of the officers and staff besides the offices of the Governor's Secretariat. Nonetheless, the general area remains apart from the rest of Malabar Hill's urban sprawl, its lawns, copses, and shady trees affording shelter to monkeys, paradise flycatchers, and similar species.

As we leave the tranquillity of Raj Bhavan and emerge onto Walkeshwar Road, we find ourselves at a junction called Teen Batti, literally meaning three lights, which was originally gas-lit like the rest of the city. This descriptive landmark leads us towards the approaches of the crest of the hill and the Babu Amichand Pannalalji Adishwar Jain Temple which overlooks the Bay.

The Jain community had arrived in Bombay by the mid-eighteenth century from Gujarat, driven from their homeland by the Marathas, reinforcing the Gujarati-speaking trading communities already established in the city. In 1903, the Shvetambar Jains built this temple dedicated to two chief deities, Rishabhadev and Parshvanath. The temple is largely attended on a daily basis and opulent festivities are held on the anniversary of its foundation. Tourists are also permitted to visit the temple.

All Saints' Church

A newspaper of 1882, the year of the consecration of All Saints', refers to it as "the pretty little church on Malabar Hill", for it has simple charm and small, friendly proportions. Its original purpose was to serve as a "chapel of ease", for the faithful otherwise had to travel every Sunday to the Cathedral, eight miles away. With a burgeoning European population, *The Times of India* commented on July 15, 1873: "Is it not surprising that the residents in or about Malabar Hill have never combined in endeavouring to get a church erected on the spot?... instead of being compelled by force of circumstances to remain in their houses on Sunday morning." A petition to Bishop Douglas ultimately led to the official granting of a church on the west crest of the ridge, and *The Times of India* reported on November 26, 1880: "the Government have generously come forward with the gift of a free site and half the cost of the building.... The site granted by the Government is situated near the reservoir and in a central position for the inhabitants of the district." In thirteen months the church was completed and on Monday, January 16, 1882, it was consecrated in the presence of about forty to fifty people. Intended initially for Sunday morning service, the church started conducting service thrice on Sundays with additional prayer meetings during the week soon after being opened for public worship. [13]

The Hanging Gardens

As we progress to the central area of the hill we come to the Hanging Gardens, today called the Pherozeshah Mehta Gardens, after the Chairman of the Bombay Municipal Corporation, 1884-85, and the Kamala Nehru Park, dedicated to Pandit Nehru's wife. This affords

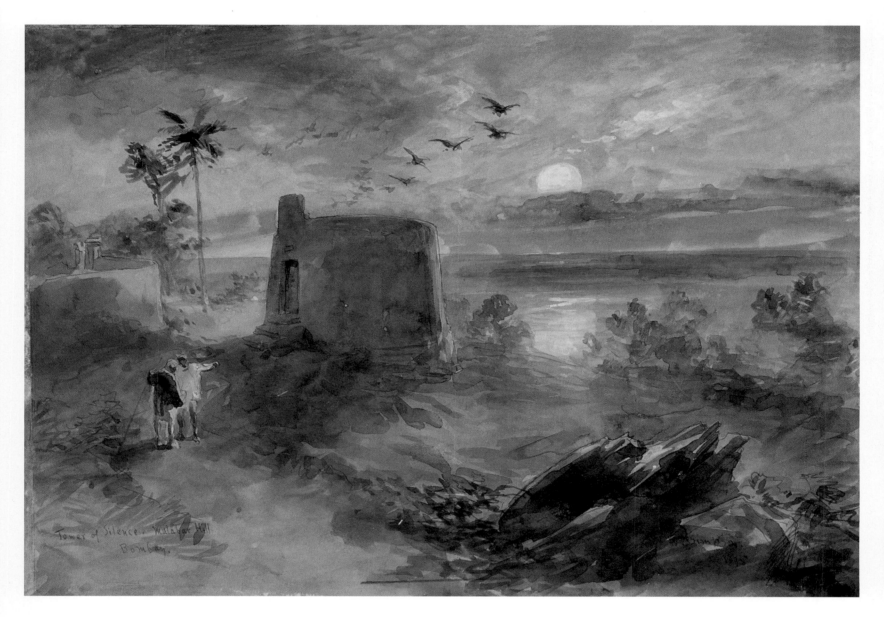

9

Towers of Silence, Malabar Hill at sunrise.
By William Simpson, 1875.
Pencil and watercolour,
20 x 28.5 cm.
Courtesy the Mitchell Library, Glasgow.

This watercolour captures the remote setting of the site on the hill. The early morning view shows the sun rising over the distant Western Ghats. The towers are massive round buildings with white plastered walls. The circumference of the largest tower is over ninety metres, the height of the wall eight metres at a distance of three feet from the ground. There is a door in the wall permitting access to the inner portion of the *dakhma*. Prayers having already been said in the rest house, the body is conveyed to one of the towers. The people in the foreground may be pall-bearers who having discharged their duties are seen resting on the crest of the ridge, while vultures hover above.

a dramatic view of Back Bay and the harbour, islands, and mountains beyond. A series of tunnels linking up with Tulsi Lake on Salsette Island was commissioned between 1876 and 1879 to provide high-pressure water supply to the properties on Malabar Hill, Cumballa Hill, the Fort, and Colaba. In 1885, in order to store and filter the water, the Malabar Hill Reservoir was provided with a roof and a filter bed, thus paving the way for "a garden comprising almost 52,000 square yards maintained at a handsome annual cost of Rs. 700, which was handed over by the Government to the Municipality in 1885". As a result the garden is situated on top of the reservoir, hence its name "Hanging Gardens".[14] In the early 1950s Pandit Nehru suggested that the garden area should slope down both eastwards to Chowpatty and westwards through the erstwhile Hyderabad and Baroda estates. Indeed this large area of greenery was the predominant landscape of that time.

A Lady's Gymkhana was established close to Hanging Gardens in January 1879. One can conjecture that it existed around the current site of the Malabar Hill Post Office. The wives of the various Governors of Bombay had honoured the Gymkhana by accepting the post of Honorary Lady President. "There were four tennis courts and three badminton courts which were well patronised throughout the year.... There was also a pavilion built in 1876.... During the cold weather subscription dances were sometimes held or the place was hired out by the committee to members for private dances, the centre badminton court having been laid with a dancing floor." [15]

The Towers of Silence

The expanse of greenery and woods afforded by the Towers of Silence area remains one of the few open spaces in the city today, so necessary to rejuvenate its polluted atmosphere. The road along the ridge (Gibbs Road) ended

abruptly at the last bungalow which was situated at some little distance from the "Towers of Silence", a term coined by Robert Murphy, translator in the Bombay Government[16] (figure 9). A footpath surrounds the outer wall to the entrance of the towers. The main approach was by a steep and rocky pathway up the cliff from Girgaum Chowpatty. Even today there exists a pathway

10
View from the ridge of Malabar Hill, looking over Back Bay with Malabar Point, its flagstaff and bungalow (right), and a distant view of Colaba and lighthouse (left). By James Wales, 1791-92. Pen, ink, and watercolour, 29.7 x 39 cm.
The view from Malabar Hill towards Malabar Point is one of the earliest recorded views of this celebrated site.

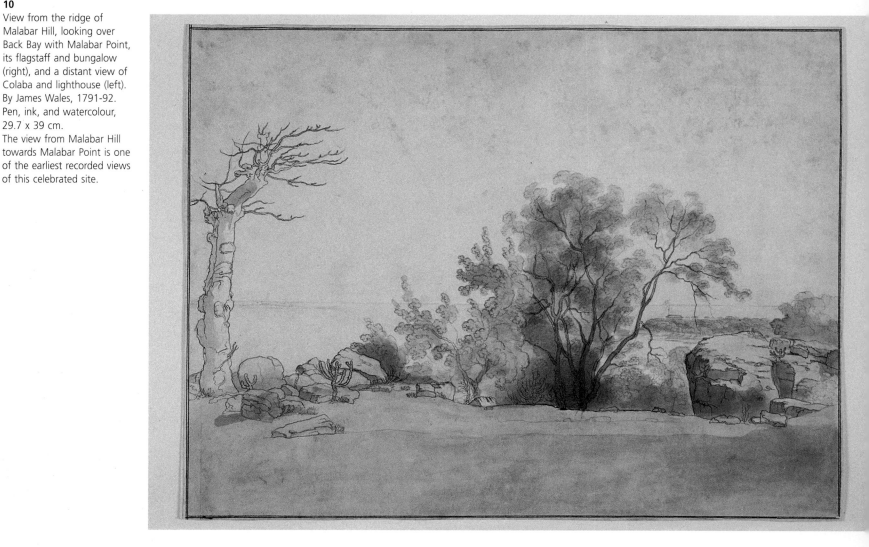

through Parsi Kharegat Colony at the eastern base of Malabar Hill. In 1858, Sir Jamsetjee Jeejeebhoy donated money for the construction of a broad carriage road from the north face of the hill up to the foot of the highest flight of steps and by this road the visitor can reach the towers without inconvenience. The towers are seven in number and are referred to as "*dakhma*" (sepulchre, roofless tower). This includes five towers at the main Malabar Hill, Dadyseth Tower near the old Dadyseth Bungalow in proximity to the current Chowpatty Bandstand, and Readymoney Tower off Ridge Road. The grounds had been granted to the Parsi community in 1672 by Governor Gerald Aungier for the growing community's requirements as "a burying place for their dead on the island", and the area is still known as "*Doongerwadi*" or Hill Gardens. As required by the Zoroastrian faith, the site on Malabar Hill, being then

11

(facing page, below)
Malabar Point and Back Bay.
By Johnson and Henderson,
circa 1857.
Photograph, 21 x 26.5 cm.
"On the tongue of land
jutting into the sea, named
Malabar Point, is obscurely
represented the marine
bungalow of the Governor of
Bombay, with some of its
outhouses. To the right hand,
on the swell of the ground,
are some of the residences,
lately erected.... On the shore
below, on the northern side
of Back Bay, are seen some
of the dykes which have
been erected by the
ingenious fishermen of our
island, to aid them in their
piscatorial operations." (*IAPA*
text to No. 15).

12

Looking towards Malabar
Point.
By Julius Middleton Boyd,
circa 1880s.
Watercolour, 16 x 22.6 cm.
This view towards Malabar
Point (flagstaff just visible
through branches of the
trees) has bungalows and the
road in the foreground. The
shape of the road seems to
suggest the junction which
could be the beginning of
the Hanging Gardens.

outside the city limits on an isolated rocky elevation, was the ideal place for building the Towers of Silence. The only other possibility within the islands' boundaries might have been Mazagaon Hill but it already had a fort on top.

The oldest tower is Modi's tower which bears no inscription and is dated *circa* 1672-73.[17] The second tower which also bears no inscription or date is known as Maneckji Seth's Tower and was in all probability constructed around 1756.[18] The third tower was built by public subscription in 1778 and is known as the Anjuman's Tower of Silence.[19] The fourth tower, Framji Cowasji Banaji's Tower, was consecrated on May 3, 1832. In about 1840 the increase in the Parsi population necessitated the building of a fifth *dakhma*, known as Cowasji Bisni's, consecrated on May 7, 1844. The grounds of the Towers of Silence are immense, a sylvan blend of forest and pasture populated by peacocks, vultures, other birds, and the odd snake. From Gibbs Road on the east they straddle the bulk of the crest of Malabar Hill reaching down almost as far as Nepean Sea Road (figure 10). Much of it remained pristine until the late

1960s, by which time most of the rest of Malabar Hill lay in private hands and was already in an overdeveloped state. By the late 1970s and 1980s, faced by an acute housing shortage and growing criticism of the Bombay Parsi Panchayat by the lay public of the community, the Panchayat commenced the construction of low-cost housing on the boundaries furthest from the *dakhmas*. However the area immediately surrounding the *dakhmas* remains quiet and respectful of the departed.

From this site, when one looks at Malabar Hill from either east or west, one is struck by the mass of greenery. Before the rains break, as the city reels with the May heat, Malabar Hill is a riot of colours. Red gulmohars, yellow laburnums, the blue and purple tinged jacaranda, pink acacia, the Indian flame of the forest, vie with each other for a spot in the sun. With the onslaught of the monsoon the area is lush and overgrown with foliage. The two large areas, Raj Bhavan and the combined space of Hanging Gardens and the Towers of Silence, gifted by nature and maintained by man, fortunately still provide a pair of lungs for a city choked by pollution.

Vestiges of a Bygone Era

By 1862 Bombay had grown beyond both natural and artificial limits and in 1865 the area of Malabar Hill known as Nepean Sea Road (now L. Jagmohandas Marg) and Wilderness Road (now Ratilal R. Thakkar Marg) had also been improved by the widening of narrow pathways into carriage tracks. With the opening of Gibbs Road in connection with the Malabar Hill reservoir, even the old

Siri Road was converted into a satisfactory thoroughfare for pedestrians. Such areas of development, Malabar Hill being no exception, reflected the society of the times and adhered to a social hierarchy among its residents. Europeans, keen to get away from the bustle of the Fort and to relax in the cool breezes, followed by affluent Parsis, Hindus, and a few Muslims, built spacious bungalows (figures 11 and 12). Under the auspices of the Bombay City Improvement Trust, plots were divided for single family occupation and over both Malabar and Cumballa hills there appeared handsome bungalows with delightful and spacious gardens. A few lone survivors exist today. Jinnah House, once the home of the first Prime Minister of Pakistan, constructed under his personal supervision, was designed as a one-family bungalow in the colonial style. It nestles in a garden now overgrown with tamarind and large banyan trees. Equally impressive

13

Randall Lodge, Cumballa Hill. By John Brownrigg Bellasis, *circa* 1850s.
Pencil and watercolour, 10.3 x 29.5 cm.
Situated at the western end of old Bellasis Road on the slope of Cumballa Hill, Randall Lodge had been the Bellasis family's home for many years and, in his journal, John Brownrigg described the house on his arrival in 1821: "landed at the new pier at half past 12 on Saturday the 12th July.... I got all my trunks from the ship sent after me to Randall Lodge where I came in a PalanquinThe three windows nearest the terrace belong to one large room which leads into another large one where we breakfast and dine under a large Punkah. The first window is a double room, Uncle's library and office."

14
Today's view of Malabar Hill from the sands of Chowpatty. Photograph: Subrata Bhowmick, 1997.
"How enormously the value of property in Bombay has increased! In 1728 a hundred and thirty rupees were paid annually to Government for the rent of the whole of Malabar Hill, and in 1747, after much consideration and some chaffering, this rent was raised to two hundred rupees. It was then a trap rock with but few mango trees, and scarcely a scrap of cultivation on it. Europeans lived in the town, and had none of those airy bungalows Much less had they macadamized roads, materials for which are amply furnished by this rock" Although these comments were noted in the last century, the following is still true today: "Few spots in the world are more picturesque than this during the rainy season.... The prospect at such a time, when sun and cloud struggle each to make its own lights and shades, and the distant shower sweeps across the ruffled sea, to scatter its last gems over the heads of the everlasting hills, is surpassingly magnificent."
(*IAPA* text to No. 13, 1857).

is Mount Nepean, with its imposing rotunda and sweeping terraced driveway. Dunedin, belonging to the State Bank of India, built in the vernacular style, and Birla House still have lush lawns, stables (now converted to garages), and outhouses (figure 13). Sahyadri, a government guest house on the crest of Ridge Road (now B. G. Kher Marg) was deemed representative of gracious colonial architecture. Politically fashionable as it sounds today to remove all vestiges of pre-independence culture, Sahyadri was demolished in the mid-1980s and reconstructed, much to the dismay and outcry of conservationists.

From the numerous and comfortable dwellings and apartments on Malabar Hill one sees the glorious panorama of water on three sides. Couched by wooded sloping hills to the east and west, the bold edifices of a great city with dramatic buildings rising around, strikes the eye from the summit of the ridge. The hill, like the city it overlooks, has remained comparatively attractive (figure 14). In the last three decades, Malabar Hill's affluent influence on the city has been immense. It remains today the most exclusive area of Bombay. The residence of power, both economic and political, reflects itself in soaring land values, putting it well beyond the reach of the common man, so dear to political leaders. It does not matter if the property in question is a shanty situated less than a kilometre from the Chief Minister's bungalow or a penthouse in one of the modern high-rises, Malabar Hill's attraction over the decades has not diminished.

Notes
1. From The Reverend Reginald Heber, D. D. to Mrs Heber, 1825 (Theodore Oliver Douglas Dunn, *Poets of John Company*, 1921).
2. E. G. K. Hewat, *Christ in Western India*, Bombay, 1950, p. 242.
3. T. G. Mainkar (ed.), *Writings and Speeches of Dr Bhau Daji*, Bombay, 1974, p. 379.
4. S. M. Edwardes, *The Rise of Bombay: A Retrospect*, Bombay, 1902, pp. 279-80.
5. Evelyn Battye, *Costumes and Characters of the British Raj*, Great Britain, 1982, p. 17.
6. Edwardes, op. cit., p. 233.
7. *The Gazetteer of Bombay City and Island*, Bombay, 1909, Vol. III, p. 329.
8. Edwardes, op. cit., p. 252.
9. *Report of the Indian Heritage Society*, Bombay Chapter Workshop, Bombay, 1992.
10. *The Gazetteer of Bombay City and Island*, Bombay, 1909, Vol. III, p. 291.
11. Ibid., p. 290.
12. Ibid., p. 293.
13. *Churches of Bombay — Anglican Churches* (no page ref.).
14. *The Gazetteer of Bombay City and Island*, Bombay, 1909, Vol. III, p. 90.
15. Ibid., p. 296.
16. James M. Maclean, *Guide to Bombay*, London, 1899, p. 245.
17. See controversy regarding this dating in *The Parsis*, English edition of Mlle. Delphine Menant's *Les Parsis*, by M. M. Murzban, Bombay, 1917, Vol. I, pp. 74-75.
18. K. N. Seervai and B. B. Patel, *Gujerat Parsis from their Earliest Settlement to the Present Time*, Bombay, 1898, p. 70.
19. Ibid.

Acknowledgements
My foremost appreciation to Shyam Chainani, Heta Pandit, and Debi Goenka who stirred in me an awareness of the concerns and needs of present-day Bombay almost two and a half decades ago. I should like to express my most grateful thanks to S. A. Ahmadullah, the Bombay Local History Society, Professor Dr M. D. David, former Head of the Department of History at Bombay University, Vikas Dilawari, John Falconer, the Indian Heritage Society—Bombay Chapter, Farooq Issa, Indar Pasricha, and the Museum Society of Bombay. And final thanks to the members of my family, Smita Crishna, Raika Godrej, Navroze Godrej, Rishad Naoroji, and Bukhtawar Shroff, without whose support I could not have written this article.

Figure Acknowledgements
All photographs courtesy India Office Library and Records (OIOC), The British Library, London, unless otherwise noted.

One of the most striking paintings of Bombay ever produced is a watercolour by an army officer. It is eighteen feet long and forms a complete circular panorama as viewed from the rooftop terrace of a house within the Fort. By the time it was painted by Lieutenant Thomas W. Wingate (1807-69) in about 1840, the vogue for the panorama as a topographical format was in full swing. Judging from the inscription on the back of the picture: "Original unpublished Panorama taken from the top of Sir Jamsetjee Jeejeebhoy's house — drawn and coloured on the spot", Wingate almost certainly intended to publish it himself, probably as a series of lithographs. Now published for the first time, its importance is even greater since it predates the earliest known photographs of Bombay by over a decade (figures 2-11).

At the time it was painted, the new three-storeyed mansion of the Parsi benefactor, Jamsetjee Jeejeebhoy (1783-1859), situated on the east side of Hornby Row (now Dadabhai Naoroji Road) near the intersection with Ragonath Dadajee Street, was one of the grandest and tallest within the Fort (see Dwivedi, "Homes...": figure 5). Built in 1834, it commanded excellent views from the terrace, over the Fort's walls and battlements to distant landmarks both within and beyond the boundaries of the Bombay islands. The watercolour is a unique urban record, full of intricate topographical and architectural detail. This article highlights the sequence of the foreground structures and distant landmarks as depicted in the panorama, thus emphasizing its special relevance as a pictorial image taken from this vantage point. These features are best understood, however, by comparing each section of the panorama with the appropriate angles of vision in the "Plan of the Fortress of Bombay" by William Tate (see Edney: figure 3). Although Jeejeebhoy's house had not yet been built when Tate's plan was completed in 1827, its future position may be located next door but one to the General Hospital, almost opposite the Banyan Bastion. In fact site "E", which was then the office of the Commissary General, marks the

OVER THE ROOFTOPS: A PANORAMIC

exact position of the later house. Known as Fort House, it eventually became the commercial premises of Evans Fraser & Co., and subsequently Handloom House, until some years ago it was gutted by fire leaving only the shell of its ground floor. Today, Fort House is being rebuilt to its old design.

Towards the Indian Township (figure 2)

The ten sections, each of which is about 21 inches long, were painted as a series. From his vantage point on Jeejeebhoy's terrace, Wingate obviously turned in a clockwise direction, moving through approximately 36 degrees for each separate view. Judging from the baseline

TERESA ALBUQUERQUE

Taken & Drawn on Stone by J. M. Gonsalves.

The building facing is the Town hall

Horses

Lithographed by R. Prera.

SAINT THOMAS'S CHURCH, BOMBAY.

SPECTACLE

of his panorama, he probably took up his position for each section near the edge of the terrace with the bottom edge of his drawing paper representing the top of the parapet from which he made his carefully calculated survey.

Looking northwards, Wingate's first section includes the north-west corner of the Fort with the cannon mounted between the battlements, and the sloping roof of the General Hospital clearly visible in the right foreground. Distinctly in his line of vision, the main thoroughfare leading out through the Bazaar Gate runs directly across the northern portion of the Esplanade and

1
"Saint Thomas's Church, Bombay."
By José M. Gonsalves, about 1833 from his *Views at Bombay*, printed by R. Prera, probably in Bombay.
Coloured lithograph, 30 x 44 cm.
Courtesy India Office Library and Records (OIOC), The British Library, London.
The view looks eastwards along Churchgate Street towards Bombay Green and the Town Hall. The long two-storeyed building to the left is the Records Office with the Chief Secretary's residence in the centre, identifiable by its projecting balcony.

into the densely populated Indian township. The Esplanade was then no longer only the "field where cows and buffaloes graze" to which John Fryer had referred in 1664.[1] In the name of progress and with a view to strengthening Bombay's fortifications, the Esplanade had undergone gradual alteration. After the palm trees had been thinned, the land was levelled and the open space extended to a distance of 1,000 yards from the Fort's walls to form a protective glacis on three sides. The Esplanade, which is dotted with wells identifiable by several isolated trees, forms the most prominent feature in Wingate's entire panorama. Mercifully part of this area is still open land, a series of maidans, forming vital recreation grounds in dense south Bombay today.

The line of buildings along the Esplanade's northern boundary runs in a straight line on the far side of the road (later Carnac Road), although the panorama gives only a general impression of the Indian town beyond. Its population was the subject of many descriptions, including one by Lady Falkland, whose husband was Governor of Bombay 1848-53: "On all sides, jostling and passing each other, are seen Persian dyers; Bannian shopkeepers; Chinese with long tails; Arab horse-dealers; Abyssinian youths, servants of the latter; Bohras (pedlars); toddy drawers, carrying large vessels on their heads; Armenian priests, with flowing robes and beards; Jews in long tunics and mantles, their dress, half Persian, half Moorish; Portuguese, small under-sized men... [and] the Parsee priest, all in white from top to toe...."[2] This throbbing township was also the city's temple stronghold and included those of Kalbadevi, Mumbadevi, and Bhuleshwar, situated close to some of the oldest fire temples, mosques, synagogues, and churches.

Across the Bazaar towards Mazagaon Hill and Elephanta (figures 3 and 4)

Turning his gaze gradually north-eastwards, Wingate observed the rooftops of the Fort's bazaar area dominating the foreground of the next two sections. These simple buildings of two and three storeys, roofed with Mangalore tiles and with protective awnings above the windows, are devoid of architectural ornament. They are shown

crammed together in this northern area of the Fort. These are the dwellings, shops, and godowns mostly situated along the three parallel roads running north to south — Bohra Street, Bazaargate Street, and Mody Street. Most of these houses would have been relatively new at the time, having been reconstructed or renovated after the great fire of 1803. In fact it was this particular area of the Fort that was most affected by the disaster. From the back of the terrace, Wingate was also able to look right down to the ground level of the adjoining lane, running behind the General Hospital (visible on the extreme left of figure 3). The two sections together provide a bird's-eye view of what was once, according to James Forbes, "one of the first marts in India" and "contained many good Asiatic houses and shops filled with merchandize from all parts of the world, for the Europeans and natives".[3]

In 1840 and even today, these houses and shops belong largely to the descendants of those merchant communities that moved into the area, a few as early as the seventeenth century, and others who, after the fire, replaced the families that moved to the newer Indian township to the north. Although the Bazaar Gate itself, the northern exit from the Fort at the end of Bazaargate Street, is not visible in the panorama, another crowded road which branches off from it, heading across the Esplanade towards Mazagaon, is included. A clump of trees to the right of this road marks the position of Fort George, which adjoined the northern end of the Fort close to the Bazaar Gate. The buildings inside Fort George, the site of which is now partly occupied by St George's Hospital, are mostly hidden from view in Wingate's panorama.

To the right of Mazagaon Hill (visible in the middle distance, left of centre in figure 3) lies the harbour foreshore, stretching northwards past Sewri, which juts into the harbour beyond the boats at anchor near Bori Bunder and Carnac Bunder. The islands of Salsette and Trombay are faintly visible on the horizon, with the entrance to Thana Creek on the right. Turning clockwise into figure 4, the island of Elephanta, situated in the harbour, extends across both sections. Then as the harbour, studded with small islands, rocky shoals, and small craft, opens up it presents at a glance a highly picturesque landscape. Cross Island (also known as Jibbet Island) appears prominently on the right of figure 4, with the much smaller Butcher Island visible between it and Elephanta. The Western Ghats in the distance, with the lower hills descending gently into the water, form the backdrop to these views and those in the next two sections. More and more ships come into view, most of

them at anchor, a few with sails unfurled. The scene recalls the account of John Henry Grose, who almost a century earlier had stated emphatically: "Certain it is, that the harbor is spacious enough to contain any number of ships; has excellent anchoring ground, and by its circular position, can afford them a land locked shelter against any winds, to which the mouth of it is exposed."[4]

Across the Harbour (figures 5-7)

Looking directly eastwards across the bazaar area in continuation of the previous section, a series of rooftops lying parallel with Jeejeebhoy's terrace are visible towards the harbour-front which is bounded by Rampart Row East (figure 5). The houses are uniformly tall structures, a number of which clearly belong to the wealthy Parsi community — several are shown in discussion on terraces and balconies, or seen peering out of windows. As one turns towards the south-east, the houses in figures 6 and 7 appear at an oblique angle, the windows of their north facades without awnings but securely shuttered. Many of these windows are full-length to floor level, thus allowing a greater circulation of air from the narrow streets outside. A lone palm tree is also visible in this otherwise congested part of the Fort. The sense of reality is further heightened by the inclusion of bedding or laundry hanging outside some of the windows, and by a group of labourers repairing one of the roofs in figure 7. Here the houses are mainly the official residences and offices of the East India Company's personnel. As time progressed, many Europeans retained their premises merely as offices, opting to move to more spacious residences in the developing and healthier localities of Mazagaon, Byculla, Girgaum, and Malabar Hill, situated in the outlying suburbs. Even in 1825, Bishop Reginald Heber had noted: "The fort, or rather the fortified town, has many large and handsome houses, but few European residents, being hot, closely built with narrow streets, projecting upper stories and roofs, in the style which is common all over this side of India... having no pillared verandahs, and being disfigured by huge and high pitched roofs of red tiles. They are generally sloping, however, larger, and on the whole better adapted to the climate."[5] It is also evident from the strong shadows cast by the rooftops and some minor architectural details, that these first few sections were painted by Wingate during the afternoon hours on a sunny day.

The full extent of the harbour, from its northern reaches towards Thana Creek to its estuary in the south, is depicted in figures 3-6. As one examines the range of shipping, there is a greater concentration of ocean-going vessels at anchor towards the mouth of the harbour. Beyond lie the distinct formations of the Ghats, the sharp-cut crests of the Little and Great Karanja islands in figure 6. Separated from Bombay by only eight miles, Great Karanja had served as a base for the enemies of the British — the Sidis, the Marathas, and the Portuguese. When Wingate painted his panorama, however, these islands were already under British control, and served largely as additional protection within the harbour area. In the distance of figure 7, the western shoreline of the mainland may be seen, stretching southwards and out of sight.

The East India Company's buildings mostly occupy the area immediately to the north of Bombay Green. This open space at the centre of the Fort is here hidden from view. Exclusively a European quarter, it had been laid out earlier with pleasant walks and planted with trees. Still encircled by fine houses, it also became a cotton market during the last few decades of the eighteenth century. After Bombay entered into a lucrative cotton trade with China at the turn of the century, the area became the Cotton Green, where public auctions were conducted. In fact, the boost to free trade under the Company's Charter at that time created a population explosion with the result that the Fort was beginning, as one writer was provoked to exclaim, to look like "a large basket stuffed so full of goods that they threatened to tumble out of it".[6]

Only the top of the pedimented Town Hall appears above the rooftops in the centre of figure 7, with the flagstaff and clump of trees to the left marking the position of Bombay Castle. Dating back to the sixteenth century, Bombay Castle was the most historic part of the Fort, and originally dominated the area. Immediately to the right of the flagstaff, the tall brab tree used for navigation is clearly shown. Once the new Mint and the Town Hall overlooking Bombay Green, were opened in 1829 and 1833 respectively, Bombay Castle was overshadowed. These elegant neo-classical structures were the first major public buildings in Bombay to be designed (the Mint by Major John Hawkins and the Town Hall by Colonel Thomas Cowper, both of the Bombay Engineers), with their rear facades towards the harbour. They were

2-11
(*following pages*)
Complete circular panorama from the top of Sir Jamsetjee Jeejeebhoy's house in the Fort.
By Lieutenant Thomas Wingate, early 1840s.
Pencil and watercolour (in ten sections), 35 cm x *circa* 6 m (14 inches x 18 feet).
Reproduced by permission of the Syndics of Cambridge University Library, UK.
Note that the handwritten numbers on the panorama sections follow an anticlockwise order.

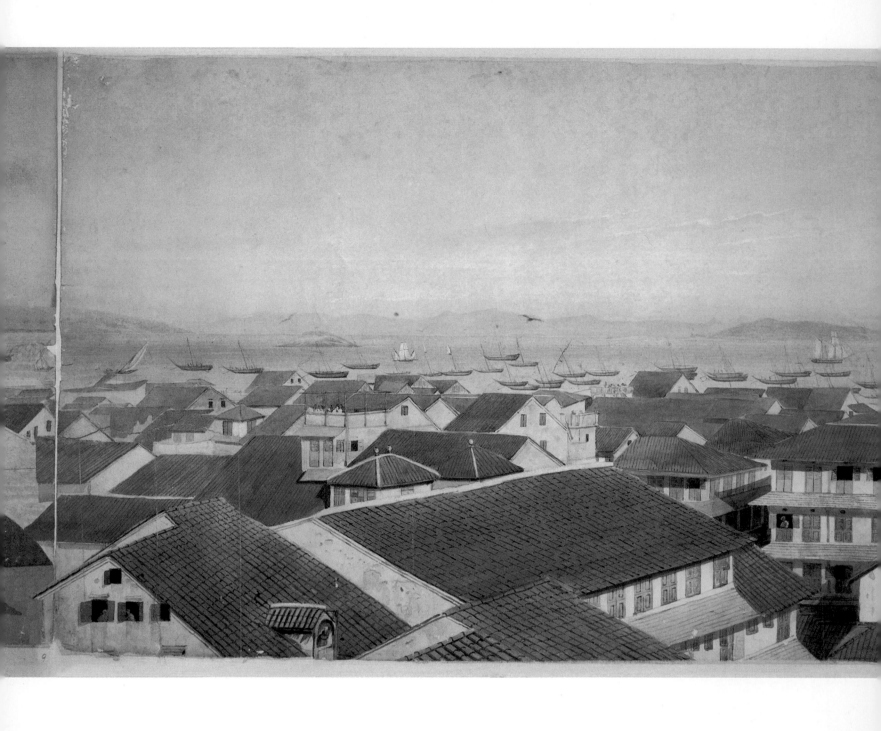

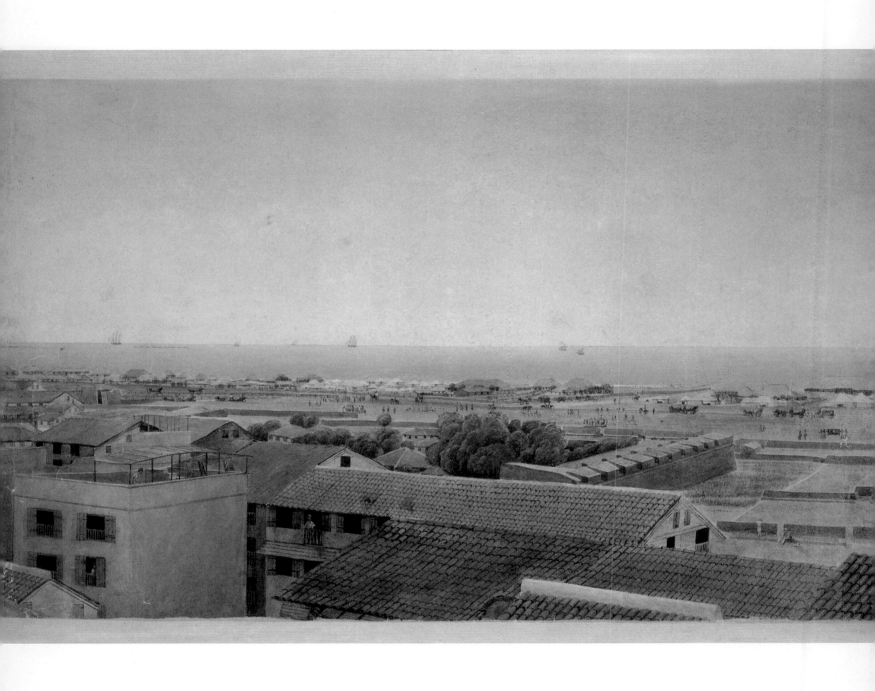

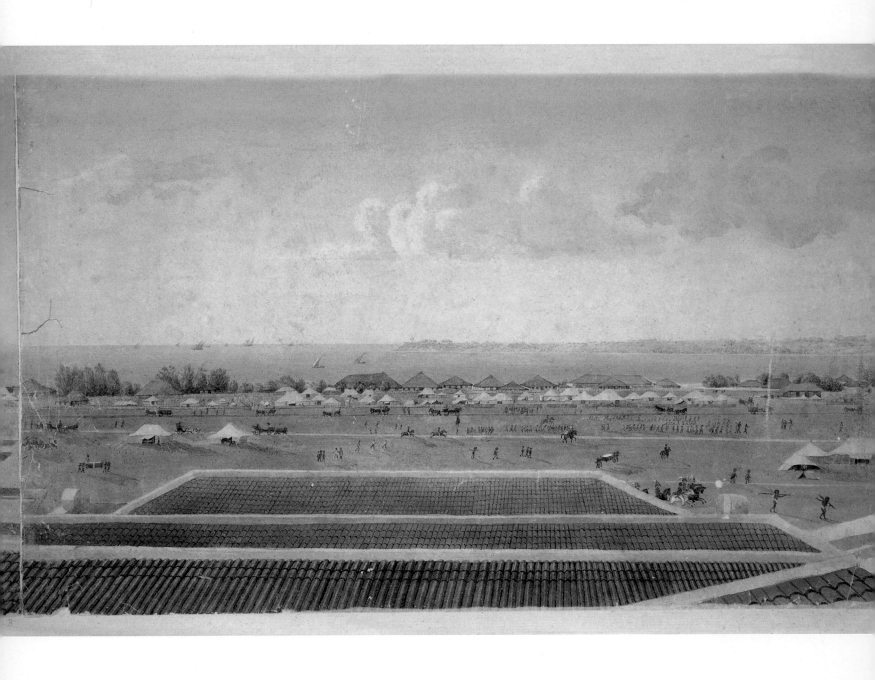

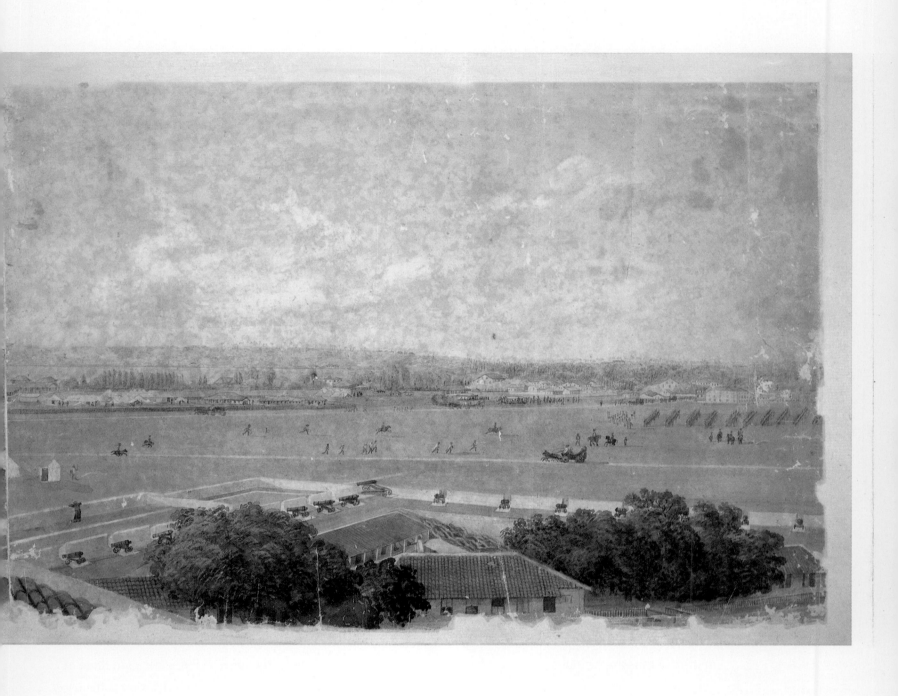

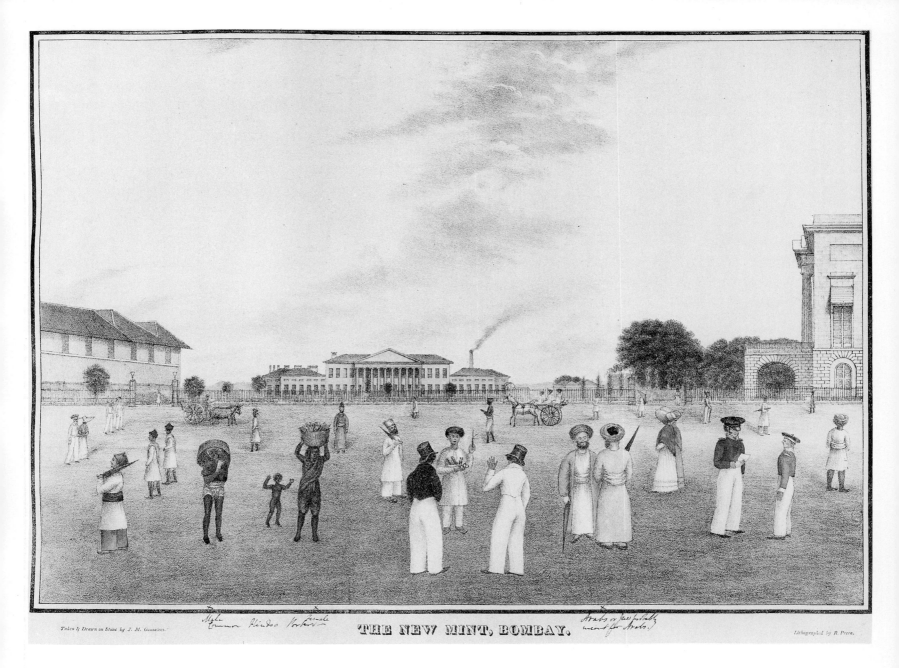

Taken & Drawn on Stone by J. M. Gonsalves. THE NEW MINT, BOMBAY. Lithographed by R. Prera.

12
"The New Mint, Bombay."
By José M. Gonsalves, *circa* 1833 from his *Views at Bombay*, printed by R. Prera, probably in Bombay. Coloured lithograph, 30.5 x 44 cm.
Courtesy India Office Library and Records (OIOC), The British Library, London.
The Mint appears in the centre, with part of the Town Barracks on the left and the northern end of the Town Hall (showing the Asiatic Society's premises) on the right.

also among the most modern structures in the city at that time. Soon after completion, their front facades were most vividly portrayed by an Indian artist, José M. Gonsalves, in a set of lithographs (figures 12 and 13). A fine view of Bombay Green could be obtained from the Town Hall's flight of steps leading to its main portico. This formed the subject of another, previously unknown, lithograph by Gonsalves, which is not part of either of his sets of Bombay prints (figure 14). His earlier set, printed by the General Lithographic Press in Bombay in 1826, includes a view of Government House on Apollo Street (figure 15).

In addition to the Mint and the Town Hall, the tops of two other buildings overlooking Bombay Green appear in Wingate's view. The tall building to the right of the Town Hall is part of the Custom House (the former Factory of the East India Company, today the Collector's Office). Almost in the same line of vision but nearer the spectator, there is another tall, box-like structure with a curious roof and window pattern. This is almost certainly the Theatre, which is also clearly marked in Tate's map of the Fort.

Southwards to Colaba (figure 8)

As the view unfolds in the next section, more houses come into view. Judging from the size of their rooftops these are distinctly larger and grander than those in the earlier sections. Dominating this view is the tower of St Thomas' Cathedral. Its former bell-turret, as depicted by Gonsalves (figure 1) and earlier by Forbes (see Rohatgi: figure 5) was replaced by this more striking architectural feature after the church became a cathedral in 1838.

Through the southern exit of the Fort, Apollo Gate (not visible in Wingate's view), the road led directly to Old Woman's Island and Colaba, both of which appear in the distance. At the tip of the latter is the lighthouse, erected about 1766 over the ruins of an old Portuguese watch-tower.[7] Even as late as 1830, these islands were cut off at high tide, and there were still no more than about fifty inhabitants on Colaba. Marianne Postans noted the dangers when she described the route across to the main Bombay Island: "a rocky sort of way, about a mile in length, connected this tongue of land with Bombay; which

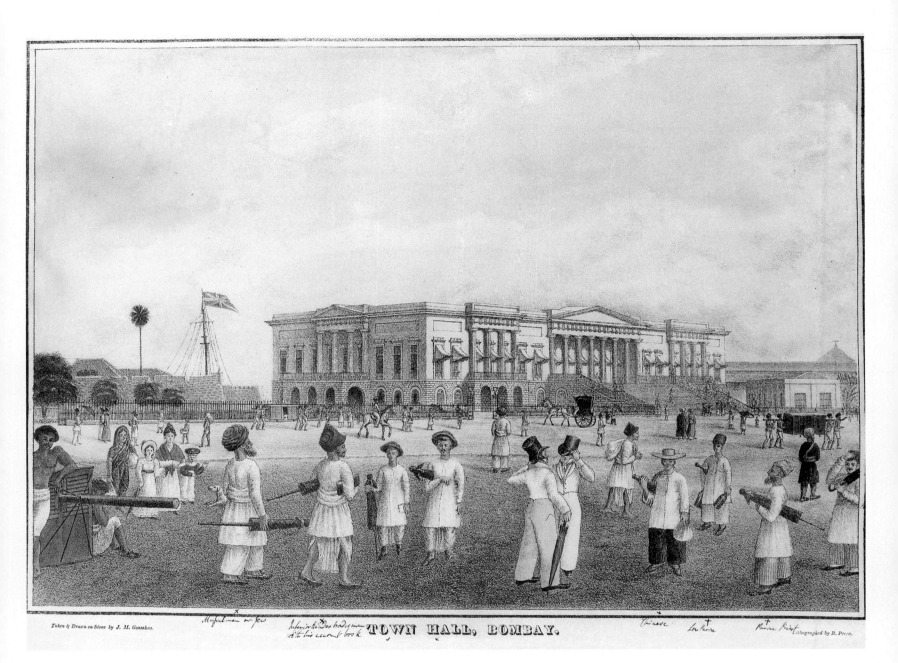

Taken & Drawn on Stone by J. M. Gonsalves. TOWN HALL, BOMBAY. Lithographed by R. Prera.

13
"Town Hall, Bombay."
By José M. Gonsalves, about
1833 from his *Views at
Bombay,* printed by R. Prera,
probably in Bombay.
Coloured lithograph,
30 x 43.8 cm.
Courtesy India Office Library
and Records (OIOC), The
British Library, London.
This view of the Town Hall
includes part of Bombay
Castle and the celebrated
brab tree on the left. As is
clearly evident here, people
of various nationalities and
communities occupy the
foreground of most of
Gonsalves' pictures.

at high tide was covered by the rolling flood. Many have
been the luckless wights, who returning from a festive
meeting, heedless of Neptune's certain visit, have found
the curling waves beating over their homeward path....
The more impetuous have sought to swim their horses
across this dangerous pass, and lives have been lost in the
attempt."[8] This hazard, plus the desperate need for
housing space promoted the construction of a firm
causeway in 1838 (see Mehrotra: figure 2). As a result
Colaba, which was once "of no other profit but to keep
the Company's antelopes and other beasts of delight",[9]
soon became an attractive residential area for Europeans.
Another lithograph by Gonsalves was drawn from the top
of Apollo Gate looking northwards along Apollo Street,
providing the finest vista of this historic street at that
time.

Westwards across the Esplanade to Back Bay (figures 9-11)

The last three sections include the sweep of the
Esplanade beyond the walls and battlements of the Fort.
The extreme right of figure 11 links with the extreme left
of figure 2 to complete the full circle of the panorama.
The buildings immediately within the walls, barely higher
than the walls themselves with trees almost enshrouding
them, extend across all three sections. The long rooftops
in figures 9 and 10 appear to be different in character
from those visible to the south of Jeejeebhoy's house. In
addition, a portion of the front facade in figure 9
indicates a passage running along the series of windows,
at one of which a figure is standing. These were the
quarters of the Bombay Army's Indian regiments. The
nearby Cumberland Ravelin, which contains the

who would move from tent to bungalow and vice-versa, selling their wares, cloth, silver, precious stones and trinkets, with baskets full of "chow-chow" — an assortion of stray goods. All found ready customers.

The Esplanade was also a popular recreation spot in Bombay, especially for those resident in the Fort itself. It was also a place of entertainment, as Lady Falkland further noted: "The band was about to play and the fashionable world just arriving in carriages or on

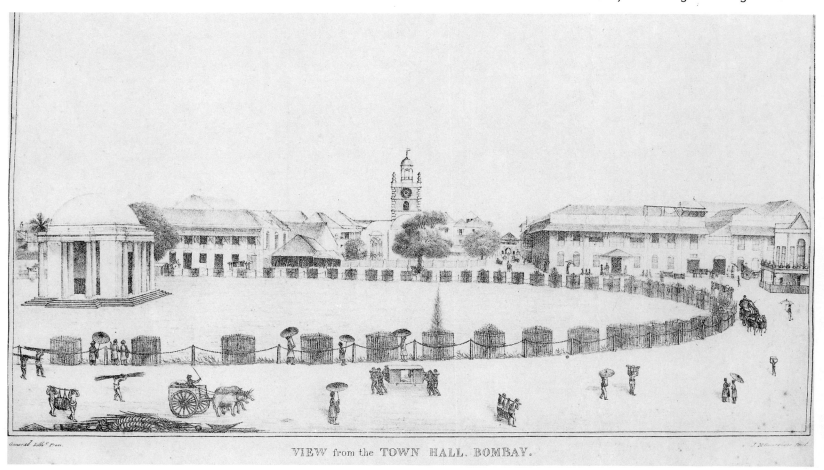

VIEW from the TOWN HALL, BOMBAY.

14
"View from the Town Hall, Bombay."
By José M. Gonsalves, about 1833, printed by the General Lithographic Press, Bombay. Uncoloured lithograph, 26.6 x 37.5 cm. Courtesy India Office Library and Records (OIOC), The British Library, London.
The view from the steps of the Town Hall includes Bombay Green encircled by a railing and newly-planted trees. At its centre is the Ionic cupola over John Bacon's statue of Marquess Cornwallis. The Church (St Thomas') with its bell-tower, dominates the scene, while the inner Church Gate can be glimpsed at the far end of Churchgate Street. To its right are the Secretaries' Offices and the pedimented Theatre adjoining the Green.

Superintendent Engineer's office, appears in the foreground of figure 11.

The Esplanade extends through five sections, figures 9-11 and figures 2 and 3. Back Bay, extending between Colaba and Malabar Point with the Arabian Sea beyond, is clearly visible in figures 8-11. The flagstaff and rooftop of the Governor's House are shown at the extremity of Malabar Hill, its thickly wooded aspect broken by a few bungalows ranged along the ridge.

The Esplanade is teeming with activity. Bungalows enclosed in a fenced compound range along the Back Bay waterfront, with tents neatly pitched behind them. The scene in Wingate's view again recalls the words of Marianne Postans who wrote: "During the hot season, the Esplanade is adorned with pretty, cool, temporary residences, erected near the sea; their choppered roofs and rustic porches half concealed by flowering creepers and luxuriant shrubs.... These bungalows are situated in line, with spaces between each, at a convenient distance from the road...."[10] She also mentions the "itinerant merchants"

horseback, and many European children on ponies, or in small carriages [prams] drawn by native servants.... The ladies remained in their britzkas [open carriages with a hood, a buggy], and the gentlemen flitted from carriage to carriage, paying their *devoirs* to the fair occupants...."[11] Wingate has included a variety of conveyances, from the sturdy bullock-hackery and palanquin carried by *hamauls* to the horse-carriage. In addition, cavalry officers are seen galloping across the grass on their chargers. Even before 1824, Captain John Seely had remarked: "Nothing can be more delightful than the rides and drives in this island: they extend 21 miles, and communicate to the neighbouring island of Salsette by means of a causeway."[12]

As Wingate's panorama completes the circle, the parade ground, known as Marine Lines marking the southern limits of the Indian township, comes into view (figure 11). Soldiers marching in formation are clearly visible. Beyond would be Dhobi Talao, the washerman's tank, and the curve of Chowpatty at the end of the bay below Malabar Hill.

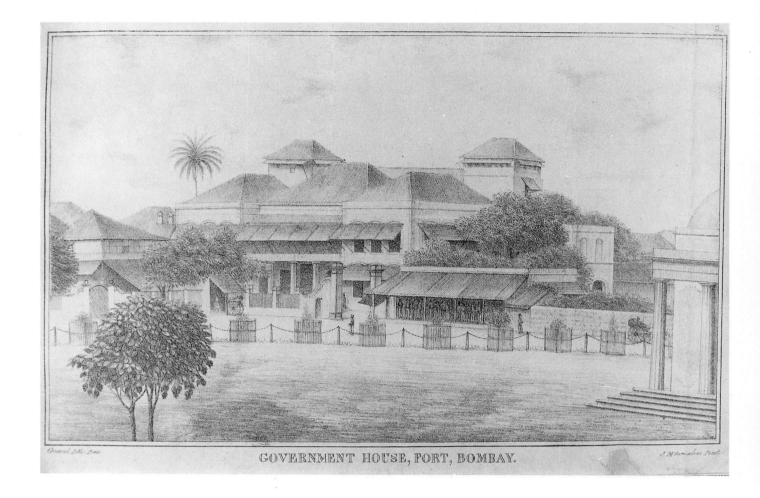

GOVERNMENT HOUSE, FORT, BOMBAY.

15
"Government House, Fort, Bombay."
By José M. Gonsalves, 1826, from his *Lithographic views of Bombay*, printed by the General Lithographic Press, Bombay.
Uncoloured lithograph, 21.8 x 35.5 cm.
Courtesy India Office Library and Records (OIOC), The British Library, London.
This view was taken from the middle of Bombay Green close to the Ionic cupola (see figure 14). The eighteenth-century view of Government House by James Forbes (see Rohatgi: figure 6) forms an interesting comparative study with this close-up by Gonsalves, and shows that considerable additions and alterations were made to this building.

Shortly after he painted his panorama, Wingate left India, probably in 1842, and joined the Recruiting Department in Glasgow. Still only in his mid-thirties, he had already spent some fifteen years serving in Ceylon, 1828-32 and India, 1835-42 with the 2nd Queen's Royal Regiment of the British Army. By 1846, he had retired as Captain and subsequently settled in Sydney, taking with him the Bombay panorama. There he not only continued to draw and paint, but also developed photography as a hobby, becoming one of Australia's first amateur photographers.[13]

Wingate's army training in survey drawing and his acquaintance with Sir Jamsetjee Jeejeebhoy enabled him to produce this remarkable panorama. Probably using survey instruments to calculate angles of vision, lines of sight, and elevations of the various landscape elements, he would certainly have taken several days to complete the task. It is a most carefully recorded document full of realistic detail. Wingate utilized cast shadows throughout the picture to increase the three-dimensional effect of the foreground, and to add a sense of depth to the entire scene, while the main focus of interest is generally in the middle distance beyond the rooftops. Thus whereas Wingate's watercolour provides a vividly realistic overview in a panoramic vista from Jeejeebhoy's house, Gonsalves' lithographs record a tapestry of street life against a backdrop of selected buildings within the Fort.

Notes
1. J. Fryer, *A new account of East India and Persia*, W. Crooke (ed.), London, 1909, p. 172.
2. Lady Falkland, *Chow Chow*, H. G. Rawlinson (ed.), Vol. I, London, 1930, p. 6.
3. J. Forbes, *Oriental Memoirs*, Vol. I, London, 1834, p. 96.
4. J. H. Grose, *A voyage to the East Indies*, London, 1757, p. 46.
5. R. Heber, *Narrative of a journey through the upper provinces of India*, Vol. III, London, 1828, p. 131.
6. S. M. Edwardes, *Gazetteer of Bombay City and Island*, Vol. II Bombay, 1978 reprint, p. 154.
7. J. Gerson da Cunha, *Origin of Bombay*, Bombay, 1909, p. 336.
8. M. Postans, *Western India in 1838*, London, 1839, pp. 30-31.
9. Fryer, op. cit. p. 177.
10. Postans, op. cit. p. 13.
11. Lady Falkland, op. cit. p. 8.
12. J. B. Seely, *Wonders of Ellora*, London, 1824, p. 4.
13. For further information about Thomas W. Wingate, see especially Joan Kerr (ed.), *The Dictionary of Australian Artists*, Oxford, 1992, p. 870. There is also an original watercolour by Wingate of the Jami Masjid at Tatta (Sind) dated January 10, 1839 in the India Office Library. In about 1842, Wingate published fourteen lithographs, entitled *The Storming of Ghuznee and Kelat*, after serving with his regiment in Sind and Afghanistan. His family papers are deposited in the State Library of New South Wales, Sydney (A 3804). The Bombay panorama was also presented to the State Library by Mrs L. Cadell, probably a descendant of Wingate, in 1953. The library then donated it to the Royal Commonwealth Society, London, whose collections are now in the Cambridge University Library. For further information about José M. Gonsalves see P. Godrej and P. Rohatgi, *Scenic Splendours: India through the Printed Image*, London, 1989, pp. 137-38.

Cathedral) and where the 'Tondal'. The Cathedral was a place of solemn worship only open on service days. Not so the Town Hall. It was a place free of access to all at certain hours of the day."

These recollections of Bombay Green and its vicinity in the 1850s were recorded in Sir Dinshah Wacha's book *Shells from the Sands of Bombay* of 1920.[1] Illustrating the memories are two photographs which form a panorama of the Green (figures 2 and 3), taken in 1856[2] from the Town Hall steps; the railed-in Cornwallis Monument dominates the left half of the picture while the tower of the "hoary Cathedral" dominates the right side. The Green had been a feature of Bombay, said Wacha, "for well-nigh two centuries";[3] photography was less than twenty years old.

Experimentation by Louis Daguerre in France and W. H. Fox Talbot in England had resulted in the invention of the photograph in the late 1830s. In the 1840s, photography spread rapidly around the world, and by the early 1850s, improved processes were available. In 1853 for the first time, the *Bombay Almanac and Directory* (the *Almanac*) included two daguerreotypists in its listing of Miscellaneous Professions and Trades: William Johnson, Grant Road, and A. G. Roussac, Medow Street; the

"The [Bombay] Green of the fifties was really a place of recreation for the young, just as Elphinstone Circle gardens are at present....

"[A]s I saw it while daily resorting to the green plot for play and amusement, I found it entirely free from the nuisance (of dumped 'cotton seed, cotton leaves, old rope and other "cutchra"', common earlier in the nineteenth century), but I used to see scattered a good deal of opium dust on the south side, just about the canopied statue of Lord Cornwallis, which was well railed in and kept free from any sacrilege, so to say, of the vicinity.

"Next to the hoary Cathedral in Church Gate Street, the object of the greatest delight and curiosity was the Town Hall, vulgarly pronounced 'Tondal'. Even in the fifties every school boy knew where was the 'Deval' (the

SUN PICTURES FROM EARLY PHOTOGRAPHY

JANET DEWAN

following year they were joined by William Henry Stanley Crawford. In 1855, Roussac was no longer listed — but Crawford and Johnson were joined by J. Evans, at Holder & Co., Booksellers, Rampart Row. They were not titled photographers until 1856. None of the men relied on photography for a living. Roussac was also a newsagent in Bakehouse Lane, Fort (1853-54); Johnson was an assistant in the General Department Secretariat, Girgaum (1853), and Grant Road (1854-55), and then in the Judicial Department Secretariat, Colaba (1856); Crawford was a partner in Crawford & Co., auctioneers and commission agents (1854-55) and manager at the Bombay Steam Navigation Co. (1856).[4]

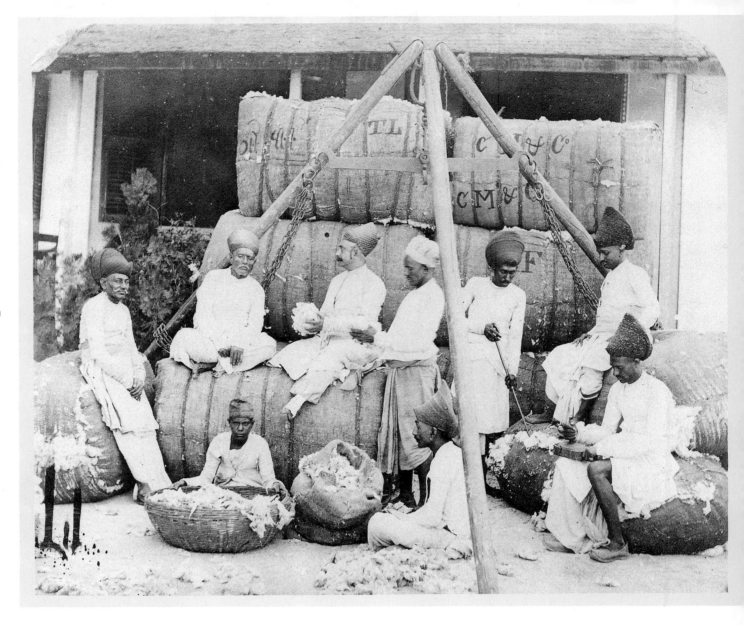

1

Cotton Market, Colaba, including "the high-turbaned Wanias of Kathiawar and Kutch, the Parsi vendor or broker with his Lohana assistant and Lohana herald and the Gujarati Wani purchasers".
By William Johnson, 1858.
Photograph, 19.7 x 24.5 cm.
Courtesy the Trustees of the Victoria and Albert Museum, London.
"We now attempt to represent the formalities of cotton purchase, connected with which there is both mystery and ceremony. The samples used are taken from the interior of the packs by a hooked stick. They are then handed to the seller and his assistant, who present them to the buyer, with such remarks on their quality as are thought likely to raise them in his estimation. A high price is asked, a low price is offered, and the parties gradually come to an understanding only after a laborious process, well evincing that *time* is at least no commodity in the Indian market. When agreement is come to, a crier-boy seated before the vendor and purchaser, announces the event, using the lucky word *Kar*" (*IAPA* text No. 5).

THE CITY OF GOLD: IN BOMBAY

By 1855, Crawford was also acting as the Bombay agent for "Bland & Long, Philosophical and Photographical Instrument Makers and Operative Chemists, 153 Fleet Street, London", and for "William Bolton, Operative Chemist and Photographical Instrument Maker, 146 Holborn Bars, London". Photographic supplies were also available from sources such as Merwanji Bomanji's "depot for sale of all material requisite for photography".[5] Photographic chemicals were stocked by John Treacher, Chemist, of Rampart Row West,[6] more famous in Bombay for the pure soda water which made his fortune in the 1850s. In addition to the part-time professionals, many amateurs made "sun pictures" as a hobby.

The Bombay Photographic Society

In October 1854, the Bombay Photographic Society (BPS) was formed, the first such society in India. It provided a forum for the exchange of technical information at monthly meetings for local members and, through its *Journal,* for corresponding members. Up-country amateurs were charged an annual membership fee of Rs 5, half the fee for Bombay members, after payment of an initial admission fee of Rs 10. Johnson and Crawford became joint secretaries of the organization and co-editors of its *Journal.*

Early members of the Society were drawn from the ranks of the civil service, the army, professions, and

2
Bombay Green with the
Cornwallis Monument.
By A.Z. [Albert Zorn?], 1856.
Photograph, 19.1 x 24.5 cm.
Courtesy Farooq Issa, Phillips
Antiques, Mumbai.

commerce. Local members included the following:
Captain Henry James Barr of the Bombay Army, who was
the founding President; Dr George Robert Ballingall,
acting assistant surgeon at the Sir Jamsetjee Jeejeebhoy
Hospital, and acting professor of anatomy and surgery,
Grant Medical College; Dr Narayan Dajee, and his
brother Dr Bhao Dajee (Bhau Daji), both surgeons; Dr
George Buist, editor, *The Bombay Times*; the Reverend
Arthur Davidson, superintendent, Money School,
Esplanade; Henry Hinton, schoolmaster, Hornby Row, Fort;
Ardaseer Cursetjee, chief engineer and inspector, Bombay
Dockyards, and later engineer in charge of the shipyard
at Mazagaon;[7] Archibald David Robertson, partner in
Messrs Martin, Young & Co., merchants and agents,
Mazagaon; James W. Robertson, deputy commissioner of
customs, salt and opium; Hurrychund Chintamon; and
William Henderson, assistant at Peel, Cassels & Co.,
merchants and agents, Colaba. By 1857, Chintamon,
Hinton, Narayan Dajee, and William Henderson were all
listed in the *Almanac* as professional photographers.

The corresponding members of the Society included
Captain Thomas Biggs of the Bombay Artillery, the first
Bombay Government Photographer; his successor, Dr
William Harry Pigou of the Bombay Medical Service;
Major Robert Gill of the Madras Army, who was engaged
in copying the wall-paintings of the Ajanta Caves; and
Captain Alexander John Greenlaw also of the Madras

Army, who is known for his early photographs of
Vijayanagara.

The subjects favoured by the early members were
both topographical and ethnographic. In February 1856,
when Lady Canning, wife of the Governor-General elect,
visited the Bombay Photographic Society and agreed to
become its patroness, she was presented with a portfolio
of about a hundred photographs "consisting of views in
and about Bombay, Salsette, Oorun, Guzerat, &c.
portraits of Natives of various castes and costumes",[8] the
work of Captain Barr, Drs Ballingall and Narayan Dajee,
and Messrs Crawford, Johnson, Hinton, Henderson, and
J. W. Robertson.

Photography and the Bombay Government

Patronage of the Bombay Photographic Society by
Lady Canning, Lord Elphinstone, the Governor of
Bombay, and Lord Frederick Fitzclarence, the Commander-
in-Chief of the Bombay Army, reflected the government's
new interest in the art. In early 1855, the East India
Company's Board of Directors pressed the government, at
Bombay Castle, to provide instruction in photography at
one of the scientific or educational institutions under
government influence or control, and to appoint an
official photographer to record objects of archaeological
and antiquarian interest. The Bombay Photographic
Society forwarded applications to the government from
Crawford and Narayan Dajee for the teaching post, and

3

Bombay Green with St Thomas' Cathedral.
By Johnson and Henderson, 1856.
Photograph, 18.7 x 24.1 cm.
Courtesy the Trustees of the Victoria and Albert Museum, London.
The railings around the Cornwallis Monument, mentioned by Sir Dinshah Wacha, are in evidence on the left side (figure 2) of this panorama. In fact the railed walkway, leading to the Monument, cuts right across the Green. The Cathedral dominates the right hand picture, and the inner Church Gate at the end of Churchgate Street is visible just to the right of the trees in front of the Cathedral. The panorama forms an interesting comparison with Albuquerque: figure 14.

after the two men were examined by a committee composed of Captain Barr, Dr Ballingall, and Mr Robertson of the Society, and Dr Giraud of the Grant Medical College, Crawford was appointed to teach the photography class at the Elphinstone Institution. Captain Biggs, who was selected as official photographer, had been lionized by the Society: a selection of his views "European and Indian" was exhibited in January 1855, and the following month the *Journal* noted that he "is a first-rate photographer, and in having him on our List of Members we have a great acquisition."[9]

Though the Bombay Photographic Society attempted to foster a cooperative spirit among professional and amateur photographers, the photographic milieu was aggressively competitive. This is illustrated vividly by Captain Biggs' outraged reaction in 1857 when Bombay Castle proposed to have his negatives printed by local professional photographers, at least some of whom would have been fellow members of the Society:

"I must protest against negatives taken by me [for government] being handed over to any professional photographer in Bombay to strike copies of....

"Such is the acknowledged jealousy and bigotry among professional photographers... that they will endeavour to make their own pet [printing] process suit every negative and will almost invariably take a pride in producing bad proofs from the negatives of others, to make it appear that they are inferior to their own negatives.

"The Professional Photographers in Bombay are... wedded to a system of printing which is totally unsuited to the negatives taken by me... & I consider it will be an injustice to me to give my negatives to men who are not competent to do them justice...." [10]

Chintamon and Hinton

Sir Dinshah Wacha remembered Hurrychund Chintamon as "the pioneer among the Indian photographers", adding that "his photos were greatly in requisition".[11] Chintamon had attended Crawford's classes at the Elphinstone Institution in 1855-56, and was awarded first prize in the student competition at the end of the first term. In 1857, Hurrychund Chintamon & Co. was listed in the *Almanac* as a professional photographic establishment in Girgaum; by 1860, the company had

4
Temple of Siva at
Walkeshwar.
By William Johnson, *circa*
1858.
Photograph, 24.8 x 19.7 cm.
Courtesy the Trustees of the
Victoria and Albert Museum,
London.
This image, first published in
IAPA, was included in both
the French and English
versions of Louis Rousselet's
L'Inde des Rajahs (1875).
See note 24.

5
Parsi Lady and Child, Bombay.
By Hurrychund Chintamon,
1857.
Photograph, 23.5 x 19.4 cm.
Courtesy India Office Library
and Records (OIOC), The
British Library, London.
This fine early studio portrait
shows an apparently relaxed
and attractive lady, a contrast
to the often stiff and anxious
sitters of the period. The
child has been sensibly posed
leaning against the back of
the chair, as a precaution
against movement during the
long exposure while the
photograph was being taken.
In a variant photograph
purchased by the India Office
from the 1867 Paris
Exhibition, a different child is
shown.

6
(overleaf)
The outer Church Gate, Fort
ramparts, and the Esplanade,
1856.
By Dr G. R. Ballingall, 1856.
Photograph, 17.8 x 25.1 cm.
Courtesy the Trustees of the
Victoria and Albert Museum,
London.
The image was published in
the first issue of *IAPA* under
the title "Bird's-Eye view of
the Church Gate and
Esplanade from the Bank of
Bombay". The Esplanade
beyond the outer Church
Gate (a fraction of the inner
gate is seen at the right side
of the photograph) is covered
with the tents and temporary
buildings which were a
feature of Bombay during the
hot weather for most of the
century. The statue of
Marquess Wellesley (here in
its original position) is just
visible on the left beyond the
ramparts.

7

(below)
View in Calbadavie.
By Captain Charles Scott,
1858.
Photograph, 19.1 x 25.4 cm.
Courtesy India Office Library
and Records (OIOC), The
British Library, London.
Louis Rousselet reproduced
this image as "Une rue de
Mazagon, faubourg de
Bombay" in *L'Inde des Rajahs*
(1875), relating it to a
description of his 1863 stay
at Mazagaon, which he
describes as "le lieu de l'Inde
le plus infesté de reptiles" (p.
23); the highlight of the stay
was an encounter with a
cobra in his garden.

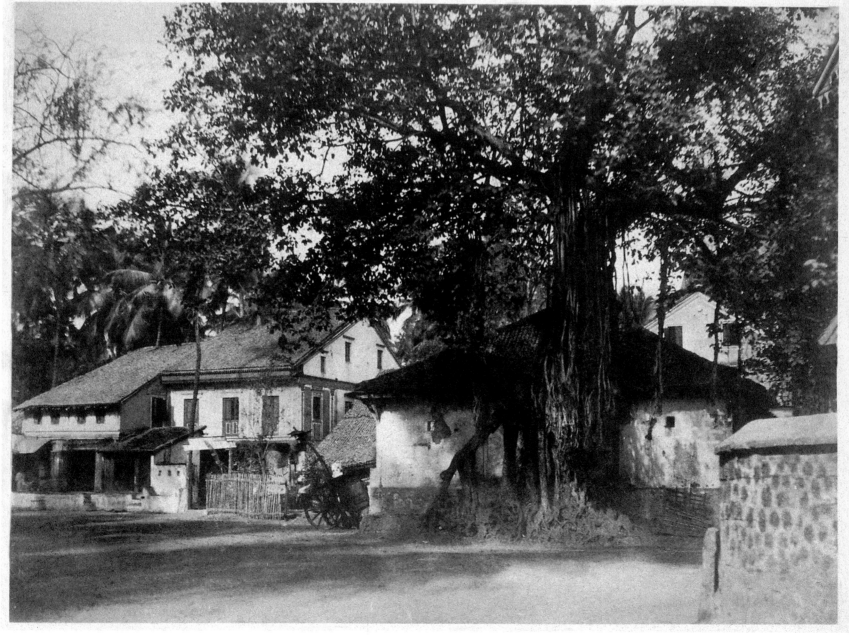

8
Scotch Church (St Andrew's).
By Captain Charles Scott,
1858.
Photograph, 20.3 x 26.4 cm.
Courtesy India Office Library
and Records (OIOC), The
British Library, London.
Captain Scott's view from the
Apollo Gate showing
St Andrew's Church, the old
ice house, Hornby House,
and the Clock Tower of the
Dock Gate, was taken from a
popular vantage point.
See note 25.

moved to the Rampart Row location which Wacha also remembered. Chintamon appears to have concentrated on portrait photography and in 1867, exhibited "studies of the castes and tribes of India"[12] at the Paris Exhibition (figure 5).

Wacha remembered Henry Hinton as the founder of one of "two private seminaries in the Fort where English was taught to sons of wealthy Indians", and observed that "Hinton was the better scholar, and his school was better attended than Boswell's. Eventually he was the only proprietor of a private English school in Bombay till the share speculation of 1864-65. Hinton, who, like others, was keenly in pursuit of riches, was greatly embarrassed

and broke up the school, he becoming for a time a photographer."[13]

Actually, Hinton's school in Rampart Row was listed in the *Almanac* under "Schools, Boarding and Day" from 1852 to 1858; after a hiatus in 1859, the 1860 *Almanac* list of schools included "Hinton, Mrs, Parell Rd, Byculla" — the same address given for her husband's photographic business in 1858 and 1859; both listings continued throughout the 1860s. In 1860, Hinton published *The Ruins of Bejapoor* with nineteen photographs, as well as a series of views of Mahabaleshwar. In 1863, he was engaged by Bombay Castle to photograph the Bombay fortifications, which were about to be dismantled.[14] His

series of Elephanta views was acquired by the eminent architectural historian, James Fergusson, and shown at the Paris Exhibition in 1867.

Johnson & Henderson and *The Indian Amateur's Photographic Album*

William Johnson and William Henderson are best known today as the publishers of *The Indian Amateur's Photographic Album* which appeared monthly for three years from November 1856 to October 1859. Each issue contained three original photographs[15] individually mounted, and a page of letterpress describing them.

Though the publication was titled *The Indian Amateur's Photographic Album*, a more accurate title would have been the "Bombay Presidency Photographic Album". Only a handful of the 108 photographs came from beyond the Presidency. The vast majority of images were of Bombay inhabitants, the city itself, or locations in the vicinity, such as Elephanta, Bassein, Tanna, the Kanheri Caves, and Ghorabunder. While Johnson and Henderson assiduously solicited negatives from amateurs in an advertisement on the back cover of each issue, the majority of Bombay photographs were taken by professionals, Henderson and Johnson themselves.

9
Ramparts of the Fort overlooking the harbour.
By an unknown photographer, *circa* 1857.
Photograph, 15.8 x 20.6 cm.
Courtesy the Trustees of the Victoria and Albert Museum, London.
This image was coyly titled "A Wee Bit of the Castle" by "An Amateur" when it was published in *IAPA* in July 1857. This view was taken from a spot near the Tank Bastion of Bombay Castle, and shows the ramparts outside the Castle, behind the Mint. Bombay Castle remains a mysterious part of the Fort area, off-limits to the public since the 1830s except with special permission.

10
Esplanade Road.
By Bourne & Shepherd, *circa* 1870.
Photograph, 23.5 x 30 cm.
Collection Centre Canadien d'Architecture/Canadian Centre for Architecture, Montreal.
Taken from Watson's Hotel, the photograph shows the Esplanade Road leading to Flora Fountain, built outside the former site of Church Gate, with the Cathedral High School beyond. A number of the pedestrians carry umbrellas, and the horse drawing the tram-car appears to be wearing a hat.

129

11
Town Hall and Bombay
Green.
By an unknown
photographer, *circa* 1858.
Photograph, 16.6 x 22.3 cm.
Courtesy India Office Library
and Records (OIOC), The
British Library, London.
The vantage point from
which the image was made
was a popular one. The
picture could be taken either
at ground level or from one
of the buildings bordering on
the Green. This version is
particularly attractive because
of the foreground interest
created by the coaches and
their ghostly attendants — an
effect of long photographic
exposure required at the
time.

Johnson and Henderson produced many important
topographical photographs (see figures 3 and 4), but they
are most often remembered for the series titled "Costumes
and Characters of Western India", drawn from the
extremely heterogeneous population of Bombay. The
quality of the series is variable, but the best images are
distinguished by the high technical skill of the
photographer, and by the elegant and graceful poses of
the sitters; three such images were made by Johnson in
the Cotton Market at Colaba (figure 1).

The *Album's* letterpress identifies only three
photographers, apart from Johnson and Henderson, whose
pictures of Bombay appeared in the *Album:* Dr G. R.
Ballingall (figure 6), Henry Hinton (figure 14) and the
mysterious "A.Z." (figure 2). It is probable that this
photographer was the bookseller, Albert Zorn, who was

recorded fleetingly in the *Almanac* in the mid-1850s, since
the initials are rather unusual.

The Indian Amateur's Photographic Album and Questions of Attribution

The first and third photographs in issue 2 of the
Album were views of Bombay Green from the Town Hall
steps (figures 2 and 3), although only the latter was
identified as such, the subject of figure 2 being given
simply as the Cornwallis Monument. The letterpress
neglected to mention that the two photographs, taken
together, formed a panorama, a point which — given the
importance of the subject matter — might well have been
highlighted. The shadows tell us that both photographs
were taken at the same time of day. Yet figure 3,
attributed to Johnson and Henderson, was obviously taken
first, as the lower branches of the tree in the right

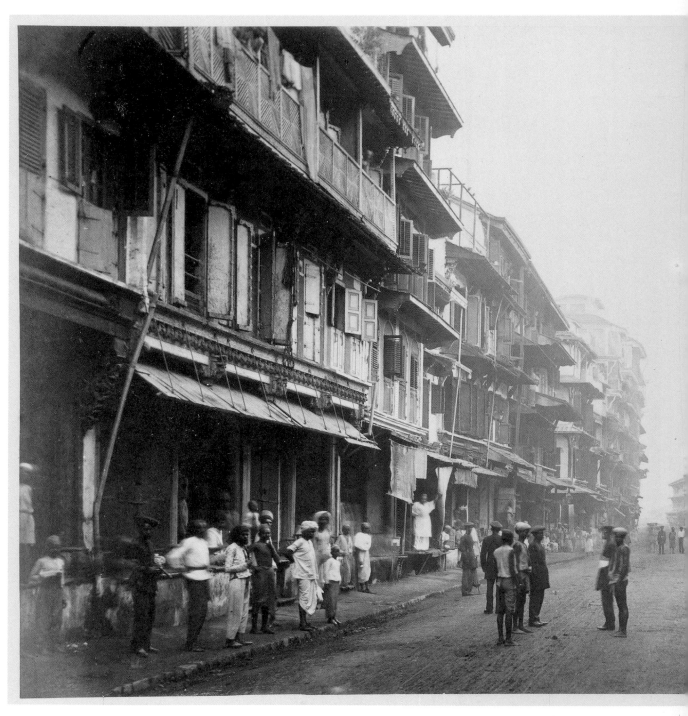

12
Bohra Bazaar Street, Fort.
By Bourne & Shepherd, *circa* 1870.
Photograph, 17.6 x 31.5 cm.
Collection Centre Canadien d'Architecture/Canadian Centre for Architecture, Montreal.
The Bohras for whom the street was named were descendants of Hindus converted to Islam in the eleventh century. The elements of the street — wooden buildings with the ubiquitous overhanging roofs, traditional overhanging balconies, and shutters — were, for Bourne & Shepherd's European customers, an old-fashioned and exotic contrast to the High Victorian buildings under construction along the Esplanade. The picture is carefully composed to lead the viewer's eye down the street, and is particularly interesting for the inclusion of many people, virtually all of whom are watching the photographer at work.

foreground of figure 2 appear in the left foreground of figure 3, while in figure 2, identified as the work of "A.Z.", these branches have been pruned. The panorama may have been created accidentally, but it seems equally likely that it was made deliberately. If so, were the two parts the work of different photographers, or is figure 3 misattributed?

Another question of attribution concerns the photograph, "Parsi Lady and Child" (figure 5). When it was published in *The Indian Amateur's Photographic Album* in March 1857, as number 5 in the "Costumes and Characters" series, it was credited to Johnson and Henderson. However, a variant pose acquired by the India Office from the Paris Exhibition in 1867 is identified

as "Photo by Hurrychund Chintamon",[16] and it is not plausible to think that Chintamon would present the work of another photographer as his own at the Exhibition.

The significance of these questions of attribution is mysterious. Were they merely errors in the letterpress? (Other instances of inaccuracies exist.) Were Chintamon and Zorn working as unidentified "staff photographers" for the publishers? This seems possible with respect to Chintamon who was just beginning his career, but it would not explain why Zorn was credited in one case and not in the other. Were Johnson and Henderson enlarging their reputations at the expense of Chintamon and Zorn? Of three studies in the cotton market by Johnson only the first (figure 1) was identified in the *Album* as his work, and

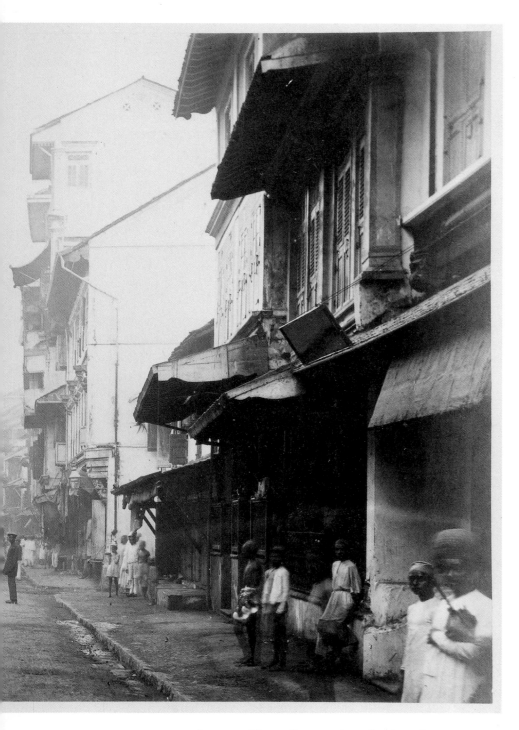

Henderson & Co. ran a Photographic Depot as well as a studio from 1860 onwards, and in the early 1860s, branched out into other areas as well — as "commission agents" (1861-65) and "share brokers" (1866). Johnson carried on his separate business in Grant Road into the 1860s, bringing out a series of photographs on the Elephanta Caves (*circa* 1860-61) and the Karla Caves (1861). The Johnson firm was listed in the *Almanac* until 1866, but Johnson himself disappeared from the list of inhabitants after 1862. He subsequently used a number of the *Album's* topographical photographs as backgrounds for ethnographic portraits in his two-album set, *The oriental races and tribes, residents and visitors of Bombay* published in London in 1863 and 1866; only a handful of the portraits themselves came from *The Indian Amateur's Photographic Album*.

Other changes were occurring in the Bombay photographic world during the 1860s. The Bombay Photographic Society, which had been a force in the early years, disappeared; after 1861, it was no longer listed among the city's cultural institutions in the *Almanac*. Commercial photography, on the other hand, grew. Crawford had left Bombay by this time to become a coffee planter, but Henderson & Co., Hinton, Chintamon, and Narayan Dajee, who carried on, were joined by a changing array of new photographers. Those who survived the longest were Kodabux Feerozsha on Kalbadevi Road, and David Sykes, who maintained a depot on Medow Street, and a "Portrait and Printing Establishment" on Bellasis Road.[18] In 1868, Sykes formed a brief partnership with Henry W. Dwyer; similarly, George Marshall took a partner, M. J. Nixon, briefly in 1866.

Photographically Illustrated Books

In early 1860, a slim volume of seven Bombay photographs (figures 7 and 8) taken in 1858-59 by Captain Charles Scott of the Bombay Engineers was published in London, along with three other equally slim books depicting Karli and Ambernath in five images, the Railway Cutting on the Bhore Ghaut in ten images, and the Bassein Fort in nine images.[19] Each volume included captions, but no additional letterpress.

Published books of photographs with letterpress, like Hinton's *The Ruins of Bejapoor* (1860) and Johnson's *The Caves of Karla Illustrated* (1861), both published in Bombay,

no photographic credit was given for the other two images. This argues against the notion that the publishers wished to take credit for more than their photographic due.[17]

The 1860s

Henderson disappeared as co-publisher of *The Indian Amateur's Photographic Album* in February 1858, and as its Agent the following September. In 1859, Henderson was no longer found in the *Almanac* list of Bombay inhabitants; in the same year, George Marshall became a partner in Henderson & Co., and he was joined in 1860 by Philip L. DeLomas. Marshall established his own photographic studio by 1861, but DeLomas continued as partner in the Henderson firm through the 1860s.

13
University buildings and Esplanade.
By an unknown photographer, *circa* 1877.
Photograph, 22.2 x 28.1 cm.
Collection Centre Canadien d'Architecture/Canadian Centre for Architecture, Montreal.
Also taken from Watson's Hotel, this view shows the Convocation Hall completed in 1874, and the University Library and Clock Tower under construction. The remains of the open Esplanade can be glimpsed behind the new buildings. Premchund Roychund, who sponsored two photographically illustrated books in 1865, paid for the Clock Tower. The image can be dated to 1877, as the Tower was completed in 1878.

became an increasingly popular format, particularly if the photographer could persuade the government to patronize the project. Since the Bombay government was interested primarily in recording the archaeological remains of the Presidency, the city itself was not a viable subject, and Bombay photographers travelled, sometimes long distances, from the city to oblige.[20]

Patronage of photographically illustrated books came also from prominent Bombay merchants. Premchund Roychund, who made a fortune in the speculative frenzy which accompanied the Bombay cotton boom of the early 1860s when the blockade of the South during the US Civil War prevented American cotton from reaching the English market, contributed £2,000 toward the publication of *Architecture in Dharwar and Mysore* and *Architecture of Ahmedabad,* two important books containing

photographs taken for the Bombay government by Biggs and Pigou. Kursondas Madhowdas similarly contributed £1,000 toward publication of *Architecture at Beejapore* with photographs by Biggs. The three books were published in London in 1866 for the Committee of Architectural Antiquities of Western India, a high-powered group whose members included Sir Jamsetjee Jeejeebhoy and the Honourable Jugonnath Sunkersett; Dr Bhau Daji was the committee secretary. The crash of the Bombay market following the end of the American Civil War in 1865, eliminated the projected publication of three more books, intended to complete the series.

As early as November 1854, Dr George Buist had recommended to the Bombay Photographic Society that it should prepare, or collect, first-rate photographs for sale "such as would be deemed desirable in England, and

14

Lady Falkland's observation
that the building of the
shrine had begun before the
railroad was even
contemplated, raises
questions about the sensibility
of the officials who chose
and approved the route of
the railway and siting of the
Byculla station. The
commentary which
accompanied publication of
the image in *IAPA* August
1857 observed blandly that
the shrine "strikes the
attention of the visitor to
Bombay from its peculiar
situation".
The Illustrated London News
(June 4, 1853) reporting the
opening of the first railway in
India, the Great Indian
Peninsula Railway, on April
16, 1853 between Bombay
(the Bori Bunder terminus)
and Thana, noted that the
Hindu temple at Byculla "has
been erected by a wealthy
Banian [Ranmal Lakha], who
hopes by this means to
propitiate the gods in his
favour, and obtain relief from
reumatic pains."

likely to be purchased by persons leaving India for Europe".[21] Photographs of Bombay and its vicinity were published commercially in increasing numbers in the 1860s, with a view to supplying visitors and returning European inhabitants with souvenirs of the city. In 1869, Sykes & Dwyer, for instance, advertised "BOMBAY AND ITS VICINITY. About sixty views of the harbour, buildings, and scenery".[22] Elephanta was a particularly popular subject, and by the end of the 1860s, there was so much demand for views that Sykes produced firstly a portfolio, and then an album on the subject with suitable scholarly letterpress.[23]

Apparently, greater choice did not necessarily mean better photographs. Louis Rousselet, the French adventurer who stopped in Bombay for a total of eight months during 1863-65, at the start of his five-year tour in India, purchased photographs of Bombay from which to produce woodcuts for his book *L'Inde des Rajahs* (1875); over one-third of the Bombay illustrations included in the book were from photographs taken in the 1850s and published in *The Indian Amateur's Photographic Album* or in Scott's Bombay album (see figures 1, 4, 5, and 7).[24]

Photographs of Bombay

Some of the features of Bombay captured by the early photographers would survive into the twentieth century: the Walkeshwar Temple (figure 4), the Elephanta Caves, St Thomas' Cathedral (figures 3 and 10), St Andrew's Scotch Church (figure 8),[25] Bombay Castle (figure 9), the Afghan Memorial Church, and the Town Hall (figure 11). The Afghan Church in Colaba, consecrated in 1858, was the only site in the city to be officially photographed for government; Pigou made several views of it in early 1858.[26] Some of the buildings featured in Bourne & Shepherd's Bohra Bazaar Street of about 1870 (figure 12) replaced houses lost in the Bombay fire of 1803[27] and, by the time the photograph was taken, formed an exotic contrast to the High Victorian public buildings under construction nearby (figure 13).

Gillian Tindall observes in *City of Gold: the Biography of Bombay* (1982): "The 1850s brought the first cotton mill to Bombay and the first railway line, but the vast transformation that these two agents of change were to bring about did not occur in that decade. The fifties were, rather, the last period of semi-rurality in Bombay...."[28] One symbol of the changing city was much photographed in the 1850s, the Hindu shrine beside Byculla Railway Station (figure 14).[29] Lady Falkland, the Governor's wife, wrote of the juxtaposition in 1853, the year in which the Bombay-Thana section of the Great Indian Peninsula Railway opened: "A very handsome new temple had been

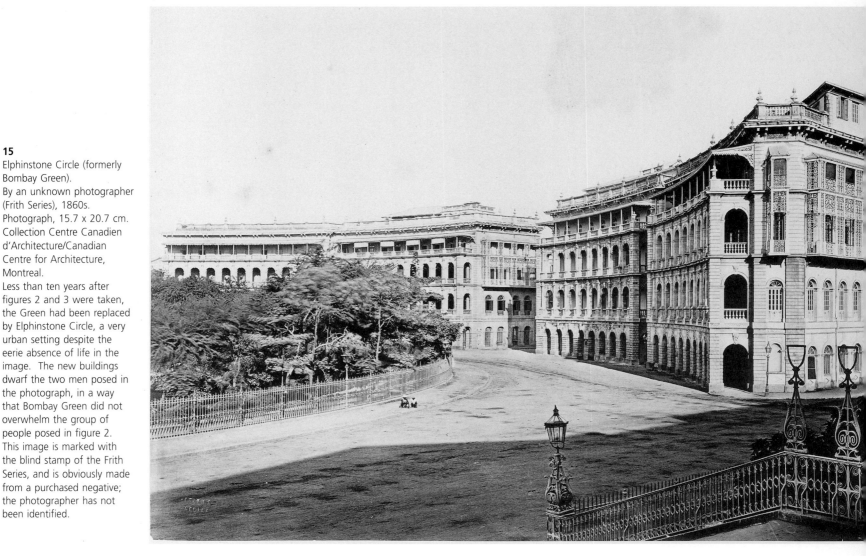

15
Elphinstone Circle (formerly Bombay Green).
By an unknown photographer (Frith Series), 1860s.
Photograph, 15.7 x 20.7 cm.
Collection Centre Canadien d'Architecture/Canadian Centre for Architecture, Montreal.
Less than ten years after figures 2 and 3 were taken, the Green had been replaced by Elphinstone Circle, a very urban setting despite the eerie absence of life in the image. The new buildings dwarf the two men posed in the photograph, in a way that Bombay Green did not overwhelm the group of people posed in figure 2. This image is marked with the blind stamp of the Frith Series, and is obviously made from a purchased negative; the photographer has not been identified.

commenced before the railroad was contemplated, actually contiguous to the station [at Byculla] and was on the verge of completion when the latter was opened. A railway station and a Hindu temple in juxtaposition — the work of the rulers and the ruled."[30]

But the most interesting sights to be photographed were the scenes that did not survive the 1860s and 1870s. Bombay Green was one, the rather pastoral scene in 1856 (figures 2 and 3) giving way in the early 1860s to the sophisticated and very urban Elphinstone Circle (figure 15). Equally dramatic was the change occasioned by the "Rampart Removal" of 1863-64 — for example, Dr Ballingall's 1856 view of Church Gate with the Esplanade beyond (figure 6) contrasts with the expansive Esplanade Road in Bourne & Shepherd's 1870 view (figure 10), and with the new buildings on the formerly open Esplanade to the west of it (figure 13).

Photographic Classics

Some of the earliest photographs of Bombay retained an unexpected currency in the 1880s as illustrations in at least two ostensibly timely books. The Reverend W. Urwick's *Indian Pictures, drawn with Pen and Pencil* was published in 1885 by the Religious Tract Society. The title is misleading: most of its woodcut illustrations were not originally drawn with pen and pencil, but based on photographs.[31] Bombay was given only a few pages, in

which Urwick discussed its heterogeneous population and mentioned the city's new "noble buildings... European in their style";[32] the two illustrations were based on Bourne & Shepherd's view of the exotic Bohra Bazaar Street (figure 12), and William Johnson's 1858 photograph "Weighers of Cotton" at Colaba Market.

India and its Native Princes, the English version of Rousselet's *L'Inde des Rajahs,* discussed earlier, was published in several American and English editions between 1876 and 1882. The 1870s editions retained the 317 illustrations of Rousselet's original, but the 1882 edition was a smaller volume with only 171 illustrations; by then, much of Rousselet's information, garnered almost twenty years earlier, was out of date.[33] At least four of the thirteen Bombay illustrations were twenty-five years old, but the topographical illustrations were outnumbered by the ethnographic,[34] which did not age as obviously as the letterpress. The major photographic lapse was the retention of a Town Hall view featuring Bombay Green in the foreground.

Perhaps Rousselet and Urwick's publishers had limited access to more current illustrations of Bombay, but the out-of-date photographs which they reproduced provided largely appropriate, if incomplete, representations of the city. In addition, the quality of many of these images had not been surpassed in the intervening years, and their publication so long after they

were made may be seen as a tribute to Bombay's early photographers and their classic images of the city.

Abbreviations

Almanac - Bombay Almanac and Directory
IAPA - The Indian Amateur's Photographic Album
Journal - Journal of the Photographic Society of Bombay
IOR - India Office Records, London
OIOC - Oriental and India Office Collections, London

Notes

1. Sir D. E. Wacha, *Shells from the Sands of Bombay being my recollections and reminiscences - 1860-1875*, Bombay, 1920, p. 328, pp. 327-28, p. 148.
2. Figure 2 is reproduced as "Bombay Green 1860" (opposite page 148) and figure 3 as "The Bombay Green 1864" (opposite page 139) in Wacha, op. cit., but both views were published in *IAPA*, No. 2, December 1856.
3. Wacha, op. cit., p. 326.
4. Details from *Almanac* 1853-56. Dates given in brackets later in the essay are also taken from the *Almanac*.
5. *Journal*, No. 9, October 1855, advertisement.
6. By 1866, Treacher & Co., Fort and Byculla, was a photographic depot. In 1855 Biggs, the Bombay Presidency's Official Photographer, obtained his chemicals from Treachers. See IOR: Bombay Public Consultations, August 8, 1855, No. 4073.
7. For details of Cursetjee's background, see Rosie Llewellyn-Jones, "Indian Travellers in Nineteenth Century England", *Indo-British Review, A Journal of History*, XVIII, No.1, 1990, p. 139, and John Falconer, "Photography in Nineteenth Century India", *The Raj, India and the British 1600-1947*, London, 1990, p. 275. Falconer notes "His [Cursetjee's 1877] obituary in the *Proceedings of the Institute of Civil Engineers* also credits him, perhaps over-fulsomely, as 'foremost in introducing photography...into Bombay'."
8. *Journal*, Nos. 13-18, February-June 1856, p. 19.
9. Ibid., No. 2, February 1855, p. 20. Neither appointment lasted: Bombay Castle reported to the Court of Directors on January 31, 1857 that they had "dispensed with the services of" Crawford, in light of the "progressive diminution of numbers attending" the photography class (IOR: Bombay Public Letter, No. 4, January 31, 1857). Biggs, whose appointment had been opposed by the army, was returned to military duty at the end of 1855, and replaced by Surgeon W. H. Pigou. See Janet Dewan, "Captain Biggs and Doctor Pigou, Photographers to the Bombay Government 1855-1858", *Photoresearcher*, No. 5, December 1993, pp. 6-13.
10. IOR: Bombay Public Consultations, December 31, 1857, No. 5996.
11. Wacha, op. cit., p. 114.
12. Falconer, op. cit., p. 276, which also contains a Chintamon photograph. Other Chintamon portraits can be found in Judith Mara Gutman, *Through Indian Eyes*, New York, 1982, pp. 27, 87, 108.
13. Wacha, op. cit., pp. 285-86.
14. In July 1864, Bombay Castle sanctioned Hinton's bill of Rs 172, dated June 24, 1864, for "copies of the Photographic views of the late Fortifications of Bombay"; the bill was "to be debited to the Rampart Removal Fund" (IOR: Bombay Public Works Proceedings, July 16, 1864, No. 1300). Unfortunately, none of the images has been located.
15. The letterpress of No. 15, January 1858, listed only two subjects, but the issue included two photographs of the second one.
16. OIOC, Archaeological Remains, Vol. 42, photograph 4334.
17. In the latter 1860s, some of the Johnson and Henderson/William Johnson negatives were acquired by Francis Frith and appeared in Frith's India series, Vol. 1. As a result, the images are sometimes incorrectly attributed to Frith. See John Falconer, "Ethnographical Photography in India 1850-1900", *The Photographic Collector*, Vol. 5, No. 1 (Fall 1984), pp. 16-47, particularly pp. 19-21 and footnote 10.
18. *Almanac*, 1860, advertisement dated December 1859.
19. The photographs were taken while Scott was Acting Deputy Superintending Engineer of the Railway Department and then Acting Garrison and Dockyard Engineer at Bombay before leaving on European furlough in April 1859. My thanks to John Falconer, OIOC, London, for drawing Scott's albums to my attention.
20. For more details of government involvement in photography in the 1850s and '60s, see Janet Dewan, "Delineating Antiquities and Remarkable Tribes, Photography for the Bombay and Madras Governments 1855-70", *History of Photography*, Vol. 16, No. 4, 1992, pp. 302-17.
21. *Journal*, No. 1, January 15, 1855, p. 10.
22. Advertising sheet, 1869, Victoria and Albert Museum, London, Indian and Southeast Asian Department.
23. In 1869 Sykes & Dwyer advertised an Elephanta portfolio of seven large photographs, and in 1871 D. H. Sykes & Co. published thirteen photographs in *The Rock Caves of Elephanta, or Gharipuri*, with letterpress, plans, and drawings by James Burgess.
24. Of twenty-five illustrations of Bombay, twenty-two were based on photographs. Two came from Scott's Bombay album, "Colline de Malabar Hill, à Bombay" and "Une rue de Mazagon, faubourg de Bombay" (sic) (Scott's "A View at Calbadavie" [figure 7]), and seven from *IAPA*: "Marché aux cotons: ouvriers" (laterally reversed; "The Lohanas", *IAPA*, March 1859); "Marché aux cotons: marchands" (laterally reversed, composition modified; "The Cotton Market" [figure 1], November 1858); "Femmes du peuple de Bombay" (laterally reversed; "Maratha Women of the Labouring Class", August 1857); "Assemblée religieuse de Jainas, à Bombay" (laterally reversed; "A Jaina Priest instructing his disciples", July 1858); "Une rue de Valkechvar" ("A Second View of the Walakeshwar Temples" [figure 4], December 1857); "Femmes hindoues de Bombay, en costume de fete" ("Bania Ladies", February 1859); "Dame parsie et sa fille" (laterally reversed; "Parsi Lady and Child" [figure 5], March 1857). Rousselet himself is credited as the photographic source for the illustration of the Hindu shrine near Byculla Station (p. 14), though the later text (p. 141) suggests he did not learn photography until after his stay in Bombay.
 The *IAPA* letterpress to another view of Walkeshwar notes that "the temple was originally situated at Malabar Point, at the extremity of the tongue of land extending a little beyond the Governor's bungalow. When it became inconvenient for it to remain at that place, it was removed to or a substitute was found for it at the present site...." (*IAPA*, No. 13, November 1857). James Douglas, writing in 1893, was more defensive: "... when the English arrived in Bombay there was nothing but a heap of ruins to mark the place where stood the ancient temple of Walukeshwar. We had, therefore nothing to do with the destruction of it.... The site of this temple is now occupied by the Governor's bungalow" (*Bombay and Western India: A series of stray papers*, Bombay, 1893, Vol. 2, p. 232).
25. A lithograph by José M. Gonsalves, circa 1833, portrays the same scene from the same vantage point (Pheroza Godrej and Pauline Rohatgi, *Scenic Splendours - India through the Printed Image*, London, 1989, p. 137; reproduced p. 138), as does a photograph circa 1910 (Gillian Tindall, *City of Gold: the Biography of Bombay*, London, 1982, reproduced following p. 148).
26. OIOC: Archaeological Remains, vol. 10, photographs 1091-94.
27. Tindall, op. cit., p. 160.
28. Ibid., p. 205.
29. *IAPA* included photographs recording the progress of both of the railway lines planned to serve Bombay, the Great Indian Peninsula Railroad, and the Bombay, Baroda and Central India line. As the latter did not reach Bombay until 1863, the *IAPA* photographs of it were received from up-country amateurs. Four years after the Bombay-Thana section of the GIP line opened, the August 1857 *IAPA* included Hinton's photograph of the Hindu shrine beside Byculla Railway Station. Narayan Dajee had photographed this scene in 1855, and Captain Scott published his own photograph of the two buildings in 1860. Another 1850s' view of the shrine and station is in the British Library, OIOC Photo. 254/3 (11). Rousselet's woodcut of the temple about 1863 in *L'Inde des Rajahs* was said to be based on his own photograph (see note 24 above).
30. Tindall, op. cit., pp. 203-04.
31. Some of the woodcut illustrations in Urwick's book (though not of Bombay) were taken from Rousselet's *L'Inde des Rajahs*. Older photographs of other locations were also used; for example, the Madras Presidency section drew on the photographs of Captain Linnaeus Tripe, Official Photographer to that Presidency 1856-60.
32. Rev. W. Urwick, *Indian Pictures, drawn with Pen and Pencil*, London, 1885, p. 204.
33. Tindall, op. cit., p. 207.
34. Nine of the Bombay illustrations from photographs used in 1882 were portraits. In *L'Inde des Rajahs* (1875), fifteen of twenty-two Bombay illustrations from photographs depicted people.

PLACES,

PART II

SYMBOLS, AND ICONS

A panoramic view from
Malabar Hill across Back Bay,
the city of Bombay, and the
harbour to the mainland.
By Horace van Ruith, *circa*
1878-84.
Oil painting on canvas,
52 x 153 cm.
Private collection; photograph
courtesy William Drummond,
Covent Garden Gallery Ltd.,
London.

This evocative panorama was painted during the monsoon shortly before sunset—generally considered the best time to observe this spectacular view. It was taken from near the Siri Road, an old pilgrimage pathway from Chowpatty, clearly visible in the foreground. As shown here, the path divides: one fork joins the tree-lined road (later Harvey Road) at the junction with the track along the shore; the other branches across to the cottages behind Lakdi Bunder. Timber landed here by country craft can be seen stacked in piles. From the shores of Chowpatty, Malabar Hill Road leading to Walkeshwar Road climbs upwards. Girgaum woods lie to the left, edged by more bungalows facing the sea. The chimney is probably that of the Victoria Cotton Mills at Girgaum.

Two especially significant urban innovations are portrayed. The first is the Bombay, Baroda and Central India Railway, built in the 1860s on a reclaimed strip of land following the shoreline. The line is marked by a train, visible just beyond the curve of the bay, pulling away from Charni Road Station (the red-roofed structure near the shore) towards Girgaum woods. From the station the track extends southwards to Marine Lines near Dhobi Talao (centre of the picture), Church Gate, and the Colaba terminus. Before the development, Queen's Road with its range of cemeteries fronted part of Back Bay; two adjoining Muslim compounds are distinguishable by their white walls.

The second development is the construction of the fine array of Victorian buildings (visible across the bay). The Rajabai Tower rising above the porch of the University Library, the Convocation Hall (right)—both flanked by the High Court (left) and Secretariat (right) are the most prominent; all contrast with the dark tower of St Thomas' Cathedral in the nearby Fort area. Spreading northwards to Mazagaon Hill (left) and bordering the harbour, is the crowded Indian township. Here the dominant feature captured by Van Ruith is the white Jami Masjid. The painting has been dated based on the completion date, 1878, of the High Court, and the empty site of Wilson College at Chowpatty, the foundation stone of which was laid in 1885. Since that time further reclamation including Marine Drive has been added to what was then Kennedy Sea Face, along which people in carriages can be seen taking their evening ride.

Interior of the Jami Masjid, Bhendi
Bazaar.
Photograph:
Bharath Ramamrutham, 1996.

(facing page)
" A street in the Native Town,
Bombay."
By William Carpenter,
1850-51.
Watercolour, 25 x 17 cm.
Courtesy the Trustees of the
Victoria and Albert Museum,
London.
Houses in the ethnic areas, such as
this street in the Indian township
to the north of the Fort, were built
in narrow lanes and in close proximity
to each other. Many of them
displayed a profusion of intricately
carved lintels and balconies, some
of which still survive.

Although the course of Bombay's history was influenced by conditions on the mainland, the sequence of events that created and shaped the city has largely taken place within its confined arena. As a result, many of these episodes tended to be dramatized, and the historical and political situations led to some momentous environmental changes. In turn, they frequently gave rise to powerful symbols and icons in various localities, which soon became a part of the cityscape. The origins of some of these hallmarks may be traced back to specific historical or archaeological beginnings, while the story of others is intermingled with legend. The objective of the second part of this volume is to highlight a few places in the city, and to extract some of its symbols and icons, while at the same time exploring their social significance in a historical or environmental context. Some of these symbols no longer exist today. Others have been obscured or overshadowed by recent developments. A few survive as reflections of the past, although many of these are under pressure to change their image as the city plans for its future in the next century.

Once this small urban arena became established and

INTRODUCTION TO PART II

protected during the first few decades of the eighteenth century, trade especially in cotton began to flourish. It was, however, always the harbour that was the focus of the town, and it is interesting to note that initially all the important East India Company buildings within the Fort area faced the harbour. At the instigation mainly of the Company, diverse Indian communities with wide-ranging skills began to settle in Bombay. Some were granted plots of land, enabling them to build homes in their own indigenous style. Taking the harbour as the springboard, Kalpana Desai analyses the effects of its very existence upon these various communities. Their highly organized and structured society became the supporting framework of the Company. Each community had its own trading or mercantile speciality. Individuals were thus dependent

upon the Company for survival and yet remained a part of their own community. The article traces three important aspects which helped to ensure their survival as they continued to settle in Bombay. Firstly the awareness on the Company's part of the ever-increasing number of people living within its boundaries and the need for land reclamation; secondly the introduction of policing for maintaining law and order; and lastly the provision of a workable monetary system for the entire population of the country.

Diversity thus quickly became a characteristic of the Indian people in Bombay, and they were easily distinguishable by their mode of dress and customs. Each separate community generally preferred to live within a precinct and close to their place of work and worship. As a result, residential patterns developed in various localities within the Fort, in the Indian township outside, and more gradually into outlying suburbs throughout the islands. By contrast and as time progressed, many including the British chose to live in bungalows outside the congested areas, and hence residential garden suburbs developed in other places such as Parel, Byculla, and Malabar Hill. Throughout the nineteenth century and for the first few decades of the present century, the great variety of housing types and styles formed one of the most significant symbols of Bombay's diverse society. In her article, Sharada Dwivedi discusses a range of nineteenth-century housing types, and explores their individual plans and styles in relation to their occupations and customs.

Even more obvious icons of the city's varied society which, unlike the housing, are still apparent today, are the numerous different places of worship. Religious freedom advocated by the East India Company in Bombay was partly responsible for the construction and survival of many temples, mosques, synagogues, and fire temples, alongside Christian churches. The range of buildings belonging to different denominations in Bombay is phenomenal. There are, for example, over four hundred temples and shrines, about eighty mosques, some forty

fire temples, and altogether about seventy-five churches and chapels of different Christian creeds still in existence. Although it is not possible to do justice to all the religions, four specialists, A. P. Jamkhedkar, Monisha Ahmed, Firoza Punthakey-Mistree, and Sharada Dwivedi describe a selection of Hindu, Muslim, Parsi, and Christian buildings, mainly from the architectural viewpoint. The individual examples have been chosen, not necessarily because they are the most important religious centres, but because they represent focal points for the faithful within a particular precinct, or are places of pilgrimage for worshippers from elsewhere.

Once founded, such religious buildings generally survive, albeit with renovations and additions. They are often found to be among the oldest surviving structures in any city, providing much information about its social history and traditions. Monuments such as those within a Christian church for example, also have a high survival rate, for to remove them would be sacrilegious. Public monuments commemorating the lives of political heroes, by contrast, tend in time to be removed or replaced once a new political scene becomes established. Statues of Governors-General and Commanders-in-Chief, leading British merchants, and even King Edward VII as Prince of Wales, formerly adorned the streets of Bombay. In her article, Mary Ann Steggles gives an account of these gentlemen, whose deeds were commemorated all over the city by statues on high plinths, often bearing reliefs depicting episodes of their lives. Generally placed at strategic focal points, these bronze or marble icons were in themselves often venerated. As a result, even after their removal, some of these spots continue to bear their names, creating places with nostalgic memories for those aware of their origin.

It is sometimes said that gardens and museums are founded only during times of economic stability and prosperity. The Victoria and Albert Museum and Gardens in the once leafy suburb of Byculla adjoining the Parel road is a typical example. Although, as described in detail

by Mariam Dossal in her article, the origins of both the Gardens and the Museum date from the 1830s and 1840s, it was only in 1872 that this institution, within the grounds of the Botanical Gardens, was declared open to the public. Its creation was due to the foresight of several leading citizens of Bombay who were aware of the need to provide for a more scientific education through the medium of displayed objects rather than through reading books. They in turn had been motivated by several factors — the impact of the industrial revolution on India in general, the economic boom in Bombay at the time, and the new-found sense of political power as a result of the take-over by the British Crown from the East India Company. The Victoria and Albert Museum was thus named in honour of Queen Victoria and her recently deceased Consort. Although the exhibits of the Museum are beyond the scope of the article, they too may be viewed as icons of the past, representative of an era when scientific enquiry was deemed to be of paramount importance.

In addition, the daily lives of the people of Bombay concerned the city authorities. In his article, Narendra Panjwani picks up the story as begun by Kalpana Desai. By focusing on the lives of the mill-workers he examines the effects of change on this new labour class of the city as they establish a standard of living for themselves. During 1865-1965 the mill-worker and his support force formed the backbone of Bombay society. They lived in enclaves that for many reflected the lifestyle of their native village. The mill itself, the place of abode or *chawl,* and the local market thus became symbols that were not only interrelated, but also became an integral part of Bombay's economic success. In turn, this process gave rise to increasing personal prosperity for the mill-owners, the employees, and their families. As a result, their aspirations began to change and the quality of their social lives improved. With this transformation and a large potential audience, it is not surprising that Bombay became the centre of the Indian film industry, supporting a great many cinema halls. The ramifications of such

social change were obviously widespread, extending across the entire spectrum of society. By singling out the mill-worker, a pattern of life of the ordinary man in the street emerges, allowing brief glimpses into the past and highlighting those features that may be classified as places, symbols, and icons unique to Bombay.

At the end of the former Apollo Pier, jutting into the harbour stands an Indo-Saracenic structure of yellow basalt. This is the Gateway of India, built to commemorate the visit of King George V and Queen Mary in December 1911 to attend the Delhi Durbar. A temporary pavilion in white plaster had been put up for the event (figure 2); it was subsequently replaced by the stone monument designed by George Wittet. Although today one might view this Gateway as a memento of the royal event, it is also a symbol of Bombay's wider historical role as an entry point into India.

Bombay has long been the country's largest port (figure 3). For many decades, an array of cargo vessels and large naval ships could be seen at anchor within the harbour, many waiting for dockside berths, and along the nearby coast. The merchandise is different now, but it was not so long ago that people of various countries would sail into Bombay harbour to enter India — "the land of spices".

Some two hundred and fifty years ago, however, nothing of this nature existed in Bombay. Although all along the west coast of Gujarat and the Deccan the sea would be strewn with a range of country craft flapping their colourful festoons, they would sail past the islands of Bombay without stopping. The ships included *batela*s and *dhungi*s carrying out local trade, *fatemari*s from the south, and the ocean-going *kotia*s and dhows generally bound for the ports of the Persian Gulf, the Red Sea, or the African coast. Larger vessels from Europe, having sailed round the Cape of Good Hope, would voyage past Goa heading northwards to Surat. During the seventeenth and eighteenth centuries, Surat was a thriving settlement where the "flags of 64 countries" fluttered on their ships, anchored off nearby Sumali in the mouth of the Tapti river.[1] There the Portuguese, English, French, and Dutch factories were situated along the river, each trading directly with the Mughals.

In Bombay things developed quite differently. It was mainly after the Bombay islands were firmly under the control of the East India Company that other European nations cast covetous eyes towards the harbour. Unlike the

BOMBAY– THE GIFT OF HER

KALPANA **D**ESAI

situation in Surat, the Company in Bombay held on to its monopoly for it had no intention of sharing trading rights with any other European nation. To protect their interests, the fortifications were strengthened, not only round the nucleus of the Fort, which faced the harbour, but also at strategic points around the islands. These included the smaller forts on the various islands such as Sion, Mahim, and Worli, besides the jetties and piers which were given added protection.

Before the Fort developed, however, the Bombay islands consisted largely of fishing hamlets around their shores. The potential of the harbour was as yet unexplored and Funnel Hill, which later became a key

1

The East India Company's armed grab in Bombay harbour.
By Lieutenant W. A. Skynner, 1776.
Pen and ink with grey wash, 24 x 37.5 cm.
Courtesy India Office Library and Records (OIOC),
The British Library, London.
Colaba lighthouse at the southern tip of the island appears in the background, while Malabar Point, its residence and flagstaff are visible in the distance to the right.
Little is known about Lieutenant Skynner except that in 1773 he prepared "A Chart of Broach Bar and River", which was included in Alexander Dalrymple's *Plans of Ports in the East Indies* (London, 1775).

THE BOMBAY GRAB.

W. A. Skynner 1776.

HARBOUR

landmark on the mainland for vessels entering the harbour, would be largely unnoticed by the early sailors. Local seaborne traffic from the north, heading for the trading centres in the Bombay region would pass Agashi and Vasai (Bassein) and then either turn into Vasai Creek, or sail down the coast to the island of Mahim, which was originally the main destination within the Bombay island group. The Vasai Creek route gave direct access to the early trading centres of Bhivandi, Kalyan, and Thana (figures 4 and 5), and to the great trade routes of northern India. As the Bombay islands developed, the usual journey to the Maratha capital at Poona was across the harbour, and then overland up the Bhor Ghat.

Around the Bombay islands, small crude landing places, known locally as Padao (later anglicized to Palva) marked the huts of the Kolis or fisherfolk, a concentration of which were on the rocky Old Woman's Island and Colaba. The thickly wooded Bombay Island was also inhabited by a population of Bhandaris, whose traditional profession was palm-tapping and distilling, and by the

Agris, who were agriculturists. Mahim was inhabited largely by the Prabhus, known for their clerical and administrative skills, the Panchakalashis, reputed carpenters and craftsmen, and the Vadavars, who as farmers and horticulturists developed large areas of land within the island.

Although all the Bombay islands had been in the possession of the Portuguese since 1534, it was at Mahim, overlooking the sea rather than at a site overlooking the harbour, that their local headquarters was concentrated. Even though in 1662, in a letter to his King, the Portuguese Governor, Antonio d'Mello de Castro, had noted Bombay to be the "best port your Majesty possesses in India",[2] as a nation, the Portuguese were in general quite indifferent to its potential. The same year, under the terms of the marriage treaty between Catherine of Braganza and Charles II, Bombay passed to the English Crown. At that time there were approximately ten thousand Indian inhabitants living on this cluster of islands.

The political scenario on the mainland at the time of the transfer was changing fast. There were continuous troubles between the Mughals and Marathas. A growing rivalry especially between the various European nations at sea caused anxiety among the East India Company officers at Surat who, as a result, were compelled to seek a safer trading place. It was thus providential that in 1668,

2

(facing page)
The Gateway of India —
the temporary pavilion
constructed in honour of the
visit of King George V and
Queen Mary to India in
1911-12.
Photograph: Vernon & Co.,
January 1912.
Courtesy India Office Library
and Records (OIOC),
The British Library, London.
This photograph was taken
on January 10, 1912, the day
of the King and Queen's
departure from Bombay.

3

General view of Bombay
harbour.
By Nicholas Chevalier,
March 1870.
Watercolours, each 29 x 39
cm (two-part panorama).
Courtesy India Office Library
and Records (OIOC),
The British Library, London.
These two watercolours
combine to portray a full
panorama of the harbour,
extending from Trombay
Island and Thana Creek (left)
to the harbour estuary (right).
They were taken from the
ridge behind Sewri Fort,
which appears in the middle
distance partially surrounded
by water. Close by, Sewri
village nestling among trees,
adjoins the bay. Masts of
ships at anchor near the Fort
are visible towards the
mouth.

Bombay with the enormous potential of its sprawling harbour became available to the Company in return for a meagre rent of Rs 100 (£ 10 in gold) per annum. The enlightened Gerald Aungier from Surat was soon appointed Governor of Bombay.

Fully aware of the opportunities offered by the newly acquired harbour, Aungier wrote appraisingly to the Company Directors in his letter of December 15, 1673: "The island is happy in several Bays and Havens for shipping, for their security against the violence of the sea and weather, as also in Docks to hale them ashore, to clean and repair them together with very convenient places to build and launch ships and vessels from 400 to 40 tons burthen. The Great Bay or Port is certainly the fairest, largest and securest in all these parts of India....

The island is as it were by Providence appointed a mart for trade and shipping to which we pray God grant increase."[3] Among the Company's directives for its establishment and expansion, the encouragement of local people to settle in Bombay became a priority.

The Company Directors in London quickly realized the worth of the harbour. Indian people were lured to settle in the islands by attractive propositions. Custom taxes were waived for the first five years, complete religious freedom was granted, and justice was assured. Out of the various communities that were encouraged, weavers in particular were given special treatment by the provision of *charkhas* (spinning wheels). This was all carried out with the intention of purchasing local produce and exporting it in *batelas* and *fatemaris* to the Persian Gulf and the African coast, thereby enlarging maritime trade and increasing the Company's revenue.

The results were as anticipated. In 1670 the local trade was limited to bullion, wine, tobacco, opium, coconut and coir, whereas the chief imports from England were confined to cloth, copper, lead, and silver. Four years later, as Aungier reported in his letter to the Directors, the imports from England had increased and included several kinds of cloths, cochlean, coral, iron, and ivory (initially

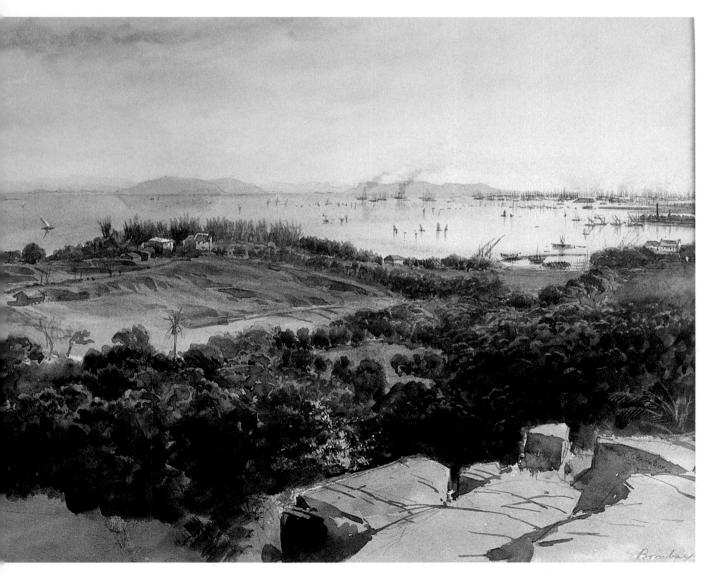

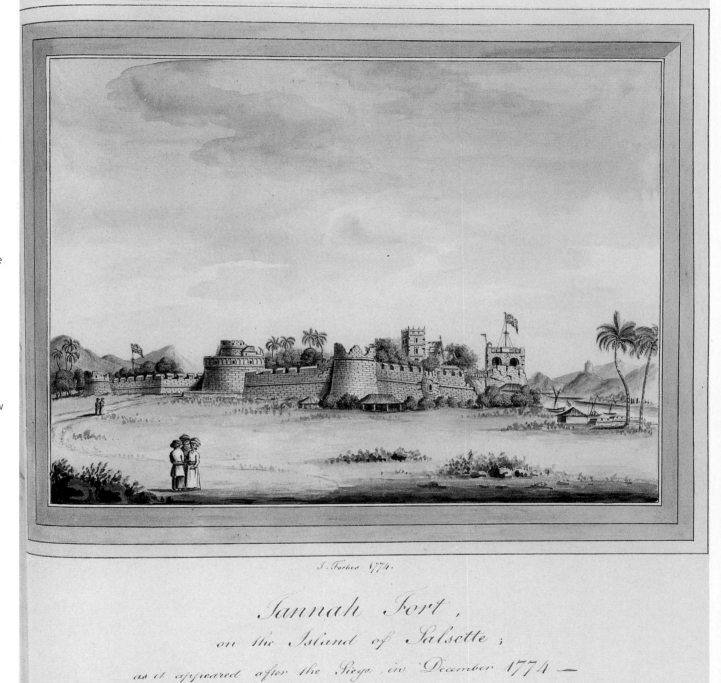

J. Forbes 1774.

Tannah Fort,
on the Island of Salsette;
as it appeared after the Siege, in December 1774 —

4
"Tannah Fort, on the Island of Salsette, as it appeared after the Siege in December 1774."
By James Forbes, 1774.
Watercolour, 18 x 27 cm.
Courtesy Yale Center for British Art, Paul Mellon Collection, New Haven.
"I paid an early visit to these new conquests: it is a pleasant passage of a few hours from Bombay to Tannah, which so soon after the siege made a desolate appearance.... When in the possession of the Mahrattas, the houses and gardens at Tannah reached very near the fortifications, the English engineer immediately removed them, to form an esplanade...." (Forbes, *Oriental Memoirs,* Vol.1, p. 453).

5
"The Mandavie, or Custom House, at Tannah, on the Island of Salsette, with a view of the Mahratta Fortress and village of Culvah [Kulva], on the adjacent Continent."
By James Forbes, no date, probably 1777.
Watercolour, 18 x 27 cm.
Courtesy Yale Center for British Art, Paul Mellon Collection, New Haven.
Forbes visited Thana again in 1777 and almost certainly painted this view of the Custom House (left) at the same time. He also noted that the Fort had been repaired, the houses rebuilt, and that it was becoming a flourishing town.

from Africa), while the export from Bombay was of cloths, dungarees, percales, pepper, drugs, and calicoes.[4]

The special facilities provided by the Company coupled with the steady expansion of trade drew many people to Bombay. Many came as agents to trade in local goods, while others came for the menial jobs relating to trade and shipping. There were Sarafs who settled and developed their business in moneylending. In 1686, a group of silk weavers migrated from Thana and Chaul to

Bombay. In addition to those who made their home in Bombay, a floating population visited the city periodically simply to sell their goods and return to their villages, doubtless with other wares to sell at home. For example, every year from 1677 onwards, the Parsi merchant Mehrji Vacha visited Bombay to sell his coarse cotton cloth.[5] Small traders from adjoining areas would also visit at intervals. Bombay's population naturally swelled. Although the figures may be exaggerated, even between

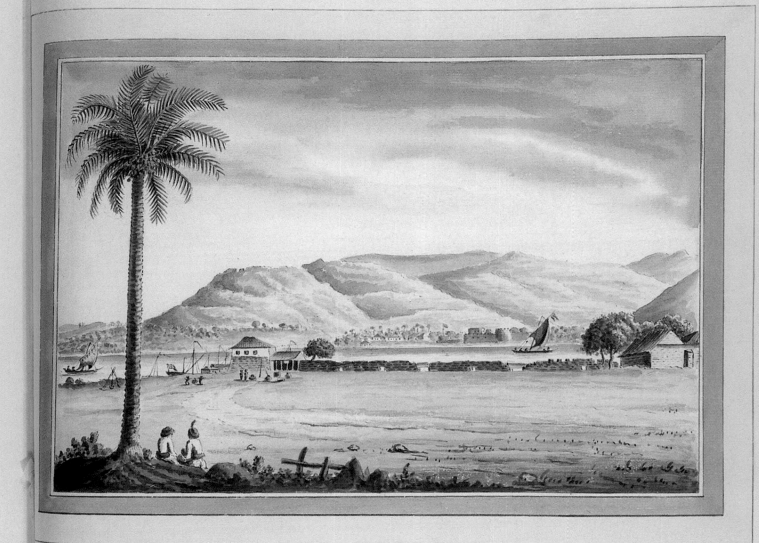

The MANDAVIE, or Custom House,

at Tannah, on the Island of Salsette;

with a View of the Mahratta Fortress and Village of Culvah,

on the adjacent Continent. J. Forbes

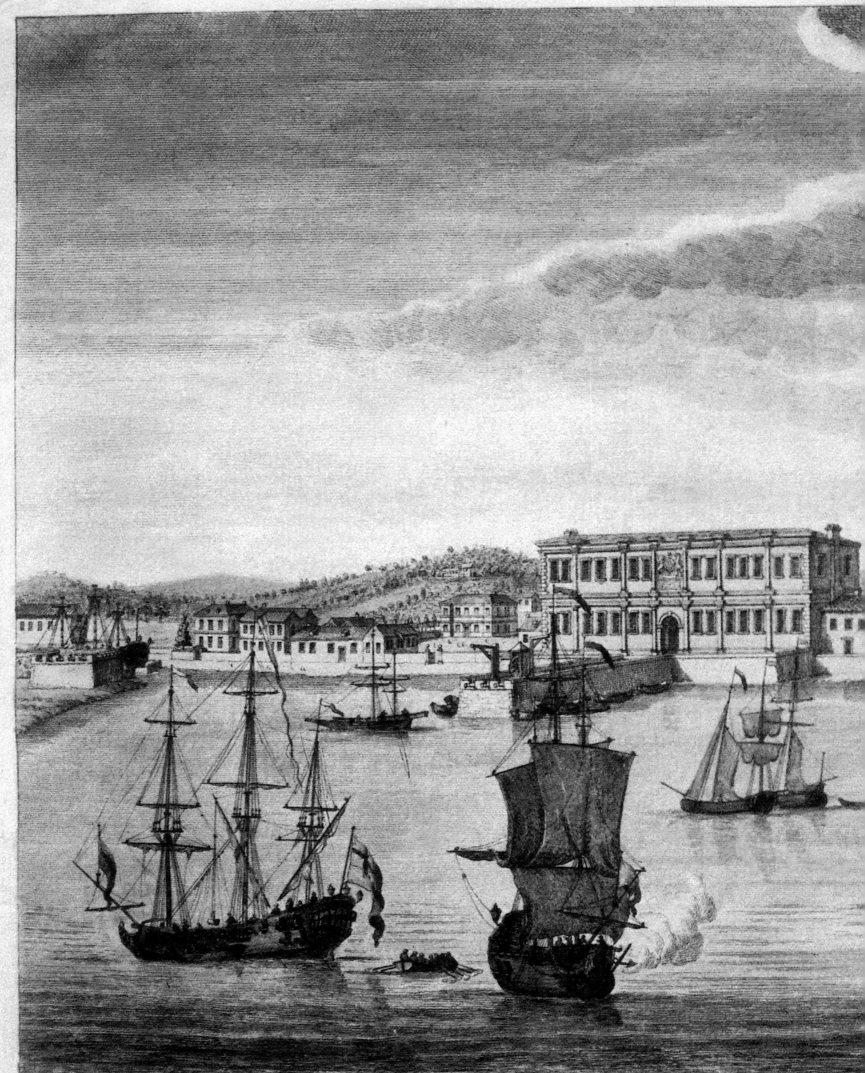

I Van Ryne delin.

Publish'd according to &c

BOMBAY on the Malabar Coast

Belonging to the East India Company of England

London Printed for Rob.t Sayer

rtiment 1754

BOMBAI sur la Côte de Malabar
Appartemente a la Compagnie Angloise pour les Indes Orientales.

site Fetter Lane Fleet Street

The Fleet under Convoy of H.M.'s Ship Clifford Capt.n Wainright leaving Bombay
Sept.r 14, 1809. From the Apollo Gate.
Published &c. &c. by W.Havers & South House Square London.

6

(previous pages)
Bombay Fort from the
harbour with the East India
Company's Factory and its
pier, and Bombay Castle
(right).
By Jan van Ryne, London,
first published in 1754.
Engraving, 23.7 x 39.2 cm.
Private collection.
Although not strictly accurate
in its topography, the print
gives a graphic impression of
the Fort area at this early
date. The Garrison Church
(later St Thomas' Church)
seen beyond Bombay Green,
is wrongly orientated and still
had its bell-tower when this
print was published. The hills
in the distance, notably those
to the left of the Factory, are
much exaggerated. It
nevertheless displays the rich
variety of shipping at anchor
in the harbour.

the time of the transfer in the 1660s and about 1674, it is
estimated to have grown from roughly 10,000 to 60,000
inhabitants. Nevertheless, this figure probably represents
the total population within the aggregate of all seven
Bombay islands.

The seaborne traffic entering Bombay harbour
increased considerably, but the Company initially
continued to depend heavily on the docks at Surat for
repairing and graving their vessels. The Directors took
time to appreciate these difficulties and only granted
permission to build a dock at Bombay in 1694. After that,
all English ships were directed to "winter at the Bombay
harbour for refitting and graving".[6] This obviously
resulted in a great boost, especially in terms of revenue for
the Company. Nevertheless, since all work at the new
dockyard had to be carried out in the open without any
form of protection for the workers, there were considerable
hazards due to lack of security and the constant threat of
fire. As the workload increased, so did the problems.
Consequently a proper dry dock for refitting and graving
was constructed and completed in 1734. The Bombay
Council wrote to the Directors on August 11, 1734: "We
are now finishing the proposed offices in the Marine yard
and the Carpenters' yard between Mr. Bradyll's house and
the Moody [Bay]...."[7]

Under the rule of the East India Company, the town
developed around Bombay Castle, mainly because the
area adjoined the harbour (figures 1, 6-8). The Company's
first Government House was situated within the Castle.
Plots of land to the north of the Castle were granted to the
various communities of Indian merchants, who then built
houses, shops, and godowns. At the same time, the
Company constructed its own offices and housing around
the nucleus of Bombay Green. The Company's
headquarters or Factory, fronting the harbour, was
situated close to the Green. Many new facilities emerged.
The increase in population and trade required a currency.
Since this was not easily obtainable from Surat or
elsewhere, the Company minted its first "rupee" of
Bombay at the Mint, which was also close to the Green,
in 1677. Then in 1720 a bank was established both for
the benefit of the Company and for the inhabitants,
although the Sarafs had been operating privately as
moneylenders for a considerable time.

Fast developing trade needed strong protection and
for added security, the Company constructed a wall
around the town, which was completed and heavily
guarded by 1715. The Fort's security was strictly
monitored. In 1741-42 for example, the Consultations as
recorded in the Bombay Diaries state that two of the town

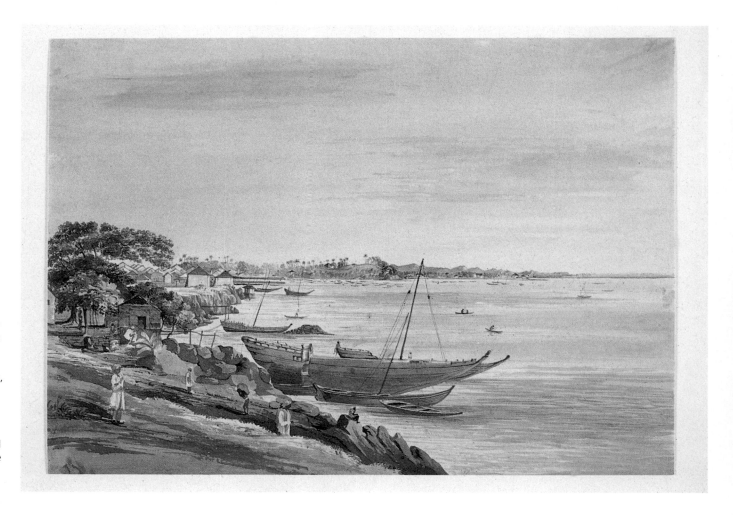

gates, Apollo Gate and Church Gate, were closed half an hour after sunset. It further noted: "A large bell to be placed over the Bazaar Gate to be rung about a quarter of an hour after sunset and continue ringing a quarter of an hour, when all the inhabitants living within the two to repair home and those living without to go out before the bell has done ringing.... But as at present there is not a bell at each gate, until they are provided, a drum may begin beating at the time pre-mentioned and continue the like space." Special permission from the Governor was required in order to entertain anybody after this hour.

Other places within the islands also required protection and accordingly three police chowkis were established, one on Bombay Island itself, and the other two at Mahim and Mazagaon, which were also among the most developed areas. Up to 1708, the developed areas that required police patrolling were only seven. They corresponded with the seven forts around the islands of Bombay — Dongri, Mazagaon, Sewri, Sion, Riva, Mahim, and Worli.

In addition, judging from the array of temples built during the last quarter of the seventeenth and the early years of the eighteenth century, the Indian population had already started spreading beyond the area of the Fort. The different community settlements were mainly at Gamdevi, centred around the Gamdevi Temple (built in 1662), at Bhatiawad around the Venkatesh Temple (built

in 1689), at Walkeshwar where a temple of the same name was built in 1702, at Mumbadevi around a temple of Murlidhar (built in 1714), and at Thakurdwar where the Gujarati Hindu Mahajan community built a Girdharilal temple in 1714.

It is interesting to note the city's pattern of physical extension. People of different communities arriving in Bombay during the first half of the eighteenth century included Parsis, Banias, and Jain Shravakas from Surat and other parts of Gujarat, Bhatias from Kutch, Marwaris, and a little later Memons and Bohris. They settled in pockets in different parts of the city and gradually established distinct community areas. The influential Parsis, who could communicate with the British, built their houses within the Fort and in central localities around Dhobi Talao as well as Parel. The Shravakas inhabited the locality known today as Khara Kuva opposite Zaveri Bazaar. The Bhatias settled near Bhuleshwar and Thakurdwar, while other Gujaratis lived at Kalbadevi. Girgaum remained the stronghold of the Pathare Prabhus. The Bohris and Memons, who were mainly in the hardware business, settled around Mohammed Ali Road (figure 9).

The year 1735 proved to be a turning point in the history of the city and its harbour. Supported by its new dry dock, the "great Bay or Port", which Aungier had declared was "the fairest, largest and securest in all these

parts of India", was now complete. In that year at the Company's invitation, the noted Parsi shipbuilder, Lowji Wadia, arrived from Surat to take charge of the dockyard. Soon after his arrival, two more dry docks were added, one completed in 1750 and the other in 1765. As a result of the growing facilities, trade flourished with ever-increasing prospects. The second half of the eighteenth century also witnessed the emergence of several private shipping companies which carried out a large import-export business. Their ports of call included Basra, Muscat, and other ports in the Persian Gulf, Arabia, China, Java, Malacca, and Sumatra, besides Madagascar, Comorro, Mozambique, and other parts of East Africa. The number of Company ships and private vessels needing dockyard facilities in Bombay thus continued to grow. In addition to carrying out repairs, new ships were being built. Between 1736 and 1800, one hundred and fourteen vessels of different types and sizes were built and launched in Bombay. In 1754, the Directors wrote: "We are satisfied of the great utility of the Dock at Bombay not only as it serves every purpose of our ships but as it brings a considerable trade to the place by repairing the shipping for Bengal and other parts of India...."[8]

Meanwhile, although the rate of migration into Bombay had reduced somewhat, since it was estimated at only 70,000 in 1744, a further rapid increase took place during the following decades. By the middle of the eighteenth century, the population had again increased so much that building programmes within the Fort had to be strictly regulated. In 1753, the area around the Fort itself was so congested that all the structures on the Maidan were bought by the Company and then demolished, thus providing the open space — the Esplanade — around the Fort. Five years later, some of the communities specializing in local crafts and living within the Fort were relocated in the suburbs. By 1780, the population had further increased possibly to as much as 200,000 according to one estimate. If their presence can be an indication of prosperity, it was the goldsmiths, second only to the tailors, that numbered the highest among the craftsmen. Throughout the history of Bombay since that time, the population has steadily grown, with marginal fluctuations due to external factors such as drought and famine in the adjacent regions.

At the same time, the various settlements throughout the islands expanded to such an extent that security again became a major problem. By 1778 the inhabitants petitioned before the Grand Jury for a proper police service in the city. In response to this, fourteen police chowkis were set up covering the areas of Dhobi Talao, Girgaum, Bhuleshwar, Mandvi, Dongri, Kalbadevi, Mumbadevi, Pydhonie, Bhendi Bazaar, Gamdevi, and Grant Road. Even before the end of the eighteenth century, the population could not be accommodated in many of these areas. The Company therefore decided to extend certain areas and make them habitable by reclamation. One area selected was Kamatipura, a low-lying locality which was quite uninhabitable due to waterlogging especially during the monsoons. But in the early years of the nineteenth century it became highly developed and when in 1824, Seth Framji Cowasji Banaji arranged a permanent water supply, its future as a suburb was assured.

In addition, those industries that were necessary adjuncts to the dockyard also developed fast. The rope-making industry, for example, was concentrated at Rope Walk (later Rampart Row). Associated with the docks from the beginning, this site was extended and renovated about 1760, when it was given a roof for shelter. In 1775, Abraham Parsons noted that: "for length, situation and convenience it equals any in England except that of the King's Yard at Portsmouth.... Here are made cables and all sorts of hemp ropes both for the Royal Navy, the Hon. Company's service and merchant vessels, also ropes of lesser strength made of coconut fiber and coir."[9] Another directly related trade was that of timber, many local merchants being involved in its supply, which was mainly for shipbuilding. Straight timber was brought from Gujarat, the Konkan, Kanara, Malabar, and Travancore, while crooked timber from Gir in Kathiawar was transported to Bombay from the port of Veraval.

By the end of the eighteenth century, Bombay was already a thriving port-city with many private shipowners. In support of this booming trade of export and import a range of companies was established, with the result that by 1805, sixteen leading Parsi firms, two Parsi China agencies, four Bohra firms, and fifteen Hindu companies had been founded. There were in addition about a dozen European and other firms existing in the city. Around the major companies, a large number of smaller trades, occupations, and small retailers gathered to supply or to purchase the goods, while shops of all levels and types

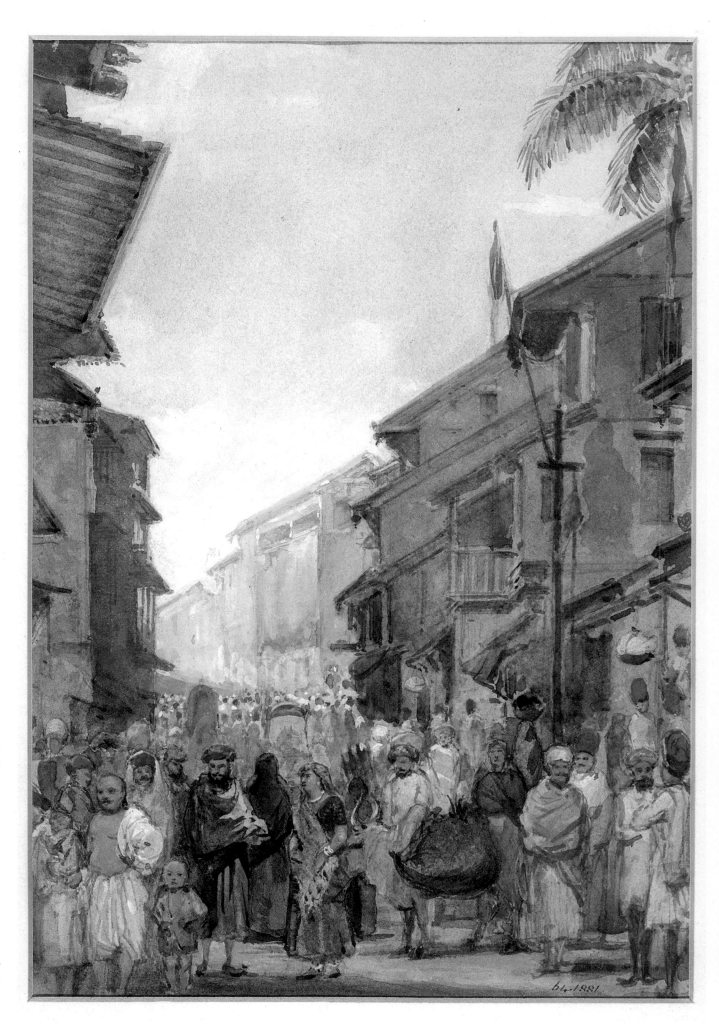

9
"A street in the Native Town, Bombay, sunrise."
By William Carpenter, probably December 1850. Watercolour, 24.5 x 17 cm. Courtesy the Trustees of the Victoria and Albert Museum, London.
"Cross but one street and you are plunged in the native town.... Forty Languages, it is said, are habitually spoken in its bazaars.... But then every race has its own costume; so that the streets of Bombay are a tulip-garden of vermilion turbans and crimson, orange and flame colour, of men in blue and brown and emerald waist coats, women in cherry-coloured satin-drawers, or mantles, drawn from the head, across the bosom to the hip, of blazing purple or green that shines like a grass-hopper. You must go to India to see such dyes."
(G. W. Stevens, *In India*, 1899, pp. 18-19).

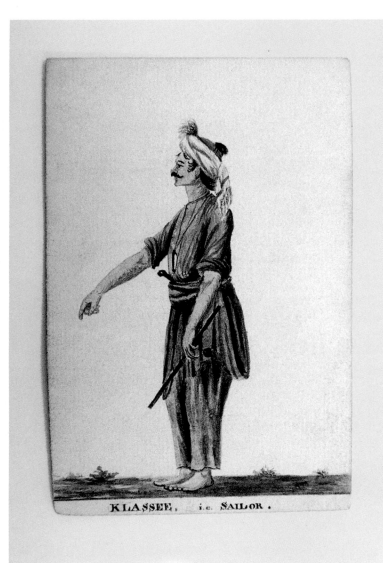

KLASSEE, i.e. SAILOR.

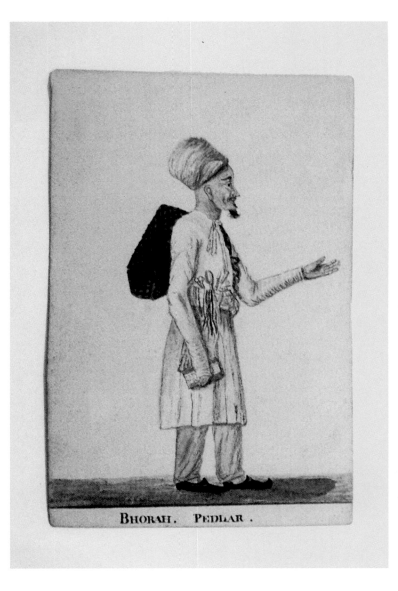

BHORAH. PEDLAR.

10

Types of local people in
Bombay.
By Robert Temple, 1810.
Watercolour on card, each
approximately 12 x 8 cm.
Courtesy India Office Library
and Records (OIOC), The
British Library, London.
These tiny studies are a
selection from a set of ninety-
five watercolours (in a small
leather box) made by Temple
mostly in Bombay. They
portray: *(above)*
"*Klassee,* i.e. Sailor";
"*Bhorah,* Pedlar"; "*Phurbhoo,*
or Native Writer"; "Police
peon, or Watch-man"; *(below)*
"*Lohar,* i.e. Black-smith";
"*Kratee, Kuntaree,* i.e. a
Turner"; "*Sunar,* or
Goldsmiths"; and "*Ducaun,*
Bazar, or Shop for Sundries".
Other subjects in the set
include Muscat Arabs,
Persians, and Armenians,
"*Sutar,* or Parsee Carpenter",
"*Serroff,* or Money-changer",
"*Banyan,* Bhateeya",
"*Mutchee Walleh,* or
Fishermen", "Parsee
Merchant", and "*Hammals,* or
Porters". Unfortunately a
"Panoramic View of Bombay
in 18 pieces" is missing from
it.

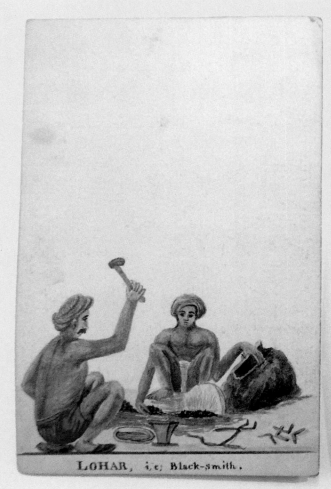

LOHAR, i.e. Black-smith.

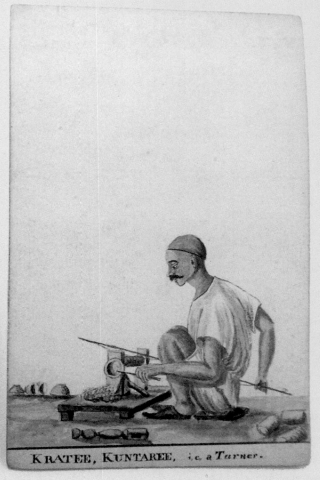

KRATEE, KUNTAREE, i.e. a Turner.

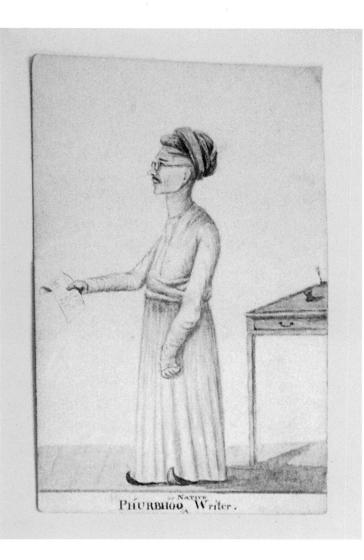

PHURBHOO, or NATIVE Writer.

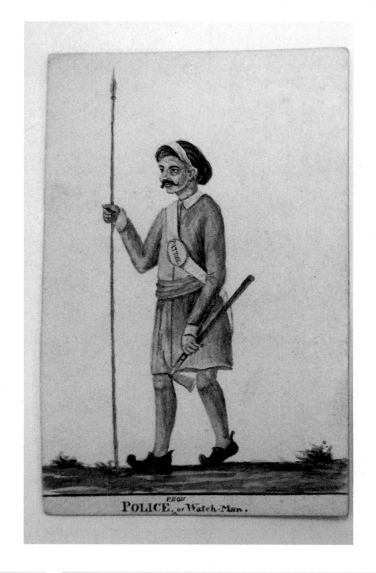

POLICE, PEON or Watch-Man.

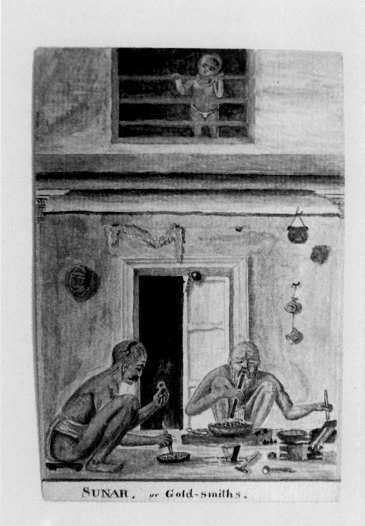

SUNAR, or Gold-smiths.

DUCAUN BAZAR, or Shop for Sundries.

11

"The Bazaar Gate and Part of the Town of Bombay taken from the Esplanade."
By Thomas Cussans, *circa* 1817.
Watercolour from a sketchbook; size of sketchbook, 11 x 28 cm.
Courtesy India Office Library and Records (OIOC), The British Library, London.
This unusual study was painted by Thomas Cussans (1796-1830) of the Madras Artillery, at the end of his journey through south India to Bombay. It shows the inner, outer, and middle Bazaar Gates beyond the Esplanade and walls of the Fort. Part of the town within the Fort appears on the right, while the large red-tiled building on the left is probably the European Hospital inside Fort George.

sprang up in the residential areas. These merchants were most prominent, however, in the Fort area which became known for a number of shops selling imported goods. Colonies of craftsmen particularly the weavers, carpenters, and printers, besides the employed and hired labourers could be seen flocking around the dockyard to assist in the marathon activity of transporting goods. As a result of this continuing network, people needed for such daily routine tasks came and settled in Bombay (figure 10).

Shipping was vulnerable to many hazards at sea and insurance was a necessity. Although several private shipping underwriters were already functioning, as stated in Milburn's *Oriental Commerce,* the first insurance company, the Bombay Insurance Society, was established in the last decade of the eighteenth century. By the middle of the nineteenth century, there were as many as twenty-five insurance companies, some of which were operating as agents of the British, while others were established locally. On the other hand the bank, which had been established by the Company in 1720, had to close down in 1778 as a result of incurring heavy debts due from the government itself. The capital market had in fact remained largely under the control of the Shroffs and continued to do so increasingly until the middle of the nineteenth century. The majority of these private moneylenders were Marwaris or Gujaratis, whose main business centre was in Bazaargate Street in the Fort. Their *hundis,* which were a kind of draft, were honoured throughout India. There are instances of some of the highly influential Shroffs even assisting the Bombay Government during critical times. They are not, however, to be confused with the small moneylenders, the Sarafs, who would operate with individuals on a small scale. The

12

(facing page, below)
Bazaargate Street in the Fort.
By Day & Son after the
original watercolour by
William Simpson, 1862;
published in W. Simpson,
India Ancient and Modern,
London, 1867.
Chromolithograph,
50 x 35 cm.
Courtesy India Office Library
and Records (OIOC),
The British Library, London.
This main road leading from
Bombay Green (Horniman
Circle) to Bazaar Gate which
is visible in the picture, had
long been a focus of trade in
the Fort. In this picture,
Simpson has captured both
the vitality and variety of its
street life, and the
architectural features of the
tall Gujarati houses with their
carved, painted wooden
balconies, and overhanging
roofs.

13

Citizens of Bombay on Ballard
Pier for the arrival of the P&O
passenger liner, the *Karanja*
(right) led by tug, *Chetla*,
with the P&O ship, *Chakdina*
at anchor (left) in Bombay
harbour, during Coronation
year.
By Leonard B. Moffatt
(Associate of the Institute of
Naval Architects), 1953.
Gouache painting on board,
38 x 68.5 cm.
Courtesy The Peninsular and
Oriental Steam Navigation
Company (Art Collection),
London.

Shroff companies functioned almost as private banks, and some would carry out considerably large transactions required for business purposes. Their powers and importance gradually reduced, however, after the Bank of Bombay came into existence in 1842. Bazaargate Street being so close to the harbour, nevertheless remained the central business market of the metropolis (figures 11 and 12).

Shipbuilding at the Bombay dockyard also reached its zenith by the end of the eighteenth century and continued into the nineteenth century. Under the Wadia Master Builders, over five hundred skilled labourers assisted in building and repairing ships for the East India Company, the Royal Navy, and the private shipowners. From only one in 1750, the number of dry docks had expanded to a total of five by 1811. In subsequent years, particularly after the trade boom in 1835 following the end of the British monopoly of the harbour, and the introduction of the steamship, there was an even greater record of progress and prosperity. The influx of people into Bombay never abated (figure 13). To cope with the situation, reclamations took place to increase the availability of land, and causeways were built to render areas more easily accessible. By the middle of the nineteenth century, Bombay had acquired the status of a renowned metropolis — and a true "Gateway of India". A firm foundation had been laid for the city to stride into another phase of development geared to the industrial revolution, of which it became a pioneering centre in the country. Yet no one would doubt that, above all, Bombay owes its development and survival to the harbour. Most of the citizens who actively participated in Bombay's early expansion and beautification, in its educational and intellectual life, and in its cultural activities were people who also prospered by the very existence of the harbour.

Notes

1. The "flags of 64 countries" have become proverbial in the local Gujarati language.
2. *The Gazetteer of Bombay City & Island.* Bombay, 1909-10, quoted in Vol. I, p. 48, Vol. II, p. 49, fn.
3. *Journal, Bombay Branch of the Royal Asiatic Society*, August 1931, p. 32, quoted in Ruttonjee Ardeshir Wadia, *The Bombay Dockyard and the Wadia Master Builders*, Bombay, 1955, p. 28.
4. Letter from Aungier to Court, January 15, 1674, reference in *The Gazetteer of Bombay City & Island*, Vol. I, p. 406.
5. R. K. Vacha, *Mumbai no Bahar* (in Gujarati), Bombay, 1874, p. 300.
6. Wadia op. cit., p. 33.
 The Bombay Council wrote to London on February 11, 1695, asking them to "issue orders to all English ships that winter on this side of India to repair to this port and in neglect thereof to deny them protection".
7. *Bombay Letters Received*, Vol. 1a, quoted in Wadia, op. cit., p. 35.
8. *Bombay Despatches*, Vol. 1, p. 38, quoted in Wadia, op. cit., p. 40.
9. Wadia, op. cit., p. 50.

Crown taking over control of the islands, the restructuring of the town after the demolition of the Fort walls in the 1860s and the period of the cotton boom, a new era of peace and prosperity prevailed. This led to the transformation of Bombay from a mere trading centre into an industrial port-town which afforded a sense of security in which migrants could take root. The ambience of the city was thus conducive to constructing permanent homes in eclectic styles, and whose interiors evidenced a significant synthesis of Indian and European traditions.

The steady but haphazard growth of earlier decades in Bombay had eventually resulted in the development of distinct residential enclaves on the basis of race and creed. Within the Fort, English residential and commercial houses dominated the area south of Churchgate Street, whilst Indian houses and bazaars sprang up in the northern area of Bazaar Gate, where the Hindu Bania, Bohra, and Parsi communities took up residence. As the town expanded outside the limits of the Fort, Hindus settled in areas like Girgaum, Khetwadi, Kalbadevi, and Bhuleshwar, and the Muslim communities notably at Market, Dongri, Umarkhadi, and Mandvi. Wealthier Indian Christians chose areas like Mahim, Bandra, Mazagaon, Cavel, and Girgaum whilst the minority communities had their own

A home symbolizes shelter, safety, security, and stability. At Bombay, although sizeable migrations took place after the takeover of the islands by the British Crown, it was not until the nineteenth century that the many immigrants from neighbouring regions began to feel a sense of belonging, of being rooted to the growing township. Until this period, Bombay was essentially perceived as a city of opportunity where money was made to send home to one's "native place" — as it was termed — to which the migrants eventually retired. The intention of such temporary residents of those early decades was thus not geared towards any form of permanence, either in terms of building residences or furnishing their interiors.

By the middle of the nineteenth century, however, following the period of stability that resulted from the

HOMES IN THE NINETEENTH

mohallas or enclaves — the Armenians in the Fort and the Jews in the vicinity of Masjid Bunder station.

The wide variety of homes constructed by the nineteenth century could be broadly classified into distinct categories: those of the poorer classes, the traditional ethnic houses of middle-class Indian communities, the anglicized homes of the Christians, Prabhus, Parsis, and Shetias or merchant princes, and the houses of the English. In addition, until the demolition of the Fort walls in the 1860s, temporary housing was very much in evidence in the form of tented colonies and *kutcha* bungalows on the Esplanade. These were erected mainly due to the lack of ventilation within the walled town and other congested areas, and as a

SHARADA DWIVEDI

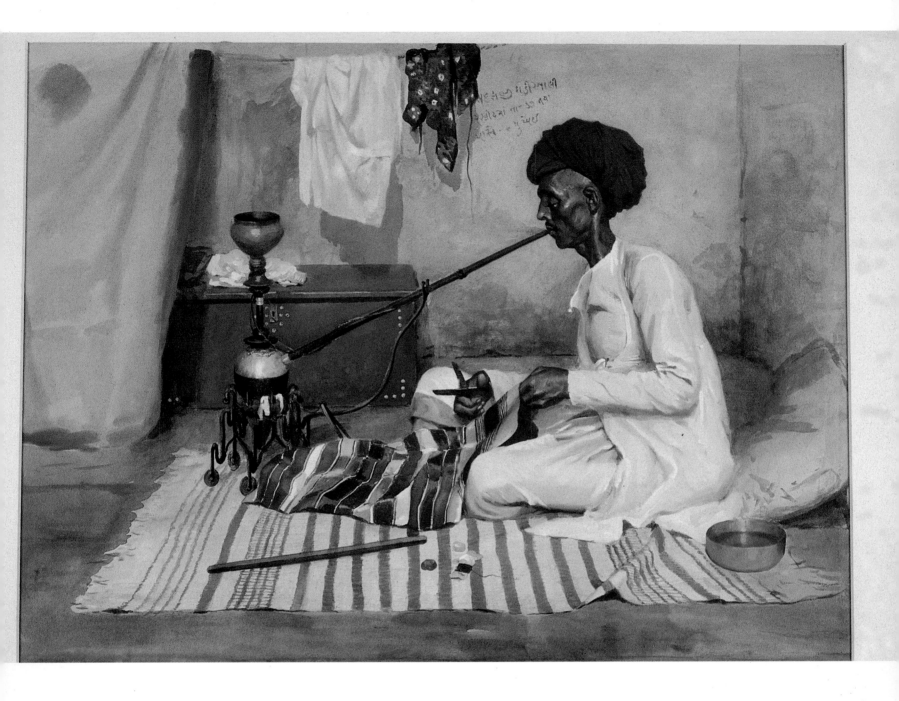

Century

1
"The Tailor, Adalji Ghadiali of Bombay."
By Horace van Ruith, *circa* 1900.
Watercolour, 50.8 x 65.8 cm.
Courtesy India Office Library and Records (OIOC), The British Library, London.
As was typical of such trading communities, the Gujarati, Adalji Ghadiali's home was also his place of work. He is shown here surrounded by articles of his trade, and smoking a hookah. Clothing, including a sari, hangs on a line stretched across the room, while other belongings would be in the trunk.

result of the housing shortage due to mass migrations in the early decades of the nineteenth century.

Homes of the Poor

The homes of the poorer classes — as Maria Graham, an English visitor, observed in 1812, were usually small huts of clay, roofed with *cadjan,* a mat woven from palmyra or coconut leaves. Some were so tiny that "they only admit of a man sitting upright in them and barely shelter his feet when he lies down". Around each hut was a little garden planted with "a few herbs and vegetables, a plantain tree and a coconut or two". The interiors of these little homes were almost identical, equipped as they were with only the basic necessities of life — bedding, woven *chatai* mats, and

a box or two to hold the family's belongings.

Professionals following specialized trades built extensions to accommodate the tools of their business. The toddy-tapper Bhandaris, for instance, occupied thatched or tiled huts in the garden-oarts, comprising a sitting room, kitchen, and *devghar* (gods' room) with a small thatched hut attached for the storage of utensils and tools used in the extraction of toddy liquor (figure 2). Similarly, well-to-do Koli homes had a verandah or *oti*, used for repairing nets or receiving visitors, and a small courtyard or *angan* where women did their household work. The *oti* and *angan* thus served as multi-functional spaces.

Affluent Koli homes also had a kitchen, central apartment, bedroom, gods' room, and a detached bathroom, usually located across a courtyard or in a corner of the plot. Occasionally, these homes were equipped with European furniture such as a sofa, beds, and chairs —

perhaps as a consequence of their desire to emulate the lifestyles of the westernized homes they visited daily for the delivery of fresh fish. In contrast, the poorer Koli families lived in a single room, furnished with earthen pots, a charpoy, mats, a grinding stone, and wooden boxes, with a corner reserved for the *devhara* or gods' stand. A distinctive feature of many Koli residences after the introduction of photography in the early 1860s, was a wall display of pictures cut out from English magazines interspersed with photographs of dead members of the family — seated corpses, dressed in finery — a custom that probably derived from the Salsette Christians.

The agricultural community of Kunbis lived in thatched or tiled houses with brick, mud, or reed walls. The homes comprised one room with a front and back door and, in many instances, a booth at the front door to accommodate cattle. The single room was simply furnished with kitchen equipment, crude cots, a cradle, and wicker baskets. Many Kunbi homes were not equipped with any form of lighting but a fire would be kept burning all night. The simple interiors of the homes of the poorer classes would often reflect the trade or occupation of the owner (figure 1).

Ethnic Houses of the Affluent Communities

The homes of the poorer sections of society thus displayed a marked ethnic character, with sporadic traces of European influence. In contrast, during the course of the nineteenth century, the residences of well-to-do Indians featured an increasingly conspicuous synthesis of the two cultures. Some Indian homes, however, continued to remain typically traditional with characteristic configuration of living space and ornate, embellished exteriors. The most striking examples were the houses of trading communities that migrated from Gujarat, Kutch, Kathiawar, and Rajasthan, who virtually transported the style of the homes from their place of origin to Bombay. Accounts by travellers and guidebooks of the period give a vivid pen-picture of these homes.

An early description by James Forbes indicates that the ethnic houses of affluent Indians were often built around a central courtyard surrounded by verandahs to ensure privacy as well as to provide shade for the inner apartments. "This court is frequently adorned with shrubs and flowers and a fountain playing before the principal room where the master receives his guests, which is open in front to the garden and furnished with carpets and cushions."

The exteriors of many such houses displayed a profusion of pierced or carved wooden brackets and lintels, *jharoka*s, trellises, balconies, and doorways, again typical of the architecture of the resident's place of origin (see page 133). The English traveller Mrs Elwood describes them as "wooden houses with their wooden verandahs, venetian blinds and heavy, sloping roofs covered with tiles, giving them a Swiss rather than an oriental appearance". Built in the late eighteenth and early nineteenth centuries, they were highly inflammable.

Henry Moses who stayed in Bombay in the 1840s, provides further details: "There are no glass windows, but their places are supplied by dusty outside shutters." Many houses had large, projecting balconies with roofs supported on elaborately carved wooden pillars, "the shafts and capitals of which exhibit various odd and fantastic devices standing out in bold relief and evidently taken from the Hindoo mythology". The ends of the supporting timbers projecting from the walls were often "ornamented by grotesque figures in strange, uncouth attitudes, though often representing very faithfully some of the favourite birds and animals".

Moses noted that the rooms were large, but low and ill-ventilated and smelt strongly of *agarbatti* and other incense. On either side of the main entrance were small niches to hold oil lamps. Some houses had exterior staircases leading to flat roofs covered with *chunam,* "which when thoroughly dry, becomes very white and polished". Ladies in purdah went up to these roofs to pray or for a breath of fresh air, unseen by the world below. Often, these spaces were decked with China vases, stone seats, and chairs or couches.

The exterior walls of some homes — and especially those built in areas like Kalbadevi and Bhuleshwar by immigrant traders from Marwar and Mewar where wall-paintings are still evident, were often decorated with frescos of floral patterns or mythological scenes in vivid shades of yellow, crimson, pea-green, and blue (see pages 2-3). In his *Hand-Book of British India,* J. H. Stocqueler gives graphic descriptions of some of the more comic murals. One depicted an obese Englishman seated on a chair, in a "grotesque military caricature dress of black, red and brown, with a round hat, and smart cockade", holding a stick in one hand and a wine glass in the other, with a row

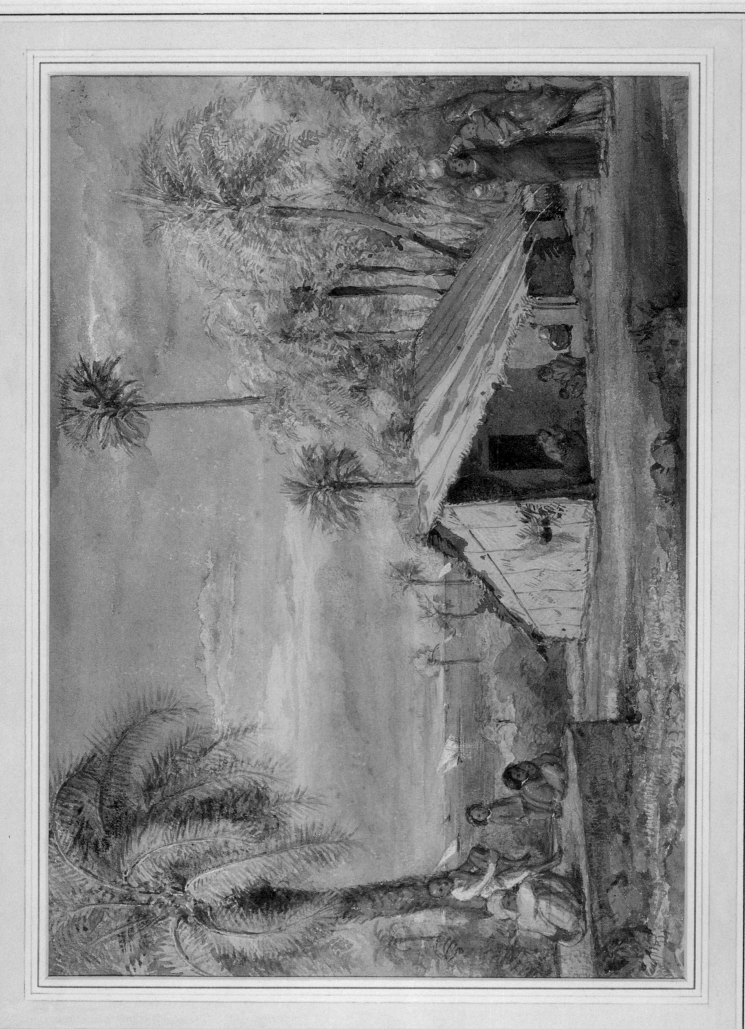

A TODDY-DRAWER'S HUT IN A GROVE OF DATE PALMS, BOMBAY PRESIDENCY.

3

"Ram Lal's House in Bombay."
By William Carpenter,
1850-51.
Watercolour, 25 x 17 cm.
Courtesy the Trustees of the
Victoria and Albert Museum,
London.
This otherwise somewhat
plain house exterior includes a
carved wooden balcony at its
first floor level, with an *otla*
below, on which can be seen
a group of men. It was the
multi-purpose *otla*
overlooking the street, and
not the interior of the house,
that served as the main social
and commercial space. Ram
Lal was probably a prosperous
Hindu merchant living perhaps
in the Kalbadevi or
Bhuleshwar area of the city.

of servants "gradually ascending into the air, with yak tails in their hands". Such murals probably lent a rare, colourful character to these localities.

A unique feature of affluent ethnic homes was the demarcation of space for various family activities. Most had a raised plinth at the front of the house (still seen in many Indian towns and villages) that accommodated an *ota* or *otla*, a verandah for the reception of casual visitors and for conducting business transactions (figure 3). The *otla* was often furnished with a long bench or swing for guests. This multi-purpose use of the *otla* ensured privacy for other family members and also indicated that it was the street itself and not the interiors of a residence that served as the main social and commercial space.

A typical example described in K. N. Kabraji's nineteenth-century memoirs was at the Churchgate Street home of a Parsi, Bomonjee Kaka, whose friends met each evening on the stone *otla* "to discuss the gossip of the day and the place was therefore irreverently styled the Gup House". In the opposite direction, near the entrance to the street, was Darashaw Captain's house, known as "Gup House Number 2", where a similar scene took place each day on his *otla*. Many Parsi homes of the time also featured a *gokhla* near the entranceway. This was a large wooden basin constructed at street level into which leftovers of food were deposited for passing cattle and goats, since wastage was frowned upon by their religion.

Upper-middle-class Hindus like the Prabhus and Maharashtrian Brahmins lived in one- or two-storeyed homes of brick, lime, and stone, with tiled roofs. Often, two or three generations lived together in a joint family system. The usual entrance to the home, according to the *Gazetteer of Bombay City and Island,* was again from the *ota* or *otla,* "through a strong door covered with wood bosses and with two brass or iron rings. On the threshold an old horse-shoe is nailed to keep away evil spirits." Inside was a long entrance room called the *osri*, from which a broad, wooden staircase with hand-rails rose to the terrace and upper storey. A small room below the staircase was used for storing tools, firewood, and coconuts. Leading off the *osri* was an open hall for women, the *vathan,* with a swinging

cot hung from the roof. This room, which was of a more public nature, was also used for hosting dinner parties, for laying out the dead, or for performing marriage, death, and other ceremonies. To the left was a row of bedrooms called *vovare,* one of which was set apart for widows, menstruating women, or for the birth of babies.

A long dining hall and a small *devghar* containing the *devhara* or carved wooden shrine for household gods were also accommodated on the ground floor. The shrines often came from Bassein, where wood-carvers of the Sutar or Panchakalashi castes had settled during the Maratha rule. Later, the Portuguese employed them in ornamenting their churches and shrines. The wood for the *devharas* was polished with scales of the *pakhat* and *mushi* fish and the colour deepened with a mixture of lampblack and beeswax, rubbed on with a brush made from the flower stalk of the coconut palm. Beyond these rooms was the kitchen equipped with low, clay fireplaces ranged round the walls — the *vail* for two pots and *chul* for one, fenced by a brick wall. Many homes had a backyard where a well, surrounded with a stone pavement, formed the focus of bathing, cleaning, and washing activities. An ornamental *tulsi-vrindavan* of clay, planted with the sacred basil, usually stood in the yard where family women performed their morning pujas. A stable and a servants' room were often built in a corner of the yard.

Members of the progressive Prabhu community were among the first to furnish their homes with items of European furniture like sofas, tables, chairs, bedsteads, chests of drawers, wardrobes and, according to the *Gazetteer,* "cases filled with books or small ornaments, chiefly European China and Indian pictures or photographs. On the walls are glass globes and lamps, and in the middle a chandelier hangs from the ceiling." Pegs were let into walls to hang coats, turbans, and caps, and large wooden boxes filled with copper and brass vessels, clothes, and jewellery were placed around the house. The affluent also stocked silver and china pots, Persian carpets, and European knick-knacks. By the end of the nineteenth century, oleographs of Hindu gods and mythological scenes by Raja Ravi Varma became popular wall decorations in many Hindu homes.

Although the same type of furniture was found in middle-class households of other communities, certain details varied according to religion and custom. The Bene Israel, for instance, hung on their walls pictures of the Kothel Maarabi, the western wall of Jerusalem or of the Candelabra symbolizing the Sixty-Seventh Psalm, and a clock. In the homes of affluent Bohras, Khojas, Memons, Konkanis, and other Muslim trading communities, where

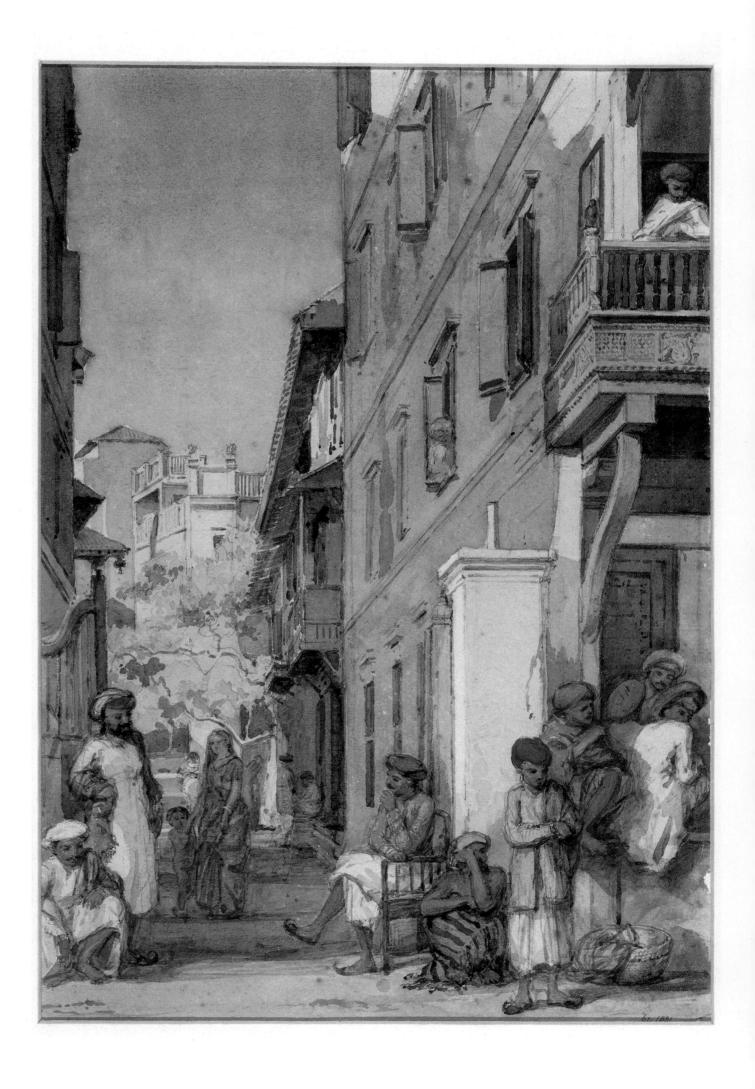

4a-e
Group of interiors of a prosperous Indian home. By the fashionable Devares Art Studio in Girgaum, 1900. Courtesy India Office Library and Records (OIOC), The British Library, London. The photographs depict three views of the drawing room; the study; the dining room. While visiting Bombay in 1900, the Viceroy, Lord Curzon, may have been a guest in this lavish home. He subsequently included these photographs in his extensive collection, which is now in the India Office Library.

5
The residence of Sir Jamsetjee
Jeejeebhoy illuminated for the
Proclamation of Queen
Victoria as Empress of India on
November 1, 1858.
After a photograph by Henry
Hinton published in *The
Illustrated London News*,
January 1, 1859.
Engraving, 15 x 24 cm.
Courtesy Jehangir Sorabjee.
Sir Jamsetjee Jeejeebhoy built
this palatial house, Fort
House, within the Fort in
1834. As is clear from this
image, it consisted of three
storeys with a classical facade,
and a broad terrace on top.
The royal event was also
reported in *The Illustrated
London News*: "The
demonstration at Bombay was
also highly successful.... Of
the various sections of the
community that were anxious
to mark the day with rejoicing
and demonstrations of loyalty,
the foremost and most
conspicuous were the Parsees.
... Conspicuous in this blaze
of light stood out the mansion
of the Parsee baronet Sir
Jamsetjee Jeejeebhoy, which
we have engraved."

purdah was strict, the living quarters of men were segregated from those of women. Describing the home of a Muslim, Kazi Shahabuddin, Maria Graham noticed in the ground floor apartments "a number of Mussulmans sitting cross legged with cushions at their backs". The women's rooms were approached by ascending a ladder removed "when not in immediate use to prevent the ladies from escaping". The room in which they were received "was about twenty feet square and rather low; round it were smaller rooms, most of them crowded with small beds with white muslin curtains".

In Konkani Muslim homes, the front portion projecting over the street was known as *ravish*. As in many Hindu homes, the ground floor included a verandah for receiving guests, sleeping apartments, a passage in which *hindla* swings were placed, and a kitchen overlooking a backyard known as the *wada* from which a door connected to *wada*s of adjacent houses. This enabled the women to go from house to house, or down the whole length of the street without violating purdah. The upper storey contained a *divankhana* (reception room) and sitting rooms. Towards the end of the nineteenth century, wealthier Muslims began to buy European furniture, but women's apartments continued to be furnished in the Oriental style.

Indian Christians lived in large tile-roofed villas with walls of wooden planks, mud, or brick and stone, built in the Portuguese style with long balconies and exterior staircases — many of which still survive in areas such as Khotachiwadi, Mhatarpakady, and Bandra. Here, the delineation of space was more westernized than that in other ethnic Bombay homes. Many homes also had an underground cellar for storage. The more affluent families furnished their homes with western style furniture and pictures of the Virgin Mary and Child, and various Popes.

Homes of Wealthy Shetias

Although Prabhu homes were the first to feature a marked western influence, gradually the homes of Shetias or prosperous merchants of other Indian communities also began to display European interiors (figure 4). The Frenchman, Louis Rousselet, noticed that the grand houses contained "such quantities of furniture, works of art, glass

and lustres, that one might fancy oneself in a shop. In a general way, these treasures are heaped together without taste or any idea of arrangement; but it must be observed that their proprietor considers them simply as a collection of valuable curiosities, calculated to inspire visitors with a great idea of his position. As for himself, he is often content to occupy a little room in one corner of his residence." On one occasion, at a wedding hosted by a rich Shetia of the Bhatia community, Rousselet observed: "Large mirrors reflected the light of a thousand lustres; rich carpets, and sofas spread with cashmeres, covered the ground; and the magnificent costumes of the guests, and the numbers of servants waving fans, gave to the scene that theatrical appearance of which Orientals are so passionately fond."

Acharya and Shingne also commented on the apparent European influence on wealthy Indians who were embellishing their homes with chandeliers, sofas, tables, and other European items of decor. "Long mirrors have come into fashion and people flock to see Jivanji Maharaj's *Arse Mahal* (Palace of Mirrors) at Matunga where you can view your reflection from all sides." Other decorative items in popular use included Bohemian or Venetian glassware and novelties like musical clocks and mechanical devices and toys, Brussels carpets, and Chinese pictures which were particularly favoured by the Parsis.

Fort House

Many influential Parsi Shetias lived near Hornby Row in the northern Fort area. K. N. Kabraji recounts the instance of Sir Jamsetjee Jeejeebhoy, who made a fortune in the opium trade with China. Sir Jamsetjee, who also owned a luxurious country villa in Mazagaon, built a residence for his son, Sorabjee, next to his own Fort House (figure 5, later Evans Fraser and Handloom House, gutted by fire in 1982). As the space between the new house and the Fort wall was too narrow, Sir Jamsetjee persuaded the authorities to break down a portion of the Fort wall and rebuild it a few yards further out. "The work was no doubt carried out at his own cost, but it was counted as his great influence with the authorities of the day that instead of telling him to set back his own house, they had consented to the wall being put back for his convenience," noted Kabraji.

When Henry Moses visited the Fort House in 1840, he described it as a large, square building, enclosed in front and separated from the street by a courtyard. A flight of steps led to a hall, the floor of which was plastered with fine *chunam* and on whose walls were hung watercolour portraits of Chinese mandarins. Seated on mats in the hallway were craftsmen, including "a shoemaker cutting out leather of various colours for slippers. In another was a dergie embroidering pretty little sadars or underdresses for

children by lining lace patterns into the muslin. A harness maker was finishing off a saddle, and another man was giving to palanquins a fresh coat of varnish in anticipation of the rainy season."

At the foot of a long staircase stood "a strong stone built room, having a lower door sunk deep in the massive masonry.... This door was bound with iron bands, and secured by three huge padlocks.... Merwanjee told us that the room being fire-proof, all the plate and jewels were deposited here every night." On the first floor were located a series of long, well lit and ventilated passages covered with fine Manila matting, affording views of "a pretty garden, tastefully constructed in a quadrangle formed by the buildings around it. Here were placed seats of porcelain, stone, and the stumps of trees curiously carved."

The first drawing room Moses saw was typically English with furniture made in London: "The walls were richly coloured: for paper can never be used in India as the white ants would eat it up in a few days." Portraits in oil of family members "by an artist who had come out to Bombay on speculation, and who had pocketed five hundred rupees for each picture" lined the walls. The next drawing room was in French style, with "lofty pier glasses, statuary, vases of artificial flowers, musical clocks, elegant chandeliers, marble brackets with groups of alabaster figures on them, Bohemian glass, gilt couches and chairs".

The most interesting apartment was the Chinese Drawing Room, decorated with articles from China, and furniture that appeared to be made of papier mache, ivory, or mother-of-pearl. Three superb folding screens with brilliant designs in gold, silver, and pearl work, caught Moses' eye. Table tops "were set out with bronze figures of birds, tortoises, Chinese idols and magnificent Japan jars; one table bore, in a glass case, a noble silver epergne, representing a plantain tree with peacocks spreading out their tails under it.... Lounging chairs, sofas, queer little couches, ottomans, and Persian and Turkey rugs and prayer carpets were distributed about in great profusion

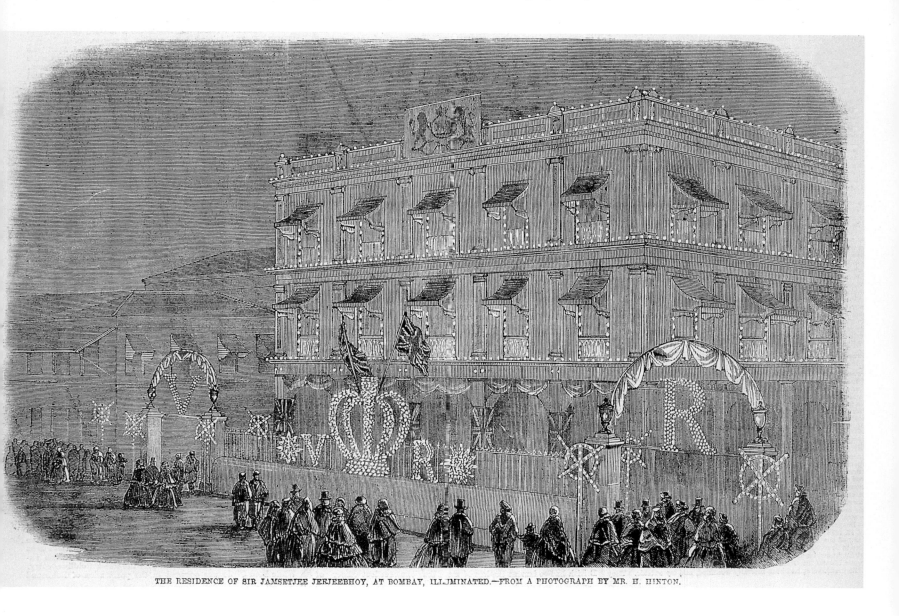

THE RESIDENCE OF SIR JAMSETJEE JEEJEEBHOY, AT BOMBAY, ILLUMINATED.—FROM A PHOTOGRAPH BY MR. H. HINTON.

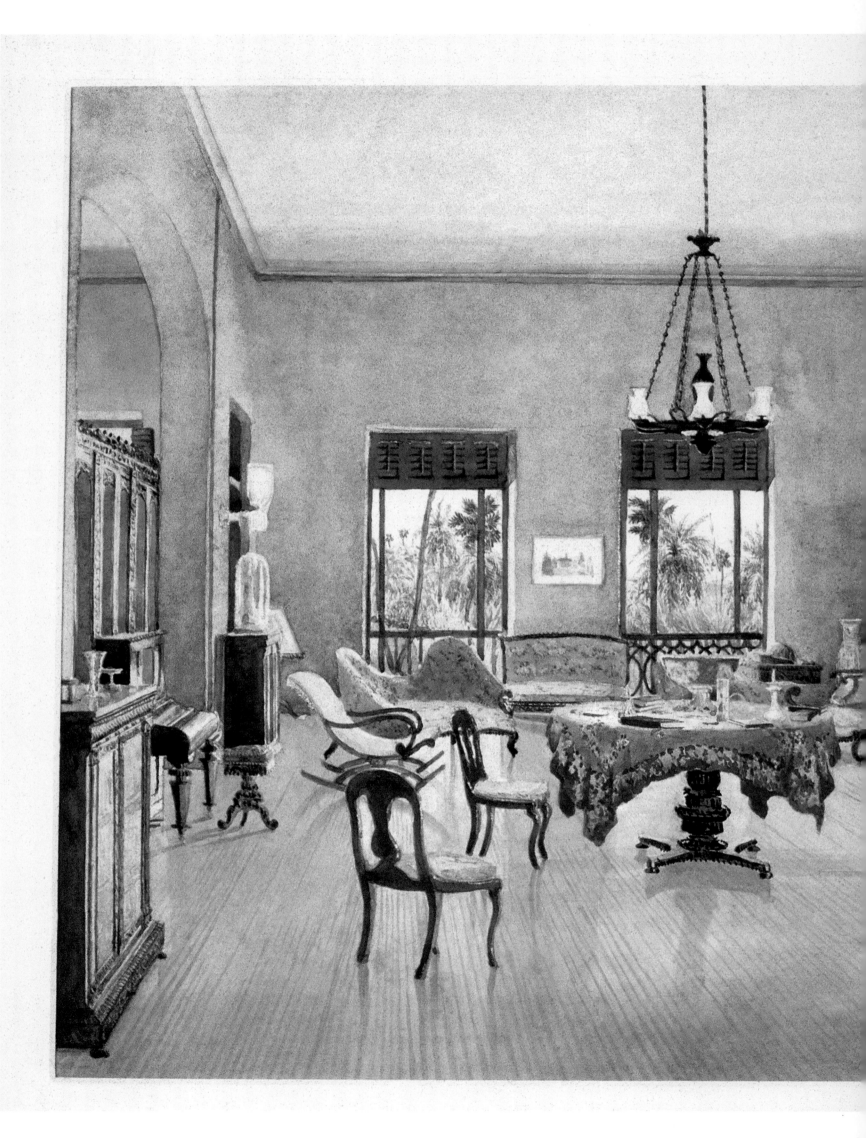

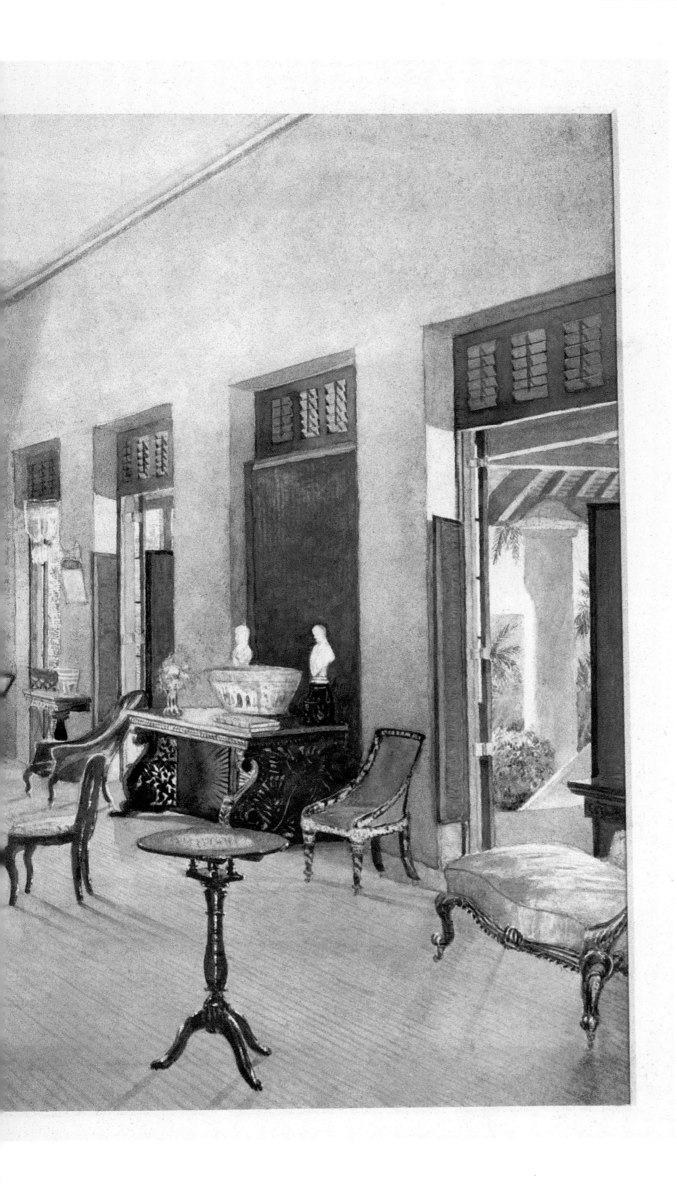

6
"Drawing room in our Grand-
father's, General W. F.
Marriott's House in Bombay
about 1857."
Probably painted by a family
member, perhaps the
General's wife, Frances, *circa*
1857.
Watercolour, 29 x 42.5 cm.
Courtesy India Office Library
and Records (OIOC), The
British Library, London.
Lieutenant-General William
Frederick Marriott (died 1879)
served with the Bombay
Engineers from 1834.
The watercolour was
obviously painted in about
1857, while the inscription
including the reference to
"Grandfather's" house would
have been added later by a
grandchild of General
Marriott. The house appears
to have been on Malabar Hill.

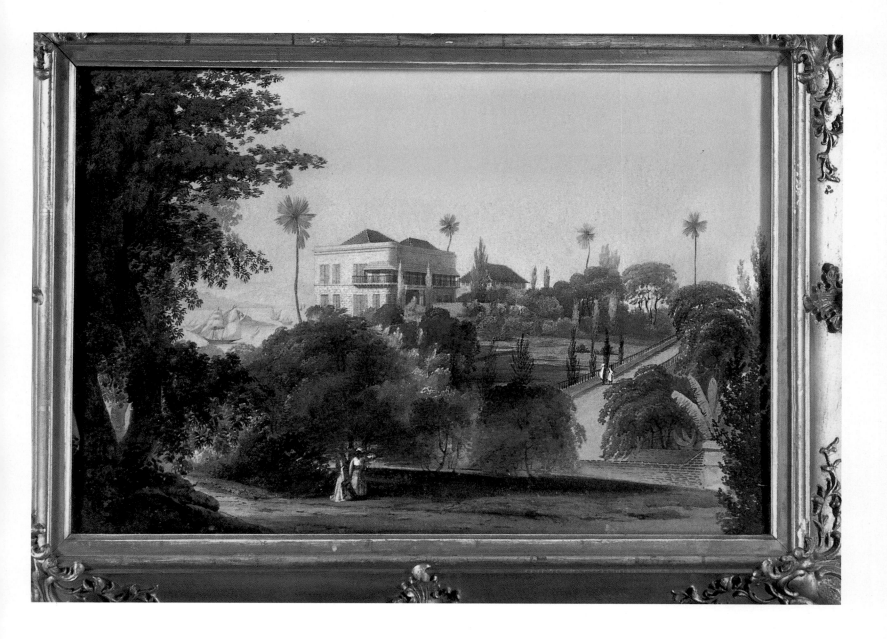

and made one fearful of almost walking upon such beautiful fabrics."

Moses found the family rooms to be comfortable and well ventilated. A visit to the dining room was followed by a walk through a series of rooms and up a flight of stairs onto the flat roof "where we enjoyed a most splendid view of the whole island of Bombay [see Albuquerque: figures 2-11]. Seats were placed on the leads for the accommodation of the ladies who retire hither morning and evening to pray and to read over their book of *Zend Avista* and study the *Dabistan* and the *Dassateer*."

Writing on other affluent homes, Sir George Birdwood — like Rousselet — observed that wealthy merchants used European furniture only in the reception rooms "from which they themselves live quite apart, often in a distinct house, connected with the larger mansion by a covered bridge or arcade". Most furniture was made of *shisham* or blackwood, elaborately carved "in a style obviously derived from the Dutch, although it is highly probable that the excessive and ridiculous carving on old Dutch furniture was itself derived from the sculptured idols and temples

which so excited their astonishment when they first reached India".

English Homes (figures 6 and 7)

Bombay Shetias often rented their bungalows to English residents. Many of these as well as those built by the English themselves were designed on western lines with wide verandahs, but were not considered as comfortable as the villas erected in and around Mazagaon, Parel, and Mahim to which they moved during the hot season. The homes occupied by the English featured well laid out gardens ornamented with flowerbeds and rows of potted plants.

Henry Moses describes one such English garden in an octagonal-shaped Colaba bungalow, approached by "a long vista of mogree and scarlet flowering acacia trees. In front of a large, handsome porch grew the custard apple and the guava in clumps, intermingled with the lovely pomegranate bearing at one and the same time, the blushing calabash fruit and its wax like flowers." Shading the dining room windows was a shrub with brilliant yellow blossoms which attracted a variety of beautiful butterflies.

Rousselet observed that the lifestyle of European residents strongly reflected the influence of the enervating climate. The luxurious houses "contain little that can recall their country to those whom commerce, or some other pursuit, has led to exile themselves in this fine country. The punkahs, enormous fans, which are suspended from the ceiling, and extend the whole width of the room, alone give a strange appearance to the interior." The vast but gloomy bedrooms had "beds surrounded with enormous mosquito nets of muslin, and placed in the centre of the room".

The interiors of English homes, like many of those of the Shetias, were often furnished with Bombay blackwood furniture from local dealers like Wimbridge and John Roberts, or with English items ordered from Whiteaway & Laidlaw's, Army & Navy Stores, or later, the more upmarket Evans Fraser. J. H. Stocqueler commented on the monotonous similarity of the homes: "The houses of the richer classes may contain better chairs and couches than those of their less affluent fellow-citizens — mahogany instead of imitative toon, jackwood or blackwood, or the lighter coloured but polishable and well-grained teak... while the silk or damask of his couches may parade it somewhat more finely than the chintz of the inferior. The wall-shades, too, may be better, by having drops to them, or double branches, and richer chandeliers may aid in illuminating the rooms of the wealthier inhabitant."

Temporary Housing (figures 8 and 9)

Temporary housing in the form of bungalows or tents erected on the vast expanse of the open green space, the Esplanade, was a unique feature at Bombay, mainly during the dry months between September and May. *The Bombay Times*, 1842, noted that these were built of wood with bamboo trellis-work and "surrounded with canvas like an overgrown tent... lined outside with curtains or ornamental

fer tents Wellington Lines Bombay

8
"Our tents in Wellington Lines
— Bombay."
By an unknown photographer,
probably 1890s.
Photograph, 15 x 21 cm.
Wellington Lines (now the
Cooperage) was, like the
Esplanade, a popular locality
for tented colonies, which
were permitted by the
government as temporary
housing. According to the
notice on the trellis outside
the tent, this was the
residence of Captain Read.
He is probably the gentleman
with the three young children
and their ayah in the
foreground.

*Our Tents
in the foreground on the left*

9
"Bombay — The Esplanade and Colaba in the distance. March 1870 (from the top of Watson's Hotel). Our tents in the foreground on the left, Lighthouse and St John's Church, Colaba in the distance. Bandstand."
By Lieutenant-Colonel John Frederick Lester, March 1870. Pencil and watercolour, 19.5 x 45.5 cm.
Courtesy India Office Library and Records (OIOC), The British Library, London.

coloured cloth", and occupied by senior military officers and civil servants. "Up to the middle of May then we have a line of beautiful rustic villas which extends nearly a mile along the sea-shore [see Albuquerque: figures 9-11]. All at once these disappear and the Esplanade for a few days presents a very unsightly appearance. The first fall of rain covers everything with grass and the Esplanade, which was on the 16th May covered by a town, and on the 1st June presented an unsightly desolation, is by the 15th June a bright greensward."

In fact, according to Stocqueler, many visitors in the 1850s preferred staying in tents on the breezy Esplanade to renting rooms in shoddy hotels. "A word to one of the dubashes, a superior sort of valet de place and cicerone, who presents himself on board most newly-arrived vessels, will ensure to the passenger, within twenty-four hours, a comfortably-furnished tent and a small retinue of servants, at an expense not greater than will be incurred at the hotel, and with the advantage of perfect seclusion and independence," he wrote.

Landlords in Bombay resented these temporary structures as is evident from a letter sent by Sir Jamsetjee Jeejeebhoy in 1835 to the financier Sir Charles Forbes, who was then in London: "We may complain, I think justly, of the Government having lately much increased the space allotted on the Esplanade for the temporary bungalows... thereby leading to a great scarcity of tenants for the costly houses situated within the Fort walls. In many places also, the bungalows have been allowed to remain throughout the year and on the north side, the standing bungalows have particularly increased. All these circumstances... have most dreadfully deteriorated the value of house property."

During the many decades following Sir Jamsetjee's concern about depreciating property values, immense migrations have resulted in an exponential growth in the city's population. Not only has the value of land and property in Bombay multiplied manifold, but the phenomenon of temporary housing is now even more evident, with a significant majority of the city's population living in temporary squatter shanties built with an innovative variety of materials. Very apparent at the other end is the incredible, ostentatious expenditure on interiors, essential to express and establish the economic identity and status of the *nouveau riche*.

(Light House - & S John's Church, Colaba - in the distance) Band Stand.

Bombay — The Esplanade & Colaba in the distance
March - 1870.
(from the top of Watson's Hotel)

SELECTED SACRED PRECINCTS

Shiva sculpture (known locally as Bradevi) at Parel, and the great Shaiva caves at Elephanta or Gharapuri (figure 5; see also Rohatgi: figure 9). Later religious activity in the region, during the time of the Shilaharas, is evident from surviving architectural remains, the most outstanding of which is the Ambernath Temple, situated on the mainland some sixty-four kilometres from Bombay.

Even though generally the religious buildings in Bombay are still more recent, dating mainly from the Maratha, Portuguese, and British periods, much of the early architectural history is obscure. Structures of different denominations abound in Bombay (figure 6). This is partly due to the attitude of the East India Company, which guaranteed religious freedom, but it also reflects the influx of the wide range of separate communities settled in various localities. Besides places of worship of the Hindus, Muslims, Parsis, and Christians, they also include Jain and Buddhist temples,

PREAMBLE

Although the Sahyadri Hills around Bombay cradle a number of world-renowned Buddhist caves dating back to the second century BC, remnants of Hindu religious monuments found in and around the city itself date from considerably later — the late fifth and early sixth centuries AD. The most important local Hindu sites are the Jogeshwari Caves at Amboli and the Mandapeshwar Cave at Borivali, both in Salsette Island, the colossal

5
Elephanta. Entrance to the small shrine, east of the main cave temple.
By Johnson and Henderson, *circa* 1857.
Photograph, 20 x 25.4 cm.
Courtesy the Trustees of the Victoria and Albert Museum, London.

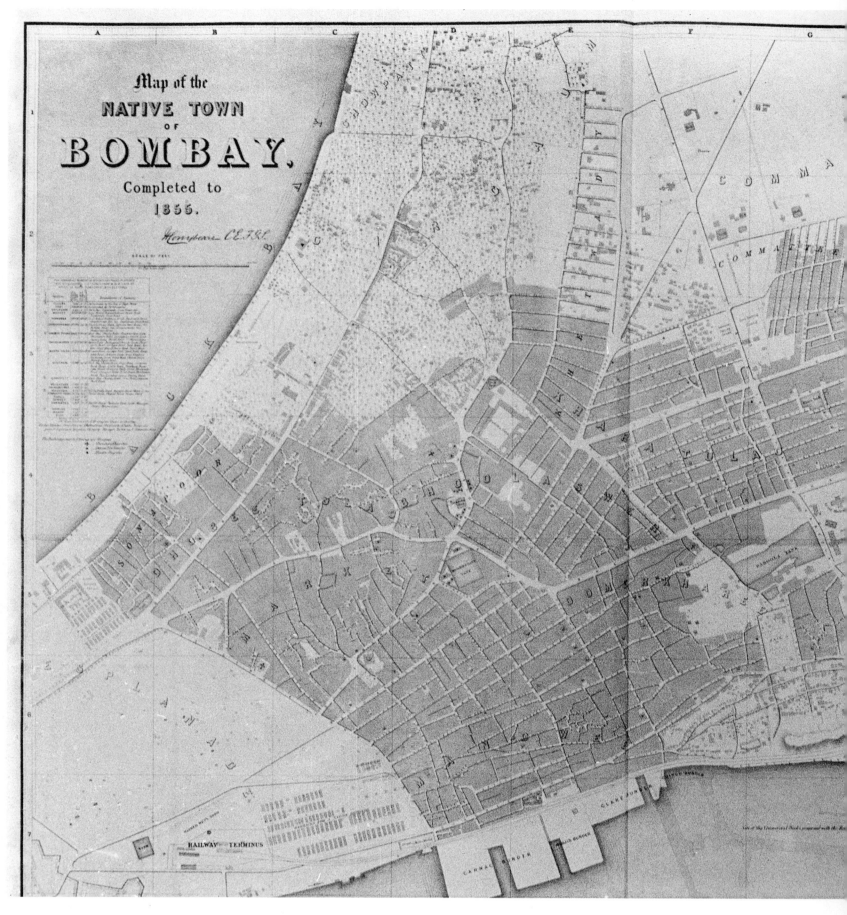

Map of the
NATIVE TOWN
OF
BOMBAY.
Completed to
1855.

6
Detail of the map showing
the distribution of religious
buildings in part of the Indian
township.
By Henry Conybeare, 1855.
Courtesy India Office Library
and Records (OIOC), The
British Library, London.

gurdwaras, synagogues, and Armenian churches Their
complex religious history in Bombay is beyond the scope
of this four-part article, which focuses instead on a
selection of Hindu, Muslim, Parsi, and Christian sites as
symbols of the social scene.

Many of the temples and mosques in Bombay were
originally small shrines constructed by local
communities. These were subsequently expanded or
reconstructed by migrants from Gujarat and western
India who settled in the city as it developed. The r

patronage is amply reflected in the additional
architectural features which are obvious borrowings
from regional styles of the mainland. The relationship
between a particular religious site and the community
which originally supported its existence is often difficult
to determine, since its origins are frequently interwoven
with legend. Rooted in the particular environment that
created the structures in the first instance, the social and
religious connotations of each successive generation are
also inextricably interlinked.

HINDU TEMPLES

A. P. JAMKHEDKAR

The Banganga Precinct and the Venkatesh Balaji Temple (figure 8)

Among the most celebrated Hindu precincts in Bombay, the area around the water tank of Banganga at Walkeshwar near the Governor's residence on Malabar Hill, may be singled out. The original temple of Walkeshwar was built at Malabar Point, close to the flagstaff, by Umbaji Rana (or Rane), a Maratha Sardar. This was allegedly destroyed by the Portuguese. The East India Company subsequently allotted a small piece of land for the surviving image, on which Ramaji Kamti of the Shenvi community built the present temple in 1702 (see also Godrej: figure 7).

Banganga then became inhabited by other brahmin communities, and by monks and mendicants. It also became a place of pilgrimage. As a result of patronage by wealthy citizens, many more temples, large and small, were established at the site. One of the earliest monuments is the Venkatesh Balaji Temple founded in 1779. Constructed in brick and timber, it is typical of the Maratha style of temple building. It consists of a courtyard, approached through a gateway, a closed hall, and the sanctum with a covered circumambulatory. The sanctum is covered with a dome of brick and lime mortar, raised on bridged arches at each of its four corners. The circumambulatory on either side of the sanctum extends the full width of the hall in the front. Its roof is supported by the four walls and two rows of four pillars running along the axis. The cypress wood pillars on stone pedestals are devoid of decoration. Other typical Maratha features are the images of Vishnu, here known as Venkatesh, Ambika inside the sanctum, the images of Hanuman and Ganesh in niches on either side of the doorway, and Garuda and Siddhivinayaka in the courtyard. Interestingly such images executed in Jaipur marble and carved by Rajasthani artists are invariably to be found in shrines of the Maratha period, from about 1780 to 1818, all over Maharashtra. Stucco work is also frequently found in various parts of these temples. Here for example, figures of doorkeepers, arches over the doorway of the sanctum, and various niches enshrining the main and subsidiary divinities are in relief, adding textural variety to the temple's interior.

Today the site is still largely inhabited by descendants of the original brahmin communities that settled here, and many of the old houses survive. The temples and shrines around the picturesque tank, one of the very few remaining in Bombay, are tended with pride and devotion by the local citizens. Still visited annually by scores of people, the site continues to be a main centre of pilgrimage, especially during festival time.

The Bhuleshwar Temple Complex (figures 1 and 7)

One of the most celebrated temple complexes in Bombay is that of Bhuleshwar, lying to the west of the Mumbadevi Temple, famous for its links with the historical and legendary origins of Bombay and its Koli community. Bhuleshwar is another centre around which several temples and other religious buildings were established in the early eighteenth century. While the worshippers at this Shiva temple belong to all classes of Hindus, its ministry is confined to Gujarati brahmins.

The three temples in this complex are important for their architectural styles. They consist of the Bhuleshwar and Rameshwar temples besides the modest Ganapati shrine situated between them. The last was built mainly in stone and brick. This simple structure consists of a hall resting on pillars and pilasters — the sanctum, its four walls incorporating four blind arches supporting the dome above. The only specially remarkable features of this shrine are the wooden struts of the two front pillars.

Architecturally, the temples of Bhuleshwar and Rameshwar belong to the same group, having the typical *nagara* mode of tower surmounting the shrine. Based on evidence of similarities between their pillar order,

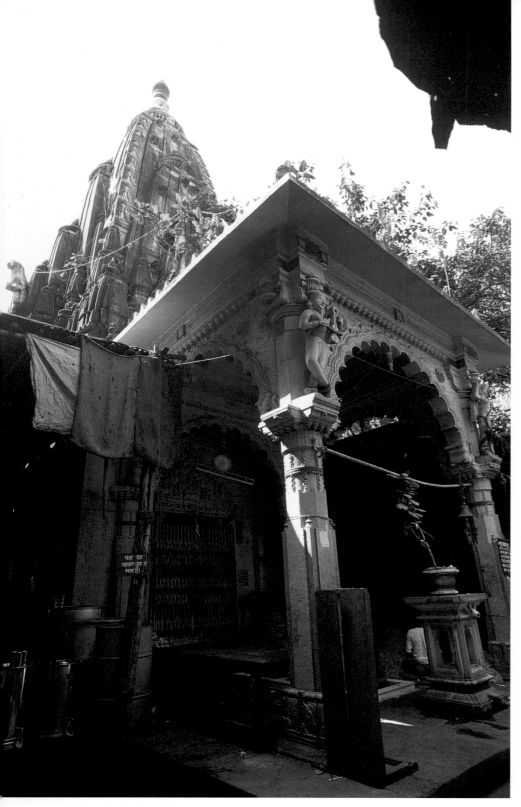

7
The Rameshwar Temple in the Bhuleshwar temple complex. Photograph: Bharath Ramamrutham, 1997.

portion above the capital. The doorway of the temple is simple and devoid of any figurative sculpture on the jambs. They are replaced instead by a decorative motif, and capped by a pediment with miniature shrines represented in sequence.

The Rameshwar Temple has an open-fronted porch instead of the large hall as in Bhuleshwar. On plan, it consists of the porch, vestibule, and sanctum. The pillars of the vestibule are the traditional square type, but complemented on their inner side by typical Maratha cypress pilasters. In contrast with Bhuleshwar, here the sanctum doorway has a figure of Lakshmi lustrated by elephants. The scene is taking place under a cusped arch of the Gujarati order, on which are perched monkeys and peacocks. The exterior of the porch has figures of musicians and elephants attached to the pillars and corners of the *mandapa* roof.

The technique of building the sanctum in both temples is distinctive and traditional. Instead of introducing arches in the corners of the four walls, as is common in medieval buildings, there are quarter pillars in each corner of the sanctum. Both these and the beams support triangular slabs. Above these rises the round ring of stones over which the dome is constructed. Other noteworthy features are the corbels, on which rest the four beams which appear at the base of this superstructure.

Another notable feature of the Bhuleshwar temple complex is the wooden balcony for musicians, the *nagarkhana,* over the main gateway. This gateway, along with the two flights of steps on the inner side, is built in stone. The square structure in wood with a pyramidal roof is a fine specimen of eighteenth-century wood carving. Carved in the typical western Indian style with a door on either side, its arcaded body has a square wooden frame with slender cypress pillars within the arches and at the edges. The spaces within these are filled with delicate floral motifs.

Like many old temples in Bombay, there are differing stories relating to the original foundation of the Bhuleshwar complex, although its long-standing connection with the Shenvi community is not in question. Many of these high-caste Hindu families settled in the nearby localities, and during one particular festival, that of Tripuri Purnima when a fair would take place, its procession visited all the places inhabited by these families.

decorative motifs, bracket figures of musicians, and especially the building techniques, they would appear to be the creation of the same group of craftsmen. The only difference is the use of Porbunder sandstone in the Rameshwar shrine for the upper parts of the *mandapa* and the tower over the sanctum, while the tower of Bhuleshwar is in trap-rock.

Access to the Bhuleshwar Temple is through a square hall, the *sabha mandapa;* each of its three walls has three arches, through the largest of which one then enters the hall. Across this main hall is a truncated vestibule of the same width, fronted by square pillars, their shafts turning octagonal, then rounded and decorated with bell motifs. Two huge figures of female musicians rest against the

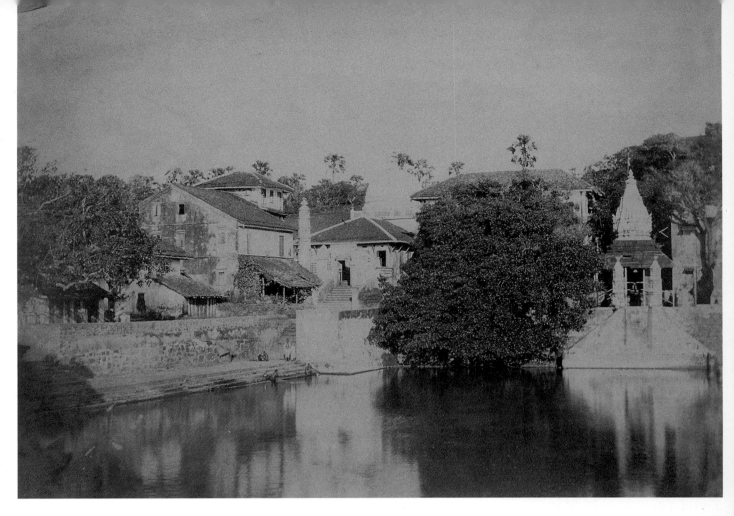

8
The north-east corner of the Banganga Tank Complex at Walkeshwar, including the Venkatesh Balaji Temple (left with the dome), and the Siddheshwar Temple (right with the spire).
By Johnson and Henderson, *circa* 1857.
Courtesy India Office Library and Records (OIOC), The British Library, London.
The photograph was published in *The Indian Amateur's Photographic Album* No. 14 in December 1857.

9
The Bhavani Shankar Temple, built near Gowalia Tank.
Photograph: Pauline Rohatgi, 1997.

The Bhavani Shankar Temple (figure 9)

Although some believe that the Bhavani Shankar Temple was built by Sunkersett Babulsett, father of the famous Jagannath Sunkersett in 1806, in my opinion it was Jagannath Sunkersett himself who built this temple in memory of his parents in 1863, in his own *wadi* (neighbourhood) close to Gowalia Tank. The foundation day on Margashirsha Purnima is still celebrated annually in memory of Sunkersett and his wife, Bhavanibai, after whom the temple seems to have been named.

It is a moderate shrine consisting of a closed hall with an open covered passage on three sides and a sanctum. The temple stands on a stone platform and is built in stone and brick with lime mortar and some stucco in typical Maratha style. The main feature of the sanctum consists of a wall with niches all around supporting a garland of sixteen small domes. Over this rises a cluster of eight replicas of the shrine, in the middle of which is the central dome with a *kalasha* (pot-like finial). Similarly four small domes adorn the corners of the large dome in the middle of the roof. The work over the tower, the miniature replicas forming part of the tower, the arches superimposed over the doorways are all in stucco. The vestibule, like those at Bhuleshwar and Rameshwar, is wider than the one seen in traditional temples of Maharashtra and is in the form of a stone arch projected in front of the sanctum doorway. The design of the battlement, like the coping over the parapet wall and over the doorway of the sanctum, is again typically Maratha. A pair of oil-lamp pillars, *deepmalas*, stand in the courtyard.

In its plan, mode of construction, and general appearance, the Bhavani Shankar Temple is reminiscent of the typical Maratha shrine model that developed in Poona during the Peshwa period between 1730 and 1818. In this connection, it is highly significant that the original patron of this temple was a member of the Marathi-speaking Daivadnya community.

The Babulnath Temple Complex (figure 10)

Situated on the south-east slope of Malabar Hill close to the steps leading to the old steps to the Towers of Silence, is the Babulnath Temple. The temples of Babulnath and Mumbadevi are very similar in their treatment of the *nagara* style of tower, the parapet over the *mandapa* arch, the doorway to the sanctum, the pediment above, and to some extent the order of the pillars. In its plan and appearance, the structure of the Mumbadevi Temple is less traditional. For example, its northern wall has not only modern balconies, but also European pilasters. Structurally, it consists of a modern two-storeyed building over which the traditional shrine rises. The ground floor is an oblong hall, providing a sanctum and a circumambulatory, with a staircase at one side leading to the upper storey.

The original shrine of the Babulnath Temple was built in about 1780, and was enlarged in the 1830s. Construction on the present temple, which was built in sandstone on a base platform of trap-rock, began in 1889 and took some ten years to complete. It is more remarkable than the Mumbadevi Temple as a result of certain innovations, as for example the introduction of modern figures within the traditional Gujarati temple scheme. It consists of a spacious open hall in the front with approaches from all three sides, which is connected to the main shrine by a flight of steps. On account of the slope of the hillside, the entrance hall is at a lower level than the remainder of the temple. Leading from the hall is a covered corridor, a *mandapa,* and the sanctum surrounded by a covered ambulatory which is apparently an extension of the pillared hall. The pillars are of the traditional Gujarati order and are joined by cusped arches, the spandrels of which are decorated with rosettes.

The parapet of the *mandapa* consists of miniature shrines, which are interspaced with dwarf columns, superimposed with sages and musicians. The sanctum doorway is situated on the east and there are two large windows in the side walls. The pediment over the main doorway depicts Shiva and Parvati seated on their

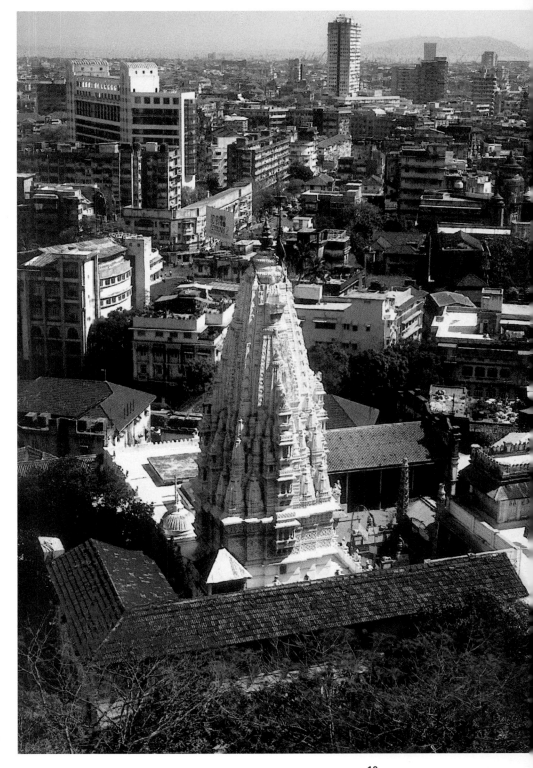

10
The Babulnath Temple, Chowpatty.
Photograph: Pauline Rohatgi, 1997.

respective mounts and accompanied by the *ganas* who attend upon them and play trumpets. The jambs of the main doorway, the arches over the side windows, and the corners are adorned with images of directional divinities with their spouses and various forms of Durga Mahishasuramardini.

The spire, which rises over the dumb second storey of the sanctum, is a fine example of the *nagara* type of *shikhara* with three typical balconies superimposed, and with elephant figures facing the three main directions. The uniqueness of this temple also lies in the faithful rendering of the mouldings on the lower end of the sanctum wall, the pillars, doorjambs, and the cusped arches. In addition, as one of the loftiest *nagara* towers in Bombay it can be compared favourably with those of the Mumbadevi, Bhuleshwar, and Rameshwar temples.

"One day when the Saint Haji Ali was deep in prayer, a woman passed by crying. He asked her what had happened and she replied that the oil she was carrying in her jar had fallen out. She was afraid to return home as her husband was very cruel, and would surely beat her. The saint told her not to worry. He placed his thumb on the earth and drew oil out from there and soon her jar was full.

"But the Earth was angered. The saint had caused it great pain while removing the oil. The Earth said to the saint, 'When you die and are buried within me, I will take my revenge'.

"Soon after that the saint fell ill. He remembered the Earth's words, and told his followers, 'When I die, do not bury me in the earth, but put my coffin in the sea'.

"After he died his followers obeyed his wishes, and it is said that the coffin drifted towards the island of Bombay. An old man who lived there had a dream of its arrival, in which he was told to bury the coffin in the rocks where it landed. Soon a shrine was built around the grave in the rocks and the shrine of Haji Ali, as we know it today, came about."[1]

Sacred space for Muslims in Bombay is conspicuously identified by the numerous mosques and shrines in the city. While the origins of some of these sites contrast legends with factual knowledge, the presence of these monuments in many areas indicates the widespread nature of Muslim settlements in the city.[2] While a detailed description of all these structures is not possible here, this article will look at three of the more renowned and prominent sites.

There are said to be eighty-nine main mosques in the city, of which eight belong to the Bohras, two to the Khojas, one to the Shias, and the remainder to the Sunnis.[3] While the oldest structure is the mosque at Mahim, adjacent to the shrine of Saint Maqdum Mohammad Mahimi, other noteworthy ones are the Jami Masjid in Sheikh Memon Street and the Minara Masjid opposite. The Zakaria Masjid in Mandvi, Sattad Masjid near Masjid Bunder station, Ismail Habib Masjid in Memonwada, the Khoja Ashna Ashari Masjid, and the Bohra Masjid to the west of the Jami Masjid[4] are also worthy of mention.

While there are several small and large shrines scattered throughout Bombay, the most well-known of these are the ones located at Mahim, Haji Ali, New Marine Lines, and Wadala.[5] These shrines are buildings erected on and around the tombs of saints, and may be known as *mazar* (tomb) or *ziyaratgah* (a place of pilgrimage), or more commonly referred to as *dargah* (a place of access, a shrine, or a tomb of a pious man).[6] These shrines are usually the tombs of venerated saints, whether actual or empty, and may exist in their bare shape or architecturally adorned. The saints either gained popularity in their lifetime, or after, with the result that their shrines have emerged as centres of pilgrimage.

Shrine of Saint Maqdum Mohammad Mahimi (figure 12)

Possibly the oldest mosque and shrine in the city is the one located on the western side of Veer Savarkar Marg (old Cadell Road) at Mahim. Although an exact date is not given the shrine is said to be about six hundred years old. Little remains of the original mosque which is probably older than the shrine since it is stated to have existed during the saint's lifetime.

SACRED MUSLIM SITES

MONISHA AHMED

Ali Bin Ahmed, later known as Maqdum Mohammad Mahimi, was born on the island of Mahim in the fourteenth century.[7] His forefathers had migrated to India about AD 860 to escape the tyranny of Hajjah ibn Yusuf, the Governor of Basra.[8] It is said that Ali Bin Ahmed received *wilayath* (sainthood) because of his mother.

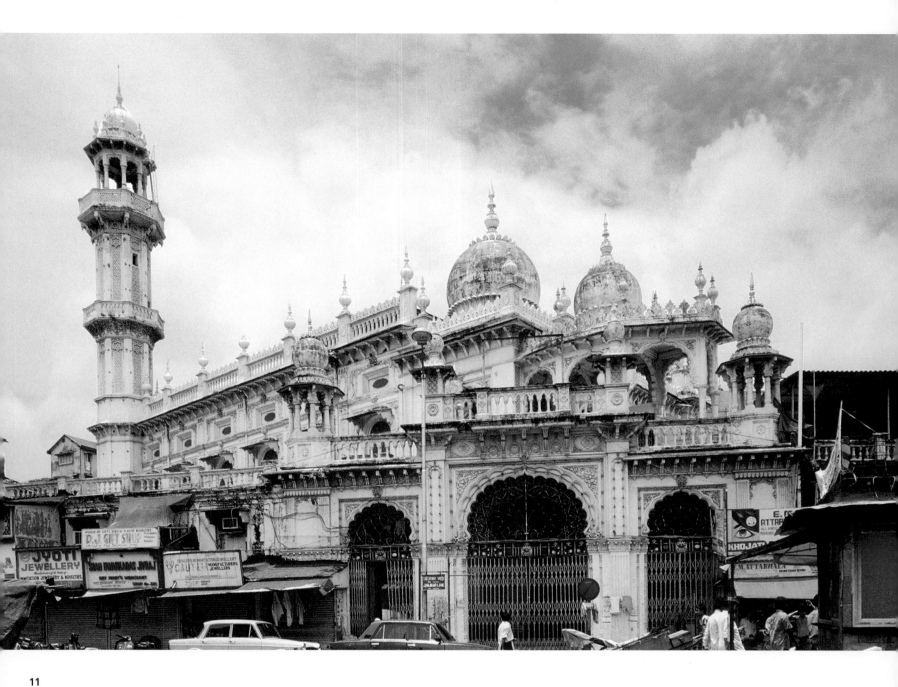

11
The Jami Masjid, Bhendi
Bazaar.
Photograph:
Bharath Ramamrutham,
1996.
Cf. figure 14, an earlier view.

"One night, when he was a young boy, his mother asked him for a glass of water. When he returned with the glass he saw that she had fallen asleep. Not wanting to wake her, he continued to stand beside her, thinking, 'As soon as my mother wakes I will offer her the water'.

"Much later at night, when she awoke for her prayers and saw him standing there with the glass of water, she was so pleased that immediately she requested Allah to bestow His blessings upon her son."[9]

It was after that night that his religious training began. The saint lived upon a small islet at Mahim, now visible only at low tide, and his fame spread during his lifetime. After his death the shrine was erected around his tomb to honour him. His mother, Bibi Fatima, who is said to have been a very pious woman, lies in the tomb beside his. Though the shape of the shrine has not altered much since it was built, the mosque has undergone several changes. During the saint's time the mosque was a very small building, but subsequently it was repaired and enlarged in 1674 and 1748. In 1952 a first floor was added and in 1970 this was extended to make it a three-storey structure. The sacred hair of the beard of the Holy Prophet is preserved in the shrine of Saint Maqdum, and the place is visited by two to three hundred people daily. The saint's death anniversary (*urs*) begins on the day of the full moon in the month of December, and is held for ten days. During this time the site is visited by thousands of pilgrims who come to receive the saint's blessings, offer their respects, and to pray that their wishes might be fulfilled.[10]

The Shrine of Haji Ali (figure 13)

The shrine that is the most well-known in Bombay today is Haji Ali, which lies on an island in the little bay that was once the mouth of the Great Breach. The saint, Pir Haji Ali Shah Bhukari, is said to have lived about five hundred years ago.[11] However, legends vary about the exact abode of the saint. While some say that he lived on a neighbouring island, others say that he was a rich resident of Bombay who, on his return from Haj in Mecca was known as "Haji Ali". At that time, Haji Ali was searching for spiritual attainment; he renounced the world, gave away his wealth, and proceeded to live on

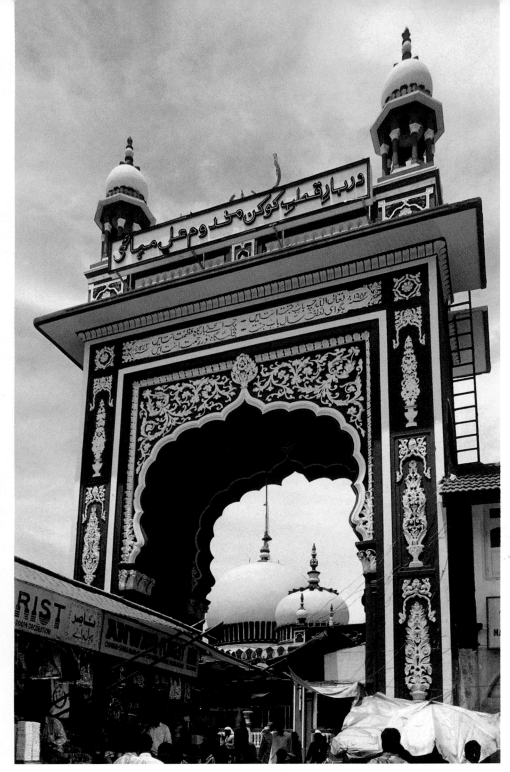

these rocks in the bay.[12] In another version of the same story, it is said that he died en route from Mecca to Bombay. His body was put in the sea, and it floated towards the island of Bombay. The people who found the body said that there was a note attached to it which asked that the body be buried wherever it landed.

At Haji Ali, there is both a shrine and a mosque. However, unlike at Mahim, the mosque was built much after the shrine. Both were very modest structures until they were expanded between 1960 and 1964. The main entrance gate, first built in 1950, was reconstructed in white marble in 1985. In fact all structures at the side are gradually being converted into marble. The trustees have aspirations to make the shrine of Haji Ali into a world famous site, so that one day it can be as widely known as the Taj Mahal.

Haji Ali is frequented by five to ten thousand people daily, the number almost doubling on Thursday evenings and Fridays. Unlike at Mahim there is no *urs* at Haji Ali. Instead their main annual function is the "washing of the tomb" ("*ghusal* of the *masba*"). The tomb is first washed with water and then rosewater, and then sandal paste is applied over it. The site is closed during this time.

The Jami Masjid (figures 2, 11, and 14)

The Jami Masjid, or the Great Mosque, was built in 1800. The land, which consisted of gardens and a large water tank, belonged to a Konkani Muslim who insisted that the tank be preserved intact. A one-storey building was erected over the tank and formed the original nucleus of the present Jami Masjid. The mosque was named *Jahaz-i-Akhirat*, "the ship of the world to come", an allusion to the fact that it was constructed over a tank.

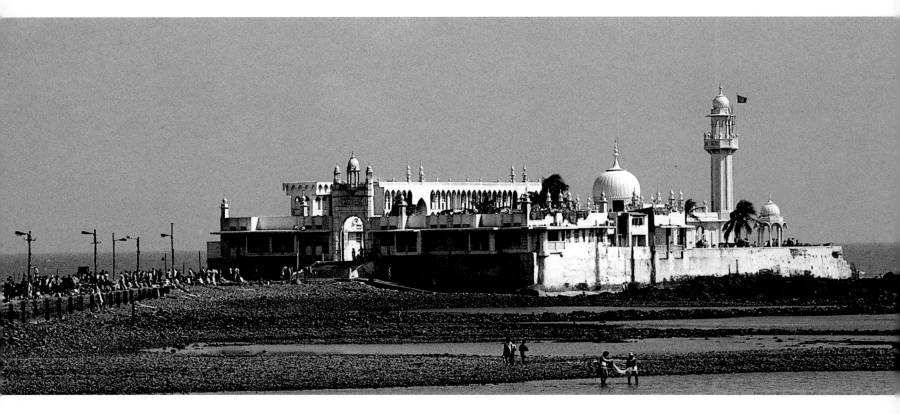

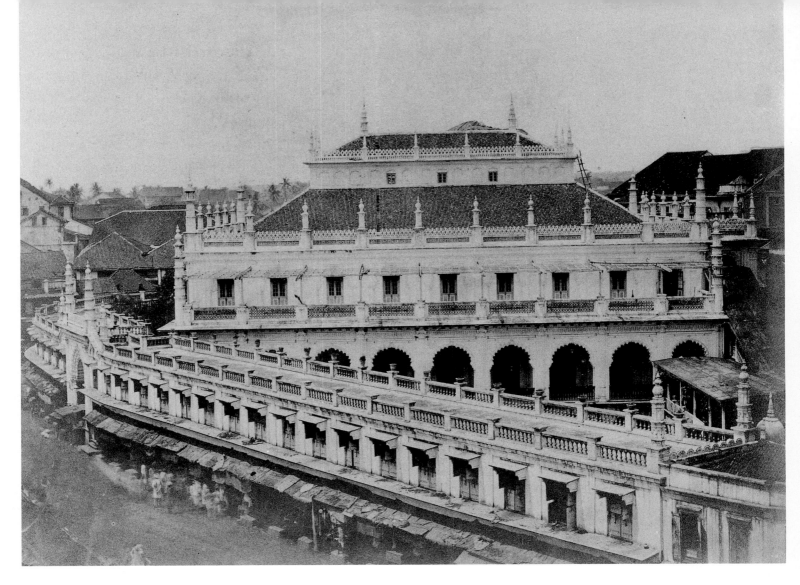

14
The Jami Masjid.
By Henry Hinton, *circa* 1857.
Photograph, 21 x 25.5 cm.
Courtesy Farooq Issa,
Phillips Antiques, Mumbai.
This photograph was
published in *The Indian
Amateur's Photographic
Album* No. 5 in March 1857.

(facing page)
12
The gateway to the Shrine of
Saint Maqdum Mohammad
Mahimi, at Mahim.
Photograph:
Bharath Ramamrutham,
1996.
The saint lies buried under
the white-domed mausoleum
behind (left).

13
The Shrine of Haji Ali
at low tide.
Photograph:
Bharath Ramamrutham,
1996.
The path on the left leads
pilgrims to the shrine.

Today, the Jami Masjid stands halfway up Sheikh Memon Street, in the crowded Bhendi Bazaar near Nakhoda Mohalla (or Captain's Ghetto). It consists of a quadrangular pile of brick and stone, encircled by a ring of terrace-roofed and double-storeyed buildings, the ground floors of which are let out as shops. In 1837 it was enlarged through the financial assistance of a philanthropic Konkani Muslim, Mohammad Ali Roghay, an upper storey was added and shops built around the periphery of the mosque.

Within Bombay, the position of the Jami Masjid has changed several times, each move relocating the mosque to a different part of the city centre. According to an Urdu account of 1836, the original Jami Masjid was situated near the Dongri Fort.[13] However, during the governorship of Richard Bourchier between 1750 and 1760, it was removed and a new structure was built on the Esplanade. Subsequently, this too was dismantled by an order of the Governor, William Hornby, who forbade the existence of any buildings within six hundred yards of the Fort. Temporarily, while the present Jami Masjid was being built, the Sattad Mosque in Mandvi was utilized.

The presence of these mosques and shrines throughout Bombay continues to accentuate the veracity of Muslim life in the city. While the mosques are specific to the Muslim population in the city, the shrines have always drawn people of all communities. According to the caretakers there, "as long as people come with faith, anybody can benefit by visiting the shrine of a saint".

Notes
1. Personal communication, Abdul Sattar Merchant, Honorary Managing Trustee, Haji Ali Dargah Trust, Mumbai, August 1995.
2. Gillian Tindall, *City of Gold: The Biography of Bombay,* London: Temple Smith, 1982, p. 125.
3. *The Gazetteer of Bombay City and Island,* Pune, 1978, Vol. 3, p. 311.
4. "The Muslim population of Bombay comprises the Bohras, Khojas, Memons, Konkanis, Deccani Muslims, Arabs, and Pathans." Sharada Dwivedi and Rahul Mehrotra, *Bombay — The Cities Within,* Bombay: IBH, 1995, p. 65.
5. The saint Sheikh Misri, who is buried at Wadala, is said to have come from Egypt more than seven hundred years ago. Therefore one source claims that this shrine is even older than the one at Mahim. However, there are others who say he came about five hundred years ago. Since very little is known about this shrine it is difficult to corroborate the information.
6. Christian W. Troll (ed.), *Muslim Shrines in India,* New Delhi: Oxford University Press, 1992, p. xi.
7. "Before the close of the fourteenth century, the only significant event was the birth of Sheikh Fakih Ali." M. D. David, *History of Bombay 1661-1708,* Bombay: University of Bombay, 1973, p. 15.
8. J.R.B. Jeejeebhoy, "A Short History of Mahim", *Ismaili,* 1941, 18:3.
9. Personal communication, Mohammad Rashad Baray, Sajjada Nashin, Mahim Dargah, Mumbai, August 1995.
10. It is said that Allah's blessings can be invoked through the saints because they are *ahluia.* This brings them much closer to Allah, and makes them nearer and dearer to Him.
11. About eighty years ago, all records at Haji Ali were burnt by some Muslims who attempted to take over the running of the Trust. They wished to destroy all historical evidence of the lineage of the previous trustees, and instead they claimed to be the descendants of the saint. They remained in charge of the shrine until a court ruling reinstated the original trustees.
12. *The Taj Magazine,* 1982, Vol. 11(2).
13. *The Gazetteer of Bombay City and Island,* loc. cit.

The Parsi Zoroastrians originally came from Iran and settled along the western coast of India.[1] In the early part of the seventeenth century, their descendants moved south to Bombay when the islands were still under Portuguese rule. Early records show that a ritually consecrated building for religious ceremonies, but without a sacred fire, was built by one of the first Parsi citizens of Bombay, Mody Hirji Waccha, in 1672 in the Mody Khana, an area within the Fort precinct around Mody Street, both of which were named after him.[2]

By the eighteenth century, the Parsi population in Bombay had increased substantially, and the elders of the community decided that more places of worship, where the Zoroastrians could fulfil their ritual obligations in the presence of a perpetual fire, should be established. By 1800, six fire temples had been built, mostly within the Fort.[3]

The rise of Parsi entrepreneurship and wealth was marked by a parallel increase in the number of fire temples built especially in the late nineteenth and early twentieth centuries. Many a Parsi, enriched by the flourishing trade with Europe, China, and the Americas, endowed fire temples as a triumphant proclamation of new-found success and prosperity. Today there are forty-three fire temples in and around Bombay; the newest one, still to be completed, is located in the Parsi enclave of Godrej Baug on Malabar Hill, overlooking the sea.[4]

OF PERPETUAL FIRES AND TOWERS OF SILENCE

FIROZA PUNTHAKEY-MISTREE

A fire temple is known in Gujarati as an *"agiary"*, which simply means "house of fire". There are three grades of sacred fires and the building housing them is named according to the type of fire it enshrines. The most exalted is the *Atash Bahram,* the "fire of victory", which is created by bringing together sixteen different fires, including one originating from a bolt of lightning striking the earth and witnessed by at least two Zoroastrians.[5] Bombay has the singular distinction of being home to four such "fires of victory". The second tier is the *Atash-e-Adaran* or "lesser fire", which is created by combining four different kinds of fires taken from the homes of a priest, a warrior, a farmer, and an artisan. Most of the sacred fires in Bombay belong to this category. The third, the *Dadgah* or "house fire" is a single ever-burning fire kept in the home of a Zoroastrian in a ritually demarcated area ranging from a specially maintained table to a small prayer room. The *Dadgah* is also regarded as sacred and hence prayers are offered to it daily. This fire may also be found in a fire temple.

The Banaji Limji *Adaran* (figure 15)

The oldest sacred fire in Bombay is housed in the Banaji Limji Agiary, installed on June 25, 1709.[6] It was endowed by Seth Banaji Limji, a wealthy merchant who came to Bombay from Surat in 1690, and made his fortune by opening up trade with Burma. As a house of worship, it was affectionately called *Kote-ni Agiary* or "the fire temple of the Fort". In its early years, it was unique in having the only seminary or *madressa* in Bombay. During the great fire of 1803, part of the *Kote-ni Agiary* was severely damaged with the result that, a few years later, the fire was transported in a ceremonial procession to another site: in the dead of night, Parsis, dressed in traditional regalia, walked with the fire for two miles, northwards to the Soonaiji Hirji Readymoney Fire Temple at Gowalia Tank where it was temporarily housed.

Meanwhile funds were raised for the new building, and even impoverished Parsis who attended the thanksgiving *jashan* at the foundation-laying ceremony, contributed. It is said that as an act of faith they threw hundreds of eggs and mugs of toddy (date-palm wine) into the excavated area;[7] these were then mixed with the building materials of its foundation. The first sacred fire of Bombay was thus installed in its new home on April 15, 1845.

15
The outer facade of the Banaji Limji *Adaran,* Banaji Agiary Street, Fort. Photograph: Noshir Gobhai, 1997.

The Hormusji Bahmanji Wadia *Atash Bahram* (figures 16 and 17)

The Hormusji Bahmanji Wadia *Atash Bahram,*[8] prominently situated on Princess Street, was built in 1830 in an area called Charni Wadi, which was an old grazing ground for cattle; later it was known as Chandan Wadi because of the many sandalwood shops in the vicinity. Housed in a sprawling single-storeyed structure, it was built by the three sons of Hormusji Bahmanji Wadia. Twenty-five years earlier, Hormusji himself had built a small fire temple, *Adaran,* in the same compound, for more than a thousand Parsis forced to move into the Dhobi Talao and Girgaum areas from the Fort, after the fire of 1803. In his will, Hormusji instructed his sons to establish an *Atash Bahram* adjoining the old building. Improbable as it may seem today, part of the *Atash Bahram* fire was obtained when a bolt of lightning struck a *tad* palm tree in Calcutta on June 15, 1828, an event witnessed by two Zoroastrians. The fire was then taken and ritually tended by a priest in the home of a Mr Meherwanji Limji until, on October 21, 1829, it was brought to Bombay and used in the making of the Wadia *Atash Bahram* fire.[9]

The building is a fusion of Indo-Iranian architecture. The external facade of the main structure reflects Parsi sentiments as a reminder of their ancient Iranian heritage.

The fluted columns, crenellated verandahs, and bull capitals which adorn the building are clearly Achaemenian (549-330 BC) in design and style. The *kusti*[10] concourse, where the external ablutions take place, has eight dressed Porbunder stone pillars surmounted by bull capitals, reminiscent of those found in the audience hall of Darius the Great (522-486 BC) at Persepolis. The approach to the inner precinct is through a pillared portico with fluted columns and huge grilles emblazoned with motifs of the sun.[11] The doors of the verandah which give access to the hallway have wooden cavetto cornices mounted on the lintels in imitation of those in the private palace of King Xerxes (486-465 BC) at Persepolis.[12]

As one stands in the inner prayer hall gazing at the "fire of victory" enthroned upon a huge silver fire vase, *afarganyu,* in the sanctum sanctorum, one notices a remarkable absence of adornment or religious works of art. The sanctum is a square room surmounted by a dome supported on squinches, an architectural concept common to fire temples in both Iran and India.[13] Two huge brass bells hang in opposite corners and are rung by the priest before the service, to clear the sanctum of any bad thoughts, words, or deeds.

The most unusual and perhaps somewhat incongruous items which are displayed above the many

The Wadia *Atash Bahram* houses two more sacred fires: an *Adaran,* which is also enthroned in a domed sanctum, and a *Dadgah* fire, which is kept burning in a large room, commonly known as the *urwis gah;* here the high rituals of the faith are performed. A door from the *urwis gah* opens onto a well from which water is drawn for all the ceremonies;[15] nearby is a pomegranate tree and a date palm, both essential features of a fire temple.

The Bhika Behram Well (figure 3)

Situated at one end of Cross Maidan (the old Esplanade) and diagonally across from the High Court, is the "Bhika Behram-*no Kuvo*", a freshwater well dug in 1725. The well became special among the Parsis because, despite then being so close to the sea, the well water was fresh. As a result, the site and its immediate vicinity became sacred. Even now, especially during the Zoroastrian calendar month of *Avan,* dedicated to the water divinity,

niches in the inner sanctum are the three short daggers, two swords, and a bull-headed mace. The mace, according to legend, is symbolic of the one used by King Faridun to defeat the cruel usurper, Zohak, whose rule is said to have brought chaos and much destruction to Iran.[14] The weapons form a reminder of the ceremonial sovereignty which the serving priest has over the fire; likewise they may also be used by the priests to protect the sacred fire.

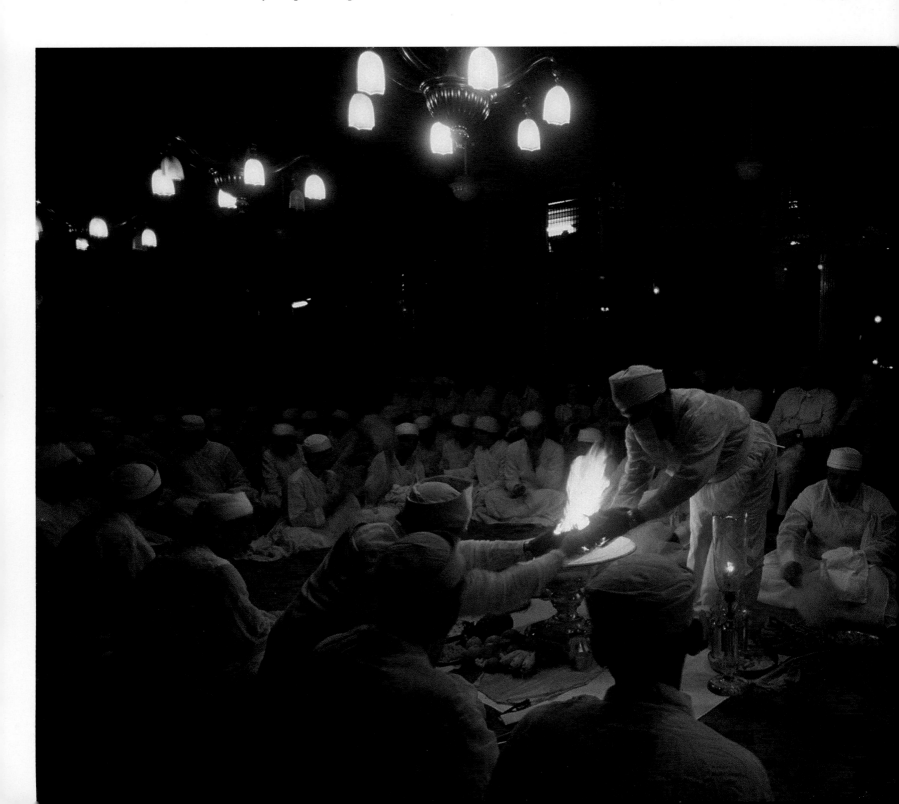

16
The external facade of the Hormusji Bahmanji Wadia *Atash Bahram*, Princess Street.
Photograph: Noshir Gobhai, 1996.
The outer pillared portico and crenellated verandah reflect several features of early Achaemenian art.

17
Interior of the Hormusji Bahmanji Wadia *Atash Bahram*, Princess Street.
Photograph:
Khojeste P. Mistree, 1994.
In this photograph a *jashan* is being performed by over a hundred priests. The walls are lined with life-size portraits of the founders and well-wishers of the fire temple. The rectangular hall forms the traditional *iwan* leading to the inner prayer hall from where the sacred "fire of victory" can be seen. Zoroastrians view fire as the physical embodiment of Order, Truth, and Righteousness. The sacred fire is seen as a living manifestation of Ahura Mazda — the Lord of Wisdom. Every sacred fire has to be ritually nourished at least five times a day by a qualified priest who offers logs of hard wood, and pieces of sandalwood left as votive offerings by worshippers. Parsis term the installation of a sacred fire an enthronement and the event is celebrated like a royal coronation.

Parsis visit the well, light oil lamps, and pray to the waters.

The well and its stone canopy with its stained glass were built by Bhikaji Behramji who, according to oral tradition, was travelling to Bombay on foot from Broach in 1715. On the way, he was waylaid by Marathas who mistook him for a Muslim and imprisoned him in the fort of Panday Gadh. By showing his sacred vest, *sudreh,* and cord, *kusti,* Bhikaji convinced his jailors that he was a Parsi. Having already vowed, if released, to create something for the community, he built a well which was named after him ten years later.[16]

The "Towers of Silence" — *Dakhma* (figure 18)

In 1792, a European resident in Bombay secretly climbed up the wall of a "tower of silence" and looked inside. The Parsis were greatly outraged by this indiscretion, with the result that the Governor, Sir Robert Abercromby, issued a proclamation warning would-be intruders that their services would be suspended by the East India Company if a "native" temple or tomb was desecrated in any way.[17]

It is not surprising that the Parsi mode of disposal of the dead aroused the curiosity of both European travellers and the ruling British. In 1875, for example, the Prince of Wales[18] and his party visited the "towers of silence", to judge for themselves the need to preserve such an unusual method of disposal (see also Godrej: figure 9). A fine model of a "tower" was shown to His Highness (later Edward VII), and the then secretary of the Parsi Panchayat explained its internal construction and the theological reasons for its use. According to Zoroastrian doctrine, death is seen as the temporary affliction of evil: hence the corpse is deemed to

The "Towers of Silence", *Dakhma* on Malabar Hill from the south-east.
By an unknown photographer, *circa* 1890s.
Photograph, 18.5 x 23.5 cm.
Courtesy Farooq Issa, Phillips Antiques, Mumbai.
In the construction of a *dakhma*, a sacred precinct is created within the "tower" by a team of Zoroastrian priests. Three hundred and one nails of different sizes are driven into the ground,

dry and then swept into the central pit, which being lined with a layer of lime enables the bones to disintegrate quickly.

To attend the actual consecration ceremony of a *dakhma* is said to be meritorious. Thus on June 3, 1831, thousands of Parsis gathered at Malabar Hill to witness the consecration ceremony of the Framji Cowasji Banaji "tower".[19] According to the *Bombay Samachar,* not a single

forming a circular geometric pattern. This staking is accompanied by the recitation of prayers, thereby making the ground sacred. The priests then twine a hundred and one threads into one strong cord, which they pass around the half-embedded nails, ensuring that this unbroken sacred cord does not touch the ground at any point. In this photograph, three out of the five main *dakhma*s can be seen along the brow of the hill. From left to right these are — the Manekji Nowroji Sett "tower" of 1754 (still in use), the Mody Hirji Vatchagandy "tower" of about 1673 (the oldest of all and no longer used), and the Framji Cowasji Banaji "tower" of 1832 (no longer used).

be ritually impure and not permitted to be brought into direct contact with the earth, water, or fire which are held sacred. A sacred precinct is created within the "tower" by a team of Zoroastrian priests who perform the relevant rituals to ensure that any defilement by the corpse is contained.

The *dakhma* is a cylindrical structure of solid stone, within which is built a circular three-tiered platform, paved with large stone slabs which are divided into three rows of shallow open receptacles. There is a deep dry pit in the centre with drainage facilities at its base for rainwater. The bodies are placed in these receptacles by the corpse-bearers who enter the *dakhma* through a small door. The bodies are then exposed to the elements of the sun and sky and are swiftly devoured by vultures. The large bones are allowed to

Parsi man, woman, or child could be seen anywhere in the Fort area. When its foundation stone was laid, the Parsis threw their jewellery and hundreds of gold and silver coins to meet the future expenses of the "tower".[20]

The Readymoney "tower", which is now in disuse, was at one time visible from Walkeshwar Road. Mancherji Readymoney built this *dakhma* exclusively for himself (figure 19). Apparently when Mancherji was returning from China, an Armenian merchant aroused a superstition in his mind by predicting that if his bones were allowed to mix with those of others, his entire family wealth would be lost. He therefore ordered his own private "tower" to be built.[21]

While it is hard to imagine that panthers and jackals once roamed the wooded slopes of Malabar Hill, even

19

An old disused private "Tower of Silence" built by the Readymoney family on the Walkeshwar side of Malabar Hill; with a view across Back Bay to the mainland.

By T.H.A. Fielding after a picture by William Westall, 1804.

Aquatint, 21.5 x 29 cm.

Private collection.

This aquatint, entitled "Approach of the Monsoon, Bombay Harbour", was published in Robert Melville Grindlay's celebrated book, *Scenery, Costumes, and Architecture, chiefly on the western side of India,* London, 1826-30.

today the sequestered area of the *dakhma* still has an air of tranquillity, and it was this atmosphere of peace that inspired the poetic name — "towers of silence".

Notes

1. The Zoroastrians are the followers of Prophet Spitaman Zarathushtra *circa* 1500 BC and are of Iranian origin. The Zoroastrians who settled in India in the tenth century AD, came from the province of Khorasan known in ancient times as Parthia. The people of Gujarat addressed the Zoroastrians as the Parsis, a term used by the Gujaratis for anyone coming from Iran.
 The commonly accepted date for the arrival of the Parsis in India is AD 936. However, Dr Homi Eduljee has recently argued for an earlier date of *circa* 780 (see H. E. Eduljee, *Kisseh-i-Sanjan*, p. 39).
2. See Firoze M. Kotwal, *Some Observations on the History of the Parsi Dar-i-Mihrs*, BSOAS XXXVII, Part 3, 1974, p. 668.
3. See Hormuzdyar S. Dalal, *151st Anniversary of Installation of the Sacred H. B. Wadia Atash Bahram 1350 A.Y.*, p. 3.
4. There were forty-four fire temples in Bombay until 1995, when the Elahibaug *Dadgah* was moved from Bombay to the Sir Jamsetjee Jejeebhoy Agiary in Poona.
5. The sixteen different fires which are ritually mixed to create the *Atash Bahram* fire are: the fire of a burning corpse; the fires of a dyer, potter, brickmaker, ascetic, goldsmith, mint, blacksmith, armourer, baker, idolator, soldier, shepherd, a Zoroastrian *dastur,* and king or ruling authority; and a fire created by lightning. (See J. J. Modi, *The Religious Ceremonies and Customs of the Parsees*, p. 210.)
6. I am indebted to Mr Noshir Dadrawala, editor of *Deen Parast,* for the information given to me on the Banaji Limji Fire Temple.
7. See *Deen Parast,* Vols. 5.3 and 5.4, July-Aug. 1995, p. 10.
8. Seth Hormusji Bahmanji Wadia was born in 1766. He was the grandson of the master ship-builder, Lavji Nasserwanji Wadia who constructed the first dry dock in Bombay.
9. See James W. Boyd and Firoze M. Kotwal, "Worship in a Zoroastrian Fire Temple—The H. B. Wadia Atash Bahram", *Indo-Iranian Journal* 26 (1983), p. 314, fn. 12.
10. The *kusti* is the sacred cord made of 72 threads of lamb's wool and is worn, loosely, by a Zoroastrian round the waist with a reef knot in the front and rear. A Zoroastrian is enjoined to untie and retie the *kusti* before entering a fire temple.
11. The sun (*Khorshed*) which is seen as the giver of life and light, is sacred to the Zoroastrians who have special prayers dedicated to it. The *Khorshed Nyaish* is a litany to the sun which is recited by the Zoroastrians during daylight hours.
12. See Sarosh Wadia, *A Study of Zoroastrian Fire Temples,* Ahmedabad, 1990, p. 92.
13. The first surviving man-made dome in the world is to be found in the palace of Ardeshir I (AD 224-41) at Firuzabad. The dome supported on squinches was developed towards the end of Parthian rule (*circa* 245 BC to AD 224). See Andre Godard, *The Art of Iran,* p. 179, fn.
14. See Stuart Cary Welch, *A King's Book of Kings,* The Metropolitan Museum of Art, p. 104.
15. The Wadia Atash Bahram has three wells though only one is kept for the use of water required during the sacred ceremonies. The water from the second well is used by the laity for the prefatory ritual ablutions and the third well in the complex is used by the general public.
16. The adventure regarding Bhika Behram, I owe to Dr Viraf Kapadia, Trustee of the Bhika Behram Well. However, according to *Parsi Prakash,* Vol. 1, p. 62 (tr. for me by Shehnaz Munshi of Zoroastrian Studies), it was Kharshedji Pochaji Panday who was kidnapped by the Marathas and imprisoned in Panday Gadh and not his grandson, Bhikaji Behramji. The family appended the surname of Panday from the Panday Fort where their ancestor was incarcerated.
17. Dossabhai Framji Karaka, *History of the Parsis,* Vol. I, 1884, p. 205, fn. 1.
18. Ibid., p. 209.
19. The Banaji *dakhma* was constructed by Seth Sohrabjee Dhunjibhai Punegar who had studied engineering in a European school.
20. See B. B. Patel, *Parsi Dharmasthalo,* Bombay, 1906, p. 62 (tr. for me by Shehnaz Munshi of Zoroastrian Studies).
21. Unfortunately Readymoney died before its completion, and his body was covered and preserved on the hill for over a month until his own "tower of silence" was completed. See Dossabhai Framji Karaka, *History of the Parsis,* Vol. II, 1884, pp. 57-58, fn. 1. See Firoze M. Kotwal, "The Parsi Dakhma: Its History and Consecration", *Au Carrefour Des Religions Melanges Offerts a Philippe Gignoux,* Belgique, 1995, p. 169, for a further elaboration on the story concerning the Readymoney *dakhma.*

Mount Mary Church, Bandra (figure 20)

Of the many Catholic churches built in Bombay, the chapel of Nossa Senhora de Monte or Our Lady of the Mount in Bandra perhaps has the most unusual history. Bandor or Bandra is first mentioned in 1505 as a coastal Konkan town (although it was actually situated on one of the Salsette islands at that time) by Faria y Sousa. In 1532, the township was burnt by the Portuguese, who, almost a century later built a fort known as Castela de Aguado at Bandra. Around 1640, they erected the chapel of Nossa Senhora de Monte on the crest of Bandra hill, with a connecting road to the Aguada for the benefit of the garrison stationed at the fort.

The Maratha supremacy in the region resulted in the destruction by fire of the original chapel in 1738. According to local legend, six months later, the famous life-sized statue of the Virgin crafted in highly ornamented wood, was recovered from the sea by a fisherman. The image was kept in the Aguada, and later for some years in St Andrew's Church nearby, until Mount Mary was rebuilt in 1761 with funds raised by the parishioners. The statue was restored to its former position above a lavishly gilded, carved altar. A long flight of handsome stone steps was built on the eastern slope behind the church, leading to the main local market.

This Church of Maulicha Dongar, or the Hill of Mother, as it was called by local residents who considered the Virgin a mother-goddess, soon became the most famous church in Salsette, where worship and thanksgiving were also offered by innumerable non-Christian inhabitants. These comprised Hindus, Parsis, and Muslims — among them many women, who prayed to the Virgin Mary for a longed-for child or recovery from illness.

In 1774, Bandra came into the possession of the British East India Company. The importance of the town grew with the construction of the Mahim Causeway in 1845, linking the Salsette islands with Bombay. With the

Although Christianity was introduced into India in the middle of the first century AD, the earliest reference to the religion in the Bombay region is to be found only in the sixth century when Christians of the Nestorian Church are mentioned as inhabitants of Kalyan district. It was only with the coming of the Portuguese in the 1530s, however, that Roman Catholicism gained a stronghold in the Bombay islands and the hinterland largely through the efforts of missionaries of the Franciscan, Jesuit, and Dominican Orders.

The *Gazetteer of the Bombay Presidency, Thana District* (1882) records that the first conversions were made by the Franciscans and later the Jesuits under St Francis Xavier and his followers. The *Gazetteer* also mentions that the Portuguese, whose main interest in India lay in proselytizing, displayed an incredible fervour in forced conversions of thousands of local inhabitants in the regions of Bassein and Bandra.

Partly as a result of this zeal, large numbers of Hindu and Buddhist temples and cave temples such as those at Mandapeshwar near Borivali in the northern suburbs were replaced by churches. In addition, new churches were raised in Chaul, Bassein, Thane, and Bandra, and also on the Bombay islands. Among the important early churches built within the islands were those of Nossa Senhora de Esperanca on the Esplanade (later moved to Kalbadevi), Nossa Senhora de Salvacao in Dadar, Gloria Church in Mazagaon, San Miguel in Mahim, and the Church of Santa Cruz in Parel.

CHRISTIAN CHURCHES

SHARADA DWIVEDI

opening of the railway and during the economic boom in 1860-64, large numbers of people moved to Bandra. Still more fled there during the plague epidemics of the late 1890s.

With the growth in population and as the fame of the chapel spread, more and more worshippers began to visit Mount Mary which evolved as an important centre of pilgrimage. As a result, the foundation for a new,

20
Aerial view of Mount Mary
Church, Bandra.
Photograph: A. R. Haseler,
1937.
Source: *Bombay — The Cities
Within;* courtesy *The Times of
India* Archives.

enlarged and well-ventilated chapel designed by architect
Shapoorjee Chandabhoy was laid on May 11, 1902 by the
Bishop of Daman. The new church, built of *khandki* and
Porbunder stone, was 110 feet long and 38 feet wide and
accommodated an inner gallery running on three sides
and two new towers, each 80 feet high. The titular feast of
the shrine, known generally as Bandra feast, has been,
and is still annually celebrated on a large scale on
September 8 and is attended not only by the
predominantly Catholic local population but also by people
of all faiths who come to Bandra from distant areas.

St Thomas' Cathedral (figure 22)

While Roman Catholicism continued to thrive in the
Bombay region even after the departure of the Portuguese,
the Anglican Church made its presence felt in Bombay
only with the coming of the British in 1661. In the early
years, the East India Company provided a temporary
chapel in two rooms of Bombay Castle for the Protestant
population, then mainly comprising the troops in the
Bombay Fort and the Company's servants.

During the term of the Reverend Richard Cobbe,
Chaplain in Bombay from 1714 to 1721, funds were
solicited from local parishioners for the building of a
church and a sum of Rs 43,992 was raised. In a letter to
the Directors after his retirement and return to England,
Cobbe wrote that the church was built so that "all the
island might see we had some religion among us, and
that the Heathens and Mahometans and Papists round
about us, might in time be brought over as converts to
our profession". However, since large numbers of
immigrants had been drawn to Bombay primarily as a
result of the Company's assurance of complete religious
freedom, the new church, in fact, thus served only as a
symbol of British supremacy on the islands.

A prominent site was chosen near the Bombay
Green, close to Bombay Castle. Construction commenced
in 1715 and the church was formally opened by Governor
Charles Boone on Christmas Day, 1718. Although grand
in size with accommodation for over a thousand people,
the new church had a flooring of earth smeared with

21
Memorial monument to
Katherine Kirkpatrick by John
Bacon the Younger, 1800, in
St Thomas' Cathedral.
Photograph:
Bharath Ramamrutham,
1996.

cowdung and window panes of thin shells of mother-of-pearl. Bombay's Indian inhabitants referred to it as the *deval* or temple.

It was only in 1816 that the church was consecrated in the name of St Thomas the Apostle and in 1838 it was designated the Cathedral Church of the See. The cathedral is a mixture of sequential styles culminating in a Gothic tower and clock which were added in 1838 in addition to a Gothic chancel, which formed part of the renovations carried out in 1863 during the governorship of Sir Bartle Frere. The elegant Gothic fountain at the west entrance was designed in England by the eminent architect Sir George Gilbert Scott and was donated by Sir Cowasji Jehangir. In 1906, electric lights were installed and a new choir stall and a bishop's throne and pulpit were added.

The cathedral contains fine stained glass windows and choice objects of worship including a silver chalice presented by Governor Gerald Aungier in 1675. It is also rich in monuments of historic interest such as a large, attractive medallion commemorating Katherine

22
Interior view of St Thomas'
Cathedral with punkahs.
By an unknown
photographer, 1870s.
Courtesy India Office Library
and Records (OIOC),
The British Library, London.

23
Memorial monument to The
Hon'ble Jonathan Duncan,
Governor of Bombay, 1795-
1811, by John Bacon the
Younger, 1817, in St Thomas'
Cathedral.
Photograph:
Bharath Ramamrutham,
1996.

Kirkpatrick (1800) by John Bacon the Younger, a
memorial to Stephen Babington, who revised the judicial
code, and a nostalgic memorial to Governor Jonathan
Duncan (1817) (figures 21 and 23).

Of the other important Anglican churches built in
Bombay such as St Andrew's or the Scottish Church on
Apollo Street, St Nicholas' Church on Frere Road, the
Wesleyan Methodist Church on Colaba Causeway,
St Mary's Church at Parel, and St Peter's in Mazagaon,

the Afghan or St John's Church at Colaba is one of the
most important in terms of its location, history, and
architecture.

The Afghan Church (figures 4, 24, and 25)

As early as 1665, the island of Colaba was utilized
as a cantonment area, although it soon in addition
became a popular centre for hunting for Europeans after
the East India Company released large herds of deer. Then
in 1779, barracks, officers' quarters, and a house of

24

St John's Church, Colaba.
By William Johnson, *circa*
1858.
Photograph, 20.3 x 25 cm.
Courtesy Farooq Issa, Phillips
Antiques, Mumbai.
This view of the Afghan
Memorial Church, seen here
before construction of the
spire, was published in
*The Indian Amateur's
Photographic Album* No. 17
in March 1858. The
description noted: "This
church, which was
consecrated last year by the
Bishop of Bombay...
commemorates our brave
countrymen connected with
this Presidency who fell in the
Afghan War of 1839-41. It is
a tasteful and commodious
building, in the Gothic style;
and it has been built partly
by subscription, and partly by
the liberality of the Indian
Government."

correction were built on the adjacent Old Woman's Island. In January 1824, the Bombay government wrote to the Company Directors in London to sanction a "place of worship for the numerous inhabitants of Colaba which must ever be an extensive Cantonment for European Troops". A temporary church was erected on Colaba Point at the entrance to Bombay harbour, possibly on or near the site of the Afghan Church. In a private letter, the wife of Bishop Heber recorded that her husband consecrated it in 1825.

Henry Moses, a visitor to Bombay, also made reference to this makeshift church in 1850. He noted that the Company had "erected on Colabah comfortable buildings... called the Sick Bungalows [now INS Asvini] enclosed in a spacious compound.... About half a mile to the south of the Sick Bungalows, and adjoining the parade ground is a neat little thatched chapel where the

English service is performed, but all who wish to avail themselves of it must bring their own chairs as it does not contain any seats."

Two years after the conquest of Kabul in 1842, Bishop Carr wrote to the authorities, "as the proposal to erect a church at Colaba in memory of those who had fallen in Afghanistan was under the consideration of the Honourable Directors I trust the want at Colaba will shortly be supplied." The temporary chapel was replaced by the imposing Afghan Church, built to commemorate the lives lost during the campaigns of Sind and Afghanistan from 1835 to 1843. The Company made land available for the church on condition that its steeple could be seen as a landmark from sea, to guide ships entering Bombay harbour. The plans were prepared by the City Engineer, Henry Conybeare, and construction began in 1847.

The construction of the church was a milestone in the history of ecclesiastical architecture in India. Until then, churches in the country were built in rubble and brick with a surface finish of smooth *chunam* or lime plaster. The Afghan Church was the first to be built with local stone — the walls of rubble with an exterior facing of coarse Kurla stone with coigns, arches, piers, and carvings in beige Porbunder stone. This use of stone set a new trend for church architecture in the country, not only in terms of its aesthetic quality but more importantly, because it required little maintenance in India's hot, humid, and rainy climate.

On July 7, 1858, Bishop Harding consecrated the Afghan Church, dedicated to St John the Evangelist and the old, temporary church became for a while the Garrison School. The elegant spire, still seen from far out at sea, was completed in 1865 and together with the tower, reaches a height of about 65 metres.

The Afghan Church, built in a simple, early English style, is set in spacious grounds neatly enclosed by a compound wall embellished with a wrought iron railing. The glow diffused through the fine stained glass windows lends an ethereal quality to the interiors. Inside, the eye is drawn to the high roof of varnished teak and at eye-level to an elegant metal screen standing at the second bay up the nave. The design for the screen was prepared by the renowned Victorian architect, William Butterfield, and was executed by students of the J. J. School of Art under the supervision of M. J. Higgins. Butterfield also designed the impressive Minton-tile paving and furnishings such as the wooden choir stalls, chancel furniture, and pews, some of which have been provided with slots as gun-rests.

It is interesting to note that the three churches described — Mount Mary's, St Thomas' and St John's — were originally built as garrison churches. All three continue to play an important role in the city's life. Mount Mary's is still visited by large numbers of worshippers of all creeds — a splendid example of faith transcending the bonds of religion. Although the number of parishioners at the Afghan Church has dwindled considerably over the years, efforts by concerned citizens are underway to restore and preserve the church. St Thomas' Cathedral, located in the heart of the commercial centre in the Fort area, continues to occupy a prominent status as the city's leading Anglican place of worship.

The commissioning of public commemorative monuments is rarely, if ever, merely an experiment in providing aesthetic pleasure. While it can be argued that bronze or marble effigies of the famous, living or dead, are tasteful elements meant to complement the architecture of a special space, they in fact represent more than that: they are manifestly political. Public monuments are a powerful means of articulating a specific representation of the ruling regime, one which embodies particular social and political aspirations. Beginning in the nineteenth century, statues erected in Bombay, whether by that most democratic of means, the public subscription, or those funded through the generosity of private benefaction, not only glorified the hero or commemorated a specific event, they also expressed a certain solidarity of the dominant elite. These symbols of allegiant nationalism, embodying the virtues of self-sacrifice and patriotic devotion, accentuate the desire of the British and their supporters to enhance the legitimacy of their reign. As such, the civic statues erected in Bombay provide a developing visual history of British rule as Bombay grew from a trading enclave into a major British imperial city.

Visualizing the Company Image

The Court of Directors of the East India Company were initially content with establishing peaceful trade relations with native rulers on the Indian subcontinent.

The decline of the Mughal Empire, rivalries amongst European colonial powers, and inter-regional conflicts between native rulers made it readily apparent to Company officials that they would require a military presence on the subcontinent in order to protect and expand their commercial interests. After defeating both native and French forces, and forming alliances with others, the Company's enterprise was extended to include economic, political, and moral dimensions by the first quarter of the eighteenth century. The reputation which the Company sought to project to the populace was that of a peaceful and prudent administration.

With this in mind, the first person whom the military

ART AND POLITICS: THE VISUALIZATION OF THE BOMBAY

MARY ANN STEGGLES

officers of the Bombay Presidency chose to glorify was Charles Cornwallis (1738-1805), Governor-General and Commander-in-Chief, 1786-93 and again for a brief period in 1805. Commissioned following Cornwallis' untimely death at Ghazipur in 1805, the white marble statue acknowledges the high regard in which Cornwallis was held by the East India Company. He was seen as a model of virtue whose public spirit drove him as an able

1

Unveiling ceremony of the statue (the "Kala Ghoda") of Albert Edward as the Prince of Wales by the Governor of Bombay, Sir Richard Temple, on June 26, 1879.
By William Simpson,
June 26, 1879.
Pencil and grey wash,
28 x 43.5 cm.
Courtesy The Mitchell Library, Glasgow.
William Simpson had accompanied the Prince of Wales during his tour of India in 1875-76. In June 1879, after visiting Afghanistan as official war artist, on a subsequent visit, he was in Bombay when this ceremony took place. This original drawing made at the time, was subsequently engraved in *The Illustrated London News* (1879) which reported: "The ceremony was performed by Sir Richard Temple, Governor of Bombay, in the presence of most of the principal European officials and other residents at Bombay, and the leading merchants and bankers, Jews, Christians, and Parsees. In the absence of Sir Albert Sassoon, his brother, Mr. Solomon David Sassoon, addressed the Governor, and invited him to unveil the statue.... The scene at the unveiling ceremony was of an interesting character, but its pleasantness was marred by a violent rain-storm during nearly the whole time. Our artist's sketch shows the statue when Sir Richard Temple had just cut the cord and let the curtain fall."

BRITISH IMPERIALISM IN PRESIDENCY 1800-1927

administrator free of the "Orientalizing" attitudes of his first predecessor, Warren Hastings (1772-1818), and more, as free of the over-zealous imperial military drive of his last predecessor, Richard Colley, 1st Marquess Wellesley (1760-1842). The statue symbolizes nothing less than the new image which the Company desired. Female allegorical figures of Prudence and Truth accompany the figure of Cornwallis, who extends the olive branch of peace in his

right hand (figure 2).

The statue, one of seven memorials intended to immortalize Cornwallis throughout the British Empire, cost five thousand guineas when completed in 1812.[1] The commission, like the administrative measures implemented by Cornwallis, was not without controversy. The local Bombay committee headed by Sir James Macintosh asked that the Committee of Taste select a sculptor and supervise

the commission in London.[2] Members of the Committee were determined that the statue should bring forward a visual association between the expanding British Empire in India and that of the Roman Empire.[3] The commission was given to John Bacon the Younger (1778-1859), who was asked on a number of occasions to alter his model to depict the figure in antique costume like the statues designed by his father for East India House in London (1798) and the recently erected figure in Calcutta (1808). Bacon disagreed and argued his case successfully in correspondence with the local committee in Bombay.[4] The figure of the former Governor-General wears contemporary military uniform under the robes and orders of the Governor-General's office. The marble image of Cornwallis was placed under an Ionic cupola symbolically elevating the man to an immortal. This device did not escape the minds of the local people

who were often seen offering puja to an image they hoped would help them when in difficulty with the police authorities.[5]

Ironically, it was military victory and imperial expansion which were celebrated in the second civic statue for Bombay, also by Bacon, completed in 1814. A female allegorical figure representing Victory crowns a triumphal soldier with a laurel wreath. A lion and lioness serve as enduring symbols of the British and their dominion for the heroic seated marble figure of Richard Colley, 1st Marquess Wellesley, Governor-General, 1798-1805 (figures 3 and 4). It was, in fact, a sweet victory for the Company, as British residents on the subcontinent quickly recognized. Troops under the command of Wellesley, a man known for his aggressive imperialism, ended all future threats by the French in India and established British dominion over much of the map.[6] Wellesley and his troops had succeeded in killing Tipu Sultan and his French allies, after which they annexed much of his territory to the extent that the Company controlled most of south India. The Maratha Confederation was defeated whilst at the same time any French involvement with the Nizam of Hyderabad was precluded by a series of manoeuvres including bringing the Nizam into a subsidiary alliance. While the British in India were celebrating their territorial expansion, the Court of Directors, not realizing the long-term benefits to their enterprise, seeing only the drain on their financial resources, were recalling Wellesley. This did not deter the efforts of the grateful merchants of Bombay, who subscribed £5,000 towards this statue in commemoration of his term as Governor-General.[7]

The Charter Act of 1793 coupled with the expansionist zeal of Wellesley established the East India Company as both the public administrator and military leader on the Indian subcontinent. Notwithstanding the need to further establish their dominion, the Company set about to project an image of their servants as capable statesmen, benevolent and learned adjudicators. Civic statues tended no longer to glorify military conquest but now alluded to peace and prosperity under the proud and stately Company administrator, firmly in command of governmental policy.

The rise of Sir Francis Chantrey, RA (1781-1841) as one of the most prestigious sculptors working in Britain did not escape the local committees of the British colonies.

4
General view of the statue of
Marquess Wellesley in its
orginal position outside the
Fort walls.
By Day and Son after a
drawing by William Simpson,
1862, from his *India Ancient
and Modern* (London, 1867),
plate 48.
Chromolithograph,
35 x 50 cm.
Courtesy India Office Library
and Records (OIOC), The
British Library, London.
The original position of the
statue was close to the
present-day site of Flora
Fountain. The original drawing
was made by Simpson while
he was in Bombay towards
the end of his first visit to the
subcontinent, 1859-62. In this
view, the outer Church Gate
and tower of St Thomas'
Cathedral appear in the
background, while Simpson
has also captured some
fascinating details of people in
the street.

WISDOM ENERGY INTEGRITY

MARQUIS OF WELLESLEY GOVERNOR GENERAL

W. Simpson 1863

5
(below)
The Honourable Mountstuart
Elphinstone (1779-1859).
By Sir Francis Chantrey,
completed in 1833.
Marble, height 2.1 m, on a
marble pedestal base.
Photograph courtesy
Mary Ann Steggles.
The statue was commissioned
for the Town Hall, where it
remains today.

6
(right)
Sir John Malcolm
(1769-1833).
By Sir Francis Chantrey, begun
1831, dated 1836.
Marble, height 2.1 m, on a
marble pedestal base.
Photograph courtesy
Mary Ann Steggles.
The statue was commissioned
for the Town Hall, where it
remains today.

Chantrey was commissioned on four separate occasions to immortalize the stately heroes of the burgeoning Indian Empire. The seated marble figure of Stephen Babington (1790-1822) successfully projects the image of the thoughtful judge, considerate of his deliberations. Funded by public subscription, the commission was supervised by Benjamin Babington, Esquire, in Britain.[8] Begun in 1824 and completed in 1827 at a cost of £1,400, the figure remains part of the collection of the Asiatic Society in Bombay, where it was originally placed.[9] Obviously pleased with Chantrey's ability to capture the stately essence of the individual, his workshop was immediately

called upon to execute the figure of the Honourable Mountstuart Elphinstone (1779-1859), Governor of Bombay, who retired from office and returned to England in 1827 (figure 5).

In the tradition of the times, the local subscription committee chose to have their interests in London represented by an agent. In this instance, the supervisory body was Messrs Baggott Calvin Crawford and Company.[10] The agreement which they signed with Chantrey on June 25, 1829 stipulated that the sculptor should complete the figure of the former Governor in the finest marble to stand no less than seventy-two inches within a three-year period.[11] The agreed fee of £2,000 was to include the cost of the pedestal and the packing and transportation of the work to the London docks.[12] The statue was completed in 1833, two years beyond the agreed-upon date specified in the contract.[13] The delay was attributed to a misunderstanding regarding the fee. On January 10, 1834 Chantrey was paid £2,100, with an additional £471.2.7 for extra expenses which he incurred with the packing and shipping.[14] A series of books carved behind the left leg of the figure allude to the learned nature of Elphinstone and his composition of *An Account of the kingdom of Caubul*. As was his custom, Chantrey exhibited the figure in the Summer Exhibition of the Royal Academy in 1833 before readying it for shipment to Bombay.

Concurrent with Chantrey's work on the figure of Elphinstone was another commission for Bombay which he received on July 23, 1831.[15] For this occasion Chantrey was requested to immortalize the governorship of Sir John Malcolm (1826-33). The local committee was headed by Sam Goodfellow and Thomas Carr, whilst the commission was supervised in London by Colonel Pasky of Chatham.[16] The heroic figure wearing military uniform cost £2,500 and was simply a variant of the figure of Malcolm which Chantrey completed for Westminster Abbey in 1837 (figure 6).[17]

The very last figure which Chantrey would execute for the city of Bombay (he died in 1841) was that of Sir Charles Forbes (1774-1849), head of Forbes and Company of Bombay. The statue aggrandizing Forbes' civic leadership was funded by a public subscription — this time by the "native" inhabitants of the city. When completed, the heroic marble figure which holds a scroll in the right hand cost £3,000.[18] All of the figures executed by Chantrey were placed in the Town Hall. All this created as it were a

7
Charles Norris (1791-1842). By William Theed the Younger, completed 1848. Marble, height 1.5 m. Photograph courtesy Mary Ann Steggles. The statue was commissioned for the Town Hall, where it remains today.

pantheon to the Company's able and learned administrators.

One of the last civic statues erected in Bombay prior to the transfer of the administration of the subcontinent to the British Crown was that to Charles Norris (1791-1842), Secretary to the Government, Member of Council, and Member of the Judicial Department (figure 7). Interestingly the sculptor, William Theed the Younger (1804-91), chose not to depict Norris in contemporary dress but reverted to the use of antique costume. The seated figure of Norris, who holds a scroll in the left hand, is heavily draped in a Roman toga. Whilst it can be argued that Theed (then

Prince of Wales' Statue (Bombay)

8
Equestrian statue of Albert Edward as Prince of Wales (later Edward VII), popularly known as the "Kala Ghoda" or "Black Horse".
By Sir Joseph Edgar Boehm, completed in 1878.
Bronze, height 5.1 m.
Photograph courtesy India Office Library and Records (OIOC), The British Library, London.
The statue was exhibited at the Royal Academy, London in 1878, and a model shown at the Exposition Universelle in Paris the same year. As shown in this photograph taken in the 1890s by W. W. Hooper, it was originally positioned at the junction of Esplanade Road and Rampart Row which is partly visible in the background (now the site of the car-park opposite the Army and Navy Stores building and the old Watson's Hotel). It is currently in the garden area inside the entrance gateway to the Victoria Gardens, now Jijamata Bhonsle Udyan in Byculla. Its original location is still known as "Kala Ghoda".

9
Statue of Queen Victoria under a neo-Gothic canopy.
By Matthew Noble, dated 1869.
Marble, height 2.5 m.
Photograph courtesy India Office Library and Records (OIOC), The British Library, London.
The statue was unveiled on April 29, 1872. It had originally been intended as a companion piece to Noble's statue of Prince Albert in the Victoria and Albert Museum (now the Bhau Daji Lad Museum). Because of its beauty, the community of Bombay decided that it should be more on public display in the open air, and it was therefore placed at the junction of Esplanade Road and Mayo Road, as seen in this early photograph. In August 1965 after the statue was vandalized, it was moved without its canopy to the grounds of the Bhau Daji Lad Museum. Its original location was known as "Queen's Statue" long after its removal.

resident in Rome) was greatly influenced by the works of antiquity which he studied in that city, the symbolic use of Roman dress on a judge in the Bombay Presidency is clearly meant to signify to all the rational and democratic character of the British when dealing with judicial matters.[19]

Dominion Secured: The Spirit and Grandeur of the Monarchy

The transfer of power in the Indian subcontinent from the East India Company to the British Crown was seen as a cause of great celebration. The Queen's proclamation of 1858 declared: "We hold ourselves bound to the natives of our Indian territories by the same obligations of duty which bind us to all our subjects." This declaration coupled with the recent democratic constitution granted to Canada symbolized new aspirations of democratic self-rule in the minds of educated Indians. To the British mind and their supporters, however, the proliferation of statues which graced all parts of the Indian subcontinent symbolized the Empire, its vitality and endurance. No statue of the Queen projects the spirit and the grandeur of the British monarchy more than the one erected at the junction of Esplanade Road and Mayo Road (figure 9). Funds for the statue by Matthew Noble (1817-76) were provided by Khande Rao, Gaekwad of Baroda, a loyal supporter of the British regime.[20] Unveiled on April 29, 1872 by Lord Northbrook, the figure under the colossal neo-Gothic canopy instantly became the focal point of the city.[21] The statue was originally intended as a companion piece to that of another member of the royal family, Albert, Prince Consort, also by Noble (see Dossal: figure 7).[22] The figure of the Prince Consort which was placed on the main floor of the newly opened Victoria and Albert Museum draws an association between the Prince Consort and his keen interest in the industrial arts.

In fact, the two female allegorical figures placed at the base of the inscription pedestal, Art and Science, symbolize the intended use the Victoria and Albert Museum was to serve — the promotion of the industrial arts in western India.[23]

Other civic leaders and members of the royal family would be immortalized in bronze and stone, but none would ever capture the youthful grace and vivacity of the Indian Empire as it was projected by the figure of Victoria Regina. Certainly the powerful image of Albert Edward as the Prince of Wales would come close (figures 1 and 8).[24] Known today as the "Kala Ghoda", the commission for the heroic bronze equestrian statue was originally given to Matthew Noble, sculptor of the figures of Queen Victoria and the Prince Consort.[25] Noble's untimely death caused

10
John, Lord Elphinstone
(1807-60).
By John Foley, completed in
1864.
Marble, height 2.1 m.
Photograph courtesy
Mary Ann Steggles.
The statue was commissioned
for the Town Hall where it
remains today.

11
Donald James Mackay,
11th Earl Reay (1839-1921).
By Sir Alfred Gilbert,
completed 1895.
Bronze, height 2.4 m, on a
tiled pedestal.
Photograph courtesy
Mary Ann Steggles.
This photograph shows the
statue in its present location in
the grounds of the J.J. School
of Art. It was originally
erected at the corner of the
Oval (Veer Nariman Road).

12
Sir Bartle Frere, Baronet
(1815-85).
By Thomas Woolner,
completed 1872.
Marble, height 2.1 m on a
marble pedestal base.
Photograph courtesy
Mary Ann Steggles.
The statue was commissioned
for the Town Hall where it
remains today.

the commission to be given to Sir Joseph Edgar Boehm, RA (1834-90).[26] Completed in 1878 and exhibited at both the Royal Academy Summer Exhibition and the Exposition Universelle in Paris, the statue celebrated the warm accord given to the Prince on his Royal Tour of November 1875.[27] Welcomed by crowded streets lined with triumphal arches reading, "Tell Mamma we're happy", the event would be one of the most well-received of royal visits in the history of British rule.[28]

The pedestal reliefs show the landing of the Prince at the Bombay docks and the presentation of prominent Bombay citizens to His Royal Highness by Lord Northbrook.[29] They included Sir Philip Wodehouse, Sir Bartle Frere, the Honourable Dossabhoy Framjee, Sir Mangaldas Nathubhai, Sir Albert Sassoon, the maharajas of Baroda, Mysore, Kolhapur, and Kutch, and Sir Salar Jung, Prime Minister to the Nizam, amongst others.[30] The opposite panel depicted Parsi girls presenting flowers at a fete held in the Prince's honour on the Esplanade.[31] It was clearly a high point in the history of the British in India. British dominion appeared secure.

Citizen Heroes

By the end of the nineteenth century demands for *Purna Swaraj* (total independence from British rule) were becoming more declared by the Congress Party.[32] The decline in British popularity did not, however, directly correspond to any decline of interest in subscribing for civic statues to the British within Bombay. After 1800, numerous works were funded to celebrate the selfless acts of certain individuals to make Bombay a better city for its citizens. They include the marble portrait statue of Dr Thomas Blaney (1823-1903) whose medical practice in the Mandvi area of Bombay extended almost to half a century. The statue commemorates Blaney's interest in environment and sanitation issues in the city as well as to his presidency of the Municipal Corporation.[33] A marble statue of Thomas Ormiston, Dean of the Faculty of Civil Engineering at the University of Bombay, recognizes Ormiston's tenure as Chief Engineer to the Bombay Port Trust and the construction of the Prince's Dock, the Sunk Rock Lighthouse, and other port developments in the harbour of Bombay.[34]

John Foley, RA (1818-74) completed the statue of John, Lord Elphinstone (1807-60) for the Town Hall in 1864. Funds for this heroic marble figure of the late Governor of Bombay (1853-59) were raised through a public subscription begun in 1860 (figure 10).[35] The stately figure of Sir Richard Temple, Governor of Bombay 1877-80, by the noted sculptor Sir Thomas Brock, RA (1847-1922) was originally erected at the north-east corner of the Oval in 1884[36] whilst Donald James Mackay, Lord Reay and Governor of Bombay 1885-90, was remembered in a bronze statue by Sir Alfred Gilbert, RA at the corner of the Oval (figure 11).[37] Thomas Woolner, RA (1852-92) executed the heroic marble standing figure of Sir Bartle Frere (1815-85), Governor of Bombay, for the Town Hall. Funds for the statue were raised through public subscription. In fact, Frere was a personal friend of Woolner whom he had met in 1868 and the statue is a

HARDINGE
OF PENSHURST
VICEROY AND
GOVERNOR
GENERAL
1910-1916

13

(*previous page*)
Lord Hardinge of Penshurst
(1858-84).
By Herbert Hampton,
completed 1920.
Bronze, approximately
lifesize.
Photograph *circa* 1920,
courtesy the Bhau Daji Lad
Museum, Mumbai.
The statue was originally
erected on a stone pedestal at
Apollo Bunder, on the left
promontory facing the
harbour, as shown here. It
was accompanied by two
female allegorical figures
symbolizing Peace and
Charity. These are now
separated but are located in
the grounds of the Victoria
Gardens (the Jijamata Bhonsle
Udyan). A bronze lion and
lioness were removed in 1990
to decorate the pedestal of
the Tilak monument at
Chowpatty.

result of numerous sittings made for Woolner during the same year (figure 12).[38]

Additional public statues include the marble seated figure of Secretary of State, Edwin Montagu,[39] the bronze portrait statue of the Prince of Wales commemorating the ground laying ceremonies of the Prince of Wales Museum,[40] the heroic marble figure of Lord Sydenham, Governor of Bombay from 1907 to 1913,[41] and the bronze portrait statue of Lord Hardinge of Penshurst, Viceroy from 1910 to 1916 (figure 13). The symbolism contained in this last civic statue is surely a projection of world events during Hardinge's period as Viceroy. Two female allegorical figures representing Peace and Charity stand alongside the traditional images of British dominion, the lion and lioness. At its onset, the First World War evoked a great show of loyalty to the British. Whilst the figure is a tribute to Hardinge, the sculptural group can also be read as a physical manifestation of the unity and hopes of the Indian troops who fought alongside the British in the European theatre of war. The seated female figure, Peace, whose arms caress a youth holding a dove, celebrates the end of the war; the second female figure, Charity, offers the hope of healing and compassion.[42] The symbolic nature of these images was paramount in the mind of the sculptor, Herbert Hampton, who worked on the figure during the later stages of the war. By the time the statue was unveiled (1920), there was a new truth to the British presence in India. Members of the Congress Party were calling for an end to British rule and the Muslims, as a result of the Sevres Treaty, were taking an aggressive anti-British stance after Britain and her allies had dissolved the Turkish Empire following World War I. British administrators responded with coercive measures known as the Rowlatt Acts, meant to counter what many British felt were increasingly revolutionary acts of conspiracy towards their rule. The implementation of these repressive acts resulted in what is today remembered as the Jallianwala Bagh Massacre at Amritsar in 1919. It was the beginning of the end of British rule in India.

A Final Tribute to British Rule

The Congress Party in Bombay was launching its most defiant demonstration during the visit by the Prince of Wales, and Muslims (once the loyal supporters of the British) were stepping up their anti-British stance. Even so, the leader of the Ismaili Muslim sect, H.H. Sir Sultan Muhammad Shah, the Aga Khan III, was ready to publicly display his loyalty to the British Crown by celebrating the controversial visit of the Prince of Wales in 1921 in the last British statue commissioned for Bombay.[43] Sir Leslie Wilson, whilst unveiling the bronze portrait statue of the

Prince of Wales in his naval uniform, stated that the work displays the soldierly bearing and, above all, the attractive personality so universally attributed to the future sovereign of the Empire....[44] The Aga Khan could not have avoided being aware of growing discontentment with the British in India. Still, communal violence between Hindus and Muslims may have accounted for the continuing support for the British by moderate Muslim leaders such as the Aga Khan. Like all unveiling ceremonies, the speakers took time, amongst much backslapping, not only to praise the merits of British rule but also to acknowledge publicly the great debt which the British owed the Aga Khan, "First Citizen of the World".[45] In expressed admiration of the Aga Khan, Lord Wilson stressed that "loyalty to the Crown is the cement of the Empire... and no one has done more to promote these feelings between various races and creeds than His Royal Highness... the Ambassador of Empire."[46] The Governor continued by adding that the statue would "not only... be an added ornament to the beauties of Bombay, but it will be a reminder, for all time, of the essential unity of the Empire...."[47] The statue was a "swan song" for both the British in India and for the relationship between the Aga Khan and the British. The Aga Khan would, ironically, realize four years later that whilst he bore the title of His Highness, the British would refuse to provide this faithful servant with an estate of land which would allow him to exercise his full privileges.[48] To add what might be seen as further humiliation, the statue was removed from its site when the Prince of Wales, now King Edward VIII, abdicated.[49]

In summary, between 1812 and 1927 the commissioning of these and the other civic statues for Bombay provided a developing visual history of Britain and her Indian Empire, "the Jewel in the Crown". From the outset the virtue and heroism symbolized in these public statues was intended to instil public emulation and patriotic enthusiasm for British reign. With the passing of the new Government of India Act (1935), it was no longer necessary for the British to seek new recruits to their cause for dominion. British authority in administration, economics, and politics was retreating. Fifty years after Independence many of these public commemorative monuments have been displaced to other sites, marking the end of an empire. Effigies of India's new heroes take their place signifying the beginning of a new epoch in the history of the Indian subcontinent.

Notes

1. See A. Cox-Johnson, "A Gentleman's Agreement", *Burlington Magazine* (1959), pp. 239-40. Bacon the Younger had, in fact, completed the statue for Calcutta following the design of his father for a similar figure funded by the Court of Directors of the East India Company. Evidence indicated that it might well have been Samuel Manning,

Bacon's assistant, who completed the figure for Bombay. The statue was exhibited at the Summer Exhibition of the Royal Academy in both 1810 (882) and 1811 (924). The other statues include the marble standing figure for Madras (1800, Banks); the heroic marble group for St Paul's Cathedral, London (1808, Rossi); the marble funerary memorial for St George's Church, Pulau Pinang (1823, Flaxman).

2. See J. Bacon, A letter to the Rt. Hon. Sir Robert Peel Bart, MP on the *Appointment of a Commission for Promoting the Cultivation and Improvement of the Fine Arts, with Some suggestions respecting a former commission, denominated, "The Committee of Taste"*, London, 1843, pp. 14-15. See also PRO (Kew) E/BN/24, E/BN/27.

3. The Grand Tour and writings by such notables as Anthony Ashley, 7th Lord Shaftesbury and Jonathan Richardson promoted the idea that the British were the rightful inheritors of the Roman Empire.

4. Ibid.

5. See C. Mackenzie, *Sunshine and Storm of a Soldier's Life*, London, 1848, entry for January 10, 1848. I am grateful to Theon Wilkinson for bringing this publication to my attention. See also O.Valladares, "Shadows of the Past. Tracing the fate of Bombay's magnificent, old statues", *Taj Magazine*, 1st quarterly issue (1985), pp. 34-35.

6. For a thorough discussion of Wellesley's military achievements, see R. C. Majumdar, H. C. Raychaudhuri, and K. Datta, *An Advanced History of India*, Bombay: Macmillan, 1978, pp. 691-707.

7. A. Cox-Johnson, p. 242. Bacon the Younger also completed the statue of Wellesley for Calcutta in 1809. The Calcutta commission was supervised by the Council of the Royal Academy.

8. See the Chantrey Accounts held at the Royal Academy, London.

9. Ibid.

10. Ibid.

11. Ibid.

12. Ibid.

13. There is a related drawing in the Ashmolean Museum, Oxford University and a marble bust in the collection of the Victoria and Albert Museum, London.

14. See Chantrey Accounts, Royal Academy, London.

15. Ibid.

16. Ibid.

17. Ibid. See also R. Pasley, *"Send Malcolm!" The Life of Major-General Sir John Malcolm 1769-1833*, London, 1982, pp. 177-78.

18. See Chantrey Accounts, Royal Academy, London. There is a related drawing of Forbes in the National Portrait Gallery, London, numbered 316a (49). There is another drawing in the collection of the Ashmolean, Oxford University.

19. The statue is signed Opus W. Theed, Roma, 1848. The work was exhibited at the Summer Exhibition of the Royal Academy, London, in 1849 (1228).

20. The cost of the statue and canopy was £15,500. See *Art Journal* (February 1867), p. 40; *Bombay Gazette* (March 27, 1869), p. 1; *The Builder* (July 17, 1869), pp. 566-67; *Art Journal* (April 1870), p. 126; and *The Times of India* (April 30, 1872), p. 3; Sir George Birdwood, Secretary of the Victoria Museum and Gardens Committee as well as for the Agricultural and Horticultural Society, was instrumental in securing the commission for Noble.
See E. Darby, "Statues of Queen Victoria and Prince Albert. A Study in Commemorative and Portrait Statuary, 1837-1924", unpublished PhD thesis, Courtauld Institute of Art, London, 1986, pp. 298-300.

21. Ibid.

22. The statue costing £3,000 was funded by Albert Sassoon. See *Art Journal* (August 1870), p. 245; *The Builder* (August 6, 1870), p. 623; *The Illustrated London News* (November 26, 1870), p. 552; I. S. Jackson, *The Sassoons*, London, 1968, pp. 40-41; and E. Darby, pp. 296-97. The figure was exhibited at the South Kensington Museum in 1870 and is a variant of the statues which Noble executed for Salford in 1865 and for Manchester in 1867.

23. It was, in fact, the Prince Consort who initiated the Great Exhibition of 1851 at the Crystal Palace which promoted the union of art and science in the form of industrial arts manufacture.

24. The statue was commissioned by Albert Sassoon in 1876 at a cost of £10,000. See Jackson, p. 56. See also *Art Journal* (1879), p. 243; *The Illustrated London News* (July 12, 1879), np; and M. Stocker, *Royalist and Realist: The Life and Work of Sir Joseph Edgar Boehm*, New York and London, 1988, pp. 101-02.

25. Stocker, p. 101.

26. Ibid., pp. 101-02.

27. Ibid.

28. See William Howard Russell, *The Prince of Wales' Tour*, London, 1877. I am grateful to Sharada Dwivedi for drawing this publication to my attention in correspondence dated May 23, 1994.

29. Ibid.

30. Ibid.

31. Ibid.

32. Demands for self-rule began during the nineteenth century. The British response was postponed due in part to World War I. The 1928 Congress Session declared an all-out effort for independence.

33. The statue was completed by C. B. Villa, an Italian sculptor practising in London, in 1893. The marble bust which formed the study for this statue is now in the collection of the Municipal Corporation.

34. The statue was completed in Glasgow in 1855 by John Mossman of the Scottish Royal Academy. Funds for the statue were raised through a public subscription. When completed, it was placed on the grounds of Bombay University where it still stands.

35. See *Art Journal* (1863), p. 39. The marble bust that formed the study for the statue is in the collection of the Bhau Daji Lad Museum, Mumbai.

36. The statue was completed in 1884. Funds for the statue were raised through a public subscription. A related drawing is in the Prints and Drawings Collection of the Victoria and Albert Museum, London. The statue was placed in the Old Town Hall. See also *The Illustrated London News* (February 6, 1886), p. 128.

37. See M. H. Spielman, *British Sculpture, and Sculptors of Today*, London, 1901, p. 79; I. McAllister, *Alfred Gilbert*, London, 1929, p. 163; and R. Dorment, *Alfred Gilbert*, New Haven and London, 1985, p. 108. The statue was cast at Broad and Son, London.

38. See A. Woolner, *Thomas Woolner, RA, Sculptor and Poet. His life in Letters* (London, 1979), pp. 289, 340-41. A marble bust which formed the study for the completed statue was exhibited at the Summer Exhibition of the Royal Academy in 1868 (item 1001). The completed work was exhibited, also at the Summer Exhibition of the Royal Academy, in 1872 (item 1513). A marble bust dated 1869 is in the collection of the Library, Bombay University. The statue was unveiled in Bombay in 1872.

39. This statue completed by S. Riccardi in 1925 is a variant of one executed by the same sculptor for Jamnagar. I am grateful to S. K. Pande for bringing the Jamnagar statue to my attention in correspondence dated December 7, 1992.

40. The statue was executed by George Wade who completed a number of monarchial statues for the British Empire which include the figures of Queen Victoria for Allahabad and Colombo; of King George V for Madras; as well as several other civic works of art dedicated to native citizens such as the figure of the first native judge for the Madras Presidency, Muthuswamy Iyer for Madras.

41. The statue, executed by Sir Thomas Brock, RA and completed in 1919, was placed inside the entrance to the Royal Institute of Science. The statue honours the insights of Baron Sydenham of Gomte who originally proposed the idea of establishing such an institute. The foundation stone was laid in 1911 but construction delays due to World War I postponed the formal opening of the Institute until 1920. A public appeal for funds to build the Institute was established by Sydenham. Contributors such as Sir Jacob Sassoon, Sir Currimbhoy Ebrahim, Sir Cowasji Jehangir, Sir Vasanji Tricumji Muljhi were amongst prominent citizens who contributed over Rs 28 lakhs for its construction. I am grateful to Sharada Dwivedi for providing much of this information in correspondence dated May 23, 1994.

42. The two female allegorical groups are now situated in separate locations within the grounds of the Jijamata Bhonsle Udyan in Bombay. Originally a bronze lion and lioness stood next to the statue of Hardinge. They were removed in 1990 by the orders of Mr Tinaikar, Municipal Commissioner, to decorate the pedestal of the Lokmanya Bal Gangadhar Tilak monument at Chowpatty. The portrait statue is a variant of another civic statue completed by Hampton for Patna in 1916. I am indebted to Foy Nissen and the staff of the Bhau Daji Lad Museum and the Jijamata Bhonsle Udyan for so graciously showing this monument to me during a visit in April 1992.

43. See *The Bombay Chronicle* (December 21, 1927), p. 7 and *The Times of India* (December 23, 1927), p. 12. I am grateful to Foy Nissen for providing transcriptions of these articles in correspondence dated May 31, 1994. "H.H.Sultan Muhammad Shah al-Husayni, The Aga Khan III: Patron of British Sculptors" was the subject of a paper presented by the author at the University Art Association of Canada annual conference, November 1994, Halifax, Canada. For accounts related to the services of the Aga Khan III to the British and his subsequent efforts to receive a portion of land in order to take full advantage of his title, see H. J. Greenwall, *His Highness The Aga Khan, Imam of the Ismailis* (London, 1952); S. Jackson, *The Aga Khan: Prince, Prophet and Sportsman* (London, nd); H. H. The Aga Khan, *The Memoirs of the Aga Khan: World Enough and Time* (New York, 1954).

44. Wilson quoted in *The Times of India* (December 21, 1927), p. 12. The headline reads: "Symbol of the Unity of the British Empire, Statue of Prince of Wales in Bombay. Sir Leslie Wilson Performs the Unveiling Ceremony."

45. Ibid.

46. Ibid.

47. Ibid.

48. For his services to the British during World War I, the Aga Khan was accorded the status of a first-class ruling prince of the Bombay Presidency in 1916. See *Memoirs*, pp. 131-47.

49. The only known extant statue of the Duke of Windsor is the bronze by Mario Rutelli for Old College, Aberystwyth, Wales, completed in 1922.

Known today as the Bhau Daji Lad Museum, the Bombay City Museum, or simply as Rani Bagh, the Victoria and Albert Museum and the Botanical Gardens of the Agri-Horticultural Society of Western India, in which it was situated, belong distinctly to the Victorian Age. This era was also termed the "Age of Improvement".[1] The concept of *improvement* was central to the ethos of the nineteenth century, and many would have nodded approvingly when the Reverend William Carey declared in Calcutta in 1820, at the time of the founding of the parent Agri-Horticultural Society, that "... there is nothing human which does not admit of improvement."[2]

The Age was characterized by a fulsome admiration of science and an unclouded belief that scientific endeavour would inevitably lead to progress and profit. For the British in India, the spread of science and the dissemination of Christianity were to be the surest ways to bring about betterment in both the moral and material world.

Within this scheme of things, museums and botanical gardens were to be developed, not merely to house exhibits but to play an important interactive role as "colleges of inquiry" — as against simply "colleges of reading". Or, as Governor Bartle Frere explained, they were not to be "mere collections of rarities and curiosities at which crowds may gaze in vacant and resultless astonishment, [but rather where] the student will read not through the imperfect medium of language or in books, but in the very products themselves, visibly placed before him, the history, as far as the human eye can trace it, of each wondrous process and product of Nature."[3] This was indeed a tall order.

Gardens of the Agri-Horticultural Society of Western India

In 1830, ten years after the Agricultural and Horticultural Society of Bengal was founded, a branch society was set up in Bombay to promote commercial agriculture, improve agricultural techniques, and introduce new crops into western India. In 1835, the Society purchased land at Sewri which was laid out by Colonel Thomas Dickinson and Dr J. F. Heddle with the assistance

THE "HALL OF
THE "GARDEN OF

MARIAM DOSSAL

of a Scottish gardener, Mr McCullock. McCullock having been earlier employed by Pasha Mehmet Ali of Egypt was able to effect an exchange of a large number of Egyptian plants with those from western India and thereby expand the collection of the Botanical Gardens.[4]

By 1842, the garden at Sewri was properly laid out (figure 2). Dr George Buist and Dr F. Giraud, joint secretaries of the Agri-Horticultural Society, contributed a great deal to its development. While Buist looked after the general arrangements, Giraud developed the botanical section. But the site proved to be too far from the town to encourage large numbers of visitors. It was therefore proposed that the gardens be relocated at a more suitable

WONDER" WITHIN DELIGHT"

1
Upper floor of the Bhau Daji
Lad Museum, Byculla.
Photograph :
Bharath Ramamrutham, 1996.
The iron work, the engraved
glass, and richly coloured
Minton tiles for the flooring
were all made in England and
specially transported to
Bombay. These features also
reflect the taste of the
founders and designers of the
Museum.

site closer to both the European and "Native" quarters and the Sewri land be converted into a new burial ground for Europeans, for which there was great need.

In return for the Sewri premises, the Bombay Government offered the Agri-Horticultural Society of Western India alternative land at Mount Estate, Byculla, on condition that the Society amalgamate with the newly formed Museum Committee to form the Victoria Museum and Gardens. The land was situated on the east side of Parel Road, a few yards north of the new Byculla station[5] (figure 3). This was finally done on May 21, 1861. Since the properties included in the Mount Estate were not contiguous, the Society was permitted to exchange certain plots with others not in their possession, and thereby to make the gardens as manageable and unified as possible. After some resistance by the landholders who were reluctant to exchange their land for plots that the Society had in its possession, the deals were finalized within a year. Land from Bomanjee Framjee Cama's Sindulpara estate lying within the plan of the Botanical Gardens was one such plot acquired in these exchange transactions.[6]

The First Museum Collection

The origins of the Victoria and Albert Museum itself may be traced back to 1848 when a proposal was put forward for setting up a museum in Bombay. However, nothing came of it until a large number of exhibits were acquired from different parts of the Presidency for display at the International Exhibition to be held in Paris in 1855. Various exhibition committees set up in the districts of the Bombay Presidency were requested by government to send duplicates of specimens of both raw materials and manufactured articles for display in a museum in Bombay.

These exhibits constituted the initial holdings of an Economic Museum which was founded on September 6, 1855 and housed in some of the rooms of the Town Barracks within the Fort.[7]

The museum owed much to the efforts of Dr George Buist, who had for long advocated its cause. Editor of *The Bombay Times* and Secretary of the Bombay Geographical Society, Buist was among the foremost men of learning in his day. When the Government Central Museum (the name given to the Economic Museum) was set up in 1855, Dr Buist's services were recognized and he was appointed its first Curator and Secretary. Other members of the Museum Committee included Dr E. Impey (President), Dr Fraser, Dr Sinclair, and Reverend W. F. Hunter. As Governor Lord Elphinstone explained, the aim was to set up "a Central Museum of Natural History and an Economic Museum of Geology, of Industry and of the Arts with the special object of developing the resources of western India".[8] Research was not intended for research's sake but for the promotion of trade, production, and profit.

Tales of anguish and delight are often woven into the story of institutions and construction of buildings. They bear witness to the conflicts, passion, and inordinate effort of individuals who made things happen; in short, to the human drama which took place around them. The story of the Government Central Museum was no different. Serious differences between Dr Buist and his colleagues in the Museum Committee surfaced within a short space of time. Buist's commitment to the cause of science, whether it be in the field of geology, meteorology, agriculture, or museology was undisputed, and the energy and drive which he brought to his work could rarely be matched. Impatient with those who did not feel as strongly as he did, he took his colleagues to task for delays in the work, and censured them on grounds of lethargy and disinterestedness. In his view, they did not recognize the great public role that museums in general, and the Government Central Museum in particular, were intended to play. Offended, they in turn accused him of high-handedness and of carelessness in arranging and maintaining the exhibits; most importantly they refused to forgive him for taking the controversy into

the open by publishing it in the newspapers.[9] The acrimonious debates between the two parties are richly documented, opening a window into the intrigues of nineteenth-century Bombay and an opportunity to understand these men and their times.

Buist resigned as curator on November 5, 1856 and was succeeded by Dr Fraser. But the contradictions remained. Only motivated individuals brought to institution-building the zeal and commitment required and provided them with vision and direction. It was this that could save institutions from the inherent inertia and the yet-another-government-department syndrome. But it is these very qualities that made it difficult for them to work with others, often to their own and the institution's loss. The contradiction would continue to bedevil museums and

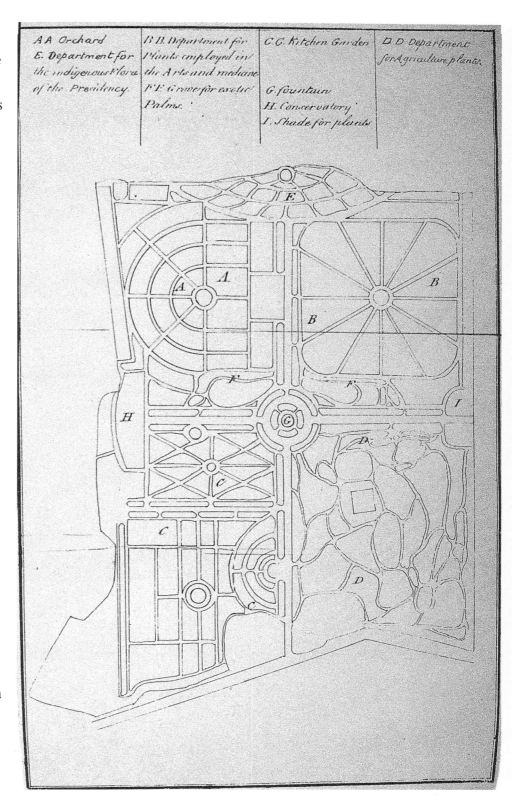

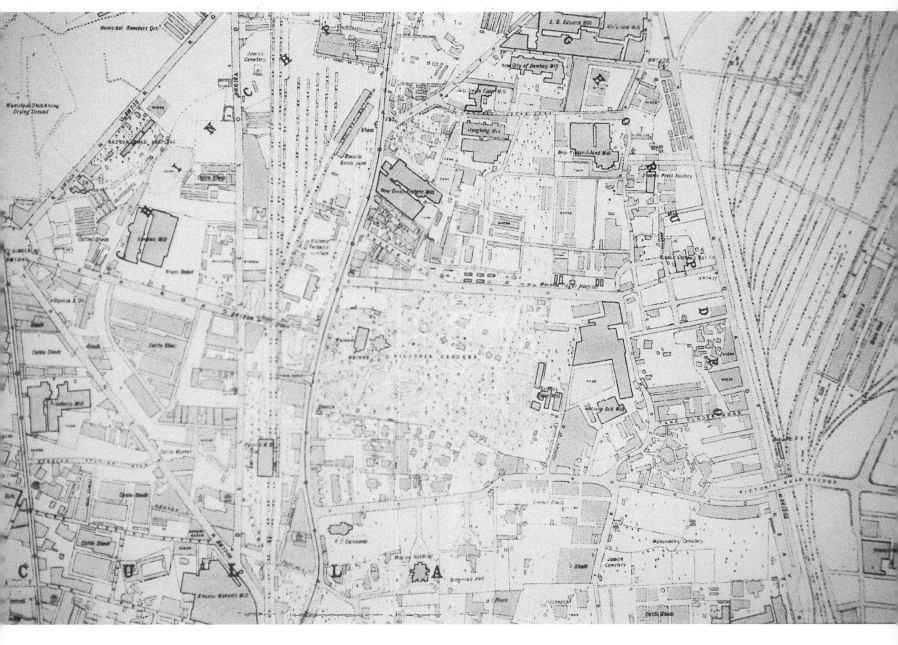

3
Detail of the Bombay City Survey Map showing the Victoria Gardens and Museum in 1914-18.

2
(facing page)
Proposed plan of the Society's Garden at Sewri, 1836. From the garden committee's report titled *The Agricultural and Horticultural Society's Garden. M.DCCC.XXXI.*
The key to the garden identifies separate areas for use as an orchard, kitchen garden, for the cultivation of "Plants employed in the Arts and medicine" and "the indigenous Flora of the Presidency". It also includes a fountain in the centre and a conservatory.
"The society's ground is situated immediately at the foot of the Parell flag-staff hill. Besides possessing a beautiful and extensive prospect, it enjoys all the advantages of a good soil...." (Report, p. 4).

a number of other public projects for a long time to come.

The exhibits suffered no better fate than the curator. When rebellion broke out in north India in April 1857, the Town Barracks were peremptorily requisitioned by the Brigadier-General to house British troops arriving in Bombay on their way to Calcutta. The Museum Committee was ordered to vacate its rooms within twenty-four hours. Coolies who were given the task of removing exhibits, wrote S. M. Edwardes, "threw most of them out of the windows onto the street", thereby destroying a large portion of the exhibits. The office records also suffered. The collection, or such as remained of it, was then housed in the Town Hall, until its final transfer to the Victoria and Albert Museum in 1872.[10]

The Victoria and Albert Museum (figures 4-8)

On November 19, 1862, some four years after the Queen's Proclamation was read out from the steps of the Town Hall by Lord Elphinstone (November 1, 1858), construction work on a new Museum building was started. The Museum was to commemorate the transfer of power from the English East India Company to the British Crown,

and serve as an expression of loyalty of Bombay's merchants to the new Raj. In the words of Jugonnath Sunkersett, President of the Museum Committee, it was to be a tribute "worthy of the august and good sovereign who wielded the sceptre of the mightiest and most beneficent empire the globe has ever bowed beneath".[11] In her honour and that of the Royal Consort, it was named the Victoria and Albert Museum. Along with the gardens in which it was located, it was popularly referred to as Rani Bagh (Queen's Garden). This was finally declared open to the public on May 2, 1872 by the Governor of Bombay, Sir William Fitzgerald (figure 6).

Funded by Bombay's leading citizens, prominent among whom were Sethias such as Jagannath and Vinayakrao Sunkersett, Mangaldas Nathoobhoy, Rustomjee Jeejeebhoy, and David Sassoon, the Museum was to display a collection of Indian and Eastern economic products, organize periodical exhibitions of the manufactures of the country, and conduct original research in Indian and Eastern natural history. Dr George Birdwood, its first Curator, envisaged so much work being carried out under

its auspices, that he believed it would be necessary to have specialist curators working in tandem. Thus, "a botanical curator will identify and verify the sources of the vegetable productions of the East; a chemical curator will give the analyses of its different productions and a geological and zoological curator in their turn will apply their special knowledge similarly to the same great end."[12]

The Museum building was to be located at Byculla within the grounds (over thirty-three acres) which were being developed by the Agri-Horticultural Society of Western India as Botanical Gardens. Thus, like the Society, the Museum had a history which went back to the second quarter of the nineteenth century. Meanwhile in late July 1862, Birdwood wrote in his report that plants were being transferred from the Sewri garden and that work had begun on laying and planting the Victoria Gardens. William Tracey, architect of the Museum building, also prepared

plans for the gardens and was assisted by George Wilkins Terry, Superintendent of the Jamsetjee Jeejeebhoy School of Art.[13] Water for the gardens was promised free of cost by the Bombay Municipality and was to be obtained from the recently completed Vihar Water Works.

Money for the Victoria Museum and Gardens was expected to come from donations from the public-spirited citizens of Bombay, many of whom were flush with profits from the cotton trade. The American Civil War (1861-65) and the non-availability of American cotton to feed the machines of Lancashire had created a great demand for cotton from western India. However, when individuals were approached by George Birdwood and Dr Bhau Daji Lad (medical practitioner and leading citizen of Bombay) to contribute liberally to the worthy cause of the Museum and Botanical Gardens, they found that the need for neither was understood by the persons they approached. It was only when the curiosity of Indians was aroused, they said, by references to the Museum and its surroundings as the "Hall of Wonder" and the "Garden of Delight", did people come forward with the sums required. Fantasy and wonderment rather than scientific inquiry was believed to be the hallmark of Indians. Given such a situation, Birdwood believed that the curator had an important educative role to play. It was he who would provide the vital interaction between the audience and the objects on display.[14]

4
Entrance gateway to the Victoria Gardens and Zoo (now the Jijamata Bhonsle Udyan), Byculla.
Photograph:
Bharath Ramamrutham, 1996.
This Italianate gateway of Porbunder stone with its Corinthian columns and decorative terracotta panels, like other architectural features in the grounds, harmonizes with the design of the Museum. Several such features, along with designs for the Museum, were published in volumes of *The Bombay Builder* between 1865 and 1867. The actual gardens were planned by George Birdwood, one of the founders of the Museum, and subsequently refurbished by Rienzi Walton, executive engineer to the municipality.

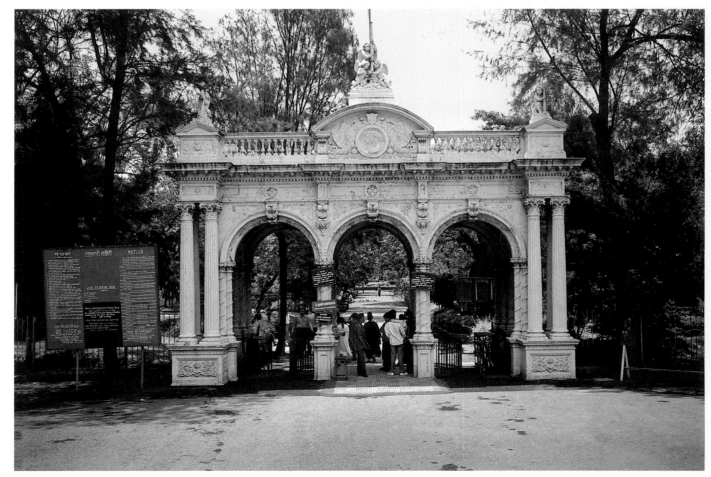

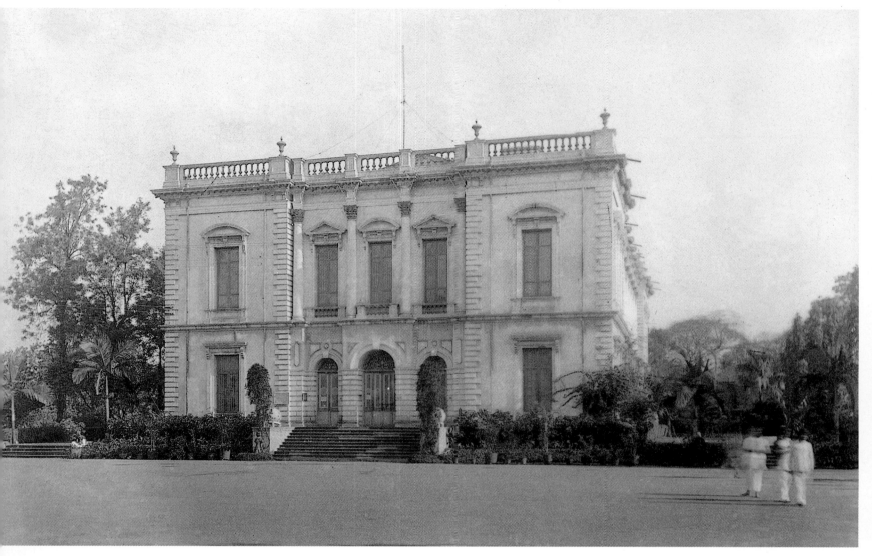

5
Entrance facade of the
Victoria and Albert Museum,
now the Bhau Daji Lad
Museum.
Photograph courtesy the Bhau
Daji Lad Museum, Mumbai.
This elegant, symmetrical
structure in the style of the
Italian Renaissance was
originally designed by
William Tracey (1831-64), and
continued after his death by
the partnership firm of Scott
and McClelland.

**Architectural Details of the Museum Building and
Other Structures (figures 1 and 9)**

The foundation stone of the Victoria and Albert
Museum was laid by Governor Sir Bartle Frere on
November 19, 1862 and the same day the Gardens were
opened by Lady Frere. The building was located on the left
of the main entrance to the gardens. It was built in stone in
the Palladian style and was 172 feet long, 84 feet broad,
and 47 feet high, except at the corners where it rose to 66
feet. It consisted of two storeys except the corners which
consisted of three. Originally designed by William Tracey,
Municipal Engineer, the designs were altered after his death
by Messrs. Scott, McClelland and Co. who took charge of
the work. The gardens, apart from displaying rare tropical
flora and fauna were to be adorned with "ornamental
borders, fountains, temples, statues, and a clocktower
sixty-five feet high".[15] Work on both the museum and
gardens was begun in 1862 and carried on simultaneously.

Started during the heyday of economic buoyancy and
optimism, the Victoria and Albert Museum, like other
public works projects in Bombay, received a major setback
when cotton prices crashed after the end of the American
Civil War in mid-1865. *The Bombay Builder* which was
closely monitoring the progress of these projects, reported
on the state of the museum and garden buildings in

September 1865 when economic dislocation in the city
began to be felt: "The Victoria Museum and the Sassoon
Clock Tower are nearly completed, and a handsome
triumphal arch at the entrance to the avenue has just been
commenced. Of Lady Frere's temple, just finished, we give
an illustration.... It is a canopy for the bust of Lady Frere by
Noble and takes the general form of the familiar circular
Greek temples. It is thirty-five feet high and of Porbunder
stone, the six columns are Corinthian but unfluted."[16] But
much remained to be done.

One cannot help being struck by the frequent
references to Greek temples and Roman triumphal arches,
to building principles and architectural details drawing the
mainspring of their inspiration from ancient Greece and
imperial Rome. Keen to assert British authority in western
India, these buildings and structures were clearly to be
statements of power in stone. To do this most effectively,
British imperialism sought to trace its lineage to the
grandest of civilizations.

Speaking of the "triumphal arch", *The Bombay Builder*
noted that it was under construction and situated at the
entrance to the broad walk, in a line with Sassoon Clock
Tower. This ornamental gateway was intended to serve as a
barrier beyond which no carriages could pass into the
gardens. Regarding its architectural style, it added: "The

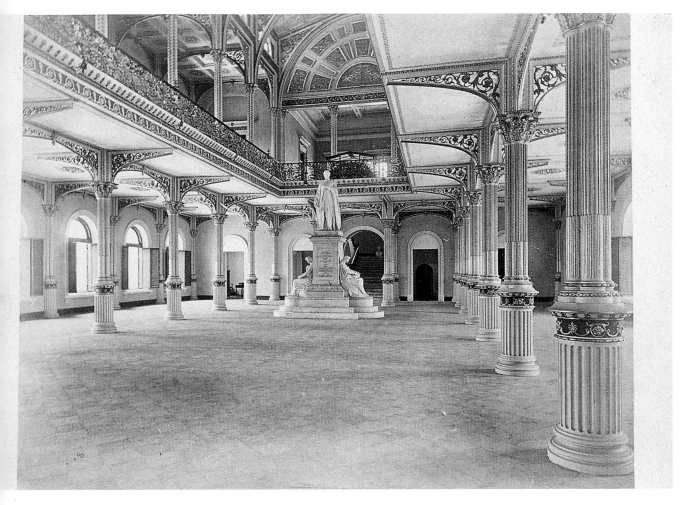

6
Interior of the Victoria and Albert Museum.
Photograph by David H. Sykes & Co., 1872.
Courtesy India Office Library and Records (OIOC), The British Library, London.
The photograph was taken in the same year that the Museum was declared open to the public, but before any exhibits were displayed. The statue of Prince Albert, Consort of Queen Victoria, by Matthew Noble dominates the ground floor of the spacious interior with its load-bearing, cast-iron columns. Following the opening, *The Times of India* reported on May 4, 1872: "The first impression a visitor is likely to receive on entering the hall, is that of gorgeousness. At first glance the interior appears to be one mass of gold and crimson and blue and green.... The fluted iron pillars which support the gallery are painted first indigo blue, then crimson; these are richly gilt along the shaft, then more paint, and then an equally rich gilt Corinthian capital.... The ornamental iron palisades round the gallery are chocolate and gold."

main portion is to be of Porbunder stone, while the caps to pillars, the ornamental panels, spandrils of arches, plinths and friezes are in Terra Cotta casting. This portion of the work is undertaken by Mr. Blashfield at his factory, Stamford, Lincolnshire. The way in which the Terra Cotta work hitherto received, has been executed gives promise of a high order of art in the remainder. In plan the building consists of three arched bays, and there is a continuous arch crossing these from end to end. It will have in reality the appearance of a stone vaulting supported upon slender clustered stone columns flanked at the four angles by coupled Corinthian columns, by which the requisite strength is attained for the corner piers: and the general effect is very light and graceful. The caps to the Corinthian columns are modelled on the original in the temple of Jupiter Status. The central portion will be occupied by a Medallion in carved stone of the Prince and Princess of Wales. This and the cupids above and at the angles are being sculptured by the London sculptor, Mr. Forsythe, in Portland stone." The lamps too were to be "of a highly ornamental character and will be lighted with Gas".[17]

Indigent Circumstances

In spite of the brave front being put up by all those concerned that work on the Museum and Botanical Gardens would go on uninterrupted during the period of great economic dislocation, the problems just could not be wished away. The Agri-Horticultural Society was the first to

be seriously affected. Unable to obtain finances for the gardens' maintenance it turned to the Bombay Municipality for aid. With little money coming in and members themselves preoccupied with staving off insolvency, and debt rampant everywhere, the Society ceased to exist in 1873.

The Victoria Gardens were handed over by the government to the Bombay Municipal Corporation which from then took on the responsibility of maintaining it as a public garden. Subsequently fifteen acres were added to the original thirty-three acres and a zoo set up which included animals such as llamas, emus, kangaroos, black panthers, and Himalayan black bears, as well as exotic birds from different countries.[18]

The Rani Bagh with its zoo holds special memories for every child who has grown up in Bombay. It is associated with school and family outings, a haven of greenery in an increasingly built-up and congested environment. What was lost in the process however was the unabashed faith and enthusiasm for scientific inquiry and research, for scientific institutions such as the botanical gardens which were expected to transform the material and moral world of the Indians.

As far as the Victoria and Albert Museum was concerned, the drying up of public subscriptions as a result of the recession posed acute problems and seriously affected the construction of the building. More than Rs 2,08,000

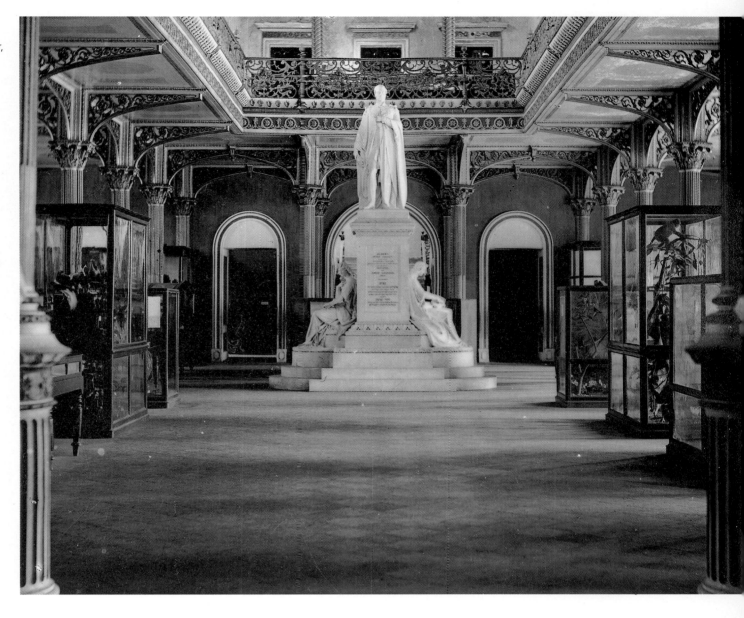

had been spent on it by late 1866 when work stopped and it was feared that left incomplete it would fall into ruin unless immediate steps were taken to secure it from further damage. Only Rs 60,000 had been promised in further subscriptions and even that was not to be paid for some time to come. There was no money to pay the architects and faults in the structure aggravated the problems. *The Bombay Builder* urged the city's "leading native citizens to come forward liberally in support of an undertaking, the failure of which would so much detract from the honour of Bombay, and more especially so from that of the native community."[19] No matter the cajoling, the problems continued.

Finally, the Bombay government was forced to step in and see to the completion of the work. It was to be done at the least expense possible with the minimum of furnishing ornament. It was hoped that once prosperity returned to Bombay, citizens would redeem their pledges and embellish it with the appropriate grandeur which was unthinkable in those straitened times.

Money however was not the only malady to afflict the Museum. The spirit itself was found wanting. When thieves broke into the Museum building on the night of June 25, 1876 they forced open the locked cases easily and decamped with valuable items, including a large silver coffee pot of Kutchi work, a heavy silver model of a Mohammedan tomb, several articles of "Koftgari" work, an inlaid silver sword hilt, a dagger with gold-plated sheath, and three gold-embroidered cummerbunds.[20] The response of the authorities was revealing. Instead of taking every precaution to ensure that such an incident would never recur, Dr W. Gray, Curator of the Museum, informed the authorities that "no extraordinary or special arrangements have ever been made for protecting the Museum at night, the presence of the garden Ramosee (watchman) being

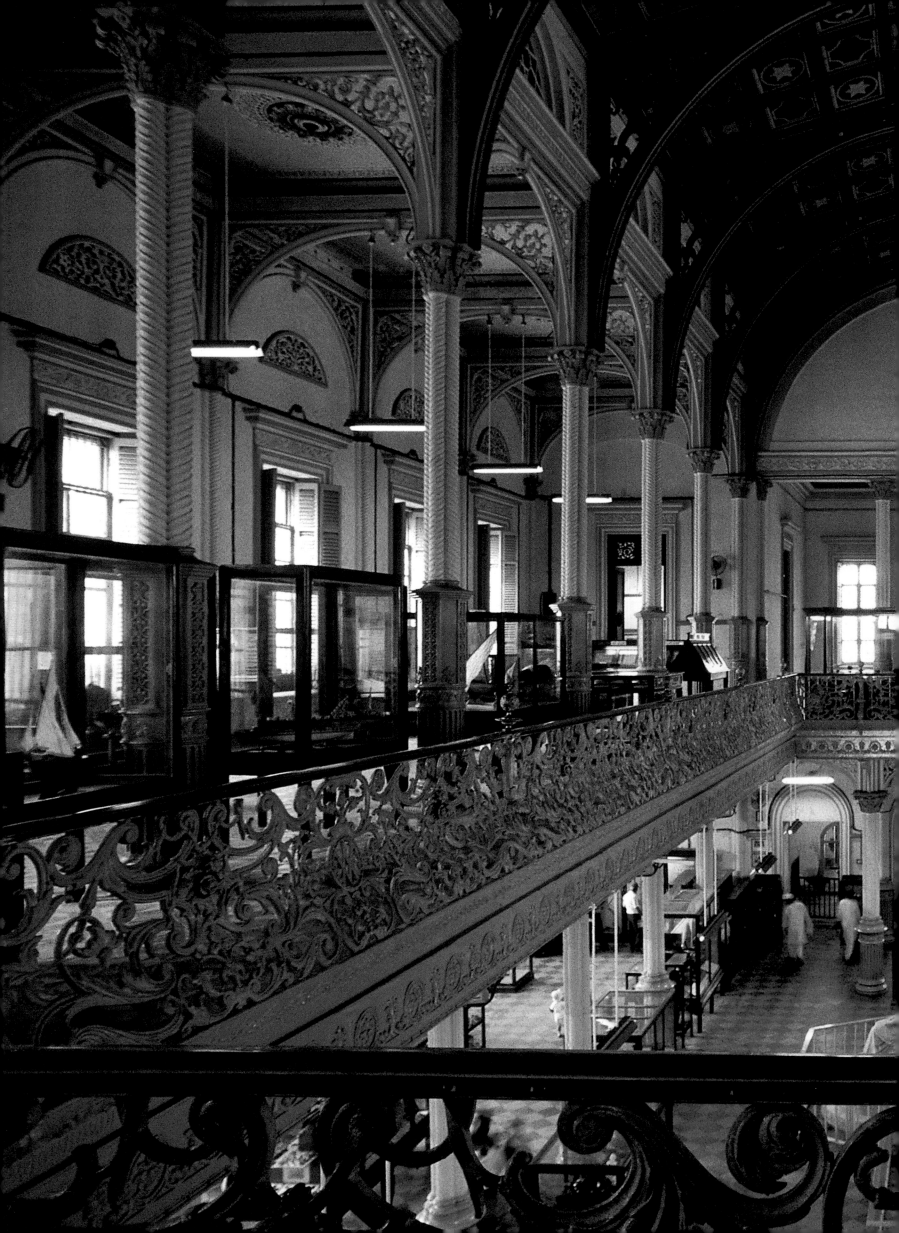

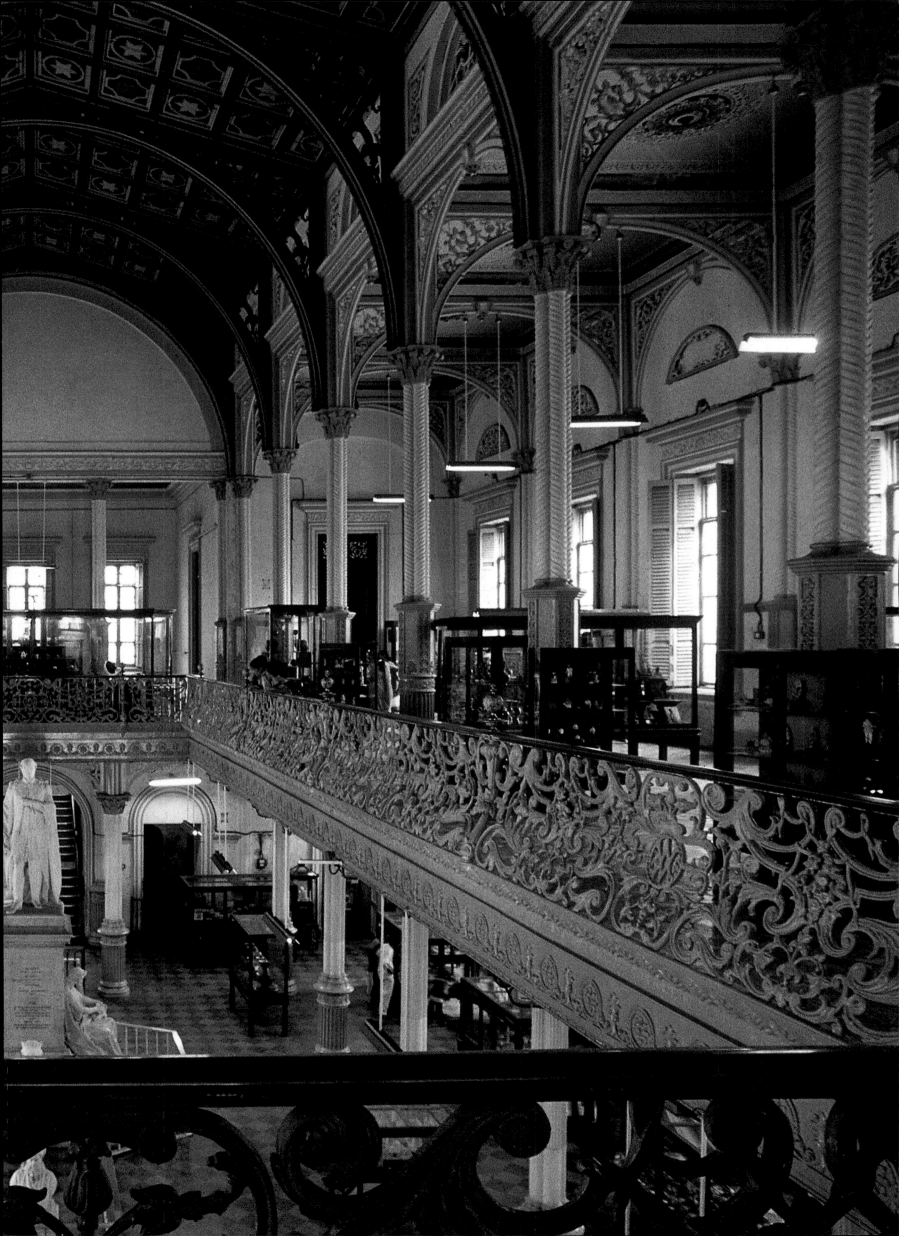

always considered sufficient".[21] No additional protection was requested.

More significant was the Government Resolution which was passed. It stated that "Government agree with the Commissioner of Police that there is no need to take any special steps for the further protection of the Museum other than requiring the Mazagon Divisional Police to examine the building during the night rounds."[22] Little remained of the passion and enthusiasm that men like Dr George Buist had brought to the Museum, little remained of the idea of what museums and botanical gardens were to stand for or what they were intended to accomplish. Now there was little left to distinguish them from any other well or not so well managed government department.

May 2, 1997 marked the 125th anniversary of the Bhau Daji Lad Museum. Today, its varied exhibits range from fine arts in the form of Indian miniatures, paintings, prints, and sculptures to cottage industries and ethnological artifacts in metal, wood, and ivory from many parts of the country, textiles and carpets, and a fine collection of small figurative models showing aspects of village life, costumes of Indian men and women, religious types, and people playing musical instruments. It also has exhibits of fossils and minerals, Indian armoury and coins, and a rich collection of photographs and other items relating to the history and development of Bombay. Like the Museum, each exhibit has a story of its own.

While its founders might have been gratified to observe today's stream of visitors examining the treasures in the galleries, they would undoubtedly have urged that museums have to play a much more dynamic role, need their exhibits to be well displayed, and require adequate resources if they are to succeed in kindling intellectual curiosity and provide important visual education.

Notes
1. Asa Briggs, *Victorian Cities,* Penguin Books, Middlesex, 1968, p. 80.
2. Rev. William Carey, "Prospectus of an Agricultural and Horticultural Society in India", in *Transactions of the Agricultural and Horticultural Society of India,* Vol. 1, Appendix, Calcutta, 1824, p. 216.
3. Governor Sir Henry Edward Bartle Frere cited in George Birdwood, M.D., *Report on the Government Central Museum and on the Agricultural and Horticultural Society of Western India for 1863,* Education Society's Press, Bombay, 1864, p. 53.
4. Birdwood, op. cit., p.56.
5. S. M. Edwardes, *Gazetteer of Bombay City and Island (GBCI),* Vol III, 1910, p. 336.
6. Birdwood, op. cit., p. 74.
7. Government Memo, Maharashtra State Archives (hereafter MSA), General Department (hereafter GD), Vol. 73, 1856, nd., p. 143.
8. Precis of the History of the Government Central Museum, MSA, GD, Vol. 43, 1871, c. September 10, 1871, p. 322. Times of India Press, Bombay, 1910, pp. 379-80.
9. MSA, GD, Vol. 74, 1856.
10. *GBCI,* Vol. III, pp. 379-80.
11. Excerpt from Speech by Jagannath Sunkersett, Chairman of the Victoria and Albert Museum and Gardens Committee, cited in Mariam Dossal, *Imperial Designs and Indian Realities. The Planning of Bombay City 1845-1875,* Oxford University Press, Bombay, 1991, p. 58.
12. Birdwood, op. cit., p. 4.
13. Ibid., p. 57.
14. Ibid., p. 64.
15. Ibid., p. 3.
16. *The Bombay Builder,* Vol. I, No. 3, September 5, 1865, p. 49.
17. *The Bombay Builder,* Vol. I, No. 7, January 5, 1866, p. 142.
18. *GBCI,* Vol. III, p. 377.
19. *The Bombay Builder,* Vol. II, No. 6, December 5, 1866, p. 117.
20. MSA, GD, Vol. 67, 1876, Dr W. Gray, Curator, Victoria and Albert Museum, to Chief Secretary, Bombay Government, Bombay, June 26, 1876, pp. 249-50.
21. Ibid., Dr W. Gray to Chief Secretary, Bombay, July 15, 1876, pp. 259-60.
22. Ibid., p. 269.

9
Interior of the Bhau Daji Lad
Museum.
Photograph:
Bharath Ramamrutham, 1996.

"It is man's nature to change his dialect from century to century.... " — Thomas Carlyle

This essay attempts to assemble an album of images of Bombay, using cotton and cinema as the "cameras" to register changes from the nineteenth-century "cottonopolis" of British India to the post-industrial metropolis of today. Inevitably this album will be partial, but the hope is that it will still throw some new light on the old city as it recycles itself once again.

The first economic and social recycling, so the historians tell us, took place between 1850 and 1900, when Bombay town became an industrialized port city — newly energized by the advent of steam shipping, the coming of the railways, and the opening of the Suez Canal. This was the period when the foundations of the city's fabric that is popularly perceived as quintessential Bombay, were laid out, linking Bombay with the mainland. The docks, the godowns, the railtracks and roads formed the most important elements of this fabric's infrastructure. A major episode in the recycling was the removal of the Fort's walls, because the growing port town could no longer be contained within its confines. The trade in cotton — its collection from the mainland, its ginning and bundling into giant bales at Cotton Green, and loading onto ships for export to Britain and elsewhere was almost the *raison d'etre* of this first recycling.

Midway through those fifty formative and turbulent years, enough cotton spinning mills sprang up in the city not only to add yarn to the export list along with raw cotton, but also gradually to provide cloth for the local market. The 1870s saw a mill boom in Bombay: at the beginning of the decade the city had 18 mills; by 1875 there were 36, and by 1880 their number had risen to 42. By this time, cotton textile manufacture had become the largest industry in India, employing over 40,000 mill-workers, most of whom were in Bombay. The labour-intensive nature of mill work, and the steady growth in the number of mills over subsequent decades led to the creation of a substantial industrial working-class. This class provided the concentration of human resources and the newly found sense of political power needed for the mass nationalist movement that grew from the 1920s until independence.

Thus, when a city changes its dialect, as it did by becoming India's "cottonopolis" evolving from its earlier status as a small trading station, much more happens than a mere increase in the scale and nature of trade. The city's entire rhythm, its demographic composition, its structural form, its culture, and its politics also change. After the gradual demise of the "cottonopolis" another change of dialect took place.

BOMBAY-THE NOW

NARENDRA PANJWANI

The Mill, the Chawl, and Girangaon as a Way of Life (figures 1-5)

By the 1890s, Bombay had become India's major port, a leading commercial and financial centre, the largest cotton market in Asia, and a nodal junction for the nation's cotton piece-goods trade. Simultaneously, it had also become a factory town — the largest centre of India's most important cotton industry, which alone employed twenty-five per cent of the city's labour force. Taking a wide-angle view, the mill between 1865 and 1965 can be seen as the city's focal point. As a result of the introduction of the railways, the cotton-producing farms of the hinterland were linked with the docks, where

शक्तीराज प्रेशर कुकर
• आशा स्टील सेंटर •
स्टेनलेसस्टील, तांबा, पितळ भांड्याचे व्यापारी.

OF THEN

1
A view of the Lalbagh market in Parel — the migrant worker's bazaar. Its choice of goods speaks of the mill-workers' rural connections.

whole armies of coolies and handlers, largely from rural Maharashtra, waited to load the ships. The piece-goods market at Kalbadevi attracted not only competing groups of Gujarati traders as distributors who decided the products' price and destination to various parts of India, but also workers who manned the mills' spinning and weaving machines. They dominated Bombay's labour force by their sheer numbers, and formed a new political and cultural entity, a new force in the city. Little wonder then that the cotton mill, being the city's economic powerhouse, was so large and spacious.

This rough sketch of the various interwoven strands of social and economic life does not include the army of

tailors employed by many of the large mills to make readymade clothes of their fabric, filling the shelves of the mills' own retail outlets. Nor does it include the story of the migrants who came over in thousands on the cotton trains to Bombay from its growing hinterland. Many of these rural folk did so to escape oppression and inequality, others came just to explore new options, and stayed on.

If you walked down the road from the mill to the workers' chawl nearby, you came upon another world, which was an important, colourful part of Bombay's history. But first a jolt for today's harried commuter who spends at least one hour on the journey from home to work. The chawl was and still is within walking distance of the mill compound. This kind of proximity was mainly because Bombay's mills developed during the period before major railway construction took place, and long before any bus service existed. Another striking characteristic of the chawl was its similarity to a small village. Transplanted to the metropolis, the chawl was still a village in the degree of intimacy between neighbours.

2
View of a Bombay chawl.
Photograph: Rahul Mehrotra,
1986.
Typically a three- to four-
storeyed structure organized
around an open quadrangle,
the chawl was a village in
spirit. Not all chawls were
multi-storeyed —
improvization and
optimization of available
space was the essence of the
mill-worker's relationship with
the city.

3
View of chimney stack at
Parel — the mill area in
Bombay. This cotton mill's
chimney stack stands alone.
At one time these stacks
dominated Girangaon. Now
they look out of place.

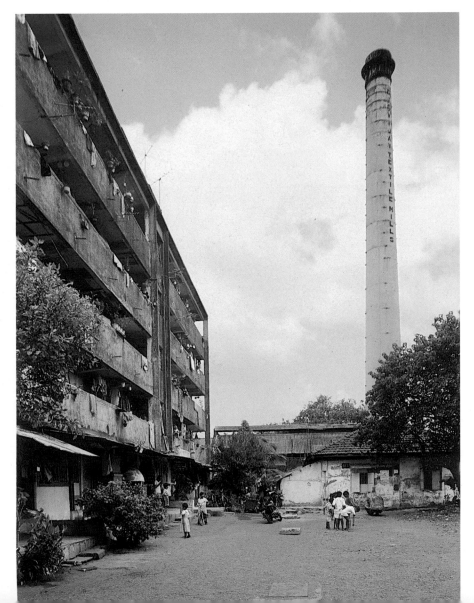

4
The Parel mill area. It is easy
to understand, looking at this
image for instance, that the
displacement of mills will
leave a hole in Bombay's
transforming landscape.
Nothing will compensate for
these lost icons.

5
View of shop at Lalbagh
market in Parel. Form is often
more important than content.
The rustic form in which
these sacks of red chillies are
displayed in the Lalbagh
market serves, subconsciously,
to make the Girangaon
resident feel at home.

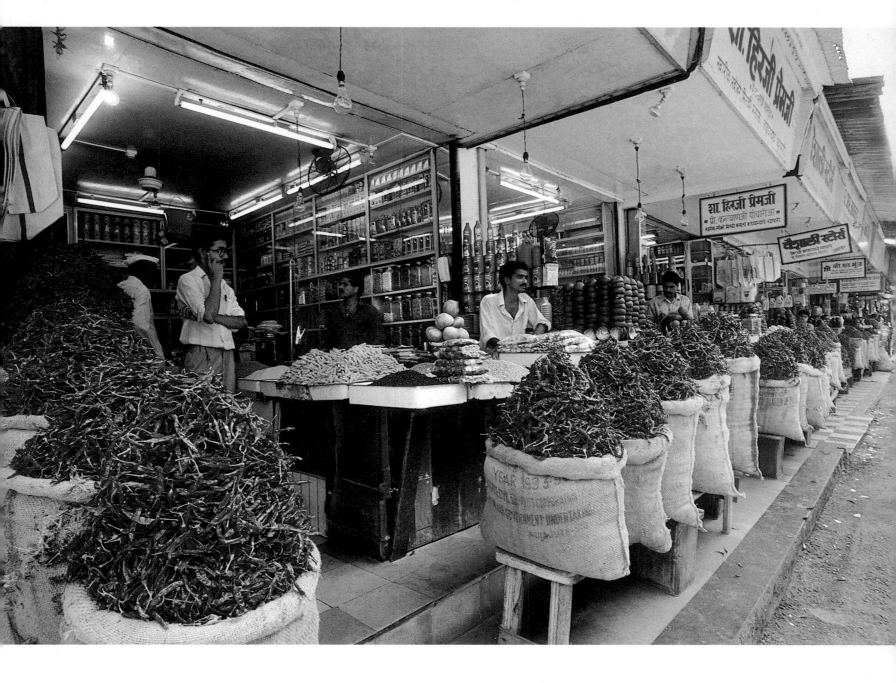

6
View of the Opera House — since the dilapidated, decaying Opera House structure still dominates this area, shouldn't it be given a new lease of life? It clearly refuses to go away. Theatres like Regal, Eros, and Metro have been revived recently; Opera House still seems to be looking for its saviour.

7
Bandra's New Talkies building gives way — under the hammer of the city's new dialect. This was where the teenagers of Bandra in the 1960s and '70s achieved a kind of nirvana watching Elvis Presley and Cliff Richard movies. *Jailhouse Rock* and *Come September* — that's what it was about.

Among ethnically compatible people, it was reminiscent of their native village lifestyle in the Konkan region, from where many of the families originated. Instead of a cluster of huts as in the village, the chawl consists of multi-storey, wooden houses, which accommodate extended families in one room, thus making each such house as populous as a village abode. Sometimes groups of men share a room, their families remaining at home in their village.

As part of this environment, the noted Lalbagh market developed into a major landmark of proletarian Bombay as a result of the surrounding concentration of mills and chawls in that area. It became the heart of Bombay's mill villages, which collectively were known as Girangaon. Its large maidans and parks became increasingly popular as social meeting places and recreation grounds for the workers and their families.

The first thing that strikes you about Lalbagh market is its rural colour, a quality absent in the other city markets: here one finds shops selling rustic lanterns, metal trunks, and colourful cow-bells of various sizes as gifts for the family's neighbours — articles which the migrant worker might take home on his periodic visits to the village, or things which villagers on a casual visit to the city might wish to purchase.

Significantly, this market was and still is located within walking distance between Lalbagh's cluster of mills and chawls, which made it an integral part of the Lalbagh way of life, although time and a quantum leap in vehicular traffic with its flyovers have taken their toll. While such ethnic markets, like the textile mills themselves, are fighting a losing battle against Bombay's new taste for boutiques, supermarkets, lavish jewellery shops, discotheques, video libraries, and smart restaurants, it is not the only one of its kind. The Tamil-dominated South Indian market around the Matunga East railway station has, for instance, created a "mini Tamil Nadu" in the middle-class heart of central Bombay.

Two features, however, made the Lalbagh market special: firstly, its choice of goods, services, and ethnic ambience, by which the mill-worker is associated with the countryside; secondly, its proximity not only to the mills

and chawls, but also to the playgrounds, maidans, hospitals, temples, theatres, and local cinemas. These together gradually turned the mill villages of Girangaon into a small town insulated from, yet integrated with, the larger city beyond. Today, although much of it still survives, Girangaon as a way of life is threatened. Many of the mills have closed down, especially after the great mill-workers' strike in 1982, following which nearly 60,000 once-proud mill-workers lost their jobs over twelve years or so. They have been replaced by a new middle class employed in advertising agencies, computer software, and the general communications industry. Their offices are slowly developing literally over the "graves" of the former cotton mills — the Phoenix Mills compound in Lower Parel being a striking example of this trend.

Unlike the workers, however, these new entrants do not live in Girangaon. They commute to it mainly from the northern suburbs. Meanwhile, Girangaon still remains largely proletarian in its residential aspect, while the textile mill is now just one of several industries in the city with a past more than a future.

Memories of Another Matinee (figures 6 and 7)

Once upon a time, cinemas dotted the cityscape — a vital, sometimes even gracious part of Bombay's cultural life. But times and habits change, bringing about environmental changes too. Many of our film theatres for instance, the old "talkies", or picture halls, once major city landmarks with a special aura of sentiment have now become shopping or office complexes. These picture halls in their mixture of colonial, Art Deco, and post-War architectural styles are icons of the past. At one time the large celluloid screen and names like Opera House, Metro, Regal, New Talkies, Majestic, Citylight, Eros, Naaz, Hindmata, and Imperial, were synonymous with show business and with Bombay's cosmopolitan cultural character. This is perhaps why those that do survive continue to be landmarks familiar to most inhabitants and to many visitors to the city.

Such is the cultural dialectic between Bombay's century-old icons and its inhabitants that physical survival is not always necessary for a building or monument to remain a landmark. Although the Majestic Cinema in the heart of Girgaum, for instance, was demolished many years ago and has now been replaced by a particularly ugly, multi-storeyed office building, the site is still popularly known as "Majestic". Another landmark which has shown even greater staying power in the downtown area, is the non-existent "Kala Ghoda" (Black Horse) which still defines the junction where the equestrian statue of King Edward stood until 1965 (see

Steggles: figure 8). Kala Ghoda, incidentally, was never its official name but like the cinemas and other landmarks, it has long been synonymous with the area.

Coming back to the picture halls, their very names evoke another era, resonant of the British Raj in the twentieth century's first half, of the first stirrings of Indian nationalism, and the early years of Indian cinema. Theatres born in the mid-1960s and later, have no such airs, carrying names with a distinctly different sound like Gaiety, Galaxy, Ganga, Jamuna, Chandan, and Satyam.

Another reason for their landmark status is the aura left behind by the formative influence of the films they showed on the city's collective imagination, its self-image: films like *Mother India, Aawara, Shree 420, CID, Pyaasa, Naya Daur, Aan, For Whom the Bell Tolls,* the Nadia films. These films have now attained mythical status in the popular imagination; little wonder then that some of that has rubbed off on the cinema halls themselves where people thronged in the 1940s and '50s to watch them again and again.

The gradual demise of many of the city's cinemas is often a long-drawn process. The land market and economic change will always prevail — as they always have in Bombay. Land uses and land values have changed dramatically over the last thirty years. Along with a quantum leap in Bombay's population, the land

on which the cinemas, the studios, and the cotton mills
stand has given way to new businesses — hotels,
restaurants, shopping complexes, banks, and offices —
which pay much more to occupy the same space.

Of the twenty-six film-making studios in Bombay at
the beginning of 1980, only fifteen are still functioning,
the other eleven having closed down in the period 1982-
92. "One by one, the builders have lured studio-owners
into selling their plots. Instead of dream factories there are
ugly residential plots, or worse still, grimy industrial
estates" (*The Saturday Times*, February 17, 1990). Even
prior to 1980, however, one can find reports of a few
studios closing down.

In Bombay, you need a sense of the present as much
as a sense of the past. The road on which Natraj and
Mohan studios are located (Saki Naka, off the Western
Express Highway, north-east of Andheri) is today one of
the busiest arteries of industrial Bombay. This change was
decreed in order to "relocate" new factories from 1970
onwards along a corridor starting from this "studio belt"
in Andheri East and stretching northwards to Ghatkopar
and Mulund. The government's decision to make this area
the city's new industrial zone was taken in the late '60s in
order to decongest the island where the concentration of
cotton mills had created an excessively congested town.

In short, the direction in which the city was set from
1970 onwards entailed a major change in both landuse
and the demographic character of this north-eastern area.
Once again, the ground on which these studios (like other
icons of old Bombay) stood had been pulled from under
their feet. They just do not belong there anymore.

Elegy for the Irani Restaurant (figures 8 and 9)

Finally let us shift our icon-seeking camera away
from public places such as the cinemas and markets, to
the individual on the street — the inhabitant as much as
the visitor to Bombay. Modes of communication between
individuals created social norms that produced another
unique icon of the metropolis in the form of the Irani
restaurant. Except among the rich in their palatial houses,
meetings between individuals generally took place outside
the home — often on the balcony or verandah of the

house, or in the adjoining courtyard. Away from home,
the Irani restaurant became a most popular and
convenient place to meet for the majority of Bombayites.
These old-fashioned tea-shops were Bombay's equivalent
of the coffee-houses in Calcutta or Delhi. They sprang up
as a result of the immigration of Iranis into Bombay in the
1920s and '30s. You could spend hours chatting with friends
for the price of a cup of tea or even ruminate like a loafer,
on flies and cats as you sat alone watching the world go
by. Although still offering low-priced menus, these "cases
of musty tranquillity in the city's frenetic life", as Gillian
Tindall described them, are gradually disappearing
from our cityscape. Nevertheless the restaurant's once
all-important function deserves notice, before the
inevitable final lament at its passing takes place.

Facilitated by the "open house" atmosphere, many
of its clients would indulge in cosmopolitan
gregariousness. Others if they so wished could just as
easily be alone in public, and in this sense the Irani
restaurants were reminiscent of *fin de siecle* coffee-houses
in Vienna, about which the little-known writer, Alfred
Polgar wrote: "The Cafe Central lies on the Viennese
degree of latitude at the meridian of loneliness. Its
inhabitants are mostly people whose misanthropy is as
violent as their need for other people, who want to be
alone, but for this purpose need human company." We
are thus reminded that obvious appearances can be
misleading, and the poem "Irani Restaurant Bombay" by
Arun Kolatkar makes a similar observation:

"the cockeyed shah of iran watches the cake
decompose carefully in the cracked showcase;
distracted only by a fly on the make
as it finds in a loafer's wrist an operational base....
an instant of mirrors turns the tables on space.
while promoting darkness under the chair, the cat
in its two timing sleep dreams evenly and knows
dreaming as an administrative problem...."

Among the most famous and popular Irani
restaurants was one inside Alice Building on Hornby Road
(now D. N. Road), which burnt down along with the
building in the early '70s; another, the Cafe Royal near
the Regal Cinema, has recently been jazzed up with an
entirely new "Hollywood" decor replacing its former
character. One that still survives in its old format is
situated at the corner of the Esplanade Mansion (formerly
Watson's Hotel). Even its location was special. Its close
proximity to the Fort University campus, Elphinstone
College, the Sassoon Library, the Jehangir Art Gallery, and
the various law courts provided a ready clientele. Now
since the street-corner "Iranis" have been largely replaced

by the fast-food "Udipi" restaurants with their laminated decor and narrow seats, the desire to linger has gone. They no longer provide a haven of peace from the frenzy outside, forming instead an extension of the busy Bombay street. One is also unlikely to find Arun Kolatkar there.

The twentieth century's approaching end has brought in its train another change of dialect in Bombay. So much so that we will soon begin thinking of industrial Bombay as old Bombay. We mean here the industries which shaped suburban Bombay from the 1960s onwards. For the city has now entered a post-industrial phase, which looks all set to make Bombay the financial node cum "head office" of the national economy.

The city's latest stars are young bankers, computer whiz-kids, financial analysts, media executives, and event managers. The filmstars of yesteryear — from Raj Kapoor to Amitabh Bachchan — have now been replaced by Amitabh Bachchan Corporation Ltd. (ABCL) and other such corporations.

Once again, the city's album of icons is set to change....

Figure Acknowledgements
All photographs by Bharath Ramamrutham, unless otherwise noted.

PART III

MAKING AN URBAN

LANDSCAPE

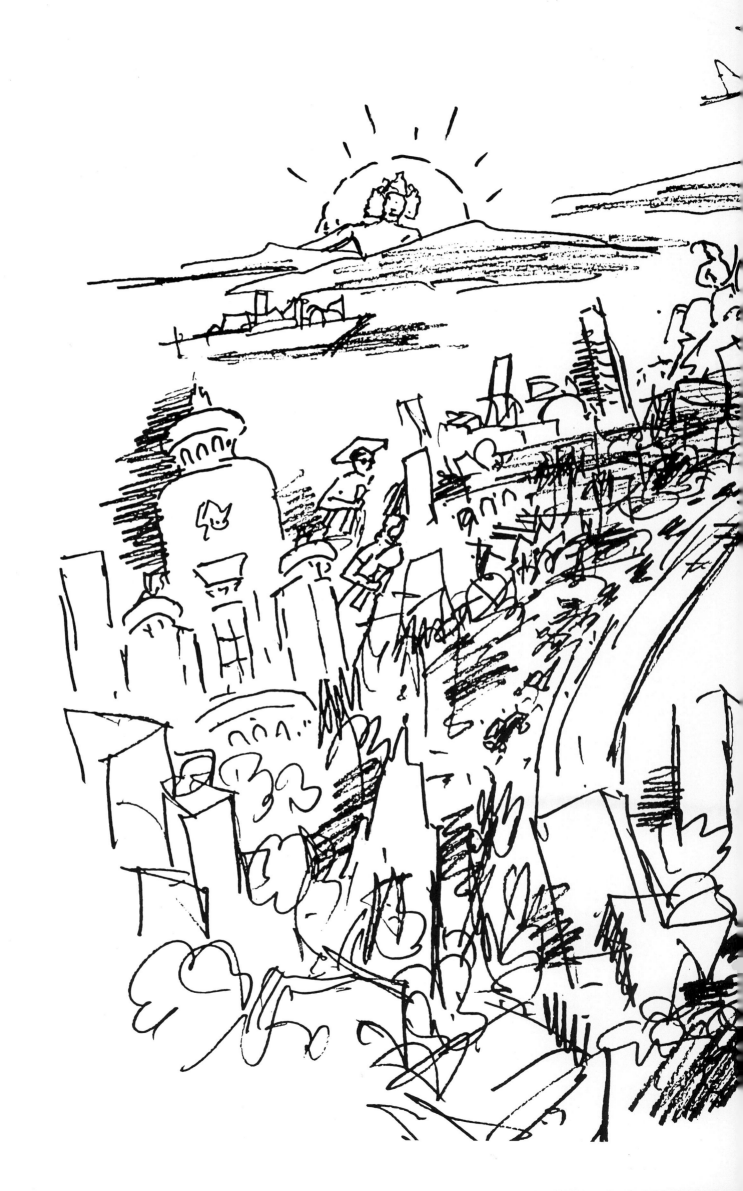

M. F. Husain's view of
Back Bay from Malabar Hill,
1997.

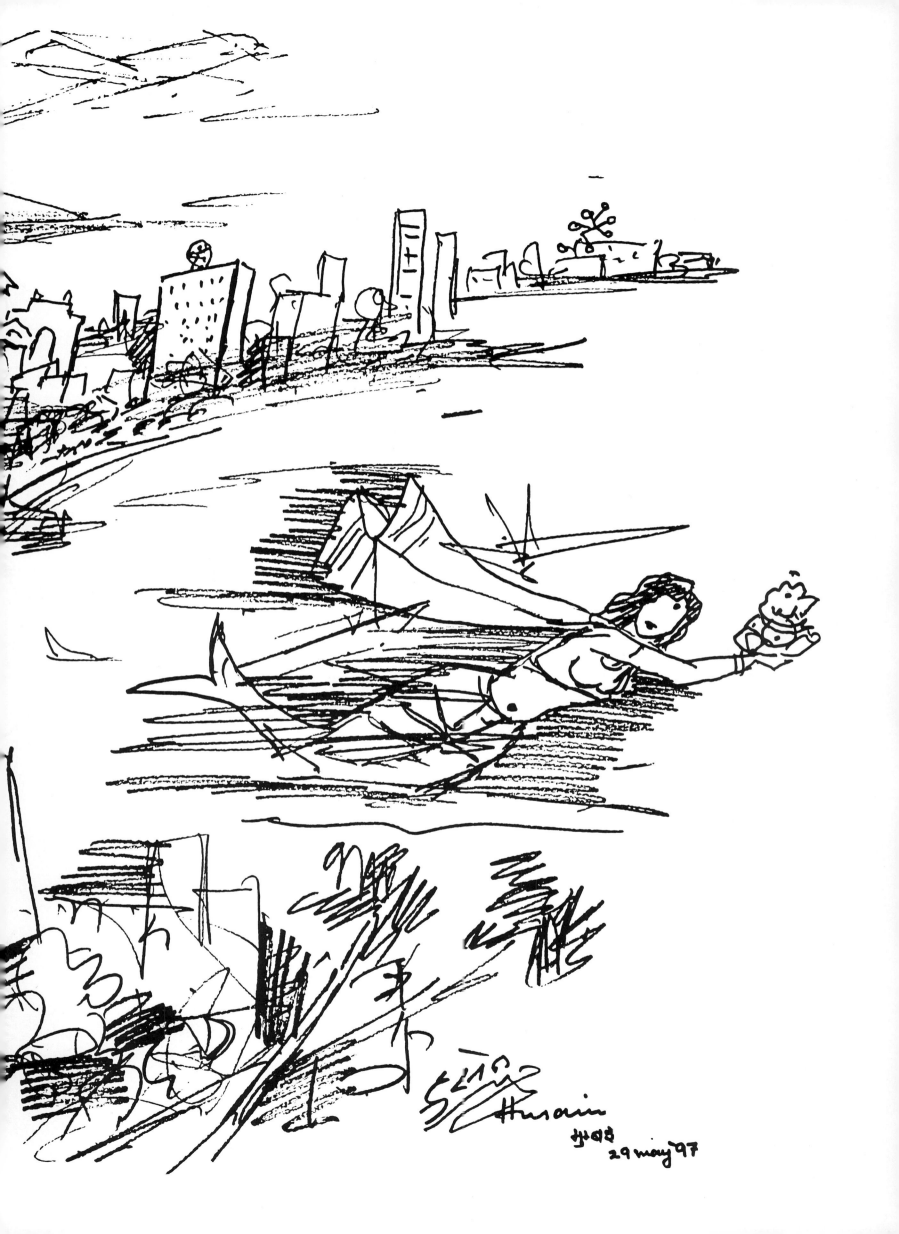

29 may '97

Stone capital detail, entrance
court to Victoria Terminus.
Photograph:
Christopher W. London, 1985.

The architecture of a city is the most tangible part of its heritage. Buildings are the sustaining thread that connect and act as constant points of reference in the many layered palimpsest that comprises the social and cultural milieu of a city. Unlike the past, in contemporary Bombay architecture is no longer looked at as an important instrument for generating, defining, and giving form to the urban landscape. Today, architecture is only the logical outcome or the end product of processes and approaches to city planning which are governed by abstract planning tools driven by economic equations, demographic statistics, and perceived infrastructural needs. This has resulted in a city form that lacks clarity and cohesiveness.

In spite of this transforming state of the metropolis, there are fragments from the past that still exert a presence on Bombay's urban landscape — fragments that continue to express and represent the ideals and processes that created them. In fact, this palimpsest quality where each explicit layer can be read simultaneously, is what distinguishes Bombay from other cities which were based on pre-determined master plans. Bombay on the other hand grew

INTRODUCTION TO PART III

incrementally with many layers added to the core land mass of the seven original islands. With each layer of reclaimed land, new processes and ideas were etched upon the landscape — the urban stage rearranged itself to accommodate a new or often renewed scenario.
The articles in this section describe some of the processes, ideas, and individual buildings which were influential and came to symbolize the touchstones in this fragmented incremental growth pattern that characterized Bombay.

Bombay achieved its first incarnation of a designed and visually cohesive city only in the late nineteenth century after the removal of the fortifications and the creation of public buildings in the restructured Fort area. The sheer

(opposite page)
clockwise from top:
Self-built housing, Bombay;
Jehangir Art Gallery, Kala
Ghoda; Navi Mumbai.
Photographs:
Bharath Ramamrutham, 1996.
Detail with peacock window,
Victoria Terminus.
Photograph:
Subrata Bhowmick, 1997.
Eros Cinema detail.
Photograph: Jon Alff.

quantum of Gothic Revival buildings built in an extremely short period during the last decades of the nineteenth century, makes Bombay a unique Victorian city. In fact, it was a period in Bombay's history where the very idea of the city was celebrated through its architecture. The Victorian architects instinctively grasped the importance of defining gestures like the points of entry, the public nodes and vistas which were endowed with architectural extravaganzas — bursts of civic definition and ambition. F. W. Stevens was an architect who worked in this spirit, and Christopher London profiles the architect, his developing practice in Bombay, as well as a number of his projects that were important in defining and giving expression to Victorian Bombay.

In spite of the definitive gestures created in the Victorian period, the city continued to transform rapidly, aspiring constantly to rebuild itself in the image of the time. A significant phase in Bombay's physical history is that which stretches from the 1930s to the 1950s when the introduction of new building materials like reinforced cement concrete (RCC) allowed buildings to be erected very rapidly on reclaimed land, thereby suddenly changing perceptions of architectural production. On account of these changes there emerged the apartment system of housing tailored to the growing cosmopolitan middle and upper classes of the city's population. Many buildings in Bombay at the time were built in a style that was vaguely a combination of the International style and Art Deco from America.

Far less exuberant, compared to similar buildings in the USA, the application of Art Deco in Bombay was consistent with the original style in that forms were angular and the facade often stepped back. This was especially true in taller and non-residential buildings such as theatres. Decorative elements in these buildings ranged from industrial symbols to palm trees, sun ray patterns, the moon and ocean being always the favourite decorative themes expressed in bas-relief, stucco panels, etched glass, and metalwork in balconies.

In fact, in Bombay, this style manifested itself consistently both in the overall form of the building and in detail, as well as in the conception of the interiors. Buildings in the Art Deco style included residences, office blocks, and a number of theatres in the city, all mainly built on the early Back Bay Reclamation which had (diagrammatically speaking) literally added another layer to the Victorian city core around the renovated Fort area. This development rapidly replaced the image of Bombay as a Victorian city with that of a cosmopolitan, international metropolis. In this process, the theatres were the trailblazers which introduced the style as they became vibrant symbols of the glamorous new lifestyle that had enveloped the city. Jon Alff outlines the development of Bombay's Art Deco style through its theatres and the impact it had on the larger urban landscape.

As the city moved beyond this phase into the post-1950s, the clarity of urban design and physical design interventions diminished. In this scenario appears an array of producers of the built environment ranging from the government to private developers resulting in the creation of a random fragmented jumble of architectural messages. Aside from this visual diversity that characterizes the contemporary environment, the shift to a repetitive high-rise type of building on account of the Development Control Rules created a monotony that came to characterize the architecture of contemporary Bombay. Himanshu Burte outlines the different forces that have created this environment and discusses the emerging issues as the 1990s come to a close.

In any case, these different architectural trends were only the end results of larger patterns that emerged historically in the urban structure of Bombay. When viewed in their own time contexts these patterns seem unique, but when viewed in the historic continuum, repetitions, rhythms, larger forces, and trends that propelled the growth of the city become evident. In his article Rahul Mehrotra examines the shift in attitudes to city design ranging from conscious design interventions to the seemingly laissez-faire

growth that characterizes the city today. The article offers a historic perspective on Bombay's urban form and outlines issues relevant to the metropolis as it embraces the future in the context of accelerated change which typifies Bombay today.

It is in this rapidly transforming urban landscape that attention to conserving fragments of the built environment that have continuing relevance is crucial to the stability of the city — at least till such time as newer image centres or cohesive patterns emerge. For, as cities grow and spread to colonize barren landscapes, they run the danger of dissipating their essential images. City centres, historic precincts, and urban symbols then play the magical role of representing myths, of putting identities "on hold' till fresher ones emerge. In relation to this issue, Cyrus Guzder has discussed attempts to conserve Bombay's heritage by presenting the history of the conservation movement from the 1980s to the present. Further, he uses actual cases to illustrate the issues, struggles, and achievements of this movement and its relevance to Bombay.

Thus the simultaneous attention to conservation and broader planning strategies is a process which must be ongoing in order to preserve the health of a metropolis. It is here that the importance of planning exercises such as the one at New Bombay is intrinsic to the development of the city. This section therefore ends with an article by Charles Correa who looks back at New Bombay approximately thirty years after it was first proposed by him together with Shirish Patel and the late Pravina Mehta. This plan was first published by *Marg* in one of its 1965 issues, and in his essay thirty-two years later, the author examines the successes and failures, and hopes that the idea carried. This article is important from the point of view of showing how overall strategy is extremely important in orchestrating the growth of a city.

In most Indian cities there are no institutional structures that focus on the ideas of the strategic orchestration of growth. In fact our cities are merely driven by land use

plans and Development Control Rules which have created a sort of fragmented cityscape devoid of rationale or cohesiveness. Therefore, the case of New Bombay is important in the hope it displays for planned growth. For as Bombay grows into the next millennium, it is clear that the city has become too complex and cannot be designed with the superimposition of a singular attitude or conceived as a comprehensive whole. At best its planners can evolve strategies and policies for new growth as well as conservation of existing city areas that would, within a cohesive framework, incorporate a pluralism of architectural attitudes, varied needs, lifestyles, and emerging opportunities. The making of such an urban landscape is the challenge that lies before the citizens of Bombay. It is our hope that the ideas presented and discussed in this volume on Bombay will contribute in some way to this process of conserving the city as well as planning for its future.

Fountain,[1] the Army and Navy Stores Building, the Standard Chartered Bank Building, and so on.

Stevens was a prolific architect. He was highly successful and he dominated the politics behind the commissions in the same way that he pushed his distinctive style forward on the city streets. Stevens also cleverly managed to amalgamate the High Victorian Gothic of Europe with a nascent Indo-Saracenic style, so that would-be patrons of both architectural types would be pleased with his designs. This ability coupled with his political and social connections ensured that the most important commissions on the most prominent sites of his day were garnered by his practice. His success with such methods from the 1870s through to the 1890s leads to our overwhelming sense of familiarity with his buildings today. In this way Stevens contributed greatly to our mental image of Bombay, an image even in the present day, largely consistent with the principles of High Victorian Gothic design prevalent during the nineteenth century.

Born at Bath in Somerset in 1847/8, Stevens spent his entire childhood and took all his training in this lovely eighteenth-century Georgian city, noted for its fine curved terrace houses above the River Avon. He died in 1900 at Bombay and is buried in Sewri Cemetery.[2]

If Bombay is the finest surviving example in the world, of a High Victorian Gothic Revival City, and many feel it is, who then was the most distinguished architect practising in that city during the Gothic's most popular moment? Frederick William Stevens, CIE, FRIBA, MSA, AMICE, should be the man who first comes to mind (figure 1). Stevens is credited with designing some of Bombay's most famous landmarks, the buildings one associates with the city as icons of its urban pride: the Great Indian Peninsula Railway Station — known as Victoria Terminus or VT (now the Chhatrapati Shivaji Terminus or CST), the Municipal Corporation Buildings, the Bombay Baroda & Central India Railway Headquarters, the Royal Alfred Sailors' Home (now used as the State Police Headquarters), the Oriental Assurance Building, the Ruttonsee Mulji Memorial

ARCHITECT OF BOMBAY'S

STEVENS AND

CHRISTOPHER **W.** LONDON

Stevens' training started with his serving articles for five years with the City Surveyor, after graduating from the Competitive College at Bath.[3] His first practical work involved the restoration of some of the Roman Baths which gave the city its name, work on local churches and on several landowners' residences in the neighbourhood.

In 1867, Stevens sat for the Public Works Department examinations at the India Office, having prepared for them at the South Kensington Museum of Science and Art, where he won several awards for his work. He passed them, and in October he arrived at Bombay. He began his service in Poona, where he did the finished drawings for the Poona

Law Courts under the direction of Major G. J. Mellis. However by 1869 he had settled in Bombay, and once established there, he never moved again.

The atmosphere in Bombay during the epoch when Stevens first arrived was of prosperity coupled with great building activity, principally focused on re-shaping the Fort area under the Ramparts Removal Committee's control. Stevens participated on all the projects assigned to the Committee's care. He worked on the proposed but never erected European General Hospital design, the revised design for the General Post Office, a design for the now demolished Telegraph Office, and also residential quarters for this service, which may still exist.

Stevens also had two of his own projects to complete, both in the vicinity of Apollo Bunder, and both now probably demolished. One was a General Post Office Mews building, the other was a residence for the Superintendent of the Post Office, now superseded by John Begg's new building with its own Postmaster General's apartment.

FREDERICK W. STEVENS, ESQ., C. I. E., F. R. I. B. A., M. S. A., A. M. I. C. E.

HALLMARK STYLE: THE GOTHIC REVIVAL

Royal Alfred Sailors' Home (figure 2)

Then in 1872, Stevens' first important commission began. He was assigned to design and construct the Royal Alfred Sailors' Home at Wellington Fountain (1872-76). The name commemorated the visit of H.R.H. Prince Alfred, Duke of Edinburgh, to Bombay in 1870, when he laid the foundation stone for the building jointly with the Gaekwad of Baroda. Stevens' work superseded the earlier proposal of John Macvicar Anderson for the site. His proposal not only improved upon the quality and luxury of the housing offered, but it also decreased the cost of the project. The building housed seventy-eight seamen in a "Domestic

Gothic" style building.

The Sailors' Home is a fine example of the superior decoration possible from utilizing the excellent stone materials available at Bombay for building.[4] It completes a decorative programme seldom found so fully conceived in buildings erected in Britain, largely due to the availability of highly skilled and affordable labour in India. The sculptural relief in its central gable is by Richard Lockwood Boulton of Cheltenham (*circa* 1832-1905), and it depicts Neptune surrounded by nymphs and sea horses in a triangular shaped pediment with crocketing above and to the left and right There are also griffins bearing armorial

1
Portrait of
Frederick W. Stevens.
Photograph courtesy
Christopher W. London

ROYAL ALFRED SAILORS' HOME, BOMBAY.——Mr. F. W. STEVENS, ARCHITECT.

shields, decorative sculpture, and a circular marble bas-relief of the Gaekwad of Baroda on the outside of the entrance porch, all designed by John Lockwood Kipling and carved by the Sir J. J. School of Art students. The highly ornamental ironwork on the building, the staircase railing, the iron finials, and the iron castings were all designed in Bombay by Burjorjie Nowrojie at the School. J. Macfarlane & Co. of Glasgow carried out the iron gates in the entrance hall and all of the iron grilles installed in the ground floor's arched openings.

Circulation of both air and people was carefully provided for in the building. A corridor nine feet six inches deep encased the structure, and the general massing of the building, with a central block and then twin sets of towers at each end of the main elevation, creates a very strong and solid design with a varied and attractive roof-line. The use of good quality sculpture on the building, the centrally placed staircase, and the deep encircling corridors all became hallmarks of Stevens' designs, and display the intrinsic quality found in his buildings.

The massive blocky use of architectural forms, the wealth of stone materials, the masculine feel to the building, and the abundance of sculptural detailing also owe debts to the architect William Burges, a possible mentor for Stevens. This cult of the "ugly" is well discussed in architectural studies of British architecture during the period.[5]

2
Royal Alfred Sailors' Home,
now the Maharashtra State
Police Headquarters.
Engraving from *The Builder,*
February 27, 1878.
Private collection.

3
The Great Indian Peninsula
Railway Terminus and Offices.
By Axel Herman Haig, 1878.
Watercolour, 90 x 155 cm.
Courtesy India Office Library
and Records (OIOC), The
British Library, London.
Haig never visited India but
nevertheless created this
spectacular perspective, based
on Stevens' design for the
Railway Terminus which he
saw during the latter's visit to
London in 1878. Two years
later in 1880, after its
construction had begun, Haig
showed the watercolour at
the annual exhibition of the
Royal Academy in London
thereby publicizing this
architectural masterpiece.

The Great Indian Peninsula Railway Terminus and Offices (figures 3-5)

Stevens then began work on the most famous of all his projects in Bombay. There had been some intervening small undertakings, but in June 1876 the first drawings for the Great Indian Peninsula Railway Terminus and Offices were begun. In 1877 the government officially "lent" Stevens to the Railway Company, and in 1878 he left on a ten-month furlough for Europe.[6] While there, he studied all the new and important termini which might aid him in the design of his Bombay undertaking. He returned to India with a complete set of plans, and in late 1878 the ten-year span of construction began.

VT was a costly building to construct at around £260,000.[7] It has a pivotal function and place within Bombay's life. It stands between the docks and harbour behind and the concentrated city centre before its principal west-facing facade (figures 3 and 4). In many ways the station serves as a link between East and West, as travellers moving from the Suez canal eastwards to India, landed at Bombay and boarded a train here for points inland. It was a true gateway into the subcontinent.

The station's appearance and plan is most closely linked to G. G. Scott's unbuilt proposal for the Houses of Parliament in Berlin, published in *The Architect* in 1872.[8] That centrally domed Gothic Revival office structure lacks a

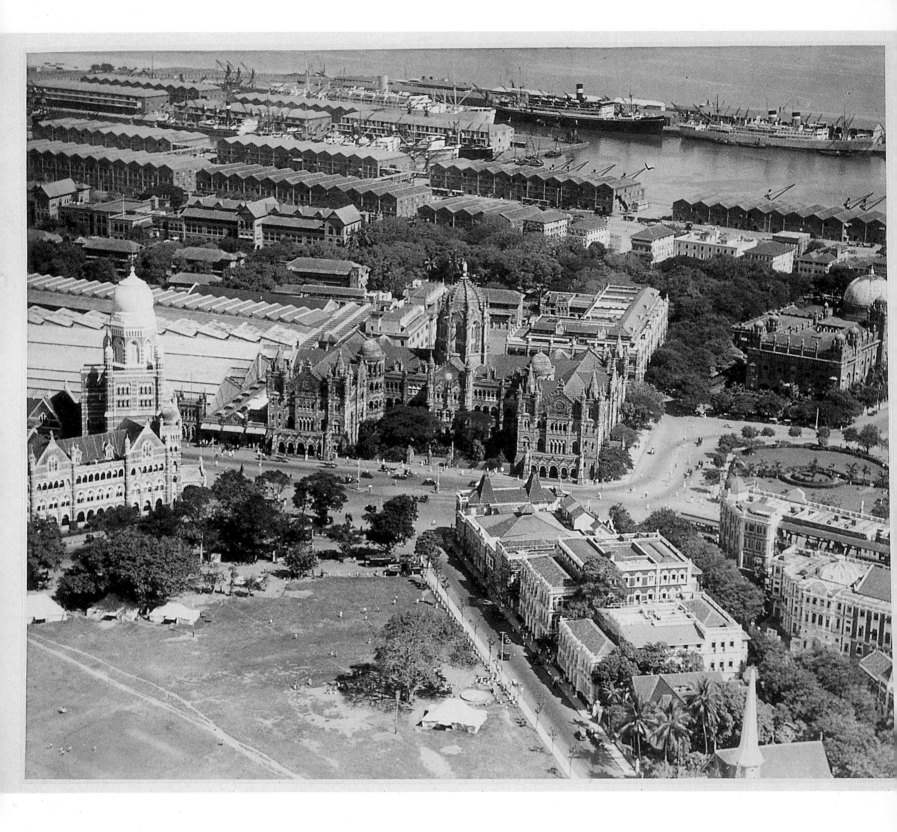

4
Aerial view of the Great Indian
Peninsula Railway Terminus
and Offices, with the
Municipal Buildings (left), and
Alexandra Dock.
Photograph by A. R. Haseler,
1937.
Courtesy India Office Library
and Records (OIOC), The
British Library, London.
Part of the Esplanade between
Cruikshank Road and Waudby
Road is visible in the
foreground. Hornby Road runs
from the right, in front of the
Railway Terminus, then
onwards between it and the
Municipal Buildings.

330 foot deep platform connected to a 1,200 foot long train shed, but its outline does provide the skeleton plan for Stevens' work. VT's dome of dovetailed ribs, built without centring, was a novel achievement of the era. Stevens placed attractively laid-out gardens at the front and back of the building, and provided one of the most opulent and durable Victorian interiors extant in Bombay. Tiles from Maw & Co. combine with richly coloured Italian marbles, white Seoni and Porbunder sandstones, teakwood etc. The J.J. School of Art professors and students designed and decorated the interior, under the supervision of Stevens and John Griffiths, its Superintendent.

The allegorical sculptural programme provided for the station was carried out in Bath stone by Thomas Earp and depicted Commerce, Agriculture, and Civil Engineering at the apex of its entrance pediments, in addition to Progress atop the dome, Queen Victoria at the second storey level, and Science and Trade tympanums at ground floor level. The railway directors and the sixteen castes are also depicted, in addition to peacock tympanums and the well-loved recumbent allegorical sculptured Lion of Britain and Tiger of India at the forecourt entrance. There are also an endless and uncatalogable profusion of other sculptures and forms which embellish the building adding to its legendary richness of detail (figure 5).

5a-c
Details of the exterior
decoration from the Great
Indian Peninsula Railway
Terminus and Offices.
Photographs:
Christopher W. London, 1985.

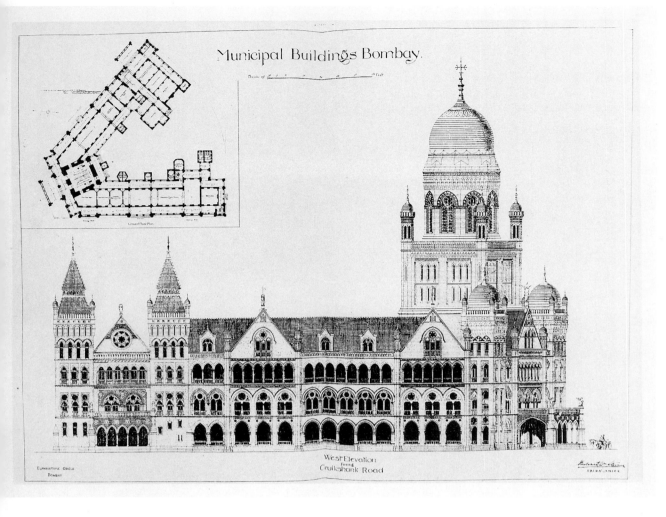

Municipal Buildings Bombay.

West Elevation
Cruikshank Road

ELPHINSTONE CIRCLE
BOMBAY

6
South-west elevation of the
Municipal Buildings showing
the tower in profile, the
southern entrance (left), and
floor plan.
Engraving from the original
design drawing by
F. W. Stevens in *The Building
News* (1890), vol. 59,
p. 644(b) (double-spread).
Courtesy The Mitchell Library,
Glasgow.

The Municipal Buildings (figures 6-8)

Stevens' next significant commission was for the
Municipal Buildings for the Bombay Corporation, a project
in part resulting from the change, in 1888, of the
"Municipal Authority" into the "Corporation", which it
remains to this day. The building history for this project is
an extended one, but when Stevens was finally selected, it
went ahead at full speed.[9] The work inaugurated Stevens'
private practice, for when he completed the VT Station, his
acclaim was so great that he felt emboldened enough to
open his own office. As before, the award of a large
commission meant that Stevens would travel to Europe,
and while at Bath all his designs were completed. He
submitted a final proposal to the Corporation on March 1,
1889. For this, he had studied all the new Town Halls being
erected during the period, in order to incorporate their best
elements into his own designs.

The style of his design was a "free treatment of early
Gothic with an Oriental feeling, which, I consider, the best
adapted for the site the buildings are to occupy". His
careful use of this style is in part due to his respect for the
style of "Frere Town", consisting specifically of the new
buildings along the Esplanade or in the neighbouring
precincts, to which he felt this building should be sensitive.
It was also shrewdly calculated to enhance and reinforce
the importance of his own VT, across the street. Though the

Municipal Buildings project was less elaborately detailed
than VT, it is still a highly complicated essay in the High
Victorian Gothic, in this case married to a nascent Indo-
Saracenic style.

The V-shaped site, which would have caused
problems difficult to resolve for most architects, was turned
to advantage by Stevens' clever plan. He placed the main
entrance at its narrowest spot, adding a *porte-cochere* with a
garden before it. The entrance also faced the newly formed
"square" he had defined with VT across the way.[10] He then
exaggerated the building's importance with a large tower
capped by a bulbous dome and by flared flanking facades
which ran off into the corners of the site. A garden with an
ornamental fountain was created inside the court formed of
this "V". Free ventilation and a place of solitude amidst the
busy city are the result of this carefully composed scheme.
To immortalize in stone the Corporation's importance he
capped the central pediment of the main facade with a
sculpture by Mr Hems (a British sculptor) which represented
"Urbs Prima in Indis".

Technically the building was in the forefront of design
of its time. It was built fully electrified twenty-two years
before the greater city was supplied, it employed hydraulic
lifts powered by water tanks stored under its dome which
doubled as fire prevention supply, and so on.[11] Its
Corporation Hall, closely based upon Birmingham's

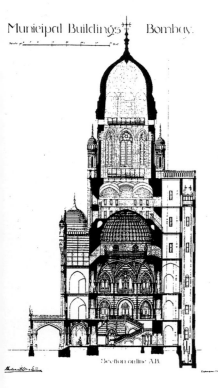

Municipal Buildings, Bombay.

7
Cross-section of the tower of the Municipal Buildings, showing the two domes — one internal and one external — the lift shaft (extreme right), and the entrance front with its *porte-cochere*. Engraving from the original design drawing by F. W. Stevens in *The Building News* (1890), vol. 59, p. 644 (a). Courtesy The Mitchell Library, Glasgow.

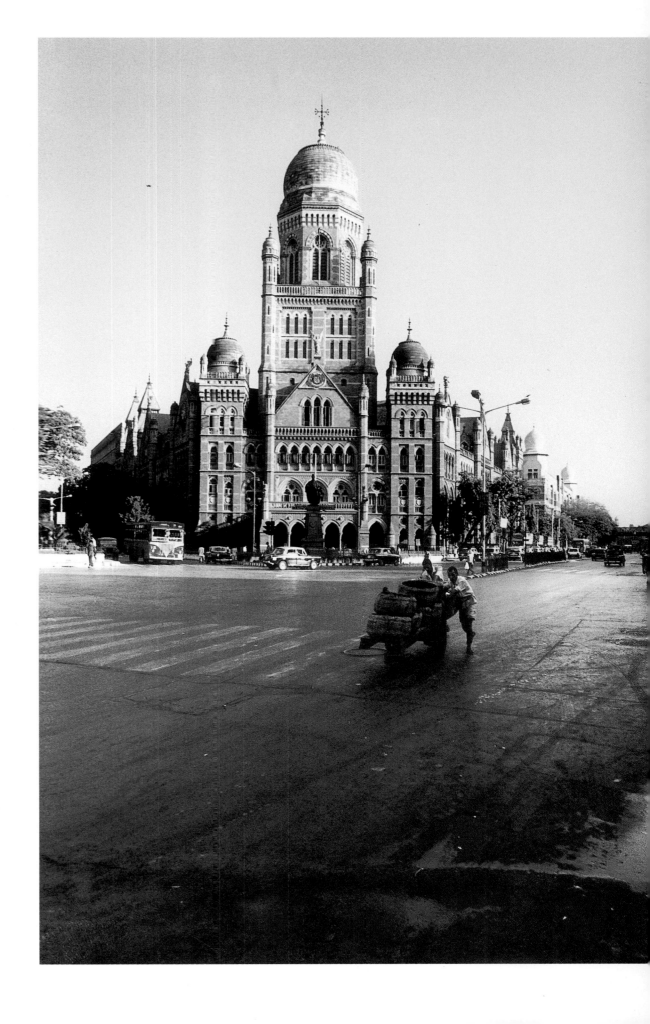

8
The Municipal Buildings. Photograph: Subrata Bhowmick, 1997.

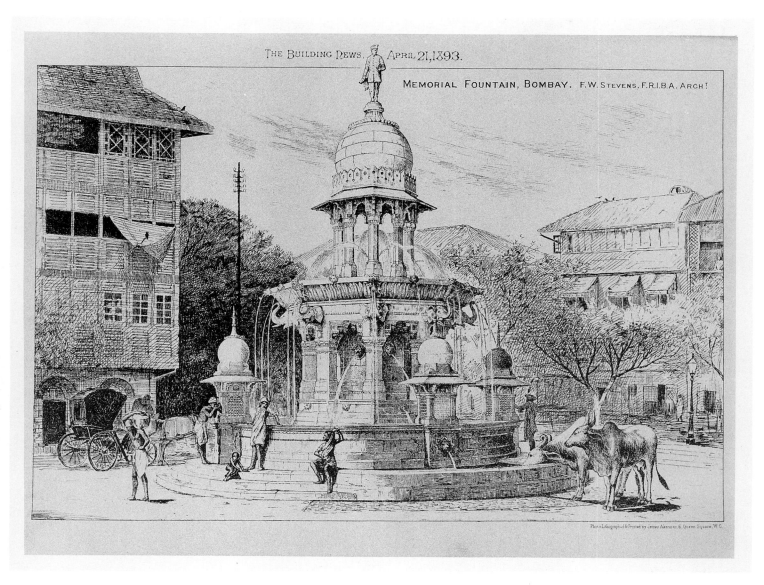

THE BUILDING NEWS, APRIL 21, 1893.

MEMORIAL FOUNTAIN, BOMBAY. F.W. STEVENS, F.R.I.B.A, ARCH.

Photo-Lithographed & Printed by James Akerman, 6, Queen Square, W.C.

9
Ruttonsee Mulji Memorial
Fountain, now the Mulji Jetha
Fountain.
Engraving from the original
design drawing by
F. W. Stevens in *The Building
News* (1893), vol. 64, p. 535.
Courtesy The Mitchell Library,
Glasgow.

Council Chamber and the Glasgow Municipal Building, is an opulent and dark interior of teakwood and stained glass. It is double height with an ample visitors' gallery served by a separate stairway. Wimbridge & Co. of Bombay manufactured the furniture to Stevens' design, and it remains unaltered and still in use. Another commendable feature of the offices is the interior dome set upon decorative squinches and massive granite brackets in the main entrance hall. Based upon examples from Bijapur, the room is more than twice as high as it is wide, giving an arresting impression of grandeur to the visitor. This interior Indo-Saracenic detail gave some consolation to supporters of Robert Fellowes Chisholm, the style's leading architect, but preserved on the exterior the High Victorian Gothic preferred by Stevens and the majority of municipal commissioners. Today, the Municipal Buildings have an added extension, as originally foreseen by Stevens, but the Corporation did not honour his plan for this, and the bridge which connects the two facilities is considerably more utilitarian than he had hoped for.[12]

Ruttonsee Mulji Memorial Fountain (figure 9)

Another project in which Stevens experimented with the Indo-Saracenic style was the Ruttonsee Mulji Memorial Fountain, built to honour the memory of a fifteen-year-old Hindu boy who died prematurely. Designed in 1892 and built in 1893 with collaboration from the architectural sculptor John Griffiths, it is Stevens' first essay in this style.

The fountain, situated at the intersection of Mint Road and Frere Road (now P. D'Mello Road), is composed of three major elements: a sculpture of the boy at the apex, a round-domed octagonal pavilion with an octastyle colonnade standing above a shallow basin on the second level, and another octastyle colonnade standing on a base above a large pool base on the lowest level. Around the pool Stevens placed a series of four miniature domed pavilions, equidistant from one another. Two of these contain drinking fountains for the public, while the larger pool offered water to animals. There are numerous jets of water, some emanating from elephants' trunks, others from lions' heads, and simple open sprays, as at the top.

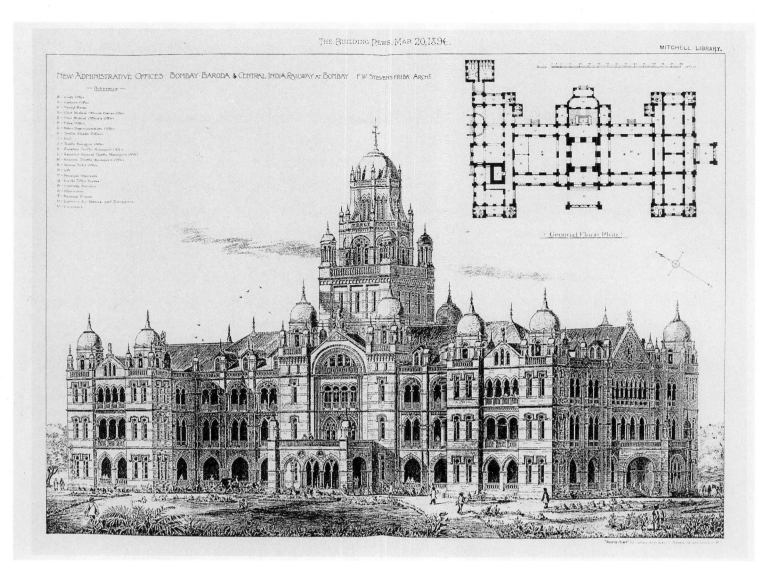

10
The Bombay Baroda and
Central India Railway
Company's Offices, with floor
plan.
Engraving from the original
design drawing by
F. W. Stevens in *The Building
News* (1896), vol. 70, pp.
419-20 (double-spread).
Courtesy The Mitchell Library,
Glasgow.

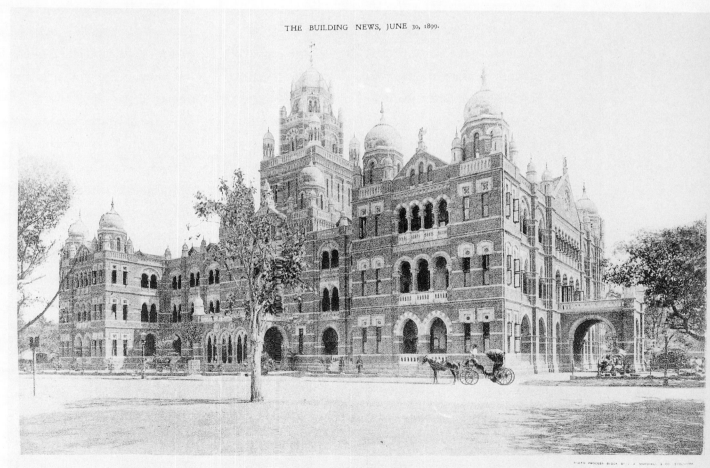

THE BUILDING NEWS, JUNE 30, 1899.

NEW BOMBAY BARODA AND CENTRAL INDIA RAILWAY ADMINISTRATIVE OFFICES, BOMBAY.

F. W. STEVENS, C.I.E., ARCHITECT.

11
The Bombay Baroda and
Central India Railway
Company's Offices.
Illustration from *The Building
News,* June 30, 1899.
Courtesy The Mitchell Library,
Glasgow.

Bombay Baroda and Central India Railway Company's Offices (figures 10 and 11)

Stevens' next important undertaking was the design and erection of the Bombay Baroda and Central India Railway Company's administrative offices. The designs were made in 1893, construction commenced in April 1894 and ended in January 1899. When completed it had cost Rs 616,000. Stevens was assisted by his son Charles Frederick Stevens and Rao Sahib Siteram Khanderao, MSA.[13] He won the commission without a competition, and no doubt rivalry between the two competing railway companies aided his strength as a contender in any discussions which prefaced this decision.[14] Like the GIP Railway Company directors, the BB&CI Railway Company wanted a major edifice to house its office staff. However, in this case, no terminus functions were included in the project as Churchgate Station was across the street. Only the growing requirements for more office space, and a desire to make a suitable display, made such a large building necessary.

Built of blue basalt stone laid in courses, white Porbunder stone was employed for the domes, mouldings, capitals, columns, cornices, and carved enrichments. The building's sculptural programme was less elaborate than Stevens' previous work, but the architect's attention to detail in the ornamental woodwork, wrought iron details, furniture design, and so on, was still executed to the same high standard.

The exterior has three storeys of offices, a centrally placed domed tower, and a slightly irregular floor plan of three facades. The centre of each elevation has a gable, and all of these were terminated by sculptural groups commissioned from E. Roscoe Mullins (1848-1907). The central southern gable depicts "Engineering", and this figure holds a train in her right hand and is supported by a cog-wheel on her left side. Colonels P. T. French and M. K. Kennedy, amongst others, were placed in sculptured portrait roundels at the ground floor level over entrances, and griffins bearing the arms of the railroad company also adorn several of the smaller gables.[15] A weathervane was placed at the top of the central dome though something larger, more prominent, and similar to that of the Victoria

Terminus may have been originally intended. To understand its employment here some of the construction history should be told. While digging the foundations for the central tower, proper bedrock was difficult to find. At a depth of between 16 to 24 feet, rock was discovered, but this slowed construction and probably forced certain changes in the building's final appearance.[16] One such logical change would have been this lighter capping feature of the central dome.

The style of the building blended the Indo-Saracenic with the Venetian Gothic, and the final appearance tends more towards the Indian than the Italian in overall effect. It is a transitional structure which absorbs from one tradition and applies it to another. The architect achieved this effect through his use of numerous onion domes and by his choice of colouring them white to accentuate their presence. Externally, the central dome of bulbous shape has an elevated profile with side buttressing developed in two stages from a square tower below. The dome looks like a Gothic Revival composition as that is the structural language employed. But, through distortions of scale and the complexity of the overall massing, Stevens deceives the eye, creating the perception that the office complex was designed as an Indo-Saracenic building. The office was not a correct historical recreation of an existing model, but rather it exudes a convincing "Oriental" appearance. The effect is much more noticeable here, than in the similar treatment which Stevens described in connection with his Municipal Buildings, because in this instance it was expressed externally. Otherwise, the side elevations appear like most other buildings in Bombay, with sprung arch openings on the ground floor and arcades with round arches above.

Oriental Life Assurance Building (figure 12)

In the commission for the Oriental Life Assurance Building only a conversion of the pre-existing structure was required (see Dewan: figure 10). The site, the former home of the Cathedral High School, was a highly desirable location opposite Frere Fountain and next to the Telegraph Office. The location was found to be too busy for a school, and yet ideal, because of its central location, for an office. Work on the building began in late 1895 or early 1896 and ended in 1898, at a cost of approximately Rs 450,000. Most of the construction was focused at the southern section of the structure and when completed, another highly ornamental Gothic building had been added to Bombay's skyline.

The school building had been designed by James Augustus Fuller. It was erected from 1878-85, and was three storeys high.[17] Like the Municipal Buildings it had a V-shaped corner site. Thus, Stevens' experience of the design problems inherent in this type of plan made him a good

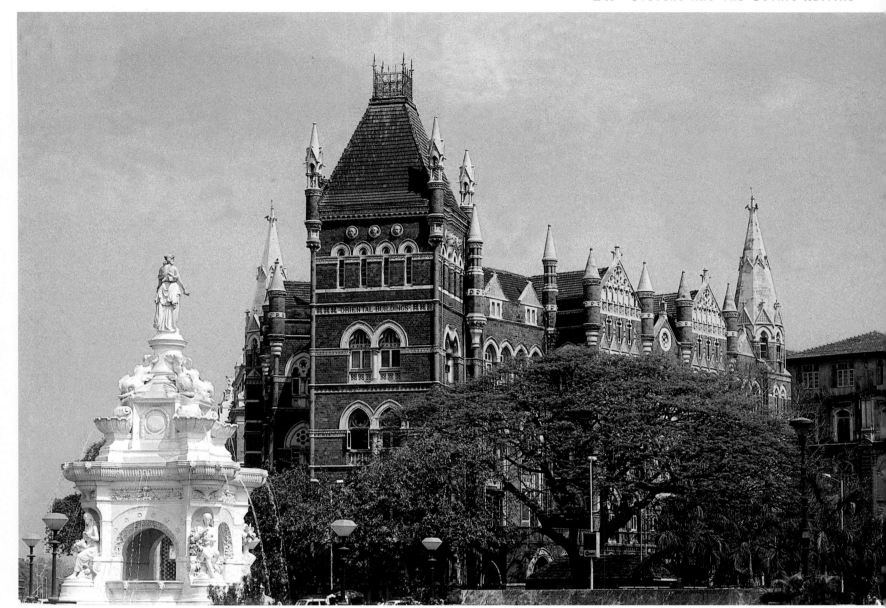

12
The Oriental Life Assurance Building with Flora Fountain. Photograph: Bharath Ramamrutham, 1997.

choice for the remodelling. He knew how to create an interesting composition on a corner site, so as to advertise effectively the company whose offices were within.

He made several decisions which echoed his earlier design for the Municipal Buildings when adapting the High School. He moved the main entrance to enable him to build up the narrow southern facade, so the offices would dominate the Flora Fountain precinct. He also added an additional storey to its height with a high and steep y sloped roof. In the area of this addition, a series of three sculptured portrait heads protruding from their rounded surrounds were then added to face the square. These depict the founders of the Assurance Company, and below this, in tall lettering, "Oriental Buildings" was spelled out. Pinnacles, bartizans, and thin engaged columns extending the full height of the elevation were also added. These increased the external surface decoration. The side elevations, which already had griffins and a series of gables with empty armorial plaques, were changed slightly to provide further embellishment, and the interior, already divided for classrooms, made conversion to offices quite simple. A programme of redecoration and the inclusion of

a lift were all that was required.

The Late Commissions

Further work by Stevens in Bombay comes late in his career, and most of it is a collaborative effort. With David Ebenezer Gostling, FRIBA (1839-1908), a partner in his firm, the Army and Navy Stores on the Esplanade Road was designed. The building stands where the former Municipal Authority's Offices were located. The project consisted largely of a refacing of the facade, and major structural and internal changes to an existing building.

The drawings for the four-storey structure were made by November 30, 1897.[18] Designed in a modified Italianate style which used neo-classical architectural language, its facade utilized Malad stone with Porbunder stone details. Its appearance relates to another building also designed by Gostling & Stevens, begun a year later.

The building of the Chartered Bank of India, Australia, and China was one of Stevens' last works in Bombay (figure 13). Unable to see its construction finished, he nevertheless involved himself with the project until his death on March 5, 1900. The offices were designed by Gostling & Stevens in 1898, construction began in 1899,

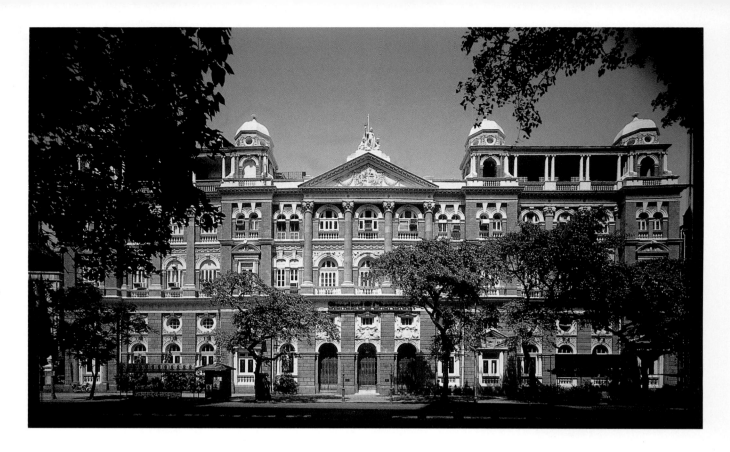

and the bank was completed on December 1, 1902 at a cost of about Rs 600,000.[19] The commission must have stipulated the Italianate neo-classical style, as it is unusual in Stevens' output, and only relates to the Army and Navy Stores' commission and his design for the Standard Buildings at Calcutta.[20]

The Chartered Bank Building served as an important office of a bank which traded between the farthest colonies and contacts of the British Empire during its most prosperous era. This office was the bank's most centralized location between London and the Far East.

The building erected made provision for a banking hall, offices, private apartments for the director and family, and supporting structures for servants' quarters behind. Its construction was supervised by C. F. Stevens, eldest son of Stevens' three surviving children. He and his brother Cecil Stevens were articled in their father's architectural practice, and the former began his training there in 1892.[21]

The bank was constructed of Porbunder stone and a Malad stone of light colour, and was roofed in the traditional ceramic tiles. Its pediment bears the coat of arms of the bank above which there is a sculptural group containing figures representing Great Britain, India, Australia, and China, with a flagpole at its apex. The interior woodwork, counters, and furniture were manufactured by Messrs. Alex Mackenzie and Co. of the Byculla Saw Mills, and there was Minton tiling on the floors.[22]

The floor plan of the building is a fairly complicated one, and this enabled a clever pattern of circulation to be realized. There were two sets of stairs provided — one south of the main entrance so that staff could enter and leave the offices without interfering with the public entrance, vestibule, and banking hall on the ground floor. The banking hall was centrally placed, and a second private entrance and set of stairs to the north led from the first to the fourth floor. These gave access to the private apartments of the director.

The last building by Stevens to be discussed is the British India Steam Navigation Building, now known as Kamani Chambers. It is located on Nicol Road, now called Kamani Marg. The BISN Building was begun in 1900 and completed in May 1903. It cost approximately Rs 350,000, almost half the cost of the Chartered Bank Building, and it was built wholly under the supervision of C. F. Stevens, to his father's plans. How much of the detail work was left undetermined at Stevens' death is hard to discover, but more than likely much of this would bear the impress of his son's hand alone.

The building is a square office block constructed of rough cut Kurla stone with Porbunder stone being used for the window surrounds. It has four principal storeys and pronounced corner towers, each castellated and an extra storey in height. Designed in the Scottish Baronial style, which must relate to the client's wishes, it is atypical in Stevens' output, and not a very successful composition. Perhaps late in Stevens' career, with commissions for work pouring into his office, some of his standards of design faltered. This seems especially apparent in his work on this commission. Whether or not C. F. Stevens altered, enlarged, or ignored his father's plan is not known, but this could provide a further explanation for this erratic composition in Stevens' output.[23]

Stevens also supervised the construction of another

building just prior to his death in 1900, the Royal Bombay Yacht Club's Residential Chambers designed by his friend John Adams, a PWD employee. The building was begun in 1896, and completed in 1898. Stevens went to England in October 1898, and this evidence gives us a firm date for its completion. In carrying out this work Stevens was assisted by his son C. F. Stevens, and the engineering details and comforts supplied are up to the usual standard as there were hydraulic lifts, electric lights, fire services etc. provided for. Though the role Stevens played in providing these may have been no more than supervisory in nature, without the original drawings this is hard to determine.

Other projects which Stevens worked on were for buildings outside the city. For this reason I shall just list these. They are: the Government House at Naini Tal, the Court House at Mehsana in Baroda State, and the Patan Public Markets, Baroda. Government House Naini Tal was in the Venetian Gothic style, and dates from 1887 The two projects for Baroda are in a Hindu style of architecture, and were designed just before Stevens' death, and built after it by the PWD in the Baroda State Office.

The forms created by Stevens during the course of his career define the emergent styles of Bombay at the end of the nineteenth century, and the opening of the twentieth. If anyone helped fashion and influence the appearance of Bombay during the height of Queen Victoria's reign, it must be Stevens who is credited with the achievement.

Notes

1. The Ruttonsee Mulji Memorial Fountain is now known as the Mulji Jetha Fountain, and it stands at the intersection of Mint and P. D'Mello Roads.
2. Stevens married a woman from Bath in 1872, Mary Elizabeth Bray, and they had four children, two girls and two boys.
3. Serving articles was the traditional way to learn about architecture in eighteenth and nineteenth century Britain — similar to apprenticeship for a trade career. An informal or signed agreement, between a pupil and the master, for the training supplied helped give consistency to this method of education.
4. The stone is not available within city limits, but all of it is available nearby. It was brought to Bombay by boat and rail.
5. See Mark Girouard's *The Victorian Country House*, 1971 and also C. M. Smart's *Muscular Churches - Ecclesiastical Churches of the High Victorian Period*, 1989. The Sailors' Home also had extra thick walls, so that another storey could be added to the present structure if needed.
6. Axel Herman Haig drew the perspective for the Royal Academy entry of Stevens, with the VT Station as his subject. Haig worked for Burges frequently. The watercolour is now in the India Office Library Collection (see figure 3).
7. Though St Pancras in London cost four times as much. That however was a hotel, this was only an office and station building, and money on that scale spent on the subcontinent went considerably further. The hotel alone at St Pancras cost £400,000 to erect, and many other comparables are confused by the time, site conditions, materials used, and place of the two buildings' construction. VT is all load-bearing masonry construction; St Pancras used structural cast-iron girders and exposed load-bearing cast-iron beams. The former is much more costly to construct.
8. A copy of the design for the Berlin Parliament Houses is also on deposit in the Maharashtra State Archives, giving further evidence of Stevens' knowledge of this design.
9. The first plan, of 1884, was based on designs by Robert Fellowes Chisholm, for which a foundation stone was laid. The cost provided for then was Rs 500,000, and Chisholm had won a competition sponsored in 1883. Then several alternative sites were proposed, including the present position of the Prince of Wales Museum. After this four-year pause, Chisholm made a new plan but was subsequently jilted by the authorities. Ultimately, Stevens began to build from his designs at the site originally proposed.
10. The space discussed here is not really a true square, but rather a "place" or intersection, but I use "square" for its associative meaning rather than its geometric form.
11. Electric supply did not come to most of Bombay until 1915.
12. Stevens proposed a "Bridge of Sighs" connection between the two buildings, and he made drawings for a continuation of the facade in the Gothic style.
13. Khanderao also assisted Stevens in his work on Victoria Terminus.
14. John Adams did make a design for this building in 1884, for the site where the Standard Chartered Bank is now located.
15. French and Kennedy were prominent pioneers of the Railway Company, whose portraits are located over the western entrance.
16. The offices are built on filled land, hence the initial problem and the need to dig so deep.
17. It was designed by Fuller, at an estimated cost of Rs 85,000, and was to be completed by October 31, 1881. It was not completed until 1885 at a cost of Rs 200,094. In 1882/83 Chisholm considered its conversion for the Municipal Buildings commission.
18. I found this information on a finished drawing dated November 30, 1897, in the possession of Julian Vaz of Gregson, Batley & King, now deceased. The drawing is signed Gostling & Stevens.
19. The partnership of Gostling & Stevens was short-lived as soon after this building was begun, Gostling formed another firm called Gostling & Chambers in 1902, and by 1905 this was called Gostling, Fritchley & Chambers. In 1907, the Messrs. Stevens & Co. firm listed as its members C. F. Stevens, B. G. Triggs, and T. S. Gregson. This firm evolved into Gregson, Batley & King.
20. Begun in 1894 and completed in 1896.
21. C. F. Stevens was educated in Bath and Bristol, from whence he returned to Bombay in 1892 to work for his father.
22. It was begun in 1899 and completed in 1902.
23. C. F. Stevens continued his father's practice after his death, and he built among other projects: Marshall & Sons (corner of Ballard Road), the Civic Improvement Trust Building (1902-04) at the intersection of Mayo and Esplanade Roads, and the Orient Club (1910) on Chowpatty Sea Face.

Acknowledgements

I would like to thank Foy Nissen who has always taken a keen interest in my research on India. Foy continues to generously serve as the most important guide to my evolving understanding of the architectural and social complexities of Bombay and the subcontinent.

Crowds merged before the Regal Cinema to observe its inauguration on the evening of October 14, 1933. The shimmering surfaces of the cinema's stepped entry tower radiated magically onto the streets converging upon its marquee. Onlookers edged forward to watch finely attired patrons step down from stately limousines as they entered the cinema's bright marble lobby. Inside, the Governor of Bombay and the ironically titled American comedy *The Devil's Brother* formally opened the cinema with the city's social elite. That night all of Bombay — smartly dressed shoppers, labourers, fishermen, and the fashionable — stood in the Regal's light to embody a Hollywood scene. A bold mythology had come to India, and would powerfully shape the emerging nation (figure 1).

Origins of the Art Deco Style

Victorian era inventions, such as photography, the internal combustion engine, and the telephone, transformed Western urban life radically in the first decades of the twentieth century. Cities exploded outwards with the automobile, and leapt skyward with steel-framed buildings. The widespread use of electricity in industry and urban homes concentrated employment, and provided millions with new access to information and comfort. Western economic and cultural power shifted decisively from the field to the factory in these years, and had begun to create a new society.

Bombay's Regal, Eros, and Metro cinemas, among India's first in the Art Deco style, illustrated the global reach of the new century. Unfolding like none before, the Modern era would present its most powerful expression in the Art Deco cinema. As India's foremost Art Deco cinemas, the Regal, Eros, and Metro would introduce many to the cultural forces which would shape India's development for years to come.

Largely French in origin, Art Deco established itself as the world's first international design movement with the 1925 Exposition International Decoratifs Moderne held in Paris. Numerous earlier movements, such as Cubist and

TEMPLES OF LIGHT: BOMBAY'S ART DECO MODERN MYTH

JON ALFF

Expressionist art, jazz music, and fashion, lay at the heart of the Art Deco style. These movements represented the twentieth century in terms of industry's growing impact upon society. Painters, sculptors, musicians, and fashion designers created aggressive, often critical, abstract fragments of day-to-day life, sounds, and motion as metaphors for the rapid tempo and chaotic character of the emerging industrial culture.

The Art Deco style drew heavily upon these predecessors, but also presented Industry as an achievement of progressive human endeavour. Art Deco designers advanced technology as the embodiment of rational forces which would create an improved future. Their designs evoked the stamped, moulded, and machined forms of industrial production with simple geometries, smooth surfaces, and repetitive decorative motifs. Radiating sunburst, wave patterns, and geometricized plant motifs associated Modernity with astrology, water, and nature, and quietly secularized traditional religious symbols.

Art Deco glorified Modernity as it redrew the line separating people and machines. Technology was humanized with a growing place in everyday life, and was seen to embody human characteristics as it reshaped society. People felt larger, emboldened with new powers, as they were liberated from labour and rewarded with new comforts by the machine. Inspired with the promise of a new society, many began to emulate the productivity and order of the machine. As partners in a Modern era, people and machines were united in Art Deco visions of a new world.

It was an astonishing vision that was well received by new classes of the Industrial Revolution. First accepted by wealthy Westerners, who found their lives heroically represented in the new style, Art Deco soon also embodied growing middle-class aspirations. By the late 1920s, New York's Chrysler and Empire State Buildings, then the world's tallest, were completed in the Art Deco style. The style soon

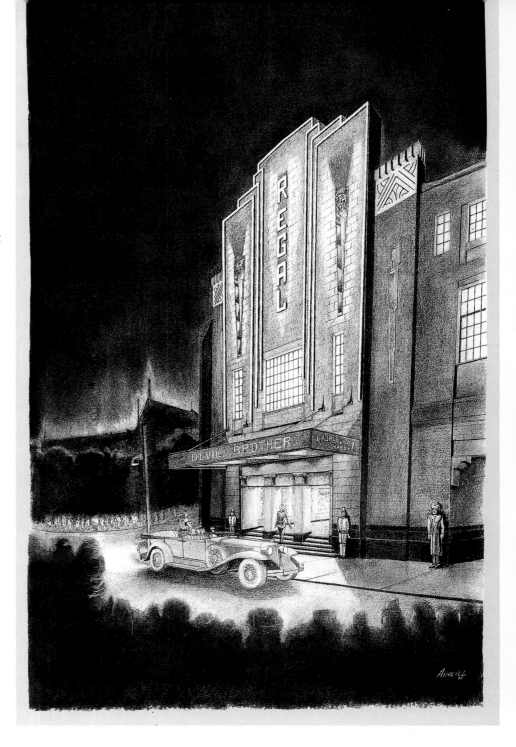

1
Regal Cinema opening night, October 14, 1933.
Rendered by Jason Anschel Shirriff.
The Regal's exciting opening brought Bombay Governor Sir Frederick Sykes, and a flock of the city's elite, to premiere the Laurel and Hardy film, *The Devil's Brother,* and captured the interest of thousands. The opening initiated a new era which would shape India for years to come.

Cinemas and the Birth of

spread throughout the United States, and associated Art Deco with progress so fully that the terms seemed synonymous.

Though not as quickly established in India as in the West, Art Deco would be no less influential upon India's cultural development. Traditionally minded Britons were reluctant with the style in India, and its adaptation was further slowed by the Second World War and Independence. As a result, most of India's first Art Deco buildings were designed for Indians building residences with British-trained architects in Bombay during the early 1930s. Bombay possessed more than sixty cinemas by 1933 (and nearly 300 by 1939), including seven talkies, located in

traditionally styled buildings. Regal, Eros, and Metro cinemas would bring Art Deco to Bombay's public, and introduce India to the new dimensions of Modern life.

Regal Cinema — Theatre Magnificent (figures 2-4)

India's film industry and audiences developed much like those in the West. France's Lumiere Brothers presented India's first film at Bombay's Watson's Hotel in 1896. The city's Royal Opera House, and several other converted stage theatres, began showing imported films regularly by 1911. By 1918 Dadasaheb Phalke, widely recognized as the Father of Indian Cinema, had completed more than twenty-five films in Bombay, including *Raja Harishchandra,* and *Krishna Janma.* As Bombay's first theatre to be

near the prestigious Taj Mahal Hotel, the cinema was readily accessible, and given obvious prestige through association with the city's elite.

British-trained architect Charles F. Stevens Jr., son of the renowned Victoria Terminus architect (see article by London), met Sidhwa's goals with a stone facade which followed the site's perimeter to impart a curved, modern form. Underneath, he designed the concrete main floor

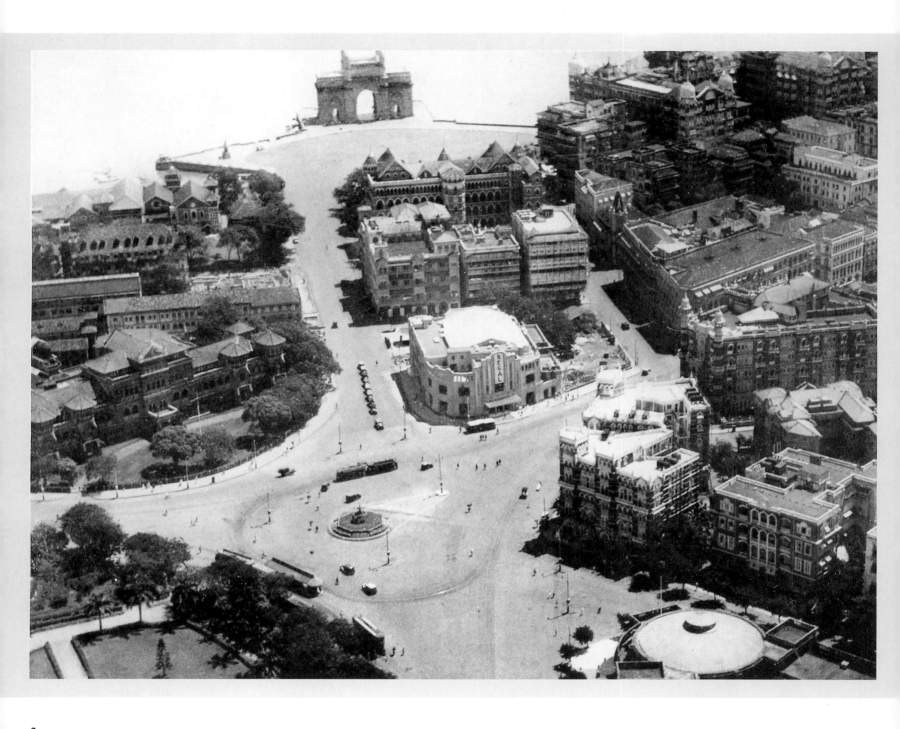

2
Regal Cinema from the air. Source: Opening night brochure — Globe Theatres Pvt. Ltd.
The Regal captured dramatic visibility on its prominent corner site and gained prestige from the adjacent, European-settled Colaba Causeway. Note the Gateway of India, the Royal Yacht Club, and the Taj Mahal Hotel at the top, with the Royal Alfred Sailors' Home and the Prince of Wales Museum garden on the left of the photograph.

designed expressly for films, Regal's opening represented the beginning of India's cinema architecture, and signified the arrival of India's Art Deco era.

Framji Sidhwa's vision, and local financial support, built the Regal Cinema. Born in 1880 to a family of Parsi priests in rural Maharashtra, he appeared destined for the priesthood. But drawn to theatre as a youth, Sidhwa eventually purchased Bombay's former Saluting Battery to build "the best cinema East of the Suez". Here, on the most visible corner of the European-settled Colaba Causeway,

and auditorium structure to cover India's first underground car park. Exterior masonry walls isolated the auditorium acoustically, and completed the building's vertical structure. To provide unobstructed seating, Stevens engineered a 65-foot-long steel balcony beam, which was fabricated by the Tata Iron and Steel Company in Jamshedpur. The building also contained apartments for the Sidhwa family, a bar, two soda fountains, an outdoor smoking balcony, and retail shops along the building's fashionable sidewalks.

3

Regal Cinema facade.
The Regal, designed in 1933
by architect Charles Stevens
Jr., was one of India's first
Art Deco buildings. Its
monumental facade was
anchored by a tall, neon-
outlined tower to attract
attention along the busy
street.

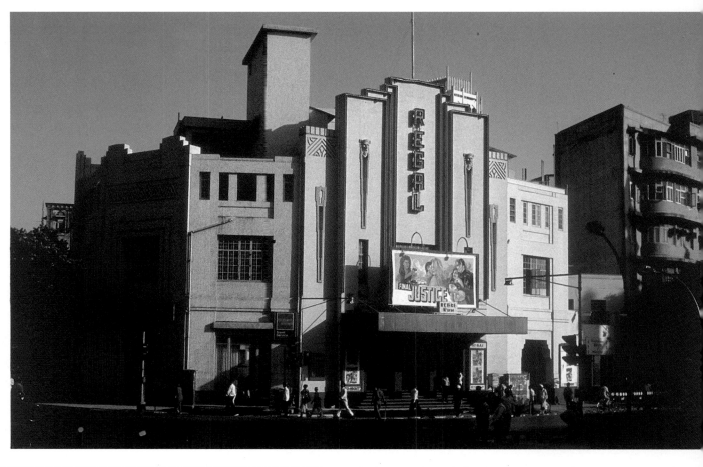

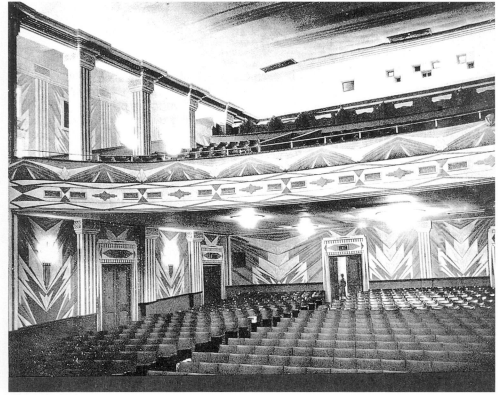

4

Regal Cinema auditorium.
Source: Opening night
brochure — Globe Theatres
Pvt. Ltd.
The Regal's "ultra modern
decorative scheme" was
carried out in jade green and
orange pastel, by
Czechoslovakia-born, and
"Cubist inspired", Professor
Karl Schara.

Solar, wave, and floral motifs in the guardrails, hanging lights, and ceiling plaster, and fantasy fountain murals encouraged increasingly poetic associations on the way to the auditorium. The 1,200-seat auditorium, then India's largest, was cooled by the country's first air-conditioning system amidst dramatically patterned jade green and pale orange walls. Angular glass lights, stained from deep to pale orange, threw warm ray patterns over ceiling-high wall panels to create "an astonishing illusion of great height and an effect of radiating light". The pale cream ceiling deepened into orange above concealed perimeter lighting, which brightened slowly at intermission to make a "glowing brilliance similar to that of a sunrise".[1]

Bombay's public and elite responded enthusiastically to the new cinema, and the predominantly American movies introduced through Framji Sidhwa's direct contract with Hollywood's Metro Goldwyn Mayer. Although some doctors advised people to wear warm clothing to ward off illness, the balcony seating quickly sold out seasonal bookings of the weekend shows. The city's "regal set" enjoyed being seen in the cinema's cafe and soda fountains, and the balcony's "dress circle" soon became a popular stage for Bombay's increasingly Modern society.

Eros Cinema (figures 5-7)

Eros Cinema, Bombay's second significant Art Deco cinema, opened in 1938, five years after the Regal. To compete with the Regal's standard was expensive. The world's continuing economic depression, lack of appropriate sites, and India's uncertain political future made such a venture highly risky. But the cinema's

The cinema's simple facade and entry tower clearly distinguished the Regal from the area's traditional buildings, but revealed little of the surprises within Designed by Karl Schara, a Czechoslovakia-born artist also known for his interior restoration of the nearby Church of the Holy Name, the interior would be India's most inspired public Art Deco creation. Schara organized the cinema's interior with increasingly intense colour and decorative complexity from the entry inwards. Visitors felt drawn toward a deceptively scaled, other-worldly space and shimmering light.

potential profitability and glamour seemed worth the risk to Shiavax Cambata.

Born in 1883 to a poor Parsi family in Karachi, Shiavax Cambata demonstrated Bombay's reputation as a city of opportunity. First working on the docks he had built a successful chandling business. Sensing the newly created Back Bay Reclamation's prestige, Cambata leased a long triangular site across from Churchgate Station. In addition to the cinema, he planned exclusive restaurants and shops, a European ballroom, an ice-skating rink, luxury offices and apartments, and a glamorous residence on the site.

Bhedwar & Sorabji Architects, one of Bombay's most accomplished firms, resolved the project's difficult programme and site geometry with established Art Deco practices. The site's narrow tip was used for the cinema's entrance and four-storey marquee, and was given prominence with a stepped, octagonal tower. The architects created horizontal banding, and smoothed the building's walls into sweeping curves to create an impression of motion and great length. These devices promoted the building's visual prominence, and gave it the image of a huge ship preparing to fly off the site.

The auditorium was isolated within the site and entered from a three-storey lobby beneath the tower. This

5
Eros Cinema.
The Eros opened in 1938. Bhedwar & Sorabji Architects, one of Bombay's most accomplished firms, painted horizontal decorative bands, window sills, and the edges of projecting sun screens to lengthen the building's horizontal appearance, and to accentuate the height of its corner tower. The cinema's name was chosen by Shiavax Cambata upon seeing the statue of Eros, the Greek god of love, in London's Trafalgar Square theatre district.

6
Eros column detail.
Golden nymphs graced columns throughout the cinema's foyer and reminded guests of Eros, the Greek god of love.

GALA OPENING TONIGHT AT 10
of India's largest
and most luxurious
Cinema

8
Metro Cinema opening night advertisement.
Source: *Flashback, The Times of India*, 1990.
"A Playhouse built especially for discriminating playgoers! No matter where you live, we urge you to see this magnificent cinema." The cinema did not fit easily into India's class and caste systems.

allowed the restaurants, shops, and offices, which could not be located above the auditorium for structural and fire safety reasons, to be given natural light and air, and public access on the site's perimeter. Shiavax Cambata's Art Deco residence was placed on the tower's top floors, where it possessed grand views, and enjoyed a wide reputation as the city's most modern residence.

While the Eros interior was far simpler than Sohara's design for the Regal, the cinema's three-storey entry foyer was grandly scaled, and richly appointed with white-veined black marble, and sleek, chrome-plated metalwork. The auditorium was flanked by dynamic, silver painted murals portraying film-making. But the Eros was most memorable through its flamboyant association with the Greek god of love, after which it was named. Bombay's increasingly urbane English-speaking audiences were no longer attracted by mere association with the rich and famous.

Metro Cinema (figures 8-12)

Metro Cinema, Bombay's third Art Deco cinema, opened several months after Eros with a gala showing of *Broadway Melody of 1938*. Developed (with Metro Cinema in Calcutta) by the world's largest studio Metro Goldwyn Mayer of Hollywood, it exemplified contemporary

American cinema design and illustrated film's growing international marketability.

Designed by MGM and the established Bombay architectural firm of Ditchburn & Mistri, Metro Cinema represented a high point in India's Art Deco evolution. The building had street-level shops, six floors of offices, and a parking lot next to the cinema. Like the Regal and Eros, it used a prominent corner site to great visual and functional advantage. But unlike the earlier cinemas, which completely filled their sites, Metro's designers physically isolated the fire-prone cinema from the rest of the building with a corner tower and a parking lot. This layout further benefited the office wing with three exterior walls providing excellent natural light and cross-ventilation.

The building was built with a reinforced concrete structure around a blocky tower at the public corner of its rectangular site. Joining the University Clock Tower and the Eros towers on the maidan nearby, the tower established Metro as a powerful urban landmark at the edge between Bombay's Indian quarter and wealthy European district. Locating the cinema in this way, MGM sought to attract formerly isolated social groups. Metro's advertisements pointedly reflected American marketing strategy by inviting "discriminating playgoers, no matter where you live".[2] As with Regal and Eros, Metro provided social separation with its more expensive balcony seating, and upper level soda fountain and bar, but more significantly, presented the same entertainment to all.

Viewers entered the cinema through its brightly lighted tower to find an air-conditioned world of elegant colours and luxurious furnishings. The two-storey lobby's richly veined maroon, grey, and white marble floors were Italian; its Burmese teak-clad columns were framed by deeply coloured American fabrics; two fifteen-foot-tall aluminium and cut-glass chandeliers hung from the ceiling, and lavish paintings hung from the walls. The balcony balustrade, and most of the cinema's exposed metalwork, was made of aluminium in geometric floral motifs fabricated in the United States. Luxurious sofas, wall panelling, and furnishings were made by Bombay's Wimbridge & Company. Two-storey tall, steel-framed windows brought cool northern views of the traditionally styled library across the street.

Deeper within, fifteen hundred viewers were seated before an enormous screen and huge murals depicting

Vedic-inspired jungle scenes. The murals, and similar ones in the lobby, were designed by Mrs Gerard, a Paris-trained teacher at Bombay's J.J. School of Art. Painted largely by her students, the murals illustrated mythic characters and natural settings in larger-than-life dimensions appropriate to the scale of film heroes. Idyllic and naturalistic, the murals created a distinct departure from the building's modern image and urban name. It was a fitting, film-like departure which created an other-worldly impression quite removed from the urban life outside.

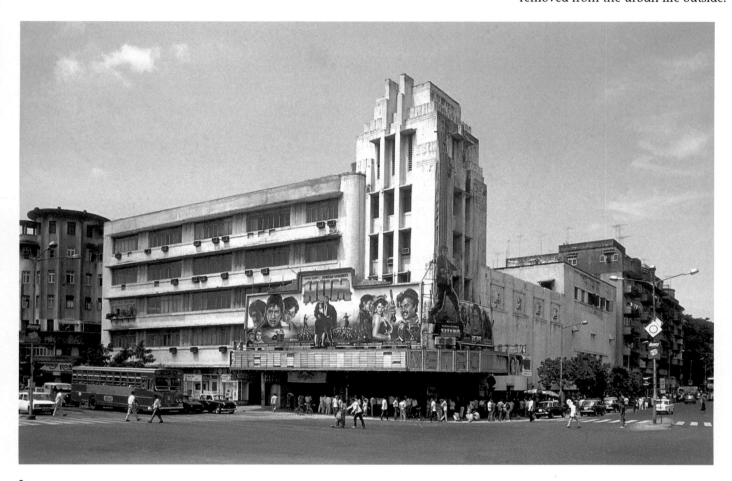

9
Metro Cinema facade.
The Metro, designed in 1938 by Metro Goldwyn Mayer, and the noted Bombay firm of Ditchburn & Mistri Architects, represented the latest in American cinema design. The corner tower dramatized the cinema's presence while separating office areas on the left from the auditorium on the right.

10
Metro Cinema lobby.
Photograph, *circa* 1939, courtesy Metro Cinema.
The two-storey lobby was decorated with American fabrics and Italian marble in deep reds with accents of black, grey, and white. Burmese teak panelling and furniture were made by Bombay's Wimbridge & Co., and exposed metal doors, railings, and grilles were made of aluminium in the USA.

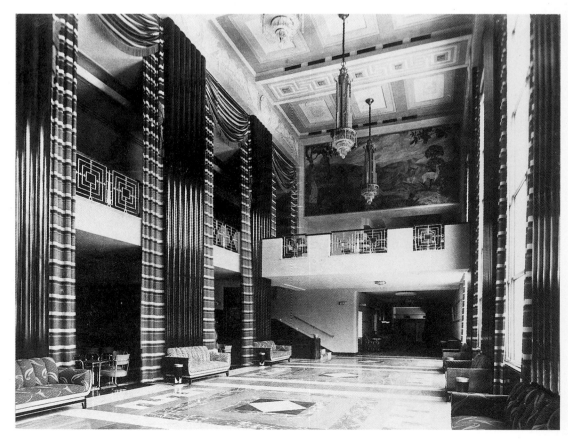

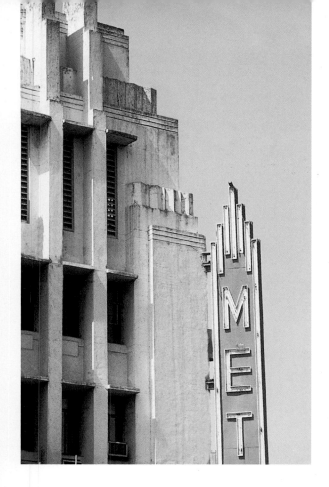

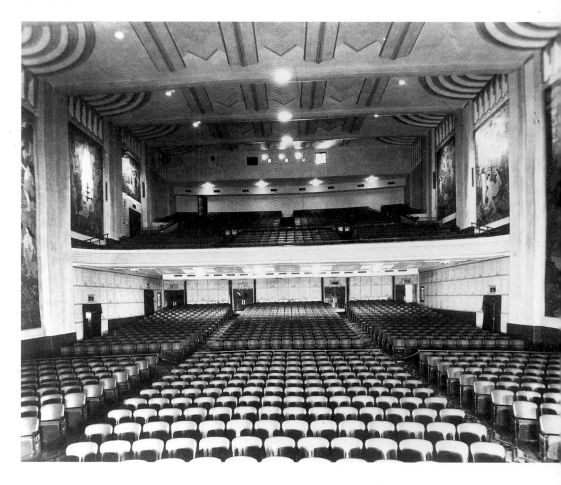

11
Metro Cinema tower.
Art Deco architects were
specially skilled in creating
drama with simple facade
manipulations. Vertical ribs
heightened the appearance of
Metro's tower with deep
shadows by day and thin
lighted edges by night.

12
Metro Cinema auditorium.
Photograph, *circa* 1939,
courtesy Metro Cinema.
Art Deco murals, designed
around Hindu epics to create
"1,500 seats in a setting of
Modernistic splendour".

Conclusions

As in England and the United States, India's earliest experience with the Industrial Age began with the cotton mill and the railroad. Though at first symbolizing a progressive advance, the era was soon associated with the personal deprivation and mechanized cruelty of the factory and the First World War. Industry and the emerging society it helped to create would be redefined, redeemed with the Art Deco cinema.

The Art Deco cinema framed dramatic stories in isolated places of wonder. Simple on the exterior, like the caves of Ajanta and Ellora, the cinemas created complex, richly layered emotional experiences within. Drawing viewers into cool, darkened interiors the Regal, Eros, and Metro distanced people from the world outside, and joined them with another within. While temple spaces were small and private, in contrast with the cinema's enormous, densely populated auditorium, both utilized conscious spatial and lighting devices to present personal impressions of distant worlds.

The Art Deco cinema embodied the Modern elegance and comfort depicted in films, but otherwise unavailable to most Indian audiences. Movie viewers experienced uniquely Modern perceptions as they were introduced to lives socially and culturally removed from their own. Regal, Eros, and Metro and the films projected within them, portrayed society with new symbols, as they idealized Modern experience. Worldwide, films transformed people's beliefs about subjects from love and greed to wealth and politics.

The incredible power of these cinemas was revealed as Art Deco buildings spread throughout India from the 1930s until long after they were built in Bombay. Hindi films, the small town cinemas in which they were shown, and numerous Art Deco-styled products (such as furniture and plasticware) brought the Modern myth to small towns and villages. As the Art Deco style was associated with the urban elite, especially through Bombay's Hindi films, it symbolized success, and became a vital component of life in rural India.

In retrospect, Modernism's inability to meet the expectations of its ever-growing promise has been greatly overshadowed by the overwhelming social transformations of the twentieth century. The Art Deco cinema physically embodied this transformation. With the Regal, Eros, and Metro cinemas, royalty and the god of love were indivisibly linked to the Indian metropolis. Desire for the wealth of kings brought millions to Bombay as it redefined values in small towns and villages throughout India. Although Modernism's promise is yet unfulfilled, its appeal remains. Are we not still drawn — like wise Parsis of old — to the light within, or rather, to the glow of a stillborn dawn?

Notes
1. Quoted from the Regal Cinema's opening night brochure, published by Globe Theatres Pvt. Ltd., Bombay, 1933.
2. Metro Cinema opening night advertisement. *The Times of India,* June 8, 1938.

Figure Acknowledgements
All photographs by Jon Alff, unless otherwise noted.

Bombay's urban form is typical of cities that are centres of trade and commerce — its planning is additive and subordinate to prevailing commercial forces and often not controlled by a singular authority. In such cities where the controlling entity is established after the emergence of the settlement, it requires will, imagination, and numerous physical interventions to transform laissez-faire growth into a coherent Urban Form. In fact, Bombay's history was a result of such a process where many impulsive and incremental gestures contributed to its creation rather than a large-scale superimposition of a pre-conceived order.[1]

This had some shortcomings, as the lack of a pre-conceived "masterplan" resulted in a situation where the city was always ill-prepared for either disaster, major influx, or even simple growth. Improvement in Bombay

thus depended upon a devastating catastrophe, be it an epidemic, fire, or terrible overcrowding. Thus the evolution of Bombay's form was always characterized by outward expansion — flights into utopia; into new areas that carried the hope of improved amenities and quality of life. These incremental additions involved either literally adding bits to the city via reclamation or opening up land through infrastructural interventions such as services and roads. The advantage of this loose open-ended approach to the development of its structure, however, was that correction and adaptations could be made to real needs and perceived deficiencies in the physical environment as the city evolved.

Evolution of Urban Form

From the 1760s, the East India Company had used land reclamations to consolidate the different land masses that comprised the archipelago of Bombay. However, till that point there had been no real impetus for development outside the Fort area where all major activities of importance were concentrated in a contained area. An important factor in giving further impetus to the growth outside the Fort was the fire of 1803 (figure 1). Although it did force the authorities to improve congested conditions within the Fort area, the importance of the fire lies in the

EVOLUTION, INVOLUTION, A PERSPECTIVE URBAN FORM

RAHUL MEHROTRA

inducement which it offered to the growth of the town outside the limits of the Fort.

However, the real planned intervention and additions to Bombay appeared only after the moulding of the islands into one large land mass which began in 1836 with the founding of Bombay's first reclamation company, the Elphinstone Land Company. By the middle of the nineteenth century a fair portion between the islands was

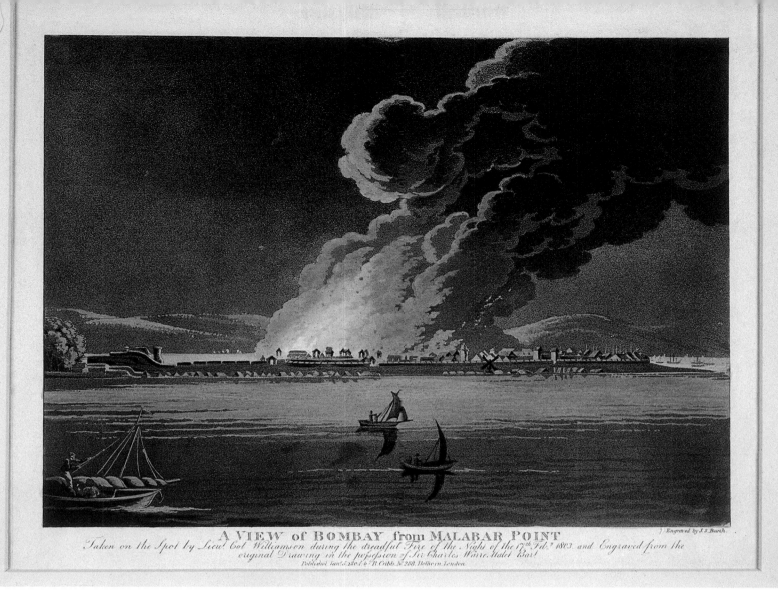

A VIEW of BOMBAY from MALABAR POINT
Taken on the Spot by Lieut. Col. Williamson during the dreadful Fire of the Night of the 17th Feb.y 1803, and Engraved from the original Drawing in the possession of Sir Charles Warre Malet Bart.
Published Jan.y 5 1804 by R. Cribb N.o 288, Holborn, London.

AND THE CITY'S FUTURE:
ON BOMBAY'S

reclaimed and the creation of Colaba Causeway in 1838 welded the southern island of Colaba with the rest of the Bombay islands (figure 2). This was a significant effort to constitute the seven islands into a singular island of Bombay, although by then little had been done to reclaim the foreshore. In spite of the various reclamation efforts, the Bombay shoreline on both the east and the west remained largely underdeveloped. The subsequent share mania and commercial delirium of the 1860s changed that. The unexpected influx of wealth gave Bombay the capital required for regulating and advancing the reclamation of the foreshores of the island as a strategy to open up additional usable land for the rapidly growing

town which was steadily metamorphosing into a city (figures 3-5).

Simultaneously with these efforts of creating new land, strong impetus to urban redevelopment was provided by the removal of the fortifications surrounding the town. Besides producing great opportunities for expansion, the rampart removal also allowed for the restructuring and reinforcing of the Fort area — the image centre for the larger urban area of Bombay.[2] In fact, the magnificent ensemble of Gothic buildings (the High Court, University buildings, Post and Telegraph offices, the old Secretariat etc.) that was built along the sea edge on the new land reclaimed from the ramparts, represents the attempt to

1
"A View of Bombay from Malabar Point Taken on the Spot by Lieut. Col. Williamson during the dreadful Fire of the Night of the 17th February 1803."
Engraved by J. S. Barth from the original drawing by Lieutenant-Colonel William Williamson; published by Robert Cribb in London, 1804.
Coloured aquatint, 22.8 x 32.2 cm.
Courtesy India Office Library and Records (OIOC), The British Library, London.
The fire destroyed and damaged many buildings within the Fort, especially in the northern part. It was observed from Malabar Point by Colonel Williamson (later Major-General, died 1815), who was serving in the Bombay Army. His original drawing which was in the collection of Sir Charles Warre Malet was later published as this dramatic engraving.

2

View of Colaba Causeway and the Fort.
By Johnson and Henderson, *circa* 1857.
Photograph, 20 x 25 cm.
Courtesy Farooq Issa, Phillips Antiques, Mumbai.
Titled "Panoramic View of the Fort from Colaba", this image was published in *The Indian Amateur's Photographic Album* in September 1857. The description noted: "Here we have brought in one view ... Bombay Fort and its associations, — the wall with moat under it, vellard, cotton-bales, dockyard, steam factory and logs of teakwood, Indian Navy Club, mercantile houses, saluting battery, English and Scotch Churches.... The vellard reminds us of the time when Colaba was really an island, tenanted, as Fryer tells us, only by 'the Company's antelopes and other beasts of delight,' or of later times when, as many persons now living well remember, guests would frequently have to hurry from the officers' mess, lest they should be too late for the tide, and unable to reach their beds in Bombay." It was only in 1838 that the Colaba Causeway was built, thus welding Colaba Island and Old Woman's Island to Bombay.

create urban design gestures in the renovated Fort area. This obviously transformed Bombay's skyline and visually structured its western edge. But more than that, the government had seized this opportunity of urban renewal to restructure the form of the town to reflect more accurately its aspiration to become a premier city in the colony where urban technology (both infrastructure and buildings) were employed in an extremely skilful manner to create a cohesive city centre — the symbol of a prosperous city.

This approach of simultaneously physically and visually structuring the city to read as a cohesive whole was furthered by the constitution of the Bombay City Improvement Trust. Its inception in 1898 heralded a new era of systematic planning and urban design in Bombay.[3] From the urban design point of view its most notable contributions were the redevelopment of the Princess Street area and the Hornby Road (since renamed Dadabhai Naoroji Road) development.

The Princess Street scheme (1901-05) extended from Queen's Road to Carnac Bridge and involved requisition of private lands and buildings to restructure an entire area that was extremely congested. The proposal involved opening up avenues and vistas with a view not only to

4
View of Mahim Creek with the Causeway, taken from the terrace of Mount Mary Church, Bandra.
By William Carpenter, 1850-51.
Watercolour, 24.6 x 34.7 cm.
Courtesy the Trustees of the Victoria and Albert Museum, London.
Looking towards the mainland, visible in the distance, the view also includes the hill with Sion Fort (middle distance right) and part of Salsette (left). Mahim Causeway was constructed 1843-45 and this picture shows it still with a bridge at its centre. Sion Causeway was built from 1798 to 1805 at the eastern end of the Creek, and until its construction, Salsette and Bombay were still separate.

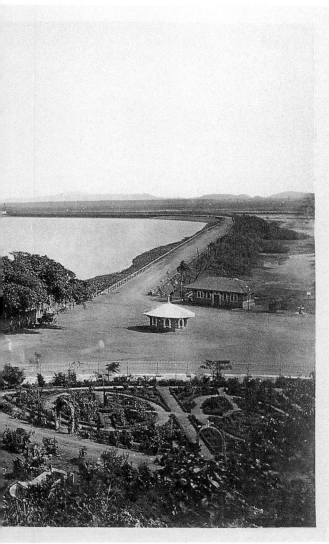

3
(left)
Hornby Vellard as viewed from the northern end of Cumballa Hill looking towards Worli.
By an unknown photographer, 1872.
Courtesy India Office Library and Records (OIOC), The British Library, London.
This thoroughfare was previously known as the Breach Causeway, which connected the northern end of Malabar Hill (Cumballa Hill) with the island of Worli; it also prevented the inner areas of land, or flats, towards Byculla from being flooded. It was considerably strengthened during the governorship of William Hornby, 1771-84, after whom it was renamed. In the foreground beyond the circular garden, Warden Road leads to the left and Mahalaxmi Road (later Tardeo Road) leads to the right. The small pavilion near the beginning of Hornby Vellard covers an old well.

funnel in the sea breezes to the dense inner city overwhelmed by overcrowding, but also to make the experience of travelling through these parts visually more dramatic. Similarly, the Hornby Road development with its continuous arcade acting as a unifying element is an example of the Improvement Trust's structuring of an urban form through mandated regulation.[4] In this case, the arcade was a necessary condition for all buildings. This approach of regulating private development through mandated controls was an important precedent for urban design conception that followed on the larger swaths of newly reclaimed land.

In addition to these contributions, what was extremely important about the Improvement Trust's role in the city was the fact that they also worked to restructure existing parts of the congested inner city. Through a number of housing and urban renewal schemes[5] the Trust improved city amenities in terms of buildings as well as services. Simultaneously, the Trust also held central to its agenda the opening up of new serviced land in the north of the city. Between 1899-1900 the Improvement Trust completed the Dadar, Matunga, Wadala, and Sion schemes to provide additional space for expansion in the suburbs (figures 6 and 7). Through these various schemes, the

5

Distant view of Hornby
Vellard, with Cumballa Hill
(left) and Worli (right) taken
from Chinchpokli Hill.
By Linette Rebecca Griffiths,
1880s.
Watercolour, 11 x 76 cm.

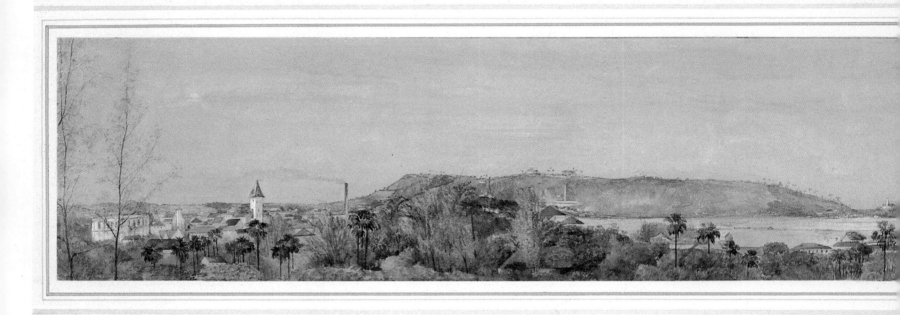

Courtesy India Office Library
and Records (OIOC), The
British Library, London.
This panorama vividly conveys
an image of the entire area
between Byculla with its mill
chimneys rising above the
garden houses, the flats
beyond, and distant hills with
the occasional bungalow. The
temples of Mahalaxmi appear
on a promontory off the
northern extremity of
Cumballa Hill, while mills are
visible on its lower slopes. The
light-coloured building
beyond the tree on the
extreme left is the Victoria and
Albert Museum (Bhau Daji Lad
Museum) while the tall tower
with pitched roof of the
Elphinstone Institution (later
the Victoria Technical Institute,
now the Dr Ambedkar
Memorial Hospital) is nearby.

Improvement Trust introduced not only an approach to planning for the city which anticipated growth and grappled with real problems at various levels (versus only simplistic flights into utopia) but also used urban design to evolve the city's form — an approach that combined concerns for sanitation and infrastructure with those of aesthetics.

In this context, another significant piece that was added to the city in the beginning of the twentieth century was the Ballard Estate scheme. With the restructuring of port activities and infrastructure north of the Town Hall (adjacent to the Alexandra Docks), this new commercial development was planned by the Bombay Port Trust in 1908.[6] The Ballard Estate scheme can really be viewed as a move by the British administration to decongest the Fort area in terms of office space — a reaction to the dense congestion. It also took on a symbolic role of representing a new image for the city as a symbol of mercantile power (figure 8). Interestingly, the new docks on this estate then became the point of arrival for foreign ships and connection for rail traffic going upcountry — a gateway to the city.

Similarly, the Apollo Reclamation (south of the Fort area) which was completed in 1869, over the next three decades facilitated the erection of buildings like the Taj Mahal Hotel, the Yacht Club, and later the Gateway of India. This not only led to intensifying the "grand" image of the city for the visitor arriving by sea, but also led to the creation of residential buildings between the Apollo Bunder promenade and the Colaba Causeway (figure 9). Following the ground rules now established by the City Improvement Trust, this area evolved as another well articulated precinct in south Bombay.[7]

Although a number of smaller schemes kept city

authorities busy up to the 1920s, the next significant proposal that caught the imagination of planners was for Back Bay. In 1929, a large government loan was floated to back a scheme which reclaimed over a thousand acres of land west of the renovated Fort area with Marine Drive — a sweeping promenade and road that was to be laid out along the magnificent natural bay, across the newly reclaimed western foreshore.[8] In 1940 it acquired its present state; however, the entire promenade was never completed — even today it peters off at the southern end, protected by four-legged concrete tetrapods. But what this sweeping gesture gave Bombay was an incredible promenade that captured and welded the entire bay edge into one.

This proposal began with high standards regarding the type of accommodation it was going to provide with the inclusion of public amenities and social institutions.

However, the government was determined to maximize profit from the scheme, and thus rationalized the layout and subdivisions on the land with a view to obtaining maximum densities. Thus, a project overlooking a beautiful bay, that had started with great potential, degenerated into a commercial venture. This was a clean break from the densities and space standards that the British had followed in their upper-class housing layouts at Cuffe Parade, at Worli Seaface, or at the Apollo Reclamation. It was, in a sense, heralding a new era of contemporary urban development which is founded on narrow intentions, overly pragmatic requirements, and extremely limited urban design considerations.[9] Nevertheless, this scheme added an incredible amount of housing stock to south Bombay, causing the old centre to swell further rather than the city diversifying in the form of new growth centres further north.

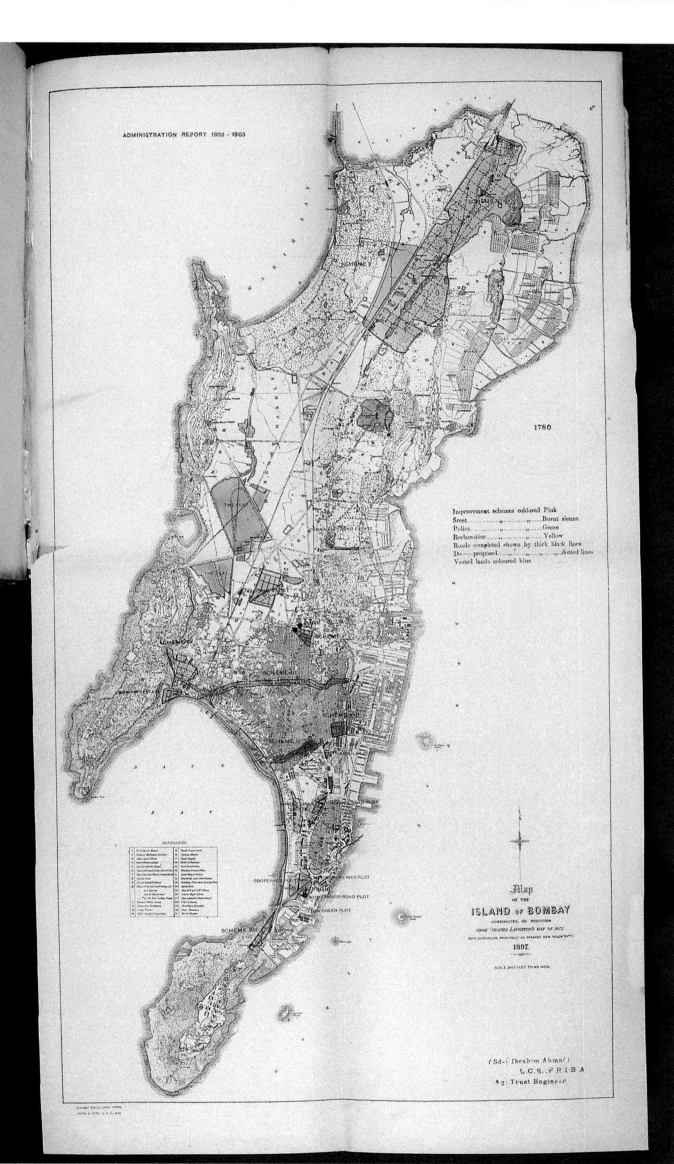

1780

Improvement schemes coloured Pink
Street..................................,,..................Burnt sienna
Police...............................,,......................Green
Reclamation.....................,,......................Yellow
Roads completed shown by thick black lines
Do——proposed............,,............dotted lines
Vested lands coloured blue

REFERENCES

Map
OF THE
ISLAND OF BOMBAY
CONSTRUCTED, ON REDUCTION
FROM COLONEL LAUGHTON'S MAP OF 1872
WITH ALTERATIONS, PRINCIPALLY AS REGARDS NEW ROADS, ETC.
1897.
SCALE 2400 FEET TO AN INCH.

(Sd-) Ibrahim Ahmadi
L.C.E. F.R.I.B.A
Ag. Trust Engineer

6
Map of the Island of Bombay,
constructed on reduction from
Colonel Laughton's map of
1872, showing the
Improvement Trust projects.
By Ibrahim Ahmadi, Trust
Engineer, published in the
Administration Report of
1902-03.
Courtesy India Office Library
and Records (OIOC), The
British Library, London.
The Improvement Trust
projects covered a wide range
from Improvement schemes,
Police Housing schemes to
Reclamations and the creation
of roads in newly reclaimed
areas as well as through
congested parts of the
existing city.

7
View of a garden in the Parsi
Colony at the Dadar-Matunga
development, carried out by
the City Improvement Trust.
By an unknown photographer,
1928.
Photograph courtesy
Sharada Dwivedi.

8
Aerial view of Ballard Estate.
By an unknown photographer.
Photograph courtesy
Sharada Dwivedi.
Note the contrasting urban
fabrics of the old Fort area
(bottom of photograph) and
the newly laid-out Ballard
Estate.

9

View of the Apollo Bunder promenade with the grand Taj Mahal Hotel, by architects D. N. Mirza, S. K. Vaidya, and W. A. Chambers, completed by 1904.
Photograph courtesy Sharada Dwivedi.
The Taj Mahal Hotel, the Gateway of India, and the Yacht Club nearby, further intensify the "grand" image of the city.

Urban Involution

Although up to the 1930s the government and the Improvement Trust had opened up land in the north, it seemed obvious that as the major job locations were yet limited to the southern core of Bombay it was extremely difficult for the city authorities to disperse the population away from the southern parts of the island city. This therefore resulted in the "huddle" around the Fort area at the southern tip — a sort of image centre that had evolved around the attractive and historically compelling Back Bay.

10
View of the development in
Cuffe Parade — a relentless
landscape of high-rise
buildings.
Photograph:
Subrata Bhowmick, 1997.

It was only in the 1940s when the industrial elite of Bombay and the indigenous business class started encouraging growth in the suburbs, that activity truly began in these areas. These patrons were instrumental in financing living enclaves for the middle classes and poorer members of their communities.[10] This move to the suburbs, and eventually into the Greater Bombay region was also an outcome of growing pressure on the island on account of migration from Pakistan and later distress migration from Bombay's larger hinterland — independent India.

Recognizing the immense explosion in population that the city was going to experience in the post-independence era, planning approaches and urban design focused on larger visions — visions of welding together a Greater Bombay region which comprised many self-contained areas such as in Bandra, Kurla, or Oshiwara that could be created by the dispersal of residential and commercial activity in the larger region around Bombay. In 1964, a Development Plan for Greater Bombay was produced and it was this document that was to significantly determine the future form of the city in the coming decades.

Besides the usual landuse recommendations, the 1964 Development Plan gave birth to two concepts that were going to be crucial to the direction and form of growth in Bombay till the end of the twentieth century. The first was the introduction of the FSI concept. FSI or Floor Space

Index is the ratio of the combined gross floor area of all storeys of buildings to the total area of the plot or premise on which they are situated. This index of FSI was introduced in the Development Plan and indices were fixed for different areas in the city. These were based on the perceived holding capacities of different localities and ranged from 1.33 to 2.45, but for the Back Bay Reclamation (or Nariman Point development) the FSI was fixed at a high of 3.5 to 4.5!

This imposition of abstract mechanisms such as FSI to govern the urban form of the city was a clean break from the earlier approach, where rules that governed urban form were formulated area-wise and were based on perceived needs. This approach was, however, relevant only when the city grew incrementally. Now, planning perceptions were attempting to prompt a new vision for Bombay — a vision which emphasized macro planning and thus needed standardization for ease of administration and implementation.

What this concept of FSI did, was to impose a somewhat blanket index and set of standardized building by-laws across the entire city. These rules resulted in an all-pervasive high-rise building pattern (figure 10), regardless of whether they were schools, apartments, hospitals, or offices. This began to drastically alter Bombay's skyline, natural features, and architecturally significant neighbourhoods and resulted in the city being recast in an identical physical mould from Colaba in the

south to Versova in the north. Ironically, as a result of these standardized by-laws and the FSI concept, a socialist housing type of equal sized repetitive apartments set in an even more monotonous building block (sans decoration) was to house in Bombay the country's greatest capitalists (figure 11).

The second significant direction and idea that resulted from the 1964 Development Plan was the idea of New Bombay. As a "reaction" to this plan which propagated growth in the northern direction, in 1964 Charles Correa, Pravina Mehta, and Shirish Patel prepared an alternative plan which proposed that growth be directed eastward to the mainland across the harbour. In a sense, this concept went beyond the Greater Bombay idea and recognized that any satellite commercial centres at Bandra-Kurla or elsewhere in the suburbs, or in any residential areas around Bombay, would only add pressure to Greater Bombay. Therefore, they suggested the creation of a self-contained twin city.[11] The idea on which their proposal hinged, however, was that of the state government moving to New Bombay. By locating government offices in the new city, the idea was to use that resource to get the twin city going as also to get people to commute on an east-west axis instead of a north-south axis. The intention was to distribute the existing population between the old and new city and also to absorb additional migration.

The significance of these two landmark changes in the planning approach is that they both addressed diametrically opposite and, in a sense, contradictory issues. While the New Bombay idea was concerned with diversifying into more dynamic and long-term options, the underlying thrust of the FSI concept was the rationalization of the process of growth within what was perceived as underutilized urban areas. The idea was that through the standardization of by-laws and building limits (FSI) across the city, landowners were being equitably dealt with. In other words, everyone in the city was allowed to build the same amount in the same fashion, in a sense overriding the more logical earlier approach where the buildable area on a piece of land was determined by the use designated to it. It is for this reason that in Bombay there now exists a ridiculous situation where public authorities such as the Railways and Port Trust all "desire" to exploit the FSI available to them and re-develop their landholdings to realize the incredible monetary gain that would automatically accrue on account of extremely high land values. Similarly, the present pressure on the textile mill lands stems from this shift in policy. For once a millowner recognizes the buildable potential on his vast tracts of land, it becomes clear that developing the available FSI is far more profitable than running an industry. This pressure to develop land designated for public and other specialized uses is directly linked to land values, and as values increase in the city, the pressure on areas such as the mill lands, warehousing zones, port-related facilities, and railway properties becomes immense.

11
The socialist housing typology of a repetitive building block sans decoration came to characterize the contemporary architecture of Bombay.
Photograph:
Bharath Ramamrutham, 1996.

This has not only negated the intrinsic character of the city in which each new addition was being dealt with differently, but has also created a situation which implicitly in one fell swoop raised the total amount of built-up area in the city. While this was a result of the government's response to the anticipated growth in the city and its desire to simplify administrating building sanctions, what it did was to create enough opportunity for the city to densify within the by then established Greater Bombay region. This, in the coming years would not only retard the growth of New Bombay but result in an irreversible densification of the city, an overburdening of its existing infrastructure, and a deadening monotony in its urban form.

Simultaneously, in spite of the recommendations to ban any further growth in south Bombay, the state government proceeded not only with the reclamations at Nariman Point, Cuffe Parade,[12] and New Navy Nagar but continued to expand its own activities in south Bombay (instead of moving to New Bombay), thus further intensifying activities in the old centre. Strangely enough, as the city sprawled out on the north-south axis, the "drama" of capturing prime locations played itself out in the east-west direction, with development taking place around and adjacent to the old core area or image centre, as well as the Back Bay.

With these events, the involution process was complete — the city authorities sought more to re-engineer the existing fabric without simultaneously diverting into new modes like New Bombay. This resulted in the city stretching out to the north, following the pattern of dormitory towns that the New Bombay plan had warned would be detrimental to the long-term interest of the city. Thus by the 1990s, the city sprawled out in the north toward Versova, Vasai, Virar and beyond in the form of unchecked pieces of urban areas grafted and organized around and along transportation lines. There now existed an inability by city authorities (who had resorted to standardized building laws) to consciously give any form or expression to the built environment. What finally manifested itself was a sharp physical duality with kinetic growth, in the form of squatter settlements and slums, forming the majority of the built environment of Bombay (figure 12). In any case by the 1990s issues and problems had transcended the question of style and design. The issues of the physical urban form had been replaced by abstract mechanisms to define the form of the city — economic equations, city revenue and taxation data, and demography had replaced architecture and urban design which had earlier been the prime instruments in defining the city's form.

12
Squatter settlements now house the majority of the city's population.
Photograph:
Bharath Ramamrutham, 1996.
These structures are put up incrementally, using a variety of building and other materials.

13
The "kutcha" city occupies
any interstitial space it finds,
including slopes of hills, the
space below transmission
lines, and along the water
supply pipes.
Photograph:
Bharath Ramamrutham, 1996.

14
A contemporary view of
New Bombay.
Photograph:
Bharath Ramamrutham, 1996.
The boulevards and grid-
patterned road system that
characterize New Bombay are
an outcome of the planned
infrastructure that played a
leading role in the
development of the twin city.

16
(following pages)
Panorama of the Fort area,
looking north.
Photograph: Rahul Mehrotra,
1986.
The maidans separated this
historic core of the city from
the later development.

15
View of the Parel mill area
with its characteristic
chimneyscape.
Photograph: Rahul Mehrotra,
1992.

Embracing the Future

In examining the evolution of the city the fact
emerges that historically in its development, outward
expansion was consistently balanced with inward growth
— involution. However, what becomes evident in the city's
evolution after the 1950s is the diminishing scale of
interventions that were needed to propel its outward
growth. This resulted in a situation where efforts were
limited to engineering the existing fabric — a process of
involution where the city took on the function of absorbing
more and more people and activities on the same space
rather than diversifying to more dynamic modes. Thus the
city continued to become internally more complicated and
susceptible to malfunction. Today, with the massive shifts
in demography where the urban poor form the majority
of the population and live in the city's interstitial spaces,
the process of involution is more acute (figure 13). Thus to

17
(previous pages)
Panorama looking over the
eastern Dock areas towards
New Bombay.
Photograph: Rahul Mehrotra,
1986.

untangle this web of internal complexity, Bombay would naturally have to again aspire to evolve in the larger region simultaneously by opening up serviced accessible land for its swelling population. In fact, given the combination of two crucial inputs — an emerging employment base and a completed rail link — New Bombay once again holds the potential to become a critical big move in the evolution of the city and possibly being able to entirely alter its relationship with the hinterland (figure 14).

Also, as the probability of a major reversal in population concentration in Bombay is unlikely, efforts should simultaneously be aimed at improving the internal efficiency of the existing urban form. This would include exploring the possibilities of re-use and approaches to recycling land and buildings — working with existing centres and weaving these environments into the larger growth patterns of the city. For, the existing city must respond and regenerate itself if it has to survive the accelerated pace of transformations that are engulfing all of urban India. Thus it is critical now for Bombay to decide what must be conserved and what renewed. That is to identify the components of the urban system that can be transformed to other uses (perhaps for an interim period) without destroying the essential physical form or architectural illusion that the city presents. In fact, the essential components of the city would have greater ability to survive on account of the adaptability of its more flexible parts. For example, the mill areas of Parel which cover approximately 1,560 hectares (15.6 sq.km) are a key component in the future of the city's renewal process (figure 15). If appropriately used, this large acreage in the geographical centre of the city could compensate for the perceived deficiencies that exist in the urban system — schools, hospitals, affordable housing, and an entire gamut of essential services critical for the well-being of the majority of Bombay's inhabitants and especially those that already occupy these areas.

Similarly, conservation strategies for the older historic areas such as Fort will have to be woven into visions and plans for the larger region (figure 16). For, the regeneration and inward structuring of these areas simultaneously will have to be related and made relevant to the regional planning issues and structure that New Bombay takes. In fact, often an involution process should be intrinsically linked to schemes for the city's outward expansion — this would truly be an evolutionary process. Therefore, to effect conservation and renewal policies for the historic Fort area or mill areas in Parel, policies should be linked with strategies for New Bombay. For example, if the historic areas are to be encouraged to take on the role of Central Business Districts or Financial Centres, then non-compatible uses in south Bombay like "government" should be moved to New Bombay simultaneously. This would not only open up space in south Bombay to accommodate ancillary functions for the financial centre but would also give great impetus to the growth of New Bombay by the presence of the government which would serve as a catalyst, as was suggested in the original (three decade old) proposal for New Bombay.[13]

In the same manner, the entire eastern coastline of the city has increasingly redundant and semi-redundant use situated on it. Could not these functions of warehousing, port facilities etc. be gradually phased out to Nhava Sheva (giving New Bombay impetus) to open up the city's congested eastern shoreline? Not only would this land add substantially to the renewal process but it would also open the city's view to New Bombay. To visually see the mainland would perhaps make connecting it more plausible. And it is by opening up this critical stretch that the harbour bay would become the nucleus between parts of old Bombay and New Bombay. And in a sense by the simultaneity of these gestures — one of opening up a new area and the other of recycling an existing zone — the oldest parts of the city will metaphorically embrace the future (figure 17).

In fact it is precisely in understanding the importance of "making" different gestures simultaneously that lie solutions for the city's renewal. In the recent past however, acute myopia amongst politicians has deprived the city of long-term or evolutionary gestures. In fact the last three or four decades in Bombay's history where the city has been governed by politicians with rural constituencies have been characterized by short-term decision-making, with increasing numbers of decision-makers "claiming" the city and a minority interested in the "making" of the city.

Today Bombay (perhaps) for the first time in its contemporary (post-independence) history has a number of ministers in the Maharashtra state cabinet elected from the city. Will the politicians whose constituency is Bombay (Mumbai?) be able to convert the immense inherent

potential simultaneously through big and small moves, through evolutionary and involutionary processes' For it is eventually this political will coupled with imagination that will deter the looming apocalyptic urban situation and propel Bombay effectively into a future of immense possibilities.

Notes

1. Examples of some cities which were conceived with predetermined masterplans are Jaipur, Madurai, Chandigarh, and New Delhi.

2. After the removal of the Fort walls what emerged as a result of a carefully orchestrated urban design excercise were east-west and north-south axes through this renewed precinct of the Fort wall. The east-west axis ran from the Town Hall through Horniman Circle, the public buildings on the western edge and ended with a vista across the bay. The north-south axis was anchored at one end with the grand Victoria Terminus (1878-88) and later at the other by the Gateway of India (completed 1924), a monument that symbolized the ceremonial entry into Bombay. This clearly was the major public avenue of the renewed town. In fact, the bow-like cross-axis within had now emerged as an almost inherent structure of the town and was further reinforced by the construction of Flora Fountain at the intersection of the axes — a sort of punctuation in this new urban composition.

3. The City Improvement Trust was a compact and effective body whose responsibilities included formulating specific development plans and controls for different parts of the city. The Trust acquired private lands, redeveloped old and congested areas, and prepared layouts for underdeveloped portions of the city. It was set up as a regular statutory authority with the specific financial support of the Government of Bombay and the Municipal Corporation.

4. This development along Hornby Road was also an important component in unifying the renovated Fort area — of connecting the crescent of public buildings south of the Flora Fountain (Elphinstone College, Sassoon Library, the University, Watson's Hotel etc.) to the grand Victoria Terminus at the north end. This link was crucial in unifying and weaving together disparate elements in the composition of the newly developed city core.

5. Some of the Improvement Trust schemes on the western edge of the city included the Colaba Reclamation, Wodehouse Road development, Marine Lines, Sandhurst Road, Chowpatty Estate, Gamdevi Estate, Lamington Road, and Agripada. On the eastern side of the city the Improvement Trust schemes included the Crawford Market Estate, Nagpada development, Parel Road, the Racecourse, Dadar Hindu and Parsi colonies, the Matunga Five Gardens scheme, and the development at Sion.

6. Ballard Estate covered approximately twenty-two acres and was laid out between 1908 and 1914 by George Wittet who, as consulting architect to the Port Trust, evolved the control guidelines for its forty-three blocks of office buildings. Most of these buildings were built in a kind of "European Renaissance" spirit and the Estate is characterized by the uniformity of building design, heights, and architectural styles — a good example of architectural control for public utility services. Of importance are the road layouts which create vistas as in the European design tradition.

7. It comprised forty-three acres and formed one of the new residential districts of Bombay, with blocks of flats and an ornamental garden of almost an acre for the residents. Shops were combined at the lower floors and the commercial strip was unified by the mandated requirement of the arcade.

8. Until 1926 this scheme, which had begun in small spurts, was riddled with controversies about the costs and technology to be employed for the reclamations. Originally, the Western Railway (then known as BB&CI Railway) ran along the seafront, and the great New Gothic buildings — the High Court, the University, the Old Secretariat, all formed part of the grand esplanade (now the Oval Maidan) along the sea's edge. After this came the reclamations of Queen's Road followed by the Marine Drive. The trade depression of the 1930s brought a drop in land values and fearing that reclamation cost might exceed profits on land disposal, the scheme was cut down in size from 1,145 to 552 acres.

9. Space standards also dropped because of the rise of single occupants, usually male members of a family who came to Bombay for employment. In any case, the Back Bay Reclamation project symbolized a major shift in the spirit of the city. A shift not only in popular architectural styles, but also as an indicator of the growing "commercialism" in property development — land, buildings, and roads rose from the sea over a very short period of time. Many of the buildings erected for residential use were now built in reinforced cement concrete and employed the "flat" or apartment system of housing. This housing was tailored to the cosmopolitan middle class and upper classes of the city's population and was built in a style that was vaguely a combination of the International style and Art Deco from America. Many buildings in Bombay that coincided with the great reclamations were built in this style and used these motifs. These included residential buildings, office blocks, and a number of theatres in the city. Their development rapidly replaced the image of Bombay — from a Victorian city to a cosmopolitan, international modern metropolis!

10. Examples of this are the Hindu and Parsi colonies at Dadar, the numerous baugs or housing estates built by the Parsis. Similarly, industrialists like the Godrejs built housing colonies in Vikhroli for their workers.

11. The starting point for this idea of a new twin city across the harbour was the already planned extension of Bombay's port at Nhava Sheva. There were also two industrial zones, Thana-Belapur and Taloja, for which housing and ancillary services would in any case have to be provided and the Thana Creek Bridge was also under construction. However, although these existing components could jump-start the process, they were not adding up to any clear end result. Thus, what the authors of the twin city idea had astutely done was to re-orchestrate these already proposed components in a new fashion, with fresh meaning. On the mainland across the harbour, the proposed New Bombay covered an area of about 344 square kilometres, integrating ninety-five villages spread over the districts of Thana and Raigad — this new city was proposed to have two million people.

12. In its first incarnation, this area was to be reclaimed as a continuation of Marine Drive, with an 80 per cent residential use and 20 per cent mixed and commercial use reservation, much like what had taken place in the previously reclaimed areas of the Back Bay scheme. In fact, the new Sachivalaya (now Mantralaya) at Madame Cama Road, together with the Life Insurance Corporation building and the garden between the two, created a mini-commercial zone. Furthermore, the government offices would form the core functions and symbolically signal a clear purpose of the new city for the state of Maharashtra. Therefore, some road, bridge, and waterway connections to the mainland from south Bombay were proposed. In retrospect, these big government establishments were perhaps clearly the early signals indicating the direction which the extension of the Central Business District was going to take. For a myopic state government in the 1970s, it seemed easier to place related commercial activities across the road, rather than across an entire bay, in New Bombay.

13. There are a number of other issues like the Rent Control Act and Urban Ceiling Act which will have to be addressed simultaneously for a successful upgrading of Bombay's dilapidated housing stock.

Acknowledgements
I would like to thank Sharada Dwivedi for all the help that she has provided in the preparation of this article as well as for giving permission to use material and reproduce illustrations that were researched as part of our work for the book, *Bombay — The Cities Within*.

2
A general view of the Nariman
Point and Cuffe Parade
developments on reclaimed
land.
Photograph: Rahul Mehrotra,
1986.
Such developments on
reclaimed land are
characterized by monotonous
and repetitive high-rise
building blocks devoid of
urban design considerations.

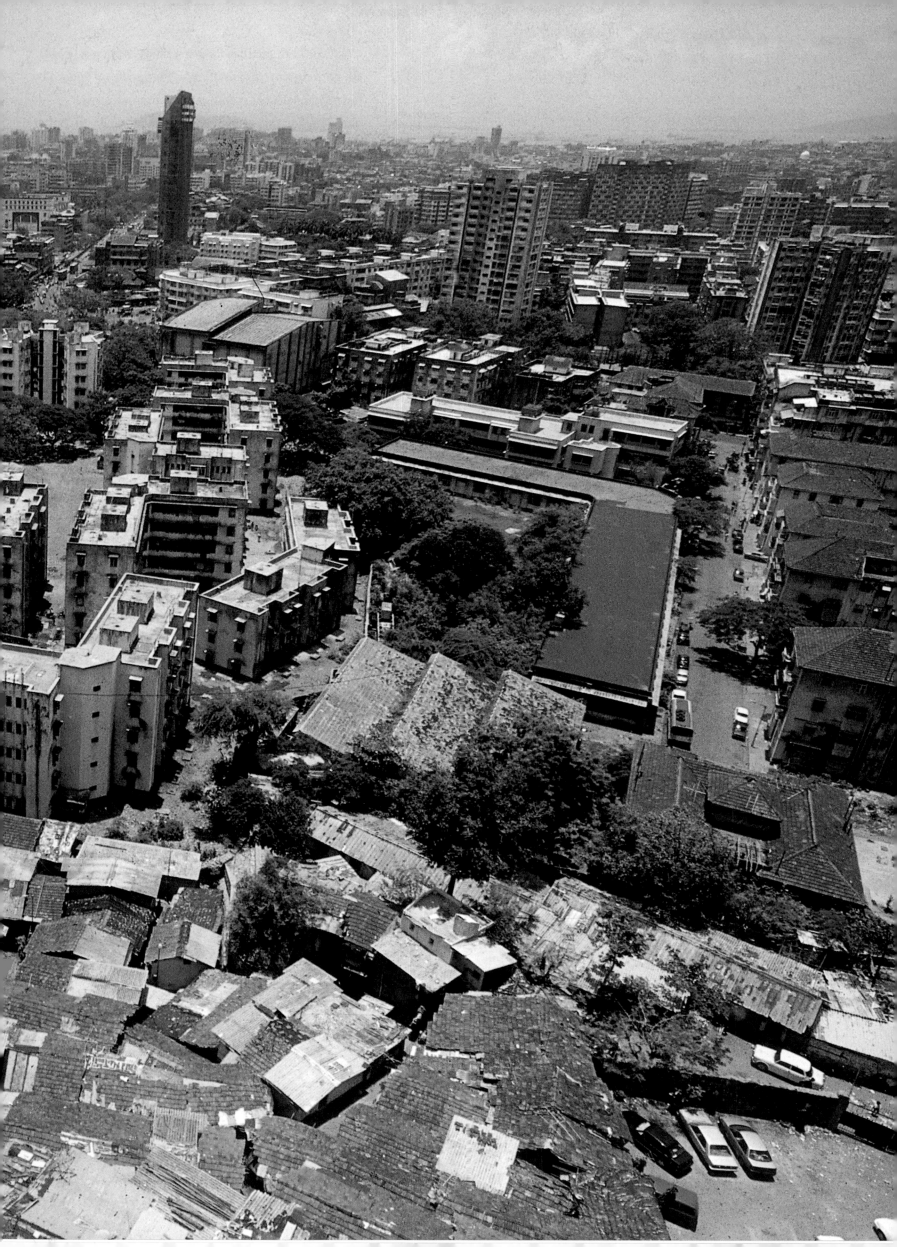

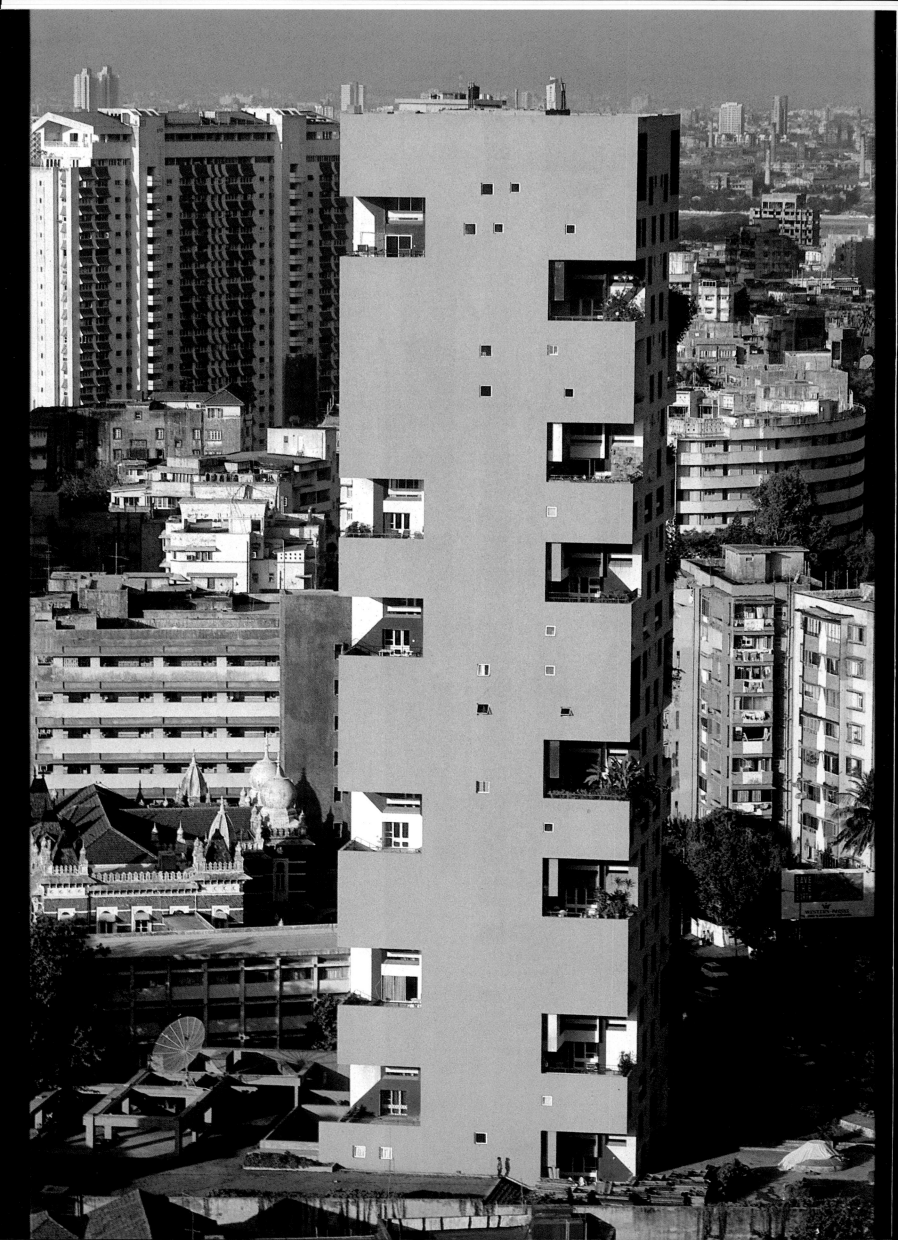

11
View of Kanchenjunga.
Photograph:
Bharath Ramamrutham, 1996.
This apartment block
designed by Charles Correa in
1970 contains duplex flats
with double-height verandah
gardens. Strategically placed
on the major arterial Pedder
Road (now Gopalrao
Deshmukh Marg), this
building exerts a powerful
presence on the south
Bombay skyline. In the
background are seen typical
examples of "only a slightly
decorated version of
governmental minimumism"
promoted by the builders in
the '50s and '60s.

12
A private house at Versova,
built 1973 onwards.
Photograph: Himanshu Burte.
Designed by Nari Gandhi, the
house is typical of his work,
where a rich array of materials
was used with a high standard
of craftsmanship.

13
The Jehangir Art Gallery at
Kala Ghoda.
Photograph:
Bharath Ramamrutham, 1996.
Designed by Vanoo Bhuta
with Durga Bajpai in the early
'50s, while employing a
modern vocabulary, it also
relates to its historic setting in
the context of the nearby
buildings on Rampart Row
(now K. Dubash Marg) and
Esplanade Road (now
Mahatma Gandhi Road), and
to the Prince of Wales
Museum in the adjoining
grounds behind.

The exemplar in Bombay is of course Charles Correa, among the few Indian architects whose work commands a high international standing on its own merit. Kanchenjunga (figure 11) stands angled and tall by the arterial Pedder Road, as a reminder of his influence on the better architectural work in the city. The major portion of Correa's work is situated outside Bombay. Yet much work on Bombay's architectural scene shares formal strategies — subtractive compositions of mass and space (Corbusian inspiration), dramatic unbroken surfaces, layered colour-fields etc., with conceptual or other variations — with Correa's work. The linkages are indirect, and rarely derivative in the best work, but they are difficult to ignore, especially as there are so few departures in the opposite direction — that of additive compositions of mass, the exploration of the sensuous and structural possibilities of materials. Only one architect seems to have held up that other end of spirit and scale in the city.

Nari Gandhi built only ten or twelve buildings in almost forty years of practice, most of them farmhouses outside the city for some of its wealthy residents. His work displays a highly rigorous whimsicality, a sensuousness tethered to a feel for the structural possibilities of every material — whether stone, glass, or metal (figure 12). While much of his approach to architecture was shaped during his apprenticeship with Frank Lloyd Wright, Gandhi walked his own path completely outside the field of "normal" professional practice in the city.

Such hermits are of course rare. Anyway, they make a positive difference to the cityscape ultimately, who make the best of the system without getting trapped in it.

10
View of Jindal Mansion on Pedder Road (now Gopalrao Deshmukh Marg). Photograph: Bharath Ramamrutham, 1996. Three additional floors were added onto a Heritage building after consultations with the Heritage Committee. The supporting structural members in RCC for the upper three floors were integrated with the old, creating a fairly seamless addition.

new upper floors of older buildings are more pleasingly camouflaged.

One successful case of addition of upper storeys to a listed building is that of the Talati-Panthaky design for the Jindal Mansion on the east side of Pedder Road. Here the architects took a vertical stucco design element in the original external moulding, and after erecting the framework to support the upper storeys, enclosed the framework in a new skin of stucco carrying the original decorative motifs. The upper floors were also set back from the front elevation to soften the impact of the superstructure (figure 10).

The main learning from these cases remains the issue of height control. In precincts where a uniform skyline is a key element of an urban form which is deemed worthy of conservation, a uniform height ceiling becomes an imperative for conservation to succeed.

Evelyn House — Newer is not Necessarily Better

It was always more difficult to deal with cases of Grade II or III buildings, or precincts, than with Grade I buildings where the necessity for conservation was rarely disputed. Evelyn House is a period-style residential building — ground plus four storeys — occupied by officers of the Bombay Port Trust (BPT) on Ramchandani Marg, a high quality waterfront precinct that stretches from the Taj Mahal Hotel south to the Radio Club. The BPT proposed a new building in place of the old one, on the grounds that many more apartments could be accommodated in place of the few large apartments in the present building.

Not only did Evelyn House form an integral part of this waterfront series of buildings — each distinctive in its stylistic elements but all part of a perfectly coherent group — it was in itself a structure with many pleasing decorative elements, especially its verandahs, awnings, balcony railings, and semicircular windows. The precinct would be shattered if Evelyn House were to be replaced by a modern PWD designed high-rise building. It could even trigger similar developments in adjoining properties.

The Heritage Committee urged the BPT to consider renovation of the existing structure, if necessary entirely reconstructing it from within to obtain the large number of

smaller dwelling units desired. However, once large government agencies commit themselves to a project, it is often impossible to get them to change course. The last resort is a recourse to litigation unless a single individual at the top of the organization is courageous enough to rethink the project.

In this case, Heta Pandit from the Heritage Committee, along with Pheroza Godrej, Joint Honorary Secretary of the Indian Heritage Society, Bombay Chapter, took it upon themselves with the help of conservation architect Ved Segan, to engage the Chairman and senior officers of the BPT in a detailed analysis of the floor area in the existing building and demonstrated how it could be rebuilt, internally, to yield the number of additional apartments desired.

After prolonged discussions, during which the Chairman of BPT showed a keen interest in conservation, it was finally agreed to proceed with a plan involving major internal restructuring, while retaining and restoring the exterior of the building — all at a significantly lower cost than the original scheme. This was another landmark case and helped to keep a threatened precinct intact.

Fires in the Fort — and Phoenixes Rise

The difficulty of promoting a conservation ethic in the context of contradictory building regulations was provided by two cases in the Fort area, where buildings had burnt down and the proposals for their replacement raised some intractable issues.

In 1973, a fire had destroyed Alice Building on Dadabhai Naoroji Road, near Flora Fountain and, in conformity with the prevailing regulations requiring new buildings to be set back from the original streetline (to permit future road widening), a new structure was erected a dozen or so metres behind the kerb. Alice Building was part of one of the finest stretches of Heritage buildings in the city, where a strong homogeneous mass of part Gothic, part Renaissance, part modern buildings are held together by a mandatory arcade at ground floor on an unbroken setback line (see figure 8). The result is a covered shopping arcade of unparalleled quality.

More recently, fires had destroyed Handloom House (also on D. N. Road), a well-known landmark originally built as the Fort House by the first Indian Baronet Sir Jamsetjee Jeejeebhoy as his residence; and Jhulelal House (on Mahatma Gandhi Road) opposite the Bombay University buildings, where the Indian National Congress had held its historic meeting to launch the movement for an independent India. Both buildings were also of great architectural interest and while some of the exterior walls were standing, the buildings were otherwise entirely gutted.

The redevelopment proposal for Handloom House

Such a proposal was originally made by the Barve Report of 1956, which recommended a direct connection between Bombay and the mainland across the Thana creek. The precise words of the Report bear quotation:

"The Communications and Traffic Panel have therefore viewed the problem from the wider angle, and it is on this account that its first and main recommendation is to the effect that the error of history must be corrected and the handicap of geography must be overcome by developing a city on the mainland-side of the Bay. Such a development would have multiple effects. Firstly it would relieve the pressure on the railways and the roadways that now have to move a considerable amount of traffic between the North and the South; secondly, it would provide room for the development of a Port on the other side of the Bay, thereby again reducing the demand for transport in the City of Bombay; and thirdly, it would open up the possibility of the development of a new township, which would in time not only draw away from the island of Bombay the over-flow of the industrial units and residential colonies, but also enable the City to develop in an orderly manner.

"There is little doubt that the development of the mainland opposite the Island of Bombay would really be a master-stroke; the progress of the country would seem to demand the siting of a new township on the mainland of the God-given harbour of Bombay. For it would permit the building of a series of docks, which would serve as termini of the vast hinter land of Maharashtra and Andhra, eliminating Bombay's precarious dependence on the bridges which link the island to the mainland. From the angle of security, a port on the Eastern side of the Bay would be ideal. In any case, the Defence Services would most certainly welcome such a development; immediately even without a railway connection, access to the Bombay-Poona route is easy. It is understood that consideration has already been given to the building of a Naval Harbour in that area; and if such a lead is followed, the growth of a satellite town would be a matter of course."

14. *Opening up the mainland opposite Bombay.*

15. *New Centre will act as a catalyst in the development of the mainland.*

Can such a centre be created?

There have been several examples through history of significant cities created around governmental centres. These examples range all the way from Washington D.C. to Chandigarh and Brazilia in recent times. Perhaps the closest parallel to Bombay would be the creation of New Delhi 50 years ago, a

creation which involved the construction of a new centre 15 miles away from the old city. It was a manoeuvre boldly conceived and executed and today the benefits of this decision are unquestioned.

It is obvious that in Bombay the importance of the second centre can be assured if Government undertakes to participate actively by moving its offices there and creating a new capital for the State. Where new capitals have been created it has been found that they not only fulfil the functional requirement of creating efficient administrative centres but they also become a source of pride for their citizens.

16. *The Capitol : Rome*
by Michaelangelo. A. D. 1540-1644

17. *Capitol Complex : Brasilia*
by Oscar Niemeyer. (1960)

TO SUM UP: The development across the water is essential to the orderly growth of Bombay; at the same time it also presents a unique opportunity to establish a new capital for the State of Maharashtra. This could be done without incurring any of the costs usually associated with creating a new capital city in undeveloped area; its creation would give a new image and new vitality to the citizens of the city and the State.

In the following pages are included further details of the city just outlined. This city is not an extravagant proposal, i.e. something divorced from reality. In fact most of the decisions have already been taken by forces operating on this city. This scheme attempts to make a *meaningful* pattern out of the haphazard occurrences which are taking place. At the present moment there are several different bodies—as for instance, the State Government, the Municipal Corporation, the P.W.D., the Railways, the Port Trust, the B.E.S.T., the Defence Services, etc., all with interests in this area and all working in a largely unrelated manner (for instance, Municipal sources state that the reason why they have developed their Plan in a northerly direction is that they have no jurisdiction over the Panvel area). It is essential, therefore, that a single co-ordinating authority be created so that an overall pattern of growth can be developed.

In other words, the Government should establish at the earliest possible date a Chief Co-ordinating Authority on the highest level whose directive would have to be followed by all organisations working in this area. Such a body would have the power to *commission* a proper master plan and, furthermore, to *implement* it.

The creation of this Authority is the single, most crucial problem we face.

Karjat link.

a created on mainland.

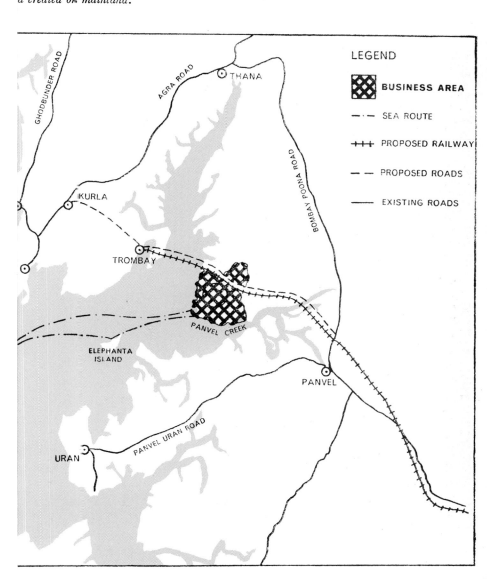

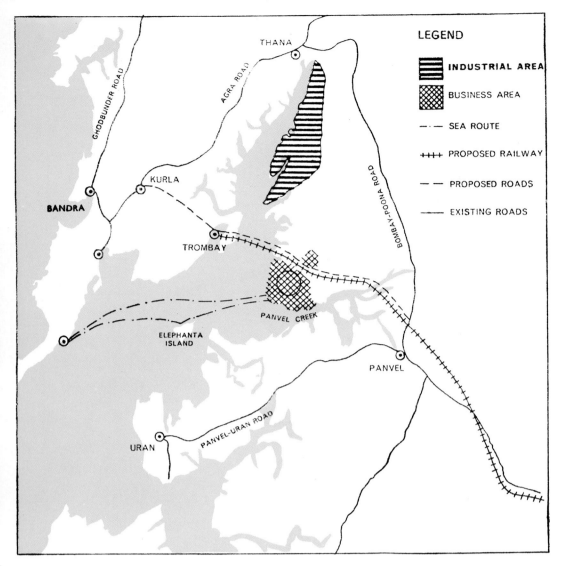

STAGE 3

The presence of the new centre would encourage industrial development along the road connecting it to Thana. This new industrial development would be a continuation of the industrial belt which already exists across the creek.

Thana creek thus becomes an Industrial waterway; and can be used by barges which can pass beneath the Thana creek bridge and which will carry material and finished goods directly from the industries to the city of Bombay, and to the docks, etc.

20. *Industrial Development along Thana creek.*

21. *Housing.*

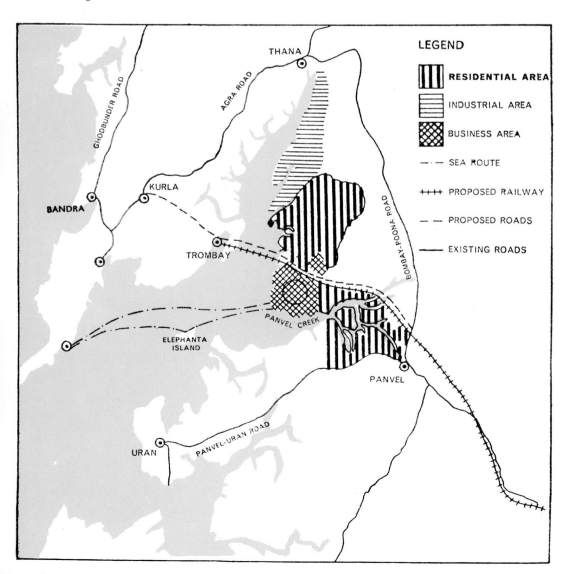

STAGE 4

As industry and the commercial centre develop, a demand for housing for all income groups will be created.* This housing can be located near the business centre on the waterfront and also on the hills beyond.

A small dam can be built on Panvel creek just east of the centre. This dam will carry the highway which connects Thana to Uran; it will also control the water levels of the rivers in the interior, which would greatly enhance the development of residential areas on the islands and river fronts.

*Even slum clearance—so difficult to enforce today would be greatly facilitated by a new city. The presence of employment areas across the harbour with their ancillary residential facilities would itself induce a movement of people out of the old slums into the new areas. The slum areas vacated could then be redeveloped with the legal and political difficulties vastly diminished.

STAGE 5

The Bombay Port Trust finds that the present docks in the island cannot be extended sufficiently for want of space. Fresh docking facilities will have to be located across the creek on the mainland and the areas most likely to be selected are adjacent to the site proposed for the new business centre. The location of the docks here would further stimulate development.

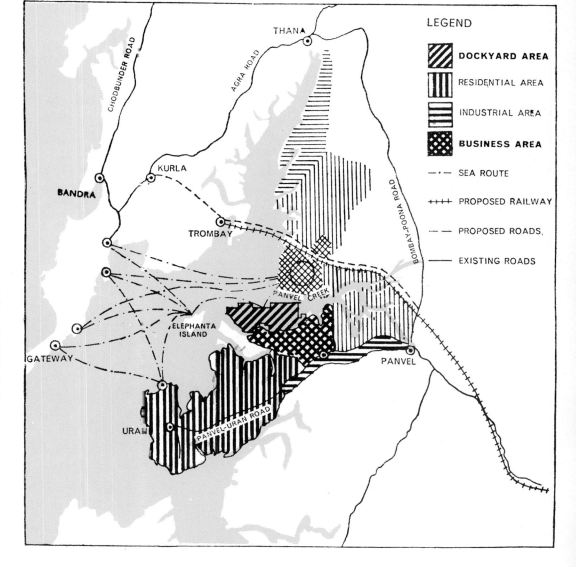

22. *New Docking facilities.*

23. *Additional Road—Rail links to Bombay Docks.*

STAGE 6

As development proceeds, the need will eventually be felt for more than one link between the mainland and the peninsula. The feasibility of a second bridge across the harbour exists from Trombay to Elephanta island and the mainland near the new dock area. Traffic coming over such a bridge into Trombay would have the choice of turning Northwards towards the new industrial areas and the suburbs or of skirting an area of 2,700 acres to be reclaimed between Wadala and Trombay (a proposal recommended by the study group on Greater Bombay) and moving directly into Frere Road and the Southern tip of the island. The large volume of traffic flowing over the bridge could thus be dispersed and the open areas available at Trombay would permit a spacious layout of fly-overs and intersections.

This area would then develop into a new self-sufficient city whose continual contact and exchange with the older city would be primarily for social, cultural and commercial reasons and not as a 'dormitory' area feeding the already overcrowded island.

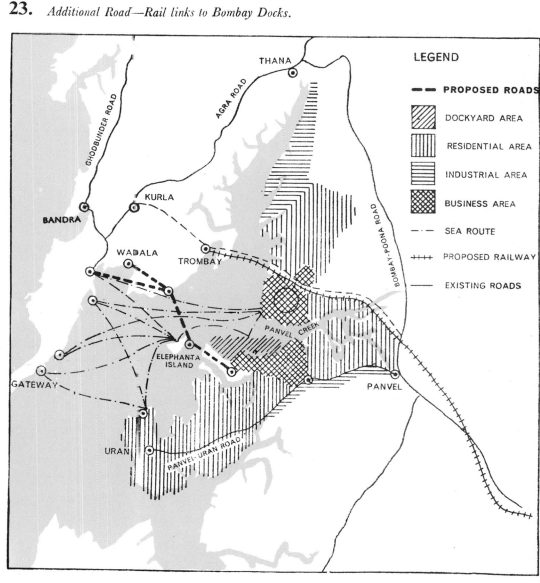

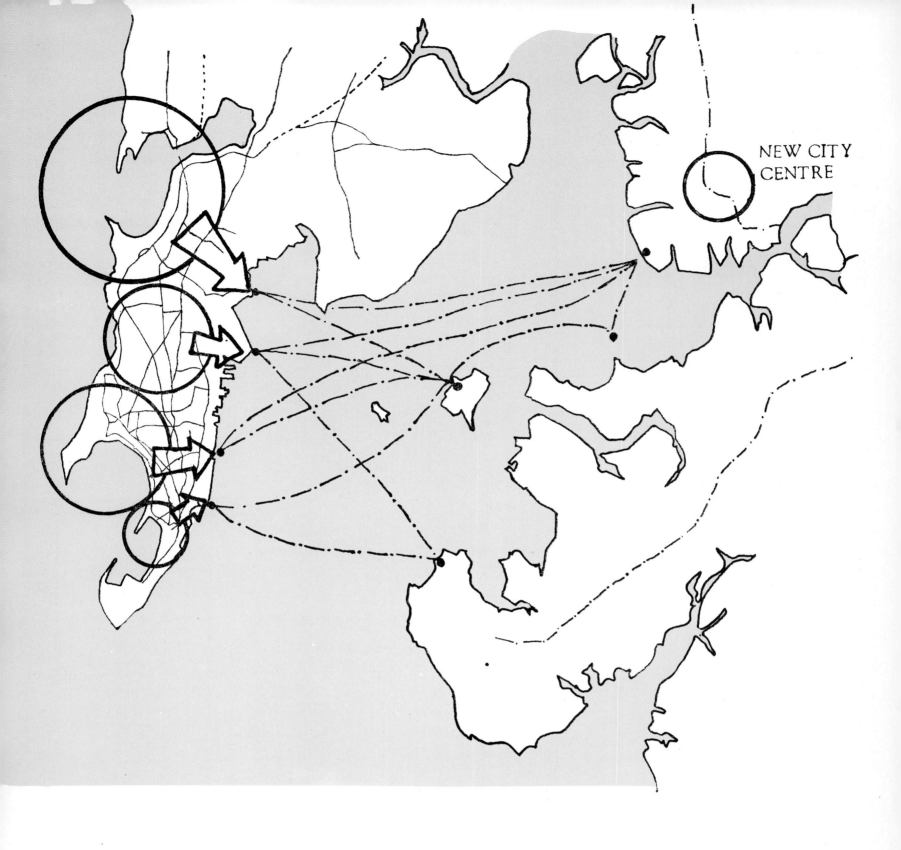

24. *Effect of the New City on the Old.*

The new twin city of Bombay would be a city on the sea, with much of its traffic moving across the harbour. Citizens who formerly spent much of their time in the interior of the island and away from its shores would begin to experience the harbour and the sea as part of their everyday lives.

Elephanta, and with it a sense of the past, would stand in the centre of the twin city. Entering the harbour one would see the city on both sides on the one side extending over the island, and on the other rising above its shores into

the hills beyond. In the harbour and across the bridges one would see a constant and busy movement. Arriving from the mainland one would descend the hills into the new city, part of the capital of Maharashtra and beyond over a bridge and the harbour into the older city.

Within the older city, the East-West road would grow considerably in importance as they would become major arteries connecting the Western areas of the island with the waterfront along the harbour. Since these East-West roads

are less than one-tenth as long as the North-South arteries, the cost of widening them would be considerably less. Citizens from all over the island would use these East-West arteries to cross to the Eastern waterfront where would be located large, magnificent plazas which would act as focal points for the island. From these plazas one would board boats and motor launches to cross the harbour. One of them—Apollo Bunder—already exists; the other two—Wadala and Sewri—would be treated in a like manner.

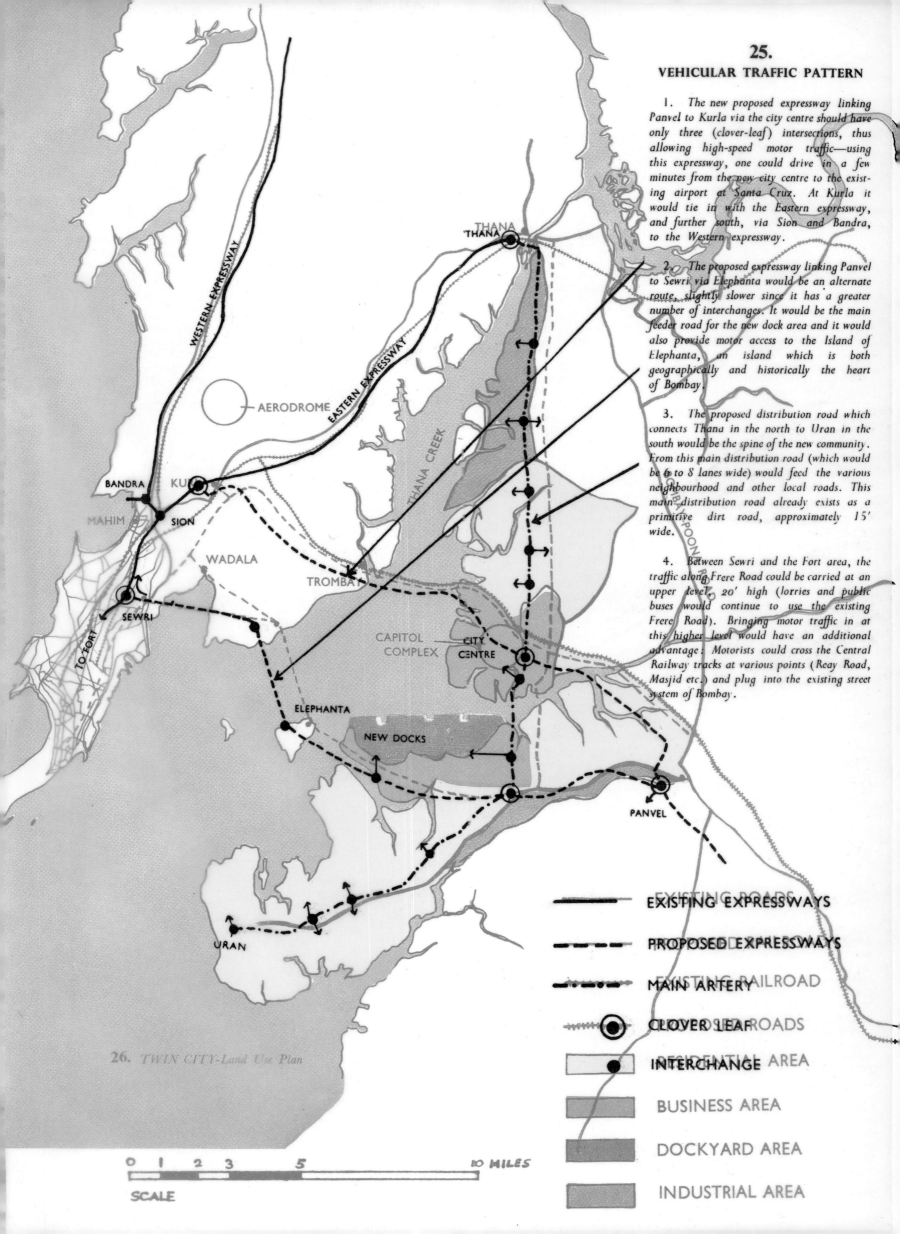

25.
VEHICULAR TRAFFIC PATTERN

1. The new proposed expressway linking Panvel to Kurla via the city centre should have only three (clover-leaf) intersections, thus allowing high-speed motor traffic—using this expressway, one could drive in a few minutes from the new city centre to the existing airport at Santa Cruz. At Kurla it would tie in with the Eastern expressway, and further south, via Sion and Bandra, to the Western expressway.

2. The proposed expressway linking Panvel to Sewri via Elephanta would be an alternate route, slightly slower since it has a greater number of interchanges. It would be the main feeder road for the new dock area and it would also provide motor access to the Island of Elephanta, an island which is both geographically and historically the heart of Bombay.

3. The proposed distribution road which connects Thana in the north to Uran in the south would be the spine of the new community. From this main distribution road (which would be 6 to 8 lanes wide) would feed the various neighbourhood and other local roads. This main distribution road already exists as a primitive dirt road, approximately 15' wide.

4. Between Sewri and the Fort area, the traffic along Frere Road could be carried at an upper level 20' high (lorries and public buses would continue to use the existing Frere Road). Bringing motor traffic in at this higher level would have an additional advantage: Motorists could cross the Central Railway tracks at various points (Reay Road, Masjid etc.) and plug into the existing street system of Bombay.

WESTERN EXPRESSWAY

EASTERN EXPRESSWAY

THANA

AERODROME

THANA CREek

BANDRA KU

MAHIM SION

WADALA

TROMBA

SEWRI

TO-FORT

CAPITOL COMPLEX

CITY CENTRE

ELEPHANTA

NEW DOCKS

PANVEL

URAN

26. TWIN CITY-Land Use Plan

— — — EXISTING EXPRESSWAYS

— — — PROPOSED EXPRESSWAYS

—·—·— MAIN ARTERY

⊚ CLOVER LEAF

● INTERCHANGE

BUSINESS AREA

DOCKYARD AREA

INDUSTRIAL AREA

0 1 2 3 5 10 MILES

SCALE

Painters and Engravers: Biographical Notes

John Brownrigg Bellasis (1806-90) belonged to this well-known family, several generations of which served in the Bombay Army. Bellasis Road near the family home of Randall Lodge on Cumballa Hill in Bombay, was named after his forebear, General John Bellasis. John Brownrigg served with the Bombay Army in western India, the Deccan, and Bombay between 1822 and 1858, retiring as Major-General. As an amateur artist he followed another family tradition — painting watercolour studies of a wide range of subjects. While in Bombay, he noted in his journal that "My Porte-Folio of drawings are thought a great treasure here, I take great care of them". (India Office Library and Records: Photo Eur. 35). See Godrej: figures 1, 2, and 13.

Julius Middleton Boyd (1837-1919), an amateur artist, served with the Bombay Army from 1854 until his retirement as Major-General in 1894. During the 1880s, he made an album of watercolour studies of Bombay, western India, and elsewhere. See Godrej: figure 12.

William Carpenter (1819-99), a professional artist, was one of the most skilled mid-nineteenth century watercolourists of the Indian scene. He was in India between 1850 when he arrived in Bombay, and 1857 when he returned to London. He travelled extensively throughout the northern regions making highly illustrative watercolours of Indian life, its scenery, and portraits of local people, some of which were reproduced in *The Illustrated London News*. See page 133; Desai: figure 9; Dwivedi, "Homes": figures 2 and 3; Mehrotra: figure 4.

Edward Brotherton Carroll (fl. latter half of the nineteenth century) was on the staff of the BB&CI Railway for about thirty years, becoming Superintendent of the Locomotive and Carriage Department at Parel by 1867. He lived on Mount Pleasant Road, Malabar Hill. An amateur artist, he specialized in landscape painting in watercolour and oils, and took part in local exhibitions. In 1890-91, he won two medals for the best oil paintings in the Bombay Art Society exhibition. Though technically accomplished, his artistic work cannot be associated with that of the progressive artists who also exhibited at these shows. His paintings belong to the traditional style of nineteenth-century English landscape painting. See Godrej: figure 6.

Nicholas Chevalier (1828-1902) was a professional artist who accompanied H.R.H. Prince Alfred, Duke of Edinburgh, as one of the official painters on his voyage round the world in H.M.S. *Galatea*, 1867-71. The royal party, which travelled extensively in India, reached Bombay in March 1870. In addition to recording official events of the tour, Chevalier produced vivid topographical drawings and watercolours, including a double panorama of Bombay harbour. See Desai: figure 3.

John Clark (*circa* 1770-1863) was a prolific engraver in London, who specialized in plates for travel books including several of oriental subjects. See Desai: figure 7.

Thomas Cussans (1796-1830) served in the Madras Artillery from 1817 until 1829, when he became Captain. As a skilled amateur artist, his work is known from a sketchbook in the India Office Library, made during a journey through south India to Bombay probably in 1817. It contains a number of vivid watercolours including one of Bombay Fort. See Desai: figure 11.

Mahadev Viswanath Dhurandhar (1867-1944) enjoyed high social standing as artist and teacher, his personal ambition dovetailing into the Raj education policy. From the 1890s, a period that coincided with the postcard "explosion" in the West, he designed postcards for a local manufacturer, the first Indian to do so. His debut at the Bombay Art Society was in 1892 as a painting student. His proposed entry so impressed Principal Greenwood that he personally submitted it to the Society. The drawing won Dhurandhar a prize of Rs 50, the first of the awards he won at the Society which made his reputation in the region. See page 1.

T.H.A. Fielding (1781-1851) was a professional watercolourist and aquatint engraver of topographical views working in and around London, and a regular exhibitor at the Royal Academy. He never visited India but in 1826 was appointed assistant civil drawing master at the East India Company's Military College at Addiscombe. He frequently engraved views of India. See "Sacred Precincts": figure 19.

James Forbes (1749-1819), an East India Company civilian, was one of the earliest amateur artists in western India, and author of *Oriental Memoirs*. See Rohatgi: article and figures 3-9; Desai: figures 4 and 5.

José M. Gonsalves (fl. 1826-42) was almost certainly of Goan origin and an artist with an individual, somewhat naive style. He was one of the first artists to practise lithography in Bombay. He specialized in topographical views of the city, that include a number of the new neo-classical buildings in the Fort area. See Albuquerque: article and figures 1 and 12-15.

Linette Rebecca Griffiths (born 1843) nee Davis, married John Griffiths (1837-1918), the noted architectural sculptor and later Superintendent at the Sir J.J. School of Art and Industry, at St Thomas' Cathedral, Bombay in 1870. Both she and her husband painted vivid images of Bombay. See Mehrotra: figure 5.

Robert Melville Grindlay (1786-1877) is probably the best known amateur artist associated with Bombay and western India. He served in the 7th Bombay Native Infantry from 1804 until he retired as Captain in 1820. His book *Scenery, Costumes and Architecture, chiefly on the western side of India,* London, 1826-30, includes two views of Bombay Green after his paintings, which have been reproduced elsewhere many times. Another aquatint of Bombay after William Westall from Grindlay's book is reproduced in this volume. See "Sacred Precincts": figure 19.

Axel Herman Haig (1835-1921), a professional artist, described as every architect's friend, specialized in "presentation pictures" especially of High Victorian buildings, for exhibition or engraving. He never visited India but painted Stevens' GIP Railway Station especially for the Royal Academy's exhibition of 1880 based on the architect's designs. See London: figure 3.

Henry Francis Hancock (1833-87) of the Royal Engineers spent much of his career, from 1854 onwards, with the Railway Department in Bombay becoming Chief Engineer, and Secretary to the Government of India, Public Works Department. He was an accomplished amateur watercolourist of topographical subjects. He married Madeline Ashmore at Bath in 1864; they lived subsequently at No. 181 Tarwady Road on Malabar Hill. He retired, a Major-General, in 1886 and died suddenly in Calcutta the following year. There is a tablet to his memory in St Thomas' Cathedral. See Godrej: figures 3 and 5.

Madeline Hancock (fl. 1865-66) was the wife of Henry Francis Hancock. An amateur artist, her work is known from an album in the India Office Library, of humorous sketches recording scenes of her domestic and social life, made shortly after she first arrived in India. She apparently prepared the album to send to a relative, Hariette Paley Ashmore, to whom it is inscribed. See Godrej: figures 3 and 4.

Charles Heath (1785-1848) was a line-engraver working in London. See Rohatgi: figure 5.

John Frederick Lester (1825-1915), a keen amateur artist, served with the Bombay Army from about 1842 until 1873 when he transferred to the Political Department. In March 1870, he visited Bombay and stayed, as was common, in tented accommodation. His sketchbook includes a vivid study of "our tents" painted from the newly-constructed Watson's Hotel on Esplanade Road. See Dwivedi, "Homes": figure 9.

William Miller (1795-1836) was a skilled amateur draughtsman. He joined the Bombay Artillery as a cadet in 1810 and graduated through the ranks to become Director of the Depot of Instruction at Matunga in Bombay. It was during this time, while living at nearby Wadala, that he made topographical drawings of Bombay harbour. In 1835 he was appointed Judge Advocate-General of the army, but died the following year at Mahabaleshwar. See Desai: figure 8.

Leonard B. Moffatt (fl.1953) was Associate of the Institute of Naval Architects, when he painted the unusual study of the P&O passenger liner, *Karanja* arriving in Bombay harbour during Coronation year. See Desai: figure 13.

James Phillips (fl. 1784-99) was a landscape engraver working in London. See Rohatgi: figure 9.

Arthur Prescott (1810-66), an amateur artist, served in the Bombay Army's 2nd Light Cavalry regiment from 1827; he became Captain in 1843 and Colonel in 1861, the year he went on furlough and retired. See Guzder: figure 4.

J. Shury (fl. early nineteenth century) was an engraver of bookplates depicting landscapes and architectural views, working in London. See Rohatgi: figure 3.

William Simpson (1823-99), professional artist and illustrator, visited the Indian subcontinent four times. He saw Bombay in the spring of 1862 towards the end of his first great tour of India, 1859-62, for the lithographic publishers Day & Son of London. Throughout his journeys, he made numerous sketches and watercolours depicting a variety of subjects, especially scenes of Indian life. His book *India Ancient and Modern* was published in 1867 with lithographs of only a fraction of those originally planned from his great collection of watercolours.

Reporting for *The Illustrated London News,* he visited Bombay again in 1875 and 1876 as official artist on the tour of the Prince of Wales (later Edward VII), and lastly in 1879 after covering the Afghan war. Like his contemporary, William Carpenter, Simpson was producing vivid watercolours at a time when photography was in its ascendancy. See Godrej: figure 9; Desai: figure 12; Steggles: figures 1 and 4.

James Storer (1781-1853) was an engraver working in Cambridge and London, who specialized in topographical views. See Rohatgi: figure 8.

Robert Temple (*circa* 1780-1818) was a prolific amateur artist, a number of whose pictures were published as engravings. He served with H.M. 65th Regiment of Foot (as a private in the band) from 1806, in the Persian Gulf, Mauritius, Bombay and western India until his death in Bombay. His unusual set of small watercolours painted on card includes some rare glimpses of people and places in Bombay in 1810-11. See Desai: figures 7 and 10.

Horace van Ruith (1839-1923), probably of Russian origin, was born in Capri. A professional painter, he specialized in portraiture, landscapes and genre scenes in oil and watercolour. Although subsequently based in England, he spent several years working in Italy. He visited Bombay sometime between 1879 and 1884 and is known to have established a studio in the city. He painted a number of works portraying the local people, especially those employed in various trades — coolies at work, a cotton-cleaner, a cord-maker, and street musicians. On return to London, he took part in the Colonial and Indian exhibition, opened by Queen Victoria in 1886, when he showed a number of similar subjects. It also included the panoramic view from Malabar Hill across Back Bay. Her son, the Duke of Connaught, noted of him in a letter to the Queen that: "No man understands the peculiar characteristics of Indian life better than he does & he is a very clever artist." After this he exhibited regularly in England including the Royal Academy exhibitions in London, where he showed "Money Changer, Bombay" in 1900. He almost certainly visited India again, probably around 1900, for he also worked in Baroda at the invitation of the Gaekwad. Despite his long life and obviously considerable output, his pictures are rare today. See section divider pages 130-31; Dwivedi, "Homes": figure 1.

Jan van Ryne (1712-60) was a Dutch topographical artist and engraver working in London. In 1754, he engraved a set of views depicting six East India Company settlements, including three — Fort William, Fort St George, and Bombay — in India. See Desai: figure 6.

James Wales (1747-95) was a professional portrait and landscape artist working in Bombay and Poona.

His celebrated set of prints, *Twelve Views of the Island of Bombay and its Vicinity* was published posthumously in 1800. See Rohatgi: article and figures 1, 2, and 9-14; Godrej: figure 10.

Edwin Lord Weeks (1849-1903), who specialized in grandiose genre scenes of the Orient, besides intimate and perceptive studies of local people, visited India during the 1880s and 1890s. On arrival at Bombay for the third time, he "went straight to a more suburban quarter in the vicinity of Malabar Hill. The chosen hostelry was the type of old-time colonial hotel, a three-storied [sic] barrack surrounded by tiers of trellised wooden galleries." (Weeks, *From the Black Sea through Persia and India,* p. 391). It was perhaps while staying on Malabar Hill that he painted, clearly on the spot, the brilliant study in oils titled "Temples and Tank of the Walkeshwar at Bombay"; the picture was exhibited, after his death, at the Empire of India exhibition at Wembley in 1924. See Godrej: figure 7.

William Westall (1781-1830) was official landscape artist on Matthew Flinder's expedition of 1801-03 to Australia. He visited Bombay on his way home to England in 1804. A number of his views of Bombay and district, including the Western Ghats, were included as aquatints in Robert Melville Grindlay's celebrated book, *Scenery, Costumes and Architecture, chiefly on the western side of India,* London, 1826-30. See "Sacred Precincts": figure 19.

Thomas Wingate (1807-69) of the British Army's 2nd Queen's Royal Regiment, 1828 - *circa* 1846, painted a complete circular panorama of Bombay from the Fort. See Albuquerque: article and figures 2-11.

William Frederick Witherington (1785-1865) was a professional artist mainly of landscape subjects, who never visited India. Between 1820 and 1828, he exhibited five views of Bombay at the Royal Academy, mostly after sketches by Lieutenant-Colonel John Johnson of the Bombay Engineers. They included an oil painting titled "View of Part of the Island of Bombay, from the hill near the Parsee tombs", which subsequently belonged to Sir James Rivett-Carnac, Governor of Bombay 1834-41. This oil painting is identical in composition to the watercolour in the India Office Library (WD 2387) which, according to an old inscription on the verso, was painted for William Page Ashburner, a member of Forbes & Co. and Mayor of Bombay during the 1820s. The inscription (written by Ashburner's son as late as 1930) also notes that it was painted by a lady artist in 1823 for her father. The watercolour is, however, ascribed to Witherington on account of its links with the oil painting. See section divider pages 18-19.

SELECT BIBLIOGRAPHY

Acharya, Balkrishna Bapu and Moro Vinayak Shingne, *Mumbaicha Vrittanta* (in Marathi), Bombay, 1889.

Albuquerque, T., *Urbs Prima in India, Bombay 1840-65,* New Delhi, 1985.

Anon., *A Description of the Port and Island of Bombay,* London, 1724.

Anon., *Catalogue of Maps in the Bombay Archives* 3 vols., Bombay, 1979; 1985; 1987.

Anon., *Life in Bombay and Neighbouring Outstations,* London, 1852.

Archer, M., *British Drawings in the India Office Library* 2 vols., London, 1969; Vol. 3 (P. Kattenhorn), London, 1995.

Archer, M., *India and British Portraiture 1770-1825,* London, 1979.

Archer, M., *Visions of India: The Sketchbooks of William Simpson,* Oxford, 1986.

Ballhatchet, K. and J. Harrison, *The City in South Asia: Pre-Modern and Modern,* London, 1980.

Banerji, D.R., *Bombay and the Sidis,* London, 1932.

Banga, I., *Ports and the Hinterlands in India,* Bombay, 1992.

Basu, D.K. (ed.), *The Rise and Growth of the Colonial Port Cities in Asia,* Berkeley, 1985.

Bcttye, E., *Costumes and Characters of the British Raj,* Gloucester, 1982.

Beattie, S., *The New Sculpture,* New Haven and London, 1983.

Belasis, M., *Honourable Company,* London, 1952.

Bence-Jones, M., *Palaces of the Raj: Magnificence and Misery of the Lord Sahibs,* London, 1973.

Birdwood, G., *Catalogue of the Economic Products of the Presidency of Bombay; being a Catalogue of the Government Central Museum,* Bombay, 1862.

Birdwood, G., *Report on the Government Central Museum and on the Agricultural and Horticultural Society of Western India, for 1863, being the history of the Establishment of the Victoria and Albert Museum and of the Victoria Gardens, Bombay,* Bombay, 1864.

Birdwood, G., *The Industrial Arts of India,* Bombay, 1880.

Black, J. (ed.), *The Blathwayt Atlas,* Providence, 1970.

Briggs, A., *Victorian Cities,* Middlesex, 1968.

Bulley, A., *Free Mariner: John Adolphus Pope in the East Indies,* BACSA, London, 1992.

Bulley, A., "The Bombay Country Ships (1786-1833)", unpublished MS, 1997.

Burford, R., *Description of a view of the island and harbour of Bombay, now exhibiting at the Panorama, Leicester Square,* London, 1831.

Burnell, J., *Bombay in the days of Queen Anne,* Hakluyt Society, London, 1933.

Burns, C.L., *Catalogue of the collection of maps, prints and photographs illustrating the history of the island and city of Bombay [in the Bhau Daji Lad Museum],* London, 1918.

Campbell, J. and R.E. Enthoven, (eds.), *Gazetteer of the Bombay Presidency* 27 vols., Bombay, 1876-1904.

Chevalier, N. and O.W. Brierley, *The Cruise of H.R.H. The Duke of Edinburgh 1867-71,* London, 1872.

Cobbe, R., *Bombay Church: a true account of the building and finishing of the English Church [St. Thomas'] at Bombay in the East Indies,* London, 1766.

Cope, Captain, *A New History ... religious customs, manners and trade ... and description of the fort ...,* London, 1754.

Correa, C., *The New Landscape,* Bombay, 1985.

Correa-Rodriques, D., *Bombay Fort in the 18th Century,* Bombay, 1994.

Cox, H.E., *The Story of St Thomas's Cathedral, Bombay,* Bombay, 1947.

da Cunha, J.G., *The Origin of Bombay,* Bombay, 1900; 1909.

Das Gupta, A., *Indian Merchants and the Decline of Surat circa 1700-50,* Wiesbaden, 1979.

David, M.D., *History of Bombay 1661-1708,* Bombay, 1973.

David, M.D., *John Wilson and his Institution,* Bombay, 1975.

Davies, P., *Splendours of the Raj: British Architecture in India 1660-1944,* London and New Delhi, 1985.

de Souza, David (ed.), *Picture Mumbai, Landmarks of a new generation*, Mumbai, 1997.

Desai, S.P. and R.S. Pednekar (B.G. Kunte, ed.), *The Handbook of the Bombay Archives*, Bombay, 1978.

Dobbin, C., *Urban Leadership in Western India: Politics and Communities in Bombay City 1840-85*, Oxford, 1972.

Dorment, R., *Alfred Gilbert*, New Haven and London, 1985.

Dossal, M., *Imperial Designs and Indian Realities. The Planning of Bombay City 1845-75*, Bombay, 1991.

Douglas, J., *Book of Bombay*, Bombay, 1883.

Douglas, J., *Round about Bombay* 2 vols., Bombay, 1883 and 1886.

Douglas, J., *Bombay and Western India, a series of stray papers* 2 vols., Bombay, 1893.

Douglas, J., *Glimpses of Old Bombay and Western India with other papers*, London, 1900.

Dwivedi, S. and R. Mehrotra, *Bombay—The Cities Within*, Bombay, 1995.

Dyson, K.K., *A Various Universe: A Study of the Journals and Memoirs of British Men and Women in the Indian Subcontinent 1765-1856*, Oxford, 1978.

Edney, M., *Mapping an Empire: The Geographical Construction of British India, 1765-1843*, Chicago, 1997.

Edwardes, S.M., *The Rise of Bombay: A Retrospect*, Bombay, 1902.

Edwardes, S.M., *The Bombay City Police – A Historical Sketch, 1872-1916*, Oxford, 1923.

Edwardes, S.M., *The Gazetteer of Bombay City and Island* 3 vols., Bombay, 1909 and 1978 (reprint).

Falkland, Lady, *Chow Chow: A Journal kept in India, Egypt and Syria*, London, 1830; and H.G. Rawlinson (ed.), London, 1930.

Fawcett, C., *The English Factories in India Vol. 1: The Western Presidency 1670-77*, Oxford, 1936.

Fleming, J., H. Honour, and N. Pevsner, *The Penguin Dictionary of Architecture* 4th edition, Harmondsworth, UK, 1991.

Forbes, J., *Oriental Memoirs: Selected and Abridged from a Series of Familiar Letters Written during Seventeen Years Residence in India* 4 vols., London, 1812-13; 3 vols., London, 1834-35 (revised and abridged by Forbes' daughter, the Countess de Montalembert); 4 vols., New Delhi, 1988 (reprint of 1812-13 edition).

Foster, W., *The English Factories in India* 13 vols., Oxford, 1906-27.

Fryer, J., *A New Account of East India and Persia, being Nine Years' Travels 1672-1681*, London, 1698; and W. Crooke (ed.), London, 1909.

Furber, H., *Bombay Presidency in the mid-eighteenth century*, New York, 1959.

Ganley, K.D., *The Art of Edwin Lord Weeks (1849-1903)*, Durham, USA, 1976.

Godrej, P. and P. Rohatgi, *Scenic Splendours: India through the Printed Image*, London, 1989.

Gole, S., *India within the Ganges*, New Delhi, 1983.

Gonsalves, J.M., *Lithographic Views of Bombay*, Bombay, 1826.

Gonsalves, J.M., *Views at Bombay*, Bombay, circa 1833.

Graham, M. (Lady Callcott), *Journal of a Residence in India ... 1812*, Edinburgh, 1813.

Graham, M. (Lady Callcott), *Letters on India*, London, 1814.

Grindlay, R.M., *Scenery, Costumes and Architecture, chiefly on the western side of India* 2 vols., London, 1826-30.

Grose, J.H., *A Voyage to the East Indies*, London, 1757; 1766; and 1772.

Groseclose, B., *British Sculpture and the Company Raj*, Newark, 1995.

Gunnis, R., *Dictionary of British Sculptors 1660-1851*, London, 1951; London, 1964 (revised edition).

Gupchup, V., *Bombay Social Change 1813-57*, Bombay, 1993.

Hamilton, A. (ed. W. Foster), *A New Account of the East Indies* 2 vols., London, 1930.

Heber, R., *Narrative of a Journey through the Upper Provinces of India, from Calcutta to Bombay, 1824-25* 3 vols., London, 1828.

Hewat, E.G.K., *Christ in Western India*, Bombay, 1950.

Hitchcock, H.R., *Architecture: 19th and 20th Centuries*, Harmondsworth, UK, 1958.

Kabraji, K.N., *Fifty Years Ago, Reminiscences of mid 19th century Bombay*, Times of India, 1901-02.

Karaka, D.F., *History of the Parsis* 2 vols., London, 1884.

Karkaria, R.P. (ed.), *The Charm of Bombay: An Anthology of Writings in praise of the First City in India*, Bombay, 1915.

Kasal, Capt. Atul, ADC to the Governor of Maharashtra (compiled by), *Raj Bhavan, Bombay*, Bombay, November 1994.

Kindersley, A.F., *Handbook of the Bombay Government Records*, Bombay, 1921.

Kosambi, M., *Bombay and Poona: A Socio-Ecological Study of Two Indian Cities, 1650-1900*, Stockholm, 1980.

London, C.W., "British Architecture in Victorian Bombay", unpublished D.Phil. thesis for Oriel College, Oxford University, 1986.

London, C.W. (ed.), *Architecture in Victorian and Edwardian India*, Bombay, 1994.

Mackenzie, G., *Pen Sketches of Scenery in the Island and Presidency of Bombay [a series of 24 lithographs]*, no place, 1842.

Maclean, J.M., *Guide to Bombay*, Bombay, 1875; then probably annually until 1902 (Bombay and London, 27th edition).

Madgaokar, G.N. and N.R. Phatak, *Mumbaiche Varnan* (in Marathi), Bombay, 1863.

Mainkar, T.G. (ed.), *Writings and Speeches of Dr Bhau Daji*, Bombay, 1974.

Mehrotra, R. and S. Dwivedi, *Banganga Sacred Tank*, Bombay, 1996.

Mehrotra, R., G. Nest, and S. Savant (eds.), *Conserving an Image Centre - the Fort Precinct in Bombay* 2 vols., Bombay, 1994.

Mehrotra, R. and G. Nest (eds.), *Public Places in Bombay*, Bombay, 1997.

Metcalf, T.R., *An Imperial Vision, Indian Architecture and Britain's Raj*, London, 1989.

Michael, L.W., *History of the Bombay Municipal Corporation of the City of Bombay*, Bombay, 1902.

Mistree, K.P., *Zoroastrianism - An Ethnic Perspective*, Bombay, 1982.

Modi, J.J., *The Religious Ceremonies and Customs of the Parsees*, Bombay, 1937 and 1986.

Morris, J. and S. Winchester, *Stones of Empire: The Buildings of the Raj*, Oxford and New York, 1983.

Moses, Henry, *Sketches of India with Notes on the Seasons, Scenery and Society of Bombay, Elephanta and Salsette*, London, 1850.

Nightingale, P., *Trade and Empire in Western India 1784-1806*, Cambridge, 1970.

Nilsson, S., *European Architecture in India 1750-1850*, London, 1968.

Nix-Seaman, A.J., *The Afghan War Memorial Church and Historical Notes on Colaba*, Bombay, 1938.

Orr, J.P., *The Bombay City Improvement Trust from 1898 to 1909*, Bombay, 1911.

Ovington, J., *A Voyage to Surat in the Year 1689*, London, 1696.

Patel, D., *Delight and Desire: An Analysis of the Indian Film Poster*, unpublished thesis for London University, 1996.

Pevsner, N., *Pioneers of Modern Design*, London, 1936.

Phillimore, R.H., *Historical Records of the Survey of India* 4 vols., Dehra Dun, 1945-58.

Poonaghur, S.D., *Plan of the Consecration with plan, elevation and section of the Sepulchre, or Tower of Silence, Erected by Framjee Cowasjee Esquire, at Chowpatty Hill in 1832*, probably Bombay, circa 1832.

Postans, M., *Western India in 1838* 2 vols., London, 1839.

Pouget, R., *A Series of Views in India and in the Vicinity of Bombay*, London, 1843.

Read, B., *Victorian Sculpture*, New Haven and London, 1982.

Rohatgi, P., *Portraits in the India Office Library and Records*, London, 1983.

Rohatgi, P. and P. Godrej (eds.), *India: A Pageant of Prints*, Bombay, 1989.

Rousselet, L., *L'Inde des Rajahs: Voyage dans L'Inde centrale et dans les Presidences de Bombay et du Bengale*, Paris, 1875; English edition by C.R. Buckle (ed.), *India and its Native Princes*, London, 1876 and 1878.

Scott, C., *Views in the Island of Bombay ...*, London, 1860.

Seely, J.B., *Wonders of Ellora: or the Narrative of a Journey to the Temples and Dwellings*, London, 1824.

Simpson, W., *India Ancient and Modern*, London, 1867.

Simpson, W. (G. Eyre-Todd ed.), *The Autobiography of William Simpson*, London, 1903.

Smith, G., *The Life of John Wilson*, London, 1878.

Spear, P., *The Nabobs: A Study of the Social Life of the English in 18th century India*, Oxford, 1932; 1963; and London, 1980.

Stocqueler, J.H., *The Hand-Book of British India*, London, 1854.

Tindall, G., *City of Gold: The Biography of Bombay*, London, 1982.

Troll, C.W. (ed.), *Muslim Shrines in India*, New Delhi, 1992.

Vacha, R.K., *Mumbai no Bahar* (in Gujarati), Bombay, 1874.

Wacha, D.E., *Shells from the Sands of Bombay being my Recollections and Reminiscences 1860-75*, Bombay, 1920.

Wadia, R.A., *The Bombay Dockyard and the Wadia Master Builders*, Bombay, 1955; 1957; and 1972.

Wadia, S., *A Study of Zoroastrian Fire Temples*, Ahmedabad, 1990.

Wales, J., *Twelve Views of the Island of Bombay and its Vicinity*, London, 1800.

Weeks, E.L., *From the Black Sea through Persia and India*, New York, 1896.

Wilkinson, T., *Two Monsoons*, London, 1976.

INDEX